AT HOME
IN RENAISSANCE
ITALY

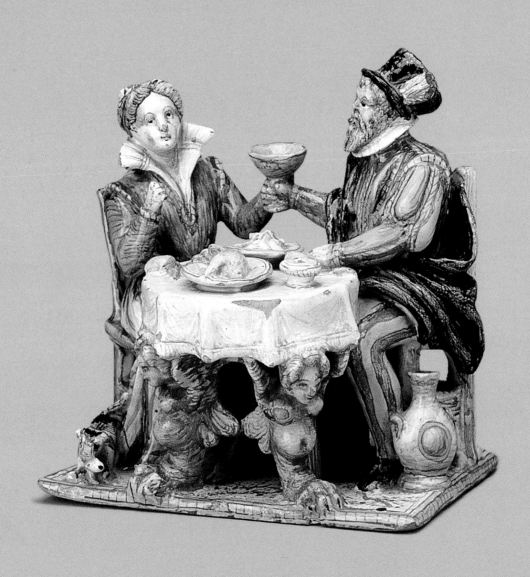

AT HOME
IN RENAISSANCE
ITALY

EDITED BY

MARTA AJMAR-WOLLHEIM
and FLORA DENNIS

SUMMARY CATALOGUE EDITED BY
ELIZABETH MILLER

First published by V&A Publications, 2006
V&A Publications
Victoria and Albert Museum
South Kensington
London SW7 2RL

Distributed in North America by Harry N. Abrams, Inc., New York

Hardback edition
ISBN-10 1 85177 488 2
ISBN-13 978 1 85177 488 3
Library of Congress Control Number 2006928678

10 9 8 7 6 5 4 3 2 1
2010 2009 2008 2007 2006

Paperback edition
ISBN-10 1 85177 489 0
ISBN-13 978 1 85177 489 0

10 9 8 7 6 5 4 3 2 1
2010 2009 2008 2007 2006

Designed by Janet James after an original design by the late Harry Green
New V&A photography by Christine Smith, Mike Kitcatt and Pip Barnard of the V&A
Photographic Studio

Front jacket/cover illustration: Sofonisba Anguissola, *Sisters Playing Chess* (detail), (plate 15.14)

Back jacket/cover illustrations (clockwise from top left): dish from Deruta (plate 7.14); spinet (plate
16.4); wedding chest from Florence (jacket only), (plate 7.18); rock crystal rosary (plate 14.8)

Frontispiece: Part of an inkstand from Urbino (plate 7.2)

Printed in Italy

V&A Publications
Victoria and Albert Museum
South Kensington
London SW7 2RL
www.vam.ac.uk

THE RESEARCH FOR THIS PROJECT WAS FUNDED BY

The Getty Foundation

Arts & Humanities
Research Council

CONTENTS

LIST OF LENDERS

Italy

Accademia Carrara, Bergamo
Museo Civico, Cremona
Museo Internazionale delle Ceramiche, Faenza
Museo Civico, Feltre
Museo Archeologico Nazionale, Ferrara
Archivio di Stato di Firenze, Florence
Museo Nazionale del Bargello, Florence
Biblioteca Medicea Laurenziana, Florence
Biblioteca Nazionale Centrale, Florence
Museo Horne, Florence
Museo Bardini, Florence
Museo degli Argenti, Florence
Museo Stibbert, Florence
Museo di Palazzo Davanzati, Florence
Museo Archeologico Nazionale, Florence
Galleria degli Uffizi, Florence
Gabinetto Disegni e Stampe degli Uffizi, Florence
Curia Vescovile di San Miniato, Pisa, loaned to the Museo di
 Fucecchio, Fucecchio
Soprintendenza per i Beni Archeologici della Liguria, Genoa
Accademia di Belle Arti di Brera, Milan
Civiche Raccolte d'Arte Applicata ed Incisioni, Milan
Museo Bagatti Valsecchi, Milan
Istituto di Storia Economica, Università 'L.Bocconi', Milan
Museo Archeologico e della Ceramica, Montelupo
Museo Archeologico Nazionale, Naples
NAUSICAA (Nucleo Archeologia Umida Subacquea Italia
 Centro Alto Adriatico), Venice
Museo delle Ceramiche, Pesaro
Museo del Tessuto, Prato
Collezione Saracini Chigi, property of Banca Monte dei Paschi
 di Siena, Siena
Museo della Casa Trevigiana Ca' Da Noal, Treviso
Museo Civico d'Arte Antica e Palazzo Madama, Turin
Soprintendenza per i Beni Archeologici del Piemonte e del
 Museo Antichità Egizie, Turin
Armeria di Palazzo Ducale, Musei Civici Veneziani, Venice
Galleria G. Franchetti alla Ca' d'Oro, Venice
Museo Correr, Musei Civici Veneziani, Venice
Museo del Vetro di Murano, Musei Civici Veneziani, Venice

The Netherlands

Rijksmuseum, Amsterdam

Poland

Muzeum Narodowe, Poznan, The Raczynski Foundation

United Kingdom

Harewood House, Leeds
Royal Armouries, Leeds
The British Library, London
The British Museum, London
English Heritage/Wernher Collection, Rangers House, London
The National Gallery, London
RIBA, London
The Worshipful Company of Cutlers, London
The Ashmolean Museum, Oxford
The Museum of the History of Science, Oxford
Longleat House, Wiltshire

USA

The Walters Art Museum, Baltimore, Maryland
The Detroit Institute of Arts, Detroit, Michigan
The Metropolitan Museum of Art, New York

A note on currency and measures in Renaissance Italy

Italian currency varied from state to state. Coins used for everyday transactions were made of silver and copper, and their nominal values were stated in terms of a money of account; in Tuscany and northern Italy this was the lira (1 *lira* = 20 *soldi* = 240 *denari*). Gold coins – *scudi*, florins, ducats – were also used. Their equivalents in silver and copper coins, and therefore also the *lira*, constantly changed as a consequence of both debasement of the latter coins and the international gold-silver ratio. Gold coins, instead, retained their intrinsic value. They were subject only to minimum adjustments and most were roughly equivalent. The Florentine florin, for instance, contained 3.53 grams of pure gold, and the Venetian ducat 3.55 grams. Gold money was used for most international transactions, for evaluating major investments and for the more expensive consumer goods, from real estate and the social capital of a capitalist enterprise to jewellery and paintings.

Measures also varied from place to place. A common unit of measurement for length was the *braccio* (plural *braccia*), which corresponded roughly to between one half and two thirds of a metre (for example, 0.58 m in Florence, and 0.68 in Venice).

DIRECTOR'S FOREWORD

At Home in Renaissance Italy is a ground-breaking exhibition, exploring for the first time the domestic interior's crucial role in the creation of Renaissance art and culture. Focusing on the urban house rather than better-known courtly interiors, and breaking down conventional distinctions between the 'fine' and 'decorative' arts, it creates ambitious displays that combine paintings and sculpture, furniture and ceramics, metalwork and archaeological finds. This approach results in an innovative three-dimensional view of the Italian Renaissance, presented as lived-in, object-filled spaces that bring to life the interior's visual and material complexity, rather than as a succession of images on museum walls. From Donatello's bronze roundel to Pontormo's birthtray, the exhibition also reveals how many prestigious artists of the time engaged in the production of objects for the home.

This exhibition has involved an extensive programme of new research. This was made possible by a Collaborative Research Grant from the Getty Foundation and the support of the AHRC Centre for the Study of the Domestic Interior, jointly run by the V&A, the RCA and Royal Holloway. This generous funding enabled an international team of scholars from a variety of disciplinary backgrounds to work jointly over a number of years. Two major conferences involved a wider audience, one organized with The Harvard University Center for Italian Renaissance Studies at Villa I Tatti, with additional support from the Samuel H. Kress Foundation and the Amici del Bargello. This joint research is fully reflected in the scope and depth of this exciting exhibition and publication.

The V&A possesses one of the richest collections of Italian Renaissance sculpture and decorative arts outside Italy. Featuring outstanding loans from museums across the world, including an unprecedented number from Italian collections, this exhibition allows us to see the extensive holdings of the V&A in a new light. It also represents a significant moment in the reassessment of the V&A's fifteenth and sixteenth-century collections, which will culminate with a major redisplay of the Medieval and Renaissance Galleries, opening in 2009.

In the nineteenth century, the V&A was amongst the first institutions to offer a new home to Italian art objects and furnishings that had been severed from their original domestic contexts. Designed to inspire generations of artists and designers, its collections also provide an invaluable source for the study of taste, consumption and cultural practice. These additional dimensions are brought to the fore in this exhibition's innovative merging of art and life. Exploiting this fruitful approach, both exhibition and book offer a fresh perspective which is set to challenge long-established views of the Italian Renaissance.

MARK JONES
Director of the Victoria and Albert Museum

ACKNOWLEDGEMENTS

It is impossible to contain within two pages the long list of individuals and institutions who have assisted this project over the past five years. We apologise in advance to anyone that we have failed to mention here.

We would like to thank the Getty Foundation for awarding us a Collaborative Research Grant, which enabled an international research team to work jointly over a period of two years. Joan Weinstein and Kathleen Johnson at the Getty Foundation assisted us admirably during the research period, and Antonia Boström and Catherine Hess at the Getty Museum provided advice and encouragement. It has been a real pleasure to share our various trips and research adventures with the scholars on the Getty research team, without whom this exhibition could have never taken place: Hugo Blake, Sandra Cavallo, Anna Contadini, Patricia Fortini Brown, Reino Liefkes, Elizabeth Miller, Brenda Preyer and Luke Syson.

The AHRC Centre for the Study of the Domestic Interior – run jointly by the V&A, the Royal College of Art and Royal Holloway – provided an intellectual home for this project together with extensive funding. We are especially grateful to Jeremy Aynsley, John Styles, Amanda Vickery, the research fellows and staff.

Special thanks must go to Joe and Françoise Connors and Allen Grieco at The Harvard University Center for Italian Renaissance Studies at Villa I Tatti for being ideal partners during the preparation of the jointly run conference, 'A Casa: People, Spaces and Objects in the Renaissance Interior'. The Samuel H. Kress Foundation also contributed very generously to a round table and conference. The Italian Ambassador in London, His Excellency Giancarlo Aragona, and Agostino Palese have provided assistance with important loans.

We are extremely grateful to our colleagues within the Museum who have assisted us with extraordinary patience and invaluable expertise. Beyond working tirelessly to edit the summary catalogue and bibliography, Elizabeth Miller's contribution to the success of the exhibition has been vital. Stephanie Cripps, the Assistant Curator, has supported us in all aspects of this project with dedication and good humour. In the early stages of the project, Reino Liefkes offered his expertise with enthusiasm and helped edit the feature spreads. We are also indebted to Linda Lloyd Jones, Anna Fletcher, Charlotte King, Poppy Hollman and David Packer in Exhibitions who have encouraged us at all stages of the exhibition organization. V&A Publications deserve gratitude for their patience with the book, and we would like to thank especially Mary Butler, Frances Ambler, Monica Woods, Janet James, the late Harry Green,

Colin Grant and Ariane Bankes. Lucy Trench has edited the panels and labels with meticulous care. The Research Department has provided us with an inspiring environment for the intellectual development of this project, and we would like to thank for their support Carolyn Sargentson, Christopher Breward, Ann Matchette, Glenn Adamson, Katrina Royall, Ghislaine Wood, Alexander Klar, Christopher Wilk, Corinna Gardner, Jana Scholze, Jane Pavitt and David Crowley. Volunteers and interns from the V&A/RCA History of Design MA Course, from the Bocconi University in Milan and the University of Rome have been of invaluable assistance: Chiara Amini, Adele Ara, Tasha Awais-Dean, Flaminia Bartolini, Melissa Hamnett, Rachel King, Denise Ko, Laura Legrenzi, Giorgia Mancini, Helena Nicholls, Kate Parkins, Alessandra Rebecchi and Abigail Wilkinson. From the Collections departments, we are particularly grateful to Terry Bloxham, Clare Browne, Marian Campbell, Alex Corney, Richard Edgcumbe, Mark Evans, Mary Guyatt, Nick Humphrey, Anna Jackson, Amin Jaffer, Norbert Jopek, Sophie Lee, Noreen Marshall, John Meriton, Susan North, Angus Patterson, Helen Persson, Michael Snodin, Susan Stronge, Mor Thunder, Rowan Watson, Paul Williamson, Linda Woolley and James Yorke. In Conservation, we thank all those who assisted with this project, especially Nicola Costaras, Charlotte Hubbard, Sofia Marques, Tim Miller, Christine Powell and Tina Cogram. We are also indebted to Technical Services and Christine Smith and Ken Jackson in the Photographic Studio, who efficiently coordinated new object photography. We have enjoyed the support of Michael Murray-Fennell, Debra Isaac, Damien Whitmore and their colleagues in Public Affairs; Justin Avery and his colleagues in Finance; Annabel Judd and her colleagues in Design; Nicole Newman and her colleagues in Development; and David Judd and his colleagues in Learning and Interpretation. We have benefited greatly from the opportunity of working alongside the Medieval and Renaissance Galleries team, particularly Malcolm Baker, Simon Carter, Stuart Frost, Katherine Hunt, Kirstin Kennedy, Peta Motture and Katy Temple. Finally, Mark Jones, Director of the V&A, has consistently provided essential guidance at crucial moments.

Opera 3D, our exhibition designers, deserve special thanks for their deep understanding of the philosophy of this project, and their support and good humour through both good times and bad: Frans Bevers, Lies Willers, Jeroen Luttikhuis, Ton Homburg and Letteke Klooster.

We are especially indebted to all lending institutions and private collectors for their generosity and support, listed in full on p.6, and to the many curators and scholars who have contributed their time and expertise. We would like

9

to thank the contributors to the book, many of whom provided extensive advice on the exhibition. Special thanks are due to Elizabeth Currie and Alexander Klar for their assistance with translations.

Various friends and colleagues have shared ideas and unpublished research with us, and helped far beyond the call of duty: Christopher Breward, Fausto Calderai and his colleagues, Simone Chiarugi, Georgia Clarke, Jennifer Fletcher, Giancarlo Gentilini, Richard Goldthwaite, Allen Grieco, Charles Hope, Ann Matchette, Sara Matthews-Grieco, Luca Molà, Antonella Nesi, Giulia Nuti, Beatrice Paolozzi Strozzi, Antonio Paolucci, Brenda Preyer, Carolyn Sargentson, Marco Spallanzani, Luke Syson, Dora Thornton, Giovanni Valagussa and Jeremy Warren. The following have contributed generously to the research and preparation of both the exhibition and book:

Doris Abouseif, John Allen, Patricia Allerston, Enrico Amante, Franco Amatori, the Amici del Bargello, Chiara Angelini, Franca Arduini, Luisa Arrigoni, Kirsten Aschengreen Piacenti, Adriana Augusti, Caroline Bacon, Pier Fausto Bagatti Valsecchi, Francesca Baldry, Peter Barber, Laura Basso, The Marquess of Bath, Armida Batori, Gabriella Battista, Graham Beal, Alessandro Belisario, Nicolas Bell, Pierangelo Bellettini, Andrea Bellieni, Anna Bellinazzi, Guido Beltramini, Jim Bennett, Jadranka Bentini, Fausto Berti, Fede Berti, Piero Boccardo, Kathryn Bosi, Annamaria Bravetti, Lynne Brindley, Alison Brown, Christopher Brown, Wolfger Bulst, Michael Bury, Suzy Butters, Paola Cacciari, Marilena Caciorgna, Caroline Campbell, Lorne Campbell, Tom Campbell, Giuliana Cangini, Niccolò Capponi, Marta Caroscio, Tiziana Casagrande, Ornella Casazza, Simonetta Castronovo, Marzia Cataldo Gallo, Francesca Cavazzana Romanelli, Giulia Ceriani Sebregondi, Beatriz Chadour, Keith Christiansen, Roy Clare, Elizabeth Cleland, Michela Cometti, Robin Cormack, Gino Corti, Irene Cotta, Thierry Crépin Leblond, Alan Darr, Fernando De Filippi, Raffaella De Gramatica, Daniela Degl'Innocenti, Ronald De Leeuw, David De Muzio, Dino De Poli, Clario Di Fabio, Simona Di Marco, Lucia Donati, James Draper, Jill Dunkerton, Andreana Emo Capodilista, Chris Entwistle, Gerolamo Etro, Anne-Marie Eze, Marzia Faietti, Iain Fenlon, Alessio Ferrari, Antonia Fontana, Luigi Fozzati, the Frescobaldi family, Lavinia Galli, Melissa Gallimore, Philippa Glanville, Heather Griffiths, Filippo Guarini, Chiara Guarnieri, Guido Guerzoni, Sonia Guetta Finzi, Piero Guicciardini, Margaret Haines, Lord Harewood, Anne d'Harnoncourt, Kate Harris, Wendy Hefford, Kristina Hermann Fiore, Charles Hind, Jack Hinton, Mary Hollingsworth, Maurice Howard, David Jaffé, Liz James, Lisa Jardine, Stephen Johnston, Larry Kantor,

Annie Kemkaran-Smith, Wolfram Koeppe, Jill Kraye, Daniela Lamberini, Amanda Lillie, Kate Lowe, Kent Lydecker, Björn Malmström and family, Francesca Mambrini, Giorgia Mancini, Rosaria Manno Tolu, Cristina Maritano, Mario Marubbi, Guido Mazzoni, Elizabeth McGrath, Neil McGregor, Massimo Medica, Piera Melli, Anna Melograni, Marja Mendera, Star Meyer, Piotr Michalowski, Lucia Monaci Moran, Philippe de Montebello, Giovanna Mori, Irena Murray, Jacqueline Marie Musacchio, Elisabetta Nardinocchi, Antonio Natali, Maria Luisa Nava, Chiara Nenci, Francesca Nenci, Fabrizio Nevola, Paula Nuttall, Barbara O'Connor, Michelle O'Malley, Enrica Pagella, Isabella Palumbo Fossati, Gabriella Panto, Claudio Paolini, Stephen Parkin, Linda Pellecchia, Loredana Pessa, Marina Petta, Lorenzo Pineider, Lucia Pini, Paola Pirolo, Massimo Pivetti, Carol Plazzotta, Ennio Poleggi, Julia Poole, Earl Powell III, Rosanna Proto Pisani, Guido Pugi, François Quiviger, Susan Rankin, Carmen Ravanelli Guidotti, Sheryl Reiss, Alison Richmond, Kathy Richmond, Giandomenico Romanelli, Niccolò Rosselli Del Turco, Davide Rossi, Patricia Rubin, Oliva Rucellai, Francesca Saccardo, Behrooz Salimnejad, Claudio Salsi, Marina Sapelli Ragni, Charles Saumarez Smith, Mario Scalini, Alessandra Schiavon, Silvana Seidel Menchi, Maria Sframeli, J P Sigmond, Chiara Silla, Maria Teresa Sillano, Farida Simonetti, Giuseppina Spadea, Joaneath Spicer, Laura Stagno, Wojciech Suchocki, Terry Suthers, Mons. Fausto Tardelli, Bruna Tommasello, Camillo Tonini, Maddalena Trionfi Honorati, Maria Grazia Vaccari, Andrea Vanni Desideri, Gary Vikan, Margherita Viola, Marino Vismara, the late Dean Walker, Ian Wardropper, Karen Watts, Evelyn Welch, Mary Westerman Bulgarella, Aidan Weston-Lewis, Timothy Wilson, Martin Wylde, Annalisa Zanni and Marino Zorzi.

No words can suffice in thanking our partners and families who have admirably endured the outlandish growth of this gargantuan beast: Alexander Masters, Nicholas, Caroline, Anna, Adam and Xanthe Dennis, the late Charles and Maisie Seeley, Bruno and Cecilia Wollheim, the late Richard and Anne Wollheim, Francesca and Roberto Ajmar and their families, Sandro and the late Lilli Ajmar, Martina Meclova and Marketa Istvankova.

MARTA AJMAR-WOLLHEIM
FLORA DENNIS

I

INTRODUCTION

MARTA AJMAR-WOLLHEIM AND FLORA DENNIS

DELLA ECONOMICA
T R A T T A T O D I M.
GIACOMO LANTERI
GENTILHVOMO
BRESCIANO

Nel quale ſi dimoſtrano le qualità, che all'Huomo & alla Donna ſeparatamente conuengono pel gouerno della Caſa.

CON PRIVILEGIO.

IN VENETIA, Appreſſo Vincenzo Valgriſi.
M D L X.

1.2 Giacomo Lanteri, *Della economica*, Venice, 1560 (British Library, London, 232.a.31) Books like this provided advice on the organization of the interior and on the management of the household.

1.1 (*right*) Vittore Carpaccio, *Birth of the Virgin*, Venice, *c.*1504–8 (cat.108) This is the first of a series of six paintings depicting scenes from the life of the Virgin, commissioned for the Scuola of Santa Maria degli Albanesi in Venice. With its prominent succession of rooms, this painting places central importance on the depiction of the interior and of domesticity.

A KEY QUESTION THAT STRIKES any scholar exploring the fifteenth- and sixteenth-century Italian domestic interior today is: why hasn't such a pivotal subject made it into the mainstream of Renaissance studies? This becomes even more perplexing when the question is asked from within the walls of a treasure-trove like the Victoria and Albert Museum, whose unparalleled Italian Renaissance collections – ranging from sculpture to maiolica, from textiles to furniture – are largely made up of objects that once furnished private houses. This book and the exhibition it accompanies are a testimony to the work of an interdisciplinary group of specialists committed to recuperating the history of the Renaissance home, surveying museum stores around the world, exhuming documents from archives and resuscitating the forgotten voices of domestic life through little-known objects and writings. The diverse backgrounds of this team – from art historians to historians of music, from socio-economic historians to medieval archaeologists and Islamic studies scholars – have ensured an equally rich approach to this complex subject and the mobilizing of a wealth of written, visual and material sources.

The 'Renaissance' becomes more remote from us every day and is subject to constant interrogation as a historical concept, from its periodization – 1300–1600 or *c.*1400–*c.*1550? – to its social and sexual meanings: for example, did women or the lower classes experience anything close to what we understand as the Renaissance?[1] Nevertheless, Renaissance domestic life has a hold on our imagination because, rightly or wrongly, we associate the emergence of a 'modern' notion of the home and the family with this period (plate 1.1), when new objects and furnishings familiar to us today, such as the fork, pairs of spectacles, the rosary and the tondo, were popularized. It is also tempting to see in Renaissance interiors the 'civilizing process' at work in everyday life, translated into new ideas of decorum, politeness and etiquette, and enforced by domestic artefacts: for

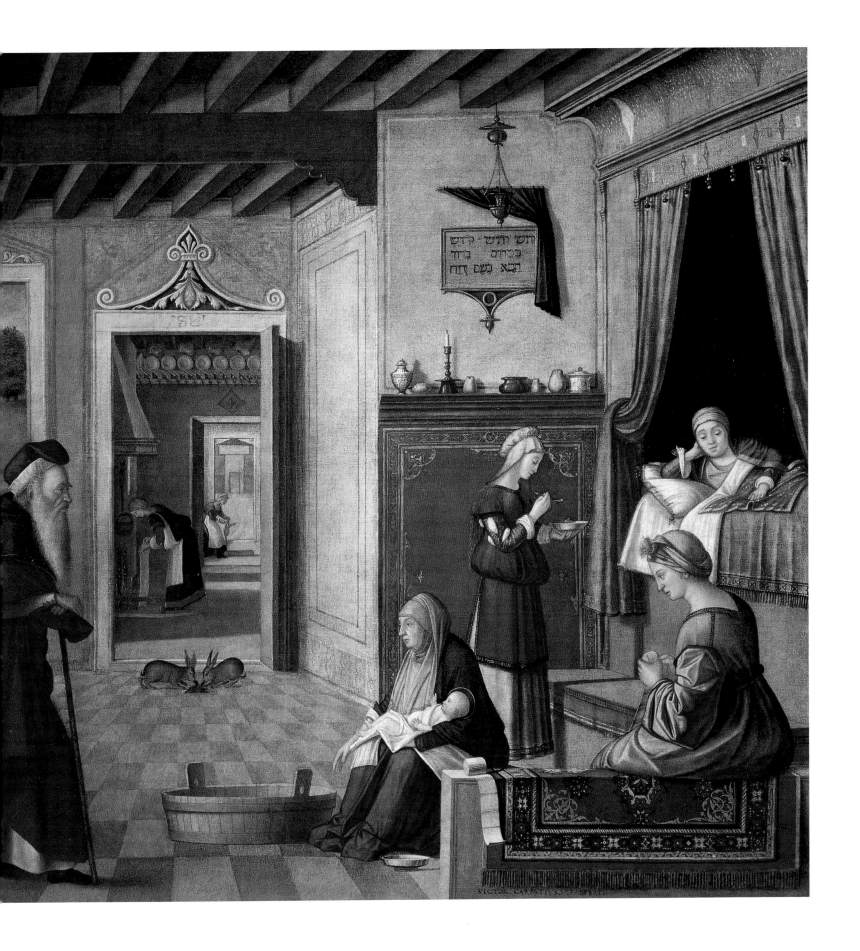

example, in the dramatic emergence of the individual table setting, requiring a separate chair, cutlery, glass and plate for each diner.

This book explores the development of the Italian Renaissance house and its contents in the belief that it is through a domestic perspective that we can best illustrate how the wider cultural, artistic and socio-economic changes we associate with this period actually affected people's everyday lives. It is also an attempt to conjure up the character of interiors and the life that took place within them by considering 'fine' and 'decorative' art objects together in the kind of domestic spaces that they originally occupied, thus restoring their original unity. By breathing some life into the many imposing Renaissance buildings that still line the streets of Italian cities today, it also aims to reconstitute a relationship between interior and exterior space, between the domestic sphere and the wider world (plate 1.3). Finally, this book challenges traditional narratives that present domesticity as synonymous with privacy, enclosure and cosiness. Contrary to the idea that the interior was a static environment dominated by the repetitive rhythms of female lives, this book brings forward a vision of the house as a central location of social life and work, responding to novelty and change, and therefore a key site – alongside the city, the court and the church – for the production of culture in all its guises.

CONCEPTUALIZING THE RENAISSANCE CASA

During the Renaissance Italians became 'the most extravagant builders Europe had ever seen'.[2] For the wealthy, building a house (casa) was by far the largest expenditure. It is not surprising therefore that the casa was the subject of intense and passionate debates, as people became acutely aware of how their status could be reflected by the rank of the dwelling that they lived in. In his treatise on architecture Filarete plays with the variety of domestic buildings, comparing them to men: 'Buildings are made in the image of men … You never see buildings … that are exactly alike … some are big, some are small, some are in the middle, some are beautiful, some are less beautiful, some are ugly, and some are very ugly, just like men.'[3]

By the early seventeenth century explicit parallels were drawn between the look of a building – both its façade and interior – and the face of its owner: 'as with a man's face, one must be able to understand that it is the house of a gentleman from these external signs', wrote the architect Vincenzo Scamozzi in 1615.[4] Significantly, in Italian – during the Renaissance as today – the word casa denoted more than just a building and its material contents: it also meant 'household', with people and things indissolubly united within the same concept. It is with this double connotation in mind that the contributors to this book have used the same term.

The notion that 'you are where you live' often betrayed an anxiety about a very different matter, the overturning of the 'natural' order of society by the new rich. 'It would not be fitting for a merchant to live in a very sumptuous palace built with great magnificence, while a titled landowner enjoying a rich income lived in a small one', wrote the architect Giacomo Lanteri in 1560 (plate 1.2), voicing the disquiet of the old families.[5] And there were good reasons to be concerned, as across Italy people without noble titles, but with considerable wealth, were building private family palaces with varying degrees of ostentation.

Perhaps the most epoch-making palace built in Florence at the time was Palazzo Strozzi. The importance of this building to the prominent merchant-banker Filippo Strozzi can be gathered by the fact that he invested more than one third of the value of his entire estate in it, the largest palace built to date in Florence.[6] Formal dedication ceremonies were held for the laying of the foundations on 6 August 1489, a date identified as auspicious by an astrologer and the Bishop of Florence. Unusually for a secular building, a beautifully detailed wooden model of the palace was made (see plate 2.1), thus placing it on a par with magnificent public and religious edifices. The palazzo was seen as the architectural embodiment of the Strozzi lineage and its continuity. In his will Filippo reinforced the ties between family, property and the male line by ensuring that it always remained in Strozzi hands.

Historians have shown how the look and character of upper-class residential buildings changed considerably during this period with the adoption of an architectural language and forms largely inspired by classical antiquity and with a dramatic increase in their size.[7] The process of building – or rebuilding –

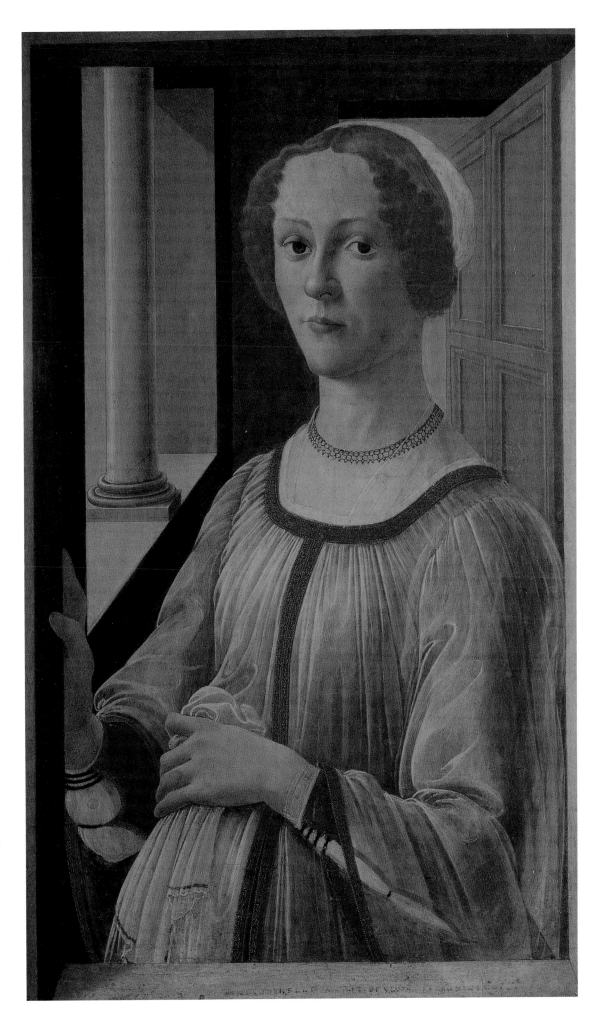

1.3 Sandro Botticelli, *Portrait of a Lady, known as 'Smeralda Bandinelli'*, Florence, 1470s (cat.1)
This depiction of a Florentine woman appearing at the window, revealing a *loggia* behind her, is a decorous but welcoming portrait of a *donna di casa*, or woman of the house. Breaking with the contemporary convention of profile portrait painting, her three-quarter pose and her everyday clothes reinforce this image of domesticity.

houses on a palatial scale was also associated with the trend of devoting a colossal level of expenditure to furnishing their interiors: large houses brought with them big demands. The Venetian author Ortensio Lando addressed these issues with a characteristic penchant for the absurd, dedicating a chapter in his book of paradoxes (*Paradossi*) of 1543 to 'Why it is better to live in humble houses than in great palaces':

Nobody ever doubted that small houses can be built with lower expenditure, and having been built in a shorter space of time they can be enjoyed much more profitably. It has also always been thought that they had better proportions, and as a result, they appeared more beautiful and conspicuous. They are less subject to the threats of burglars, and it seems to me that by virtue of their low height they cannot be struck as easily by celestial lightning. And beyond being better to live in, they are also better to adorn and with lower expenditure. People are excused from having parties, and from hosting princes because of the constriction of the house.[8]

As the size of the new palaces expected of urban elites expanded, internal spaces also developed dramatically to respond to new demands in the ways in which rooms were used and to the increased quantity and range of domestic objects that now furnished the house. Expenditure on furnishings continued to grow, while new ideas modelling domestic life on the principles of beauty and civility were promoted. Italians coined a new term to describe the aims of decor and expenditure in the home: splendour (*splendor*). Splendour was 'primarily concerned with the ornament of the household, the care of the person, and with furnishings', wrote the humanist Giovanni Pontano in the 1490s (see pp.306–7).[9] Pontano argued that the splendid man was expected to surround himself with objects that reflected his aesthetic discernment, civility and cultural standing. As he put it:

The base man and the splendid man both use a knife at table. The difference between them is this. The knife of the first is sweaty and has a horn handle; the knife of the other man is polished and has a handle made of some noble material that has been worked with an artist's mastery.[10] (plate 1.4)

He also acknowledged that objects could be splendid exclusively by virtue of their craftsmanship, thus opening the door to many new goods that could not boast great intrinsic value, but were notable for their artistry, such as glass, maiolica and intarsia work.[11] Renaissance Italians loved and coveted their domestic possessions and were prepared to invest a considerable part of their disposable income on goods that were manufactured in accordance with contemporary ideas of beauty, and for durability, thus helping to ensure their survival to this day.

Such objects provide some of the best evidence of the importance that Renaissance Italians assigned to domesticity, and are a key source for expanding and challenging our understanding of the domestic interior. For example, the existence of large quantities of customized domestic objects designed to mark, celebrate and commemorate rites

1.4 Set of twelve knives and serving knife, Milan, *c*.1460 (cat.86)

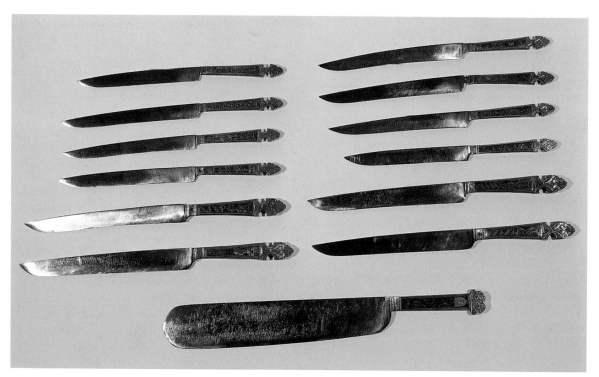

1.5 *De mineralibus*, from a series of manuscripts cataloguing Andrea Vendramin's Venetian collection, ink and colour wash on paper, Venice, 1627 (British Library, London, Sloane, MS 4007. fol.47r) Coral was believed to have talismanic qualities and was often worn by children and adults for self-protection. Here it is also recommended to protect houses against lightning.

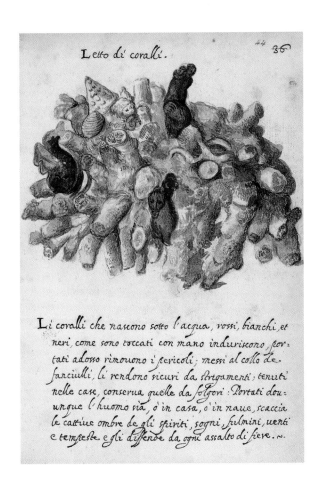

of passage such as marriages and births – ranging from beds and chests to ceramic accouchement sets – testifies to the significance that people attributed to these life-defining events. However, using objects to investigate social history demands special care. Objects rarely speak for themselves and their meanings can only be teased out with the assistance of other source materials (plate 1.5).

By the late fifteenth century detailed representations of interior spaces and objects became almost a subject in their own right, combined with scenes of a religious or secular nature (see ch.6, pp.86–101). Carpaccio's *Birth of the Virgin*, for example, gives great prominence to the domesticity of the scene and to the succession of rooms guiding the eye from the *camera* (bedroom) via the kitchen into the courtyard, lingering on details such as the racks of plates (see plate 1.1). Although these images can be intensely seductive and evocative to the modern eye, they cannot be treated simplistically as evidence of contemporary practice. Sometimes pictures of interiors were also the actual furnishings of Renaissance

houses, thus raising even more pressing questions about the role and meaning of images in relation to their location within the interior (see ch.19, pp.268–83). This is the case, for example, for the famous *St Jerome in his Study* by Antonello da Messina (plate 1.6), described in detail by the Venetian art lover Marcantonio Michiel, who saw it during a visit to the house of Antonio Pasqualino in Venice in 1529 and appreciated it greatly: 'all the work – its finish, colouring, strength, and relief – is perfect'.[12] Even in well-documented instances like this, however, much is left to speculation as to the picture's specific location within the house. Was it in the *camera* or in the study? Did it hang on the wall or was it stored away?

Beyond the buildings themselves and their furnishings, Renaissance Italians have left an extraordinary quantity of written sources that reveal how important the *casa* was to them. Alongside a stream of treatises addressing domestic architecture, a whole body of new literature devoted specifically to household management emerged in the early fifteenth century in which the structure, organization and social meaning of the *casa* were conceptualized. Inspired by the classical tradition, but soon available in the vernacular in cheaply printed editions, these texts combined very general instructions on the building of a house and the organization of its contents, with suggestions on how to find a wife, bring up the children and deal with servants. Such treatises were conventionally addressed to the pater-familias,[13] who was regarded as the head of the household, but often also gave prominence to the duties of the wife as *donna di casa* (see plate 1.2 and ch.11, pp.152–63). According to this literature, the household was conceived as the primary cell of society and its good organization was thus a matter of utmost importance. These works provide unique insights into the system of values at the heart of the Italian concept of *casa*.

Alongside household management books, a vast number of more specific hands-on vernacular writings dealing with domestic matters emerged in printed form at this time (see pp.164–5). Recipe books provided practical instructions on subjects as far apart as making remedies to cure ordinary diseases (see ch.13, pp.174–87) to removing stains from fabrics; cookery books assisted the preparation

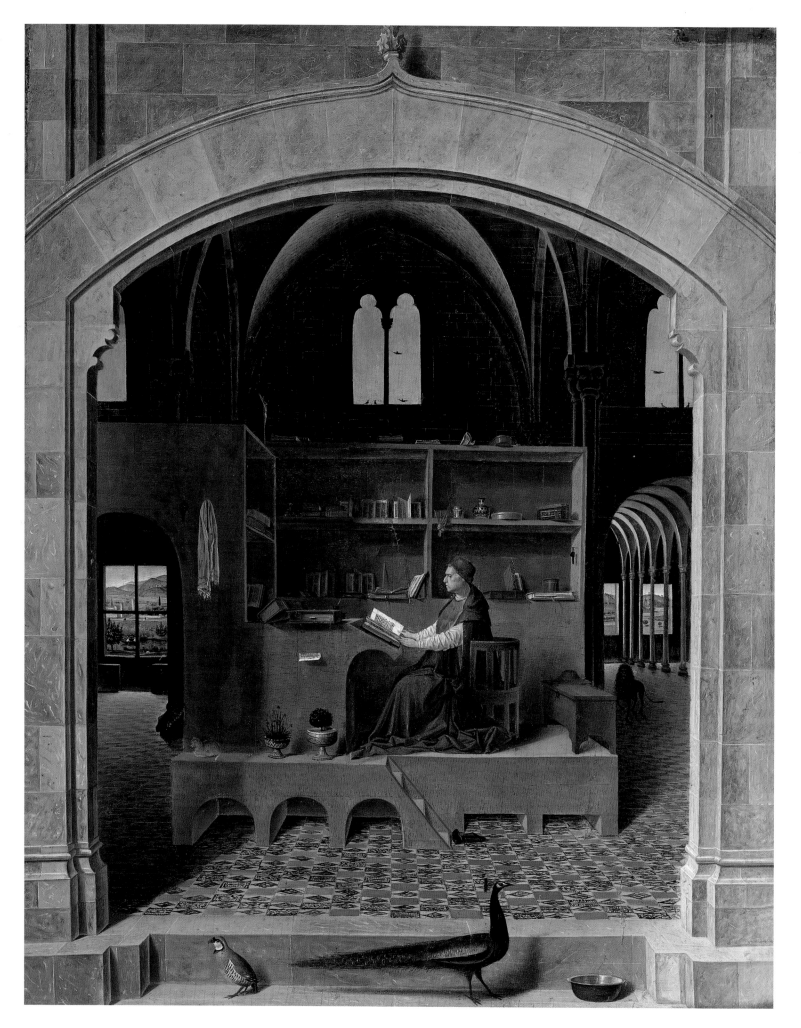

of meals and preservation of foods (see ch.17, pp.244–53); sewing and needlework manuals inspired the manufacture of domestic textiles (see chs 11 and 24, pp.152–63 and 342–51); and music books stimulated playing and singing at home (see ch.16, pp.228–43). Collectively, these writings testify to the importance of the house as a place not just of consumption but also of active production, and highlight its crucial role in the creation and transmission of culture.

Moving from mostly printed materials to manuscript sources reveals another rich world of disparate writings, ranging from *ricordanze* to more prosaic inventories.[14] Written for the most part by Tuscan professionals in the period spanning the thirteenth to the sixteenth century, *ricordanze* combined financial accounts with family memoirs and practical and moral instruction (see plate 2.15).[15] They record, often in great detail, not only life-cycle events, such as births, deaths and marriages, but also everyday matters, such as petty household expenditure or the circulation of furnishings through lending or borrowing.[16] Generally written by the paterfamilias and aimed at his sons and other male relatives, they represent an invaluable source for the understanding of patterns of domestic life and its values. *Ricordanze* can also provide rare insights into issues such as the permeability and fluidity of the urban interior, testifying, for example, to a constant flow of goods such as wine and oil from the country estate to the city dwelling, and out again to be sold; or to the movement of seasonal furnishings from the *palazzo* to the villa and back.[17]

Inventories have supplied some of the most fruitful sources for the study of the interior and have informed many of the essays in this book. Consisting of lists of objects, often presented room by room, they give an unrivalled sense of the overall material contents of a house. However, as Syson points out, they should be approached with some caution (see

1.6 Antonello da Messina,
St Jerome in his Study,
Venice, c.1475
(cat.231)

p.86): they were generally drawn up at unusual times in the life of a family, often after the death of the head of household, and they are static representations of the contents of a house at a specific moment in time. They may also omit certain categories of objects, such as items of negligible value like wooden spoons or perishable goods, since they were designed to be estimates of the worth of domestic possessions, and the very act of compiling the inventory may have meant moving them from their usual locations.

'RECONSTRUCTING' THE ITALIAN RENAISSANCE INTERIOR

Collectively, these different bodies of evidence – from surviving buildings and objects to written sources – suggest that Renaissance Italians invested their homes with deep and affective meaning. But while we are well informed about the exteriors of many prominent domestic buildings, little is known about their interiors and even less about the life that took place within them. The traditional association of the study of the interior with the 'decorative arts', and of 'domesticity' with the female sphere, has meant that this subject has long ranked low within modern scholarship, resulting in a dearth of publications. But this has not always been the case. Part of the inspiration for this research comes from a re-reading of late nineteenth- and early twentieth-century 'cultural history', which attributes a central role to the domestic sphere in the definition of the Italian Renaissance. This is particularly evident in Jacob Burckhardt's pioneering *The Civilization of the Renaissance in Italy* (1860), in which he established a direct correlation between Renaissance culture and its domestic manifestations:

Outward life, indeed, in the fifteenth and the early part of the sixteenth centuries, was polished and ennobled as among no other people in the world. A countless number of those small things and great things which combine to make up what we mean by comfort, we know to have first appeared in Italy. We read in the novelists of soft, elastic beds, of costly carpets and bedroom furniture, of which we hear nothing in other countries. We often hear especially of the abundance and beauty of the linen. Much of all this is drawn within the sphere

of art. We note with admiration the thousand ways in which art ennobles luxury, not only adorning the massive sideboard or the light-brackets with noble vases, clothing the walls with the moveable splendour of tapestry, and covering the toilet table with nonetheless graceful trifles, but absorbing whole branches of mechanical work – especially carpentry – into its province.[18]

Burckhardt thought that 'art' was able to 'ennoble' mundane domestic objects and that in turn domestic life was transformed into an art form in its own right through a new rational approach to architecture and to household organization:

The spirit of the Renaissance first brought order into domestic life, treating it as a work of deliberate contrivance. Intelligent economical views, and a rational style of domestic architecture served to promote this end. But the chief cause of the change was the thoughtful study of all questions relating to social intercourse, to education, to domestic service and organization.[19]

Burckhardt's seminal book was an important influence in the wave of local historians writing about Renaissance domestic life that appeared across Italy in the next fifty years: for example, Luigi Tommaso Belgrano (1875) focused on Genoa, Lodovico Frati (1900) on Bologna, Pompeo Molmenti (1906) on Venice and Attilio Schiaparelli (1908) on Florence.[20] These texts all shared a concern for the destructive inroads that modernity was making into their historic cities, and passionately appealed for re-awakening a sense of civic identity through the study of the material survivals of a distant past. Schiaparelli's *La casa fiorentina e i suoi arredi* poignantly makes the case by setting up an opposition between the 'glowering and murky buildings' and 'grand and magnificent palaces' scattered across the old city of Florence on the one hand, and their interiors on the other:

Very few remains are now left of the long-gone good old days, and even these, dispersed as they are, and separated from all of which they were once part, have lost all their suggestive power. The aim of this book [is] to offer to those spirits who love the past some help to evoke in its entirety the domestic environment in which the contemporaries of Dante, Boccaccio, Brunelleschi and Botticelli lived.[21]

Schiaparelli was writing at a time when large parts of central Florence were being torn down (plate 1.7). This process of demolition, which involved ripping off façades and laying bare interiors, also provoked new thoughts about the relationship between the exterior and the interior and its contents. Schiaparelli was attempting on paper to collect together knowledge of these spaces and of the categories of objects found within them, re-evoking the unity of the domestic sphere, from façade to furnishings, from wall decoration to furniture, from rooms to the courtyard and garden. Alongside this process of conceptual 'reconstruction', another reconstructive process was in operation, that of registering the emergence of domestic rituals and types of objects still in use when he was writing:

Along the way, we will discover the origins of some customs still in use today, and of no small number of objects which we use even today without knowing where they came from and when they were introduced amongst us; in this way, by studying one of the least known aspects of the life of our ancestors, we will shed some light on our own lives. And since that life was suffused with aesthetic qualities, it will often provide us with the opportunity to talk about art, especially decorative and applied art.[22]

Obviously many features of these writings – such as their tendency to over-generalize, their fierce local bias and their weak grip on primary sources – appear totally outdated today. However, their creation of a close link between 'public' and 'private' life and their focus on raising the status of domesticity by placing the everyday centre stage makes them very appealing.

This lively period of scholarly interest in the study of the domestic interior was paralleled from the mid-nineteenth century by an unprecedented campaign of acquisition launched by the newly established decorative arts museums across Europe – from the V&A in London to the Castello Sforzesco collections in Milan. The enthusiasm of individual

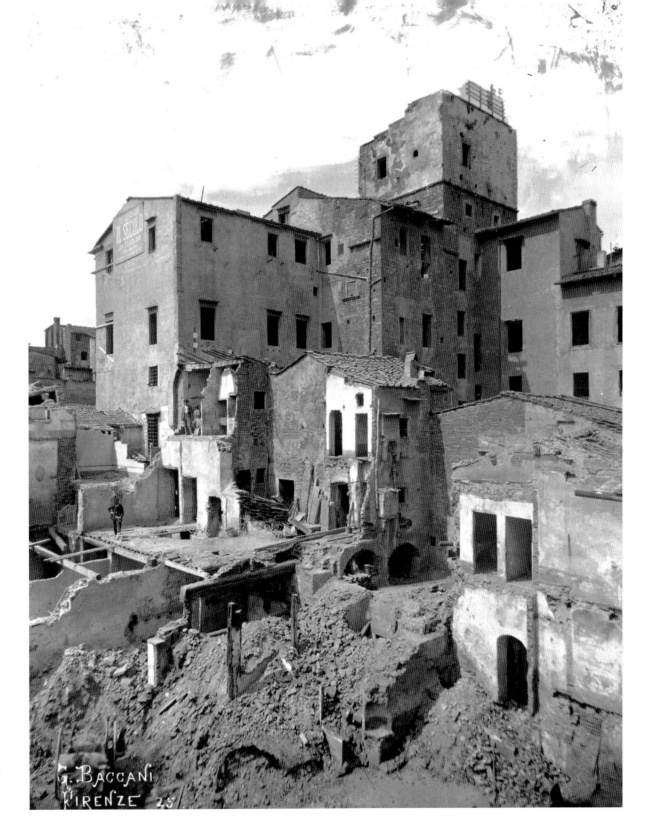

1.7 Demolition in 1890 of the houses of the Alfieri Strinati family of Florence on the east side of the Piazza del Mercato Vecchio, Florence.

curators, such as Wilhelm von Bode in Berlin, led to early publications of Renaissance domestic furnishings.[23] This revival of interest was fostered by the art market and embraced by European and American collectors like Herbert Percy Horne, Edouard and Nélie Jacquemart André, the Bagatti Valsecchi brothers, John Pierpont Morgan and Isabella Stewart Gardner, keen to 're-live' the Renaissance.[24]

Undoubtedly, however, this global demand for Italian art was also one of the factors behind the nationalism of Schiaparelli and his generation, afflicted by a sense of unredeemable loss caused by the rapacity of the market. The scattering of domestic objects across the world is a consequence of this period of avid collecting, and the effects of the dislocation generated then are still evident today.

From the 1930s this subject faded into the background of Renaissance studies.[25] It was not until Kent Lydecker's ground-breaking thesis on the domestic setting for art in Renaissance Florence (1987) and Peter Thornton's impressive visual repertory, *The Italian Renaissance Interior 1400–1600* (1991), that a new phase in the study of the interior began.[26] Lydecker's work, based on domestic inventories, wills and accounts, emphasizes the importance of the domestic sphere for the study of art of this period. However, concerned primarily with objects as they exist on paper, this thesis does not specifically address their materiality. Thornton, while referring to documentary sources, places images rather than objects at the centre of his research. In his masterful survey, *Wealth and the Demand for Art in Italy, 1300–1600* (1993), Richard Goldthwaite has established the framework for an understanding of the cultural and economic dynamics at the heart of Renaissance domestic consumption.[27] More recently, a number of studies – most notably Raffaella Sarti's *Europe at Home* – have begun to address the social meanings of the house and to examine domestic practices, but again without much attention to objects.[28] However, a steady stream of focused works over the past few years have been exemplary in weaving together documentary evidence and surviving artefacts: Dora Thornton's *The Scholar in His Study*, Jacqueline Marie Musacchio's *The Art and Ritual of Childbirth in Renaissance Italy*, Luke Syson and Dora Thornton's *Objects of Virtue* and Patricia Fortini Brown's *Private Lives in Renaissance Venice*.[29]

The broad approach inspired by Burckhardt and his Italian contemporaries obviously requires major methodological adjustments for use today. Recent historical research is concerned with new issues, which range from an awareness of the impact that trans-national forces had on the home, to an understanding of the role of social and gender dynamics within the household. This immediately raises larger questions related to the occupants of the house, their material surroundings and the spaces that constituted the setting for domestic life.

PEOPLE, SPACES AND OBJECTS

Connoisseurship – by far the dominant approach for the study of the so-called decorative arts – has long provided powerful tools for the technical analysis of objects, their authenticity, authorship and dating. It has been crucial in the assessment of some key areas of scholarship and display, notably furniture. Historically, the study of furniture has been deeply affected by the demands of the Neo-Renaissance art market, which required domestic furnishings, from beds to chests, chairs and tables. Many supposedly authentic Renaissance pieces in collections around the world are in fact recent concoctions, artistically combining elements derived from old pieces with new insertions designed to update or aesthetically improve an item of furniture, sometimes even resulting in new forms.[30] Creating a general suspicion around the history of Renaissance furniture, this has resulted in its marginalization as a historical discipline. Restoring credibility to this fundamental body of objects requires a thorough and consistent analysis of furniture. Specialists Fausto Calderai and Simone Chiarugi have assisted the project with their familiarity with Italian furniture forms and decorative language, and their profound understanding of the materials and techniques in use during the fifteenth and sixteenth centuries, combined with an awareness of modern methods of restoring and faking older furniture, have been an invaluable contribution. Thanks to their in-depth assessment and careful selection of pieces (plate 1.8), this book provides an initial step towards rebuilding this field (see pp.120-3 and 224-7).[31] However, this process has forced us to discard objects long regarded as landmarks in Renaissance furniture. The 'Davanzati Bed' at the Metropolitan Museum is a case in point (plate 1.9). Close examination has revealed that this supposedly fifteenth-century bed is in fact a modern fake, made by covering old wood with an intarsia-like veneering – a technique never used in the Renaissance – now peeling off to reveal the bed's true status.[32] Its construction relies on different types of woods not justified by any decorative purpose. Closely resembling the type of bed with attached chests often depicted by fifteenth-century Florentine artists, it exemplifies the problem at the heart of the study of Renaissance furniture. Its close affinity with beds painted by Ghirlandaio and his contemporaries meant that it could easily find a

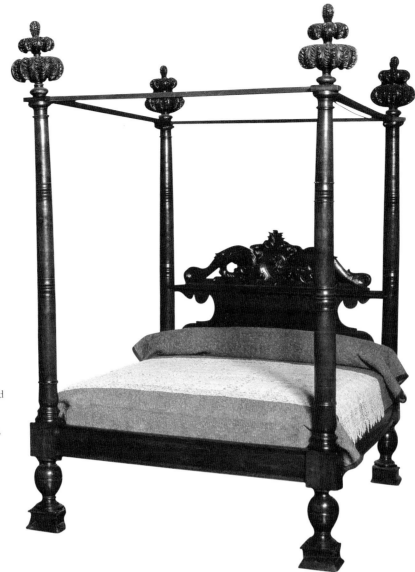

1.8 Bed, central Italy, 16th century (cat.109) This type of bed on four legs, which originally would have been endowed with rich hangings and a canopy, became popular in the mid-sixteenth century.

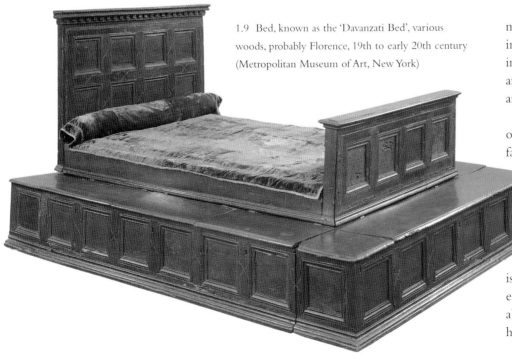

1.9 Bed, known as the 'Davanzati Bed', various woods, probably Florence, 19th to early 20th century (Metropolitan Museum of Art, New York)

market among collectors familiar with these paintings, and later be accepted by furniture historians into the canon. It is an irony that these visual sources are precisely what enabled modern fakers to produce and sell such pieces.

The hegemony of connoisseurship has often obscured attempts to see objects as 'cultural artefacts'.[33] So many domestic items have been detached from more than just their provenance, with the result that their biography, and with it a substantial part of their meaning, have been lost too. Reversing the diaspora of objects that were taken from people's houses and transformed into disembodied museum exhibits is a central aim of this book. This has led to an engagement with the wealth of sources discussed above, which have overturned many commonly held assumptions about Renaissance domesticity.

Combining these sources has allowed us to create a much richer and nuanced understanding of the dynamics of life in the *casa*. We have sought to bring coherence to the exhibition and the book by asking a key question: how did people, spaces and objects interact within the Italian Renaissance home? It is generally accepted that people have an impact on the context in which they live, but less widely acknowledged that domestic spaces and their contents could shape the identity and behaviour of their occupants.[34]

One of the most important shifts within the structure of Renaissance interiors was the change from relatively few, multifunctional spaces to a greater number of increasingly specialized rooms.[35] By the end of the sixteenth century we see the growing presence of the dining room, the music room and the *sala/salotto/saletta* (reception rooms of various sizes), sometimes associated with specific individuals or activities. Even bathrooms emerged in some cities, notably Genoa (see pp.222–3). Specialization can be seen at work across domestic material culture in all its forms. In furniture it was exemplified by the shift from benches to chairs of various types and sizes, and in the appearance of specialized storage furniture, such as the *credenza* (plate 1.10) and the large *armadio*, or wardrobe. As this process of specialization unfolded, the relationship between spaces, objects and people was significantly affected.

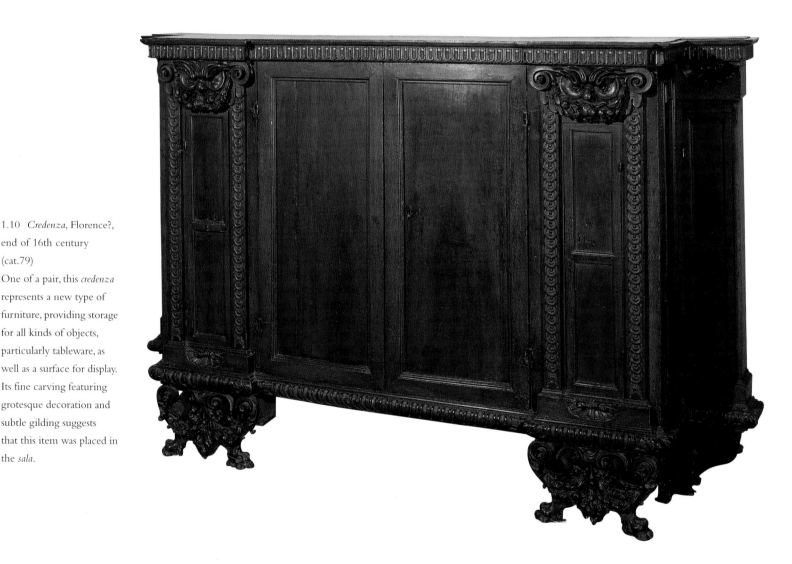

1.10 *Credenza*, Florence?, end of 16th century (cat.79)
One of a pair, this *credenza* represents a new type of furniture, providing storage for all kinds of objects, particularly tableware, as well as a surface for display. Its fine carving featuring grotesque decoration and subtle gilding suggests that this item was placed in the *sala*.

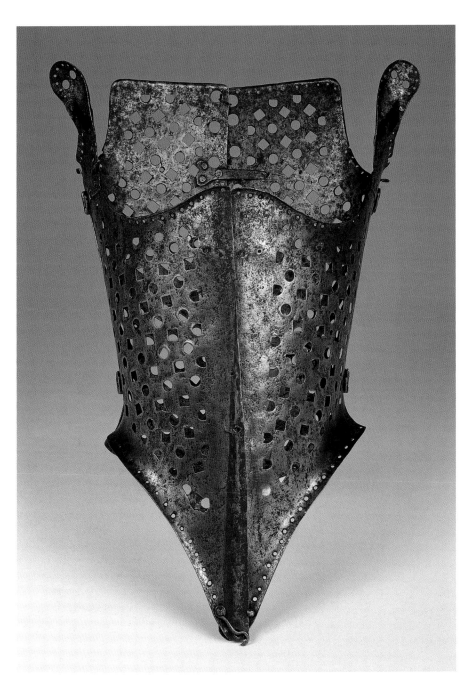

Another key concern at the heart of this period is the decorum of place. In his classic manual of manners, the *Galateo* (1558), Della Casa makes it clear that:

> Nobody should undress, particularly take off his hose, in public, that is, where honest company is [gathered]: because that act is not appropriate for that place, and it could happen that those parts of the body which are normally covered are revealed, bringing shame to him and to those who see him. Nor is it desirable to comb one's hair and wash one's hands among other people, since these are things to be done in the *camera*, and not in the open.[36]

Traditionally, in the wake of Norbert Elias's *The Civilizing Process* (1939), scholarship has associated this notion of increasing civility with courtly contexts. However, a reading of the wealth of prescriptive texts mentioned above, intended for a much wider readership, indicates that manners were also a central preoccupation of a large urban community. While it is certain that the mobility of elites helped to bridge the gap between court and city cultures, it is also clear that the new civility code was the result of different forces outside the court, from late medieval monasticism to humanism.[37] Just as spaces could inform behaviour, so objects could condition and act as prompts for practices and rituals. The woman's steel corset illustrated here (plate 1.11), which would have been padded, was designed to enforce good posture, but in practice would have had a radical effect on female deportment and ease of mobility. Believed to cause miscarriages, it was outlawed in Venice in 1547.[38] Similarly, wearing a sword – a skill that had to be learnt – conditioned the way in which men walked (plate 1.12). These examples show the direct impact that everyday objects could have on people's conduct.

1.11 (*above*) Metal corset, Italy, mid-16th century (cat.183)

1.12 (*below*) Rapier, Italy, *c.*1600–1630 (cat. 6)

Weapons were a key attribute of manhood, and swords were believed to encourage a child to develop into a fully fledged man. This rapier corresponds closely to the ones worn by Iseppo da Porto and his son (see plate 9.2).

AT HOME IN RENAISSANCE ITALY:
BOOK STRUCTURE

This book is divided into five sections, which approach the subject from a variety of perspectives. Part I, 'Defining the *Casa*', provides a framework for an understanding of the physical and human structures at the heart of the home. Conventionally, Italian history has been considered from the viewpoint of a single city or region, thus obscuring the importance of shared cultural practices across Italy. The essays by Preyer and Fortini Brown set out the complex layout of Renaissance houses and the use of domestic spaces, and show how, in spite of evident aesthetic differences, the interiors of houses in Tuscany and the Veneto were constructed and perceived in significantly similar terms. Cavallo expands this reconstruction of domesticity within non-elite contexts. She highlights the key importance of social and familial networks and the role of the neighbourhood, setting domestic life against the background of a mobile household constantly changing in composition and location. Her essay shows that viewing the material worlds of different social strata as discrete separate entities is misleading, with many categories of objects – such as devotional items, cooking implements or even jewellery – being shared across social boundaries. The household and its gender dynamics are at the heart of the concept of *casa* that this book proposes. From the management and use of domestic spaces to the patterns of acquisition, employment and transmission of objects, the roles of men and women were constructed in very distinct ways. Bellavitis and Chabot demonstrate the tensions at the core of an inheritance system that had to take into account often irreconcilable demands: guarantee the anchoring of property to the male line on the one hand, and endow women with sufficient material wealth to ensure that their marriage prospects would not be compromised on the other. Pictures – whether paintings, reliefs, prints or drawings – play a pivotal role in conveying Renaissance perceptions and ideas about the domestic sphere, as Syson demonstrates. Our interpretation of their function and meaning, however, should go beyond seeing them as a passive representation of reality, and consider instead their power to inform contemporary thought and practice.

In Part II, 'Living in the *Casa*', compelling insights are provided into the momentous events in the life of the household. By highlighting the interaction between rituals and objects, Matthews-Grieco and Musacchio demonstrate the impact that rites of passage such as marriages and births had on the overall look and character of the interior, while Fortini Brown explores how children and their upbringing were a central concern of the *casa* (plate 1.13).

The processes allowing the house to function on a daily basis are explored in Part III, 'Everyday Practices in the *Casa*'. The multi-layered organism of the household could not operate without additional support, which ranged from permanent servants and even slaves to occasional but regular visitors such as chimney sweeps. Guerzoni alerts us to their rich variety and to the wealth of tools, which collectively ensured that the domestic machine ran efficiently, while Bennett highlights the regular engagement with scientific instruments. Ajmar-Wollheim and Franceschi consider the house as a productive space in which the very different tasks performed by men and women played an equally vital role in the smooth running of the household. Cavallo describes the use of a surprising array of domestic objects in the routines of personal health and hygiene (plate 1.14), and Cooper shows that devotional activities in the house had a daily rhythm, while at the same time conforming to the Christian calendar.

1.13 Mirabello Cavalori (?), *Portrait of a Youth*, Florence, 1560–70 (cat.165)
Vasari described the Florentine artist Cavalori as a successful portrait painter. In this sensitive portrait of a youth the sitter holds a drawing of the three-quarter profile of a man. This may be his own work and, with its shadow of a moustache, may represent a projection of his future self.

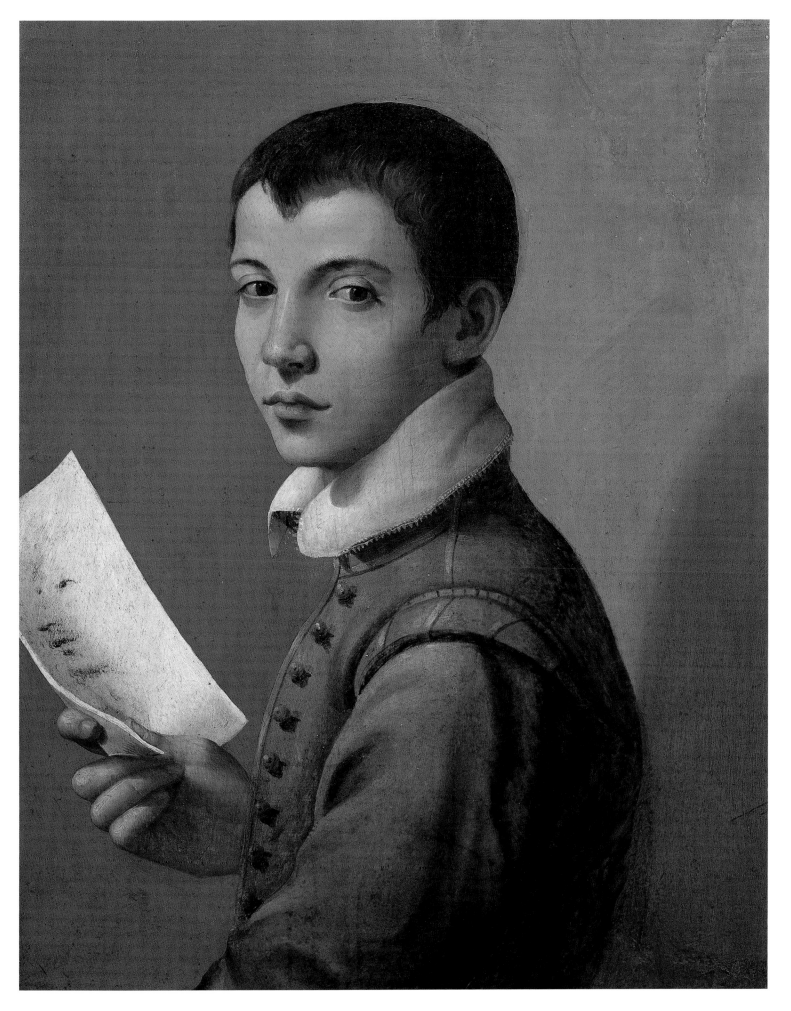

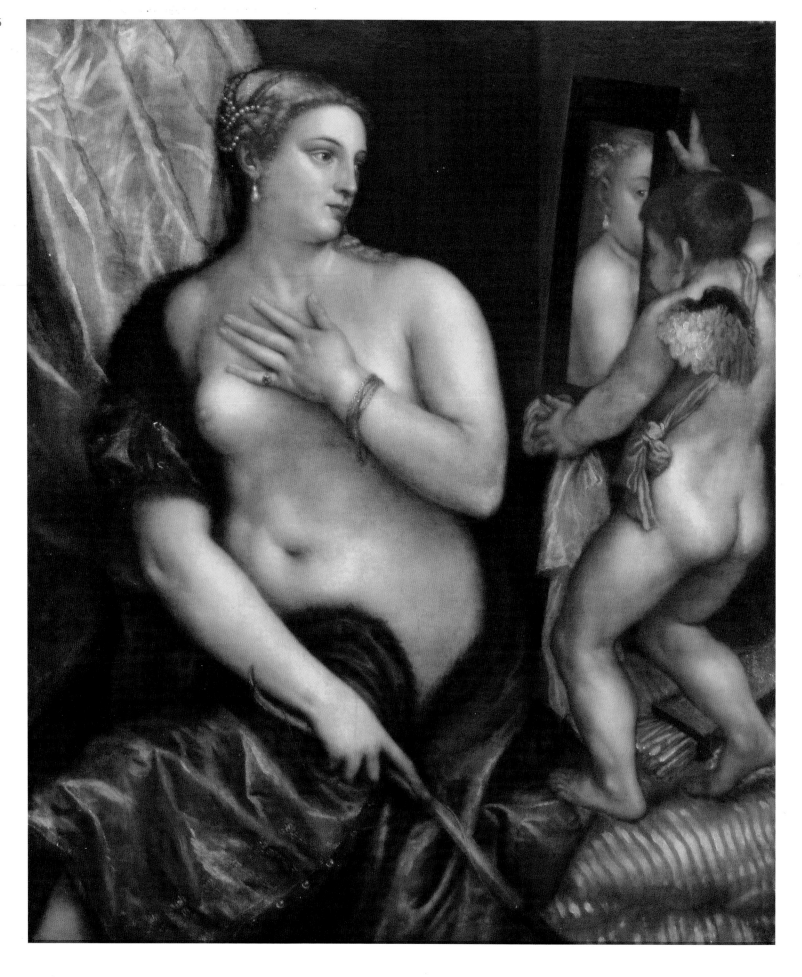

1.14 (*left*) Titian and workshop, *Venus at the Mirror*, Venice, 1560s (cat.178)
This is one of several versions of Titian's famous painting, carried out by the artist with his workshop. The painting places great emphasis on the luxurious textiles, furs and jewellery that surround the naked figure of Venus, celebrating her idealized beauty. The cupid holding the mirror highlights the subtle eroticism of the picture. Her pose is thought to be derived from ancient Roman statues.

Part IV, 'Sociability and Entertainment in the *Casa*', reveals the house to be a place of social exchange and cultural performance. As well as challenging traditional distinctions between the 'public' and 'private' sphere, the essays by Ajmar-Wollheim, Dennis, Grieco and Liefkes open up a novel vision of the interior as a context for social interaction. They show that, despite the diversity of social levels and local conventions, practices and objects connected to sociability and entertainment went a long way in providing a shared culture across Italy.

The last part, 'Art and Objects in the *Casa*', reminds us that the character and aesthetic appearance of interiors at all social levels relied on the active role of objects and furnishings of all kinds, from painting and sculpture to furniture and textiles: Motture, Syson, Warren, Miller and Currie provide a broad-ranging perspective of the categories of artefacts that made the house a place of artistic display and intellectual engagement. Through a case study of the world-famous Medici *scrittoio*, Syson explores the notion of the room as a work of art. By examin-

ing the role of Middle Eastern objects, Contadini's essay highlights the complex international network of political, commercial and cultural relations that left a durable mark on the *casa*. Blake alerts us to the contribution of everyday artefacts, which have surfaced mostly thanks to archaeology, thus providing a useful corrective to an over-aestheticized view of the interior.

Aiming to advance our understanding of the web of relations that brought together people, spaces and objects in the Italian Renaissance home, this book chooses the materiality of the domestic interior as its vantage point. In this way it locates itself within the recent stream of material culture studies that has been especially successful at unravelling the meanings of objects and at placing them at the centre of historical narratives. While reclaiming the centrality of material culture in the reading of the past, however, we are also conscious that our research, led by an object-based approach, has required a narrowing of focus and that this has been made more conspicuous by the demands of narrative and visual coherence within the accompanying exhibition. In terms of the geography of the interior, for example, the decision to concentrate predominantly on Tuscany and the Veneto does not do justice to the variety of local cultures that thrived in the Renaissance and still represents an important part of Italian identity today. Genoa is a case in point: with its legendary wealth, this political and economic powerhouse at the centre of international relations fuelled an unprecedented demand for high-prestige housing and domestic goods. While a number of essays in this book touch on the Genoese interior, the city's refined textiles, elaborate silver tableware and highly wrought furniture (plate 1.15) are so distinctive and little explored as to deserve an in-depth study of their own.[39] Like other Italian commercial centres,

1.15 Chest of drawers, walnut and other woods, Liguria, late 16th century (Civiche Collezione, Genoa)
Known in Genoa as *canterali*, chests of drawers were a new form of furniture in the sixteenth century. Often coming in pairs, they were generally used for the storage of textiles, papers and personal effects. They were usually recorded in the *camera*, but could also feature in the *sala*. The elaborate carving would have made them ideal showpieces.

1.16 The Cornaro Atlas, Venice, c.1490 (cat.242) Named after its owners, the Cornaro family of Venice, this compendium includes 35 sea charts, lists of prices at different ports and a treatise on the making of sails in Venetian dialect. Much of this information would have been useful for a Venetian merchant to consult in his *scrittoio*. This opening shows the British Isles, France, Portugal and Spain.

Genoa alerts us to the importance that trade connections (plate 1.16) – from northern Europe and Spain to China – had in shaping the Italian interior, something that requires further exploration.[40] Similarly, the parallel issue of the interior of minority groups – from Jews to Germans or Slavs – promises rich rewards but was beyond the scope of this project. Another valuable avenue of research that has not been included in this volume is the relationship between the urban interior and the suburban villa, two domestic contexts that often existed in a symbiotic relationship.[41]

'The only reason to study artefacts is to get at the people behind them' is one of the guiding principles of material culture studies.[42] 'Objects are ideas in material form' is another of its mottoes. In recent years calls have been made from different quarters to reinstate for the Renaissance that vital relationship between the study of artefacts and the study of

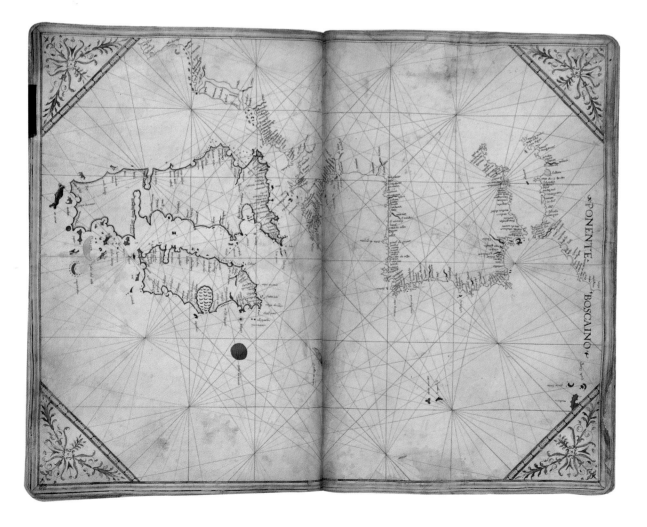

1.17 Vincenzo Campi, *San Martino* (St Martin's Day), also known as *Trasloco* (Moving Home), Cremona, 1580s? (cat.263) This unique painting depicts in lively detail the moment at the end of the harvest on 11 November, when many families traditionally

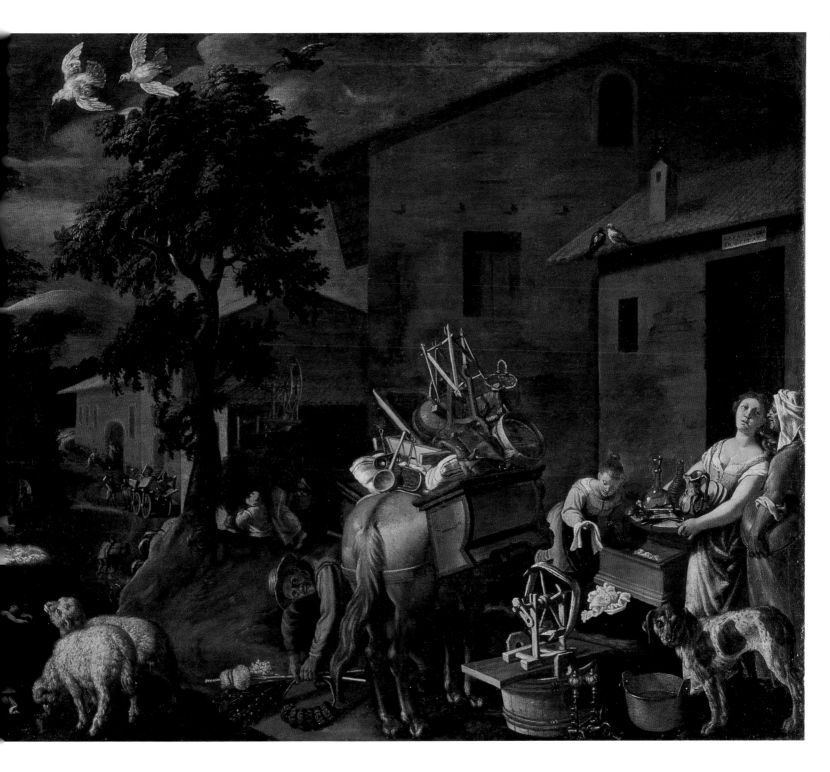

moved house. Although this painting has a countryside setting, it acts as a reminder of the regularity with which house moves took place. The contents of the house are spilled out into the open, revealing the identity of the family.

people and culture which arguably existed at the time of Burckhardt and which would allow us to recapture the 'real passage of life into art' that he invoked.[43] We hope that by looking at the *casa* as a primary site in which objects and people interacted, giving rise to the creation of a distinctive domestic culture, this book will make a significant step in the direction of reuniting Renaissance art with life (plate 1.17). Renaissance art still dominates many museums

across the world. Highlighting its domestic identity encourages the visitors who crowd displays, 'those people who now stand *in front* of the enormous cache of artefacts that have survived to our own time', to engage with these iconic objects.[44] By opening up the contents of the Italian Renaissance *casa*, we are confident that this book will enlarge our understanding of a historical period whose material and cultural output still resonates so strongly today.

AT HOME IN RENAISSANCE ITALY:
THE EXHIBITION

A late sixteenth-century booklet aimed at the new bride suggests that, when visitors come, she should be an exemplary hostess and open her house to them:

> Take them to the fire, or the window, or the garden, according to the season and the weather; guide them around the house and in particular show them some of your possessions, either new or beautiful, but in such a way that it will be received as a sign of your politeness and domesticity, and not arrogance: something that you will do as if showing them your heart.[45]

Taking inspiration from this text, the exhibition has been structured as a visit to the *piano nobile* of a Renaissance *palazzo*, ranging from the more 'inclusive' spaces to the more 'exclusive' and moving from the *sala*, or reception room, to the *camera*, or bedroom, and the *scrittoio*, or study. These were the principal rooms of most patrician interiors and also provide the best way to exemplify the momentous changes that affected the domestic interior in both aesthetic and functional terms. Combining impressionistic installations suggesting fragments of interiors with thematic displays inspired by family rituals and everyday practices, the exhibition aims to evoke the Italian Renaissance *casa* through an innovative design. This is based on the concept of the three-dimensional drawing, shown both in the markings on the floor and in the metal skeleton defining the dimensions of the rooms (plate 1.18). This radical design without walls allows the exhibits to take centre stage, unencumbered by material partitions, and to engage in a dialogue with each other. While regional differences are expressed by the spatial distance between Tuscany and the Veneto in the exhibition layout, shared cultural forces are also visible, as displays straddle the geographic divide. This design concept also highlights architectural features and furnishings which have not survived, evoking them through metal outlines, like ghosts.

1.18 Mock-up design by Opera 3D of the exhibition introduction showing the three-dimensional drawing used for outlining spaces and architectural features, March 2006, Amsterdam.

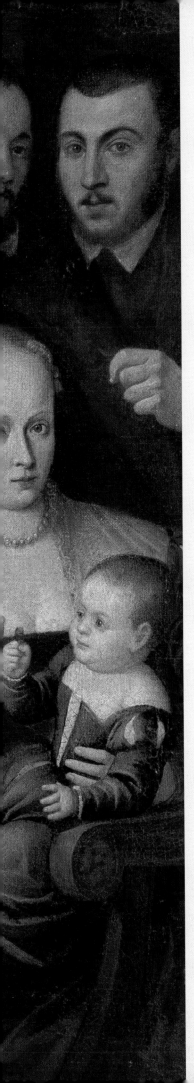

PART

I

DEFINING
THE *CASA*

<div style="text-align: center; border: 2px solid black; display: inline-block; padding: 10px;">2</div>

THE FLORENTINE *CASA*

BRENDA PREYER

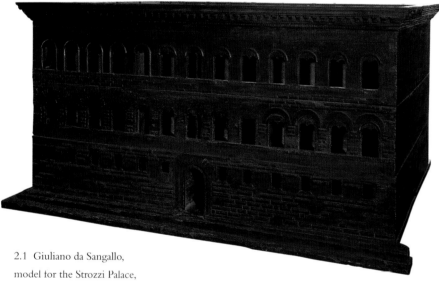

2.1 Giuliano da Sangallo,
model for the Strozzi Palace,
Florence, 1489–90?
(cat.2)
This unusual model of a private
palace shows the arrangement of
interior space as well as the
exterior. The plan is close to the
palace as it was built, with a *sala* at
the front corner on each side,
and the service wing, with small
rooms, across the court.

ARCHITECTURAL ORGANIZATION

Florentine domestic interiors of the period 1400–1600 were architectural settings of pronounced character. At the grandest level there is the great block of the Palazzo Strozzi in Florence, the model of which shown here (plate 2.1) emphasizes the design of the exterior, but also shows the main internal spaces.[1] The unusually large and regular site, and the decision not to reuse old walls, which significantly affected the layout of most new buildings, permitted an elegant and symmetrical configuration of the interior. Despite the differences in expenditure and the variety of styles during these two centuries, there were many constant themes in interiors that can be identified by examining both the physical evidence and the documentary data, such as inventories, letters and construction accounts. The buildings' large scale and the contemporary penchant for social interaction indicate that houses were designed for sharing with friends and displaying to acquaintances, as well as for family living.[2]

A starting point for understanding the basic elements of Florentine interiors is the Palazzo Medici, Florence, begun in the 1440s, which despite its atypical richness is representative of the general organization of interior space (plate 2.2). A wide range of sources can be used to build up a picture of life inside the palace and create a basis for a general consideration of houses in the fifteenth and sixteenth centuries. These include the detailed inventory taken after the death of Lorenzo de' Medici in 1492 recording the contents room by room; plans dating from 1650, and thus before much of the remodelling undertaken by the Riccardi family; and scattered references in other inventories, chronicles and letters.[3]

The Medici palace's main portal, which had carved wooden doors, leads into a high barrel-vaulted hallway and then to a square courtyard with colonnaded walkways on all sides (plate 2.3). Even in very elaborate houses, courtyards often had just two or three

2.2 Medici Riccardi palace, Florence, begun 1440s

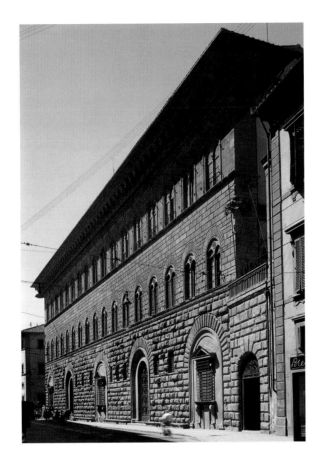

2.3 Plans of the ground floor and *piano nobile* of the Medici Riccardi palace (begun 1440s), black ink with colour wash on white paper, Florence, 1650 (Archivio di Stato, Florence, Guardaroba Medicea, filza 1016). Drawn before major changes were made to the building, which was bought by the Riccardi in 1650, the plan of the *piano nobile* is the only one to show Piero and Lorenzo de' Medici's famous *scrittoio*. North is to the right.

lavishly, and the unusual imagery on the step-ends was intended to impress visitors.[4] Similarly, in the courtyard of the Medici palace the coats of arms and sculpted roundels, based on ancient cameos and set against elaborate graphic decoration on the plaster walls, trumpeted the identity and culture of the owners. Standard practice dictated that one arm of the courtyard should be broader than the rest: called the loggia, it had built-in benches along the walls, and here and in most Florentine palaces of the fourteenth to sixteenth centuries these generous protected areas were used for outdoor dining. Beyond the loggia in the Medici palace is a garden, a feature found in a surprising number of large Florentine houses, even in the crowded city centre, and another loggia here provided a further entertainment area. All the sizeable rooms on the ground floors of major buildings had stone-vaulted ceilings that rose 6 to 8 metres high and were finished with fine plaster, sometimes covered with painted decoration. While courtyards were paved in stone, all interior floors were of polished brick, except in some cases where inlaid marble or ceramic tiles were used to create special effects.

such arms, still providing an adequate space where residents could enjoy light and air. An example of inventive design in a building of only moderate size is the Palazzo Gondi, where the staircase is set into one of the four arms of the courtyard. The opportunity was taken to decorate the open side of the stairs

The principal living spaces inside Florentine palaces were on the first floor (*piano nobile*), but frequently there were important rooms on the ground floor as well. Typically all these rooms were arranged in suites laid out in a strict sequence. On the ground floor of the Medici palace were a rectangular *sala* measuring about 8 x 12 metres, followed by a nearly

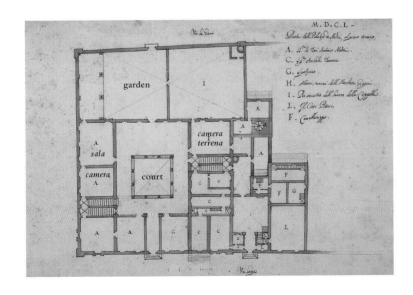

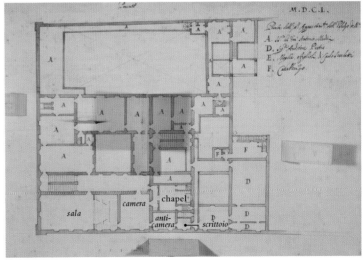

square *camera*, an *anticamera* and a *scrittoio* (small rooms under the stairs). In general, a *sala* was a formal reception area used by large numbers of people, especially for eating and dancing. A *camera* was for sleeping in, though this sizeable room also served for many other activities. An *anticamera* was a smaller, and often more elaborate, extension of the *camera*. A *scrittoio* was an office or study, and sometimes a place where one kept valuables. *Anticamere* and *scrittoi* usually had rather low wooden ceilings, with mezzanine levels above for storage. The suite on the ground floor of the Medici palace may have been used for summer living by members of the family, but the quantities of rich trappings stored in chests in the *camera* also suggest that it accommodated guests.

On the other side of the courtyard was Lorenzo's *camera terrena* (ground-floor *camera*) – not part of a full suite – where the celebrated paintings by Paolo Uccello depicting the *Battle of San Romano* (see plate 19.9) were placed above wooden panelling covering the rest of the walls.[5] Probably, clients and associates were received in such sumptuous ground-floor *camere*. The big rooms along the front of the Medici palace were for guests and secretaries, while the service wing spilled into a second courtyard to the north, with its own entrance from the street. Horses went down a ramp there to stables in the basement, which had storage space for wine. An establishment like this required extensive service facilities: kitchens on at least two floors, rooms for storage of oil and for making bread, and quarters for male and female servants.

Although the locations of the toilets in the Medici palace are not clear, other buildings show ample evidence of them in small spaces under stairs or near sleeping quarters. Drainpipes in the thick walls went down to cesspools in the basement. The toilets at the late fifteenth-century Strozzi palace were carefully planned. On every floor there were units at the back, which were accessible from the *anticamere* at the corners; stylish framed doorways opened into small vestibules with, on one side, a tiny room for the toilet and, on the other, a spiral staircase – for use by both master and servants – that ran from the top to the bottom of the building.

The main staircase to the *piano nobile* of the Medici palace went up to the hallway, or *ricetto*, which overlooked the courtyard and led to the chapel, the latter an unusual feature of this building. In all palaces the *ricetto* tended to be a congregation point for people who had come up the stairs and were waiting to be granted entrance to the main *sala* (*sala principale*), so it usually contained benches. During the course of the fifteenth and sixteenth centuries *ricetti* became larger and more elaborate, though in any period if space was limited – for instance at the Palazzo Rucellai – there was no *ricetto* at all and the stairs opened directly into the *sala*.

The Medici palace's original *sala principale* on the first floor (divided in the seventeenth century as the plans in plate 2.3 show) was very spacious, about 20 by 10.5 metres and 6.5 metres high. On this floor all ceilings were wood with big exposed beams, except in the *sala* and chapel, where the hung ceilings were fashioned into coffers, and in the *scrittoio*, which had a terracotta vault. As a rule, beamed ceilings were painted in complex patterns, while coffers were also decorated with gold. This *sala* would have had a great deal of natural light from five big windows high on one façade wall and two on the other. Even in the sixteenth century windows in Florentine private houses rarely had fixed glass. Rather, there were elaborate systems of heavy wooden shutters capable of infinite adjustments, and a few movable frames stretched with waxed cloth (*finestre impannate*), which could be placed over the window openings. From the *sala* a line of doorways led first to the *camera*, then to the *anticamera* and finally to the *scrittoio*. The *anticamera* deserves special mention, for in Tuscany the prefix *anti* signified 'next to', not 'before'. This room always followed the *camera* and was smaller and presumably more intimate. As it seems not to have had a special function that distinguished it clearly from the *camera*, the two rooms should probably be considered as a pair.[6]

The *piano nobile* of the Medici palace was designed to accommodate three families: Cosimo de' Medici with his wife, and his sons Piero and Giovanni with their wives and children. In 1492 a second apartment across the *ricetto* consisted of a *saletta*, *camera*, *anticamera* and a *cappelletta* (a small chapel transformed from an earlier *scrittoio*). The *saletta* also communicated with the third suite overlooking the garden. The term *saletta*, or *salotto* (the words were interchangeable), signified a small *sala*, but it also had less formal overtones (the staff dining rooms in the service areas

on both floors were called *salette* in the inventory of 1492), suggesting that these spaces served as alternatives to the *sala principale* for everyday eating.[7] In the sixteenth century references to *salette* increased, perhaps indicating more specialization in the use of rooms.

The floor above the *piano nobile* in Florentine palaces was necessary to give the exterior its customary proportions. All indications are that the rooms here were not of great importance, though of course they could accommodate changing family arrangements as well as provide storage. In covered areas open to the courtyard or to the façade clothing could be aired or dried. But the elaborate frescoes once on the terrace above the cornice of the Rucellai palace, as well as the beautiful view, suggest that the function of these areas was not simply utilitarian.[8]

The façade of the Medici palace was entirely faced with three differentiated levels of crafted stone capped by a classicizing cornice and decorated with elaborately framed windows. Its revolutionary character has perhaps given rise to the suggestion that the plan of the building was innovative as well, for historians tend to favour the notion of change over that of tradition. But plans of earlier buildings show similar arrangements. Indeed, the terminology in inventories for internal spaces, and descriptions of this and other buildings of the fifteenth century, do not differ substantially from those used for earlier houses.[9] Thus, while after the middle of the fifteenth century there were certainly developments in architectural style, the assertions that there were fundamental changes in the organization of houses, and specifically that the apartment, or suite, came into being only in these years, seem unwarranted.[10] Basic patterns of inhabiting houses continued as in the past, and the novelty lay in the details: more finely tuned planning, new kinds of furniture as well as increasingly elaborate versions of traditional types, and constantly greater numbers of items.

There are few studies on the interiors of non-princely houses built in the sixteenth century. Further research is needed, in particular to determine whether the contrasts that one would expect to find between interiors of the fifteenth and the sixteenth centuries really existed. The fact that in the sixteenth century the individuals who inhabited fifteenth- and even fourteenth-century buildings were of the same social level as those who built new houses indicates that the older organization of spaces continued to be deemed acceptable.

THE *SALA, CAMERA* AND *SCRITTOIO*

With an understanding of the general layout of houses, a focus on three important rooms, the *sala, camera* and *scrittoio*, will give a broad picture of Florentine practice regarding objects that complemented the architectural shell, and will indicate the activities associated with each type of room. A significant generalization will emerge: the *camera* and the *scrittoio* were often crowded not just with furniture, but also with decoration, while the effect in the *sala* was less dense. We have few indications of frescoes, in contrast to the numerous examples that can be adduced for the fourteenth century,[11] but painted ceilings, fabrics draping the walls and hung at the doorways, and wood panelling – with or without paintings set into it – were common in the fifteenth and sixteenth centuries. In addition, Florentines were in the habit of putting paintings, sculptures and other objects above doors, fireplaces and large pieces of furniture. The basic aesthetic seems to have consisted of walls covered with rising decoration (see pp.271–8).[12]

The *sala principale* on the *piano nobile* was always located near the top of the stairs and at the front of the house. As a great entertainment room, it had built-in wooden benches all around, sometimes with high backrests. Well into the sixteenth century benches – attached to the wall or freestanding – were the predominant seating accommodation throughout houses of all economic levels. The large windows, set high in the walls and reached by stone steps, left little empty surface above. Long tables, on trestles until the later sixteenth century, were another constant feature in *sale*, and they could be disassembled easily after a meal to free space for dancing and other activities (see p.224).[13] During the Renaissance the *credenza*, used first as a simple sideboard, developed into a vehicle for display, and on special occasions tiers of metal vessels were set on it.

An essential element of the *sala* was a very large fireplace, a visual focus and a symbolic, as well as a real, source of warmth. Benches, chairs and sometimes tables were associated with the fireplace. The

2.4 Drawing related to the Borgherini fireplace, pen and brown ink and wash on white paper, Florence, *c.*1510 (Gabinetto dei Disegni e Stampe, Uffizi, 663, Orn)

dramatic development of fireplaces can be seen by comparing the V&A's Boni fireplace of *c.*1458 (see plate 19.12) with a drawing of about 1510 related to the fireplace of the *sala* in the Borgherini palace (plate 2.4).[14] The two fireplaces were in rooms similar in size, but while the earlier measures 3.65 metres wide by 2.6 metres high, the Borgherini fireplace, which has roughly the proportions of the drawing, is about the same width, but 5.1 metres high, and it reached almost to the lower cornice of the ceiling in the palace's *sala*. The difference in height is due to the fireplace's heavier architecture and additional frieze, and especially to the superstructure displaying the family's coat of arms. This fixed ornament was a formalization of the sort of decoration attested by countless fifteenth- and sixteenth-century inven-

tories and images, which featured movable sculpture or paintings above fireplaces (see pp.285–6).

Throughout Florence during this period water in a basin was offered to diners for the ceremonial washing of hands, and there are allusions to water in *sale* from the fourteenth to the seventeenth centuries; in 1545 at the Bartolini palace the *sala* had 'a pedestal, with the brass basin and bucket'.[15] This use of water was sometimes given more concrete form in the *acquaio*, a stone basin installed in the wall with an elaborate frame and, occasionally, running water. The magnificent example in the V&A, which comes from the *sala principale* of the Girolami palace in Florence and dates from around 1500, had water spouts (see pp.284–7).[16] Few *acquai* survive *in situ*, and perhaps because they do not figure prominently in the documentation regarding the Medici palace, they have not been recognized as one of the common fittings in these rooms, especially in Florentine palaces of the later fifteenth and early sixteenth centuries. The scale of *acquai*, like that of fireplaces, could be enormous: in the *sala principale* of the Corsi-Horne palace the *acquaio* rose nearly to the ceiling, as we know from the drawing that the English scholar and collector Herbert Horne made of the outline he found in the lowest layer of plaster.[17] Both Vasari around 1560 and the historian of sculpture Leopoldo Cicognara in the early nineteenth century mention elaborate 'sets' of fireplace and *acquaio*.[18] Construction documents for the dignified but not palatial row of houses built in the sixteenth century on the Piazza Santissima Annunziata in Florence confirm that both elements were common in *sale* and *salette*.[19]

The Boni fireplace probably comes from the *sala* of a palace for which there is a detailed description from 1803 referring to 'a fireplace and an *acquaio* facing each other, and richly designed with frames carved with decoration and figures in low relief'.[20] This suggests that these major fixtures were conceived in tandem and decorated in a similar manner. In a section drawing of the Gaddi houses (*c.*1560; plate 2.5), in the room labelled 'salla' at the right on the third level, the *acquaio* is shown facing the viewer, with the fireplace at the left seen from the side. The curving forms above the *acquaio* and fireplace in the drawing may refer to the terracotta angels that Vasari tells us the sculptor Tribolo

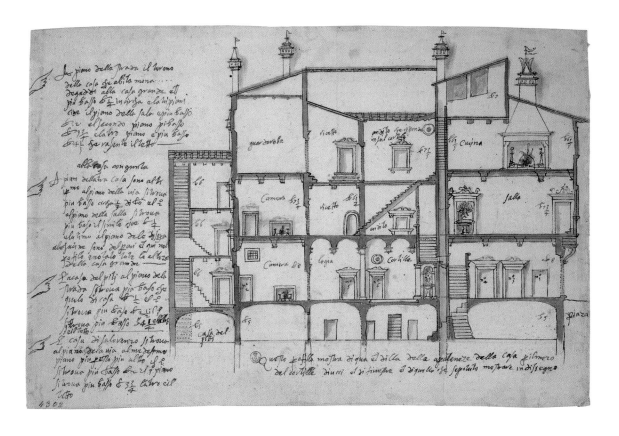

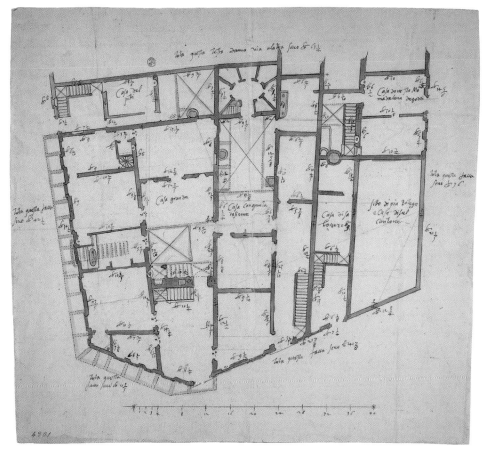

2.5 Plan and cross section of houses belonging
to the Gaddi family of Florence, Florence, *c.*1560
(cats 8 and 9)

In the cross section the spaces are labelled; the stonework
of doorways, fireplaces, *acquai* and cupboards is indicated.
The plan indicates the numerous wells, basins and toilets.
These drawings were probably made when the houses
were remodelled.

produced for the fireplace and *acquaio* designed by
Jacopo Sansovino for the friend and patron of artists,
Giovanni Gaddi, who owned this house in the first
two decades of the sixteenth century.[21] The many
items associated with *acquai* in inventories – includ-
ing brass ewers and basins, copper buckets, terracotta
vessels, maiolica and glass, shelves, brass candlesticks,
and even sculpture or paintings placed above the
cornice – testify to the *acquaio* not only as a working
structure but as a place for display.

The fireplace and *acquaio*, together with other
stonework in the *sala* – the steps at the high win-
dows and door and window frames – and the deco-
rated ceiling, all contributed to the impressive tone

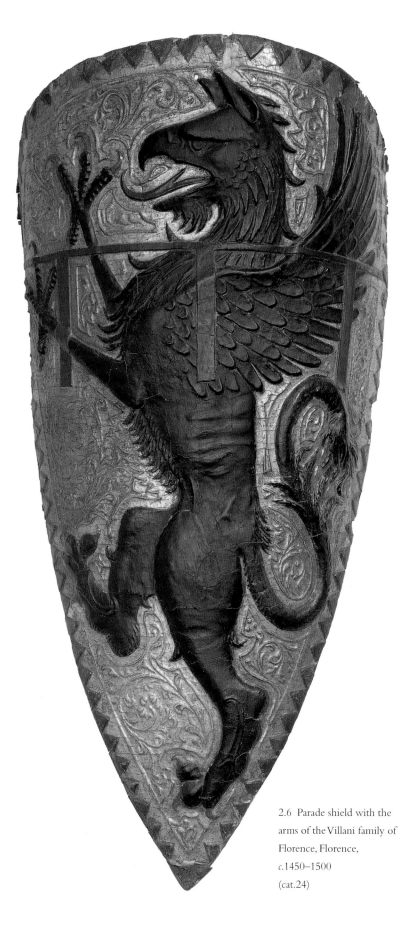

2.6 Parade shield with the
arms of the Villani family of
Florence, Florence,
*c.*1450–1500
(cat.24)

of these rooms. A showpiece like the Villani shield
(plate 2.6), made probably for the merchant Jacopo
di Giovanni Villani or one of his many sons in the
second half of the fifteenth century, is likely to have
hung in the *sala* of the family's house, and its excel-
lent condition suggests that it was treasured. But
aside from the benches, *credenza* and items over
doors, above the fireplace and at the *acquaio*, we have
little information about other decoration of the vast
expanses of wall space. Occasionally there were
paintings, tapestries and other hangings that could be
put up for special occasions, but scholars are right to
comment on the paucity of items listed for *sale* in
inventories, which makes these rooms seem impossi-
bly sparsely furnished.

While the *sala* was usually a long rectangular
space, the *camera* into which one then passed was
nearly square. Typically, a *camera* was furnished
around the time that a man married,[22] and the most
prominent piece of furniture was a very large bed.
We should not ignore the symbolic overtones: in a
society rooted in the family and with overwhelming
attentiveness to blood relations, the bed was a monu-
ment to the very idea of procreation.[23] Already in
the fourteenth century beds measuring 3 metres
wide were common in Tuscany. In the fifteenth
century they sometimes reached 3.5 metres and
included chests on three sides, which, like the ones
in *The Birth and Naming of St John the Baptist* by
Benedetto da Maiano (plate 2.7),[24] gave a platform
to the bed and served for storage. Depictions some-
times show people sitting or standing on chests,
and they provided surfaces upon which objects
could be placed. During the course of the sixteenth
century these projecting bases disappeared and beds
acquired freestanding legs. Inventories indicate that
most beds were surmounted by canopies and had
curtains that could be closed, though these are
sometimes excluded from images in the interest of
clarity of presentation; the importance of such trap-
pings is attested by the astonishing quantities and
valuations given in inventories. Frequently an upper-
class and even middle-class *camera* also had a *lettuccio*
(a daybed used as much for sitting as for sleeping) as
wide as the bed; the two could face each other, or
they could be lined up or attached at right angles to
make a unified area of impressive furniture (see
pp.122–3).[25] Pieces of sculpture, especially heads, and

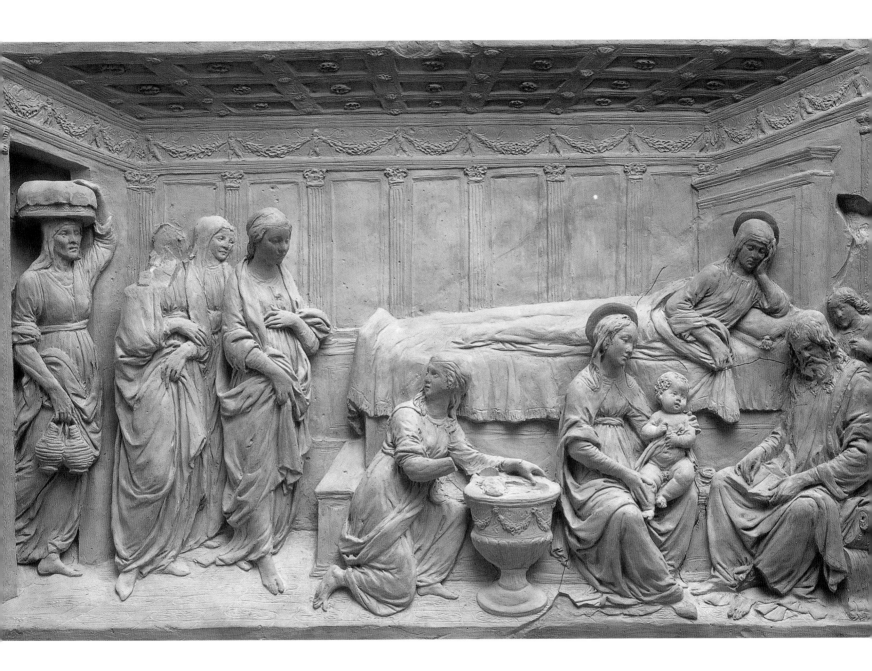

2.7 Benedetto da Maiano,
*The Birth and Naming of
St John the Baptist*, Florence,
*c.*1477
(cat.159)

also paintings are mentioned in inventories above the *lettuccio*'s high back, which itself could be abundantly ornamented, or above the bed's headboard (see pp.272–5).

Camere contained many other storage chests, including the luxurious pairs that are today called *cassoni*, again sometimes having vertical painted elements rising behind them against the wall. There was always a fireplace, smaller than the one in the *sala*, sometimes an *acquaio* and often a small table and a chair or two; in the sixteenth century octagonal tables came into fashion (see p.225). Musical instruments were occasionally listed as being in *camere*. An account of a banquet given in the home of a Florentine in Naples in 1477 states specifically that after eating in the *sala* guests moved to the *camera* and *anticamera* to make music (see p.233).[26] Finally, in virtually every *camera* there was at least one image of the Virgin and Child, usually painted but sometimes in relief, often set in a carved, painted and gilded wooden frame and veiled with a curtain. A special type of round religious picture, the *tondo*, became popular in the late fifteenth and early sixteenth centuries for the *camera* or the *anticamera*.[27]

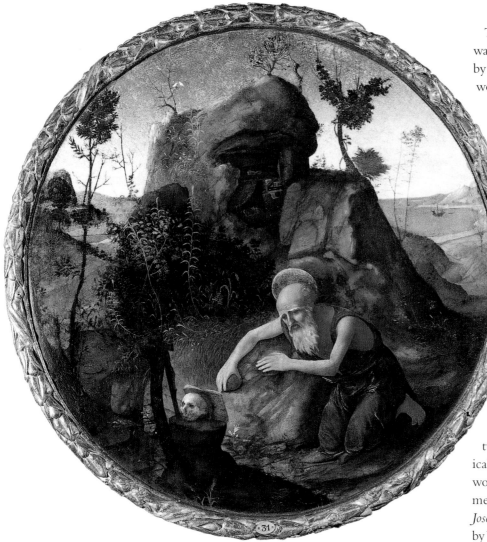

2.8 Piero di Cosimo,
St Jerome in the Wilderness,
Florence, *c*.1495–1500
(cat.113)

The great example is the Borgherini *camera*, which was decorated between 1515 and 1518, and described by Vasari in his 'Lives' of the architect and wood-worker Baccio d'Agnolo and painters Andrea del Sarto, Granacci, Bacchiacca and Pontormo.[28] Fourteen surviving pictures forming a Joseph cycle, and a *Virgin and Child* by Andrea del Sarto, may have constituted all the painted decoration in the room,[29] and because the room itself can be identified, a reconstruction can give us a specific sense of the ensemble.

The main suite of the Borgherini (now Rosselli del Turco) palace in Florence was west of the *sala*, and the corner room overlooking the Piazza Santi Apostoli must have been the famous *camera*. Doors to the *sala* and *anticamera*, two windows and a fireplace restricted placement of furniture in the space, so that the bed and *lettuccio* must have been set against the north and south walls.

The first twelve paintings can be arranged in two groups, which present the story in chronological order and read from left to right. Five episodes would have been near the *lettuccio* and the *cassoni*, also mentioned by Vasari, on the south wall: Granacci's *Joseph Taken to Prison*, the painting by that master seen by Vasari above the *lettuccio*; two panels by Andrea del Sarto (*Early Life of Joseph*; *Joseph Presented to Pharoah*) flanking the Granacci; and two smaller paintings by Pontormo (*Joseph Sold to Potiphar* [plate 2.10]; *Pharoah with his Butler and Baker*) perhaps incorporated into the sides of the *lettuccio*. All this would have formed a coherent sequence in the area of the room most visible to a person entering from the *sala*. Associated with chests at the base of the bed on the opposite wall would be the next seven scenes: a long panel by Pontormo (*Joseph's Brothers Beg for Mercy*); followed by two small paintings by Bacchiacca (*The Arrest of the Brothers*; *Joseph's Release of his Brothers*) set at the corner of the bed; then another Bacchiacca (*Joseph Receives his Brothers*), with a centralized composition, at the end of the bed; two more small paintings by Bacchiacca (*Searching the Sacks of Grain*; *Benjamin and the Finding of the Cup*) at the corner; and a last long panel by Bacchiacca on the side of the bed (*Joseph Pardons his Brothers*).

An interesting example, with a fine original frame, is the *St Jerome in the Wilderness* (*c*.1495–1500) by Piero di Cosimo (plate 2.8; see p.194).

In the *Birth of the Virgin* (1514) by Andrea del Sarto (plate 2.9) the furniture almost fills the room. Reconstructions to scale of the beds and *lettucci* in the *camere principali* of the Medici palace in 1492 and the Gianfigliazzi palace in 1485 give the same impression, and inventories invariably list many more times the number of items here than for the *sala*. In addition to everything mentioned so far, typically in the *camera* there were curtains at the doors, and rugs and other fabrics strewn over tables, benches and chests. Fitting the *camera* with an elaborate ceiling and panelling on the walls, as seen in the relief by Benedetto da Maiano (plate 2.7), was fairly common in wealthy households, and sometimes painted panels were set into the woodwork.

THE FLORENTINE *CASA* 43

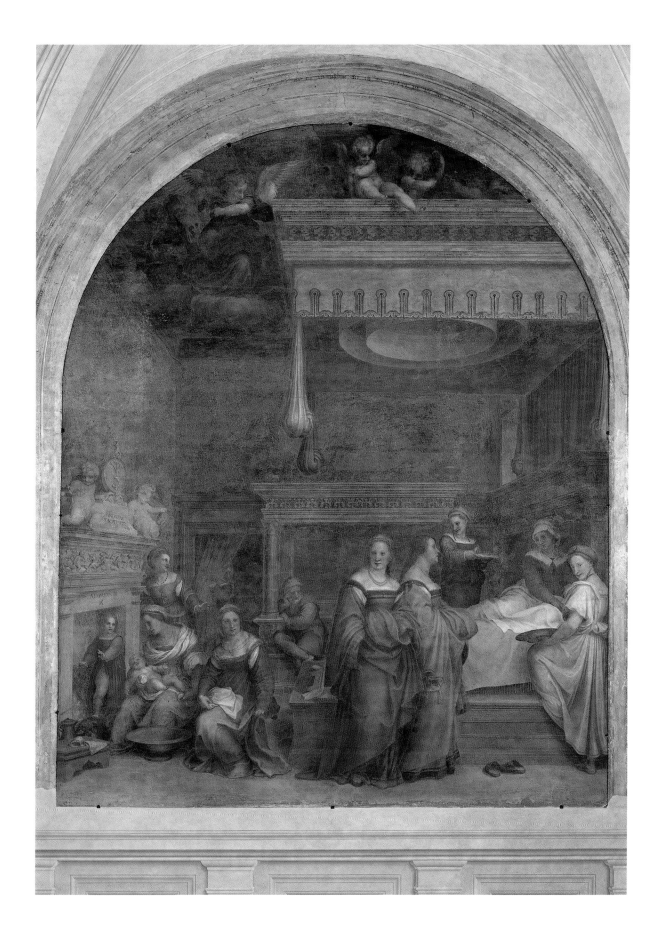

2.9 Andrea del Sarto,
Birth of the Virgin, fresco,
Florence, 1514
One of the scenes from the
Life of the Virgin cycle in
the forecourt of the Servite
church of Santissima
Annunziata.

Alternatively, the long panel by Pontormo and the last painting by Bacchiacca were perhaps on two *cassoni* under the windows. This reconstruction places the second, very large Granacci (*Joseph Introduces his Father and Brothers to Pharoah*) above the door to the *anticamera*, and indeed the picture looks best seen from below and the left. Vasari wrote that the final painting of the story, the big Pontormo (*Joseph with Jacob in Egypt*), was on the left in the corner as one came into the room; he was surely referring to the entrance from the *sala*, and on the west wall near the door to the *anticamera* this picture would be in the proper sequence with regard to the big Granacci. The *Virgin and Child* by Andrea del Sarto, probably the beautiful picture now in the Galleria Borghese in Rome, was perhaps placed above the fireplace. Light in most of the paintings is shown from the left and thus was not always coordinated with the light entering the room from the windows. It should be emphasized that the paintings were not framed and 'hung' but let into the furniture and the extraordinary woodwork by Baccio d'Agnolo, who made the ceiling, bed, *cassoni* and chairs as well; in 1563 the room was called the 'Camera d'Oro', signifying that there was much gilding.

Lamentably, no intact woodwork in Florentine palaces survives, although the decoration of three rooms dating from the 1430s to the 1470s – the Sacrestia delle Messe of the Florentine cathedral, and the *studioli* of Federigo da Montefeltro in Urbino and from Gubbio – help one visualize this combination of architectural articulation and flat figurative elements.[30] From the later fifteenth century until well into the seventeenth century tooled and gilded leather hangings covering the walls of *camere* gave an even more sumptuous effect in the houses of the very rich. After the middle of the sixteenth century *camere* were also adorned with numerous framed easel paintings on wood or canvas.

The lists of objects in inventories, considered together with other documents, show that the *camera* was the residence of the head of household, used by a man and sometimes also his wife not only for sleeping, but also for conversation, needlework, reading and keeping accounts. Political and business meetings could take place here, and notaries came to the *camera* to write acts in the presence of the principals and witnesses. This wide range of activities is evoked by the items listed for the main *camera* in the inventory of Francesco Nori's house: apart

2.11 Inventory of Francesco Nori's house, Florence, 1478 (cat.12)

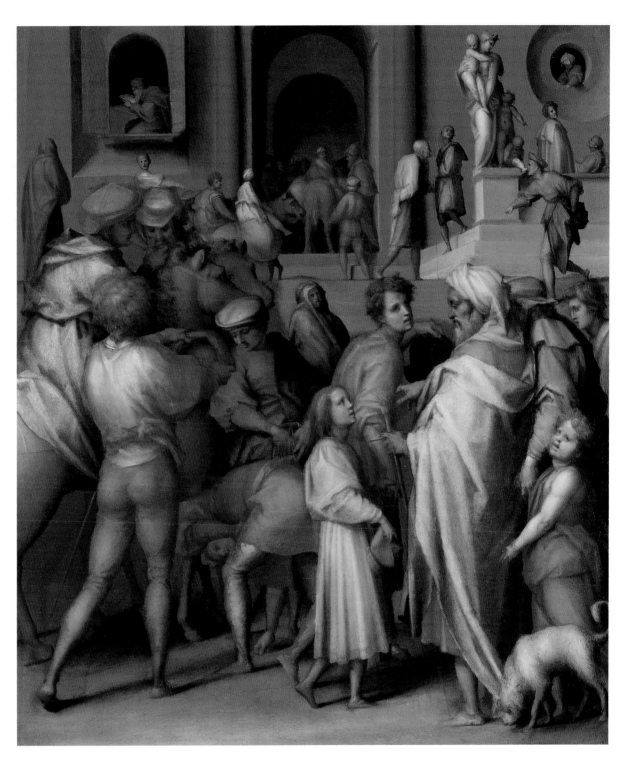

2.10 Detail from Jacopo Pontormo, *Joseph Sold to Potiphar*, oil on wood, Florence, *c.*1515 (The National Gallery, London)

from the bed and *lettuccio*, there were more than forty books in Italian and French, several paintings, a device for loading a crossbow, a nautical map, a few pieces of cutlery, a table for writing, items of clothing and account books for construction and household expenses (plate 2.11).[31] Thus over-emphasis on the *camera* as a 'bedroom' has obscured a more complex story: though a room for sleeping, the *camera* could also accommodate music, eating simple meals, or even wakes for the dead just like the *sala*, where greater formality was the salient distinction. The *camera* was by no means secluded and, when it was followed by an *anticamera*, it became, like the *sala*, a room through which people would pass to reach another space deeper in the suite.

2.12 Benedetto da Maiano,
portrait bust of Pietro
Mellini, Florence, 1474
(cat.114)

The decorative effect would have been enhanced by paint on the eyes, mouth and hair, as well as on the brocade and fur of the opulent garments. The whole range of people who entered the *camera* – the man of the house, his wife and family, and also their numerous visitors – were the audience for the many works of art, sometimes collected over generations. In 1506, fifty years after the bust of Giovanni Chellini (plate 2.13) was made, Chellini's heir urged his own six sons to keep this 'marble head of maestro Giovanni' in the house (we do not know in which room) and not to move it without consensus among the brothers, implying that it had become an object of reverence within the family.[33]

There seems to have been no fixed pattern in Tuscany for where the head of the household's wife habitually lived and where she slept – houses that were not princely residences did not have separate quarters as a matter of course. The issue is important for understanding the extent to which the *camera principale* was the realm not only of the man, but also of his wife. Evidence for locating the wife comes from inventories, which sometimes mention a 'camera di Madonna' or 'di monna X' or permit identification of the wife's room through the objects listed, from analysis of buildings' plans, and especially from men's wills. Frequently a man left to his wife the bed and *lettuccio* from his *camera*, or – if he designated her as the guardian of their children – even the room itself. In these cases we can presume that the widow remained in the *camera principale* that she had shared with her husband. But when the wife was given the room where – as some wills clearly state – the couple had slept together, and the *camera principale* is not specified, probably the reference is to her own room, to which the man would go to be with her. We can probably identify the wife's room in several palaces built in the second half of the fifteenth century which have a second big *camera* next to the *sala*.[34] We should also wonder about lying-in rooms and where, in an important social ceremony, a wife received visits on the birth of a child.[35] While the *camera principale* may have begun as a nuptial chamber, and may also have been where visitors came to see the new mother, it was a locus of too many aspects of the man's life for his wife to take it over for long periods. The placement of the *anticamera* with access only through the *camera*, in addition

The *anticamera* was often even more lavishly appointed than the *camera* to which it served as an appendage: here, too, were a bed and a *lettuccio*, and sometimes even more works of art. Its smaller size and lower ceiling meant that the doorway leading to it from the *camera* was also quite low. It is possible that the marble bust of Pietro Mellini by Benedetto da Maiano (plate 2.12), dated 1474 and surely made for the palace that this banker built on the via dei Neri around this time, would have originally been placed above this kind of door.[32] The eyes, dramatically turned to Mellini's left, together with the inquiring brows, cocked ears and mobile mouth, give the face a sense of alert attention. Mellini, who was very active in financial and political circles, would have received numerous colleagues and clients at his house, and we can imagine that his bust was designed to interact not just with his family but with visitors entering the *camera* from the *sala* and looking across the room towards the door to the *anticamera*.

2.14 Donatello, *The Virgin and Child with Four Angels (Chellini Madonna)*, probably Padua, before 1456 (cat.14)

Donatello gave this unique bronze roundel to his doctor, Giovanni Chellini, in 1456 in gratitude for care during an illness. Chellini recorded that it was designed as a mould to make replicas in glass.

2.13 Antonio Rossellino, portrait bust of Giovanni di Antonio Chellini da San Miniato, Florence, 1456 (cat.13)

This bust was made when Chellini was about eighty-four and is inscribed on the inside with the names of the sitter and artist, and the date.

to the fact that there is no pattern in inventories of associating women with it, probably rules it out as the usual residence of the wife.[36] These two issues – wives' quarters and rooms used for confinement, childbirth and ceremonial visits afterwards – merit further research.

In Florence the study, or *scrittoio*, could take different forms that frequently coexisted in the same building. The famous study deep in the main suite on the *piano nobile* of the Medici palace was highly ornamented: small, about 4.5 by 3.6 metres,[37] the room had a curved ceiling decorated in the first half of the 1450s with the twelve *Labours of the Months* by Luca della Robbia, who also made a pavement of glazed terracotta, which does not survive (see pp.288–90). The walls were sheathed with panelling of inlaid wood, probably organized into separate fields by pilasters that framed fanciful representations of cabinets, in a system similar to the one still seen today in the Florentine sacristy and the Montefeltro studies mentioned earlier. The inventory of 1492 lists the room's remarkable contents; among the many treasures were vessels of semiprecious stones, ancient gems, jewels, religious objects and texts, vernacular literature, paintings, images made in mosaic, bronze sculptures, medals and maps.

The houses of more ordinary Florentines had *scrittoi* of several different sorts. Those that were part of a suite could be for the businessman, scholar or person of culture, with just one or two 'collectibles', such as a head of an ancient sage or a small sculpture. Perhaps the *Virgin and Child with Four Angels* (plate 2.14), given by Donatello to Giovanni Chellini, though listed in a *cassone* in 1500,[38] was kept in this

doctor's study during his lifetime together with his *ricordanze*, where Chellini wrote of Donatello's gesture (plate 2.15).[39] These *scrittoi* could contain popular religious books, and texts by Latin and vernacular authors; there were also account books, books of records and letters. Even cutlery, especially made of silver, shows up in many inventories, and often studies held jewellery and other valuables. Finally, aids for reading and writing that appear in inventories include candlesticks, lamps and inkwells. A second type of *scrittoio* was located on the ground floor, and it functioned primarily as an office, easily accessible to people coming in from the street. In some houses *scrittoi* of a third type, half-way up the stairs in both Florence ('a mezza schala') and Venice ('in mezà'),[40] were private spaces for the head of the household which could also be used for more commercial purposes.[41] One can find indications of all situations in the inventories of large houses and palaces (see pp.166-71). *Scrittoi* were small and had no fireplaces. Woodwork lining the walls helped make them comfortable, while windows usually had glass. Finally, the *scrittoio* could simply be a piece of furniture in a *camera*, anything from a plain table to something like the complex room-within-a-room that Antonello da Messina devised in his *St Jerome in his Study* of *c*.1475 (see plate 1.6).

★ ★ ★

The character of Florentine interiors during the fifteenth and sixteenth centuries derived from the standard sequence of rooms in the suite on the *piano nobile* and from the scale of the architecture, usually very large, but allowing the inclusion of smaller spaces. The look of the *sala* depended largely on the stone fittings, while the *camera* was filled with monumental wooden furniture and numerous smaller items. *Scrittoi* of any type compressed elaborate woodwork and objects into a small space. Walls in all three rooms seem to have been covered – with wood, fabrics or other decoration – although as we have noted, there is little information available in this regard about the *sala*. The distinct uses of the three rooms sometimes became blurred, most importantly in the *camera*, which was as much a site for meetings as for sleeping. In general, these houses were set up not just for daily living but for impressing visitors. More research is needed on the nature of women's and children's quarters, and their relationship to the main suite. While many instances of change are found over the course of the two centuries – larger *ricetti*, more *salette/salotti*, the development of the *credenza*, larger fireplaces, more elaborate *acquai*, tables in new forms and sizes, leather hangings, more paintings, more rooms for the wife – continuity seems just as important. Although this essay has treated Florentine interiors as if the buildings were new and the rooms designed for specific inhabitants, alterations were required to living arrangements as families evolved. The living space was often divided – especially after the death of the head of the household if there was more than one adult son – to give several families separate quarters. The heavy construction made extensive remodelling impractical, but almost invariably each party was left with at least one suite, the basic unit for living in these houses. While few Florentine palaces continued to be inhabited for more than one generation in the way that the planners envisioned, the suite proved adaptable for use over many generations. In new houses the suite could accommodate the numerous minor developments that we have observed over the fifteenth and sixteenth centuries, without, however, undergoing major changes in organization.

2.15 *Ricordanze* of Giovanni
Chellini, Florence, 1425–57
(cat.15)
This book, continued after
Giovanni's death, records in
the fifth entry on this page
Donatello's gift in 1456 of a
bronze roundel identified
with that in plate 2.14.

THE VENETIAN *CASA*

PATRICIA FORTINI BROWN

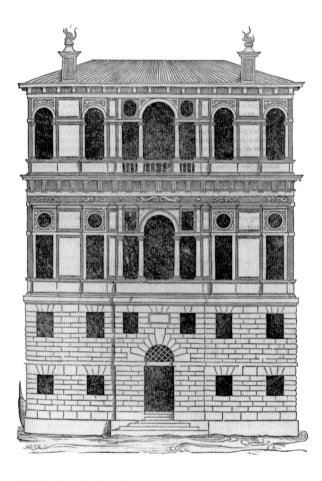

3.1 Sebastiano Serlio, palace façade in the Venetian manner with the Doric and Ionic order, from his *Regole generali di architettura*, Venice, 1537 (cat.11)

NOWHERE IS THE NOTION that 'geography is destiny' more demonstrable than in the Veneto region. The major *terraferma* (mainland) cities were built on ancient Roman foundations with solid ground and ample space for capacious homes with large interior courtyards and gardens to the rear. Venice, by contrast, was situated in salt water and built up on some seventy small islands in the midst of a lagoon. Land was limited and builders had to deal with plots whose irregular contours were determined by the ebb and flow of tidal action. With boats the primary means of transportation and commerce, water frontage was a highly sought after feature. As will be shown, the distinctive Venetian palace type – a tall, deep structure with a relatively narrow façade ideally facing a canal – was the product of nature, economics and human artifice (plate 3.1).

The primary residential model for the region as a whole was the late medieval upper-hall house type. Built of masonry, it consisted of a two-storey block, with service rooms on the ground level and residential rooms above. The *sala*, sometimes supported by a ground-floor arcade, was located at the front of the house on the upper level and denoted on the exterior by windows evenly spaced across a wide façade.[1]

By the fifteenth century in mainland homes in the Veneto, these basic elements would be augmented by an attic and basement, with the principal floors separated by mezzanines and the ground plan expanded with wings. Palaces were built directly on the street with an imposing entrance portal surmounted by a coat of arms in a bold affirmation of family identity. Many included ground-floor arcades serving as public passageways, a feature that still remains in many Veneto towns, such as Padua and Conegliano, but was eventually eliminated in Verona in the sixteenth century with the growing privatization of public space.[2]

TERRAFERMA HOUSES

With the basic footprint determined by the ancient Roman street grid, houses on the mainland typically featured an L- or C-shaped plan. The *sala* maintained its position of pre-eminence on the upper floor, extending across the width of the façade, with the *camere* in the wings behind it, flanking a large central courtyard on one or both sides. The *studio*, or business office, of the proprietor was often located on the ground level near the entrance so that clients could be received without disturbing the rest of the house. Secondary reception rooms, often elegantly decorated and furnished, might also be found on that level, as in Andrea Palladio's Palazzo Barbaran Da Porto in Vicenza (1569). The kitchen and storage areas were located behind them or in the basement and not visible to visitors. Servants' quarters and storerooms were typically located on the mezzanine and attic levels.[3]

In the fifteenth century primary access to the upper floor was still provided by an uncovered staircase in the courtyard. Over the course of the sixteenth century the staircase was moved inside one of the wings, taking on monumental proportions and becoming a grand ceremonial passageway up to the *sala*. A spacious hall and the primary site of family representation, the *sala* was illuminated by tall windows distributed regularly across the façade and often featured frescoed walls and plaster ceilings with stucco decoration. However, inventories suggest that it was sparsely furnished, with only a few items kept there all the time: typically a large table, *credenza* and benches. Floors throughout the house, if not made of wood, were paved with ceramic tiles. All the principal rooms – the *sala* and *camere* – were heated by fireplaces, often of monumental proportions.[4]

HOUSES IN VENICE

In Venice the layout of residential building lots was essentially fixed by the onset of the fifteenth century, except for some expansion through landfills at the margins. New palaces were built on the footprints of the old, but rather than tear something down or build out, Venetians often simply added floors on top. Three or four storeys, consisting of a ground floor surmounted by two residential floors, mezzanines and an attic, were not unusual. With the

principal façade on the narrow side, these houses tended to appear taller than those in the Veneto. Those on the Grand Canal seemed to rise directly out of the water.

Unlike many mainland communities, Venice rejected primogeniture and adhered to the principle of equal division of property amongst all the sons of a family (see p.78). In many cases, unless the family owned several houses that could be distributed between the heirs, this practice meant that the family home was held jointly by several brothers. These circumstances led to creative living arrangements, and the larger palaces were often virtual apartment houses. In some cases one brother occupied the entire house with his wife and children and paid rent to his brothers who lived elsewhere. Or in palaces with two residential floors each floor might be occupied by a married brother and his family, and a spare floor or mezzanine rooms might be lived in by a bachelor brother or rented out to strangers.[5]

Late medieval palaces in Venice featured a *sala* extending the width of the façade, as in mainland homes, but with a deep hallway called a *portego* behind it creating a T-shaped plan. Extending to the back of the house, the *portego* provided access to the *camere* aligned in a row behind the *sala*. The plan offered maximum flexibility, with doors kept open or locked up, adapting to different family situations over the generations.[6] The *sala* and *portego* combination seems to have functioned as a unified space, but over time corner rooms were carved out of the sides of the *sala* in most palaces. Eventually all that was left was the *portego* that took on the functions of the *sala*; flanking it on one or both sides were *camere* that, when possible, opened one into the other (plate 3.2). The architectural theorist Sebastiano Serlio defined the adoption of the *portego* plan in Venice as 'the universal custom of the city' in his treatise on domestic architecture (Book VI, 1540s).[7]

Another notable distinction between Venetian palaces and those on the mainland was the absence of the large courtyard surrounded by porticoes that formed the core of the Veneto house. In Venetian palaces light was supplied to the interior by one or more small courtyards at the side or rear, creating C, L and U-shaped plans.[8] Some had larger courtyards to the side and gardens to the rear. But compensating for the lack of a spacious interior courtyard, the

Venetian house often had a terrace on the roof made of brick or wood. In his guide to the city of 1581 Francesco Sansovino reported that 'these are called *altane* and are used for hanging out washing in the sun; from them one sees, beyond the long stretches of water, all the surrounding countryside'.[9]

The water entrance was yet another peculiarity unique to Venice: homes situated on canals had two entrances, one accessible by land and the other by water. Serlio had observed that 'the most noble entrance to these houses is by water', and water gates of the larger palaces were comparable to the massive

3.2 (*right and opposite*) Milli Culiat and Massimo Brusegan, cutaway, plan and elevation of Ca'Gussoni (1548–56) designed by Michele Sanmicheli, pen and ink, Venice, 2005 (studio of Giorgio [Nubar] Gianighian). The façade of the building, which is situated on the Grand Canal at the corner of Rio di Noale, was once decorated with frescoes by Jacopo Tintoretto.

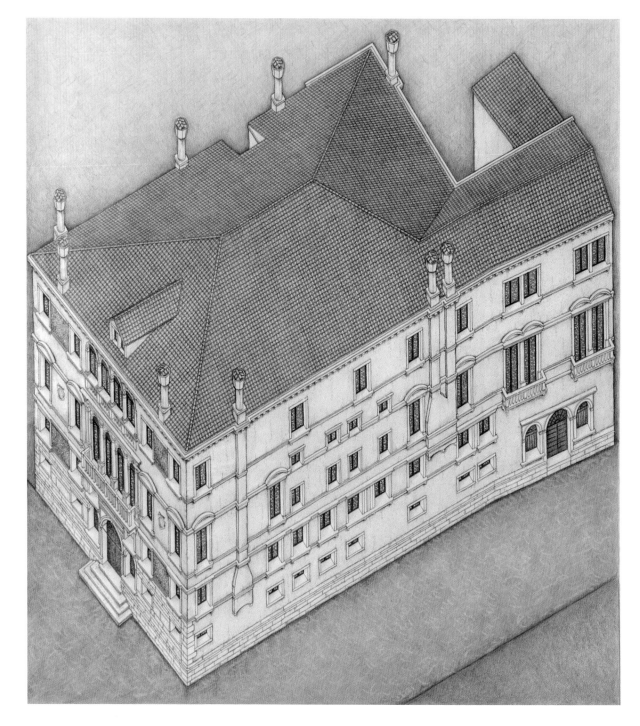

sculpted portals on mainland palaces.[10] They also had a utilitarian function; goods were transported most easily around the city by water, with deliveries made through water portals when possible. But the land-

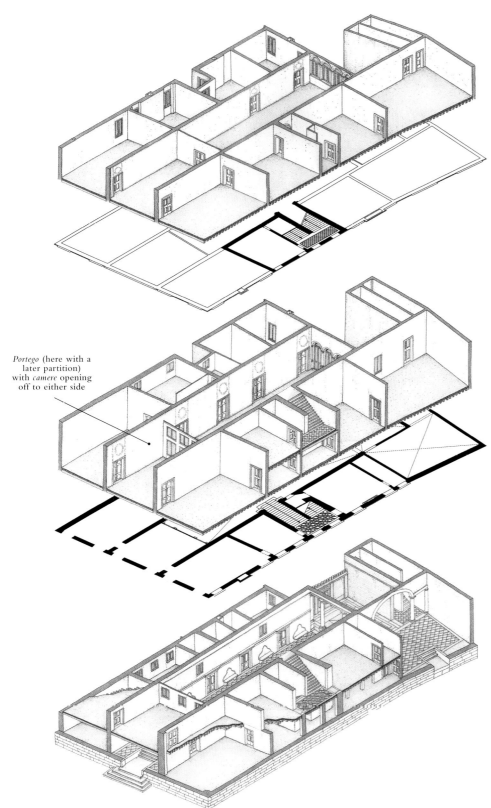

Portego (here with a later partition) with *camere* opening off to either side

ward entrance also offered opportunities to impress the visitor with the noble status of the house by featuring coats of arms, carved doorways and elaborate bronze doorknockers (see plate 20.5 and p.269).[11]

Behind the water portal was the ground-floor *androne*, or *sottoportego*, an open hall suitable for storing boats, wine and household supplies. Any rooms to the sides, if not used for storage, might be rented out, but were not used as living space or even as offices by any moderately well-to-do family. Inventories tell us what we might find there. The palace of the patrician Piero Gritti on the Grand Canal had two rooms on the ground floor. One, called the *magazen*, or storeroom, must have served as the laundry. It held nine tubs, both large and small, with their washboards; a copper ladle for the cooking pot; and two pairs of andirons. The other room was called the *caneva*. A virtual wine cellar, it contained five large casks, five barrels of different sorts and three medium-sized marble jugs for oil. Likewise, the *caneva* of the patrician Donato da Lezze on Campo San Stefano contained a large cauldron that could hold eight buckets of water, three wine casks – one full, one half full and the other empty – and a device to bottle wine. But here laundry was done out in the open courtyard near the well, where there were two large tubs, some firewood and four *caponere*, cages containing birds that would end up on the dinner table.[12] These everyday items remind us that even in urban Venice each family had to maintain a certain self-sufficiency, providing for its own needs.

Herein lay another distinction between Venetian palaces and those on the mainland, where reception rooms and offices might be located on the ground floor, with a wine cellar in a basement beneath. Since Venetian houses had no basement the ground floor functioned essentially as a cellar above ground and was therefore dedicated to mundane activities that were largely carried out by servants. Again, it was a matter of environmental factors outweighing convenience, for the bottom floor of Venetian homes was damp and subject to periodic flooding even in the Renaissance period.

Indeed, water – how to obtain it, how to preserve it and how to control it – was a constant concern in Venice. That a city surrounded by water should be short of water to drink was an irony often commented upon. While mainland homes had proper

wells or fountains in their courtyards, Venetians were supplied with rainwater, funnelled from rooftops through gutters and downspouts or falling directly on the pavement, and collected in a cistern beneath the courtyard or in the adjacent public square. Sansovino reported that 'every comfortable palace has an uncovered courtyard with a well in the middle, because sweet water is made more perfect by air than by darkness, since sun purges it and releases from it every defect'.[13] Water was drawn from well-heads – *vere da pozzo* – made of Istrian stone or Verona marble and shaped like large capitals. Their utilitarian function did not deter Venetians from exploiting their symbolic and aesthetic possibilities and many were elaborately carved. The disposal of wastewater was a less attractive proposition, with sewage emptying directly into canals to be washed away by the tides.[14]

THE *PORTEGO*

As in mainland houses, in Venetian courtyards in the early sixteenth century uncovered exterior staircases began to give way to monumental staircases enclosed within the fabric of the building. These led directly to the first floor and into the *portego*, the most public room of the house. Upon entering, visitors would experience three striking visual effects. First, their eyes would be drawn to the luminous wall of glazed windows at the far end. These were a luxury in that

period and often remarked upon. Sansovino wrote that 'all the windows are covered not with waxed canvas or paper, but with fine white glass mounted in wooden frames and sealed with iron and lead … to the amazement of foreigners'.[15] Such amenities were not new in his time and had long been characteristic of Venetian palaces. Nearly all the windows of Ca' d'Oro, built in the 1430s, had been glazed, including those of the kitchens, the project requiring over two thousand roundels or *occhi* (eyes) of bottle glass.[16] The diarist Marin Sanudo wrote in 1493: 'There are so many glass windows that the glaziers are continually fitting and making them … in every district there is a glazier's shop.'[17] By Sansovino's time flat crystalline glass in rectangular panes had come into use in the grander homes, and the writer further observed that 'besides being offered a beautiful view, the eye is free to range unimpeded and the rooms are light and full of sunshine'. The windows on the façade, often augmented by projecting balconies, not only served as the focal point of the *portego* for those inside it, but also marked its location to those passing by.[18]

The attentive guest would next become aware of reflected light throughout the room, glancing off surfaces and changing throughout the day. The speckled floor, a major feature of the *piano nobile* of any upper-class residence, was composed of chips of coloured marble tamped down smoothly in a bed of slaked lime and was known as *terrazzo*. Polished to a high shine and spreading out like a pool, the pavement captured a lustrous reflection of the windows on its glassy surface. Windows of bottle glass produced a chiaroscuro effect of light and shadow, enhanced by mirrors and the flickering of glass lamps and chandeliers (plate 3.3).[19] In the fifteenth century mirrors were still disks of highly polished metal and of modest dimensions, but by the sixteenth century mirror-making had been taken over by Murano glassmakers. They had learned how to back a plate of flat glass with a highly reflective amalgam of tin and mercury, and large mirrors began to brighten the *porteghi* of the wealthy.[20]

3.3 Sconce, Italy,
16th century
(cat.34)

3.4 Tapestries with the arms of the Contarini family of Venice: *A Woodland Park with Palace and Pavilions* and *A Woodland Glade with Horsemen*, Brussels, before 1589 (cats 26 and 27)

Even the ceiling, typically constructed of cross-wise parallel beams, called *travi,* was defined by the light. Streaming in through the façade windows, it played over the dark wood beams, creating a corrugated pattern of alternating light and dark stripes. The effect was to draw the eye, without lingering, back to the windows at the end of the room. Often painted or papered with multi-coloured patterns, the beams also responded in chromatic counterpoint to the *terrazzo* floor below.

Finally, the occasional visitor would also have been struck by the relative emptiness of the *portego*, more a reception hall and passageway than a centre of everyday domestic activity. Inventories place a variety of objects in the Venetian *portego*, but sets of matched chairs and benches providing seating along the side walls for several dozen people were basic – and essential – items. Also common were *credenze* and chests of cypress or walnut. Such furniture was used not only for storage but also for the display of luxury objects such as large maiolica platters and artfully wrought pitchers of glass and enamelled

copper. At least some *porteghi* must have had wall fountains as was common in Florence (see pp.284-7). Although such items did not appear in inventories, since they were part of the fabric of the house, they are depicted in paintings (see plate 17.1), and several survive in museums.[21] *Porteghi* rarely contained fireplaces and would have been heated with portable braziers.

The walls behind were not bare. For special events, and 'according to the season', as Sansovino put it, they were decorated with tapestries from the Low Countries and sumptuous wall hangings of brocade and damask. Tapestries depicting imaginary landscapes, relating to a north Italian life style of *villeggiatura* – spending the summer months in the family villa – exemplify the taste of Venetians for surrounding themselves in their city homes with *verdure* (decorations depicting mostly green foliage and flowers) and pastoral scenes.[22] A set of five tapestries carrying the arms of the Contarini – a distinguished Venetian patrician family – includes garden scenes framed by allegorical figures (plate 3.4).

3.6 Paolo Veronese, *Portrait of a Gentleman, probably of the Soranzo Family of Venice*, Venice, 1575–87
(cat.31)
Unusually, this portrait is thought to have been paired with one of his wife.

3.5 Section of a cornice from Palazzo Benci, Venice, 1581–1621
(cat.25)
This could have formed the upper part of a continuous frieze running around the top of the wall just below the ceiling.

Rather than the frescoes common in the *sala* in affluent mainland homes, easel paintings dominated the walls of the Venetian *portego*. Canvases painted with allegorical or mythological scenes, or carved reliefs might be set into a frieze that ran around the top of the wall (plate 3.5), and many *porteghi* were adorned with portraits, thus functioning as galleries of male lineage (plate 3.6). While portraits of patrician wives were common in the mainland *sala*, they were rare in the Venetian *portego*.[23]

The family's piety was also displayed in the *portego* with paintings of religious subjects, many described in the inventories as *grande*, or large. Such lists cite not only the ubiquitous Madonna and Child and depictions of saints, of whom Jerome and Mary Magdalene were the most popular, but also themes from the Old and New Testament such as Adam and Eve, the Prodigal Son, the Adoration of the Magi, the Last Supper, Christ in the Garden and the Assumption of the Virgin. An icon of the Madonna and Child might be specially illuminated by a hanging lamp, such as a *cesendello*, made of glass with gilt and enamel decoration (plate 3.7). Other items expressing a family's ideals included secular paintings of the virtues and the ages of man and objects such as maiolica ware decorated with allegories of virtues and images of heroic deeds.

3.7 (*right*) Lamp with the arms of the Tiepolo family of Venice, Venice, early 16th century (cat.127)

3.8 (*far right*) Lantern, Venice, *c.*1570 (cat.29) Probably inspired by trophy lanterns from Venetian galleys, this example was most likely made for an interior and not for use at sea.

In addition, most patrician *porteghi* contained at least a few weapons or trophies of a military nature. Arranged in a traditional display called the *restelliera* or *lanziera dell'arme,* it could include swords, banners, shields, quivers and arrows, standards, lances, and ship accoutrements such as lanterns and trophies taken from the Turks (see p.320). The message was clear: this was a family that had performed valorous service for the republic (plate 3.8).[24]

Thus the function of the *portego* was, first and foremost, display. This was a privileged space of hospitality and celebration, the chairs lining the walls ready for guests, the polished floor awaiting dancers, the empty centre space to be filled with tables –

generally sitting on trestles to be easily mounted and dismantled – set with crystal goblets and silver flatware for a wedding banquet. The *portego* was also the major site of nuptial celebrations, arguably the most significant event in the life of the family. The festivities were initiated by a coming-out reception, with the bride presented to relatives and friends, and included several banquets, with *credenze* piled high with costly silver and pewter platters meant for show rather than use and even basins filled with gold ducats. With balls and other entertainments the *portego* was filled with music, food and guests for several days or even weeks (plate 3.9).

THE *CAMERA*

3.9 Jacob Matham,
A Venetian Ball Scene, pen
and brown ink with brown
and grey wash and touches
of red chalk, heightened
with white, Venice, 1605
(Windsor Royal Library, The
Royal Collection, Inv. 12838)

Sixteenth-century literature distinguished between the 'public' space of the mainland *sala*, or Venetian *portego*, where visitors and friends were received and banquets held, and the more 'private' environment of the *camera*, where only intimates were entertained.[25] As the *portego* was meant to impress, it was not a cosy place, and the *camera* had to serve many purposes. First and foremost was sleeping. Sansovino wrote that, unlike the *portego*,

> all the *camere* have fireplaces … and this is certainly wise, because when one gets out of bed the fire not only dries out the damp that gathers while one sleeps during the night, but it warms up the room and purges it of unhealthy vapours which rise in the air or in other places (see pp.184–5).[26]

In the fifteenth century fireplaces usually took the form of a trapezoid-shaped hood above a decorated portal. They would become far more elaborate with significant sculptural elements and a classical vocabulary over the course of the sixteenth century (see p.269 and plate 19.1).[27]

The *camera* was also used for dining, for small formal dinners and for large banquets when guests spilled over from the *portego*, as well as for everyday meals during cold weather. A contract of 1520 signed by six brothers who shared the patrician palace Ca' Foscari referred to the *camera* with a polished floor (*spazada*) 'where we are generally accustomed to eat in the winter', suggesting that the family dined in the *portego* only during the warmer months.[28] Tables on trestles, which could easily be set up in different

rooms, were the norm in this period (see p.224). Wall hangings, table linens and other objects were moved around as needed.

Venetian kitchens were typically on the first floor next to the bedrooms. Alternatively, they might be located on a mezzanine, with ovens on the ground level, but the widespread practice of renting out one or both residential floors of the palace often made a kitchen on a separate level impracticable.

In assessing the comfort and convenience of an apartment, present-day Venetians still put light and air at the top of the list, since the great depth of many Venetian palaces poses problems of lighting and ventilation. *Camere* might be quite dark if not at the front of the house. Those on the first floor received no direct sunlight if their windows faced a tall building across a *calle* (alley) or narrow canal. Some rooms had light coming only from the *portego*

or a small courtyard, and inventories often mention a *camera scura*, or dark chamber.

The rooms flanking the *portego* on the façade end of the house were thus privileged spaces and might even be the *camere d'oro* – golden bedrooms with coffered ceilings – often remarked upon by visitors to the city. Philippe de Commynes, the French ambassador to Venice in 1495, noted that most houses 'have at least two rooms which have gilded ceilings, rich mantelpieces of cut marble, gilded bedsteads, and painted and gilded screens, and very fine furniture inside' (plates 3.10, 3.11, 3.12 and 3.13).[29] In the same period Pietro Casola, a priest visiting the city from Milan, attended a childbirth celebration for a lady of the Dolfin family and estimated that the ornamentation of her chamber had cost two thousand ducats or more. His observations offer a rare eyewitness account of a very affluent Venetian interior:

3.10 Attr. Lambert Sustris, *Venus in her Bedchamber*, Venice or Padua, *c.*1548 (cat.128)

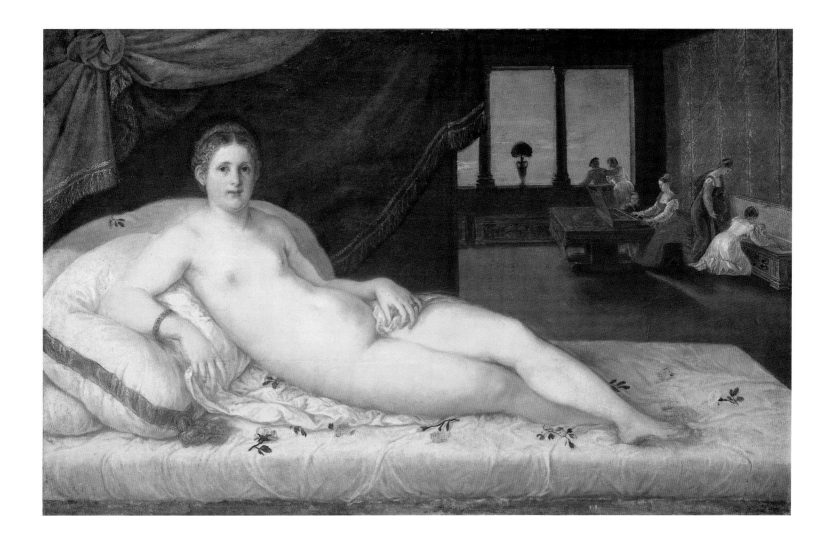

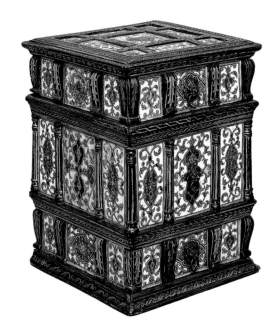

3.11 Dressing case with painting and gilding imitating Middle-Eastern ornament, Venice, *c.*1580 (cat.136)

3.12 Gilded leather panel (detail), Florence?, 16th century (cat.129)

The fireplace was all of Carrara marble, shining like gold and carved so subtly with figures and foliage that Praxiteles and Phidias could do no better. The ceiling was so richly decorated with gold and ultramarine and the walls so well adorned, that my pen is not equal to describing them ... There were so many beautiful and natural figures and so much gold everywhere that I do not know whether in the time of Solomon ... in which silver was reputed more common than stones, there was such an abundance as was displayed there.[30]

Sumptuary legislation was passed from time to time in an attempt to restrict the amount spent on decorating such rooms, but to little effect. In 1476, two decades before Casola and de Commynes would be dazzled by the Venetian *camera d'oro*, a law had been passed, condemning 'the immoderate and excessive expenses that are made in this city in ... the decoration of beds and chambers to the great offence of our Lord God and the universal damage of our gentlemen and citizens' and limiting the cost of decorating the bedroom itself with wood, gilding and paint to 150 ducats.[31] In 1489 the law was augmented by a prohibition on two new items, 'completely vain and superfluous, which exceed the private', that had recently entered the *camere*: 'the *restelli* and gilded chests, very sumptuous and valuable' (see pp.188–9 and p.121).[32] The futility of such attempts to legislate against conspicuous consumption in domestic space is demonstrated not only by inventories and reports like Casola's, but also by the prohibited objects that survive.

The *camera d'oro* could be used for sleeping, but it was also a primary site for elegant entertainment – small dinner parties, visits from friends, chamber music and childbirth celebrations, for example – in more intimate and comfortable environs than the *portego*. Music was the most popular entertainment in the Venetian house, with singing and solo and ensemble playing by the family, as well as performances by professional musicians. Inventories suggest that few affluent homes were without at least one harpsichord or spinet, and several lutes. Like trestle tables, musical instruments were portable and could be used in the *camera d'oro*, another chamber or even the *portego* (see p.233).[33]

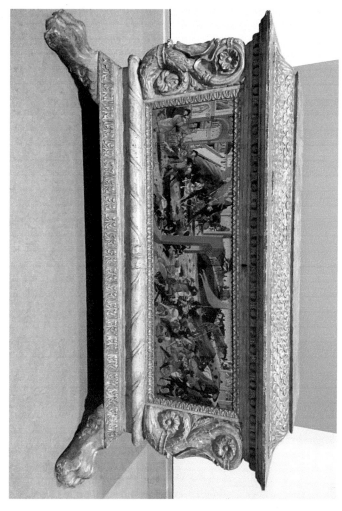

Biagio d'Antonio (1446–1516)
Jacopo del Sellaio (about 1441–1493)
Zanobi di Domenico (active 1464–1474)

**Cassone with the Arms of
Lorenzo Morelli and Vaggia Nerli
(The Morelli Chest), 1472**

Tempera, oil and gold on wood

1911.1. On loan from The Samuel Courtauld Trust.
The Courtauld Gallery, London. Above 1911.2

In 1472 Lorenzo Morelli arranged to marry
Vaggia Nerli. They both belonged to Florence's
patrician elite. To mark this event, Lorenzo
ordered lavish furnishings for his chamber in the
Morelli palace, including these chests (cassoni)
and their backboards (spalliere).

Lorenzo's chest and spalliera panel tell stories
from Roman history. Furius Camillus chased the
Gauls from Rome, while Horatius Cocles single-
handedly kept invaders from the city's gates.

Lorenzo and his peers were taught to follow
their example, and to be prepared to defend
their families and the Florentine Republic.

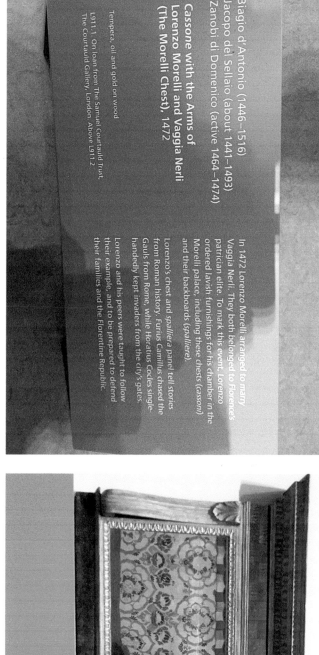

National Gallery

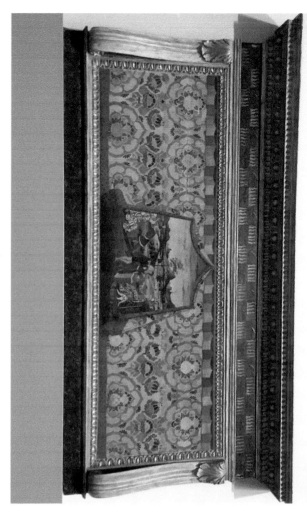

Biagio d'Antonio (1446–1516)
Jacopo del Sellaio (about 1441–1493)
Zanobi di Domenico (active 1464–1474)

**Cassone with the Arms of
Lorenzo Morelli and Vaggia Nerli
(The Nerli Chest), 1472**

Tempera, oil and gold on wood

1912,1 On loan from The Samuel Courtauld Trust,
The Courtauld Gallery, London. About 1922

Furniture paintings often told their viewers
how to behave, and what to avoid. The spalliera
panel above the chest shows Mucius Scaevola.
He plunged his hand into a fire to convince
Rome's enemies of her citizens' bravery.

The main painting set into the chest tells the
cautionary tale of a teacher who offered his
pupils as hostages to his city's enemies. He was
caught and punished.

This was an important message for Florentine
Renaissance women like Vaggia Nerli, who were
instructed that their principal responsibility was
to care for their husband's children.

National Gallery.

Most *camere*, however, served more mundane purposes and were less sumptuously fitted out than the *camera d'oro*. Although freestanding canopied beds were common, the built-in alcove bed was a characteristically Venetian accoutrement, remarked upon by visitors to the city. During the day the bed curtains, flush with the wall, were tucked in to hide the alcove. In grander palaces with taller ceilings, the bed would be flanked by cupboards, one of which contained a staircase leading up to a small mezzanine room called a *sopraletto* ('above the bed'). The architect Vincenzo Scamozzi wrote in 1615 that such rooms were intended for the children and their nurse so that the mother could 'give orders when [the children] are healthy and take care of their needs when they are sick'.[34] Over the course of the sixteenth century the sleeping niche grew in size to accommodate a freestanding bed and remained common in Venetian bedrooms until the end of the eighteenth century.[35]

Aside from the bed, storage chests were the most essential pieces of furniture in the Venetian *camera*. These typically came in ensembles of four, five, six or more matching pieces. In the fifteenth century such a chest, called a *cassa* in the inventories, was usually flat on top and might be covered with a runner or table carpet. The *cassa* served not only as a container, but also as a seat and a step to the bed; it might also

serve as a table. Most chests were decorated with a variety of surface treatments and conceived in more graceful shapes than the severe rectangular box depicted by Vittore Carpaccio in his *Birth of the Virgin* (1504–8, plate 1.1; see pp.120–1). Even in palaces which had a room called a *guardaroba* – designed to store clothes – near the sleeping chambers, inventories reveal that all clothing, linens and small items were stored in chests.[36]

The *camera* was also a woman's workspace, as indicated by numerous inventory citations of 'a table to work upon' and baskets of thread and yarn. With linens and underclothing made by the women of the house, needlework was a home industry in the houses of both rich and poor. Embroidery and lace-making were highly esteemed activities, even by noblewomen, throughout the sixteenth century (see pp.157–62).[37]

Virtually every *camera*, no matter how modest, was protected by a painting of the Madonna and Child (plate 3.14). Beyond that, the *camera* might also be a sanctuary, fitted up with a small altar and prie-dieu (see pp.201–2). Sometimes devotional furnishings were located in an even more private space adjacent to the camera, called a *camerino*, *cameretta* or a *studio*. The *studio* of the *camera grande* in the Da Lezze palace on Campo San Stefano was furnished with 'a little altar with a sculpture of Christ on the cross

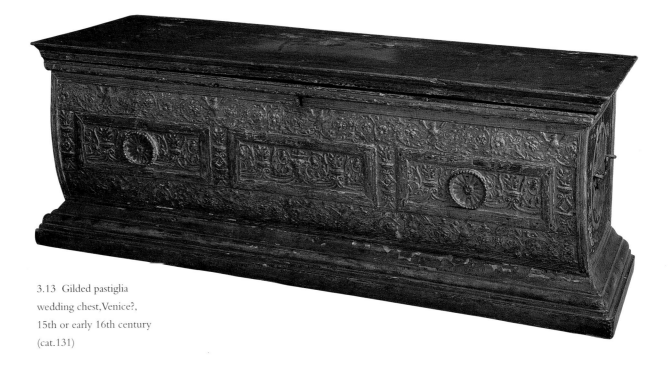

3.13 Gilded pastiglia
wedding chest, Venice?,
15th or early 16th century
(cat.131)

3.14 *(left)* Giovanni Bellini
and workshop, *The Virgin
and Child (The Madonna
of the Pomegranate)*, Venice,
probably 1480–90
(cat.30)

above it', a painting of the three Magi with a walnut frame, two small pictures, a strongbox containing documents, a small walnut casket filled with trinkets, and a cushion to make bobbin lace. This group of objects suggests that this was the retreat of the mother of the house.[38]

Other studies had a distinctly masculine flavour. The *studiolo* (small study) adjoining a *camera* in the home of Nicolò Padovano, secretary of the Council of Ten, was devoted to business rather than devotion. Decorated with three pieces of Bergamesque cloth around the walls and a double portrait of two members of the Trincavilla family, the room was comfortably furnished with a pine trestle table covered by a yellow tablecloth and two gilded chairs upholstered in velvet. A basket and a walnut casket (*cassella*) were filled with documents and a walnut writing desk (*scrittor*) contained 'sacks full of writings'.[39]

DISPLAYING COLLECTIONS

During the sixteenth century a few Venetians who had formed a collection of antiquities or art objects converted one or more rooms into an exhibition space to display their acquisitions to friends and acquaintances. The Venetian Marcantonio Michiel made notes on collections in eleven homes in Venice and six in Padua in the 1520s and 1530s. Works of art originally intended to decorate the home were set apart in a dedicated space, and the private art gallery was born, an aristocratic amenity that flourished in the seventeenth century.[40]

3.15 *(top right) De picturis*,
from a series of manuscripts
cataloguing Andrea
Vendramin's Venetian
collection, ink on paper,
Venice, 1627
(British Library, London,
Sloane, MS 4004. fol.17r)

3.16 *(right) De annulis et
sigillis*, from a series of
manuscripts cataloguing
Andrea Vendramin's Venetian
collection, ink on paper,
Venice, 1627
(British Library, London,
Sloane, MS 4005. fol.10r)

The two-room cabinet of curiosities (*c.*1615) in the Grand Canal palace of the Venetian patrician Andrea Vendramin is a case in point. Encyclopaedic in scope, his collection included not only the usual paintings (plate 3.15), ancient marbles and medals (plate 3.16) but also minerals, precious stones and other natural wonders (plate 3.17). Known as a *Kunstkammer* in German-speaking countries, such a collection aimed to capture the entire world and these personal accumulations of the rare and the wonderful became a European-wide phenomenon in the seventeenth century.[41]

Vendramin was perhaps the first Venetian collector to compile a catalogue of his holdings as an entity, with the objects grouped into categories. As he proclaimed in his will, the collection was 'a most honourable and esteemed adornment', worth more

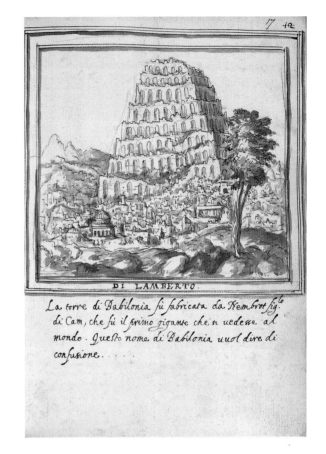

3.18 *De sacrificiorum &
triumphorum vasculis,
lucernisque, antiquorum, urnis*
from a series of manuscripts
cataloguing Andrea
Vendramin's Venetian
collection, ink on paper,
Venice, 1627
(Bodleian Library, Oxford,
Ms. D'Orville 539)

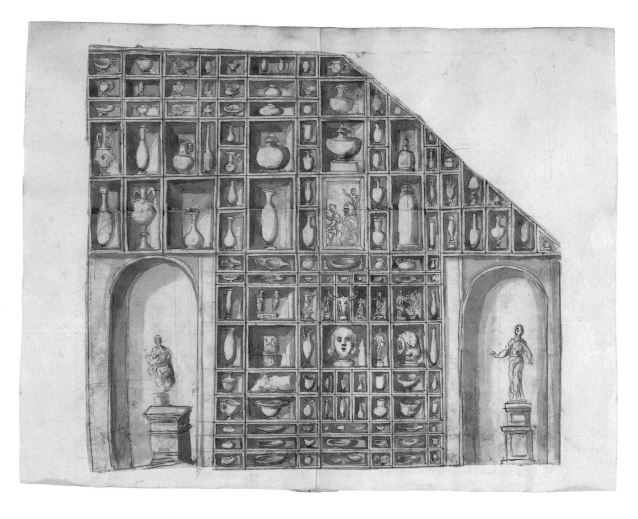

intact than dismembered.[42] Vendramin's catalogue, compiled in 1627, consisted of sixteen small volumes, with one book for paintings, another for sculpture, two for coins (one for Roman and another for Venetian) and the rest for various types of object including vases, minerals, manuscripts, Egyptian rings and seals. When the collection was sold off after Vendramin's death, the catalogue was broken up and dispersed. The book on paintings, one of four catalogue volumes now in the British Library, contains 155 wash drawings of pictures in the collection, most with attributions. At the end is a list of works not illustrated. These include 'Medium and small sized pictures in the studies, that have not been depicted because they are old and they are put in some places to fill the compartments' and 'diverse portraits that are for adornment of the house'.[43] Thus a distinction was made between works in the collection and those acquired for interior decoration or simply to fill empty spaces on the study walls.

Another part of the catalogue was acquired by the Bodleian Library (plate 3.18). Entitled 'Ancient instruments of sacrifice and triumph, including urns and lamps', it offers an invaluable illustration of how such objects might have been displayed. A wash drawing shows in great detail a wall section divided into small compartments containing vases, urns, dishes, lamps and small pieces of sculpture. It is clear that this space was contrived especially to hold a specific collection of pieces, rather than the objects being fitted into a pre-existing interior.[44]

The Englishman Fynes Moryson, who visited Venice in 1594, called such domestic galleries not museums, but libraries: 'Also private Libraries may be found out by those that be curious, and will bee after the same manner easily shewed them, and are indeede most worthy to bee sought out for the rarenesse of many instruments, pictures, carved Images, Antiquities, and like rare things.'[45]

BEHIND THE SCENES

The *studio* was an inner sanctum, but it was perhaps not the most 'private' space in a large Venetian house. Venetians were notoriously protective of their unmarried daughters, who were rarely seen in public, and even wives were said to seldom venture unaccompanied outside the palace. Many writers of the period both inside and outside Venice counselled that the women's rooms should be the furthest from the entrance and close to the garden and the places of washing and storage so that the women could go freely from one place to the other 'without passing through the rest of the house where they can be seen'.[46] Even within the protected environs of the family home, a higher level of security was offered by the secret hallways cited by Serlio, 'through which one passes from room to room without going through the *portego*' and a 'secret loggia' in which 'the daughters remained in order not to be seen from any side'. That such arrangements continued to be a preoccupation was confirmed by Scamozzi, who wrote:

The male servants never go into the women's apartments when they do not know for certain if there are daughters of marriageable age in the

house, and likewise the young female servants do not appear, or do so only rarely, in the apartments of their masters, but they serve in the apartments of their mistresses … and they go there through very secret staircases.[47]

Servants were an essential, if shadowy, presence in the Venetian house. Even large households might have only two or three servants, in contrast to the large numbers common in mainland homes of the period. Some servants were slaves, others free. They laboured in the kitchen and drew water from the well in the courtyard, helped the lady of the house to keep it in good order, and tended the children. They slept in rooms on the mezzanine floor, in the attic, in *sopraletti* with the children or perhaps even in the *camera* of their employers.[48]

★ ★ ★

Several tendencies can be noted in Venetian homes over the course of the fifteenth and sixteenth centuries. First, houses grew in size, often as a result of remodelling, although the basic floor plan remained remarkably stable. Second, it was not unusual for several nuclear families to occupy apartments within the same house. Third, the lifestyle became more 'aristocratic', with larger numbers of servants necessary to care for the larger homes. Reflecting a growing desire for privacy, the 'apartment' concept, with a sequence of rooms leading to, and protecting, the innermost sanctums of the house, was increasingly a residential ideal. Related to this development, the *camera*, which had always had a range of functions, became more specialized. The same was true of furniture, with the traditional chest being joined by new types of storage containers such as wardrobes, chests of drawers and tables used for specific purposes.

Observing that Venetians called even their grandest homes *case* (houses) rather than *palazzi*, 'out of modesty', Francesco Sansovino declared that 'one does not count less than a hundred, and all, ancient as well as modern, [are] magnificent and great, in their design, as well as in their ornaments, partitions, and as beneficial places to live'. Nowhere else in Italy, he continued, could one see 'buildings that are more comfortable, more inviting, nor more well equipped for human use than these'.[49]

3.17 *De mineralibus*, from a series of manuscripts cataloguing Andrea Vendramin's Venetian collection, ink and colour wash on paper, Venice, 1627 (British Library, London, Sloane, MS 4007. fol.47r)

THE ARTISAN'S *CASA*

SANDRA CAVALLO

4.1 Palazzo Fieschi, the church of Santa Maria in via Lata and neighbouring houses, Genoa, detail from Cristoforo Grassi, *View of Genoa in 1481*, oil on canvas, Genoa, 1597 (Museo Civico Navale di Pegli, Genoa)

Among the labouring classes, artisans were a broad group whose work concentrated on production, ranging from painting to baking. But artisans did not just produce goods, they also supervised the work of others and traded in manufactured commodities. Despite the fact that artisans comprised such a large portion of society, there is a lack of focused studies on the house of the Italian artisan.[1] This is not merely due to the scarcity of sources for this social group but also to the underlying assumption that the dwellings of artisans are of little interest, and that the lower and middle classes inhabited standardized and boringly repetitive homes where domestic possessions followed a basic pattern. Perhaps for this reason studies of the lower-class interior have been characterized more by the search for the typical or average interior than have those of the patrician house, which have been relatively relaxed about focusing on the unique and the singular.[2] The implicit view is that individual taste, variety and choice are exclusive prerogatives of the wealthy.

The following analysis of inventories of domestic possessions belonging to Genoese artisans, combined with evidence from the diaries of artisans living in Florence and Bologna, challenges the idea of a radical divide between the domestic values and cultures of the elite and those of artisanal classes.[3] In many respects the possessions encountered in the artisan's house – and the symbolic values attached to them – are not very different from those in the patrician home. There is likewise a similarity in the basic organization of domestic space between the *sala* and the *camera*, as well as in the distribution of objects between the two rooms, although among the artisan classes the overlap between domestic and productive space is particularly pronounced.

Some specific features of the artisan's house, however, start to emerge. The neighbourhood, the district and the city's public life had a substantial

bearing on the rhythms of domestic living, and on the character and nature of domestic possessions. The life of the artisan family was projected towards the world surrounding the house. It was characterized by fluidity of domestic space and by different patterns of cohabitation. The family life of this group was punctuated by continual separations: infants were sent out to wet nurses; male offspring were sent away at the age of fourteen or fifteen to work as apprentices or in the employ of some nobleman; and fathers might leave to look for work elsewhere.[4] The frequency of accidents at work, exposure to infection and the economic impossibility of leaving the city during outbreaks of plague meant that death was a common visitor to these homes. The plague would drastically reduce households or sweep away entire families. Marco di Zanobi, a Florentine *rammendatore* (specialized wool-worker), lost his wife, daughter, two sons and grandson during the 1523 plague epidemic, so that only he and his daughter-in-law were left in the house.[5] At the same time, these traumatic experiences extended the confines of the household, bringing in orphans, widowed sisters or sisters-in-law. In the course of only two weeks, during the 1458 plague outbreak in Florence, the painter Neri di Bicci, already living with his wife, two sons and his mother, took in his two sisters, one of them pregnant, who had both lost their husbands. These sisters, Andrea and Gemma, moved house with little in the way of chattels, but each had a son and Gemma also had a female slave.[6] Even during normal times, however, life was marked by the temporary returns of young sons or widowed parents to the household. Apprenticeship rarely meant leaving home for good. Often it was not completed and the young boy moved between different occupations before settling in one job. Geronimo, the son of Nadi, a Bolognese master mason, twice embarked on learning to be a tailor, then was apprenticed to a butcher, after which he disappeared for a few years, only to wind up joining the builders' guild in Bologna like his father. With each of these changes he came back to the family home.[7] This fluidity is reflected in the objects in the home, for example in the number of beds dismantled but ready for new arrivals.

The house itself had considerably less stability than among the more prosperous classes, since families and individuals changed premises frequently. For artisans, whose economic fortunes varied in relation to the number or age of their children and their own age and physical state, ownership of the house they lived in was a transitory experience, but not an uncommon one.[8] It has been said of the Venetian *popolani* (populace) that 'there was no traditional hearth that could serve as the psychological and social focus of family life. This contrasted with the experience of many patrician families who, even though dispersed throughout the city, felt attachment to a particular palace.'[9] The neighbourhood, however, seemed to replace 'the house' to some extent for artisans, who usually established strong connections with a particular part of the city and its social fabric. While it was common for artisans to move from city to city, it was more unusual for them to move area within the same city. Moreover, the network of kin available (often in the same neighbourhood of the city) formed the framework within which many of these house moves took place. The homes of parents, parents-in-law and children as well as more distant kin all represented opportunities to be relied on for a temporary welcome whenever other kinds of cohabitation became undesirable, or for the sake of giving the domestic unit a more stable form. Sometimes people moved into a relative's home even if it was just for the time of an illness. When, for instance, the mother-in-law of the Bolognese mason Gaspare Nadi was taken seriously ill in his house, she had herself moved to the house of her niece, where she died. Likewise, Antonio, Gaspare's son, who had stayed with his father after his parents' separation, wanted to be moved to the house of his mother and step-siblings when he fell ill with the plague.[10]

Like patricians, artisans maintained significant bonds with their kin, and these often took the form of cohabitation. But blood relations were not of fundamental importance within the artisan's nuclear family, which was often made up of siblings by different fathers and mothers. The early age at marriage of artisan men, who, unlike patricians, were frequently wed by their early twenties, meant that widowhood and remarriage were fairly frequent events among men as well as women. For many men marrying twice and often three times seems to have been common. Complex domestic units were therefore the norm among these groups.[11]

WHERE DID ARTISANS LIVE?

Although there were areas in which artisans' families tended to concentrate, on the whole there was little social segregation in Italian cities. Their houses and workshops could be found anywhere: they opened beneath patrician palaces or beside the walls of churches.

Three typologies of houses are detectable: one was the *domuncula*, or *casetta* (small house), of one or two storeys, originally for servants, with a little garden. This type of house could be found in the city outskirts near wealthy suburban villas (plate 4.1). In the fifteenth century *domuncule* could also be found by patrician palaces in the city centre. The second type was the multi-family house in which different households occupied one or two floors of the same tall building (plate 4.2). The third type was the multi-storey house occupied by one family. The second sort was the most common and became prevalent in the sixteenth century when most *domuncule* were absorbed as parts of larger buildings.[12] In Genoa, famous for the height of its buildings – one contemporary visitor described it as 'a city that stands up straight' (*che sta in piedi*) – four

or even five floors rose above the mezzanine of these plebeian houses, while in Florence and Venice similar buildings had only two or three floors.[13] The families that inhabited these buildings were usually of artisan background, but there was some internal stratification, based on economic conditions, age and marital status. Large families and artisans from the most prestigious and prosperous trades occupied more than one floor, while the less well off, the single and the elderly lived in the mezzanine or the attic.

Artisan housing grew between the mid-fifteenth and mid-sixteenth centuries. In some cities demographic pressure and urbanization led to buildings becoming taller and narrower in order to accommodate more people. In Genoa houses were now built on an area of 10 by 8 metres, whereas a century earlier they occupied a minimum plot of 30 by 35 metres.[14] In the second half of the sixteenth century more imaginative architectural forms were also developed in artisans' housing. In Venice there was an explosion of newly built terraced houses (plate 4.3) containing twenty-five to thirty household units. One model that became common was defined by Palladio as having a staircase *alla Leonardesca*, inspired

4.2 Modern drawing showing 14th century houses in Genoa (Rivotorbio) designed for multiple families (Archivio Capitolare di San Lorenzo) The rent paid and occupation of the people living in these houses are shown.

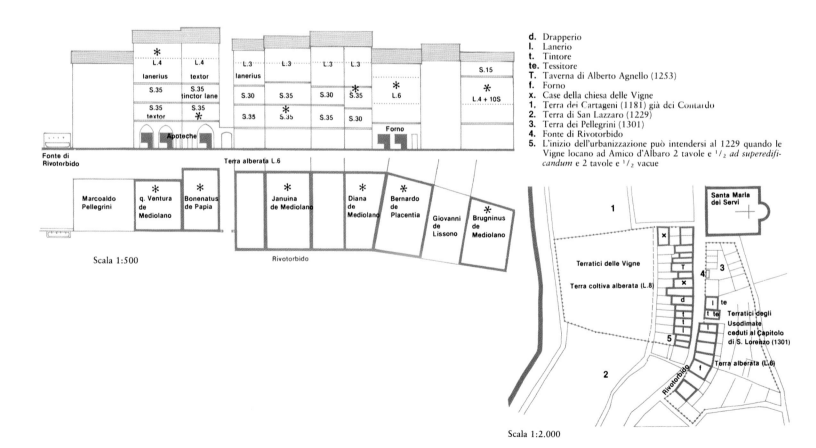

d. Drapperio
l. Lanerio
t. Tintore
te. Tessitore
T. Taverna di Alberto Agnello (1253)
f. Forno
x. Case della chiesa delle Vigne
1. Terra dei Cartageni (1181) già dei Contardo
2. Terra di San Lazzaro (1229)
3. Terra dei Pellegrini (1301)
4. Fonte di Rivotorbido
5. L'inizio dell'urbanizzazione può intendersi al 1229 quando le Vigne locano ad Amico d'Albaro 2 tavole e $^1/_2$ *ad superedificandum* e 2 tavole e $^1/_2$ vacue

4.3 Terraced houses in Venice (Rio San Lorenzo) Venice, 1539–40

by Leonardo da Vinci. This bypassed a floor so that one household could be sandwiched between the floors occupied by their neighbours, making it possible for each family to have its own entrance and a separate stairway, thus giving the illusion of living in an independent house.[15] These were comfortable apartments on two floors that included a vestibule, a kitchen and two rooms, with a hearth (*fogher*) only in the kitchen. They were equipped with a toilet space, or *necessario*, an element also present, with different names, in the Genoese, Florentine and Bolognese artisan house (*agiamento*, *destro*; see p.183).[16] In other Venetian cases three-storey apartments alternated with much smaller ones that occupied only the ground floor and were divided into kitchen and sleeping quarters.[17] In general, artisan families seem to have occupied modest, but not minimal, living spaces.

THE TRANSIENCY OF DOMESTIC SPACE AND LIVING ARRANGEMENTS

Housing was closely linked to the shifting circumstances of individual families. During the lifecycle of an artisan family the size and nature of their living arrangements could improve or deteriorate as they moved from smaller to larger homes or vice versa. Residential mobility was not just the experience of the most humble worker. The Florentine woolworker Marco di Zanobi (1467–1538) moved house nine times in the fifty years of his adult life, going from a five-room house with a garden in the first fourteen years of his marriage to a smaller rented house, then to another. He later bought a large property and stayed there for fourteen years with his wife and eldest son's family. After losing most of his family in the plague, he remarried and moved briefly into his new wife's house, but the marriage did not work

and he left. He lived for a short time with his daughter and son-in-law, then moved again, twice, to rented rooms. Finally, in 1535 he entered the San Paolo hospital and worked there as a nurse until his death.[18]

Apart from illustrating the transient character of living space, this case suggests how the composition of the household could be similarly fluid: Marco lived in domestic units with his wife and father; then with his wife and children; with his wife, married son, daughter-in-law and grandson; briefly with his daughter-in-law after the plague; with his daughter and her husband; and finally on his own. Although the orthodox view has long been that artisans lived in nuclear arrangements, unlike patricians, biographical stories such as this one show that domestic aggregates were changeable and varied among artisans.[19] Nuclear and extended family arrangements could alternate several times during the life of an individual.

Death, job mobility and the formation of new families could all have an impact on living arrangements. Conflict could also be a catalyst for change. The late fifteenth-century diary of the Bolognese master mason Gaspare Nadi is especially eloquent in this respect. The departures of his children, particularly the restless Geronimo, are frequently recorded as taking place without the father's 'permission' and knowledge, so that they are tantamount to running away from home.[20] Even the departure of Agnola, the mother of his first wife, took place in secret after Gaspare's remarriage while he was at the mill buying flour. This also involved the theft of a chest, stolen with the help of Agnola's children and other relatives.[21] For better or worse, therefore, the kinship group played as significant a role in the lives of the artisanal classes as among the patriciate.

These episodes indicate how vulnerable family bonds and living arrangements were to quarrels and ruptures, but there is just as much evidence in favour of their capacity for recovery. The turbulent relationship between Gaspare Nadi and his third wife, Chatelina, exemplifies this ambivalence. After thirteen years of marriage she left him to go and live with her two adult children from an earlier marriage.[22] Five years later, however, when Gaspare and Chatelina's son succumbed to the plague and died, their common loss reunited the couple. Gaspare went to his wife's house 'to weep and lament our very great misfortune', and his stepsons invited him to stay and make his home there.[23] This cohabitation lasted for a number of years even though there was no shortage of problems. By August 1497 Chatelina no longer wanted to share her bed with her husband and went to sleep with her unmarried son, compelling Gaspare to sleep with the waged labourers – 'May the good God give me patience'.[24] A month later, verbally attacked by one of his stepsons, Gaspare moved out of the house. It is clear, however, that he went back a short time later and remained until 1502, when at the age of eighty-three he went to live with one of his sons-in-law.[25]

DOMESTIC AND WORKING SPACE

Workshops could be clearly demarcated from the rest of the house, having their own entrance and no direct communication with the building above. This was the case in many of the Genoese examples, in which the workshop was not for living in, but in general it was unusual for dwellings and workspaces to be in the same house. A recent study on Florence shows that in 1427 only 26 per cent of master artisans lived above their workshop, and this percentage fell considerably over the next fifty years. The co-existence of living and work arrangements within the same building was confined to particular food trades, such as bakers, and was likely to be related to the need of these trades to work for extended hours or throughout the night.[26] Apothecaries, expected to be on call during the night, were another case.

Obviously, the convergence of workplace and home was also found among those workers who exercised their trade not in proper *apotheche* – ground-floor workshops lining the street – but in their own apartments. These were often individuals involved in the various stages of textile production, for example, those who carded wool and hemp and manufactured silk fabrics. Even more than the declining wool industry, the booming production of silks in the fifteenth century was largely carried out from home by various specialist workers.[27] Inventories frequently indicate the presence among household goods of a variety of tools: skein-winders and bobbins needed by women winders; cumbersome warpers, spinning machines and looms. In the

mid-1400s there were over a thousand silk-weavers in Genoa, increasing to more than two thousand by the 1530s.[28] Women, children and old people alike took part in silk production at home. While the women were involved primarily in winding (threading hanks of silk) and in warping, any member of the family could contribute to the weaving and throwing. Throwing involved continuously turning the *filatoio*, a bulky spinning machine often set up in the attic or the mezzanine of a multi-storeyed house.[29] As for the weaving, some of the more refined fabrics called for a number of different hands, including those of children, who were light enough to be able to work the cords while perched on top of the loom.[30] However, work at home and labour in a workshop were seldom alternative sources of income, being frequently found side by side within the same family: the head would be in a workshop, likewise his adolescent sons, while other members of the family group took in work at home.[31]

Although living space and workshop were often separated, biographical evidence suggests that this was not a consistent pattern or a deliberate choice. There were moments in an artisan's career in which home and workspaces were brought together. Workshops, like houses, were often transient spaces and most rental contracts were short. But moving house and moving workshop took place for different reasons. In 1461, on the death of their father, the Genoese brothers Antonio and Nicola Balbi, both tanners and both married, agreed to continue living with their families in the paternal home, sharing kitchen and *sala* and dividing the rest of the rooms between them. As for work, they would continue to exercise their trade in the same workshop, keeping tools, furnishings and raw material in common. In the next ten years they moved house only twice, but their tannery changed premises five times, though without ever moving out of the same neighbourhood, the Roso. Antonio finally left the area in 1472, when he separated from his brother and brought his residence and economic activity together in new premises in the nearby district of Sant'Agnese. Nicola instead continued to work in the same area as before, this time in partnership with his brothers-in-law.[32]

High workplace mobility was therefore combined with a strong loyalty to the locality. We know already that Marco, the Florentine *rammendatore*, moved house nine times, but always within one area of the city.[33] It would seem that the neighbourhood was the real 'home' that one did not want to leave.

COMMUNITY RELATIONSHIPS

Work relationships were often grounded in the same district. Working space, for example, was frequently shared among neighbours. In 1465 in Genoa Antonio Navone rented a tannery to Battista de Albara, but reserved the right to use the workshop himself, and in particular two of its vats for three months every year. In that period he would pay for the work that Battista's apprentices and workers did for him, but as part of the deal the latter would be obliged to 'crush the myrtle' necessary for tanning his leather.[34] Agreements of such complexity seem vulnerable, yet they were common. They worked because they were just one aspect of a chain of personal ties and exchanges that were grounded in the locality and involved a whole network of people who were all interested in the preservation of this web of relationships.

Permanence of residence in one district was therefore desirable. Reciprocal solidarities and ties were reinforced by participation in social and ritual activities occurring in the communal space. In Genoa neighbourhood life was strongly developed and took place in specialized architectural structures resulting from the division of the city into *alberghi*, the enclaves of the patrician families. Neighbourly sociability had its centres in the local small square, in the church of the *albergo* or in the confraternity, but above all in the loggia, the private open room to which only those belonging to the *albergo* and enclosed neighbourhood were admitted. The loggia was a frequent feature in the Genoese landscape: each neighbourhood had one built by the patrician *albergo*, the council of neighbours or by the local guild.[35] In these open spaces neighbours spent the evening watching plays, or participated in the games and dances of the carnival period and in other civic and religious celebrations.[36] The loggia was also the site where marriages and funerals took place: there was an unwritten obligation to invite neighbours to such family events (plate 4.4).[37]

The neighbourhood seems to have been particularly structured in Genoa, where we even find

4.4 Lower-class wedding scene, from Alessandro Caravia, *Naspo Bizaro*, engraving, Venice, 1565 (British Library, London)

councils of heads of households that met regularly.[38] But in other cities, too, the neighbourhood has been indicated as an important organizing principle and one that provided a shared identity to a population which was largely made up of migrants.[39] Ritual confrontations between districts, such as the Venetian *bataiole* (wars of the bridges), further contributed to the strengthening of these territorial identities.[40]

THE MOST VALUABLE POSSESSIONS

The involvement in outdoor and public activities could have important repercussions on the ways artisan families lived in their houses and on the character of their possessions. Clothes were the most valuable component of artisans' assets. A large number of bulky items of clothing for both men and women, sometimes lined with fur, filled the coffers and chests of their homes, together with different types of headdress. Jewels were also present in surprising quantities. In the early fifteenth century it is difficult to separate garments and jewels, as pearls, for example, were often embroidered into headdresses or onto the fabric of a dress.[41] Another precious item of clothing was the belt: normally silk with silver bars to keep it rigid and with silver buckles (see plate 7.4). Belts, represented by Cesare Vecellio as the typical ornament of the Genoese noblewoman, were often listed in artisans' domestic inventories.[42] Here they often appear in the variant of a *clavacuore*, that is a belt from which hung a collection of small silver objects symbolic of female virtues and the woman's domain: keys, little scissors, a tiny case containing needles or a pomander filled with perfumed herbs.[43] Later, jewels took on a wider variety of shapes and acquired independence from dress.

In this period clothes and jewels, as well as household linens and lengths of cloth, were often used as currency to pay off debts.[44] They were also the most likely objects to be pawned. The widow of the Genoese tablecloth-maker Bottino, for example, had to pawn a silver chatelaine with a green belt in order to pay for the candle wax at her husband's burial, along with other household possessions, pawned to pay the pharmacist's bill.[45] Pawning was an extremely common activity to which people had recourse not only in periods of crisis. Nearly all artisan inventories include examples of detachable velvet sleeves, caps, gowns, rings and other pieces of jewellery that were

said to be out of the house because they were *in pignore*, or pawned.[46] The economy of artisan families during this period was based on credit, as we can see at a glance in the *ricordanze* of Neri di Bicci, which minutely recorded all his debts and credits. Not only are almost all his purchases bought on credit, but he frequently turned to Jewish pawnbrokers – as many as fourteen times in four years, between May 1453 and June 1457 – pledging, redeeming and exchanging items belonging to himself and his family: cloaks, men's and women's belts, rings, a tapestry, pieces of fabric, a sheet, napkins and handkerchiefs.[47] At the same time Neri kept on buying material for clothes for himself and his children and, to a lesser extent, for his wife and mother, having these made up by tailors and trimmed by other specialist workers. The cost of clothes was the most regular and conspicuous of his expenses.[48] In general, it appears that artisans preferred to keep their savings in the form of clothes and jewels rather than in cash. These were forms of investment that could then easily be turned into currency through the pawn bank when cash was needed. At the same time the variety and value of clothes were assets to be displayed in the public arena of communal events and neighbourly sociability: unlike hoarded money, they produced prestige and status in everyday life. As in the case of the patrician, the quality of an artisan's outfit at social gatherings was central to his projection of a respectable and honourable public image.

Another valuable domestic item that attests to an investment in public display was the bed. The value and complexity of bed furnishings is at first sight puzzling: expensive feathered pillows and quilts, numerous bedspreads for different seasons, and several pairs of bed sheets were the norm. Bed curtains hanging from a *cielo*, or canopy, became increasingly common in Genoa in the sixteenth century, and a painted canvas surrounding the bed also featured.[49] The furnishings in the rest of the house were comparatively cheaper and more modest: chairs and stools, for example, were inexpensive and far from numerous. Even the inlaid chests, or those painted with stories (*dipinte con vite*) sometimes found in the artisan's house, were vastly less expensive than clothing and bedding.

The bed's role in domestic ritual perhaps explains its importance. The bed was not only the place where the most salient events of a person's life took place – conception, birth, death – it was also the focus of ceremonial life within the home. We know that friends, neighbours, kin and patrons turned up on the occasion of childbirth to celebrate with the mother and child. Similarly, they visited the sick and the dying at their bedside, to offer consolation and support.[50] Frequent illness can also explain this focus on the bed. The master mason Gaspare Nadi, admittedly someone whose occupation made him particularly vulnerable to accidents, records being confined to bed on a number of occasions for periods longer than a month.[51] Other exceptional activities took place there: a will could be dictated to a notary by the bed-ridden person with a large turnout of witnesses, a priest might bring the last sacraments, a medical practitioner might be called in to see the patient, or members of a confraternity might visit, bringing charity and compassion to the sick. At these times people who were not part of the inner circle of regular visitors to the house were admitted to the *camera*, and among them there were often persons of a higher station. The bed was therefore charged with symbolic meanings: like dress outside the house, it communicated statements about the honour and decency of the person and their family, but it also conveyed respect for visitors and recognition of the social distance between visited and visitor.

THE USE AND DISTRIBUTION OF DOMESTIC SPACE

In Genoa the artisan house usually had a *camera* and *caminata* (the Genoese word for *sala*). An area called the *cucina* (kitchen) was often, but not always, present. Sometimes the kitchen's functions were carried out in what was called the *sottotetto* (the attic), at other times in the *camera* or in the *caminata*, and this seems to have depended on the composition of the household. In the house of the wool-worker Giovanni Ricci (1408), which was limited to two rooms and had no kitchen, the cooking equipment was found in the *camera*, where there was also a table *pro comedendo* (for eating) and a few seats, evidently for the family. The *caminata* seemed to be occupied by *famuli*, apprentices, who had their own bed and a table, suggesting that they could also have eaten here, separately from the family.[52] In terms of position, if the house was multi-storey, the kitchen tended to be

at the top, with either the *camera* on the same floor and the *caminata* below, or both rooms on the same floor. Kitchen and *caminata* were not normally on the same floor, possibly to minimize the effects of cooking smells and smoke.

In the artisan's house the *camera* was the space with the most defined character. Already by the early fifteenth century it appeared as the repository of family identity and symbolic and material wealth. Valuable possessions were usually concentrated here, although groups of precious objects could also be found in chests and coffers in the adjoining smaller rooms mentioned above. It was exceptional for riches to be in the *caminata*, as in the case of the apothecary Geronimo Bianchi, obviously a very active moneylender, who stored more than fifty pledges in his *caminata*. Even in this case, however, the family's precious possessions were mostly kept in the *camera*.[53] The *camera* was the most crowded space, occupied by the large bed with associated chests and various kinds of boxes in greater numbers than elsewhere in the house. Here the clothes and jewels were stored, together with bed and table linen: *tovaglie*, *tovaglioli* and *lenzuoli* (tablecloths, napkins, bedsheets).

Silver, another common item to be pawned, appeared frequently in the chests in the *camera*: sets of six, nine or twelve silver spoons were found in many of the houses considered here. Presumably, these items were used for special occasions, not in everyday life, and were treasured for their value. In the second half of the sixteenth century new types of silver objects were stored in the chest: the *saliera* and the *portaspezie* (receptacles for salt or spices), and cups with a silver foot.[54]

Normally, no other furniture was present in the *camera*: there were no individual chairs or stools. The benched chests surrounding the bed were obviously used for sitting on informally. The arrangement of the room was therefore more suitable for family gatherings than for accommodating external visitors. Other elements reinforce this impression that the *camera* had a family focus: it was usually the only room containing candlesticks or chandeliers; similarly, tools for the fire were most likely to be found here. Despite the fact that the Genoese *sala* was called *caminata* – allegedly from the Italian word for fireplace, *camino* – the fireplace seemed to have been

in the *camera* rather than in the *caminata*, which often had just a brazier. The presence of portable working tools like the wool-winder, as well as a bag of thread for embroidery, seems to confirm that the lighted and heated space of the *camera* could have been used at least in the cold season by women for textile work. It is also common to find in the *camera* one or two beakers and a small wine barrel. Sometimes, as in the house of the gem-cutter Everaldo de Egre, there is a full set of bowls, dishes and cooking pots, suggesting that eating arrangements varied and that food could have been warmed and consumed in the *camera*.[55] Finally, the most typical objects of the *camera* were a basin for washing hands and the *maiestas*, the Genoese term for a devotional image.

The *caminata* was normally a larger, but much barer space than the *camera*: it often contained a small trestle table, a few stools, one or two chairs and even a tablecloth, which suggests that meals could have been taken there. The number of benched chests varied but tended to be lower than in the *camera*. A table was not always present, however, and sometimes a table and stools appear in the mezzanine suggesting that family dining took place in a smaller and cosier space which was easier to heat. The only object regularly associated with the *caminata* was the copper or tin ewer, and sometimes the basin, presumably for washing hands. Normally, the *caminata* appears as a spacious storage area in which quantities of food and goods could be found: barrels of oil, olives and vinegar, bales of cloth, such as the 87 kilograms of *panno blano* (a type of cloth) that one maker of blankets kept in his *caminata*, or work equipment, such as a warper.[56] Sleeping in the *caminata* did not seem to have been unusual, given the relatively frequent presence of a *letto da campo*, a camp bed, likely to be for temporary visitors or lodgers, rather than members of the family.

The *caminata* was therefore a versatile space, more open to outsiders than the *camera*, but not equipped for large social events. Giovanni Agostino Marchi, the silk producer who kept a *uomo di legno* in the *caminata*, a wooden dummy on which he probably draped his silk fabrics, may have received his suppliers and clients there.[57] However, the paucity of seats and the absence of long trestle tables in many houses rule out the idea that the *caminata* could have been turned into a festive space. The *caminata* also lacked

decorative items: very rarely do we find carpets in it. Similarly, for most of the period there were no images in the *caminata*: devotional pictures belonged to the *camera* and made their appearance in the *caminata* only when a bed was also present in it, as if the protective power of the sacred image was felt more necessary during the hours of sleep and the time of illness. The most prestigious pieces of furniture, such as inlaid or painted chests, were kept in the *camera*, not in the *caminata*. Wall hangings were rarely found in the Genoese house: the Lombard baker, Antonio di Pavia had a *tella celeste* (a light blue cloth) all along the walls both in the *camera* and the *caminata*.[58] This is such an isolated case that it makes us wonder whether he was reproducing specifically Lombard ways of furnishing the home.

There were often other little rooms in the house, such as smaller *camere*, pantries and attics. In these spaces were also frequently found a table, a bed together with various types of containers and chests filled with family possessions, and a variety of other objects, such as a cross-bow, parts of the master's armour, laundry and bath tubs, and even a birthing stool. Often defined in the literature as storage spaces, in reality these rooms were also living spaces. They seem to have been used regularly as sleeping areas by members of the family, for example children or servants, making it possible to implement some sort of separation between generations and classes in the house. This effort is also underlined by the existence of specific items – beds 'for the children' or the already mentioned table and bed 'for apprentices'. This invites us to re-think the forced cohabitation often attributed to the pre-industrial home. Moreover, the types of belongings that were concentrated in these rooms, give the impression that they sometimes had strong male or female connotations. In this way they were turned into spaces that the master or mistress of the household could consider his or her own: another element that brought the artisan's house closer to the homes of the more prosperous classes.[59]

Evidence relating to the kitchen is particularly hard to decipher and reveals most acutely the problems raised by the use of inventories. When it existed as a separate space, the kitchen (often defined simply as 'the room above') appeared as a place where food was prepared, probably not on a daily basis, but not consumed. Goods that you expect to be there are often not listed: the kitchen contained almost no furniture, only the *madia* (the kneading-trough used to make bread, pasta and pastry) and sometimes a chest, but there were no table or seats, except for one chair, often in poor condition and probably used for attending to the cooking on the fire hearth. The cooking equipment was not always found in the kitchen, where frequently there was no obvious container for it. Some of these items could have been left out of the inventory because of their almost insignificant value, or were not included because they did not legally belong to the deceased but were, for example, the property of his wife.

These same features, however – for example, the absence of cutlery in most Genoese artisan inventories – could also be a sign of specific eating habits. The type of cooking equipment (a pan for chestnuts, a pan for fish), the presence of jars of salted fish and the ubiquity of the mortar could suggest that the food preferred by this social group required neither elaborate implements to be prepared and consumed, nor a proper table. Eating and cooking could also have taken place outside the house: food was commonly sold in the street, and in taverns and bakeries, while *torte ripiene* (typical Genoese pies), as well as roasts, were brought to the local oven to be baked.[60] Meals were unlikely to be an obligatory domestic ritual for these families. The evidence concerning food consumption confirms once again the permeability of the house of the artisan and the blurring of the private/public divide in his daily life.

PEOPLE AND PROPERTY
IN FLORENCE AND VENICE

ANNA BELLAVITIS AND ISABELLE CHABOT

COMPARISONS BETWEEN VENICE and Florence are a classic theme in Italian Renaissance historiography. The similarities and contrasts between family and housing structures in the two cities constitute a subject of great interest, even though it has been hindered by some fundamental differences in the sources available. For Venice, for example, there is no systematic report like the Florentine *catasto*, a survey of families and their goods for tax purposes, and

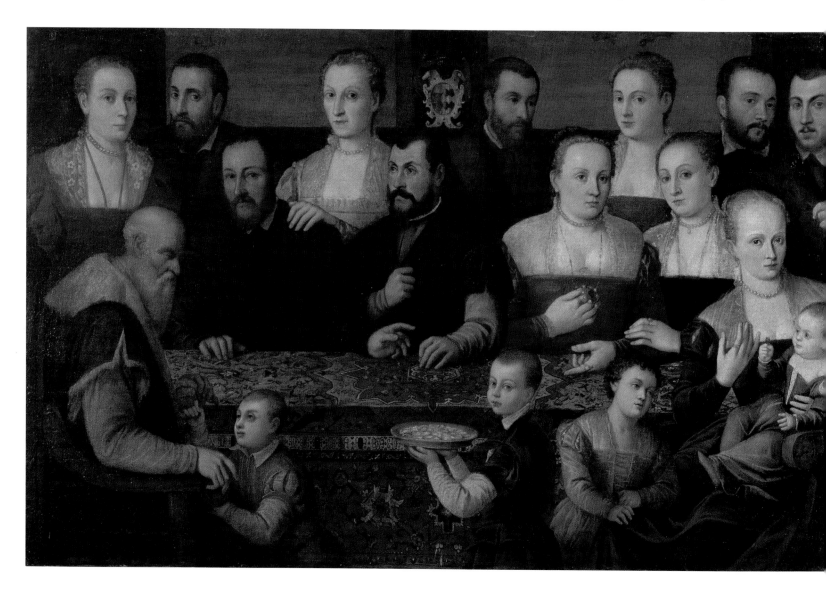

there are very few family record books (*libri di ricordi*), in which the head of the family wrote down important events, such as births, marriages and deaths. Consequently, notarial records, especially wills, have been privileged. This has unexpectedly brought to light the importance of ties among women in the relationships between families, an aspect that is less apparent in the Florentine family record books kept by the paterfamilias.[1] We should not, however, define these two cities by their sources and the varied perspectives they disclose. In fact, the typical structures of the family are very revealing and form a necessary starting point for an investigation of the household and ways of living within it.[2]

DOMESTIC SPACE, GENDER AND OWNERSHIP

The house is such an identifying location for a family that the very word itself, *casa*, embodies the dual semantic meaning of a habitable building and the group of individuals living in it, of residence and family intended, particularly in wealthy social groups, as a line of descent and, in a broader sense, as a lineage (plate 5.1). For elite families the identification of *casa* (house) with *casata* (family), often manifested by the presence of family coats of arms on the façade, was reinforced by the ownership of the building and the convergence of several nuclear families of different generations living under the same roof. Not everyone, however, owned a 'family house'. Late-medieval tax records, such as the famous Florentine *catasto* of 1427, clearly demonstrate that within working-class families cohabiting groups were much smaller, with less complex structures, and were generally based in rented houses or parts of them.[3] While a degree of residential mobility characterized the experience of the less well off, the directly owned house, the 'permanent address', anchored the families of rich artisans, merchants and patricians in urban space and time, giving them a sense of perpetuity that was immediately obvious to the eyes of the entire community. For many the house was a symbolic as well as a material possession that was passed down and inherited. The strong identification between house and family raises several questions. Who in the family was most associated with the Renaissance house? Within the inheritance structure of Renaissance Italy, was the 'family house' fundamentally a male asset? Whatever the answers to these questions, the house was a space where the lives of men and women intertwined and generations succeeded one another.

Was the Renaissance house a male possession? The communal statutes of central and northern Italy appear to provide a conclusive answer: between the twelfth and sixteenth centuries a new legal system excluded women from owning immobile property belonging to the family line, and accorded it exclusively to men. Daughters and sisters who left home in order to marry or enter a convent received a portion of the inheritance, in the form of a *dote*, or dowry, calculated on the basis of the family's mobile goods. Among the land-owning elites, daughters were provided with money, while the rest of the inheritance was divided equally between all the sons. But attempts were made to preserve the integrity of strategic goods, as well as symbolic ones, such as any houses, towers, city palaces (*palazzi*) or castles situated on the land owned. In Venice, however, some immobile goods were more easily accessed by women: these were *de foris* goods, located outside the city, and were the first items from a dowry to be returned to a widow on the death of her husband, as was customary. *De foris* and mobile goods were as one in Venetian law, resulting in the paradox that immobile sites on the mainland were considered to be 'mobile', and therefore inheritable by women, while houses and *palazzi* built in the lagoon, on the uncertain divide between earth and water, were 'immobile'. Retaining urban palaces within the family and preventing them from being dispersed along the female line was a common preoccupation among European patricians and nobility. In Venice, where the built and buildable environment, shored up from the waters, was so precious and limited, this strategy became a necessity for survival.

Legal records confirm that this was a universal phenomenon. In Florence very few houses were included in the dowries of the daughters of the elites marrying for the first time. If the dowry could not be given in money, it was preferable to relinquish land than to hand over built property. On his deathbed a father generally preferred to leave the family house to his sons. Matteo Strozzi's will of 12 October 1429 is emblematic of this desire to keep the family house within the line of direct descendance and, in the absence of heirs, within the lateral

5.1 Cesare Vecellio, *Family Portrait*, Venice, 1550s (cat.138) The painting portrays seventeen members of a family from the Veneto, ranging from a small child on her mother's lap to the figure of the old man in the foreground representing the patriarchal head of the family. The bonds of blood and affection are highlighted through the gestures connecting different members of the group. The coat of arms has not been identified.

branches of the family line:

> I wish that the house where I live in corso Strozzi should be left to my sons and their descendants and that it should never be sold or given up in any other way, except to my descendants in the male line, and if they fail, to the descendants of Filippo di Messer Lionardo, and if they fail, to the descendants of Messer Iachopo degli Strozzi.[4]

If these various male candidates were lacking, Matteo Strozzi preferred to leave the house to the city's two great convents of Santa Maria Novella and Santa Croce rather than to allow it to be dispersed forever along the female line. A pious bequest to the church had the added advantage of supporting his desire for eternal life. There are many similar examples but here we will limit ourselves to examining the 1542 will of the Venetian patrician, Giacomo Corner, who left the 'Ca' Granda' Corner, which he had built and owned, *in perpetuum* (forever) from one eldest son to the next born from a legitimate marriage. Alternatively, 'in the absence of male descendants', it would be left to the first-born son of his brothers or of the daughters of his sons and, finally, to the eldest son of his daughters.[5] In this case, Giacomo Corner's daughters entered the inheritance game, but only in fourth position, after his brothers and even after his granddaughters. The choice of binding the transmission of immobile goods according to a strict hierarchy was known as 'entail'. It not only excluded women, but also privileged the line of descent of only one of the sons, generally the first born, and was a widespread practice among the European nobility. There was, however, a Venetian variant that linked mercantile society with the transmission of family palaces by organizing the succession according to the *fraterna* (brotherhood). This partnership among brothers formed the basis of Venetian entrepreneurial activities well into the sixteenth century. Entail could also, during this period, oblige all the brothers to live and trade together, at least for the first generation or for a fixed time. Brothers were also expected to nominate themselves in turn as heirs and to leave their wives the choice of living as widows with their brothers-in-law.

In the middle and at the lower end of the social scale modes of living diversified and the multiple forms of use and possession of houses – outright ownership, but also more frequently renting, sub-renting, free use, life ownership, hospitality – weakened the strong identification of people with their houses. Even though male wills excluded female offspring, in the absence of men, daughters – especially if they were the only children – could, in practice, inherit urban property and include it in their dowries. This is what happened, for example, in 1542 with Marietta di Nicolò dalla Seda, who gave her husband, Gerolamo Tiepolo, a house on two floors with a courtyard, well and its own access to the canal, valued at 700 ducats and located in the Venetian parish of Santi Apostoli.[6] There are also examples of property forming part of dowries originating from the dowry of the mother. This was possible either because it had been returned to the mother when she was widowed or because she bequeathed it directly to her daughter.[7]

The house a woman received from her family when she married did not always become the couple's residence. In 1424 the dowry of the young wife of the Florentine notary Giovanni Bandini included a house worth 200 florins, inherited from her mother. However, her husband was eager to emphasize that they were going to live 'in my house'.[8] During the following years, while they lived in his house, he managed his wife's property, which he was also able to use as he thought best. If, however, money from a dowry was invested to acquire a family home, it became a form of 'wifely' (*uxorilocal*) residence so that the new family was established in a property belonging to her.

The most common experience for a new bride was to move into her husband's house and live with his family. The daughters of Venetian patricians and citizens were destined to leave their fathers' houses between sixteen and eighteen. When she moved into her new home, the young bride took many family possessions with her: typically, her trousseau, jewellery, a 'walnut chest' or some other pieces of furniture (plate 5.2). Francesca Michiel, the wife of Domenego de Zuanne, a 'ship owner', even took her own portrait with her.[9] It was customary in Venice for the bed to feature in inventories of marriage dowries, and it was always 'furnished', that is, equipped with bedding. This included 'gold curtains' like the ones owned by Medea Morosini, who mar-

ried Francesco Becicheni,[10] or 'two cushions and two bolsters' as in the case of Ludovica Scotto, a widow who was remarried to Cornelio Zambelli.[11] The same bed sometimes reappeared in women's wills, bequeathed to a grandchild or servant 'for her marriage' or to a charitable institution. In Florentine patrician households, however, women contributed very little to the furnishings of the nuptial chamber, which were normally provided by the husband. In this intimate space belonging to the couple, brides only supplied the chests containing their trousseaus: up until the mid-fifteenth century these itinerant pieces of furniture followed new brides – and eventually also widows – as they moved from one house to another. Later on, they were acquired by the husband and remained in the chamber.[12] The bed, the most permanent element of the room's furnishings, does not feature in dowry inventories and a widow was only able to continue sleeping in it if her husband left it to her in his will. Only very personal items were brought by new brides into patrician Florentine houses, duly inventoried and valued. These formed part of their dowry and could be reclaimed if they were widowed. In the country

or among the city's lower-class neighbourhoods trousseaus of workers and peasants followed a less standard pattern, consisting of fewer, more utilitarian objects. This reminds us that for these social groups setting up home required a concerted, joint effort on the part of the couple after the marriage.[13]

Studies on the Renaissance home have been keen to point out that domestic spaces were organized very differently according to the gender of the occupants. Alberti's possibly unrepresentative precepts go so far as to suggest that wives were not provided with the key to the study, the supreme male space, while husbands did not even set foot in the kitchen, where the 'queen of the house' reigned undisturbed.[14] Among the elites, the type of inheritance, the residence of the married couple (whether in the house of the father or that of the husband) and the ownership of the furnishings gave a decidedly male imprint to houses at a material and symbolic level. Although this does not mean that women were only 'guests' in their homes, the fragile nature of their connection with houses is demonstrated by the fact that their residency, use of spaces and domestic furnishings were matters for negotiation.

5.2 Box with the arms of the Buondelmonte family of Florence, Florence, c.1460 (cat.119)

DOMESTIC SPACE AND FAMILY CYCLES

The fifteenth-century Florentine *catasto* and the six-teenth-century Venetian *Stati delle anime* (registers of family members listed parish by parish) show that Florentines and Venetians mainly lived in relatively small family groups. This evidence goes against the monolithic image, so idealized by the wealthy, of an extended family living side by side in domestic harmony.[15]

Like patricians, many Venetian merchants or pro-fessionals enjoyed cross-generational cohabitation, perhaps in a rented house rather than a family *palazzo*. The circumstances of the Ziliol family, however, demonstrate the gap between the ideal of residential continuity and reality.[16] The lawyer Alessandro Ziliol paid an annual rent of 140 ducats during the first decades of the sixteenth century for the 'great house in Campo Sant' Angelo', where he lived with his wife and many children. According to a custom established by previous generations, he should have housed the wife of his only son destined for marriage, as well as any unmarried sons who did not join the Church and, if necessary, their illegiti-mate children. His daughters, however, would have either left to live with their husbands or joined a convent. Instead, after the lawyer's death his grand-son described the dispersed living arrangements of Alessandro's children. Some had decided to marry or live with women who had not been chosen by the family and had left the family house. Another, on his return from a long journey to Syria, had asked to live in the family house. Two sons, Camillo and Giulio, had made good marriages with the daughters of the patrician Tommaso Bragadin and had gone to live on their own.

Within working-class groups, at the age of about fourteen but sometimes much earlier, the destiny of male sons was decided by an apprenticeship. In con-trast, the sons of patricians and citizens left home much later, and could also be forced at their father's wish to live together in the family house against their own will until the age of thirty or even later. Some sons never left the family home and eventually took over their father's business.

Sisters did not have access to a system analogous to the Venetian *fraterna*. Those who did not marry young or enter a convent sometimes continued to live in their father's house as *chietine* (religious women who took some vows) or *pizochere* (women committed to a religious life who remained at home and did not take vows), taking care of single broth-ers. More rarely, sisters went to live on their own, an eventuality that was sometimes provided for in their brothers' wills. Elena Ziliol, a cultivated woman and writer of sonnets, who preferred to remain unmarried at home rather than go to a convent, eventually married an older man late in life who tormented her with his jealousy to the point that – according to her nephew – he caused her premature death. Lower down the social scale, however, daughters often left their family in childhood to go into domestic service in patrician households, where they exchanged long years of toil for a miserable dowry paid by the employer.

Domestic employees, servants and also slaves – Turks, Tartars or Africans – were another constant presence in wealthy households.[17] Some of them were only transitory – during this period servants frequently moved from house to house – but others remained in one home over a long period of time, following the children from infancy to adulthood. Sometimes an elderly wet nurse was taken into the home of her 'milk child', by now an adult, and could count on finishing her days there. So Magdalena from Cremona, widow of 'Bartolomio the comb-maker from Padua', lived in the house of the Venetian patrician Zuan Agustin Moro and left all her belongings to 'madonna Andriana Barbaro', the widowed owner of the house described as 'my child, whom I breastfed', and her sister Maria.[18] In addi-tion, some wills reveal rather unorthodox cohabita-tions with domestic servants, as in the case of Nicolò dalla Bolza, who left funds to say mass for his soul and for 'the soul of Franceschina Morato, who was my companion and housekeeper'.[19]

The Renaissance house was populated by children and youths of various origins: children of different couplings including natural or legitimated children, young relatives on temporary visits, as well as chil-dren 'taken for the love of God' from city hospitals. Among Venetian citizens, worries regarding the fate of children whose father or mother remarried were expressed primarily in women's wills. Towards the end of her pregnancy Beneta di Maistri-Gigante asked her husband to behave well towards her children and not to distinguish between them and

any others he might have after her death, 'for the love we had for each other'.[20] Paola Orio, the wife of a coal and wood merchant, leaving her inheritance to her children, forbade them to leave wills in favour of their father, because she did not want her possessions to finish in the hands of any children, legitimate or otherwise, that her husband might produce after her death.[21] 'With words full of love' Camilla, wife of Andrea Frizier, the grand chancellor entrusted her husband with her son Carletto who was but a 'small child, according to my wishes I recommend Carlo to you, adding that if you ever remarry no one should hit him'.[22]

Hierarchies between or within generations evolved as fathers, children and groups of heirs lived together in different combinations. They were also influenced by the arrivals and departures of various family members, due to business, vocational or study trips, marriages or the deaths of spouses. Hierarchies between cohabiting brothers can be identified through the control of objects, for example, of books bequeathed to children: 'Also I wish the library that contains many books in Hebrew, Latin and Greek to be shared by all my children, but that my son Alessandro be placed in charge of it', wrote Bartolomeo Zamberti in his will of 1547.[23] In contrast, another Venetian, the doctor Nicolò Massa, left all his books in Latin and the vulgate to his daughter, stipulating that if any of them were later banned by the Council of Trent, they were to be burnt.[24] Indeed, not everything was passed down to the following generation, and not all objects symbolized family continuity. Objects could even be seen as dangerous. Jacopo Brochardo, a notary at the Curia Forinsecorum, did not want his heirs to pay the price of his foolhardiness and stated in his will: 'I do not know where the works and printed portrait of Luther are, but if they are found among my books they should be burnt immediately.'[25]

In complex family groups both members of a married couple often experienced an ongoing struggle for independence. This process was also made tangible in terms of the expanding domestic space at their disposal, from the nuptial room of the young couple living with their parents to the entire household of which they eventually became owners. Various temporary 'desertions' from the conjugal home provide an eloquent indication of the tenuous position of the

young bride in her husband's house during the early years of marriage. In Florence in 1374 when Agnola, who had married Amerigo Zati a few years previously, became severely ill, she sought refuge in her father's house – the Florentine notary Ser Ventura Monachi – taking with her the only possessions that truly belonged to her, namely her trousseau stored in a chest. For more than a month Agnola was attended and treated by her mother, and there she died on 15 September surrounded by the love of her own family.[26] After a miscarriage and nine months of agony Bandecca Berardi, the first wife of the merchant Goro Dati, also returned to die in the house in Florence where she had been born, a domestic space that clearly felt more familiar than her marital home. She had been married for five years and had not yet provided her husband with a child.[27]

Without their own study married women sometimes sought a secret or private place outside their home in order to manage their own interests with greater freedom. In 1537 the Venetian Felicita Pegoloto, pregnant with her first child, summoned the notary who was to draw up her will to her father's house. If she were to have no direct heirs, she intended her belongings to go to her brother and his daughter, 'declaring that I leave nothing to my husband as I have received nothing from him'.[28] Like her, other young Venetian brides, sometimes pregnant at the time, preferred to escape marital control by dictating their last wishes at the house of a close relative. In 1410 the will of the Florentine Francesca Filipetri revealed the existence of a chest deposited at the hospital of Santa Maria Nuova, the trusted institution that was to inherit from her. It provided a form of safe, where this wealthy woman kept her 'writings', deeds of ownership, credit and some precious objects pertaining to her principal debtor – namely her husband – as well as two or three other male members of the Florentine elite. A piece of writing signed by her husband testified to a debt of no fewer than 200 florins *pro masseritiis* (domestic furniture); two rings with a diamond and emerald were the pledges for another of her husband's debts of 11 florins; other credits for over 50 florins were guaranteed by private writings.[29] The main Florentine hospital therefore also acted as a bank vault and occasionally as a wardrobe or repository, where women knew they could safely deposit

their papers, documents, wealth or items they wished to bequeath to their daughters. In her will Binda, the widow of a Florentine notary, announced her intention to deposit the trousseau she had amassed for her daughter at Santa Maria Nuova, so that it could not be claimed by the family of her dead husband before the girl married.[30]

The cohabitation of a young couple with the parents of the bride was not a common practice and it was not always a long-term solution. When he married in 1453, the Florentine notary Agnolo Bandini rented a portion of his father-in-law's house, but after no more than four years he preferred to move 'to his own house' in order to escape an overly interfering father-in-law.[31] This type of cohabitation became less temporary when the dowry of an only daughter, the heir to the family fortune, included a house. An elderly uncle could assert, in the dowry contract of his niece, his right to continue living in his own house together with the young couple 'in order not to go wandering at my age'.[32] A mother could add that if a son-in-law 'was not a good companion' to his wife, sister-in-law and mother-in-law, he would forfeit various special legacies.[33] However, especially in patrician families, it was a situation that was clearly perceived to be anomalous and a father who received a son-in-law under his roof might feel the need to make a concerned appeal to 'not deface or obliterate the family coat of arms from the façade of the house'.[34]

WIDOWS AND HOME OWNERS

The fate of widows was often uncertain. Because of their allegiance to two families and houses, women could not take for granted their continuing residency in the marital home after the death of their husband. Furthermore, the destination of their dowry goods was closely linked to the house where they lived. If they continued to inhabit the house of their deceased husband, their children's maternal inheritance was assured, but if they returned to their original home and then remarried, their dowry was given back to them and could be used for their new marriage.

Generally, the communal statutes only guaranteed the widow the right to repossess her dowry. Venetian law laid out in detail the timescale and means of restitution and, as we have seen, attempted to protect

the family home and goods located in Venice itself from a possible migration into female hands. As well as guaranteeing the return of the dowry, Florentine statutes also required fathers to rehouse their widowed daughters without, however, their children, who therefore often remained in the home of their deceased father.[35] In Venice, by contrast, this right to return was not included in the statutes, although this does not mean that daughters could not request asylum in the paternal home if necessary.

Theoretically, therefore, in the absence of other family guarantees, widows could only count on their dowry to purchase and furnish lodgings. In fact, a striking number of widows in the 1427 Florentine *catasto* associated the spartan nature of their domestic furnishings or even the lack of a home and furniture with their marital status. 'I have neither house nor household goods', 'I have no household goods because I was widowed and was left without them' and 'a house with very minimal furnishings, which is expected of us widows' are common declarations that betray a more specifically female discomfort.[36]

Male wills were therefore often crucial in reiterating and expanding the legal guarantees and defining the rights, residency and the material conditions of women during their widowhood. In Venice, as in Florence or elsewhere, the obligation to restore the dowry was always underlined, sometimes with additions. Clauses such 'as a sign of love and in recognition of the good companionship' were included according to the specific family situation. If the wife was no longer young, a husband could afford to be generous and repay fidelity and conjugal devotion with the assignment of complete power over the household. In 1508 the Venetian Zuanne Salvador left all his belongings to his wife Marina, including his house with private moorings, on the condition that she remained a widow, 'because I hold her to be wise and a servant only to God, given that she is of an age to commence preparing her soul and mine and to expect no further vanities from this world, nor to subjugate herself to any other being except God the omnipotent'.[37]

In his will of 1429 the merchant Matteo di Simone Strozzi, like many other Florentines with young sons, invited his wife Alessandra to remain in the family home with them without requesting her dowry. In return, he assured maintenance for herself

and a servant and guaranteed that 'she would not be sent away from the house'. Matteo also allowed for the possibility that her situation might alter over the years, as their sons became adults, and that the cohabitation might become difficult once they got married.[39] A Venetian will-maker also spelt out the reasons why a widow might no longer wish to live with her sons 'because of the wives'.[38] In that case, as long as Alessandra still did not reclaim her entire dowry credit, Matteo assigned her a landed income so that she could live elsewhere. Such concerns reveal the fragile nature of residency in a house that belonged to others, even for a widow who had remained faithful to the household and its heirs.

The lack of children, or male children, could make the residence of widows even more uncertain. The use of a house, or merely a part of it, throughout their natural life was a right that the husband's heirs might not respect because it imposed a cohabitation that was not always welcome. In the will of another Florentine patrician, Agnolo da Uzzano, drawn up on 16 January 1424, the use of the term 'hospitality' to describe the conditions reserved for his wife Bamba is significant. As well as returning her dowry of 700 florins, Agnolo left her all her clothing and jewellery and stipulated that 'she can legally stay without expenses all the time she will live in the said new house … and in the Uzzano fortress', where she was to be 'seen and received *with goodwill whenever she pleases*'.[40] Precisely because Bamba was to continue living with her son-in-law Niccolò and his family in the Florentine house, Agnolo allotted her specific areas – the *camera*, the *anticamera* and two other rooms on the ground floor with all their beds and furnishings – the same spaces that, if necessary, she would share with her daughters if they were widowed and wished to return home. If, however, the owner of the house and, in the future, their children did not fulfil their duty of hospitality and courtesy, Bamba would be able

> to demand the ownership of the said *camera* and
> *anticamera* and ground-floor room and the
> aforesaid goods and keep and use them as long as
> she lives and remains a widow, *without harassment or
> contradiction* from the author's heirs and without
> the license, authority or prohibition of any judge
> or court of law.[41]

But, over and beyond the commendable concern to guarantee his wife's rights expressed in the will's change of tone here, we might question both the need for the coercive power of these words and the quality of life of a woman who was no longer considered a welcome guest but rather an undesirable intruder.

Like many other Florentines who invited their widows to remain in their household, without, however, reclaiming their dowries, Matteo Strozzi and Agnolo da Uzzano also encouraged their daughters to 'return' to the paternal home if they were widowed. Strozzi transformed this 'return' into a collective right available to the female descendants of a branch of the family: by saying that 'all the existing and future descendants of Messer Iacopo dello Stroza degli Strozzi have the right to return if they are widowed', he recognized that his female relatives belonged to the house.[42] Nevertheless, it was an ambiguous form of recognition, as it only gave them rights of use and was therefore temporary, lacking the extended period of the full ownership accorded to male heirs. Agnolo also wanted his three daughters – Costanza, Giovanna and Alessandra – to be 'received' in the Florentine house and the fortress in Chianti 'if any of them are widowed or for any other necessity', and, like their sisters-in-law, they were reserved some rooms under the same conditions. But it was, above all, in the use of domestic furnishings and objects that the temporary nature of the daughters' connection with the house became apparent:

> And furthermore, he desires that his daughters in
> such cases of widowhood and need, in the said
> Uzzano house and fortress, are to be assigned the
> use of household furnishings and goods as they
> wish, by the heir of the author of this will, as long
> as the said daughters *only request reasonable items and
> ones that can be repossessed*, taking their word that
> they received them or not.[43]

The male identity of a patrician house was also founded on the permanent nature of the mobile goods that furnished it. Women only had a limited control of objects over time, which did not normally extend beyond their death. Lisa de' Mozzi, the widow of a Florentine apothecary, knew that she only had the use of her marital bed during her

lifetime because it had already been bequeathed to the city hospital of Santa Maria Nuova in her husband's will.[44] Understandably, widows who inherited the outright ownership of furniture and goods through a will felt the need to affirm their rights by creating an inventory of them. In February 1507 Marietta, the mother of Dietifece di Daniele del maestro Ficino, was bequeathed the use of all her son's possessions, which were eventually to be inherited by her paternal uncle and her cousin. The will specified, however, that she was to inherit outright the bedroom with all its furniture. And so, two months after the death of her son, Marietta went to the property court and undertook to give the heirs the goods kept in Florence and in the villa, which she could only use temporarily, while an inventory with object evaluations, a copy of which was kept by Marietta, was drawn up 'in order to show what was freely hers and what she had to preserve for the heirs'.[45]

The Renaissance house and its furnishings therefore had a distinct identity. Their destiny ideally followed a series of norms as well as a system of values, whereby it was the duty of men to preserve them over time and prevent women from dispersing them. Young widows who left with their dowry to remarry were often accused of 'ruining the house', forcing the heirs to dispose of family goods in order to cancel out the total debt. And yet, in other examples, it was precisely this obligation to restore dowries to widows that enabled them to 'save' the house and its contents from ruin. Alessandra Macinghi, the widow of Matteo Strozzi whose will we have discussed, is a famous example of fidelity and female dedication to the male house. Thanks to her, the house on corso Strozzi – which meant so much to her husband – was saved from the confiscation of goods imposed by the Florentine commune on political exiles.[46] There are other, similar cases of patrimonies saved by widowed mothers. In his family chronicle Donato Velluti relates that his cousins refused the inheritance of their father Bindo di Piccio Ferrucci and, in order to avoid honouring his debts, they transferred the paternal goods to their mother.[47] When, in December 1495, Biagio Buonaccorsi's father died bankrupt, leaving a debt of 1,500 ducats, Biagio was forced to renounce his inheritance and abandon the paternal home, but during the following months the property court assigned Buonaccorsi's house and furniture to his widow and stepmother, allowing Biagio to return to the home of his father.[48]

Women whose dowry included the residence of the married couple were also home owners. In such unusual situations women were the ones concerned about their husband's residence after their death. Lucrezia Corbeli, a Venetian citizen, married a patrician, Sebastiano Priuli, who was presumably rather impoverished, and in her will of 1503, which she wrote herself, she bequeathed him her house in San Gerolamo for the rest of his lifetime, as well as two rooms, one large and the other small, in her house in the country with two 'furnished' beds,

because the said Messer Sebastian came to stay in my house when we married and remained there and brought his own furniture. However, I wish him to keep all his furniture: everything that he says is his belongs to him and no difficulties should arise from people contradicting him on this matter.[49]

Women whose dowries included a house were usually widows, as a house was often given as restitution for their first dowry. However, the record book of a Florentine *rammendatore* (specialized wool-worker) is a lively testimony to the effects that living in the wife's house might have on the power balance and hierarchy within the couple's relationship, particularly when the wife resolutely asserted her identity as owner. 'That woman came to flaunt her textiles and furniture!'[50] was the very revealing accusation made by Marco di Zanobi, who was compelled to separate from his wife in January 1524 after barely six months of marriage. The fifty-six-year-old craftsman had decided to remarry in reaction to the traumatic experience of losing his wife, three children and a grandchild to the plague in spring 1523 and his choice of a new bride was perhaps a little hasty. Ginevra de' Castroni was a widow and received Marco in the house she owned as part of her dowry. In these circumstances he felt that he was treated as a guest by a woman who not only was the proprietor of the house in which he lived, but also paraded her property with arrogance. This challenge to the traditional hierarchy was sufficient to destroy the

marriage, forcing Marco to leave the house and, initially, to ask to be taken in by his daughter's husband. However, the separation appears to have been temporary: in 1528 he returned to his second wife.

CONCLUSIONS: IDEALS AND REALITY

When norms and practice, ideals and reality are examined simultaneously, Venetian and Florentine families appear to have much in common. The 'desire for immortality' was frustrated by the reality of demographic accidents and economic conditions. The idealized continuity of the house, understood as a physical space as well as a group of blood relatives linked by the same surname, was rarely fulfilled and underwent the necessary adjustments to adapt to concrete situations. The legitimization of illegitimate children, the adoption of distant and less fortunate relatives, and as a last resort transmission along the female line were common occurrences. It is also true, however, that the differing demographic and political situations of the two cities between the fifteenth and sixteenth centuries also affected perceptions of the family and lineages. During the prolonged population crisis that struck Florence during the fifteenth century the need to safeguard properties in order to avoid their dispersion was felt particularly strongly. On the other hand, the search for political legitimacy in a context typified by internal conflict within the elites could create a foundation for family strategies specifically focused on preserving goods and identities, and it should be remembered that the great proliferation of family chronicles has been linked with the political instability of Florence during the Renaissance.[51] In contrast, Venetian family memoirs expressed the search for identity by the middle classes, who were denied political power.[52] At the end of the thirteenth century the transformation of the Venetian patriciate into a closed and hereditary group definitively excluded families who had previously contributed to the Great Council, the city's most important political body. As a result of this, in the words of Alessandro Ziliol, 'many houses and nobles were reduced to the state of families'.[53] By the time Ziliol was writing only those who were still part of the political elite and sat on the Great Council could call their lineage a 'house' (*casa*), while the others had to content themselves with being merely a 'family'.

6

REPRESENTING DOMESTIC INTERIORS

LUKE SYSON

6.2 Filippino Lippi, *The Virgin Annunciate*, one of a pair of tondi depicting the Annunciation, tempera on panel, Florence, 1482–4 (Museo Civico, San Gimignano)

ANY ATTEMPT TO ENVISAGE the domestic spaces of fifteenth- and sixteenth-century Florence or Venice is beset with problems. Huge categories of objects have simply disappeared: both highly expensive things – precious metalwork or bulky items of furniture – and completely mundane ones, too ordinary to preserve. And despite the frequent (if often compromised) survival of their architectural shells, not a single scheme for interior decoration remains intact. As other authors in this book demonstrate, some gaps can be filled by written documents; inventories, for example, provide snapshots of the moveable goods a room contained at a particular moment,[1] but they are of less use in helping us to understand the precise locations and arrangements of furniture and other objects in these rooms, or to reconstruct their surroundings. Moreover, in most instances, inventories give only limited information as to what individual items actually looked like. Recently, some historians have made great strides in linking preserved artefacts to those recorded in written accounts,[2] but here again their efforts are hampered by limited survival rates, and many documented objects remain stubbornly unidentifiable.

It is no surprise therefore that historians have frequently turned to paintings and other images to provide extra evidence for the appearance of rooms and their contents. The vivid and painstaking naturalism with which many leading artists of this period depicted objects has convinced many modern scholars that their paintings can provide empirical evidence for the appearance, setting and ordering of the kind of goods that were owned or encountered by the men and women who originally viewed such pictures. We only need think of the scenes of the Births of the Virgin or St John the Baptist, with their bedroom locations and abundant 'incidental' detail, executed in the mid-fourteenth century by the Sienese Lorenzetti brothers and by generations of Tuscan painters (and sculptors: see plate 2.7) following them.[3] Vittore Carpaccio's *Birth of the Virgin*

6.1 St Peter with a knife
and glass beaker, detail from
Domenico Ghirlandaio,
Last Supper, fresco, Florence,
1480 (Church of Ognissanti,
Florence)

(plate 1.1) has also been regarded, like so many of his paintings, as a 'truthful' record of a real Venetian room. Works by north Italian artists in the second half of the sixteenth century, above all paintings and drawings by Jacopo Bassano and Vincenzo Campi (plate 1.17), similarly invite analysis for what they reveal of domestic life and its physical context. And the many pictures of the Annunciation painted in Quattrocento Florence, with the Virgin surrounded by (at first sight) any number of domestic objects, which will be the main focus of this chapter, have proved particularly seductive.

However, these interpretations are now sometimes thought to be over-literal, taking too little account of the primary (often religious or mythological) subject matter of such images, of their imagined status or of the ways in which they distort or diminish spaces that we know from existing buildings to have been larger or differently proportioned.[4] On the other hand, perhaps the dismissal of accounts of the domestic interior by historians who relied in part on paintings and other representations has become too easy. The insertion of realistically painted domestic artefacts into ostensibly domestic interiors is, for instance, an undeniably prominent characteristic of one very distinct strand within the Florentine visual tradition. The clear glass beakers on the table before Christ and the Disciples in Domenico Ghirlandaio's depiction of the *Last Supper* (1480; plate 6.1) in the Church of Ognissanti, Florence, look very like a rare example, now in Pistoia, of this formerly omnipresent type. This chapter will ask if this method might profitably be revived (if modified) to arrive at a greater understanding of object categories that, unlike the Pistoiese glass, have disappeared completely.

Since comparisons of this kind demonstrate so unequivocally that many depicted objects closely resembled actual, 'contemporary' things, it needs to be asked why this may have been important to the first audiences for these pictures. This feature of the art of this period has been differently construed by twentieth-century art historians. It has been argued, for example, that, with such references to the contemporary in pictures of the sacred, the Gospels could have been regarded as both historical and modern, collapsing the boundary of past and present between holy protagonist and fifteenth-century

believer to create a temporal no-man's land, which ensured the identification and involvement of the viewer.[5] Such realistically painted modern objects would therefore become empirical evidence for imagined records of sacred events, rendering them 'truer'. Others have suggested that the abundance and variety of such objects, as well as the cities, animals, plants and costumes of the kind stipulated in the 1485 contract for Ghirlandaio's frescoes in the Tornabuoni Chapel at Santa Maria Novella, were prompted by an adherence to the Albertian notion of visual delight derived from controlled *varietas*.[6] This view does not contradict the first, and in fact the pleasure in viewing things depicted with startling naturalism is also a key feature of various Renaissance Italian observations on the art of the Netherlands.[7] Indeed, some art historians have explained equivalent features in Florentine painting as resulting quite straightforwardly from the impact of these aesthetically and commercially desirable imports. This again is certainly a factor, and even if the direct 'influence' of Jan van Eyck on Fra Filippo Lippi and others of his generation is disputed, it would be foolish to deny the connections between, for example, the Eyckian *St Jerome in his Study* (plate 19.30) and Domenico Ghirlandaio's 1480 fresco of the same saint at the Ognissanti, or between the arrival in Florence in 1483 of Hugo van der Goes's *Portinari Altarpiece*, with its exquisite depiction of a Hispano-Moresque *albarello* (pharmacy jar), and the similar details in Filippino Lippi's two tondi of the Annunciation, executed for the town hall in San Gimignano in the same period (1482–4; plate 6.2).[8] It would not do, however, to exaggerate the impact of Netherlandish painting upon equivalent Italian scenes set within domestic interiors; while Florentine artists not infrequently pilfered landscape elements from Netherlandish paintings (and were to go on doing so from German prints in the sixteenth century) to create fantasy settings for their own portraits and devotional images, there is no evidence that individual features in Netherlandish painted interiors were similarly quoted.[9] The objects depicted are different from those found in Netherlandish interiors, and the accurate representation of things in Italy and the Low Countries is more likely therefore to be a matter of equivalence of approach than literal quotation.

But can these parallels be explained as more than a matter of aesthetic choice? The art historian Erwin Panofsky famously, but controversially, claimed that such inclusions in Netherlandish pictures represent a system of 'concealed or disguised symbolism', one that could be decoded to arrive at the single and unified meaning of a work.[10] Panofsky's formulation that, because of a new realist imperative in Netherlandish painting, symbols demanded disguise through their naturalistic depiction and incorporation is deeply mistrusted in some quarters.[11] Yet in others it is still taken as read, and extended to those Italian paintings that look enough like Netherlandish pictures to warrant such decipherment.[12] However little documentary proof there is that such a system ever existed, it is often assumed that Florentine painters adopted (or at least adapted) the same method. This is the implication of, for example, one art historian's remark that the accumulation of artefacts in the cupboard behind the Virgin in Filippino's tondo are 'objects that represent a learned commentary on her role in God's plan for human salvation'.[13] Once, it is implied, the spectator knew what each object meant, then the text of the commentary would become clear. This is an assertion that, while not wholly wrong, requires modification and proper justification. As will be argued below, 'symbol' may not be the correct word. Moreover, it remains to be asked what such an assertion, if it can be demonstrated, does to the reading of such paintings as evidence of the appearance of real Quattrocento domestic interiors, and especially of classes of object depicted within them that have largely or totally disappeared. Is it possible, for example, to trace the chronology and development of the 'lost' beds of the fifteenth century of which no authentic examples survive? Peter Thornton reconstructs this history through their depiction in paintings, such as the many Annunciation scenes by Fra Filippo Lippi (plate 6.3) in which beds are represented, sometimes backing this up with inventorial evidence.[14] Is this legitimate?

These two questions – of the 'symbolic' and the documentary – are best answered together. Art historians' temporal distance from the varied contemporary experience of these images has permitted them to argue for a fixed symbolic language that is at the same time dependent on the accurate depiction

of things but (seemingly) almost entirely divorced from the multivalent social meanings of those objects as they were encountered and interpreted in daily life. That is not to say that such elements are merely descriptive, with little or no contribution to the function and meaning of the image. Nor are they merely ahistorical or modishly Netherlandish. Indeed, the decision to include such objects (as opposed to only the imaginary or the obviously emblematic) in devotional images suggests, in fact, that the represented and the actual should be seen as crucially interrelated. Not only might the social (in the broadest sense of the word) meaning of an object contribute to its significance when painted, but it can also be argued that paintings might reflect, inform, confirm or amplify the meanings of the real things in real interiors. This will be best demonstrated by concentrating on the ways in which the bedroom – the *camera* – was represented in Florence – most frequently in images of the Annunciation (the moment of Christ's Incarnation) and, to a lesser extent, of the Virgin and Child. By examining the things 'owned' by the Virgin in the paintings that depict her it should be possible to establish the extent to which these two issues are connected. Within a devotional context such images might have a key role in establishing dialogues between art and life.

The worldly poverty of the Virgin Mary is paradigmatic. It is therefore somewhat startling to realize that, as they are depicted in paintings, the Virgin Mary's belongings were highly select. This last is a deliberate choice of word: her goods (including her costume) often seem to be extremely expensive; but at the same time their range is strictly limited. Some of the many things she does *not* possess can be explained by artists' pictorial decisions. This point is perhaps banal, but it is worth noting, as we consider these pictures as potential evidence, that the Virgin almost never has any figurative works of art – tapestries or paintings – that might compete pictorially with the principal image or would be deemed anachronistic by their subject matter. Similarly, the interiors in which the Virgin is represented often lack doors, curtains or other such devices for stopping drafts, and other architectural elements that would have been encountered in real life but in a painting might obscure the legibility of the narrative

or hide a feature that was intended to contribute to the overall meaning of the work. It is crucial to bear in mind the subject and the devotional function of such works: altarpieces, declaring and explicating the mystery to which the altar was dedicated, or pictures made for sustained private contemplation. Some objects might simply have been thought indecorous, and their exclusion from the sacred realm may have been prompted by anxieties about them in everyday life. It is certainly significant that fripperies of a type often recorded in the 'real' *camera* but regularly damned by preachers and outlawed by sumptuary legislation are almost always edited out. There are very few 'vanities': no jewels, decorated carved bone or pastiglia boxes; no painted chests, mirrors or ivory mirror cases; no portraits, perfume bottles or cosmetic jars. The Franciscan preacher San Bernardino da Siena explicitly condemned 'silken and linen sheets, with borders of fine gold embroidery, precious coverlets … painted and provocative of lust, and gilded and painted curtains'.[15] The associations of these objects would have been inappropriate. Where such textiles appear, they are usually invested with extra, non-materialistic meaning or converted into less offensive, but equally meaningful veil-like cloths. Fra Filippo Lippi, for instance, in his undocumented *Annunciation* of *c.*1445–50 transformed a peculiarly arranged canopy for the bed behind the Virgin's bench into a cloth of honour for a (heavenly) throne (plate 6.3).[16]

Fra Filippo's bed and hangings look convincingly real. However, their unlikely arrangement within the composition suggests that they, like other such 'real' elements, should be linked and contrasted with other items that were, for good reason, entirely invented but are now sometimes erroneously credited with documentary value by their naturalistic depiction and inclusion in interiors whose other elements are subject to empirical proof. The issue of the Virgin's seating arrangements is perhaps the most complicated. It has been frequently observed that chairs with arms and backs, as opposed to much smaller stools or larger benches and daybeds, appear in fifteenth-century inventories hardly at all.[17] The presence of such chairs in otherwise credible domestic spaces would therefore have been noted as contrastingly distinct and they are likely to have been recognized as standing for the Virgin's symbolic

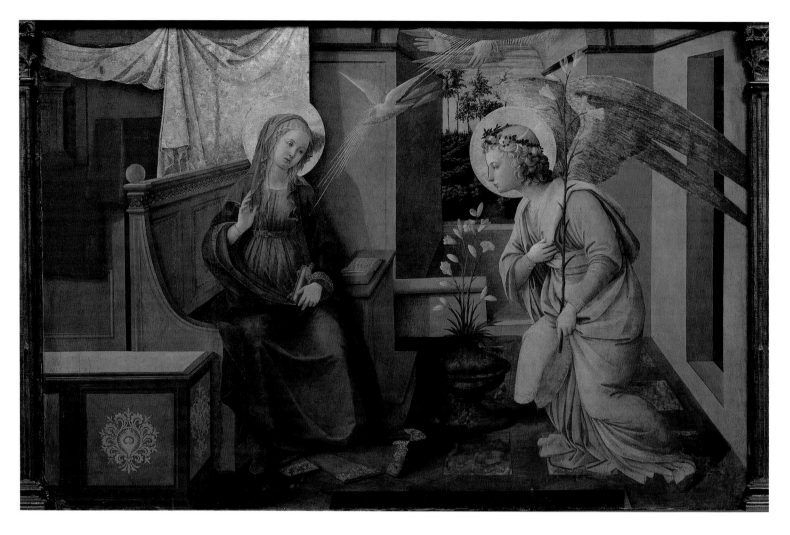

6.3 Fra Filippo Lippi,
Annunciation, tempera on
panel, Florence, *c.*1445–50
(Doria Pamphilj Collection,
Rome)

throne, signalling her future role as Queen of Heaven. The jewelled chair or throne in Piero del Pollaiuolo's Berlin *Annunciation* teaches us to be sceptical of other naturalistically depicted furniture.[18] Referring to the tondo by Filippino Lippi in San Gimignano (plate 6.2), Peter Thornton should perhaps have hesitated before he wrote of the X-frame chair, which he suggests might be made of steel (actually surely intended to be read as silver and silver gilt), that, despite the absence of any such object in inventories,

> It is too precisely depicted to be imaginary (note the accuracy with which the artist represents two Hispano-Moresque vessels on the shelves and the clock alongside) so Lippi must have seen it and included it as something exceptional. A column rises from the desk and presumably forms a screening for the bed beyond.[19]

The column, too, was in fact a familiar attribute of Mary at the Annunciation.[20] It might be suggested that the more fantastic an object appears, the more likely it is to be related to a non-worldly realm.

An awareness of this combination of the likely and the implausible assists us, however, when we consider the former. Panofsky characterized paintings like this as realistic, which *in toto* is clearly not right. These images certainly contain some rigorously realistic aspects. Moreover, they are set within spaces that are treated naturalistically. The imagined elements (such as the figures themselves) are also intended to convince, although in a slightly different manner. However, and consequently, any contrasting lapses from the order of (real) things would have been, though perfectly legitimate, immediately apparent. The historian of Netherlandish art, Catherine Reynolds, has challenged Panofsky by proposing an alternative interpretation of the inclusion of such incongruities

in her convincing discussion of paintings of the Virgin within interiors executed by artists in the circle of the Netherlandish painter Robert Campin, in which Mary is shown nursing her child and seated sometimes on the ground with her hair loose.[21] Reynolds argued that this activity and the style of her hair would have been considered indecorous were she a real married lady of the status suggested by her costume (rich wives wore their hair up and farmed out their children to wet nurses), but in this context would have been read as signalling her virginity, humility and humanity according to social custom and pictorial precedent. She wrote:

> Contemporaries would have seen, in these plausibly real and very grand settings, grandly dressed ladies who flagrantly break the conventions of the real world: the realistic details add up to an unreality. Impossible therefore as straightforward representations of the real world, the images would have been instantly recognizable to the Christian viewer as devotional.

Her observation should not, however, be restricted to fashion or behaviour. Similar responses would certainly have been induced by, for example, combined but jostling styles of architecture, modes that could be associated, for example, with church and palace.[22] And this would also have been true of combinations of real and imagined objects and settings. Indeed, all these different kinds of discrepancy within the context of a religious work, set in a biblical *past*, signalled the non-descriptive significance or intent of objects that are depicted as contemporary and 'real', as well as the ones that make no such claim. By rejecting an *entirely* realistic mode, the artist signals that all the elements, both real and fantastic, should be rethought as conscious 'what-is-it-doing-there?' invitations.

How then should we interpret those things that were intended to look 'real'? If certain kinds of forbidden object were excluded, it is equally the case that other items that were troublingly expensive were regularly depicted. Can one justify the assertion that these are more than set-dressing to make the sacred past present; that they are as Panofsky, quoting St Thomas Aquinas, would have it, 'corporeal metaphors of things spiritual'?[23] The pictorial

disjunctions discussed above might in themselves indicate such a reading. However the nature of their setting is also important to establish; we need to discover where the Virgin and the Archangel Gabriel in Annunciation scenes are supposed to be. One feature appears more frequently than any other in their settings. From at least the second half of the fourteenth century the bed had become a standard part of the iconography of the Annunciation, usually placed behind the Virgin who is often painted in an interior space distinct from that occupied by the Archangel Gabriel, who is often shown outside it.[24] (This contrasts with Netherlandish depictions of the same subject in which the space occupied by the two protagonists is generally unified.) Different theologians proposed various theories as to where the Annunciation had occurred. Sant'Antonino, the Dominican Archbishop of Florence, identified the space as a secluded chamber within the Temple of Ezekiel, a room sealed by her virginal *porta clausa*.[25] However there was also a more mainstream tradition – that it took place within the chamber (*cubiculum*) of the Virgin's own house, a tradition that can be traced from the apocryphal Gospel of the Birth of Mary to the anonymous Franciscan text, the *Meditations on the Life of Christ*.[26] The inclusion of a bed *may* therefore do no more than indicate her domestic bedroom setting.

But beds were made for more than just sleeping; they were places for conception, and in the context of how these images were read it is important to recall the long-established connection between the Virgin's bedroom and the bridal chamber – the *thalamus* – in that extraordinary and mysterious sequence of Old Testament love poems, the Song of Songs.[27] By doing so, we start to see what this setting actually signified. The Song of Songs, with their central protagonists of Bride and Groom, was, like the Psalms, a traditional focus for biblical exegesis throughout the Middle Ages, with the Commentaries of the Cistercian St Bernard of Clairvaux (1090-1153) proving particularly influential. Commentators interpreted this difficult text in various ways: the Groom was taken by some to stand for Christ, the Bride for his Church (Ecclesia); others thought of the Bridegroom as God and the Bride as the human soul; while a third tradition linked the poems to the mystery of the Incarnation, the Word

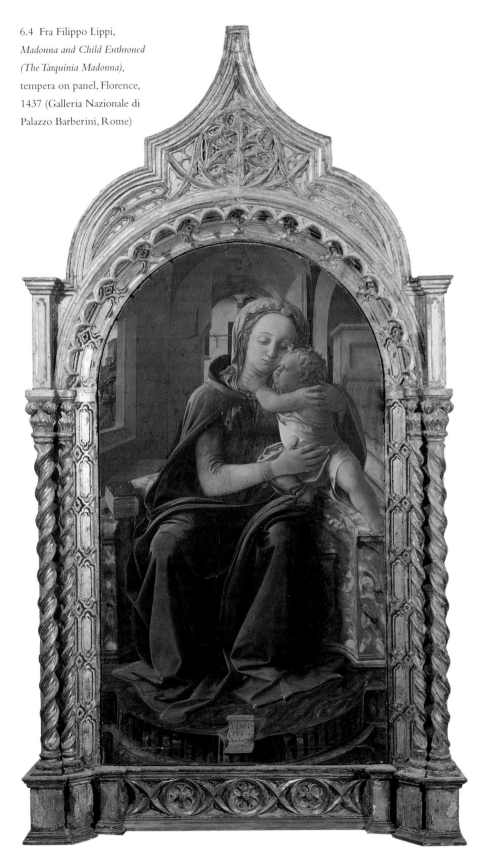

6.4 Fra Filippo Lippi,
Madonna and Child Enthroned
(The Tarquinia Madonna),
tempera on panel, Florence,
1437 (Galleria Nazionale di
Palazzo Barberini, Rome)

made Flesh, positing the Bride as mystically representing the Virgin, while the Bridegroom stood for Christ. These different approaches fed one another and could overlap, especially as the poems were used as sources for imagery of Christ and the Virgin. The bridal chamber in the Song of Songs therefore became both the Virgin's and Christ's. Indeed, St Augustine wrote of '[Christ's] appearance as an Infant Spouse, from His bridal chamber, that is from the womb of a virgin', and in another sermon Augustine further explored this theme of the Virgin's bridal chamber/womb and the Incarnation of the Word 'by a marriage which it is impossible to define'.[28] This Old Testament text and the monastic exegeses upon it have been used to explain the *thalamus* setting of Fra Filippo's 1437 enthroned *Tarquinia Madonna* (plate 6.4);[29] and the link between the *thalamus* of the Song of Songs and the bedroom setting of the Annunciation has since been proposed in relation to Netherlandish examples.[30] The bedroom setting was certainly to become a regular feature of paintings of the Virgin and Child made for private devotion.

Moreover, in considering both the bed and the other furnishings of the bridal bedroom, it is important to note that in the early Middle Ages (and probably later) the Bride's *thalamus* was identified as an artificial memory *locus*, visualized within the monastic tradition as the 'place' for 'remembering' the Incarnation of Christ.[31] This fact takes us to the heart of the tradition of devotional memory technique, the memorizing and envisioning of a number of connected spaces or places as the 'containers' of distinct sets of ideas relating to particular religious themes, these *loci* to be furnished with *imagines*, or mnemonic prompts, for detailed parts of arguments. Although these techniques are now frequently invoked by historians, and despite the fact that in 1435 Leon Battista Alberti welcomed 'a view of painting as an art of memory',[32] they have only infrequently been linked by art historians to the making and understanding of painted images. Nonetheless, though the specific connection with the Bride's *thalamus* has not formed part of the argument, the Annunciation setting in Italian paintings has recently been recognized as the painted equivalent of a *locus* of memory, their ambitious perspective schemes connected to the construction of

memorable architectural *loci*, the pictures contributing to the creation of mental devotional spaces.[33]

Albertus Magnus and St Thomas Aquinas have long been identified as the founders of a monastic tradition of memory technique to assist contemplation and the oratorical skills required for preaching, and it has been shown that *ars memorativa* treatises to aid devotion were the specialism of a series of Dominican and Franciscan authors in the early Renaissance. These were treatises that, after the advent of printing, were published in sufficient quantities as to suggest that they had a lay as well as a monastic market.[34] They employed and modified schemes to be found in Quintilian's *Institutiones*, Cicero's *De Oratore* and another text wrongly ascribed to Cicero, the *Ad Herennium*, all well known to a lay audience in Florence by the beginning of the fifteenth century. It is worth quoting, as others have done, from the *Ad Herennium*, which explains the system with admirable clarity:

> Begin by fixing the plan in your imagination; then order the ideas, words or images that you wish to remember, placing the first thing in the vestibule, the second in the atrium, then more around the *impluvium*, into side rooms, and even onto statues and paintings. Once you have put everything in its place, whenever you wish to recall something, start again at the entrance, and move through the house, where you will find all the images linked one to another as in a chain or a chorus.

The link between the verbal, the actual and the visualized is all-important here. Albertus Magnus had advocated using 'real' memory places, and various later authors gave them prescriptive form. These were frequently domestic (or based on domestic spaces); a copy of the 1434 treatise in the British Library by Jacopo Ragone, for example, even contains a rather basic drawing of a *palazzo* of the type to be used for forming memory places, while the Florentine Michele del Giogante placed *imagines* in his own palace.[35] The 'furnishings' of these naturalistic *loci* might remain fantastic or precious. However, building on examples where the real furnishings of an altar became memory prompts,[36] mnemonic *imagines* sometimes became fully domesticated in fifteenth-century treatises; the text by Fra Lodovico da

Pirano, for example, included long lists of domestic *imagines*, such as lanterns and tripods.[37] A book by another Dominican, Johannes Host von Romberch, the *Congestorium artificiose memorie*, first published in Venice in 1520 and reprinted with illustrations thirteen years later, has also been categorized as belonging to the tail end of this long Dominican and Franciscan tradition.[38] One of the most celebrated of these illustrations is the page with objects of exactly this kind placed in the memory *loci* of the *aula* (hall), *biblioteca* (library) and *capella* (chapel) of an abbey (plate 6.5). Here, internal mental images received concrete form in a way that seems to have been anticipated in pictures by Lippi and several of his peers and immediate successors: paintings that contain a set range of objects (*imagines*) in interiors (*loci*). Thus the furnishings of the bride's bedroom become in essence the *imagines* for the metaphorical womb of the Virgin, the memory place for considering the Incarnation. As in different memory treatises, these

6.5 Johannes Host von Romberch, 'Aula, biblioteca, capella', from *Congestorium artificiose memorie*, Venice, 1533 (British Library, 1030.a.3)

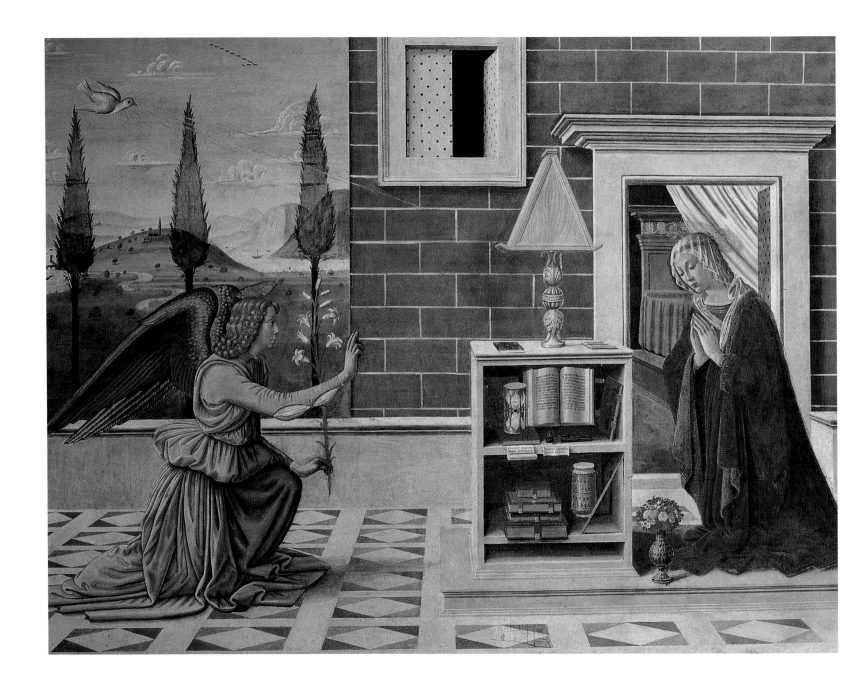

6.6 Attr. Bastiano Mainardi,
Annunciation, fresco, c.1482
(Collegiata di San Giovanni,
San Gimignano)

various paintings contain different combinations of
the real and unreal, depending on what they were
supposed to evoke, all the ingredients, however,
designed to be memorable.

When considered as a group, it is clear that the
Incarnation *imagines*, those that are real objects, are
remembered as a limited repertory. Its range is typi-
fied by the contents of the niche in Filippino's Virgin
tondo (plate 6.2) and the cupboard base of the
lectern in the *c.*1482 Annunciation fresco most often

attributed to Ghirlandaio's brother-in-law, Bastiano
Mainardi, also in San Gimignano (plate 6.6).[39] These
were all things that can be found in contemporary
inventories of the *camera*: apart from the bed itself,
we see transparent glass beakers and carafes; candles
and candlesticks; hourglasses and clocks; *albarelli* and
vases – often highly ornate; closed wooden boxes;
and devotional books and their bindings.[40] Once
again, it is possible to 'test' the accuracy with which
at least some of these artefacts are depicted, since

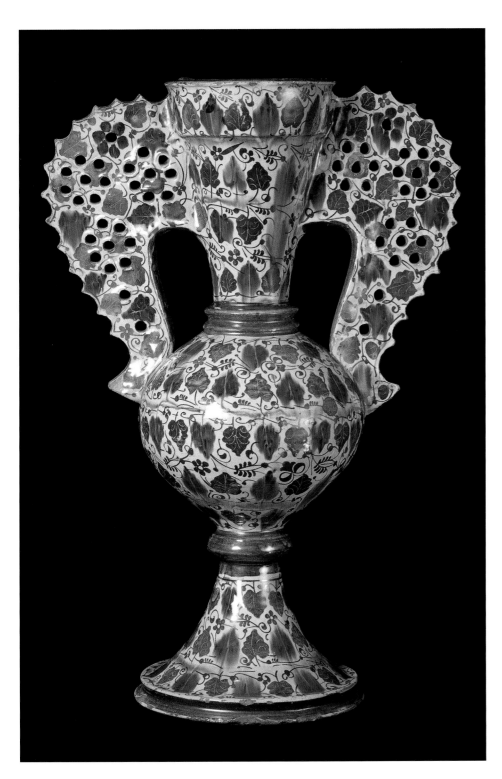

6.7 Flower vase, Valencia, probably Manises, 1435–75 (cat.118)

examples survive. A comparison of the two-handled vase in Filippino's tondo and the beautiful Hispano-Moresque vase in the V&A (plate 6.7) is a good test of the painter's veristic achievement.

To posit these objects as *imagines* of a particular devotional *locus* (rather than as Panofsky's fixed symbols) is to confirm the notion of the Quattrocento altarpiece as a 'painted sermon'.[41] Pictures made for sustained contemplation (including those for a domestic context) can be seen as the visual equivalents of popular sermons and of the texts composed or collected together to assist private devotion. In the sermons of Sant'Antonino or San Bernardino, for instance, the preachers drew *exempla* from a great range of sources to make their arguments memorable and thus convincing.[42] They deliberately chimed with strands of popular devotion, citing arguments and images familiar to their audiences from their inclusion in the liturgy, in medieval *laude* and in much-read devotional writings like the *Golden Legend* by Jacopo da Varagine or the *Meditations on the Life of Christ*. In this way, they drew upon texts of all kinds: patristic writings and monastic commentaries upon them, much quoted exegeses on parts of the Old Testament, as well, of course, as the Apocrypha and the Gospels themselves.[43] According to the theory of mnemotechnics, which was designed for preachers, *exempla* were arrived at by envisaging a personal or advocated set of *imagines* in the specific memory places devoted to the themes that they were expounding.[44] Some of these *imagines* even enter their texts, and one can assume not only that their audiences, or at least the most educated elements within them, were aware of the techniques they employed, but also that the sermons themselves went some way to popularizing them. Thus, to arrive at the potential meanings of *imagines* as they appear in paintings, one needs to draw upon the same array of texts, while at the same time taking proper account of an accumulation of visual precedent.[45]

It should be stressed, however, that for devotional memory to function properly it had to be personal to the individual believer (and therefore the viewer). Pictures provided viewers with supplementary images (such as the domestic objects discussed here) that expanded and expounded upon a main theme (such as the Incarnation), using the objects as prompts for private meditation on that theme even

in the absence of the picture itself. It was therefore important that such images, while adhering to recognizable textual and visual traditions, could also be flexibly interpreted rather than having pre-fixed meanings. For this very reason Panofsky's theory of symbols (disguised or otherwise) that could be consistently read, and that could thus be deciphered to arrive at the single message of a work of art, is seriously flawed. All the objects listed above could be recognized by their reiteration and context as pertaining to the Virgin – the boxes and vessels of various kinds, closed, transparent or full of flowers – but while the signs might remain within a consistent range (and therefore have some prescriptive aspects) so as to be easily remembered, what precisely they signified to individual beholders varied. Some indeed might have been synecdochic – a single item standing for a whole episode or idea in which it features, one related to the main theme, or reminding the viewer of a future event or another key mystery; it has sensibly been proposed, for example, that the prominent knife held by St Peter in Ghirlandaio's *Last Supper* (plate 6.1) may have been intended to summon up thoughts of the Betrayal of Christ that would follow (and Peter's cutting off of the soldier's ear).[46] The Virgin's heavenly throne in scenes of the Annunciation also comes into this category. So does the column that could be read as either the Virgin's birthing column or seen as prefiguring Christ's scourging (or both). This apparently nuanced approach to imagery does not, however, give us leave today to make up readings on behalf of fifteenth-century viewers; it is not, for example, legitimate to argue, as some art historians have, seemingly plucking the interpretation from the air, that an empty candlestick in an Annunciation scene 'symbolizes' the world before the light of Christianity.[47] The efficacy of these signs relied on a range of texts (rarely just one) and external visual references to support them. Thus the frequent appearance of candles, lit or unlit, and candlesticks may have been linked in the minds of some with the account of the Feast of the Purification of the Virgin – Candlemas – in the *Golden Legend*:

> In the candle there are three things, the wick, the wax and the fire. These three signify three things about Christ: the wax is the sign of his body,

which was born out of the Virgin Mary without corruption of the flesh, as bees make honey without mingling with each other, the wick signifies his most pure soul, hidden in his body; the fire or the light stands for his divinity, because our God is our consuming fire.[48]

For others this *exemplum* may have been associated with the Revelations of St Bridget of Sweden, where the light of Christ is described as overwhelming the light of a candle.[49] Thus Panofsky's assertion that the motif derives from the early fourteenth-century *Speculum humanae salvationis* in which the candlestick is a metaphor for the Virgin supporting Christ – the candle – is not wrong; it is simply one of several possibilities.[50] For an image to remain effective as the focus for sustained contemplation, it had to contain options.

The representational strategies of, above all, Fra Filippo Lippi, his son Filippino and Domenico Ghirlandaio and his assistants look increasingly like those of San Bernardino and Sant'Antonino when they composed sermons, for which artificial memory techniques have been recognized as essential.[51] But this still may not go all the way to explaining the contemporizing accuracy with which these permissible classes of object were depicted. The tactic would not have worked if it had not found a receptive audience. It is therefore worth remembering who commissioned altarpieces and displayed these kinds of devotional pictures in their homes: the leading members of the city's banking and mercantile families. Florence was, of course, a place particularly concerned with the world of goods, on which its economic success depended. Thus it is revealing to witness these Florentine painters taking very different aspects from Netherlandish painting to those imitated by Cosmé Tura and Francesco del Cossa in courtly Ferrara or, a little later, by Perugino in Perugia. Moreover, it is also essential to ask how these pictures may have reflected the theological and social preoccupations of this mercantile elite.

In a city like Florence it was of enormous concern to provide solutions as to how the contradictions between money-making endeavours and a properly pious life could be negotiated and reconciled. The distinguished economist R.H. Tawney and others have fingered San Bernardino and Sant'Antonino as

apologists for a proto-capitalist system.[52] As many as twenty-three of San Bernardino's Latin sermons, aimed at an educated elite, were devoted to economics. Once again the influence of St Thomas Aquinas was essential, as Bernardino promoted Aquinas's definitions of the value of goods based on their usefulness, scarcity and desirability. Both preachers have been seen as defenders of private property and of the useful role of their three categories of merchant in society (also first defined by Aquinas). The three categories – those who import and export, those who store goods for periods of need, and those who transform raw materials into finished products – commendably covered the range of activities in Florence.

These preachers, therefore, while not afraid to condemn avarice or *lussuria*, were able to construct a pious mask for the dirty face of real commerce. The *imagines* employed by Fra Filippo and the others were also goods, although transformed by their context into unworldly ones. So, too, were modern brides. In 1403 the widower and merchant Gregorio Dati stated baldly in his *ricordi*, in a section on his trading accounts, of his need to raise 2,000 florins for a new shop, '[which] I expect to obtain if I marry again this year, when I hope to find a woman with a dowry as large as God may be pleased to grant me. If I do not marry, I will find the money some other way.'[53] In a letter of 1439 Fra Filippo himself fulminated: 'God has left me with six sick and useless nieces to get married off.'[54] These were hardly very loving or pious approaches to the sacred union of man and woman, and, as well as finding an appropriate role for the devout merchant, the arguments of San Bernardino and other preachers sought to mitigate the economic side of such transactions by rendering them more humane, identifying the wife as the moral arbiter for her husband and arguing for her respectful treatment.

The sermons of San Bernardino and Sant'Antonino also recognized the financial risks of a decline in the number of marriages and pragmatically promoted the benefits of matrimony for both men and women; these arguments did have an overt economic ingredient. Thus, while the husband made money outside the home, the wife was promoted as the guardian and protector of the household goods, the family assets, or *la roba*. San Bernardino said of the wife:

'She takes care of the oil jars … she sees to the spinning and the weaving … She looks after his wine barrels … *She sees to the whole house*.'[55] And this view is reinforced in Alberti's treatise *I libri della famiglia*, in which he famously delegated to the wife the sacred (a telling choice of word) responsibility for running the home and caring for the goods it contained: 'Santa cosa la masserizia!'[56] *Masserizia* was the umbrella term that linked the concept of domestic thrift in managing the household to its material assets – furniture and utensils.

Thus if the paintings by Ghirlandaio and the Lippis can be seen as the visual equivalents of San Bernardino's sermons or other kinds of accessible instructive Christian text, were they similarly intended to shape or reflect thinking on the domestic economy, the world of goods and women's role within it? And might such a goal provide another part of the explanation for the accurate rendition of objects of the kind found in the home – the wife's domain? It would be misleading to posit these pictures as didactic in exactly the same way, but it is surely no coincidence that, as we have seen, there is greater emphasis in the pictures of the life of the Virgin on those items that could be classed as *masserizia*, beds, for example, or pharmacy jars, the permanent symbols of domestic and economic prudence, rather than categories of object condemned by preachers and sumptuary laws.

The wife was certainly perceived as the devotional centre of the household. When San Bernardino wrote 'Husbands, love your wives, as Christ also loved the Church',[57] he was not alone in linking secular marriage to the mystical union of the Virgin Mary (Ecclesia) with Christ (and by implication to the Song of Songs). He also understood that the use by real women of the Virgin as their ultimate exemplar might be mediated by her pictorial representation, adding ballast to the suggestion that the Virgins painted by Fra Filippo and his successors might have been invested with the same function. Certainly the identification of contemporary brides with the Virgin as the Bride of Christ is an idea contained within pictures themselves and was clearly understood, for example, by Fra Filippo. It seems plausible that the construction of his double profile portrait of *c*.1436–8 reflects the inside/outside compositions of so many Annunciation scenes

(plate 6.8). Indeed it has even been suggested that it commemorates the birth of a son to Lorenzo Scolari – it contains the Scolari arms – and Angiola Sapiti or, more conventionally and convincingly, that it is their 1436 marriage portrait.[58] However, if the portrait marks their marriage in Florence, it also presupposes the conception of a child, by showing Angiola in her Virgin's *thalamus* and turning Lorenzo into a quasi-Gabriel. The image may even refer to the phrase in the Song of Songs, referring to the

6.9 Fra Filippo Lippi, *Portrait of a Woman*, tempera on panel, Florence, mid-1440s (Gemäldegalerie-Staatliche Museen, Berlin)

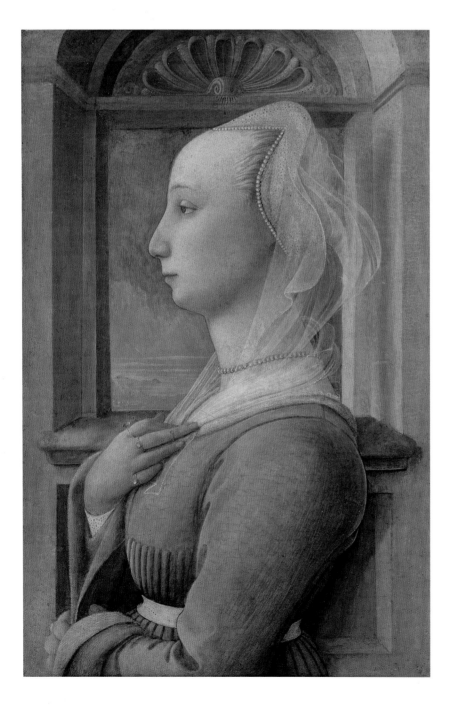

Bridegroom: 'Behold, he stands behind our wall, looking in through the windows.'[59] In Lippi's Berlin portrait (plate 6.9)[60] the female subject, also perhaps a bride, or bride-to-be, holds her hand in the modesty or sincerity gesture derived from the Annunciate Virgin and the artist places her in front of a window surmounted by a shell-niche – a motif used consistently by Lippi in his Virgin and Child images – framing a view of the sea, perhaps a reference to the convention of the Virgin as *stella maris* (star of the sea).

Thus Lippi's depictions of a domestic space – the Virgin's bridal chamber – and the others that followed them seem to have implications for the meanings and prescribed functions of real lived-in spaces. And here the French philosopher Henri Lefebvre's now celebrated notion of 'representational space' is useful.[61] Lefebvre proposed that the functions and meanings of a physical space are inscribed upon it, allowing them to 'be decoded and read', and that his three categories of space – physical, mental and social – are more unified than others had previously implied. The tendency in recent studies has been to over-secularize the Quattrocento domestic interior. Clearly the *camera* interior could declare all sorts of simultaneous, nuanced and overlapping meanings, secular and religious. But the particular role of pictures in fixing memory suggests that, when recognizable domestic objects are depicted within a sacred context, paintings of this kind may have had a key role in forging a desirable unity between mental, social and physical spaces. By this means, therefore, the real *camera* in an actual palace could be reinvented – remembered and occupied – as a central pious space within the mercantile house. The *camera* was suggested as the place for secluded, religious, visualizing contemplation, especially for women,[62] and paintings can be seen to reinforce this idea, acting as connective gateways between imagined or 'remembered' spaces – indeed those imagined for remembering – and real social and physical spaces. The *camera* could thus become a combination of real bridal chamber and the Virgin's *thalamus*, the devout space of the pious (but spiritually anxious) merchant and his wife.

This might all seem arcane or over-imaginative, and certainly the argument requires more empirical support. It should first be pointed out that marriage

was famously the moment when the *masserizia* for the bridal *camera* was commissioned, usually by the groom or his father.[63] Notoriously, the bed was the most important – in terms of expense – of these furnishings. And, by their representation in paintings of the Virgin and her *thalamus*, and by the urged identification of the bride with the Virgin, even real objects could therefore be seen as both actual and devotionally meaningful. This is demonstrated not least by the fact that inventories of bedroom furnishings are almost always headed by an image of the Virgin (and Child).[64] It can be demonstrated through numerous documented instances that there was a direct connection between marriage and the buying or commissioning of devotional art.[65] Thus the Virgin herself was actually present in the *camera*, acting as a focus for devotional ritual, emphasizing the sense of the room as a devotional space, and requiring certain forms of decorous behaviour. San Bernardino even condemned women who allowed their devotional images to see them in their homes while wearing inappropriate clothing and applying cosmetics.[66]

And the contents of the real room could be transformed into *imagines* for a physical memory *locus* of devotion to the Virgin, prompts in themselves for contemplation. A passage in one of San Bernardino's sermons might be recalled, an allegorized description of marriage boxes that women were supposed to remember and apply: 'that little box that you, women, have with you when you go to marry: that small one … in which you hold inside your ring, pearls, jewels and other similar things'.[67] Each of the contents was rendered symbolic: the ring represented Faith and so on. In a similar way the symbolic associations of objects in 'painted sermons' might be carried over to inform the meaning of such objects in life. Here, then, is another reason why their accuracy of depiction might be so crucial. By these means the goods themselves, the assets of the merchant and his family that could so easily be condemned for their material expense were rendered pious. It is certain, for example, that candles, whose spiritual significance has already been suggested, were used in this way; to cite just one example, we know that after Lena, wife of Giovanni Boninsegni, was delivered of a daughter in 1471, her husband purchased wax to illuminate the image of the Virgin.[68]

That material artefacts might have functioned in this way is confirmed by the religious imagery or inscriptions not infrequently to be found on extant domestic objects made across Italy. Not all of these are Florentine, though some are of kinds that were imported into the city. No surviving piece has a provenance of any length, and thus it is possible that some at least were made for ecclesiastical or monastic contexts. However, while it is true that the substantial majority of vessels and other domestic objects of this period are decorated with various systems of ornament (which does not, of course, obviate their potential as devotional prompts), and while secular figurative designs probably outnumber religious ones, the latter seem to have been produced in such quantities as to allow us to suppose that some at least were used by patrician and mercantile households. This is not the place for a complete survey and here it will be enough to demonstrate that religious mottoes and designs were applied to a range of products.

Hispano-Moresque lustreware was exported across Europe and was highly prized in Florence and elsewhere in Italy, where its presence is confirmed by archaeological finds and where pieces, as we have seen, were represented by Filippino and others. Dishes with San Bernardino's deliberately memorable monogram of the name of Jesus, 'IHS', or encircled by the Ave Maria, appear to have been popular.[69] The IHS monogram also appears on plates and dishes produced in Pesaro in the second half of the Quattrocento, while Ave Maria is inscribed upon at least one jug from the same area,[70] this last perhaps especially revealing of an attitude of mind to these objects given the association between the Virgin and such vessels and in the light of the pitcher associated with the Annunciation in the apocryphal *Protevangelium of James*. Other more modest jugs made in Orvieto have a crowned 'M', perhaps for the Virgin as Queen. In medieval Venice clear glass beakers were manufactured that literally embodied the link between transparent glass and the Virgin Mary. One such piece in the V&A, which has the remains of another Ave Maria inscription (the glass now shattered and repaired), was manufactured in Venice in the early fourteenth century and evidently exported to England – and we can imagine that such objects were also exported from Venice to other parts of the

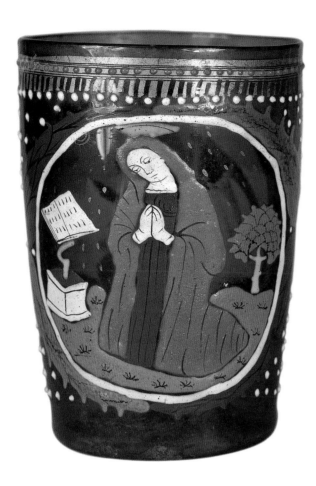

6.10 Beaker with roundels depicting the Annunciation, enamelled and gilded glass, Venice, late 15th century (Musée Jacquemart André, Paris, MJAP-OA 934)

Italian peninsula.[71] Another, with a more complete inscription, is dated to the late thirteenth century.[72] Such pieces were updated in the fifteenth century: a remarkable historiated beaker survives at the Musée Jacquemart André, Paris, on which the images of Gabriel and the Annunciate Virgin were painted on clear glass roundels (plate 6.10). That an otherwise transparent lamp-glass with the Annunciate also still exists suggests that such decoration may not have been unusual (and this choice of motif, once again, given the manifold devotional meanings of light discussed above, seems unlikely to have been arbitrary).[73] It may even be possible that paintings of the Virgin or the Annunciation were painted on bed-heads.[74]

These objects were, therefore, quite explicitly intended to remind their users of the Christian resonances associated with them, to act as prompts to pious thought as they were encountered during the business of daily life. Paintings, which included familiar domestic objects, assisted the maintenance or at least re-envisaging of environments that otherwise might become worryingly worldly as devotional. For these pictures to function effectively the domestic items 'portrayed' within them had to be recognizably the same as those that could be found in the home. This is not an invitation to take everything we see in paintings at face value. We need to think carefully about why each object has been included, assessing both their (potential) spiritual and their social meanings. But when an item – like the bed – is one that so obviously creates a connection between mental and physical spaces, then it is likely that we can, just as Peter Thornton claimed, analyse their representations to trace their history and development.

Cristoforo Bertelli,
The Steps of a Man's Life
(La scala della vita dell'uomo),
Venice, *c.*1580
(cat.139)

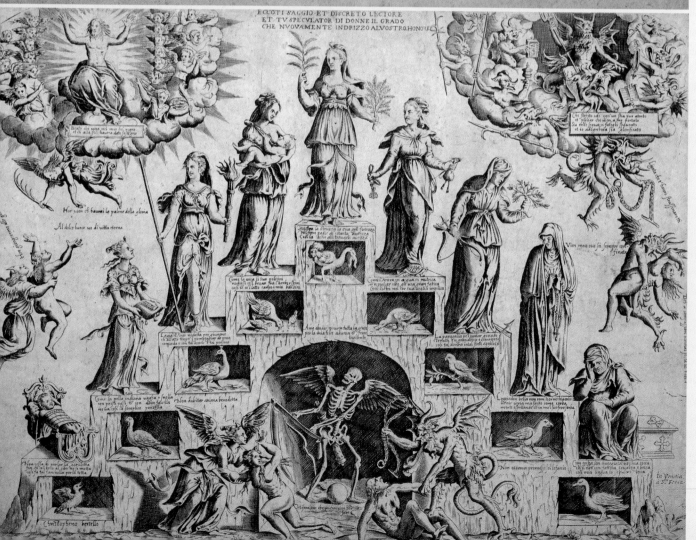

Cristoforo Bertelli,
The Steps of a Woman's Life
(La scala della vita della donna),
Venice, *c.*1580
(cat.140)

LIVING IN THE *CASA*

MARRIAGE AND SEXUALITY

SARA F. MATTHEWS-GRIECO

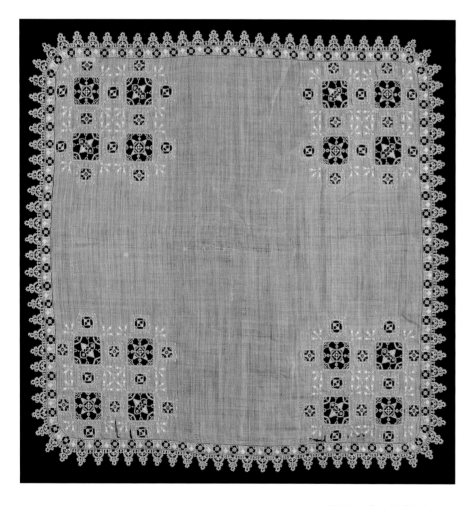

7.1 Handkerchief, Italy, c.1600 (cat.145)

IN RENAISSANCE ITALY betrothal and marriage were legitimized less by written documents than by eyewitness testimony of the rituals that accompanied the nuptial process and by the continued presence, in the household, of objects exchanged during the various steps of this process. At all levels of the social ladder, betrothal and marriage entailed a series of symbolic items exchanged as gifts and, in the more affluent classes, a variety of domestic paraphernalia commissioned to commemorate a union between two individuals and the lineage they came from. Such objects were fraught with meaning with regard to the social purpose of marriage and the reproductive sexuality that it sought to encourage.[1]

The offering and acceptance of such gifts and commemorative objects were considered integral parts of the marriage process, to the extent that they could be used as evidence in legal disputes. Marriage litigation called upon the testimony of family, friends and neighbours, as well as on the presentation of any material or written evidence the opposing parties might possess. In mid-fifteenth century Florence the accusation of bigamy brought against the newly-wed Giovanni della Casa by Lusanna Nucci, his mistress of twelve years and self-declared wife, was harmed as much by the absence of a wedding ring as by the fact that Lusanna had never born a child.[2] Over and above the fundamental importance of the ring in the ritual consecration of a new union (even in clandestine nuptials), Lusanna's sterility was considered a consequence of a lustful – and thus illegitimate – relationship. Excessive lust was believed to be inimical to conception. Even medical authority asserted that the heat of passion rendered prostitutes barren, while properly married couples were expected to engage in the more temperate and decorous techniques, considered appropriate to conjugal concourse and theoretically guaranteed to result in numerous offspring.[3] In the context of marriage litigation, Lusanna Nucci's barrenness thus weighed heavily against her claim to the status of a wife.

COURTING TOKENS, BETROTHAL PRESENTS AND NUPTIAL GIFTS

The criteria governing the choice of a marriage partner varied largely between social classes and between rural and urban areas. Peasants, labourers and lower artisans tended to get married in their mid or late twenties to women of the same social and professional groups who were just a few years younger, and both men and women tended to enjoy a certain degree of freedom of choice in the search for a suitable mate. In the propertied classes, where family strategies demanded the submission of the young to the greater good of the extended kinship, marriage candidates for sons and daughters were chosen by parents or legal guardians, often with the help of a marriage broker, and courtship consisted of a series of ritual exchanges witnessed by relatives and friends.

Among the labouring classes, lower artisans and peasantry, considerations of physical attractiveness were secondary to a number of prerequisites that conditioned courtship. Good health, physical strength and a willingness to work were often more important than good looks or the size of the woman's dowry. Often a meagre affair, the dowry could be restricted to a few articles of clothing, some bed linens, a couple of measures of grain and a cooking pot or two. The main asset looked for in a spouse was that of a reliable working partner, whose industry would ensure the survival of the household. It is for this reason that, at the more modest social levels where there was little or no property, a certain amount of courtship was permitted among the young in order to ensure the compatibility considered necessary for a stable household. Aspiring suitors might first encounter prospective partners when attending church, during religious processions and festivities, in the course of collective agricultural tasks such as the grain harvest, at local markets and fairs and, above all, during evening gatherings of neighbours known as *veglie*, where youths were admitted to participate in the tale-telling and dancing that characterized such assemblies.

In the process of courtship, small, symbolic gifts were exchanged between aspiring couples, who often marked their first, tentative steps towards betrothal via the offering and acceptance of any of a number of objects – ribbons, gloves, handkerchiefs (plate 7.1), rings, coins and locks of hair – all of which were invested, by custom, with particular meaning in this context. Should the courtship be terminated by either partner or by parental interference, the gifts were to be returned. There remained, however, a certain grey area between the process of courting and the act of betrothal. The acceptance of a courting token could be considered as binding as the given word, and the formal gestures of betrothal could often be considered the equivalent of marriage, thus permitting the consummation of the relationship even though co-habitation would be postponed until after public nuptial festivities. It was not until the Council of Trent decreed a standard procedure for marriage, known as the *Tametsi* decree (1563), that there was any attempt to regulate the potential confusion in traditional marriage practice. The *Tametsi* made a clear distinction between betrothal (where vows were to be pronounced in the future tense) and marriage (where vows were spoken in the present tense). The *Tametsi* decree also imposed the presence of an officiating priest, the reading of bans and obligatory witnesses. Custom was, however, to continue to co-exist with ecclesiastical legislation in the rituals associated with betrothal and marriage well into the eighteenth century, especially in more rural areas.[4]

In Bologna in 1549 a court case to dissolve a promise of marriage, made (under parental pressure) by Maria da Reggio to the market gardener Andrea Lappi, shows the importance of courting gifts and betrothal presents in the traditional marriage process. The local baker, tailor, cousin and family friends who testified in Maria's favour pointed out that on a feast day she had refused to wear to church the ornaments Andrea had given her as gifts: a coral necklace, a white bonnet interwoven with gold thread, and a black velvet belt studded with silver. A servant of the household also declared that her father had struck her as a consequence of her refusal to wear these items; such accessories were important to family honour insofar as they would have confirmed her betrothed status to the neighbourhood at large. When her brother had asked her for an explanation, she petulantly answered that she did not wish to wear them, and when further pressed, she made her point more explicitly, 'Because I don't want Andrea!'[5]

Among the labouring classes, pre-nuptial and nuptial gifts tended to be fairly utilitarian and were destined to be used regularly by their recipients. In the Tuscan countryside, where poverty meant that farmers donned shoes (as opposed to going barefoot or wearing clogs) only for going to Mass, for special festivities and holidays, a gift of a pair of shoes was considered a highly significant and binding gesture between a young man and his intended. Such presents necessitated a serious cash outlay, which incited many a young *contadino* (peasant) to pilfer from their employer. In a treatise on Christian behaviour, the seventeenth-century Jesuit Paolo Segneri chided his hypothetical flock on the sin of theft: 'How many times, in order to buy a sweetheart tassels, ribbons and shoes, one steals, in youth, part of the harvest on the farm?'[6] In the second half of the sixteenth century, when the use of the pocket handkerchief (*pezuola* or *pezzola*) had spread from the city into the countryside, a standard gesture of acceptance on the part of the young lady was the return gift of an embroidered handkerchief. This custom was to be found across central and northern Italy: in the Friuli and in Venice, in Pisa and Florence (plate 7.1).[7]

Once parental consent had been given, formal betrothal would take place in the house of the bride, where the couple would share a meal at the same table together with the family, drink out of the same vessel, and exchange vows and a kiss, accompanied by a ritual handclasp and the present of a ring to the young lady. The presence of family, relatives and friends at this event ensured its legitimacy, and the betrothal would henceforth be considered binding, to be further consecrated only by more public festivities: the wedding feast and procession though the village or neighbourhood to transfer the new bride to her husband's home.[8] Formal betrothal gave the new couple a certain degree of sexual licence, and gave men certain rights with respect to their intended. Court cases for broken promise of marriage reveal the common presumption that kissing and mutual fondling, in front of the family and even in public, were considered entirely acceptable, a coded behaviour announcing a new conjugal relationship to the community. In Pisa in 1568 a parish priest testified in favour of a jilted girl by the name of Dinora, asserting that the unfaithful swain, Nando, had repeatedly enjoyed sexual familiarities

with her in her father's house, as was customary (*come s'usa*) after formal betrothal. Nando came often to visit Dinora at home, where he would kiss and caress her, and on one occasion, at table in front of the family, he took out his member and put it in Dinora's hand.[9] In some areas of the peninsula it was considered not only inevitable, but even desirable, that the promised couple should indulge in full sexual relations in the period between formal betrothal and public nuptials. The birth of children less than eight months after nuptials is understood by demographers to indicate that the bride was already pregnant at the time of the public wedding. Bridal pregnancy was to be found throughout the peninsula, averaging between 5 and 20 per cent according to social class and rural or urban context. In some regions, such as Piedmont, pre-marital relations and conception were considered quasi-obligatory – a kind of fertility testing – before the marriage was finalized.[10] In many rural areas a couple's ability to have children was a stark necessity for the equilibrium of the household: when each member was assigned a task specific to his or her age and gender, the absence of a category of worker (such as a child to herd goats) could jeopardize the survival of an entire family.

In the propertied classes family strategies allowed the young less leeway in choice of marriage partner. Marriage was a serious business in which the inclination of a son or daughter weighed but little in the face of the political and economic interests represented by the merging of two kinship networks. Women tended to be married young, in their mid- to late teens, while men were expected to establish themselves in business before settling down to start a family. This made them easily ten to fifteen years older than their intended bride, and veterans of a variety of pre-conjugal sexual adventures: affairs with domestic servants, kept mistresses, concubines or prostitutes. Although sons and daughters were nominally consulted in the process of selecting a spouse, they were nonetheless presented with candidates pre-selected by their elders and betters, with the aid of family friends and relations. The steps in the process towards marriage were numerous and entailed a considerable amount of ritual exchanges and festivities, all accompanied by gifts and a series of commemorative objects required by custom.

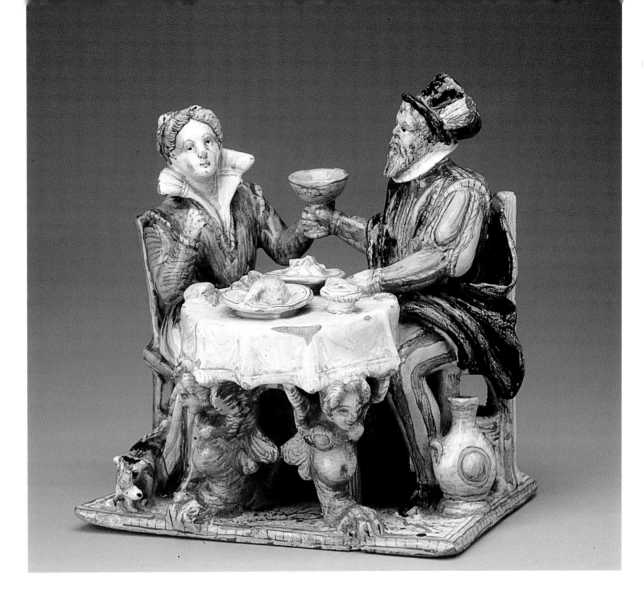

7.2 Fontana workshops, sculptural group which constituted the top of an inkstand, Urbino, 1575–1600 (cat.142)

Those who made up the propertied classes of Renaissance Italy were the well-to-do artisans, merchants, notaries, lawyers, doctors and bankers whose domestic paraphernalia have occasionally survived the depredations of time and the disdain of their descendants. This heterogeneous social category nonetheless shared a common approach towards marriage as being an affair to be handled as carefully as any important business arrangement. As fifteenth- and sixteenth-century authors of treatises on marriage and the family never tired of pointing out, the precautions to be taken in the choice of a wife should be as painstaking as those applied to the acquisition of any new piece of property.[11] Once the parents or guardians of a young person had settled on a likely candidate, and initial negotiations with the other family had resulted in a preliminary agreement about dowry and other details, the respective heads of family would meet in a neutral place, such as a church, in the presence of a notary and a select group of male friends and relations on both sides.

This was a relatively private moment in which a *scritta*, or written contract, was signed by the heads of both families, accompanied by a ritual gesture that was as binding as any written document: a handclasp (known as the *impalmamento* or *toccamano*) and sometimes a kiss (*bacio*) between the two fathers.[12]

It is possible that some of the sixteenth-century maiolica inkwells that have survived were commissioned as commemorative objects to be used at this particular event. These small polychrome sculptures represent a variety of devotional or classicising themes commonly found on marriage paraphernalia, such as the Nativity or the Judgement of Paris.[13] A particularly interesting example of such an inkwell depicts an elegantly dressed couple sharing a sumptuous meal, holding aloft a shared goblet (plate 7.2). As drinking from the same vessel was one of the standard rituals of betrothal, these figures might have represented the future bride and groom, absent players in the *scritta* stage of the nuptial drama. The commemorative function of such objects is occasionally

emphasized by inscriptions, specific dates or coats of arms. A more conventional inkstand from Faenza (*c.*1500) features images of a couple facing each other, a representation of clasped hands between them, and the inscription: 'IO.TE.DO.LA.MANE / DAME.LA.FEDE' ('I give you my hand, give me the ring' – betrothal and wedding rings take their name from the Italian word *fede*: faith).[14] Whenever such commemorative inkwells may have been brought into use, the *scritta* stage of marriage procedures was the only moment at which a written document was drawn up. Also known as the *giuramento* or *sponsalia*, the signing of a marriage contract by the legal representatives of the two future spouses, in the presence of a notary, constituted a kind of formal betrothal, even though the young people in question may not as yet have ever met. Once the process was set into motion, as much as a year could pass until the wedding actually took place and the bride was transferred to her new home.

The next series of steps towards marriage entailed not only an increasing number of events and a larger public, but also a crescendo of ritual gestures and gifts. The ball was in the court of the young man, who would now delegate one of his male relatives or friends to bring to his intended a small box, called a *coffanetto* or *forzierino*, filled with jewels and other presents (plate 7.3). Made of precious materials and elaborately decorated, the *coffanetto* often bore representations of well-known classical or biblical scenes – Diana and Acteon, the Judgement of Paris, Susanna and the Elders, the Judgement of Solomon – all of which paid homage to the power of love and the strength of female virtue.[15] Inside might be any of a number of objects traditionally given to the future bride: a brooch set with precious stones, a jewelled pendant, a gold chain, a silk girdle studded with silver (plate 7.4), an ivory needle-case. Many of these gifts would be inscribed with the initials of the new couple, with their family coats of arms or with amorous mottos (plates 7.5 and 7.9). Some of the earliest portraits of young women depict them adorned by such jewels or surrounded by objects that were most probably betrothal gifts. Doubtless commissioned to commemorate this critical moment in their life and in that of their family, the portraits of young brides wearing such finery constitute a visual record of marital status, as well as a memory trigger in terms of subsequent generations and the recycling of jewels among descendants.[16] Filippo Lippi's

7.3 Pastiglia box with scenes from Roman history, Ferrara or Venice, 1500–1550 (cat.153)

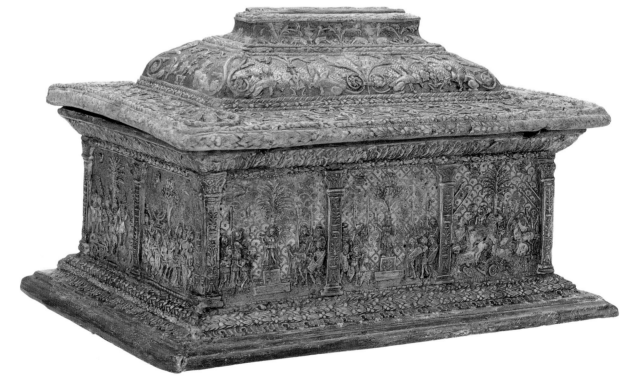

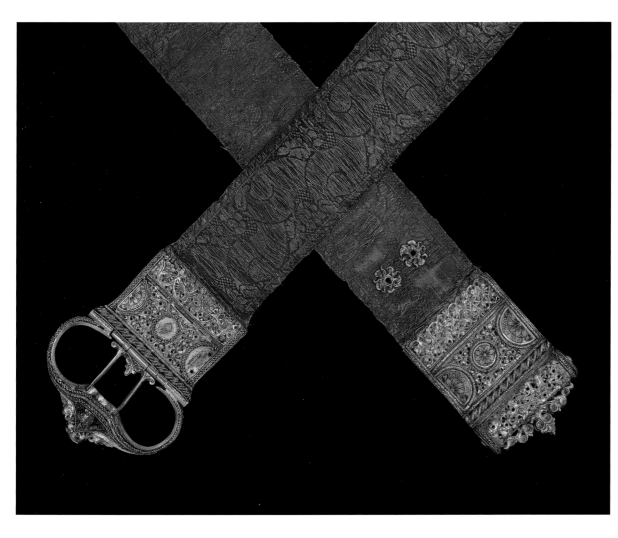

7.4 Girdle, Italy, 15th century (cat.155) With its original cloth of gold, this girdle measures 158.7 cm and would have been worn around the waist with one end hanging down.

7.5 Necklace, Italy, c.1540 (cat.154) This necklace carries an amorous inscription: 'Ubi Amor Ibi Fides' (Where there is Love, there is also Fidelity).

portrait of a couple from the Scolari family (see plate 6.8), for example, depicts the husband looking at his new wife through a casement: her wedding jewellery (head brooch, shoulder brooch and double gold chain necklace) defines their new marital relationship. Sumptuary laws sought to regulate the ostentatious consumption that regularly escalated in the exchange of nuptial gifts, as well as in the festivities that accompanied the marriage process, but surviving objects indicate that legislation tended to be blithely ignored when it came to honouring such an important event.

Other items, which might not fit into the *coffanetto*, could be delivered by hand on this or future occasions. Devotional literature, such as *Orations to the Virgin Mary* or a Book of Hours (see plate 11.18) – richly bound and even studded with precious stones – was another typical gift, as were any number of finger rings, with or without stones. Gold or silver bands, featuring clasped hands (known as *fede* rings, plate 7.6), or hearts or cupids, were particularly associated with such events, while coral, pearls and other precious stones (sapphires, rubies, emeralds

7.7 Ring, northern Italy,
early 15th century
(cat.148)

and diamonds) were considered to have particular
powers: medical and moral properties beneficial to
conjugal life. Sapphires were believed to encourage
marital chastity, bring about peace and stimulate
piety. Rubies were believed to promote health, dispel
bad thoughts, reconcile discord and combat lust.
Blue sapphires and red rubies were often associated
in wedding rings, perhaps for the further symbolic
associations of these stones, as explained by the
Roman patrician Marco Antonio Altieri in a dia-
logue entitled *Li nuptiali* (1506-29):

> the sapphire is sky blue in colour, and denotes our
> soul, which derives from it [the sky, meaning
> heaven]; and then the balas [ruby], made of fiery
> matter, denotes the body, receptacle of the heart,
> burning with amorous flame, and for this reason
> [this type of ring] represents the gift of both the
> soul and the heart.[17]

Emeralds were equally frequent in nuptial jewellery,
as they were supposed to incline the wearer towards
chastity, increase wealth and strengthen eyesight. The
adamas, or diamond, known as the 'stone of reconcil
iation', was attributed the power to ensure conjugal
fidelity, as well as to maintain physical and emotional
concord between man and wife. Coral, believed to
be a sea plant that turned into stone when it met the
air, was attributed powers to ward off evil, to prevent
excessive bleeding and to increase fruit production

when powdered and sprinkled on plants – whence
its frequent use in jewellery and talismans, especially
for women and children. Pearls were also considered
to be a type of stone whose colour was associated
with purity, virginity and marital chastity[18] and
whose opalescent sheen was compared to the
fair complexion that determined female beauty.
Precious stones were often associated with inscrip-
tions on betrothal and marriage rings, such as the
diamond flanked by the words 'Lorenzo /a.
Lena.Lena', which indicates the identity of the
couple united by this band (plate 7.7). Also found on
these items are amorous mottos such as 'AMORE
VOL FE, DVLCE DONVM FIDES' (Love wants faith,
faith is a sweet gift) or more specific declarations –
'P.N. SOLA F.A. AMA' (P.N. only F.A. loves) – which
served to contextualize the meaning of the object as
a betrothal or wedding gift and perpetuate the
memory of its purpose.[19]

Finger rings play the role of protagonist in the
next of the many ritual festivities leading up to
nuptials. The *annellamento*, or ring ceremony, took
place in the bride's home, where her promised hus-
band placed a ring on the fourth finger of her right
or left hand (a finger believed to be directly con-
nected by a vein to the heart). The new bride would
subsequently receive a number of additional gifts and
rings from various members of her husband's house-
hold, both men and women. The detailed memoir
left by Francesco di Giuliano di Averardo de' Medici
(1415-*c*.1441), grandson of the influential merchant
banker Cosimo de' Medici, contains a description
of the salient public and festive moments of his
marriage, as well as a long list of the rings and other
gifts given to his bride. This memoir shows the
importance of keeping track of who gave what ring
(and its value), as most of these rings were to be
re-circulated on similar occasions, thus cementing
the networks of kin, friends and allies by the ritual
exchange of gifts.[20] The 'ring day' included a variety
of entertainments over and above the ceremony
of the *annellamento*. In families whose social rank
demanded a public display of wealth and status,
every step in the marriage process entailed days and
nights of music, feasting and dancing, which served
to announce the new union to the neighbourhood
at large, the respective households of bride and
groom alternately hosting the festivities (plate 7.8).

7.6 *Fede* ring, Italy,
15th century
(cat.147)

7.8 Stratonice Master, *Story of
Antiochus and Stratonice*, two *cassone*
panels, Florence, 15th century
(The Huntington Art Collections,
San Marino)
The lower panel shows the moment
of the *annellamento*.

7.9 Embroidered cover
with amorous inscriptions,
Lombardy or Piedmont,
1450–1500
(cat.146)

THE TROUSSEAU, NUPTIAL ACCESSORIES AND BRIDAL PARAPHERNALIA

Family and community memory of such important rites of passage was fixed by oral tradition, by notarial contracts regarding dowry, and by entries in family memoirs (*ricordanze*). At the same time, they were perpetuated by objects – nuptial gifts and commemorative items – whose continued presence in the household acted as an ongoing testimony to the validity of a union, and preserved genealogical memory over many generations. Thus one of the reasons for the often lengthy period between the signing of the marriage contract and nuptials was the time needed for both families to commission furniture, clothing and commemorative items for the new couple, as well as organize series of banquets and other entertainments.

Although most well-to-do households would have been putting aside linens and textiles in anticipation of such an occasion, the tailoring of clothing and embroidering of personal and household linens would often include, over and above the usual motifs of hearts, putti and amorous mottos, the names of the new spouses or their coats of arms (plate 7.9). In fifteenth-century Florence, at the moment of the *domumductio*, when the new bride was transferred between her father's and her husband's home mounted on a white horse, she would be escorted by a group of elegant young men who would joust in the street as they cleared the way for the nuptial procession. It is at this moment that certain items in the bride's trousseau (*corredo*) would be exposed to the public gaze, especially the large marriage chests commissioned for the conjugal chamber and carved or painted with appropriate iconography and the two families' coats of arms.[21] Other, equally luxurious articles might also be displayed at this time: robes in precious materials, silver or gilt tableware and embroidered household linens were often carried through the streets, held up to impress onlookers with the wealth and importance of the bride's family. In Udine, the evening before nuptials were to be celebrated, the bride's personal trousseau – dresses and jewels, personal linen and household textiles – were put on view in her father's house for neighbours and relatives to admire before being packed into several chests and carted off to the bride's new abode.[22]

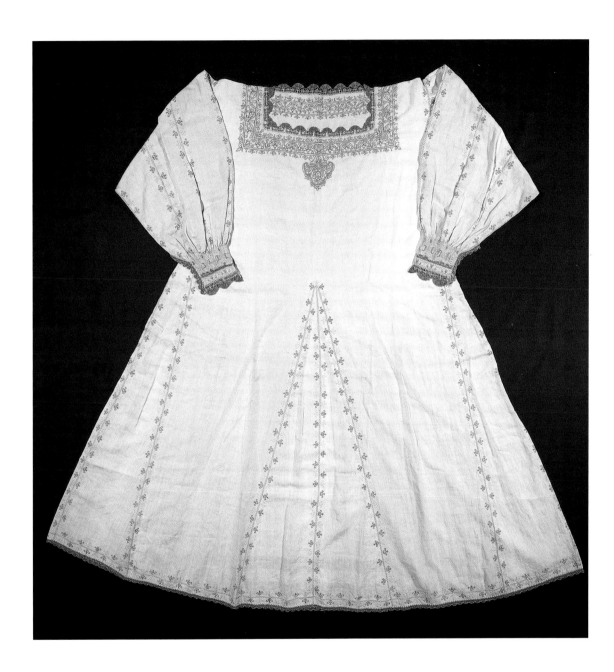

7.10 Embroidered woman's
shirt with lacework, Italy,
1550–1600
(cat.157)

Intimate items not necessarily put on public view were nonetheless conscientiously listed in the inventory of material goods that made up the dowry. In 1517 the trousseau of Giulia da Ponte Spilimbergo, daughter of a Venetian patrician, included the latest in fashionable female lingerie: white silk bloomers (*calzoni*).[23] While women of elevated social rank might bring with them as many as fifty or sixty *camicie* (undershirts; plate 7.10) – all embroidered in coloured silk, silver or gold, with tassels or bordered in lace – women of less elevated social rank also demonstrated that the new fashion for white blouses and body

linen had been quick to penetrate even the most humble social circles. In 1515 the dowry of a tavern keeper (*ostessa*) boasted sixteen undershirts, and in 1520 the daughter of a mere carter had as many as fifteen. Large embroidered kerchiefs were an equally important accessory and were often woven in silk or other precious materials to be worn around the neck or tucked into the bodice. In 1567 Aurora d'Arcano brought no less than sixty-eight *fazzoletti* (kerchiefs) with her when she transferred to her new husband's home, while in 1571 her sister Riccarda d'Arcano had six gold-cloth *fazzoletti* in her trousseau.[24]

7.11 (*opposite*) Shoes
(*pianelle*), probably Venice,
late 16th century
(cat.184)

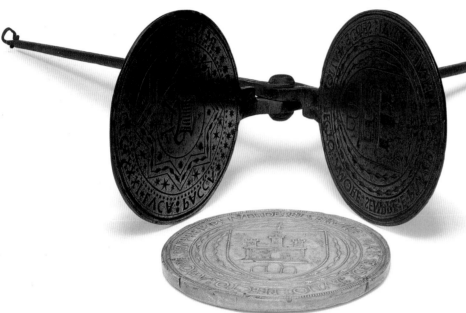

7.12 Wafering irons,
Umbria, 1481 (cat.150)
These utensils were used to
make wafers or waffles (*cialde*
or *cialdoni*) at weddings,
baptisms and other festivals.
After they had been greased
and heated, batter was
poured onto the plates
which were then pressed
together, creating wafers
decorated in relief. The
inscription on these irons
suggests that they were made
for the wedding of Lorenzo
and Lucia Pacca in 1481.

Other items commissioned specifically for nuptials were household linens: towels, pillowcases, sheets and tablecloths. Inventories distinguish between articles that were embroidered (*lavorati*) and those that were plain (*schietto*, usually destined to be used by servants). Clothing articles included not only body linen and fine dresses but also furs, diaphanous veils worked with pearls and gold thread, jewellery, gloves (common as of the mid-sixteenth century) and platform shoes (*zoccoli, pianelle* or *calcagnetti*). Whereas footwear worn inside the house was often made of velvet or embroidered cloth with a cloth sole (plate 7.11), the sorry state of most urban streets and public thoroughfares made it imperative for women to wear high shoes outside the home. In Venice the *calcagnetti* used by sixteenth-century women of fashion became vertiginously high, necessitating an escort to maintain one's balance, while the more humble womenfolk of merchant and artisan households also took care to preserve their skirts with similar, if less elevated, footwear. In 1542 a *popolana* (woman of low birth) had in her trousseau three pairs of *zoccoli* made of leather and one of velvet.[25]

Betrothals and weddings were occasions when generosity and ostentatious consumption were considered obligatory, conferring honour on the families concerned (plate 7.12). Banquets were often held outside in gardens, courtyards and loggias, where the space would be decorated with fine textiles and carpets, paintings and *credenze*, on which were displayed valuable plates and serving vessels. A large amount of possibly commemorative tableware – such as maiolica plates, bowls, jugs and glass goblets – have survived. Although their function is not clear, it is possible that some of these objects were used as betrothal gifts or during nuptial festivities, and that they supported the preservation of the memory of such events. In the fifteenth and sixteenth centuries Faenza and Deruta turned out vast amounts of ceramic tableware with amorous motifs, while Murano predictably specialized in glassware. The most common motifs were profile portraits of men or women, and couples looking into each other's eyes (mutual gazing was an amorous theme),[26] often accompanied by dates, initials, names or inscriptions such as *Amore* (Love), *Fede* (Faith) or *Bello/Bella* (Handsome/Beautiful). Other common iconographic signs associated with love and marriage were hearts (surmounted by flames, pierced with an arrow, placed on an anvil or fitted with wings), cupids or wingless putti, joined hands (the handclasp, or *dextrarum junctio*, see plate 7.13) and rabbits (a symbol of fertility). The vastly different quality of this production suggests its use at all social levels in the later fifteenth and sixteenth centuries. Some of the plates and jugs are crudely executed, with few colours and extremely stylized profile busts, and the inscriptions (*amore, bella*) are ubiquitous, all of which suggests a ready-made production available for a lower-end consumer.

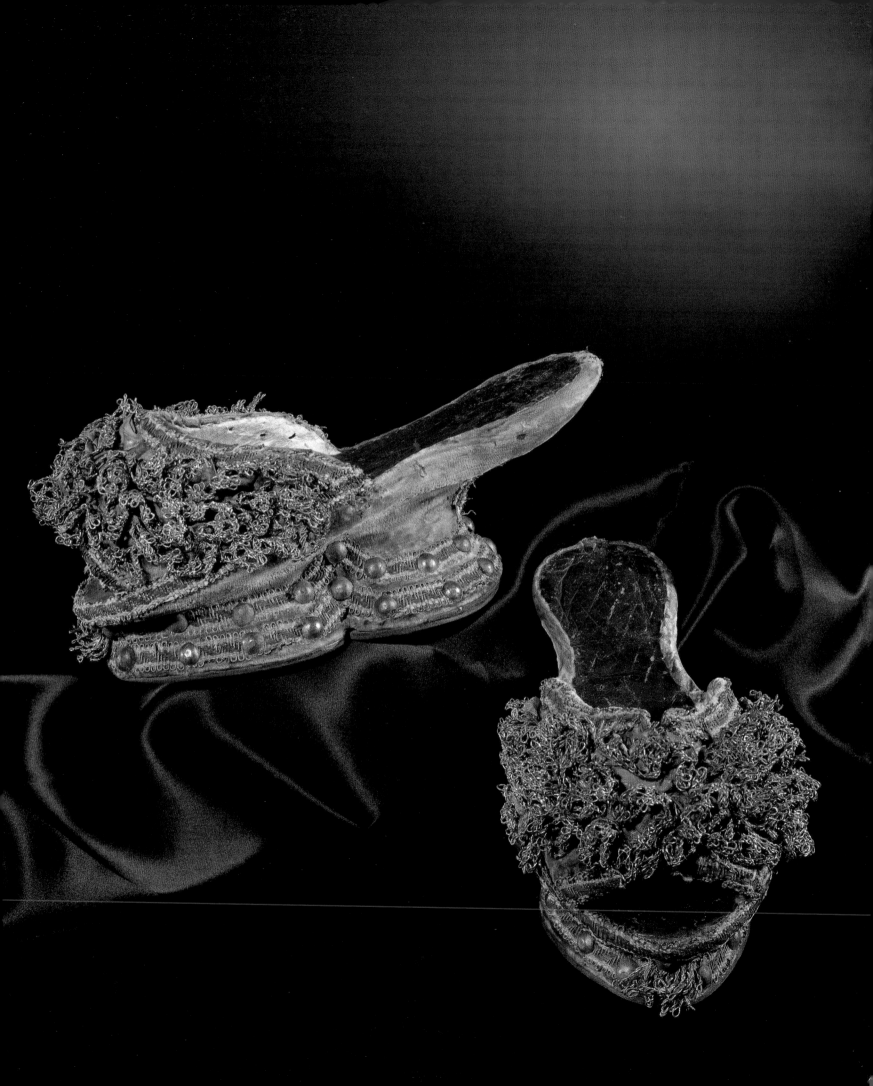

7.14 Attr. workshop of Giacomo Mancini, dish on a low foot, Deruta, mid-16th century (cat.144)

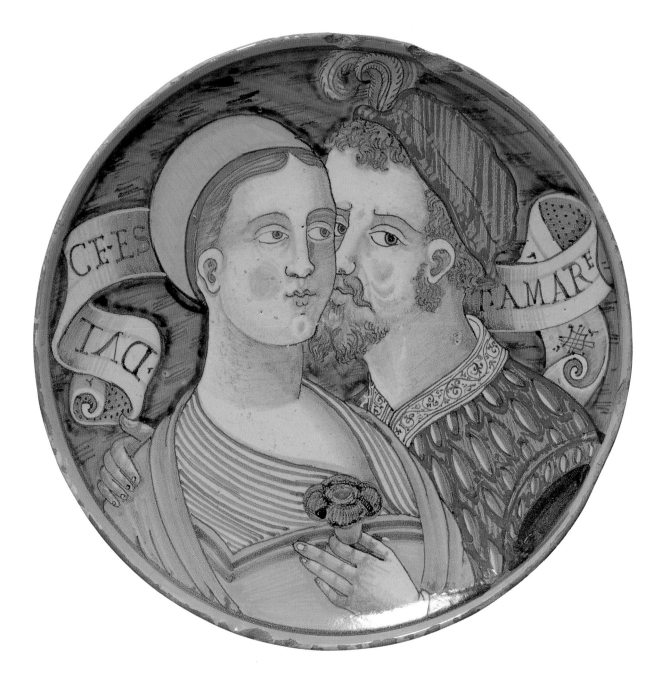

Other ceramic items are much more carefully carried out, with better quality painting and specific names or dates, such as the quasi-portrait busts that appear on some Faenza ware: a jug dated 1499, for instance, features a bust of a woman in profile with an arrow piercing her breast and the inscription 'AMORE', while an early sixteenth-century plate has an elegant female portrait and the words 'IVLIA B[ELLA]'.[27] More ribald iconography was not infrequent, such as the couple depicted on a mid-sixteenth-century maiolica plate (plate 7.14), which

bears the Latin inscription: 'DVLCE EST AMARE' (Loving is sweet). Here a bearded man is represented embracing a young woman, his hand explicitly placed on her bodice. This type of plate is relatively common and constitutes a visual evocation of the types of amorous dalliance expected of betrothed couples, and an acknowledgement of the physical intimacy that the new couple was expected to share. Matching borders on plates and other vessels with amorous motifs suggest that sets were made to order, while account books from noble and patrician

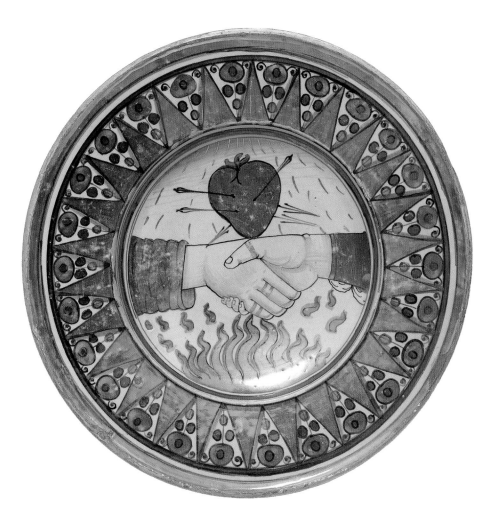

A few, rare woodcuts and paintings illustrate the moment when the reluctant bride was abandoned by her female friends and relatives in the nuptial chamber, while other sources give titbits of information on this momentous rite of passage in a woman's life.[30] Household recipe books also abound in advice with respect to the propitious and nourishing foods to be served to the new bride on her first morning as a married woman – above all, eggs for fertility and sweetmeats to augur sweet love between the new

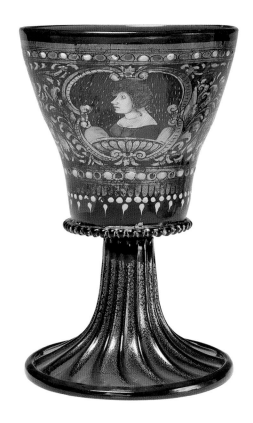

7.13 (*above*) Dish with amorous symbols, Italy (probably Gubbio), 1500–1510 (cat.149) The joining of hands, as shown on this dish, was a crucial moment in the marriage ritual.

7.15 (*right*) Goblet with double portrait, Venice, 1475–1500 (cat.143)

households confirm the manufacture of several hundred pieces for specific wedding feasts.[28] Individual items, such as glass goblets from Venice featuring portraits of the bride and groom, along with pairs of putti or other traditional motifs, were probably used for the moment in the nuptial ritual when the new couple drank out of the same vessel, a symbolic gesture signifying the fact that, as a married couple, they were to share the same table and same roof (plate 7.15).[29]

According to the social class to which a couple belonged, the consummation of the marriage could take place immediately after formal betrothal and the exchange of promises, or after the ring ceremony, or after the wedding feast. Although consummation did not always coincide with the onset of cohabitation, in the more affluent social circles it generally followed the transfer of the bride, with part if not all of her dowry, to her new husband's residence. More is known about the public ceremonies and festivities surrounding marriage than the more private moments, when many newly-weds found themselves sharing the same bed for the first time.

couple. These were meant to restore the balance of her bodily humours after the trials of the night before and set the tone for her future relations with her new husband. On the night of 30 September/ 1 October 1506 the young Venetian patricians Giustina Zaccaria and Lodovico Bianco consummated their union. At daybreak the best man offered the bride a rather luxurious restorative breakfast and a number of gifts: 'sweetmeats of sugar and pine nuts surrounded by gold, hens' eggs, a nymph moulded in sugar with a flag, a small oblong silver basket, skilfully made, a needle case, likewise of silver, filled with needles from Damascus, and silver tongs and a thimble covered in fine filigree work' (plate 7.16).[31]

7.16 199 pins and 1 needle, northern Italy, 1500–1550 (cats 156 and 209) Pins and needles were commonly found in brides' trousseaus.

At this moment the husband was expected to shower his bride with yet more nuptial finery: embroidered sleeves, gauzy veils, fine jewels and expensive dresses, which wcrc to be worn as an outward and visible sign of the woman's new marital status and the esteem in which her new husband held her. In a letter to her son Filippo, Alessandra Macinghi Strozzi comments with pride on the fact that her new son-in-law, Marco Parenti, dressed his new bride in clothes and jewels worth a small fortune. Parenti went well beyond what was normally expected in equipping Caterina Strozzi with fine and expensive clothing, both after their formal betrothal and in preparation for her appearance as a fully fledged wife:

When she was betrothed he [Marco] ordered a gown of crimson silk velvet for her and a surcoat of the same, and it is the most beautiful cloth in Florence, which he had made in his own silk manufacture. And he had a garland of feathers and

pearls made [for her] which cost eighty florins. To go under it there is an arrangement of two strands of pearls costing at least sixty florins, so that, when she leaves the house, she will be wearing more than 400 florins on her back. And he is ordering for her some crimson velvet to be made up into long sleeves lined with marten [fur], for her to wear when she goes to her husband's [Marco's] house. And he is having a rose-coloured gown made, embroidered with pearls.[32]

Bridal finery of this sort was a kind of 'counter-dowry': a temporary bequest on the part of the husband, whose financial outlay for the new wife's wardrobe was considered but a passing use of wealth, usually equivalent to a third of the value of the dowry, to be recuperated as soon as the transitional, early wedded period was over. Those who could not afford to buy bridal paraphernalia were obliged to borrow or rent items in order not to dishonour their new wife and her family, which gave rise to a flourishing second-hand trade in the clothing, jewels and furnishings necessary for newly-weds.[33] Fifteenth- and sixteenth-century portraits of young women often identify them as new brides, painstakingly rendering the assortment of jewels and accessories that defined their recent marital status: pearl necklaces, gold chains, shoulder and head brooches, jewelled pendant crosses, gold belts and numerous finger rings.[34] Such portraits preserved for posterity one of the most important moments in a woman's life, and remained as a testimonial to future generations of the beauty and decorum embodied by the new bride, as well as the wealth and status of her new husband. Portraits of couples also appear more frequently from the early decades of the sixteenth century. Commissioned as both a genealogical statement and as an exemplum of social responsibility, double portraits such as that by Lorenzo Lotto showing Marsilio Cassotti together with his young wife Faustina (on whose joint shoulders Cupid is placing the yoke of matrimony) take care not to omit the panoply of bridal accessories that defined the new couple's social standing (plate 7.17).[35]

A sumptuary law passed in Florence in 1472 describes the jewels newly married women might wear and emphasizes the material and temporal limits put on bridal ostentation. New wives

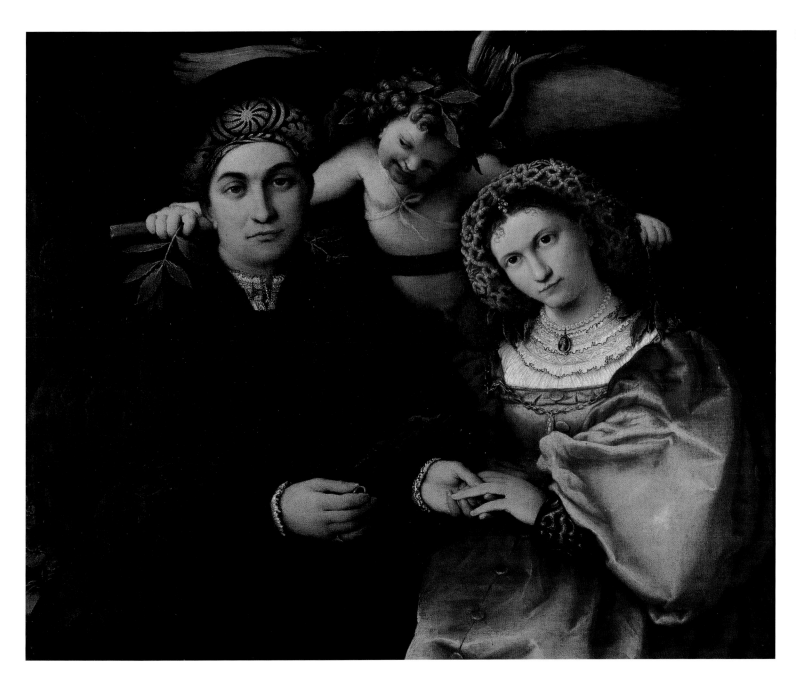

may wear necklaces, veils and two brooches – one for the head and one for the shoulder. And these above mentioned things they may wear for three years from the day that they went to marriage … And after the said three years, they may wear the necklace alone and only one brooch for another three years, and after that it is entirely forbidden them the power to bear any of the above said things.[36]

Six years of marriage was usually enough to provide ladies of the patrician and merchant classes with an average of four children, and women of the labouring classes with two or three. Should these women survive the perils of childbirth and its accompanying risks of infection and fever, six years of married life and its attendant responsibilities would have taken their toll on their physique and their looks: no longer could they be considered new brides, but rather mature matrons, at the prime of reproductive life and household responsibility. Not only would their attire have changed to reflect this new identity, but also the objects with which they surrounded themselves. Once the rites of passage particular to betrothal and marriage had been left behind, the real purpose of conjugal life – that of procreation – became a joint responsibility of both husband and wife: a civic, religious and social duty, never to be taken lightly.

CHESTS

CLAUDIO PAOLINI

7.18 Attr. workshop of
Lorenzo di Credi, wedding
chest with the arms of
the Rossi family (?) and the
Pitti family of Florence,
Florence, *c*.1480
(cat.117)

Chests (*cassoni* and *forzieri*) were the oldest and most popular types of furniture in use between the fourteenth and sixteenth centuries.[1] Even though their basic form was extremely simple, they fulfilled a variety of different functions. Above all, they stored and protected valuable goods, but they could also be used as seats. Several chests could be placed side by side to form a makeshift bed, and, in the event of moving house, they could be balanced on either side of horses or fastened to the back of carts, making them ideally suited for the transport of household goods.

At the same time, the chest could vary greatly in terms of shape and dimensions: although the term *cassone* is now used exclusively by scholars, archival documents actually distinguish between the *cassone*, the *cassa*, the *forziere* and the *cofano*. Scholars have yet to agree on the correct interpretation of each term, although many have chosen to identify the *forziere* with the wedding chest. From documentary evidence it seems likely that *forziere* in fact indicates a chest equipped with a lock (as was often the case with wedding chests), a security device not used on other types of chest. The origins of the word would appear to confirm this hypothesis: the term is derived from the fourteenth-century French word *forcier* meaning '[something to be closed] by force', force here signifying the action, requiring effort, of opening or closing a lock. The term *cofano*, from the Latin *cophìnus*, meaning 'basket', appears to denote an elongated form of chest, like the *cassone*, but with a rounded lid.[2]

Wedding *cassoni* were the most ornate type of chest, decorated with intarsia and gilding or pastiglia (moulded decoration), painted or carved. Commissioned not so much out of necessity but in order to commemorate a defining moment in social life, the wedding *cassone* represented one of the most precious pieces of furniture in the Renaissance home.

During the fifteenth century the front of a *cassone* was generally decorated with intarsia or paintings. A significant portion of the paintings from the period held in museum collections today are in fact *cassone* panels isolated from the integral piece of furniture. Giorgio Vasari in his life of Dello Delli referred to the custom of painting stories on *cassoni*, the subject of which was often specified by the client.[3] This is well documented in the Florentine workshop book of Mario del Buono Giamberti and Apollonio di Giovanni, kept from 1446 to 1463, which records that these expensive chests were generally commissioned in pairs for the weddings of the daughters of the wealthy ruling classes.[4]

Cassoni were often exhibited during the procession that accompanied the young bride to her new home, and therefore depicted subjects appropriate for this public function: representations of exceptional undertakings or legendary heroes, stories intended to underline the strength of love, conjugal virtues, and cautionary tales reminding husbands of their authority over their wives. Decoration was sometimes limited to naked little boys, or putti, who held up the families' coats of arms. These represented symbols of good luck and fertility and therefore the continuity of the family line.

During the sixteenth century the painted chest rapidly disappeared. The inventories of the Medici wardrobe from 1553 reveal that they were relegated to the 'rooms of the women and wet nurses', while new, carved chests were placed in official spaces. This was the period when the chest responded to Mannerist fashion, producing modelled shapes and turning the chest into a structure with a curved silhouette that recalled ancient Roman marble sarcophagi.

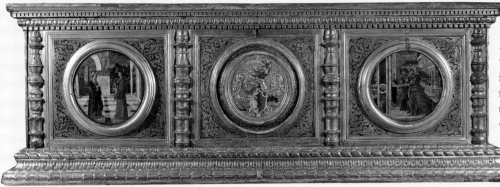

7.19 Attr. Bartolomeo Montagna, pastiglia *cassone*, probably Venice, late 15th to early 16th century (Museo Poldi Pezzoli, Milan)

The chest in plate 7.18 (*c.*1480), characterized by the high quality of its ornament, is from Lorenzo di Credi's workshop.[5] It depicts two putti converging in the centre holding a shield with the arms of the Pitti and possibly the Rossi families of Florence.[6] Acquired in 1909 on the Florentine antiquarian market by Herbert Horne, it underwent restoration immediately afterwards. The simple, floor-level supports and the lid were reconstructed and several layers of varnish and glue were added to the pictorial surface, with the aim of enhancing the colours. In reality, however, the rapid alteration of these layers darkened them so much over time that the surface became illegible, losing a sense of the quality of the work and its context. Conservation work undertaken in 2001 reversed this damage and entirely recovered the legibility of the front of the chest. It became possible to attribute the object to the circle of Lorenzo di Credi. The classical references in the decoration are striking, influenced by the sarcophagus in Verrocchio's funerary monument for Piero and Giovanni de' Medici in the church of San Lorenzo, Florence, as are the metallic consistency produced by the paint tones and the three-dimensional feel conferred by the shadows cast from the various elements of the composition.

In contrast, the chest from the Poldi Pezzoli Museum in Milan (plate 7.19),[7] created shortly afterwards, is an example of the type described as 'in the Venetian style', with a front divided in three by half-columns, and framing panels containing three tondi. Here, the tondi are decorated with friezes resembling damascened ornament. In the centre they contain pastiglia coats of arms, probably those of the Buri family of Verona, with the stories of Duilius and Bilia, and Tuccia, the vestal virgin, on the sides. The chest can be dated to *c.*1490 on the basis of these pictorial scenes, and could be the work of Bartolomeo Montagna. They can be linked to another two tondi in the Ashmolean Museum, Oxford, representing Claudia, the vestal virgin, and the marriage of Antiochus and Stratonice. These are probably all that remains of the *cassone* that formed a pair with the Poldi Pezzoli chest. Furthermore, the stories – being connected with concepts of female virtue and intended to underline the subordinate position of the wife – confirm without doubt that these were commissioned in conjunction with a marriage.[8]

The pair of chests in plate 7.20 represent the type of carved sarcophagus that became standard during the course of the sixteenth century, in particular in Venice, Florence and Rome.[9] Carving was often used not only to illustrate the stories on the panels but also to shape the very design of the chest, with angular sculptures underlining the continuity between front and sides. Similar *cassoni* can be found in various public collections dating from 1540 up to the end of the sixteenth century.[10] Furniture historians have argued that these chests were made by Roman carvers.[11] Various *cassoni* similar to those described here were Genoese commissions designed by the Florentine-trained artist Perino del Vaga and his workshop.[12] However, like many other masters of the time, he was extremely mobile and had various followers across the country who produced chests similar to the ones shown here.

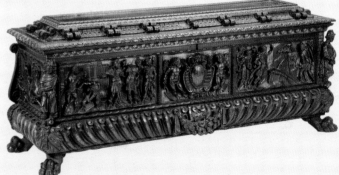

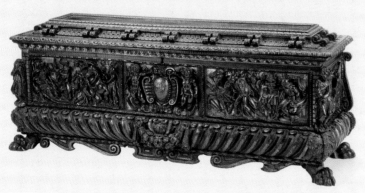

7.20 Pair of *cassoni* with scenes from the founding of Rome. Walnut and chestnut, Tuscany (?), late 16th century (V&A: 7708, 7709-1861)

THE *LETTUCCIO* (DAYBED) AND *CAPPELLINAIO* (HAT RACK)

FAUSTO CALDERAI AND SIMONE CHIARUGI

The typology of the *lettuccio*, or daybed, is now well documented, thanks to various contributions that have appeared over the last decades with a large collection of images and archival sources, and several surviving examples.[1] This piece of furniture, which probably emerged during the mid-fourteenth century, was used in the *camera* as an addition to the bed itself. It enjoyed an important role during the Italian Renaissance, particularly in Tuscany, not just for its practical function as a daybed, a precursor to the modern sofa, and for storage, but also for its symbolic value as an indicator of wealth. The *lettuccio* was often placed near or immediately adjacent to the *lettiera* (bed) and was equipped with

7.21 *Lettuccio* and *cappellinaio*, various woods, Siena, 1450–75 (Banca Monte dei Paschi, Siena)

a small mattress. Its elaborate structure encouraged the combination of diverse forms of decoration, including intarsia, paintings and carvings, to an extent that was not always possible on the bed. Only a small number of *lettucci* survive and doubts remain regarding their integrity.

The illustrated *lettuccio* and *cappellinaio* (a rack surmounting the *lettuccio* carrying pegs for hanging clothing and other objects) are of considerable importance because of their demonstrable authenticity, and their early date (plate 7.21). The structure and the intarsia decoration, rich with geometric and perspectival designs, suggest the work of local artisans active in the third quarter of the fifteenth century. It would therefore appear to be the earliest surviving example of its type.

The original arrangement of this *lettuccio* is worth discussing. Since its arrival in the Sala delle Biccherne in the Palazzo Pubblico in Siena in 1884, the ensemble has been displayed with the *lettuccio* placed on a platform underneath the *cappellinaio*, which simply leans against the headboard of the *lettuccio* and is fixed to the wall with two rings and iron clasps. Given that the sides of the *lettuccio* and the pilasters of the *cappellinaio* do not fit together, it has been suggested that the latter was originally displayed in a different position. The *lettuccio* without the *cappellinaio*, however, appears too low when compared with visual sources such as Biagio d'Antonio's *Stories of Lucretia* (1450–75; plate 7.22), which includes a representation of a very similar *lettuccio* with *cappellinaio*. It seems likely, therefore, that these items of furniture are in fact a matching ensemble. They represent two surviving elements from the type of richly decorated *camera* that numerous contemporary sources describe as containing a *lettiera* with a headboard, surrounded by chests and also, perhaps, wooden panelling decorated in the same way as the other furnishings in order to form a unified whole.[2]

This piece was acquired in 1883 by a bank, the Monte dei Paschi of Siena, for 3,200 *lire* from the Real Conservatorio del Refugio, a historic educational institution for girls founded in Siena at the end of the sixteenth century. The sale documents, traced for the purposes of this research, relate that the ensemble had long been in disuse and its condition was deteriorating.[3] We do not know how it arrived in the Refugio, but the most likely scenario

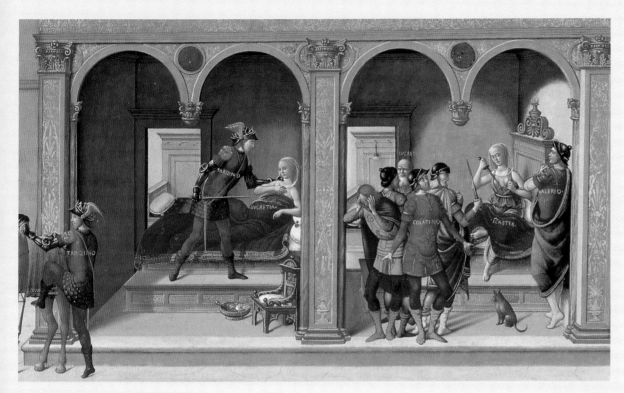

7.22 Detail from Biagio
d'Antonio, *Stories of Lucretia*,
tempera on panel, Florence,
1450–75 (Galleria
Franchetti alla Ca' d'Oro,
Venice)

is that it formed part of the dowry of a young pupil, or
was donated by a local family keen to support the institu-
tion. To date, it has only been possible to trace it back to
1818 when it appears, under the title *residenza* (item to sit
on), in the room described as the infirmary.[4]

The *lettuccio*, installed in the Palazzo Pubblico immedi-
ately after its sale by the Refugio, is recorded in the
inventory of the council's furnishings in 1897 as a 'cappuc-
ciaio'.[5] A few years later, this object is described as being
in good condition and it seems relatively unlikely that
it underwent conservation during this period.[6] It was
displayed at the exhibition *Antica Arte Senese* in 1904, and
the photographs taken for the catalogue show that the *cap-
pellinaio* still had its pegs and the areas with intarsia were
obscured by a thick, dark patina.[7] The current state of
conservation, comprising the substitution of the pegs with
intarsia in the shape of clover leaves, as well as a thorough
cleaning of the surface areas, was probably carried out
after 1925 when new doors and wooden floors were made
for the Sala delle Biccherne, which was the office of the
Sienese mayor.[8] It is still unclear why the pegs were taken
off, but it is likely that their domestic nature was seen as
inappropriate for the object's new prestigious setting.

This ensemble is made up of three separate elements:
the platform, *lettuccio* and *cappellinaio*. Apart from the
platform, which is old, but not contemporary with the *let-
tuccio*, the other two elements are almost entirely original.
The sides, being made entirely of solid oak, were designed
from the start without decoration. Further confirmation

of this can be found on the
left-hand side where there was
originally a hinged lid to a small
container, now lost and substituted
with a later copy. Here the remains
of the twisted nails of the two
hooks that acted as hinges are still
visible under the dark stucco work.
The remaining body of the chest,
with its opening lid, and the frame
of the back of the *lettuccio* and *cap-
pellinaio* are entirely made of poplar
wood. While the interior and the
lid have smooth surfaces, the back
of the object is composed of rough boards approximately
15–17 mm thick, jointed together and secured with two
vertical nailed batons, also in poplar. The front has been
executed by applying a grille of poplar strips approxi-
mately 10 mm thick onto the planks. The surface is
decorated with veneers, geometric figures and perspectival
motifs approximately 2 mm thick. The seat, which was
perhaps originally veneered with walnut, has a lid hinged
with the original hooks and a lock with its catch. The fake
clover leaves are easily identifiable on the *cappellinaio* and
conceal the original peg-holes. Apart from this, and the
reconstruction of a section of the cornice on the left-hand
side of the architrave, there are no signs of other interven-
tions. The pilasters with capitals and the consoles carved
in walnut are also original, although their appearance has
been altered by a thick coat of varnish. The technique of
assembling the cornices on the top is of great interest,
as they are attached to the poplar frame using a system of
nails hammered in from above in a diagonal line. Finally,
the container positioned at the base of the *cappellinaio* is
worthy of note. It was perhaps intended to contain rolls of
paper and is equipped with a single, long and very narrow
folding lid in poplar and walnut, hinged with two hooks.
The construction of this lid possibly indicates the height
at which the object was intended to be placed. Given that
the walnut was only used for the front edge of the lid,
revealing the poplar framework on its upper surface, it is
probable that the latter was not intended to be visible to a
person of average height.

8

CONCEPTION AND BIRTH

JACQUELINE MARIE MUSACCHIO

DURING THE ITALIAN RENAISSANCE childbirth was encouraged, celebrated and commemorated with a wide variety of objects. In fact, the importance of childbirth in the life of a Renaissance family is emphasized by the very density of the material culture associated with both it and the related ritual of baptism. Childbirth attained this significance for a variety of reasons. Certainly the most critical was the drastic decline in the population caused by the plague of 1348 and its recurring outbreaks over the next two centuries. The demographic tensions inherent in post-plague society demanded material objects to mediate between the real and the ideal worlds. Their appearance, meaning and function, as well as the social and cultural context that produced them, are all essential to an understanding of the Renaissance home and how families lived inside it.

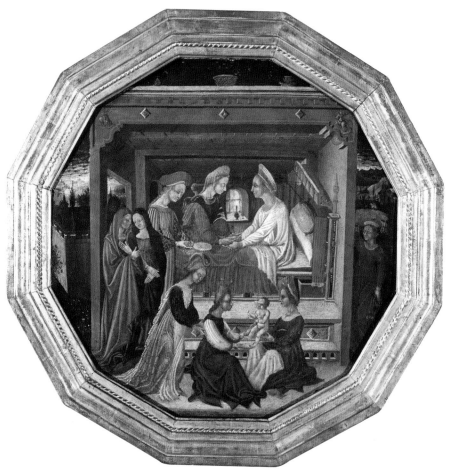

8.1 Domenico di Bartolo (?),
birth tray, Tuscany, before 1445
(cat.116)

8.2 Jacopo Pontormo,
wooden birth bowl with
The Naming of St John the Baptist
(obverse) and Della Casa
and Tornaquinci coats of arms
(reverse), Florence, *c*.1525
(cat.160)

Most of the objects associated with childbirth were both decorative and utilitarian. Some were permanent household accessories, while others were more ephemeral tokens. Wooden and maiolica trays and bowls represent the best surviving evidence for an active and material-oriented birth culture; given to women before childbirth as encouragement, they were used during confinement to carry celebratory offerings into her chamber and they often remained in the home to commemorate the event long after the children had grown. A prime example of this is a wooden tray painted by a Tuscan artist in the mid-fifteenth century (plate 8.1).[1] The scene on the front represents a mother seated in bed, receiving guests, while her newborn is cared for in the foreground. The women are well dressed, the linens are sumptuous and the furnishings are grand. The tray back is dominated by two boys, naked except for flowing sashes and coral amulets, playing a tambourine and singing in a flowering meadow. This type of tray was known as a *desco da parto*, or childbirth tray; although confinement scenes and naked boys were common, these trays also had literary, mythological or biblical iconography on the front, and allegories or heraldry on the back. A related object is the wooden birth bowl, or *tafferia da parto*.[2] Most of these bowls were painted with sacred scenes; one of *c*.1525 by Pontormo has *The Naming of St John the Baptist* in the concavity, and heraldry of husband and wife on the reverse (plate 8.2).[3] Some maiolica wares were painted with similar, though occasionally more intimate, scenes (plate 8.3).[4] On one from Casteldurante, of 1525–30, a midwife sits in front of the labouring woman and reaches under her skirts; midwives, with the assistance of female friends and relatives, were the primary birth attendants at this time.

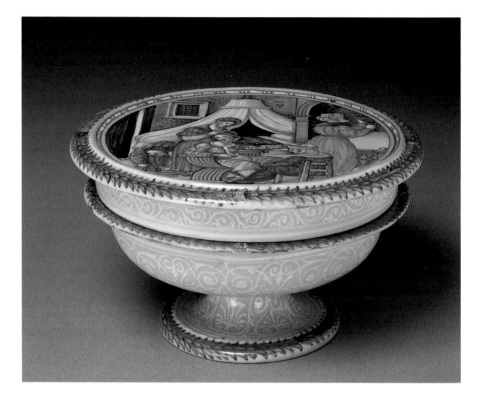

8.3 Attr. Nicolò da Urbino, broth bowl and tray from a childbirth set, Casteldurante, 1525–30 (cat.161) These objects were used to bring nourishing food to the new mother.

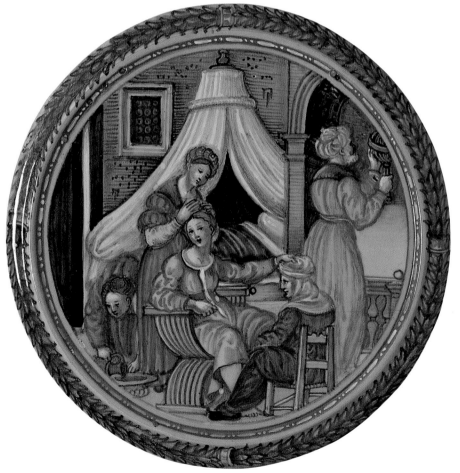

Another woman comforts the mother, who cries out and grabs the midwife's head in her distress, while an astrologer casts the newborn's chart.[5] This type of maiolica set, sometimes referred to as a *scodella da impagliata*, or childbirth bowl (*impagliata* came from the word *paglia*, or straw, recalling the straw mattresses on which some women rested), was common enough to warrant description in Cipriano Piccolpasso's sixteenth-century maiolica treatise.[6]

Wooden and maiolica trays and bowls were popular from the fourteenth to the sixteenth centuries in the economically solvent and artistically advanced regions of north-central Italy. Evidence for these and for more ephemeral birth objects can be found in the detailed descriptions of quotidian events in contemporary inventories, texts and paintings.[7] They represent a complex mix of the sacred and the profane, including embroidered sheets, pillows and tablecloths, painted tables and birthing chairs, and carved cradles (plate 8.4). Babies had mantles and swaddling (plate 8.5), and new mothers had elaborate clothing and head coverings. To replenish what they lost during labour, these mothers enjoyed a special diet, including poultry and salt served from special receptacles.[8]

8.5 Swaddling band, Italy,
1590–1600
(cat.162)
A decorative band like this
was the last to be applied,
after the child had been
wrapped in plain bands.

New mothers or grateful fathers presented churches with silver or wax ex-votos, in the shape of swaddled babies or other relevant subjects, to give thanks for safe deliveries.[9] And they kept relics by their sides during these deliveries.[10] The hat of Sant' Antonino of Florence was thought to have powers to aid conception and birth, as did the Virgin's girdle in Prato.[11] Perhaps because of this connection, special girdles were made for infertile women. The childless Margarita Datini of Prato was

8.4 Cradle, walnut,
Italy, 16th century,
(Philadelphia Museum
of Art, 2000-117-1)

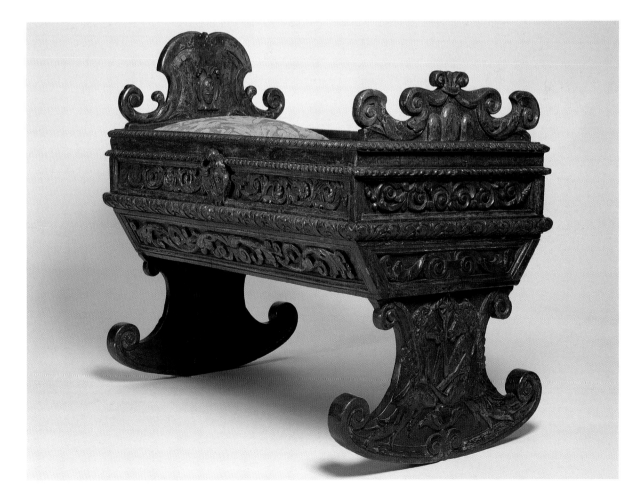

told – in vain, it transpired – to get a virgin boy to place an inscribed belt around her waist while she recited three paternosters and three Ave Marias, after which she was sure to conceive.[12] Entrepreneurial monks put torn parchment into small pouches to make protective charms for women and children called *brevi*.[13] Related objects were represented in a Pistoia altarpiece by Bernardino d'Antonio Detti, where St John offers a branch of coral, a cross, an Agnus Dei medallion and an animal tooth to the Christ Child (plate 8.6).[14] These objects were considered talismanic; coral, for example, warded away evil, and teeth encouraged the growth of the infant's own (plate 8.7).[15] Other aids included the Rose of Jericho, or Selaginella, a cruciferous plant thought to help women by enabling them to give birth as easily as a plant blooms.[16] Pulverized snake-skins, rabbit milk and crayfish were also recommended.[17] So were aetites; these hollow geodes, their loose pieces rattling inside when shaken, recalled the child in the womb.[18] The Marchioness of Mantua, Isabella d'Este, wrote of her faith in these stones, although her deliveries were so easy they had no chance to demonstrate their powers.[19] Some, mounted in precious metals and worn by attached chains or strings, were referred to as stones of St Margaret.[20] Margaret was a patron saint of child-birth; her affinity with pregnant women is explained by her legend, in which she emerged unharmed from a dragon's belly.[21] The legend could be read during labour or, if the participants were illiterate, the book could be placed directly on the woman's stomach.[22] Birth trays and bowls also incorporated texts; one maiolica bowl has the name 'Silvia' painted in its concavity and 'piena' (pregnant) hidden under its foot ring, to help Silvia conceive.[23]

These varied objects reveal the great efforts taken to create Renaissance families. Legislation also encouraged childbearing. In 1433 the Florentine state, worried about the declining population following several plague outbreaks, condemned women who ignored childbearing duties and instead spent their time and their husbands' money on costly clothing and accessories.[24] When these women did have children, it was apparent that not all children were equal; on the most basic level, most families preferred sons. Contemporary writers, adapting long-standing antique and Christian traditions, placed great emphasis on producing male heirs and advocated childbearing as the primary reason for marriage. The dowries needed to make an alliance for daughters, who left the natal family to produce heirs for another, was reason enough for this bias. In fact, more girls were abandoned than boys, and more died at their wet nurses.[25] Of course, the birth of a daughter could be a happy occasion in a family that already had a son; if they could afford to dower her, they could look forward to important in-laws when she married. But the birth of male heirs was critical, and great efforts were taken to produce them. The humanist Leon Battista Alberti (1404–72), the historian Benedetto Varchi (1503–65) and the Parisian surgeon Ambroise Paré (1517–90) all cited the importance of the maternal imagination; controlling

8.7 Coral pendant, Liguria, late 16th to early 17th century (Soprintendenza Archeologica, Liguria – excavated in Finalborgo, PT 4174)
The coral bears evidence of an earlier mount.

8.6 Bernardino d'Antonio
Detti, *Madonna della Pergola*,
tempera on panel, Pistoia,
1523 (Museo Civico, Pistoia)

what the woman saw determined what she ultimately produced.[26] This might explain why some brides received life-size terracotta or stucco baby boy dolls as part of their marital goods (plate 8.8). These dolls were played with and cared for like real children, prompting devotion to the holy figures and encouraging the conception of similarly beautiful infants.[27] And this certainly justifies the presence of the naked boys on the reverse of many birth trays and bowls; they prompted the maternal imagination to produce the desired heir. Extra encouragement can be seen in the animal on the back of a tray of *c.*1427 attributed to Masaccio (plate 8.9); it is almost certainly a type of weasel or marten, which, according to Ovid's *Metamorphoses*, was thought to either conceive or give birth by the ear.[28] This associated weasels with the Immaculate Conception, and made them a childbirth talisman, eminently appropriate for a tray back or any other domestic object that came into contact with a potential mother.[29] Women wore weasel furs for similar reasons; Lorenzo Lotto's portrait of Lucina Brembati (*c.*1518) plays on the woman's name and Lucina, the goddess of childbirth, through the rebus of her name in the top left and the fur – its weasel head visible – over her shoulder (plate 8.10).[30] Perhaps Brembati was having difficulty conceiving, and the weasel and this portrait

8.8 Workshop of Andrea della Robbia, *Christ Child*, Florence, *c.*1490–1510 (cat.151)
This sort of devotional statuette has been associated by some scholars with the baby dolls contained in trousseaus.

8.9 Attr. Masaccio, birth tray (verso) showing boy with weasel, tempera on panel, Florence, *c.*1427 (Gemäldegalerie-Staatliche Museen, Berlin)

8.10 (*opposite*) Lorenzo Lotto, *Portrait of Lucina Brembati*, Bergamo, *c.*1518 (cat.158)

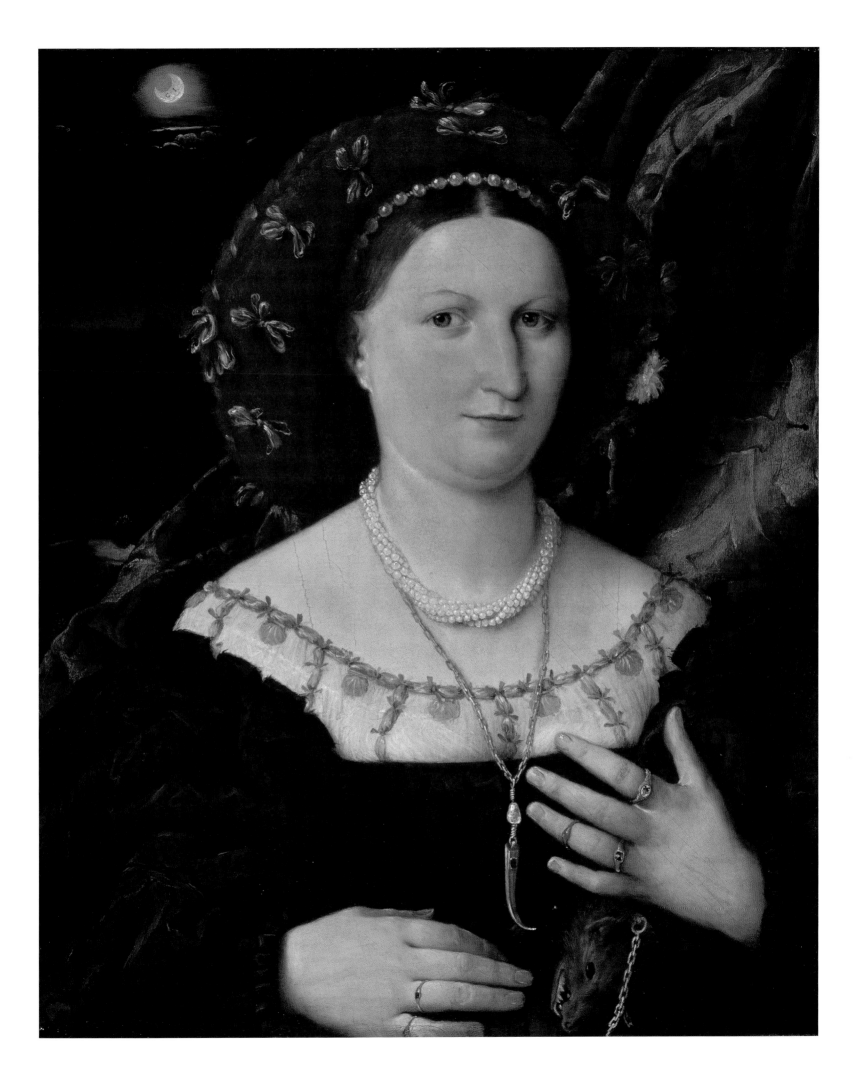

8.11 Marten head,
Venice (?), mid-16th century
(cat.7)

8.12 (*opposite and page 134*)
Giovanni di Ser Giovanni,
the Medici-Tornabuoni
birth tray with the Triumph
of Fame (obverse) and the
device of Piero de' Medici
with the Medici and
Tornabuoni coats of arms
(reverse), Florence, 1449
(cat.213)

were meant to assist her. Some of these weasel furs were ornamented with metalwork heads, making them even more precious and elaborate (plate 8.11).

The wealthiest members of society had the most birth objects, and the most elaborate ones. For example, the Florentine Francesco Inghirammi was an especially rich man at his death in 1470, when he left seven children ranging in age from a few months to twelve years. His estate included two painted trays, a box of charms, a mantle, two sets of embroidered sheets and pillows and a chair, all for childbirth, demonstrating Inghirammi's affluence and the importance he accorded childbirth.[31] Other families of this stature were similarly well equipped. The Medici had many birth objects, including a large and lavish wooden tray painted by Giovanni di Ser Giovanni for the birth of Lorenzo di Piero de' Medici in 1449 (plate 8.12).[32] Although made for Lorenzo's mother, the tray had particular meaning for Lorenzo, too; it was hanging in his *anticamera* at his death in 1492. This tray was certainly a special commission, but most birth objects were produced for the open market, to meet demand from all levels of society.[33] The estate of a blacksmith in Livorno included three pairs of embroidered linen pillowcases for use in childbirth.[34] A pregnant servant woman in a Florentine household received clothing, chickens and wine.[35] And the Ceppo, a charitable foundation in Prato, gave sweets, nuts and candles to poor families celebrating births and baptisms.[36] Birth objects

could be loaned or acquired on the second-hand market, and after they were used, they were stored away for years, together with other items too precious to discard but not needed on a regular basis.[37] In some cases wear and tear is evident from their descriptions; even when used, old, broken or 'sad', birth objects were still included in the evaluation of estates, indicating a sentimentality that transcends their original function and inherent value.[38]

Some birth objects were so ostentatious that cities tried to control them via sumptuary laws.[39] Even the parsimonious Florentines, who advocated hiding their wealth, did not hold back on these occasions.[40] Venetians were even more extravagant; a visitor to Venice in 1466 observed a sumptuous confinement at the home of a prominent merchant, involving furnishings of alabaster, gold and silver at an estimated cost of 24,000 ducats.[41] Both the cities of Mantua and Pisa forbade certain ornaments for the mother, the child and the confinement chamber, and Florence prohibited gifts of more than ten pounds of candle wax and twelve pounds of sweets.[42] But these laws were ineffectual; visitors arrived in their best clothes and jewels, so the new mother had to look good, and her chamber had to be well appointed and stocked with food and drink. Paintings like Domenico Ghirlandaio's *Birth of John the Baptist* (1485-90) from the church of Santa Maria Novella in Florence represent this ritual in great detail. In some cases, these visits took on an almost sacred aspect; some men bought candles to light before the devotional paintings in the chambers where their wives received visitors following childbirth.[43] Despite what must have been, at times, an astonishing expense, men profited socially and politically from these events, so the purchase, use and display of birth objects continued unabated.

Baptism, which occurred within a few days – or, if the infant was in danger, within a few hours – of birth, was equally important.[44] It welcomed the newborn into the sacred and civic community. But it also enlarged the family through the naming of sponsors, or co-parents, and solidified these new relationships through visits and gifts, replicating, in some ways, the gifts presented to the Christ Child by the Magi.[45] In the sixteenth century the artists Francesco Salviati and Guido Reni presented drawings and paintings to the mothers of the children

they sponsored.[46] More typically, sponsors gave special breads, sponge cakes, boxes of red and white sweets, and candles.[47] They might also give coins, which were placed in the child's swaddling, lengths of fabric, silver cups and sets of silver forks or spoons in special holders.[48] In Florence this silverware may have had additional meanings, especially when ornamented with figures of St John the Baptist or Hercules, both civic symbols.[49] These more durable gifts were obligatory objects that were passed on from one mother to the next within the extended family network. The exchange of these gifts constantly reminded those involved of the larger responsibilities to their family.[50]

But why did Renaissance society consider this proliferation of birth objects necessary? Certainly important was their role as a type of insurance in an uncertain world. Sexual activity, pregnancy and childbirth were often shrouded in considerable mystery; poor health and unsanitary conditions created serious risks, and the lack of reliable contraceptives and the use of wet nurses decreased time between pregnancies and took a heavy physical toll. In fact, according to the best estimates, it seems that at least 20 per cent of the deaths of young, married women in early Renaissance Florence were birth-related, and there was a similar mortality rate among newborns and young children.[51] An awareness of this made some women write their wills before their due dates.[52] However, although the prospects for both mother and infant were guarded, their deaths were not accepted with equanimity. In his treatise *I libri della famiglia*, written in the 1430s, Leon Battista Alberti described the great love of a father for his children, and the worries he faced over their health and welfare.[53] In 1477 Giovanni Tornabuoni commemorated his wife and stillborn child with an elaborate but now dismantled tomb in the church of Santa Maria sopra Minerva in Rome, a moving example of husbandly and paternal grief.[54] But comments like Alberti's and monuments like Tornabuoni's were unusual; tangible evidence of reactions to childbirth tragedies is otherwise rare, since few men described childbirth, successful or not, and fewer women left any records at all. Yet death was an omnipresent facet of Renaissance life. So the scenes on childbirth trays and bowls counteracted this danger with images of easy births in well-appointed homes.

But the demographic crisis was perhaps an even stronger impetus. The plague struck the Italian peninsula at least a dozen times between 1348 and 1600; in 1348 alone it killed between one-third and one-half of the population and caused social, political and economic chaos. The city of Florence exemplified the catastrophic decline in population, dropping from 120,000 inhabitants in 1338 to 37,000 in 1441.[55] By the late fourteenth century the recurring epidemic created an overwhelming awareness of mortality that touched every part of life.[56] Art historians from the 1950s onwards have focused on the influence of the plague on Renaissance art, usually concentrating on grim monumental art, in religious or civic settings.[57] But this was not the only kind of art affected by the plague. Domestic art, which surrounded people daily, was also influenced. The items associated with funerary rites in post-plague Florence have been described as 'ceremonial buffers', which offered both stability and protection to desperate survivors.[58] At the other end of the life cycle childbirth had these buffers, too. Both cities and families felt an urgent need to increase their numbers; both required a large population to survive on the most basic level, as well as to fight wars, rent homes and shops, maintain low wages and pay taxes. This combination of childbirth's inherent risks and its absolute importance resulted in the many objects discussed here. And these objects remained popular as long as they were necessary; by the late sixteenth century there was a drop in the production and possession of birth objects, concurrent with the beginning of steady demographic recovery on the peninsula.

In this context anything that provided a certain amount of protection and mediation – whether it consisted of trays, bowls, clothing, coral, ex-votos, poultry or even weasels – was desirable. In the wake of the catastrophic population decline caused by the plague, birth and baptism objects emphasized the family and procreation and enforced obligations across the community. They stimulated the imagination of the Renaissance woman, and they emphatically encouraged her to fulfil the maternal role prescribed to her by society. The Renaissance family needed this rich and varied material culture to encourage, celebrate and commemorate childbirth.

CHILDREN AND EDUCATION

PATRICIA FORTINI BROWN

9.1 Giovanni Battista
Moroni, *Young Girl of the
Redetti Family*, Bergamo,
1566–70
(cat.164)

THE PRESENCE OF CHILDREN was felt throughout the Renaissance home. As Leon Battista Alberti wrote in his treatise, *I libri della famiglia*, 'children act as pledges and securities of marital love and kindness' and 'offer a focus for all a man's hopes and desires'.[1] This presence was both real and virtual, with domestic space populated not just by actual children but also by images of infants sacred and profane. Household inventories tell us that almost every home, even those of the most modest artisan, had an icon of the Madonna and Child on the bedroom wall.[2] But more affluent homes had a variety of such images and objects in media ranging from panel paintings and sculpture to metal icons and prints. The baby Jesus was literally a part of every family. In addition, the revival of classical antiquity inspired an alternative tradition of infant representation, with chubby putti becoming a popular motif in the decorative and fine arts.[3]

But what about actual children? In the fifteenth century they were portrayed occasionally in frescoes in devotional settings, such as the Sassetti Chapel in Santa Trinita, Florence, where Domenico Ghirlandaio included the sons of the patron, the banker Francesco Sassetti, in narrative scenes from the life of St Francis.[4] But few individual portraits of young children survive from domestic space in that period. Among the earliest examples are a group of Florentine sculpted busts of baby boys dating to the second half of the fifteenth century. Although some seem to have been intended to represent the infant Christ or John the Baptist, others depicted real children. The genre was undoubtedly inspired in humanist Florence by antique busts of Roman children, but those were commemorative, appearing in a funerary context. By contrast, the Florentine busts recorded the present, and looked to the future. These pieces capture the particular look and personality of their subjects, and, according to one interpretation, whether they represent a saint or actual children, they created an ideal that their young viewers should

More often, children appeared in portraits with one or both parents as participants in a family relationship. Full-sized portraits by Paolo Veronese of Livia da Porto Thiene and Iseppo da Porto (*c.*1551), each with one of their children, once greeted visitors to their palace in Vicenza (plate 9.2).[7] Livia, like a good wife, looks not at the visitor, but at her husband; her small daughter Porzia, clinging timidly to her mother, peers unabashedly at visitors to the house. The young Adriano looks playfully at his sister, while protected by his father Iseppo, who in turn addresses the onlooker with a steady, watchful gaze. The daughter is a miniature version of her mother, even to the cut of her dress, and the boy is the mirror of his father – the carrier of the family name and the progenitor of generations yet to come. They are replications – and replacements – of their parents. One writer of the time, who praised a young woman who had given birth to five sons and five daughters, declared that she had 'renewed, both men and women, the major part of the ancestors and herself'.[8]

A late sixteenth-century drawing by the Mantuan artist Ippolito Andreasi represents the domestic ideal (plate 9.3).[9] The father, probably the artist himself, sits with calipers in hand at a tilted drawing table and plays the central and most active role. He is proffered a sketchbook by a well-dressed young boy, an apprentice or more likely his own son. An image of the Madonna and Child and a statue of a nude Venus reveal both the family's piety and its elevated aesthetic taste. The mother is seated in the foreground on a low, rush-bottomed chair, of a type called *da donna*, 'for the woman'. Absorbed in her children, she teaches a younger child, apparently a girl, her letters, while a naked baby boy plays with a cat and dog at her feet. On the floor at her side is a sewing basket holding scissors and a cushion to make bobbin lace, an activity that she will resume when the reading lesson is over. The gender roles are complementary but well defined: the male domain, even inside the home, is the world of work and action; the female's is circumscribed, centring on her children and household duties. Within these separate, but overlapping, spheres, the husband provides for the family; the wife nurtures and protects the young.

What was it like to be a child in this period and what was his or her place in the domestic interior?

9.3 Ippolito Andreasi, *Self-Portrait of the Artist with his Family*, pen and brown ink over traces of black chalk and white lead, probably Mantua, 1578–80 (Gabinetto dei Disegni e Stampe, Uffizi, Florence, 15989F)

emulate.[5] A handful of individual painted portraits of very young children are also documented in this period, nearly all in a courtly context. Portraits of royal babies were sometimes commissioned when marriages were being negotiated, to exchange with the parents of a future spouse.[6]

Young children were portrayed more frequently in the sixteenth century. In his charming portrait of a young girl the artist Giovanni Battista Moroni captured the dignified comportment expected of the very young daughter of an aristocratic family (plate 9.1). She is expensively dressed in a heavy brocade gown with a snowy white under-shirt with ruff at neckline and wrist and adorned with a jewelled headdress, earrings of tiny pearls, a heavy rope of pearls around her neck and a coral bracelet. But it is her dignified comportment that reveals an upbringing suitable to a *donna da ben*, a 'woman of honour'.

9.2 Paolo Veronese, *Livia da Porto Thiene and her Daughter Porzia* and *Iseppo da Porto and his Son Adriano*, Venice, *c.*1551
(cats 5 and 4)
Separated for centuries, these paintings have suffered different fates. The sides and lower part of the portrait of Livia have been trimmed and repainted.

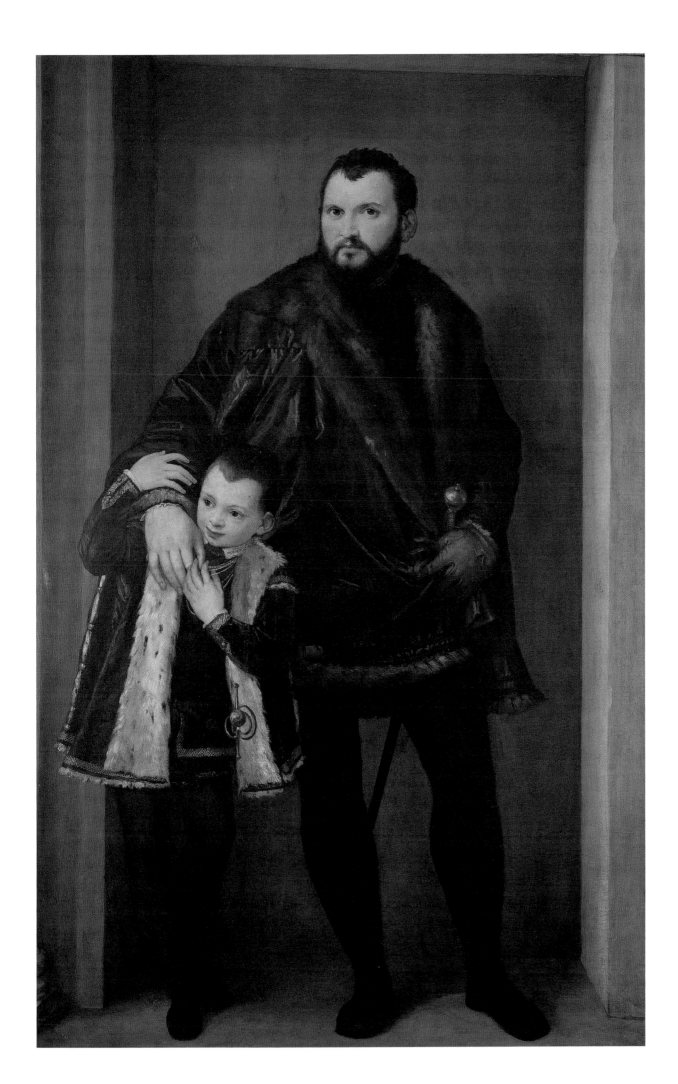

As infants they might not be there at all. Many middle- and upper-class families handed over their newborn babies to a wet nurse immediately after baptism, typically when they were three days old. In Florence infants were often sent out to a peasant woman in the countryside until weaned at around the age of two. In other centres, such as Venice, they remained in town and would often have been cared for by a nurse in the parental home. Why did women not breast-feed their own children even though strongly encouraged to do so by preachers, humanists and other reformers? The reasons were several, but social expectations that middle- and upper-class women should not suckle their own young and maintaining fertility are probably at the top of the list.[10]

In well-to-do households, for those babies who remained with their parents, their first bed might have been a splendidly carved cradle that rocked either from side to side or from head to toe (see plate 8.4). Many such pieces were adorned with a coat of arms, a mark of family distinction that decorated a wide variety of items – baby rattles, chairs, dishes, silverware, pewter, chests, tapestries, bedspreads and even curtains – in affluent homes. The newborn

was swaddled – wrapped in bands – for the first six to twelve months. Once unswaddled, the child learned to walk with the help of a *girello,* the equivalent of today's baby walker (plate 9.4). Writing in the late fourteenth century, Francesco da Barberino counselled a cap with visors front and back, reinforced by leather, to make inevitable falls less dangerous. At around twelve months, the toddler would be dressed in a tunic or skirt – the same for boys and girls – up to the age of around three years. Once walking, the child was often secured by leading strings, like a leash, sewn to his or her clothing.[11]

Children who had outgrown the cradle frequently slept two or three to a bed, sometimes sharing it with their nurse, although in the more affluent homes they might sleep alone. The parental bedchamber in larger Venetian palaces typically featured an alcove with a built-in bed that was surmounted by a mezzanine room called the *sopraletto.* Reached by a staircase in a closet adjacent to the bed alcove, the *sopraletto* might serve as a bedroom for young children and their nurse. They were directly above the matrimonial bed, often with windows that looked directly into the parents' bedchamber. Reminding us of the relative lack of privacy in Renaissance homes, such an arrangement suggests that close supervision of the young by their own parents – particularly the mother – who were just a few steps away during the night, was a desirable norm.[12]

Renaissance parents recognized the first stage of life – *infantia* – as a separate period, when children were to be treated kindly and allowed to run around and play their games without the many constraints of adult comportment. During these early years children of both sexes lived in a world dominated by women: their mother, the wet nurse, aunts, sisters and female servants. Alberti had written, 'It seems to me that this whole tender age is more properly assigned to women's quiet care than to the active attention of men ... So let that earliest period be spent entirely outside the father's arms. Let the child rest, let him sleep in his mother's lap.'[13]

9.4 Baby walker,
Lombardy (?), 16th–17th century
(cat.163)

But it was never too soon to attend to the child's moral formation. Writing in the first decade of the fifteenth century, the Dominican preacher Giovanni Dominici produced a detailed treatise advising a mother on how to raise her young children. He was well aware of the powerful exemplary role of the visual arts in moulding impressionable young minds:

The first regulation is to have pictures of saintly children or young virgins in the home, in which your child, still in swaddling clothes, may take delight and thereby may be gladdened by acts and signs pleasing to childhood. And what I say of pictures applies also to statues. It is well to have the Virgin Mary with the Child in arms, with a little bird or apple in His hand. There should be a good representation of Jesus nursing, sleeping in His Mother's lap or standing courteously before Her while they look at each other … This age is like soft wax that takes whatever imprint is put upon it …[14]

9.5 Giovanbattista Verini, *Luminario* (primer), Toscolano (?), *c.*1527 (cat.167)

Aware that actions spoke louder than words, some mothers were particularly creative in their efforts to instil in their children a love of God. It was reported that the mother of the fifteenth-century French theologian Jean Gerson 'made a hole in the attic, through which she occasionally dropped cherries, apples, plums, nuts, figs, raisins, little shoes, stockings and so on, urging him to pray earnestly and diligently to receive such great bounty from Heaven'.[15]

Rudimentary instruction in reading began at the mother's knee, with children as young as three or four learning their ABC. The first textbook was a primer from which they learned the alphabet, followed by the syllables – such as Ba, Be, Bo, Bu and so on – and then the prayers, including the Pater Noster, Ave Maria, the Apostles' Creed and some psalms (plate 9.5). Once the primer was mastered, they might go on to the *Fior di virtù* – the Flowers of Virtue – a fourteenth-century story book of virtues and vices that used animal stories to instil proper moral values and remained popular throughout the Renaissance period.[16]

The stage called *pueritia*, which began at age seven, typically marked the beginning of formal education. Now gender lines were more clearly drawn. A boy would be put into breeches or *calze* (knitted hose) – a singular event in the life of a male child – and was no longer considered an infant. Girls at that age were dressed like their mothers as in Veronese's portrait (plate 9.2). While the mother continued to educate her daughters, fathers assumed fuller responsibility for their sons.[17] Now, Alberti observed, 'the child begins to make known his wishes and partly to express them in words. The whole family listens and the whole neighborhood repeats his sayings, not without joyful and merry discussion, interpreting and praising what he says and does.'[18]

Although some wealthy boys studied at home, often with their sisters, learning from private tutors hired by their parents, most boys went outside the house to schools sponsored by the commune or the Church or run by independent masters. Most girls were taught at home, either by mothers or other women of the house or by tutors. Some were educated in convents, and a very few went to school with the boys in the younger years. Children of the lower classes received little formal schooling, and were expected to contribute to the family economy

from a young age as servants, apprentices and unskilled helpers in the workshops of artisans.[19] But home schooling manuals began to appear in the sixteenth century. The Venetian teacher Giovanni Antonio Tagliente published his *Libro maiestrevole* in 1524, promising that 'it teaches anyone who knows how to read to teach his son or daughter or dear friend who know nothing about reading, so that each could learn; and even adult and young women who do not know anything could learn to read'.[20]

In his treatise on the education of women, published in 1545, the Venetian writer Ludovico Dolce rejected the common view that learning for females led to a loss of chastity and cited numerous examples of admirable ancient and modern learned women. He recommended that girls read 'little holy books' and write down correct precepts. But he allowed that girls did not have to learn as much as boys since a woman would not ordinarily have to rule a republic but 'only herself, her children and her home'. The late sixteenth-century Venetian nobleman and Bishop of Verona, Agostino Valier, also counselled women to read good, spiritual books and mothers to 'teach their daughters to be silent and to keep the needle and spindle going', with their reading overseen by spiritual advisors, a practice he recommended as 'a path to virtue'.[21]

9.6 Wooden spinning top, probably Genoa, 17th century (cat.168)

Spinning tops like this were popular toys in the 15th and 16th centuries

Silvio Antoniano, a Venetian priest writing at the end of the sixteenth century, expounded a gender- and class-based curriculum: in his view, girls of noble status should know how to read and write well and understand basic arithmetic. Those of the middle class should learn to read and write a little, and girls of humble status should be able to read (or at least recite by rote) books of prayers. Latin and Greek were not necessary: 'A good father should be content that his daughter be able to recite the Little Office of Our Lady and read saints' lives and other spiritual books. A girl should attend to sewing, cooking, and other female activities, leaving to men what was theirs.'[22]

Aside from book learning, toys and games were intended to train the young for adult life. Giovanni Dominici did not approve of the 'little wooden horses, attractive cymbals, imitation birds, gilded drums and a thousand different kinds of toys', which too many parents gave their children. Instead, he advised mothers to build 'a little altar or two in the house', encouraging their daughters to adorn the chapel with garlands of flowers and greenery and their sons to dress themselves in coloured vestments 'play at saying Mass'.[23] Dominici's aim was to guide the impressionable young towards a pious, preferably clerical or monastic life.

But similar concerns were also voiced in the secular realm. Ludovico Dolce advised that once a little girl has taken her first steps, her activities should be carefully monitored: 'her first games should be with girls of her own age, with her mother or wet nurse or other mature and honourable woman always present', using playtime to guide her towards honour and virtue. Nor should she be allowed to converse with boys, he adds, since the strongest emotional bonds are formed with one's first companions. Furthermore, parents should take away the 'silly dolls', which their young daughters liked to dress up with jewellery and various costumes, since they resemble idols and can only 'teach them to value ornaments and pomp'. In exchange, they should give them miniature household tools of wood and various metals, 'so that they will learn with delight the name and function of each'.[24] In all likelihood, few parents were so austere, but one writer of the period listed numerous games played by boys and could think of only three games of young girls: 'dolls, playing godmother, and playing house'.[25] Indeed, while boys joined neighbourhood groups or gangs, girls stayed closer to home and spent much of their time knitting, mending clothes and making lace.[26]

Indeed, Alberti and other writers consistently stressed that 'young boys should be segregated from all feminine activities and habits'.[27] It has been noted that children's games through the ages can be classified as 'chasing, hunting, racing, daring, guessing and pretending'.[28] While boys were more involved than girls in sports and activities involving physical contact such as tag, hide-and-seek, ball games and spinning tops (plate 9.6), children of the educated classes played a variety of board and card games, including

chess, backgammon and draughts. They also played with pet dogs, cats and birds, as attested not only by their presence in art works of the time, but also by the birdcages, little harnesses and collars with tinkling bells cited in inventories. Then, as now, doting parents listened to songs sung by warbling voices and music played by tiny hands on spinets and lutes. Nor were the visual arts ignored. A portrait of a young boy proudly displaying his stick-figure drawing of a man, datable to the first half of the six-

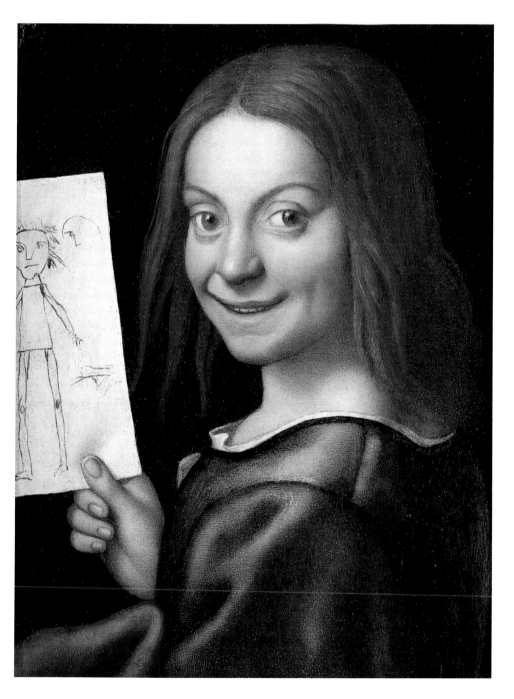

9.7 Giovanni Francesco Caroto, *Young Boy with his Drawing*, oil on panel, Verona, 1500–1550 (Museo di Castelvecchio, Verona)

teenth century, reminds us that a child's way of representing the world has stayed the same across the centuries (plate 9.7).[29]

How did parents really feel about their vulnerable young children? By the late sixteenth century, around one child in seven would not reach the age of twelve months and another two out of seven would die by the age of five. That is a hard-to-imagine survival rate of only about 60 per cent, and even more children would be lost before they reached adulthood.[30] Some historians have argued that the high mortality rate of young children led people to have 'several children in order to keep just a few' and that parents did not have the same deep affection for young children that we have today, since the possibility that they might soon die was always present.[31] Such claims have been largely disproved in recent scholarship.[32] That people treasured their small children is amply confirmed not only by diaries, wills and other writings, but also by Renaissance moralists offended by what they considered unnecessary coddling. Giovanni Dominici, writing in the first decade of the fifteenth century, admonished indulgent parents:

> At present how much you work and strive to lead them about the whole day, to hug and kiss them, to sing them songs, to tell them foolish stories, to scare them with a dozen bogies, to deceive them, to play hide and seek with them, and to take pains in making them beautiful, healthy, cheerful, laughing and wholly content according to the sensual.[33]

He was soon echoed in the 1440s by Antonino, Archbishop of Florence: 'Oh how many are they, who serve their children like idols!'[34] A century later, in the secular sphere, another Florentine, Giovanni Della Casa, sounded a similar lament in his *Galateo*, an etiquette book for families aspiring to gentility: 'Equally unpardonable are those people who can never talk of anything but their children, their wives, and their nursemaids. "My son made me laugh so much yesterday" they say. Or "Listen to this … you never saw a sweeter child than mine …"'[35] As Alberti had put it so aptly a century earlier, children were the centre of domestic life in the Renaissance home, and then, as now, provided the focus for the family's hopes and desires.

PART

III

EVERYDAY
PRACTICES
IN
THE *CASA*

SERVICING THE *CASA*

GUIDO GUERZONI

HOME COMFORTS

One of the distinctive characteristics of Italian Renaissance houses was the abundance and specialization of passageways and service areas. Corridors and stairways, stoves and latrines, wardrobes and washrooms, kitchens and servants' dining rooms, stoves and ice houses, cellars and wood stores represented the hidden face of domestic economy, ensuring the conservation, distribution and sometimes

10.1 Giovanni Ambrogio Brambilla, Kitchen scene from the *Commedia dell'arte*, engraving, Rome, 1583 (Biblioteca e Raccolta Teatrale del Burcardo, Rome)

also the production of foodstuffs, clothing, furnishings and paraphernalia (plate 10.1). These important functions were entrusted to individuals who, at least from the early sixteenth century, toiled far from the eyes, ears and nostrils of household owners and their guests, frequently in the 'lowest part of the building, which I often place underground' in the words of

Palladio.[1] These were obviously areas whose presence, size and articulation were proportional to the rank and ambitions of the owners. Between the early fifteenth and mid-seventeenth centuries, however, their dimensions increased significantly, a testimony to the comfort (*comodità*) of living referred to in contemporary architectural treatises.

Indeed, as the early twentieth-century historian Attilio Schiaparelli has shown for Florence, while during the fourteenth century

five or six rooms were sufficient to house a well-off family and more important dwellings did not possess more than thirteen or fourteen, during the fifteenth century the *palazzi* inhabited by the great Florentine merchants were so large and comfortable that they merited comparisons with the residences of several sovereigns … The one built by the Da Uzzano brothers in via de' Bardi, although it was not one of the largest, contained nine rooms on the ground floor, ten on the first and eleven on the second.[2]

More recent research on Rome further confirms this phenomenon, showing that during the Renaissance circulation spaces (stairs and corridors) occupied 22 per cent of the total surface area of a building. By comparison, in the medieval period their presence was minimal, constituting only 5 per cent.[3] In modest urban apartments of two or three rooms or in small country houses these spaces disappeared completely, substituted by a single piece of furniture that took on the same name.[4] In the *palazzi* and *palazzetti* of the urban elites, however, they occupied increasingly large areas, in order to guarantee perfect and orderly household management.

The Renaissance house was where the owners and heirs of the household practised such dignified activities as sewing and embroidery, performed the rituals of patrician daily life and enjoyed social pleasures. But it also featured the odours of sweat and mould, the shouts of suppliers, the burning embers in the kitchens and the damp of the wood stores. These were two different worlds, forced by necessity to co-exist, even more so in the houses of the lower-middle and working classes (see pp.66–75). Given the very scarce attention paid by historians to kitchens and bathrooms, it is hardly surprising that

other functional areas have attracted even less interest.[5] Nevertheless, they raise various significant issues that will be explored here, focusing mainly on the sixteenth century.

OUT OF SIGHT, BUT IN THE MIND

Two characteristics of service areas should be considered, namely their refined design and their spatial complexity since the mid-fifteenth century. In fact, these rooms and functions were often independent from the other areas of the household: hidden quarters with their own entrances and passageways, responding to clear hierarchies of access and functional logic. This minor and parallel universe, therefore, which intimated the bustle of work but did not always reveal it, was protected by passages and secret corridors, bells and horns, trap doors and spiral staircases. They marked an almost unbridgeable divide between the spaces of the owners, which were often impeccable in terms of order, decorum and wealth, and those inhabited by domestic servants, cooks and their assistants, porters and washerwomen. But the subordinate role of servants (up to fifteen to twenty in the grand palaces, but only three or four in smaller buildings) and the preferably discreet nature of their business still demanded careful architectural planning.

The positioning of these areas and the organization of the activities assigned to them posed significant problems for architects that required sophisticated solutions, from the layout of drains and water outlets in the washrooms – the *destri* (lavatories) and *sciaquatori* (large water faucets used for washing pots and tableware) – to the vertical connections for the stores. These included grain stores, *grasse* (stores containing non-perishable foodstuffs, for example hard cheeses, salami, salted and smoked meat and fish, spices, pasta and rice), *dispense* (rooms containing perishable foods) and secret kitchens. These matters were followed with great attention by prestigious artists and architects, as confirmed by the famous fireplaces, chimneys and stacks designed by Francesco di Giorgio in Urbino, and the solutions devised by Raphael and Antonio da Sangallo the Younger to avoid the propagation of smoke, odours and noise between kitchens, servants' eating quarters and dining rooms.[6] Towards the end of the sixteenth century Vincenzo Scamozzi continued this tradition

10.2 Fireplace hood,
Treviso, *c.*1450
(cat.91)

by designing the layout of sewage pipes, drains and cisterns. Certainly, these were not exercises in style. However, they were well-considered choices, given that the concept of splendour as described by Giovanni Pontano could and should emanate even from the most inconspicuous, or entirely invisible, details – the fruit of truly sophisticated architectural planning and logistical solutions (see pp.306-7).[7]

DAILY CARE

The beating of this hidden heart dictated the rhythm of household life, ensuring the circulation of the lifeblood of toil along the great and small arteries of domestic service. Strength and stamina were required

10.3 Firedogs, Italy,
16th century
(cat.92)

to be able to celebrate the many daily rituals. Mechanical and periodic routines, which altered according to the changing seasons, festivities, habits and movements, were mostly planned by the owners of the household, quite often by the lady of the house, whose pivotal role should not be forgotten. Common sense, tradition, popular almanacs and age-old wisdom suggested how and when to placate the demands of houses, which could be seen as living creatures. *Palazzi* and *palazzetti* reacted to hot and cold weather, succumbed to the ailments of old age, withstood infestations of fleas and rats, and were resigned only to the insults of the inhabitants and the more badly behaved passers-by.

Day by day, week by week, year by year, the same tasks were repeated: bundles of sticks and tree stumps were distributed as firewood, torches and candles were lit and extinguished, ashes and wax were collected, coals placed in warming pans, floors cleaned with brooms and rakes, urinals and bedpans emptied, cloths and tablecloths cleaned, underwear and linens washed, clothes changed with the seasons, textiles mended and rags torn up, poultry plucked and game singed, and waste and scraps collected.[8] These simple acts should not be forgotten, because the houses in question were not only inhabited by their proprietors but were also enjoyed or suffered by many other individuals, who managed them and treated their ailments.

For this reason it is important to focus on the household staff who slept on the mezzanine floors, under the roofs, in the stables and halls. They, too,

10.4 Trivet for supporting cooking pots, northern Italy, 1535–40 (cat.93)

with a mixture of dedication, petty thefts, disobediences and compromises, made a decisive contribution to the achievement of a look and the diffusion of an image. This might appear static to the modern eye but was in fact the result of tireless labour, care or neglect by individuals who rarely rested.

Although today they appear to be immobile, austere and mute, Renaissance houses were in fact frenetic and teaming organisms. In their golden days they provided a stage for many appearances and starring roles, both human and animal. Cockerels and capons, mice and horses mingled with servants, craftsmen, peasants, beggars, members of the Church, urchins and pickpockets, who sweated, puffed, urinated, fornicated, played, taunted one another, argued, fought and prostrated themselves. Far from glacial and impeccable, this world was animated by sounds and stenches that we have forgotten or never even knew, and constituted the continuous bass line marking time for the daily grind and its minute compensations.[9] The prattling next to the great fireplaces (plates 10.2 and 10.3), squawks from the card games played in the cellar, gossip that arose between one laundry wash and another, whispered seductions, the swish of cloths hung out to dry and mumbled evening prayers were interspersed with orders delivered at full blast, the crack of a hand slap, the blaspheming carters and the braying donkeys. Until finally night fell and silence struggled to descend – intermittently broken by the closing of doors, shutters, locks and latches. A chattering chorus accompanied the flow of those long days, thanks to a vast, competing range of work tools and instruments.

HOUSEHOLD PRODUCTS

This is a different material culture, not defined by furniture, textiles, furnishings and equipment, or the tools brandished by artisans and workers.[10] The priest Silvio Antoniano was scandalized when he complained in 1584 that 'furnishings have reached such heights of excessive luxury that nowadays the objects used in villas greatly surpass those adopted by our greatest, and some of our most noble, citizens, only a few years ago in our capital cities'.[11] This material fever nourished a demand for household utensils and instruments – whose existence we often forget – triggering a rapid process of differentiation, specialization and functional improvements. Moreover, this process was often accompanied by related artistic or, more simply, decorative developments: even a ladle or a lemon-squeezer could become a piece of art. It is enough to turn the pages of the inventory of a medium-sized sixteenth-century kitchen to find lists of numerous forms of pans, sieves, receptacles of all shapes and materials, bowls, basins, grips, ladles, skewers, trivets (plate 10.4), creamers, oil presses, graters and mortars. Such sources reveal a taste for detail and a common desire to innovate and improve the form and functionality of all types of objects, even the most base and banal, from the handle of a colander to the hinges on a pair of bellows (plate 10.5).

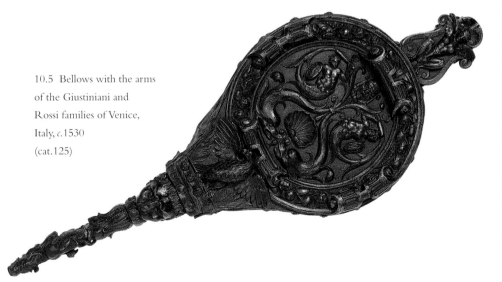

10.5 Bellows with the arms of the Giustiniani and Rossi families of Venice, Italy, c.1530 (cat.125)

Furthermore, it should be remembered that the very same process determined the advent of a vast selection of products and substances that have vanished without trace. Any list of goods stocked by apothecaries provides an idea of the vast range of these 'products for the home'. They significantly contributed to a specific culture of living, and transmitted a precise sensory memory. Anyone who has slept between sheets washed in a solution of ashes and perfumed with quince apples or bitten into homemade bread cooked on the embers of a dying fire will understand what I mean.

FROM CRAFTS TO ARTS

The variety and complexity of the tasks carried out in these spaces accompanied the precocious process of definition of various professional figures: *palazzi* and *palazzetti* were peopled by servants who were chosen by their employers with the greatest care. Intimacy and physical proximity entailed many risks, while thefts and pillaging were the order of the day, since even very banal tasks could strongly test the integrity of the most honest servants. In the kitchens the cooks' assistants carried objects of great value, while the porters and servants working in the wardrobes rearranged garments whose embroideries alone were worth more than they could earn in a lifetime. For these reasons the clergyman Lucio Paolo Rosello recommended in 1549 that extra attention should be paid to the physical traits of potential servants, avoiding candidates with 'eyes that are large, round or rather deep-set, small, narrow faces, eyebrows like a fox, joined in the middle and turning down towards the nose, a coarse, thin voice … very clear signs of inebriation and uncontrolled anger.'[12] Discussing the appropriate age of a *maestro di casa*, the officer who managed the household when the major-domo was absent, the writer Reale Fusoritto da Narni emphasized in 1581 that he should be 'between thirty and sixty … because if he is very young he will have little authority or experience. Too old and he will not be able to withstand hard work such as writing, walking to and fro in the house and wherever else might be necessary.'[13] In 1579 Monsignor Bartolomeo Frigerio recalled that the major-domo

as suggested by his title, is the most important manager in any household where he presides, immediately taking charge if the owner is away. Although the latter is the supreme manager, he must accord his major-domo considerable power and authority, otherwise he will be useless, and his volition and ability to organize all things will come to nothing if he lacks the power to act.[14]

No job was too humble to be left to chance. Domestic service, far from being an entirely unspecialized activity, actively encouraged the development of numerous professions, whose appearance was often accompanied by the publication of texts that brought together wisdom refined over centuries of practice, from infallible remedies for moths to the secret of perfect starching or the best method for folding linen cloth.[15] It is therefore no coincidence that the treatises emphasized the high-minded, liberal, rather than the mechanical, dimension of many household skills. In Bartolomeo Scappi's 1570 description of a model cook, for example, the need for specialized knowledge was highlighted from the start:

> the profession is founded on the understanding and experience of different ways of doing things … the cook must know every type of meat, fish and all other things … and distinguish between all four-legged beasts and fowl, identify all sea and fresh water fish, and the best ways and parts to roast and boil … and to a large extent have knowledge of all types of spices … the quality of all liquors, both thick and thin, and all sorts of fruits and herbs and their seasons.

Only after having exalted the virtues of the cook, did Scappi list the moral attributes required of an ideal candidate, who was to be

> quick, patient, modest, sober … in person clean and neat … he must not entirely count on or trust his assistants, or others working for him, remembering the old saying that those who have great faith are deceived.[16]

THE JOYS AND PAINS OF MISMANAGEMENT

The theme of the deception and insidiousness of servants often recurs in manuals of *Oeconomica* (texts of household management),[17] given that the functioning of great houses nourished a vast network of suppliers, moved humans and objects and caused a whirlwind of deliveries, accounts, payments, exchanges, loans, gifts and favours of various kinds. It cannot be denied that these events allowed mismanagement by household staff, giving rise to tacit agreements regarding the nature and size of illicit gains, such as keeping a little of the shopping money, accepting suppliers' gifts or stealing provisions. Nevertheless, these unwritten rules triggered the parallel traffic of goods, often bordering on the illegal, enabling many objects to continue their adventurous life-cycles: an out-of-fashion cardinal's chair could cut a fine figure in his cellarer's grandson's bedroom. Things moved continuously, not only from room to room or floor to floor, but also from one hand to the next as part of a process sometimes lasting centuries of promotion and degradation. This resulted in pilgrimages to minor rooms, to the servants' quarters and then to the attics, ending up in the stables, grain stores and country residences, where they fulfilled new functions or carried out their original ones with increasing fatigue.

The household staff represented a formidable vehicle for these movements, which altered the uses, functions and meanings of objects. This is clearly synthesized in the view of the renowned major-domo Domenico Romoli on *spenditori*, the domestic buyers whom he considered to be 'by nature thieves, and their greed in managing money is the undoing of them … so that if they steal by the dozen for an ordinary meal, they steal in the hundreds for a great banquet or other celebrations'.[18] Obviously, these forms of appropriation were not always illegal. Old and worn objects were often given by owners to their domestic staff, who took advantage of their customary right to cast-offs by exercising control over the final destination of refuse. Servants were sometimes allowed to sell ash, rags, feathers, bones and fats, kitchen leftovers and even the fertilizing contents of cesspools. In this way, disgraced goods could hope for a new life, falling immediately into the hands of new owners or staying temporarily in the second- and third-hand markets, where they found themselves in good company with all the other objects that had been uprooted due to different events – unpaid pawns or legal sales, for example, following convictions, bankruptcies and deaths. In any case, the invectives of treatise writers regarding the easily corruptible nature of many servants were not simply examples of a rhetorical tradition, given that large sums of money did circulate within households, together with equally large numbers of artisans and vendors, often hired for cleaning, maintenance and repair jobs. Sometimes these were routine services, such as the water vendor, the chimney sweep or the well drainer. Alternatively, they were unplanned interventions or actual emergencies, such as when infested rooms were treated or breakages needed mending swiftly.

Account books often contain records of payments for mending table legs, the bottoms of pans, seat backs and locks of various types, since – without wanting to deny the dynamism of novelty in Italian domestic culture – it should be remembered that nothing was wasted and little was thrown away, with continuous repairs, adjustments, modifications and re-uses. This explains the large number of individuals who mended buckets and barrels; of copper and pewter craftsmen, blacksmiths and carpenters, turners and builders, makers of gesso; of bottle stoppers, knives, knife sharpeners; of purveyors of animal and vegetable fat, leather and hides, barbers and low-skilled medics, vendors of cheap silks, chests and rope, lenders of sacks, barrows and carts, porters, mattress makers, menders and stain removers, paper sellers. These were just some of the very widespread and varied professions that provided services and supplied tools or materials of different kinds for the household. It should not be forgotten, however, that they were an important domestic presence, given that most services were carried out on site and many items were purchased in the home from a variety of travelling vendors. Acknowledging this presence contributes a new and intriguing dimension to this genre of studies.

HOUSEWORK

MARTA AJMAR-WOLLHEIM

11.1 Apron, Italy,
1550–1600
(cat.88)
Aprons were commonly
worn for housework. This
example, embellished with
fine lacework and with a
later belt, could have been
made in the home.

IN HIS *DELL'HONOR DELLE DONNE* (1587) Stefano Guazzo admirably summed up the multiple skills of the housewife (*donna di casa*):

> This woman would not have reached the peak of virtue, if beyond the preservation of goods she would not also provide to increase them with her own industry, in such a way that all household servants were constantly kept busy with some useful activity … Don't expect me now to lower myself [to describe] the minutiae of the threads, and the textiles for the use and ornament of the house, or the polishing of the furniture, or the needlework, the distaff, the wool winder, the breeding of the silkworms, the looking over the cellar, the granary, the pantry, the garden, the poultry hut, and the courtyard animals, the keeping count of the laundry, and all crockery, the cooking of ordinary foods and preserves for all the year, because it would mean instructing women on the management of the household, which is not our task.[1]

The association of women with household activities became very marked during the Renaissance period, as both the increasingly regulated access to work and the rise of male professions contributed to the reduction of female work opportunities outside the home.[2] While the lives of upper-class women traditionally unfolded within the domestic walls, for women from the labouring classes such changes must have been more tangible. The wide variety of female occupations evident in early fourteenth-century tax records disappeared, and women seemed to have withdrawn into the home, where they could combine unskilled and underpaid work, such as spinning and weaving, with family duties, such as looking after children.[3] Girls were required to have a different upbringing and education to boys, and access to training and knowledge that would lead to a profession was generally denied to women.[4]

11.2 *Ufficio della madre di famiglia* and *Ufficio del padre di famiglia*, engravings, Italy, *c.*1600 (Civica Raccolta delle Stampe Achille Bertarelli, Milan)

Furthermore, the authorities increasingly prevented female involvement in commercial and artisanal activities, for example by excluding them from guild membership.[5] This process of domestic confinement went hand in hand with a vociferous campaign promoting the exclusively domestic role of women as wives and mothers (plate 11.1).[6]

When discussing the work of women, therefore, we must be aware that its meaning during this period was shifting and becoming more and more identified with house-related activities. In affluent households, however, a new concept of domesticity was also gaining ground. As the financial and symbolic value of the house and its possessions grew, women running the household required new management and social skills, which partly reversed this process of domestic seclusion.[7] Women were expected to look after not only the everyday running of the house but also aspects of its aesthetic and economic management, and this fostered access to specialist knowledge, ranging from books of remedies to needlework pattern-books and basic

literacy and numeracy manuals. In addition, hospitality and entertainment in the home provided *donne di casa* with opportunities to develop social and recreational skills (see pp.206-21). As the house acquired a central meaning in the identity of the wealthy urban community, *donne di casa* were expected to gain 'professional' competence in line with these new social demands.

Housekeeping – often referred to as *governo della casa* – was seen as intimately connected with women, as shown in a print of *c.*1600 illustrating the duties of the mother (*Ufficio della madre di famiglia*; plate 11.2). The poem at the bottom reads:

It is the woman who governs and rules
the household, and keeps the family together
and preserves the goods, and disciplines
and instructs her son and daughter
and loves and protects her husband's honour
and never departs a hair's breadth from his will
but, executing all his plans,
day after day goes from strength to strength.[8]

11.3 *Psalmista secundum ordinem biblie*, psalter, Venice, *c*.1515 (cat.173)
This tiny psalter would fit in the palm of the hand.

In the picture at the centre of this print – a popular agent for the transmission of ideas throughout Renaissance Europe – three women carry out different tasks within a domestic interior. The *madre di famiglia* is embodied by a pregnant woman placidly looking up from her embroidery, while sitting next to a baby happily smiling in the cradle. In the background two maids are busy with their chores, carrying water and warming some nappies by the fire. The household is prosperous – as symbolized by the basket full of fruit and the good furnishings – and well organized. This representation conjures up comfort, fertility, household order and feminine virtue. The image of domestic bliss, however, is overshadowed by the framing wreath bursting with scrolls full of admonitions such as 'Be contented with the husband that God has given you' and 'Feed your children with your own milk'.[9] The exemplary mother is thus expected to reconcile household management with child-rearing, and love for her husband with tolerance of his shortcomings. Effectively put in charge of domestic life, the *madre di famiglia* must not abuse her power: as the poem states, she 'never departs a hair's breadth from his [the husband's] will'.

This print was published with its companion illustrating the husband's duties (plate 11.2).[10] In contrast to his wife's domesticity, the husband stands in the street outside the house accompanied by a servant carrying foodstuffs, thus emphasizing his role as the provider and the bridge between the outdoor and the indoor. Once these prints are put together, it becomes obvious that while the man stands for the exterior, the woman personifies the interior. This clear-cut division of roles between husband and wife was also promoted by Renaissance moralists like the Paduan writer Sperone Speroni, who wrote in 1538 that such an arrangement was at the heart of a successful household, and presented it as instituted by God: 'Men are naturally stronger and bolder than women; and in this God has acted quite reasonably; so that, inside and outside of our house, with one part of the family unit careful, the other spirited, we lead our lives acquiring and preserving what we have acquired.'[11]

The household was seen as the fundamental unit within the city state, and its good management was believed to contribute crucially to an orderly and well-run society. While the paterfamilias was expected to retain authority over the house, the wife was held responsible for its successful running. His tasks involved building the house and the acquisition of goods, while she was in charge of its day-to-day workings and decor. Housekeeping was so closely linked with womanhood that even conduct books for the spiritual education of girls featured domestic chores. In his *Decor puellarum* of 1471 the Venetian prior Giovanni di Dio gave instructions for the typical day of a virtuous young woman:

As soon as you wake up, say the *Benedictus es domine* ('Blessed are you, Lord') … Then take care of household chores: that is, call the servants who have not got up; set up and prepare the fire; sweep the house; put the midday meal on the fire; dress the children; make the beds; and do all the other things that belong to that hour … Then for the space of about half an hour, if it can be managed, remain in prayer. As soon as it is time for the midday meal, issue orders and prepare the table yourself with all the things that belong to it. If then you can spare a little time before lunch, return to praying on your knees.[12]

11.4 Cover with cutwork and needle lace, Italy, late 16th century (cat.133)

This layering together of acts of devotion and household chores in a tight, relentless daily schedule, so that the time of the household and the time of God became one, was inspired by monastic living, in which worldly and spiritual activities were carefully interwoven under the motto 'ora et labora' (pray and work). Devotional books were often seen as a quintessential female accessory, and minute psalters like the one in plate 11.3, easily carried in a pocket, could have accompanied a woman's devotion during her daily domestic routine.

As humanistic ideas about marriage spread throughout Italy, views of women's domestic role began to include access to basic learning to ensure, for example, their effective control over some economic aspects of household management.[13] Speroni put his daughter Giulia in charge of the administration of his country villa, including rent collection and negotiations with troublesome tenants.[14] Writing in Siena in the 1550s, the humanist Aonio Paleario promoted the role of women as domestic administrators: 'Because the preservation of goods entering the household is the concern of the woman, we want her to assume control of everything without any hesitation, so that nothing necessary to the life of the family can be bought or sold without her command.'[15]

FROM HOUSEWORK TO HANDIWORK

Women's tasks in the routine upkeep of the *casa* were expected to include its decor. As the bride explains in Giacomo Lanteri's *Della Economica* (1560),

> I went around [the house] to investigate ... if anything concerning the ornament of the house was missing ... Firstly, and most importantly, I dealt with the adornment of the rooms, that is of the hangings which were lacking, or that were not suitable and needed to be replaced. I did the same with the household linen.[16]

Soft furnishings – from wall hangings to covers (plate 11.4) – played a pivotal role in houses whose surfaces (whether walls or furniture) were largely designed to be covered up (see pp. 342–50). Activities ranging from the washing, storage and display to the actual commissioning or manufacture and decoration of household linen were thus of central concern to the *donna di casa* (see pp. 343–5).

Echoes of how demanding this could be emerge in the letters written between 1592 and 1605 by the Venetian noblewoman Fiorenza Capello Grimani to her husband Antonio Grimani. She often left Venice to take care of her family properties in the country,

11.5 Unglazed bowl for washing (*conca*), Montelupo, 1540–70 (cat.104)

and this distance meant that she communicated regularly with her husband in writing. In her letters she did not shy from describing her daily routine, in which soft furnishings and clothing occupied a key place: 'In the morning [I get] the house clean, the meal well prepared, the children well dressed and all set, and no complaints: then comes the … weaver, the blanket-maker, the tailors.'[17] She also wrote to Antonio about the domestic chores, particularly the laundry (*lissia*), a Herculean task that traditionally

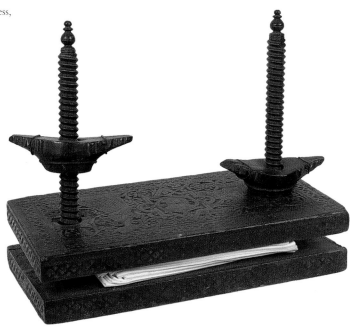

11.6 Handkerchief press, possibly Venice, early 15th century (cat.212)

took place twice a year and lasted several weeks. Although most houses had the dedicated space and basic equipment for everyday washing – such as cauldrons, wash tubs and bowls (plate 11.5) – many Venetian noblewomen, like Fiorenza, carried out their large-scale laundry at their country estate. 'With great effort I have begun the laundry, but it is impossible to get men or women [to help] for money,' she remarked.[18] Complaining about the uncertain weather that would not allow the washing to dry, she wrote: 'It did not help me to work with all diligence and finish [the laundry], now I can only wait for the sun.'[19] While his wife was away doing the laundry, Antonio was having an affair with a local prostitute, known as 'la Valacha'. In response to Fiorenza's accusations of adultery, he blamed her over-zealous housekeeping, which had allowed her 'to depart from your husband to do the *lissia*, and leave him to the dangers of life'.[20] In wealthy houses the laundry had become such a massive undertaking because of the increased quantity of soft furnishings, household linen and clothing. To assist in the maintenance of these costly and delicate textiles, publications provided hands-on advice (see p.176) ranging from mixtures for removing all sorts of stains on different types of fabric to instructions on how to fold linens (plate 11.6).[21] In this way even a humble task such as the laundry could foster women's access to the written word.

11.7 Spindle whorls
inscribed with women's
names, possibly Faenza,
early to mid-16th century
(cat.204)

The housewife's involvement in the aesthetics of the household, however, went beyond the preservation of the material status quo, and could include the manufacture of domestic textiles and even some items of clothing. In affluent households she was also expected to supervise the maids who 'spend their time in sewing silk and linen fabrics … and supply the house with of all sorts of household linen'.[22] Sewing clothes, embroidering linen and even small-scale weaving were all much needed and highly recommended activities.[23] During the Renaissance, however, needlework and weaving took different social routes, the former becoming increasingly associated with virtuous domestic occupations for elite women, and the latter with the lower classes (or, alternatively, with professional male production). The domestic occupations that suited a well-born housewife were distinguished from those that could be seen as out of date or not appropriate to her rank, including spinning and weaving: 'Today they are both left to women of low status, since this good practice is not in use anymore,' wrote Ludovico Dolce in the 1540s.[24] In reality, however, such distinctions were unlikely to be so clear-cut, and spinning wheels could still be found in late sixteenth-century patrician households.[25] The earthenware whorls illustrated here (plate 11.7) were designed to weigh down the spindle while spinning wool or flax and were probably given to women as part of marriage rituals. The women's names inscribed on them range from the popular, like 'Antonia', 'Margarita' and 'Agnola', to the sophisticated, like 'Chasandra', 'Violante' and 'Beatrice', thus suggesting recipients at different social levels.[26]

The association of textile manufacture with lower-class women is demonstrated by ample documentary evidence. By the fifteenth century the industry had

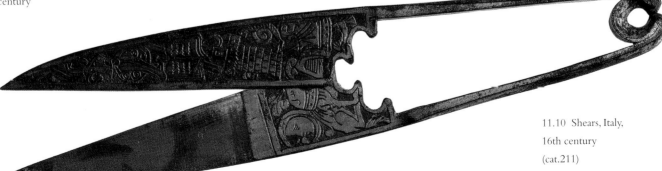

11.10 Shears, Italy,
16th century
(cat.211)

11.8 *Tombolo* for making
lace, Venice,
late 16th or early
17th century
(cat.205)

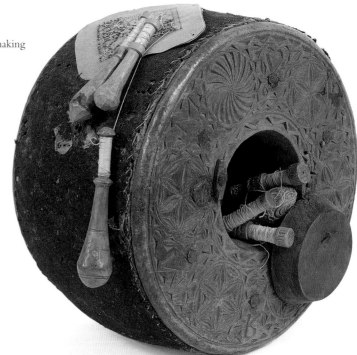

11.9 Lace border made
on a *tombolo*, Venice,
late 16th century
(cat.206)

become highly specialized and dominated by male workers, confining female labourers to the humblest, least-skilled and worst-paid jobs.[27] Interestingly, however, connections between women and textile production could also exist at the opposite end of the social spectrum. Elite women in Venice occasionally participated in the local silk industry, making luxury commodities such as light fabrics, veils, ribbons and haberdasheries of different kinds for their own use and possibly for the market as well.[28] By the late sixteenth century lace-making was monopolized by female workers. Because of its highly decorative character, pillow-lace was in especially high demand. A very specialized and excruciatingly elaborate activity, it was mostly carried out by 'professional' women from the labouring classes (plates 11.8 and 11.9).[29]

Sewing was traditionally associated with women of all classes. Often seen as the essence of femininity, sewing marked girls' passage into adulthood as they manufactured items for their trousseau. Accordingly, a sewing basket, shears (plate 11.10) and needle-case were standard components of the bride's trousseau.[30] Requiring minimal equipment (plate 11.11), sewing and embroidery were universally presented as an activity embodying virtuous womanhood. Representations of the Virgin Mary, a role model for all women, often prominently featured sewing utensils. Sewing carried strong ethical connotations, often being presented as an honest alternative to less respectable – but clearly fashionable – activities, such as singing, dancing, and playing music or table games. As moralists put it, how else was a woman

11.11 Thimble and ring
thimble, northern Italy,
16th century
(cats 207 and 208);
button, northern Italy,
1500–1550
(cat.210)

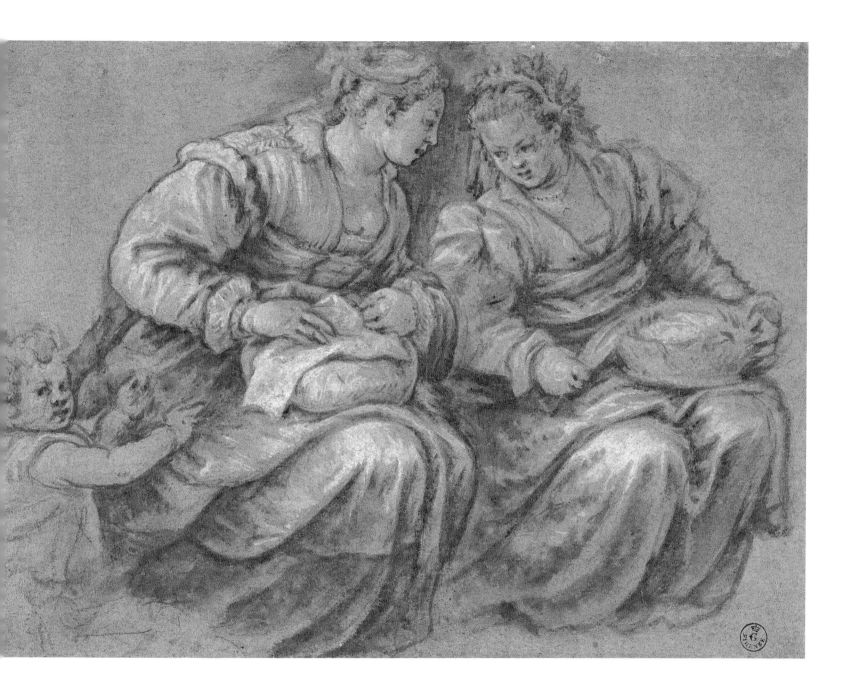

expected to earn praise and honour for herself, if not by making clothes for her family, 'perhaps by playing chess, cards ... or dice, or by being able to sing and play [music] like a whore'?[31] Sewing combined utility and virtue with opportunities to socialize with other women within the home, as suggested in this drawing (plate 11.12). Although the two women are vividly portrayed with their handiwork and tools – including a sewing basket and shears – their attention is not concentrated so much on the work or the

11.12 Jacopo or Francesco Bassano, *Sewing Scene*, Bassano, 1587 (cat.200)

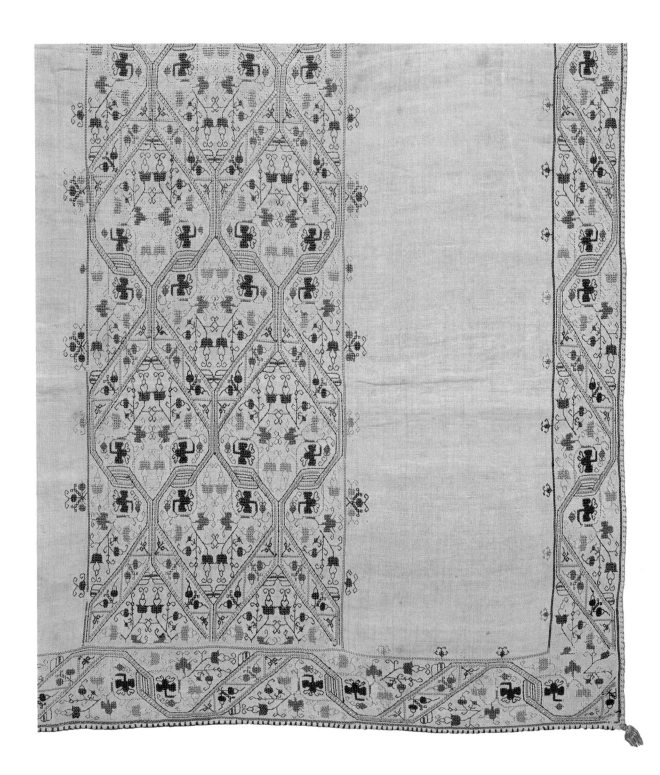

11.13 Cover with
polychrome silk embroidery,
Italy, 16th century
(cat.203)

demands of the small child, but on their intimate conversation. Sewing could also provide some handy additional income, although for reasons of decorum women were encouraged to sell their goods through intermediaries rather than directly. Home-made clothing could include items such as shirts, doublets, socks, leather goods and furs, while items for the house could range from blankets and tablecloths to door hangings, often complementing the work of professional craftsmen.[32] The fine linen covering illustrated, with colourful silk embroidery and repeated ornamental patterns demanding more patience than technical virtuosity, could have been produced at home (plate 11.13).

WRITING WITH THE NEEDLE: MODEL-BOOKS AND WOMEN'S EDUCATION

Needlework and writing were often used to embody the irreconcilable opposition between female and male activities. In Dolce's *Dialogo della Institutione delle Donne* (1545), for example, the female character Dorothea suggests that the ability to sew belongs to women in the same way as the ability to write belongs to men.[33] And yet in reality such divisions were less clear-cut, as tailoring and embroidery grew as male professions, while housewives learned to use the written word to support their domestic activities. Often designated as *esemplari* (books of samples), on account of the examples of needlework that they contained, printed model-books are a fertile source for the understanding of sixteenth-century domesticity and of women's access to basic learning (plate 11.14, overleaf).[34] This Europe-wide publishing phenomenon gave rise to around 190 volumes in Italy between 1527 and 1600, and went into decline only in the seventeenth century.[35]

Initially presenting collections of pre-existing design drawings, these model-books developed at a steady pace, constantly expanding and updating their repertory of patterns in line with changing fashions. As their technical content and know-how grew, they became increasingly specialized. Cheaply printed in small formats on the same presses responsible for producing literacy and numeracy manuals, with which they shared their overall look, model-books were unquestionably one of the most successful genres ever aimed at a socially wide female readership. In the hope of enhancing their commercial prestige, however, many of them were dedicated to women of the elite, mostly Venetian. For example, in 1543 Mathio Pagano dedicated his *Ornamento de le belle et virtudiose donne* to the sisters Petronilla and Catharina d'Armer, while Giovanni Ostaus addressed his *La vera perfettione del disegno*, published in 1557, to 'Signora Lucretia Contarin', from the distinguished Contarini family. For the privileged few, model-books could also take the form of fine manuscripts. In 1559 Lunardo Fero dedicated a book containing dozens of embroidery patterns to the 'virtuous and noble' Venetian Elena Foscari. Beautifully crafted with pen and watercolour, it displays an impressive range of floral and ornamental motifs, some inspired by classical forms, others by contemporary Middle-Eastern designs (plate 11.15). On the last page the Foscari arms feature prominently, as both a mark of the book's ownership and a pattern to be applied to all kinds of household textiles.

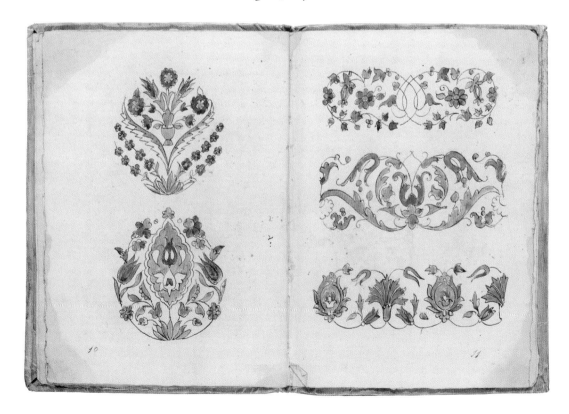

11.15 Lunardo Fero, opening from a manuscript of needlework designs presented to Elena Foscari, Venice, 1559 (cat.202)

11.14 Nicolò D'Aristotile,
known as Lo Zoppino,
Gli universali de i belli recami,
model-book for needlework,
Venice, 1537
(cat.201)

needlework. In this way they highlight their own commercial value as manuals, while at the same time promoting educational relationships among women. The title page of Vavassore's *Esemplario di lavori* (1530), for example, illustrates a group of women ranging from childhood to middle age (plate 11.16, left). The little girls are busy scrutinizing the work of their older counterparts or consulting the books directly. Embroidery is shown alongside weaving, so that the whole process of textile manufacture, from design to sale, is represented. The role of these books as agents in promoting and reinforcing women's literacy is most clearly demonstrated by a page in Vavassore's model-book devoted to 'ancient letter-forms', showing a pattern with the twenty-two letters of the Italian alphabet written in Roman script (plate 11.16, right). In the introduction he advises women to use it to 'write with the needle, and embroider the names of everyone as needed',[40] thus spurring women to familiarize themselves with writing, while providing them with a practical rationale for doing so. With their elaborate title pages, dedicatory letters, poems and precise instructions, these books are a powerful testimony to the emergence of a distinctive female readership, literate and competent enough to embrace the written word as part of their domesticity.

It is not yet possible to prove the existence of organized schools within elite houses, but there is little doubt that needlework played an important part in the upbringing of girls.[36] Nunneries involved in female education adopted it as standard practice in preparation for married life.[37] Needlework was unanimously seen as a highly desirable activity, since it was seen to keep girls busy and protect them from the dangers of an idle mind. On entering the house of her friend Margherita, the protagonist of Alessandro Piccolomini's *La Raffaella* (1538-40) congratulates her on her industriousness: 'Your hands are never idle, as I always find you busy making and embroidering something.'[38] By the late sixteenth century the *donna di casa* was often advised to create suitable sewing and needlework activities as a safeguard for the virtue of her daughters and other women of the household.[39]

Title pages of model-books emphasize the role of the mother in the transmission of this form of domestic knowledge to her daughters and other young girls. Alongside the various stages of manufacture and sale of textile items, they often include domestic scenes representing women teaching girls

★ ★ ★

During the Renaissance the figure of the *donna di casa* developed in line with the house itself, acquiring new domestic skills. While the aesthetic importance of the house for the family identity grew, women were often put in charge of domestic decoration, including the active production of soft furnishings. Sewing and embroidery were traditional activities in girls' upbringing, but they also fostered women's access to the written word.

11.16 Giovanni Andrea
Vavassore, *Esemplario di lavori*,
model-book for needlework,
Venice, later edition of 1540
(cat.166)

BOOKS

ROWAN WATSON

B ooks made only a modest appearance in Alberti's *I libri della famiglia*, written in the 1430s. While the 'cultivation of letters' would help gain fame, Alberti stressed that fathers should ensure that their sons learnt mathematics and geometry, and pursue sports, as 'practised in antiquity by good men'. Buying the most beautiful books (*bellissimi libri*) was unnecessary, although it denoted a generous and magnificent nature (*animo generoso et magnifico*). Women were given little attention, even when married: the wife of Alberti's protagonist was allowed access to all valuables in the house except family books and records, something not necessarily typical of the wealthier urban classes. People with scholarly interests collected editions of classical and patristic writers in large-format volumes (plate 11.17). Such works were supplied by booksellers like the celebrated fifteenth-century Florentine, Vespasiano da Bisticci,

11.17 Attr. Girolamo da Cremona, illumination from Plutarch, *Vitae virorum illustrum*, Venice, 1478 (Bibliothèque Nationale, Paris, Velinus 700 f.ir)

11.18 (*above*) Book of Hours with the arms of the Serristori family of Florence, Florence, *c.*1500 (cat.152)
This illumination attributed to Mariano del Buono depicts David and Goliath, a theme with powerful resonance for Florentines.

who sold manuscript books to clients as various as Cosimo de Medici and Andrew Holes, an Englishman working in Rome, before his retirement to write his memoirs.

Vernacular texts, usually circulated in humbler books at the beginning of this period, were enjoyed in courtly circles for relaxation and amusement. Ludovico Sforza, ruler of Milan from 1480 to 1499, had Dante read to him; Petrarch's sonnets were expounded to ladies and gentlemen as part of court entertainments. Early editions of vernacular texts were printed in large handsome volumes from the 1470s, increasingly with commentaries, those for Petrarch written by Filelfo and Bernardo Illicino originally for the Visconti and Este courts. By 1500 large illustrated editions of works like Boccaccio's *Decameron* or Dante's *Divina Commedia* could be bought for home reading, representing the growing prestige of vernacular works.

Books of Hours or Offices of the Virgin were widely owned. These were usually small-format volumes, sometimes wonderfully illuminated (plate 11.18). Florence maintained a tradition of producing de luxe illuminated manuscript versions for some decades after the arrival of printed editions in the 1470s. Many devotional books were imported from Paris, where publishers specialized in printed versions from the 1480s that were extensively decorated. In 1545 Francesco Marcolini in Venice printed a decorated Hours to rival French editions.

11.20 (*right*) Sixteenth-century Italian binding on an edition of works by Thucydides in Greek, Venice, 1502 (cat.247)

11.19 (*below*) Lodovico Ariosto, *Orlando furioso*, Venice, 1556 (cat.47)

11.21 (*below right*) Mid-16th-century Roman binding on an edition of Girolamo Malipiero, *Il Petrarcha spirituale*, Venice, 1538 (cat.248) This binding is decorated with an exquisite plaquette showing Apollo and Pegasus.

Small, pocket-format books for individual rather than collective reading at home emerged around 1500. Initially such books were written by hand, scribes like Bartolomeo Sanvito supplying princely scholars with classical texts. The Venetian publisher Aldus Manutius reproduced the idea in a series of small printed volumes that found an enthusiastic market in Italy and beyond, initially with texts in Greek and Latin and then in Italian, beginning with Petrarch in 1501. Such works might be given elegant bindings to match schemes of ornament. Private reading of vernacular works became widespread, with women providing an important part of the market. Ariosto's chivalric poem *Orlando furioso*, for example, appeared from 1516 in a series of versions to which illustrations were progressively added; those in Vincenzo Valgrisi's editions from 1556 in Venice provided a visual summary of the plot (plate 11.19). Other books found in domestic environments from the 1520s included manuals for practical activities, such as the primer by Giovanbattista Verini for learning how to write or improve your writing (see plate 9.5).

Books were scattered throughout the house, but were found in the greatest quantity in the study. They could be stored in chests or on shelves, often piled horizontally on their sides, unlike today. Decorative bindings were fashionable, featuring coats of arms and elaborate ornament (plates 11.20 and 11.21).[1]

BUSINESS ACTIVITIES

FRANCO FRANCESCHI

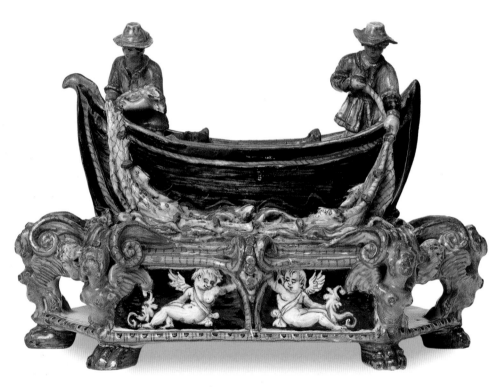

12.1 Possibly the workshop of
Patanazzi, inkstand, tin glazed
earthenware, Urbino, 1584
(Philadelphia Museum of Art,
Inv 1999-99-2a, b)

12.2 (*opposite*) Lorenzo
Lotto, *Agostino della Torre with
his son Niccolò*, Bergamo,
c.1513–16
(cat.232)
Agostino is depicted beside
his desk and holds a copy
of Galen's medical works.
On the table a number of
medical prescriptions are
visible.

WORK IN THE HOUSE, or rather the house as a place of work, is a theme that is often evoked but rarely investigated by historians of the pre-industrial period. The difficulty of locating the appropriate sources in order to penetrate the domestic walls has certainly contributed to this bias, but stereotypes have also played a part. In the case of the guild professions, in particular, the association between productive or commercial activities and public spaces has been so strong, it has completely obscured the discourse on domestic work. In fact, in Italian cities during the Renaissance the locations of economic life were not confined to the workshops of artisans and retailers, the warehouses of merchants or the counters of money-changers. Numerous male workers – and above all a significant proportion of the very many involved in the textile sector – used their own home as an 'instrument of work',[1] experiencing on a daily basis the benefits and drawbacks of the interaction between the functions of production and habitation (see pp.70-71). Tax records, inventories of goods and court documents highlight this widespread reality, while more vivid testimonies can sometimes be found in narrative sources. For example, the sixteenth-century Tuscan author Antonfrancesco Grazzini describes a weaver working at his loom alongside his wife; a usurer who transforms his small house into a safe; a goldsmith intent on melting metals, with his door open onto the street; and an elderly doctor writing prescriptions for those in need as a pastime (plate 12.2).[2]

However, the house was not necessarily an alternative to the workshop, as demonstrated by the behaviour of the socio-professional group to be considered here, namely businessmen. In the fifteenth and sixteenth centuries the process that had gradually transformed travelling merchants into sedentary businessmen, working primarily in one place, had long been completed. Only those of limited financial means accompanied the movements of their goods on a regular basis.[3] The international merchant, who

12.3 Bernardus Sylvanus,
Ptolemaic world map,
Venice, 1511
(cat.243)

One of the examples used by Luca Pacioli in his *Trattato de' computi e delle scritture*, published in 1494, refers to 'goods at home, or rather in warehouses'[5] and this is confirmed by inventories of objects. In the Venetian house of Antonio Diedo, destroyed by a fire in 1495, oil, spices, wool and other commodities were stored together with the 'treasures and precious furniture'.[6] The rooms and corridors of the homes of the Rubbi family, small-scale merchants originating from Bergamo and working in Venice during the second half of the sixteenth century, were just as cluttered with similar goods.[7] The 1604 inventory of the Venetian residence of Francesco Urins, striking for its large number of paintings (including many family portraits), several musical instruments and a large map of the world (plate 12.3), records that the house was equipped with capacious stores full of all sorts of products.[8]

The organic link between the spaces of work and habitation is also documented in other cities, albeit in different forms. In Rome the Leni family, a prominent lineage of merchants active in the fifteenth and early sixteenth centuries, lived in residential complexes containing areas where they also carried out their business activities, either personally or with the help of administrators.[9] In Renaissance Milan merchants of medium wealth normally lived in houses with two or three floors and with one or more workshops on the ground floor, connected internally by staircases to the upper rooms. The houses of wealthier merchants, however, were structured in a way that was more similar to noble *palazzi*, evolving around a central courtyard. But even in these cases the hall, garden and service areas were accompanied by ground-floor spaces designed specifically for commercial activities or − in the case of merchant-entrepreneurs − production processes. In the mid-fifteenth century the arrangement of the Missaglia family house, located in the heart of Milan, allowed these famous armourers to oversee at all times both the traffic of materials through the shops,

was generally also involved in financial operations, managed his business without any need for frequent travel. In such circumstances, the city headquarters of the company, which could be an integral part of the businessman's home, played a definitive role.

The Venetian tradition of using the home additionally as a warehouse (*casa-fondaco*), where the ground floor was set aside for commercial functions, is well known. In such cases, a *portego da basso*, a ground-floor space that extended across the entire length of the building, opened onto the *rio*, or canal, the area for delivering and unloading goods, while the remaining spaces were used as warehouses and offices. A staircase led to the first floor, with a *portego di sopra* laid out in the same way, surrounded by the rooms of the house, starting with the *camera* belonging to the head of the family (see pp.54-7).[4] This peculiar form of juxtaposition between 'private' life and the economic sphere lessened, in some cases from the beginning of the fifteenth century. Various ground-floor premises were transformed into storage spaces for commodities arriving from estates owned on the mainland, or into opulently decorated reception rooms where the family received guests. However, it was not a widespread or uniform process.

which faced the street on the entrance hall side, and the finishing-off of armour, which took place in the workshop situated at the back of the building.[10]

Still in Lombardy, in the town of Cremona, the professional activity of Gianfrancesco Amidani, a merchant-banker who died in about 1580, was carried out entirely within the *palazzo* he owned in the Santa Lucia neighbourhood, made up of approximately twenty rooms. In the building, where he lived together with his three children and the family of his nephew and cashier Cornelio, ten servants and three youths (perhaps apprentices), he set up a 'little warehouse of things' and a 'warehouse by the door'. While the former was used mainly as a depository, the acts of the notary Raffaele Gariboldi make it clear that the latter was also used by the businessman to draw up contracts and to receive clients who required the services of his bank.[11]

While many other examples could be added, it is sufficient to note that prescriptive literature sometimes reflects the existence of these 'polyvalent' residences. In his treatise *Della economica* (1560), a typical example of the genre of literature for the household popular in the Renaissance, Giacomo Lanteri established a strong link between the layout of the house and the social profile of its owner, following in the footsteps of Sebastiano Serlio and Andrea Palladio.[12] Although it was a classification formulated mainly on ideological grounds – since it was necessary for social hierarchies to be manifested in hierarchies of external symbols and lifestyles[13] – it embodied the principle that different types of residences were required for different forms of professional activity. In the case of the merchant, the principal criterion was not that of the 'magnificence' expected of members of the highest nobility, but instead that of comfort and convenience (*comodità*). For Lanteri, therefore, the merchant should 'first of all choose the site of his house preferably in the part of the city that is most convenient for his business activities'. Furthermore, workshops and warehouses should be located where they are protected from the heat, cold and damp, and the distribution of space should be organized according to commercial needs.[14]

Certainly, this model was not always applied everywhere. In Rome and Genoa the spaces for economic use that grew up inside mercantile residences were often rented out in order to supplement the revenues of the proprietors, while in Florence it seems that the great *palazzi* 'did not include any commercial … space'.[15] It was no coincidence that Benedetto Cotrugli from Ragusa, the author of the *Libro dell'arte di mercatura* (1458) strongly inspired by Florentine practice, made no reference in his description of the typical merchant's house to the presence of warehouses or workshops. Nevertheless, his indications are just as revealing because, although on the one hand they describe a habitation that was not equipped for the physical movement of goods, on the other they ascribe a fundamental role to the home in the running of the company. With experience derived from his own practical involvement in commercial activity, Cotrugli advised the merchant to choose a home near the central marketplace, since he had often needed to 'go or send someone else home' in haste for work matters. He reminded his readers that, to the eyes of strangers, a beautiful building assisted in improving the image of the owner, and he also suggested furnishing the *primo solaio*, or mezzanine, with a *scrittoio* in order to do business and receive clients, with the recommendation that it should be 'separate' from the rest of the house so that the people arriving would not disturb the family.[16] Cotrugli perhaps based his description partly on the rooms in Venetian *case-fondaco* long used as offices. They were known as *mezà*, or mezzanines, and were generally located on the first landing on the staircase that led from ground level to the first floor. These areas were easily accessed from both above and below and were close to the rooms inhabited by the family and to the entrance to the house, but at the same time relatively isolated.[17]

The *Libro dell'arte di mercatura*, however, also reflected another phenomenon, highlighted in numerous contemporary sources, namely the increasing diffusion, even in merchants' households, of that 'very special room' (*scrittoio*, *studio* or *studiolo*) that was destined to become one of the most characteristic aspects of ways of Renaissance living.[18] As is well known, it was an exquisitely personal environment whose character altered according to the needs of the owner and the different functions it performed: office, archive, library, place of study and meditation, repository of precious objects (see pp.288–93).[19] The *scrittoi* set up in Prato by Francesco Datini in around 1400 were essentially centres intended to manage the

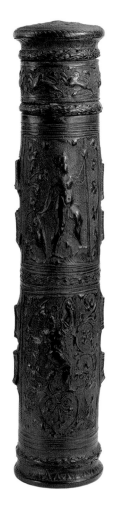

company and the family patrimony. For Datini, who was not personally interested in humanistic pursuits, they were, above all, the solution to various logistical problems that affected the businessman: the need for seclusion, the necessity of storing confidential documents (plate 12.4), the desire for a comfortable place to conduct long work sessions.[20] The type of merchant referred to by Cotrugli was probably moved by the same practical concerns, but it is significant that the author thought it appropriate to include a few words about the merchant who 'delighted in letters'. The latter was an increasingly present figure on the urban landscape in fifteenth-century Italy and was advised not to 'keep his books in the shared *scrittoio*' but to provide for a 'separate *scrittoio* in his *camera*, or at least next to it, in order to be able to study' whenever time permitted.[21]

It was often the case that patrician residences were equipped with more than one room used exclusively by the head of the family, for different purposes. According to the inventory drawn up in 1424, the Florentine Niccolò Da Uzzano owned two *scrittoi* located on the ground floor of his building, one for business activities and the other serving mainly as a

library.[22] More than a century later the Venetian Stefano Silvestri had no fewer than three *mezà*, one of which was 'for writing'.[23] However, specialization was not the rule. In the 'beautiful and comfortable' house owned by the Florentine Francesco Sassetti, a partner in the Medici bank as well as a refined bibliophile, a single space was designated for both work and study: the *scrittoio* connected to one of the rooms at the back of the house, which was heated by a fireplace and furnished with a bath.[24]

The *scrittoio* formed a very strategic location in terms of the firm's administration. The businessman moved among the objects that shaped his daily activities: chairs, desks, tables 'to count money', coin caskets, chests, shelves and cupboards for documents, series of accounting books, loose papers and bundles of letters, scissors, lanterns, sometimes also a clock, weighing scales and some geographic or nautical maps.[25] Naturally, these were complemented by the necessary tools for writing (plates 12.1, 12.5, 12.6 and 12.7), commencing with *scrittoi* desks like one in the office of the Venetian merchant Alessandro Borghetti in 1594: a writing-desk surmounted by two small walnut intarsia cabinets with drawers for papers.[26]

12.4 Case for documents and writing materials, Italy, 1500–1550 (cat.235)

12.5 Lower part of an inkstand, Urbino, 1584 (cat.240) Such inkstands were used for storing writing tools, as is reflected in the interior of this object.

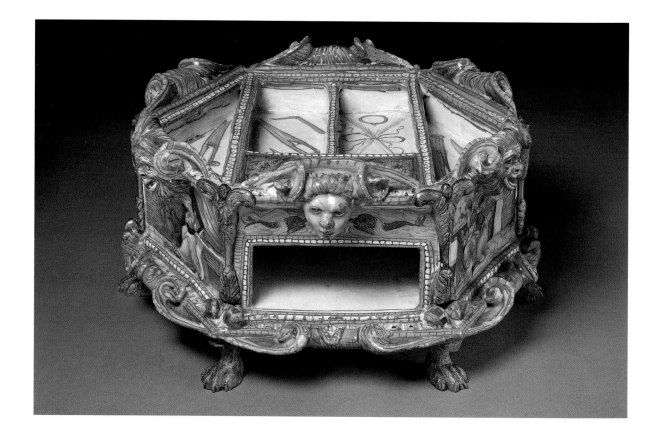

12.7 Spectacles frame, probably Florence, end 14th to mid-16th century (cat.237)

The chronicler Dino Compagni, a contemporary of Dante, had already described the principal quality of the merchant as the ability to 'write beautifully'.[27] The figure of the merchant with his hands permanently 'stained with ink'[28] enjoyed a long fortune, which was hardly affected by Giovanni Della Casa's ironic image of 'those who emerge from their study to join the people, with a pen tucked behind their ear' (plate 12.8).[29] Businessmen were happy to describe themselves in texts and be represented in portraits in the process of updating their account books and attending to correspondence.[30] The reality, however, was decidedly more prosaic than these representations suggest, given that both occupations required organization, rigour and constant application. Benedetto Cotrugli admonished:

You should … keep your desk in an orderly fashion and record the provenance, year, month and date of all the letters you receive, put them in one place, reply to them all, and mark them with 'replied'. Then, every month you should tie them in a bundle and store them. In the same way you should string together the bills of exchange that you have paid and make sure you keep the most important documents, such as private and notarial papers. And keep your writings always in your mind …[31]

These were certainly onerous tasks, even for those with assistance. Not all were able to follow their affairs in the calm methodical way that Nicomaco, the merchant in Niccolò Machiavelli's *Clizia* (*c.*1515), did.[32] Francesco Datini, for instance, often complained in correspondence of exhaustingly long periods of work, the haste and 'melancholy' of some days, and the nights spent with a pen in his hand, until he finally asked God, rather melodramatically, to grant him an existence better than the 'dog's life' he was leading at the time.[33]

These preliminary thoughts deserve to be developed more systematically. A deeper understanding of the material context that informed the activities of businessmen would represent a small, but significant, step towards increasing our knowledge of the development of economic life and social behaviour in the Italian Renaissance.

12.8 Fountain pen, probably Tuscany, mid- or late 14th century (cat.239)

12.6 Signet ring with a coat of arms and inscription 'Petrus Novarino', Italy, 15th century (cat.238)

SCIENTIFIC KNOWLEDGE

JIM BENNETT

Among the disciplines that are today classified under 'scientific' knowledge, the two that were most conspicuous in a Renaissance home were medicine and astronomy. Both subjects conformed to a broad 'natural philosophy' that was taught at a technical level in universities but also pervaded a good deal of everyday thinking about nature. Derived from the writings of Aristotle, it explained the material content of the world and the causal relationships between these material things, relationships that lay behind the changes we observe and experience, such as motion, growth or decay. Change in the body was perceived as the shifting balance between health and disease; in the heavens the movements of the sun, stars and planets were experienced through the cycle of day and night, through the progress of the calendar and the seasonal year, and through the unfolding of individual destiny. These two aspects of domestic learning – focused on health and the heavens – were not unconnected.

Medicine could be practised in the home in a variety of ways and with a range of professional interventions (see pp. 174-8), according to inclination, wealth and social standing. Much was done in the family, through the use of dietary regimes and medicinal herbs. A surgeon might dress wounds or set bones, while at the top of the professional tree, and of the scale of charges, was the university-educated physician, diagnosing and prescribing according to the Galenic theory of health, consistent with Aristotelian natural philosophy.[1]

Astronomy, too, had different levels of expertise and of professional service. Here there might be instruments as well as books in the home. At a basic level were common calendars and almanacs, and simple sundials. But, again depending on wealth and inclination, there might be different types of mathematical instruments, for contemporary geometry was largely a practical discipline, with a range of applications to everyday life. There were different types of portable sundials for telling the time, and vernacular books were published to instruct owners in the efficient use of their instruments. While sundials were commonly used, only a professional or a serious enthusiast

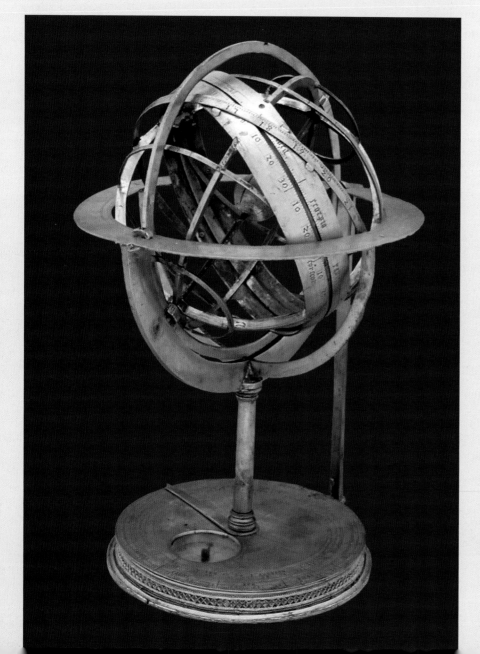

12.9 Armillary sphere,
Italy, *c.*1500
(cat.261)

12.12 (*right*) Set of
drawing instruments,
Italy, early 16th century
(cat.236)

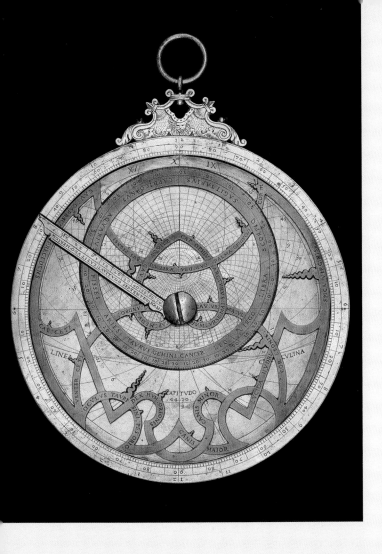

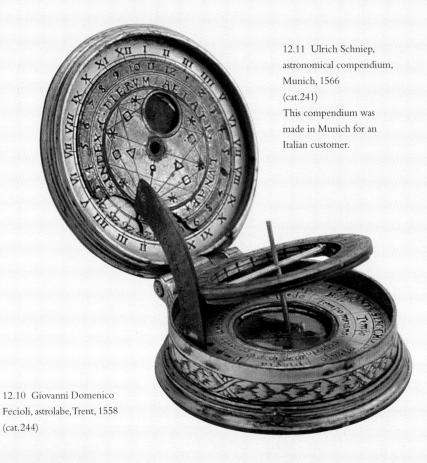

12.11 Ulrich Schniep, astronomical compendium, Munich, 1566 (cat.241) This compendium was made in Munich for an Italian customer.

12.10 Giovanni Domenico Fecioli, astrolabe, Trent, 1558 (cat.244)

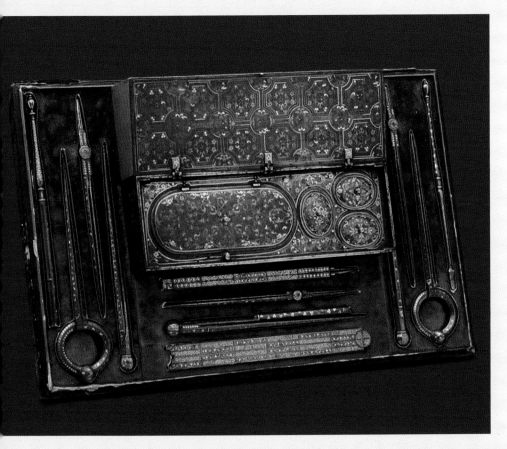

would have an astrolabe for astronomical calculations (plate 12.10), but one might be encountered, perhaps alongside an armillary sphere (plate 12.9), when an astrologer attended to cast a horoscope, for example at the birth of a child (see p.126). Although the use of instruments was widespread, only the expensive and elaborate examples have generally survived, since they were prized and collected, and were made of more durable materials. Wood and paper devices were commonly used, but mainly those made of brass, gilt brass and sometimes silver are seen in collections today.[2]

Astrology provides the link between health and the heavens, and not only through the predictive power of the horoscope. A physician was trained in consulting the heavens for predicting the course of disease and determining the most propitious time for therapeutic intervention. Using an astrolabe would certainly have inspired confidence in a patient. Individuals, too, might wish to match their actions with the influences of the planets, and a pocket astronomical compendium, as well as telling the time by the sun or the stars, might have specific features for self-help astrological guidance (plate 12.11). Drawing instruments, including different types of compasses, dividers and rules, were useful for the many applications of geometry, such as consulting maps, making plans of a garden or an estate, or even for working on schemes for altering the house itself (plate 12.12).

HEALTH, BEAUTY AND HYGIENE

SANDRA CAVALLO

13.1 *I secreti della Signora Isabella Cortese*, recipe book, Venice, 1561 (cat.90)

The health of household members was taken care of first and foremost in the home. The sick were treated with the assistance of doctors, barber-surgeons, apothecaries and other healers, but primarily through treatments self-administered by patients, or dispensed by their family members, servants and neighbours. Domestic medicine was a significant reality: medical wisdom and techniques, as well as the properties of the substances of which remedies were composed, were available to lay persons rather than being exclusively the domain of medical professionals. This is confirmed by the widespread circulation, from the mid-1500s, of printed recipe books – sometimes called 'books of secrets' – which were largely based on medical prescriptions for the treatment of all kinds of ailments. These were not just the most common illnesses (stomach upsets, haemorrhoids, leg ulcers, burns, nose bleeds, hangovers, toothache or flatulence) but also the most serious and irreversible (paralysis, plague, syphilis, deafness). In the *Secreti del reverendo donno Alessio Piemontese* (1555), one of the most successful examples of the genre, around a third of the 350 recipes were for the making up of medicines.[1] But even in the early decades of the century short recipe collections such as the *Dificio di ricette* (1525), only some thirty pages long, were circulating in Italy.[2] These books were sold by pedlars and reached a wide popular market, albeit a pre-eminently urban one. This was not a variety of medicine alien to the learned medical tradition, as the recipe books were sometimes vernacular editions of works originally produced for a professional audience, then adapted for a lay clientele.[3] The popularization of medical knowledge has a long history predating the advent of print: for centuries domestic practice drew on the rich literature of herbals and regimens of health, whose advice was often presented in easily memorized rhymes and sayings.[4]

Even after the advent of the printing press the collecting of practical advice about health management and domestic economy still relied widely upon both oral and handwritten transmission. Libraries and archives are full of domestic manuscripts that present similar features to the printed books of secrets. Collections of recipes such as Leon Battista Alberti's *Amiria* or Caterina Riario Sforza's *Experimenta* – compiled in the late 1400s – circulated for centuries as manuscripts and were published only in the nineteenth century.[5] We are not therefore in the presence of a shift from script to print. Rather, the printed book became a source to be drawn upon in the compilation of domestic recipe collections. The derivation of recipes and advice from books of secrets, as well as from more specialized medical treatises, is apparent in manuscripts.[6] But it is also

13.2 Recipe to cure toothache included in the Cronaca de'Freschi, a manuscript chronicle of the Freschi family, Venice, early 16th century (Biblioteca Marciana, Venice, mss Italiani CL.VII.165 (8867))

clear that numerous recipes have been handed down orally: among the sources plundered by the anonymous writer of the *Medicinalia quam plurima*, a manuscript compiled in Genoa at the turn of the fifteenth and sixteenth centuries, we find, for example, 'the doctoress of Montogio', 'Friar Pietro of the order of St Augustine', and 'a Genoese apothecary who had it from a Milanese Carmelite Friar who in turn had it from a Milanese witch in confession'.[7] The sources are mentioned primarily when they consist of a professional healer, whether male or female, orthodox or unorthodox; clearly, professional experience enhances the status of the recipe. But special authority on the subject is also invested in the advice of ecclesiastics or foreigners, especially if they belong to religious minorities ('a Hungarian doctoress', 'Adam the Jew'). The exoticism of recipes that come from distant places implies the promise of a miracle cure. Far from being an uncritical assimilation of learned medicine or the written word, every manuscript is therefore an original collation of advice from diverse origins, uniquely selected by the compiler.

Who composed these books and for what purpose? Female authorship is declared, though unconfirmed, for only two of the numerous printed recipe books, including that of Isabella Cortese (plate 13.1).[8] What we know about the disparities in education between men and women during the Renaissance suggests that the compilation of these collections must be attributed chiefly to men, and only to those women belonging to the elite.[9] However, reading literacy was much more common than writing literacy, so we can surmise that the use of the recipe books was mixed, both in gender and social terms. In any case, domestic medicine and more generally the sphere of domestic economy do not seem to have been an exclusively female domain. The forms in which the recipe compilations appear – often as self-contained manuscripts, but sometimes just as a bundle of papers combined with writings on other matters – suggest that there was a family aspect to their use. For example, a list of recipes to combat every manner of ailment occupies the final pages of the book of memories by the Freschi family in Venice, tacked onto an account detailing family genealogies, dowry contracts and their honorary titles (plate 13.2).[10] The sense of an accumulation of medical knowledge across the generations is also

conveyed by the existence in individual family archives of more than one domestic manuscript, compiled in different periods,[11] or by the succession of different hands in the writing of the same recipe collection.[12]

Of course not everyone produced their own medicines, cosmetics or perfumes, and many relied on remedies sold by apothecaries and charlatans, who were proliferating at this time.[13] However, there was not a complete shift from the domestic to the commercial production of remedies. Domestic recipe books were also used for ordering their 'own' prescriptions from the apothecary and thereby keeping a check on his services.[14] Moreover, the domestic production of these concoctions by lay people also had commercial ends; it seems, for example, that the household manufacture of cosmetics for sale was widespread among Jewish women.[15] In any case, the recipe books should not be seen merely as manuals for personal use but as a way of building up the kind of know-how that could be dispensed to others; making a gift of remedies or giving medical advice were widespread practices that enhanced individual prestige, patronage connections and social bonds in general.[16]

THE HOME AS A FOUNT OF REMEDIES

For the modern reader the most intriguing feature of domestic recipe books, whether printed or in handwritten form, is their varied nature. Frequently these are compendia in which recipes for remedies and therapies to cure every manner of disease are combined (to different degrees in the different works) with entries for the making of cosmetics and perfumes and others dealing with domestic economy. There are measures for keeping body lice at bay, likewise bedbugs out of the bed, fleas out of the *camera*, and spiders, flies and even snakes out of the house, reminding us how much the presence of these unwelcome guests was a constant of domestic life. There are also various methods for removing stains (a chronic problem) from particular fabrics and for making paint, glue, ink and dyes. The domestic recipe collections therefore help us to appreciate the variety of activities that could take place in the home and the range of preoccupations involved in managing the household. Culinary recipes are, on the other hand, absent or few in number and are usually confined to instructions for making preserves and candied fruits. But there is no shortage of instructions for entertainment and the performance of amusing tricks that will make people laugh: for example 'to make men appear of different colours' or 'to make cooked meat look wormy on the table'.[17]

Despite the variety of their purposes, there is considerable unity within these collections. The recipes employ fairly similar ingredients: herbs, plants and seeds of every kind, both local and imported from Africa and the Far East (ginger, cinnamon, saffron, cloves, nutmeg), as well as foodstuffs such as butter, lard, rice, eggs, flour and animals (for example, pigeons, dogs, frogs, hens, snakes, toads, scorpions), of which every part is used, the dung included. There are also human fluids, such as mother's milk and children's urine. Likewise the techniques employed in the manufacturing of remedies are similar and form part of everyday domestic culture: the ingredients are pounded, boiled, strained into a frying pan, distilled and left to separate. Moreover, we can see the versatility of the utensils that to the modern mind are merely connected with cooking: mortars, cauldrons, pots and pans, storage jars, frying pans, chopping-boards and scissors are mentioned at every turn in the household recipe books as tools for making rosewaters, oils, electuaries, perfumes, potions and ointments. There is no specialized apparatus, with the sole exception perhaps of the alembic, which was used in the process of distillation.

The composite nature of the recipe books, in which entries relating to spheres that we see as distinct (health, emotional life, beauty treatments, food, ornament) sit next to each other without any logical sequence, appear less odd if considered in the light of contemporary understandings of the body. One crucial principle is the idea of communication between the surface and the inside of the body. Thus treatment for gallstones may consist of the application to the sufferer's side of a hot concoction (made from the wool 'that lies around the testicles of the ram' with the addition of honey), and to keep the bowels regular, the navel will be smeared with an ointment made from boiled sage ground up with pork fat.[18] The same principle of permeability of the body also explains why cosmetic and hygienic practices are seen as having value for health: for example, washing one's hair with lye, as well as

making the hair 'long, blonde and very beautiful', also has the advantage of 'strengthening the brain and the memory' (plate 13.3).[19]

The ideals of feminine beauty, which women sought to emulate with the aid of cosmetics, were themselves strongly influenced by the medical theory of the humours that was dominant during this period. Since the predominant humours in women were held to be cold and damp, the expected outcome would have been blonde hair and a paleness of complexion that is just tempered by some colour in the cheeks, indicating the presence of the vital heat. The proliferation of make-up boxes in household inventories, tweezers for plucking the eyebrows (plate 13.4) and straw hats with a brim but with no crown (so that the hair could be bleached in the sun without any harm to the skin) does indeed confirm the explosion in treatments for facial appearance in the fifteenth and sixteenth centuries.[20] The use of a thick foundation, which could make a woman's face, hands and neckline extremely pale, of blusher to redden the cheeks and dye to lighten the hair all enhance the characteristics associated not only with female health but with emotional and moral equilibrium.

13.3 Palma the Younger, *Two Seated Women, One Dressing the Hair of the Other*, pen and brown ink, brown wash and black chalk on brown paper, Venice, late 16th century (The Pierpont Morgan Library, New York IV, 84)

13.4 Tweezers, northern Italy, mid- or late 15th century (cat.193)

Mind and body were in fact closely connected in contemporary notions of the body: each individual's particular cocktail of humours (the 'complexion') determined his or her psychological inclinations as well as physical weaknesses. The individual 'temperament' (choleric, stolid, melancholic, optimistic), along with moral characteristics and distinctive dispositions of a person (tendency to honesty or deception, determination or fickleness), could be read into physical features, following the dictates of the new science of physiognomy. The face in particular was seen as the mirror of the soul, of inner virtues and vices, and beauty a divine gift granted to those most deserving.[21] This emphasis on the appearance of the face is perhaps a contributing factor in the popularity of small-scale, portable mirrors, made of steel or, increasingly, of glass (plates 13.5 and 13.6). These were also employed in male beauty treatments; although male make-up was not in fashion yet, the appearance of a man's face received considerable attention. Men often shaved at home in the fifteenth century, frequently assisted by a professional barber (plate 13.7). In the following century the ritual of shaving was replaced by the careful trimming and grooming of beards, which had become an essential component of an adult man's look.

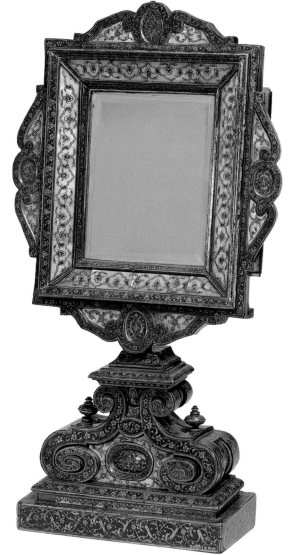

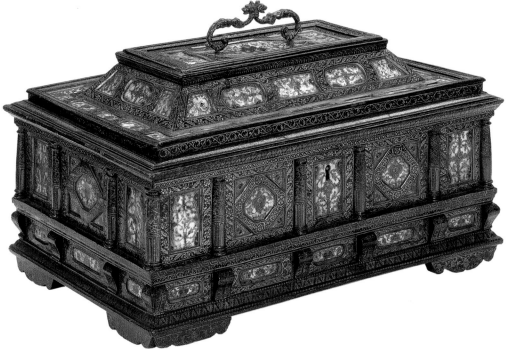

13.5 (*left and above*) Casket and glass mirror both with painting and gilding imitating Middle-Eastern ornament, Venice, 1575–1600 and *c*.1590 respectively (cats 186 and 187)

13.6 Workshop of Neroccio
de' Landi, mirror frame,
Siena, *c.*1475–1500
(cat.185)

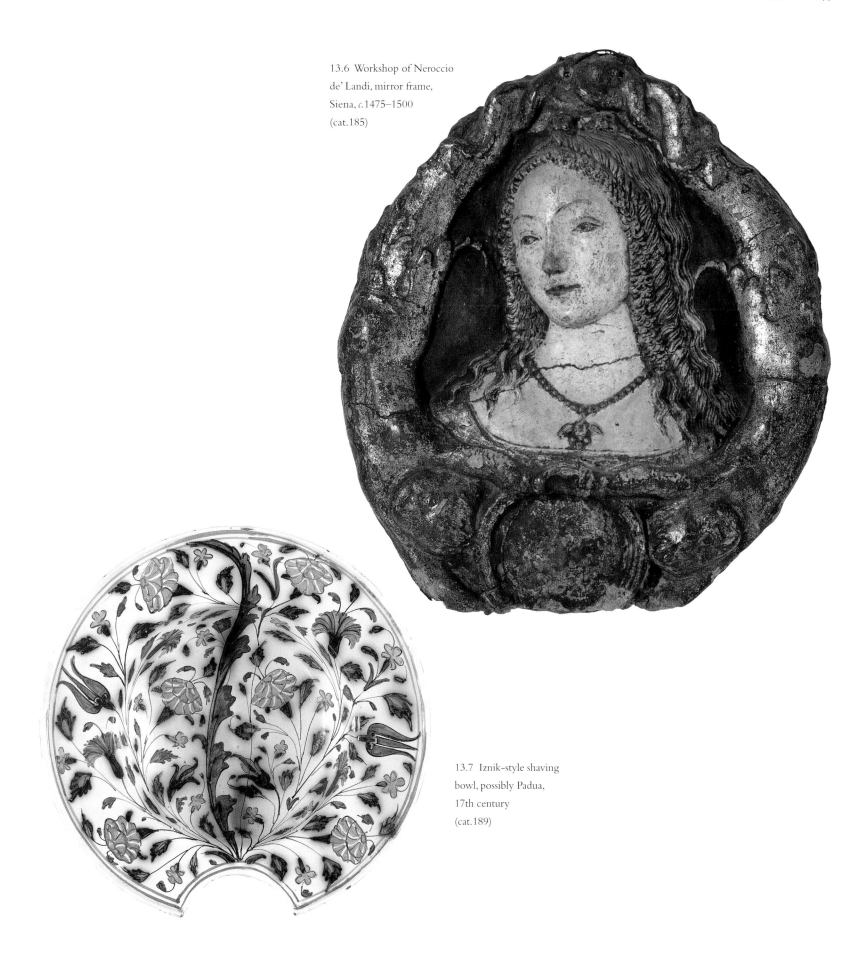

13.7 Iznik-style shaving
bowl, possibly Padua,
17th century
(cat.189)

13.8 Ear cleaner,
northern Italy, mid- or
late 15th century
(cat.194)

THE MANAGEMENT OF HEALTH

During this period health was approached in pre-
ventative terms as well as in terms of treatment and
cure. Rest, diet, physical exercise, sexual activity and
the quality of the environment were seen as having a
powerful effect on the balance of an individual's
humours. Many of the activities that took place
in the home were consequently dominated by
concerns about health; advice relating to diet and
other personal habits can be found in all kinds of
texts. Types of food and how they were to be pre-
pared are discussed on the basis of their appropriate-
ness to the humours rather than their taste. Sex was
regarded as necessary, because semen was seen as
a form of excrement that men must purge them-
selves of, but was to be practised in moderation – in
the household recipe books there are countless
remedies for keeping the libido at bay.[22] Some of
these opine that men should practise sex with their

wives only up to the age of thirty-five and they
advise against it as age advances.[23] There are no
sexual prescriptions for women; in health advice
books the female body is only depicted as an instru-
ment for procreation not as a sexed one. Accordingly,
remedies are for healing inflammation in the breasts,
for bringing on periods or making them less heavy,
and for becoming pregnant.

Even the part of the city where one should live
was a matter for medical pronouncement: altitude
and exposure to wind, and the quality of the air were
central considerations. The orientation of the house
was a matter of concern for most architects. Inside
the house damp air was to be avoided: high ceilings,
enabling the dampness to rise, were therefore prefer-
able to low ones, and those that were lined with
wood (*coperte di tavole*) preferable to vaulted ones.
Wall hangings were recommended for the winter –

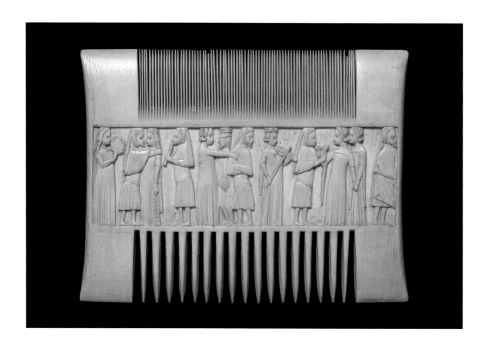

13.9 Comb,
northern Italy, *c.*1400
(cat.191)

13.11 Woven linen and cotton towel ('Perugia' towel), Italy, 15th or 16th century (cat.190)
Hand towels like this were widely used.

especially in the low-ceilinged mezzanine apartments where even patricians resorted to living – because they 'draw in' the dampness that would otherwise, if breathed in, make the humours 'greater and denser', creating a dangerous obstruction within the body.[24]

The theory of the humours also dictated rules of hygiene. A healthy body was one that regularly expelled the poisons that were produced within it. Every kind of evacuation was seen as healthy and approved of, especially those from the nose, the mouth and the ears, allowing 'the purging of the brain', one of the most important parts of the body.[25] We should not be surprised therefore to find, in the inventories of the Milanese aristocracy and the Florentine patriciate, specific objects for cleaning the teeth (spazadente) and the ears (stuzicatoio da orecchi; plate 13.8). These were made of silver or even gold and enamel, often in the shape of a horn hooked at the bottom, and hung on a chain as in Lorenzo Lotto's portrait of Lucina Brembati (see plate 8.10).[26] Further down the social scale, we find instructions for 'picks for cleaning the teeth' appearing regularly in household recipe books.[27] The cleaning of the body was always perceived as a form of purge, so hair-washing consisted of scrubbing the head with substances such as bran and using a number of fine-toothed combs and pieces of rough cloth 'for the head' (plate 13.9).[28] Rather than being a total immersion of the body in water, bathing meant a

steam bath, along with 'scrubbing and anointing' to make the skin porous and promote the expulsion of 'excrements', such as sweat and grime, whose stagnation in the body could provoke disease. In cities with the benefit of aqueducts and where water might easily be supplied to houses, such as Genoa and Rome, early sixteenth-century architectural plans for the palaces of the aristocracy, and even for the dwellings of middle-ranking families, make provision for a 'steam chamber' as an adjunct to the bedroom.[29] In these same cities this custom even extended to the lower orders, although they had to resort to public 'steam baths', which in Rome, for example, existed in every district at the start of the seventeenth century.[30]

The use of steam baths did, however, go into decline in Italy in the late Renaissance and was increasingly regarded as a 'German custom'.[31] The rise of an ideal of comfort and rested life (vita riposata) as a model for the true nobleman impelled the elites to abandon the practice, which was regarded as an example of the vehement physical training commonly performed by the ancients and thus associated with the martial arts, with 'vigorous' (gagliardi) movement, 'scrubbing and smearing'. 'Washing, scrubbing and anointing provoke great fatigue, besides being superfluous', was the comment of the Portuguese doctor Roderigo Fonseca.[32] In the popular treatises this activity is seen as a cause of blindness, a malady deemed to be particularly

common in the environs of the River Reno, 'where baths and steam baths are much frequented'.[33] Classified as one of the various forms of 'exercise', that is activities necessary for good health, steam bathing and scrubbing were still recommended for the old, who cannot undertake alternative forms of exercise, two or three times a month in the summer, once a month in the winter. It was also advised for children under five and those 'in service' and 'accustomed to immoderate movement' but was discouraged in adult and 'temperate' gentlemen who usually took their exercise walking, out riding or in carriages.[34] Bathing, moreover, was discouraged for women, especially if pregnant.

This is also the period in which the purging role of the bath was increasingly assumed by the linen worn on the body (plate 13.10). Therapeutic baths in the mineral waters of spas were in fashion among the elite, but in everyday life shirts performed the function of absorbing sweat and dirt.[35] This transformation was clearly delineated by the doctor Bartolomeo Paschetti (1602):

[The bath] was the discovery of the ancients for keeping the body fresh and clean, for since they did not have the custom of wearing linen garments, or even if they did these were used by few, they were apt to become covered in dirt of all kinds … but in our own times since all, rich and poor alike, are accustomed to wear shirts and thereby more easily keep the body clean, the bath is neither so widely nor frequently employed as in the times of the ancients.[36]

13.10 (*left and above*)
Embroidered man's shirt,
Italy, 1550–1600
(cat.179)

13.12 *Pitale* (chamber pot),
Liguria, early 17th century
(cat.199)

There is in fact evidence in inventories that the wearing of linen and shirts became widespread; even the poor owned more of them in the sixteenth than in the fifteenth century. It was thought that personal linen 'cleaned' and that changing it frequently meant the same as keeping clean.[37] Shirts became a symbol of both inner and outer cleanliness, of decorum as much as of health, and the women of the household set great store by providing a proper supply of them.[38]

The increasing density of the urban population, together with the scarce availability of water in cities is perhaps another, often neglected factor in this replacing of water by linen. Certain cities (Siena, Genoa, Rome) boasted aqueducts, sometimes restored from the ancient Roman installations, allowing for the distribution of a fixed supply of water. Otherwise water reached the home by way of a well or, as in Venice for example, from a cistern

that collected rainwater under the house. In grander houses it could usually be brought up with a system of pulleys from the ground level to the first floor, into the *sala* or loggia.[39] This was often the only water source in the house and it would be used for the numerous ablutions connected with eating. Even in less well-off households hands would be washed there before and after meals; 'hand towels' (*serviette da mano*) for this purpose are to be found even in households of modest means (plate 13.11).

Not far from the sink we often find the *destro, agiamento* or *necessario* (the latrine or lavatory). In the early period this was often merely a doorless niche located close to the kitchen, the loggia or the *sala* so that it could use the same waste pipes as the sink.[40] In the sixteenth century it became common to have an individual privy as an adjunct to the bedroom (plate 13.12). While there were a great many of these in palaces, which often even contained a row of latrines close to the kitchen, they were also to be found in the humble dwellings of two women suspected of magical practices in Venice – when the Inquisition guards arrived to arrest them the incriminating magic spells were aptly thrown into the *destro*.[41]

However, as this convenience became widespread in homes it had the drawback of producing foul smells. Sewerage with plentiful running water began to be built only at the turn of the fifteenth and sixteenth centuries, and only in certain cities. Until then the processing of sewage was a matter of relying on rainwater channels or cavities often placed under the cellar, which were liable to pollute the wells for drinking water. The bad odours exuding from the latrines were an even greater problem inside the house and for this reason attempts were made to close them off with doors and cover them with lids to contain the exhalations. Architects also experimented with different ways of ventilating this small space in order to resolve the pressing problem of the illnesses resulting from the 'foul and noxious' air.[42]

NATURAL AND RELIGIOUS AMULETS

After the Black Death the quality of air and odours became a source of particular concern in view of the fact that the disease was seen as originating in tainted air. There was a belief that odours were a substance, a physical entity with a direct effect on the mood as well as the body, and that they actually entered the brain. If they were bad odours, the poison they contained gave rise to physical and psychic disturbances; if they were good odours they had an invigorating and cheering effect.[43] The use of perfumes arose as a response to this growing fear of bad odours; they had a sanitary significance. They would 'purify' the air, not just perfuming it but altering its substance, making good what was bad in it. In periods of plague, which was deemed to be highly contagious,

it became customary to burn perfumed herbs and spices for therapeutic purposes. As a consequence, the use of liquid perfumes, perfumed pastes and resins to be burned became increasingly common. Each substance was regarded as having particular powers relating to its odour: for example, the smell of amber was thought to cure infertility, give protection from the plague and slow down ageing.[44] For the perfume to work, however, it had to be breathed in continuously and worn on the person. Hence the fashion for perfumed buttons, gloves, necklaces and pendants; rosary beads were even made with solid perfumed substances such as amber and musk.[45] Moreover, there was a widespread use of perfumed waters (known as *acqua vitae*) for washing the face and hands, to keep them healthy and to beautify

13.13 Ewer and dish, Deruta, early 16th century (cat.188)
The dish has a central emplacement for a ewer, of similar form and decoration to the ewer shown, though the objects are not a pair.

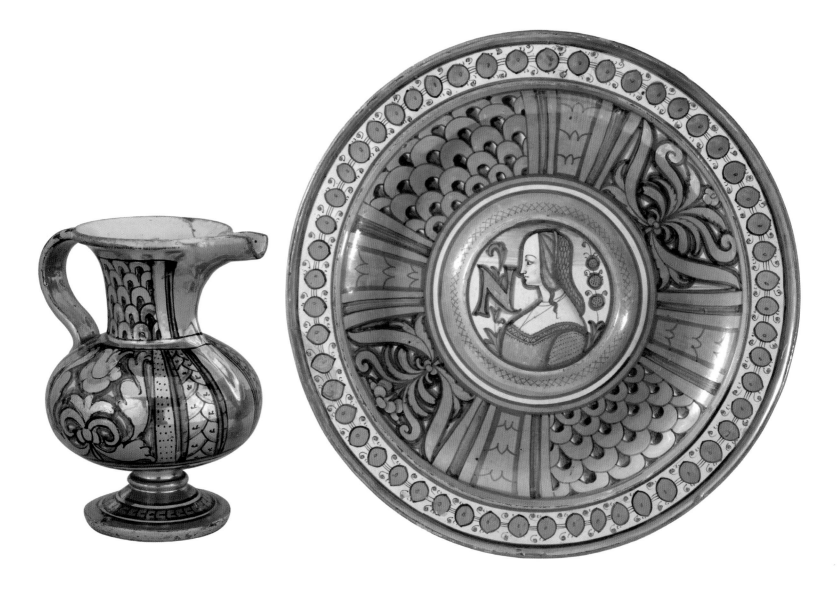

13.14 Pomander, Italy,
14th century
(cat.197)

the skin. At banquets these waters were offered to the guests for the ritual washing of the hands before and after meals in great bronze or silver containers known as *acquamanili*, while those found in the *camera* were more often made of glass or maiolica (plate 13.13).

Household objects and the ambient air were also perfumed. Little bags filled with violet and rose blooms and exotic essences were placed in chests to scent clothes and linen, as well as under mattresses.[46] Specialized jewellers modelled fragrant pastes in the form of tiny birds (known as *uccelletti di Cipro*), which released a pungent smell.[47] New objects also made an appearance, designed specifically for perfuming. The pomander (plate 13.14) – from the French *pomme d'ambre* – was in the fifteenth century a small globe of gold or gilded silver, perhaps set with precious stones and enamels, with its surface pierced to emit the scent of the pellets of musk and amber or fragrant resins lodged inside it. It opened out into two half spheres so that these substances could be placed inside and had a ring attached so that it could be worn as a pendant around the neck, on the belt or the finger, or else simply carried in the palm of the hand. Probably of Arab origin, the perfume-burner, or *profumatoio*, is an object that had become common in Europe in the fourteenth century. It was always spherical and made of either beaten brass or gold and silver; it was likewise pierced but bigger in size. It too opened out into two half spheres and in its centre was a small cup for burning perfumed essences with coal. It would be set in a room to purify the air (see pp.309-10 and plate 21.1).[48]

Thus in the Renaissance house everything was scented. The substances employed were often costly: perfume was no longer made just from essences of locally grown flowers but from exotic products of animal origin – musk, ambra (ambergris), civet – and from oriental or African plant resins.[49] But the culture of perfuming was not an exclusive business: for every one of these new devices there were also cheaper, more affordable versions that could be made at home with less refined substances. The Bardi family's book of recipes has as many as six recipes for making perfumed gloves, these being labelled as 'better', 'excellent', 'thrifty' and 'most noble'.[50] 'Thrifty' (*di manco spesa*) recipes for fragrant little birds, scented bags and candles are to be found in all the recipe books, presented as 'genteel' (*da signore*) luxuries. There were also rough and ready imitations of the scented rosary, made with 'black earth, rose water and tragacanth gum', yet another indication that ideals of consumption related to beauty, health and ornament were widely shared, although standards differed considerably.[51]

Jewels, too, were acquired and worn not just for their monetary and ornamental value but for their protective and magical potency. Precious stones were regarded as amulets with the power of safeguarding people from the evil eye, accidents, misfortunes, epidemics and infections, and as able to cure certain diseases. They had, moreover, an effect on the temperament; different stones communicated particular emotions and therefore strengthened specific characteristics: courage, steadfastness, purity, etc. For example, the hyacinth could immunize you

against the danger of plague, could generate gaiety, protect travellers and promote sleep; a topaz placed on a wound would staunch the blood, it would be a good antidote to haemorrhoids and rage, and would banish melancholy.[52] Often, the images carved on the gemstone further increased the protective and healing power attributed to the particular mineral. Scorpions, dragons and serpents were especially popular, and through their contact with the body they were even expected to heal the patient from poison (plate 13.15).

These beliefs did not come to an end with the Counter-Reformation and its war on superstition; instead, the protective value of minerals was enhanced by the use of religious symbols and images. The name of Christ or Mary engraved on precious stone, the relic of a saint's body or the sacred words written on small pieces of paper tucked into rings or clasped in pendants, were regarded as making an item of jewellery all the more efficacious.[53] Religious language and symbols are also encountered in therapies and frequently appear among the ingredients for a cure in handwritten household books, which were not subject to the purgings of censorship. A recipe against the pain of colic, for example, prescribes a potion of rue and laserwort boiled in ordinary oil, to be drunk making the sign of the cross over the glass with every sip and saying 'Ex latere Domini Nostri Ihesu Christi exivit sanguis et acqua' (Blood and water were dripping from the chest of our Lord Jesus Christ).[54] We also find a great many recipes for breaking spells, harming enemies and even 'for bringing about a speedy

death'.[55] A world of magic? Or simply a world in which the divine and the natural are not separated, and every element (including minerals and vegetables), every smell and colour are perceived not as inanimate but as a living, active force. Their use in various types of care for the body was widespread and filled the Renaissance house with objects and practices that simultaneously cured, purified, beautified and adorned. They acted on physical and mental health, on outward appearance and moral condition.

13.15 Ring, Italy, setting
15th century, antique onyx
intaglio of a scorpion,
second or first century BC
(cat.198)

THE *RESTELLO*
FURNITURE FOR BEAUTY

PATRICIA FORTINI BROWN

W hat is a *restello*? First cited in Venetian inventories of the *camera* around the middle of the fifteenth century, the *restello* was a wall-mounted piece provided with pegs to hold items ranging from clothing and writings to toilet articles, such as hair or clothes brushes, a *coda* (horsehair switch) to clean and support combs, and a *scriminal* (bodkin). Fulfilling an important role for storage and display, the *restello* was essentially a decorated rack and took a variety of forms. The most luxurious examples consisted of a mirror with an elaborate gilded frame carved in relief with hooks in the base moulding (plate 13.16); some, like one mentioned in the will (1525) of the Venetian artist Vincenzo Catena, might be painted *con molte figure* (with many figures). When not in use, they might be covered with a cloth drapery (plate 13.17). *Restelli* became so luxurious that their production was banned by a sumptuary law of 1488, but they continued to be made.[1]

13.16 *(top right) Restello,* Italy, 1500–1550? (cat.134)

13.17 Detail of Cima da Conegliano, *Two Young Men Visit a Maiden,* oil on wood panel, Venice, *c.*1510 (Musée des Beaux-Arts de Tours)

The four small paintings by Giovanni Bellini identified as *restello* panels are among the most enigmatic works of the Venetian Renaissance (plate 13.18). Their modest dimensions and allegorical subject matter indicate that they were 'cabinet paintings' – art works once affixed to a piece of furniture and later detached to be exhibited as independent pictures. But what type of furnishing might Bellini's paintings have embellished? They have been credibly linked, without certain proof, to the intriguing passage in Catena's testament that mentions 'my *restello* of walnut with certain little figures in it painted by the hand of master Giovanni Bellini'.[2]

Bellini's allegories consist of a series of moralizing virtues and vices, but the interpretation of their subject matter has found little consensus among scholars. Indeed, painted and sculpted images of the personified virtues, such as Fortitude grasping a column, were among the most popular subjects for secular art in the Venetian home. But vices were seldom depicted; the most common was probably Vanity, often in the guise of a sumptuously adorned young woman. The iconography of Bellini's panels, however, is less straightforward. Melancholy has also been identified as Fortune or Inconstancy, or as a combination of all three. Prudence has been seen by some as Self-Knowledge or Truth, but conversely as Vanity or Vainglory by others. Perseverance is generally viewed as an allegory of Virtue, but it might be read as Abstemiousness or Heroic Virtue or, less favourably, as simply Bacchus. And does the fourth panel signify Envy, Calumny or Infamy, or does it actually celebrate Virtue-Wisdom as one scholar suggests?[3]

Thus the same image might appear as a virtue to some and as a vice to others. We may never know for sure, and that is the point. These works are among the first surviving examples of the allegorical paintings of elusive meaning for which Bellini's pupil Giorgione became particularly renowned. Their meanings seem deliberately masked to complicate their interpretation, thus stimulating intellectual discussion and debate.

13.18 Giovanni Bellini
(*clockwise from top left*), *Allegories
of Melancholy or Fortune,
Prudence, Envy* and *Perseverance*,
oil on wood panel, Venice,
*c.*1490 (Gallerie
dell'Accademia, Venice)

DEVOTION

DONAL COOPER

14.2 After Donatello,
The Virgin and Child,
Florence, late 1430s
(cat.172)

IN GIOVANNI MORONI'S *Portrait of a Gentleman in Prayer before the Virgin and Child* (plate 14.1) – an image that was almost certainly painted for a domestic setting rather than a church – all barriers between the devotee and the holy are suspended. The anonymous donor is much larger than the Virgin and Child, and his act of prayer is as much the subject of this picture as the sacred figures to the left. The Virgin's diminutive scale establishes her as an image within an image, and Moroni's painting thereby recalls the devotional relationship between holy image and viewer within the domestic interior. Moroni's devout protagonist has entered the Virgin's pictorial space, at the same time as she is imagined as physically present in the home.[1]

Present dichotomies between sacred and secular would have meant little to the urban inhabitants of Renaissance Italy, where the borders between private domestic and public ritual spaces were repeatedly and consciously blurred. Wealthy lay patrons could enjoy substantial authority over church interiors through private chapels – chantry foundations that not only provided burial space but also expressed individual and family honour through inscriptions, portraiture and heraldic ornament. At the same time, charismatic preachers constantly reminded their urban audiences that family and private life were to be measured against ideals of pious behaviour and that the home was a place of devotion and prayer. All were implicated in the burgeoning religious economy of penitence and salvation, where prayers and indulgences prepared one's own soul for inevitable judgement and ameliorated the lot of one's forebears in the arithmetic of purgatory. In an overwhelmingly Christian society demonstrable piety was an essential element of social respectability and – as Amanda Lillie has observed – of public prestige, whether at church, in the street or at home.[2] And within the home, an ever more elaborate paraphernalia of devotion allowed Renaissance Italians to express their piety and to invoke sacred intercession.

14.1 Giovanni Battista Moroni,
Portrait of a Gentleman in Prayer before
the Virgin and Child,
oil on canvas, Bergamo, *c.*1557–60
(National Gallery of Art,
Washington)

The principal devotional focus within the Renaissance home was the holy image – sometimes a representation of Christ or one or more of the saints, but most often of the Virgin and Child.[3] Italians invariably kept at least one such image in their bedchamber, the locus of conception, birth and death.[4] However, as the fifteenth century progressed, inventories indicate a steady accumulation of religious images in a wide variety of formats and media. Many remained concentrated in the *camera* or adjacent rooms, but others are recorded elsewhere in Renaissance houses and *palazzi*.[5] For Florence the proliferation of devotional images is well documented in the workshop records of the painter Nero di Bicci from 1453 to 1475.[6] In Venice a pair of merchants could place a bulk order for 700 icons from three painters in Crete in 1499 in the expectation of selling them on to a lay market.[7] These objects had monetary worth and were bought, sold, loaned and pawned, but their devotional efficacy did not depend on their material value.[8] A gesso or terracotta relief of the Virgin and Child taken from a mould could serve just as well as a carved marble or painted panel example.[9] Indeed, it seems that more money was sometimes spent on the frame than the image.[10] This is likely to have been the case with a small tabernacle from the V&A (late 1430s), where a gesso relief taken from a bronze plaquette attributed to Donatello (itself a serially produced object) is set within a wooden frame painted and gilded by a minor Florentine painter, perhaps Paolo Schiavo (plate 14.2).[11] The inscription 'Ave Maria Gratia Plena' (Hail Mary full of Grace) provides a prompt for the recitation of the rosary, while the linen cloth held aloft by the two flanking angels recalls the fabrics that often acted as veils for these domestic images.[12] The inclusion of Eve below takes up a well-known theme of Marian exegesis, the Virgin as a new Eve, redeeming the latter's fall through her virtue and virginity. The 'Ave' of the Hail Mary was often seen to mirror 'Eva', and here the fallen Eve looks directly at the 'Ave' of the inscription. The motif of the reclining Eve at the feet of the Virgin is known from contemporary altarpieces, but her inclusion in domestic images is sufficiently rare to suggest that this tabernacle was intended for a female patron or audience.

The symmetrical traces of hinges on either side of the tabernacle indicate that this was originally a triptych that has now lost its wings. To judge from the numerous references to veils and shutters in contemporary inventories, the ability to cover such domestic images was important.[13] They were not only the focus of meditation and prayer, but also inherently powerful objects, manifesting and locating the presence of the sacred within the home. In some fundamental way they looked back at their viewers, casting their protective gaze over the domestic interior.[14] In the case of sculpted or moulded reliefs of the Virgin and Child, these talismanic properties were often enhanced by the placement of jewellery inside and outside the image.[15] This perception of presence had many positive aspects – these bedside icons watched over their owners in their sleep – but it also placed demands on the viewer. In their sermons both San Bernardino of Siena and Girolamo Savonarola cautioned women against appearing before their devotional images wearing cosmetics or jewellery, and it is unsurprising that Italians often chose to veil their images, to direct and to conserve their power.[16] In this they followed the example of the clergy, who would veil (and dramatically unveil) prominent cult images, like the miracle-working fresco of the Annunciation in the church of Santissima Annunziata in Florence.[17]

Sacred presence could also be signalled through light, and many images of the Virgin and Child were provided with prickets for candles.[18] The oblique view of a Marian image afforded by Vittore Carpaccio's setting of St Ursula's dream (1490-95) within a contemporary Venetian *camera* indicates how such candelabra could project in front of domestic images to light them more effectively (plate 14.3). In addition, the St Ursula tabernacle is equipped with a sprinkler and bucket for holy water, perhaps an Islamic object adapted for this purpose (see plate 21.7).[19] The owners of such ensembles could acquire consecrated water from their local priest and sprinkle it over their image to increase its efficacy with a sacramental gloss. In this way the laity appropriated the liturgical practice of the clergy to frame the sacred within their own homes.

Domestic images could vary greatly in scale, format and material. Some were small and clearly intended to be portable, for example a small diptych of the Annunciation by Pesellino in the Courtauld Galleries with the coat of arms of the Gherardi, a

14.3 Vittore Carpaccio, *The Dream of St Ursula*, tempera on canvas, Venice, 1490–95 (Gallerie dell'Accademia, Venice)

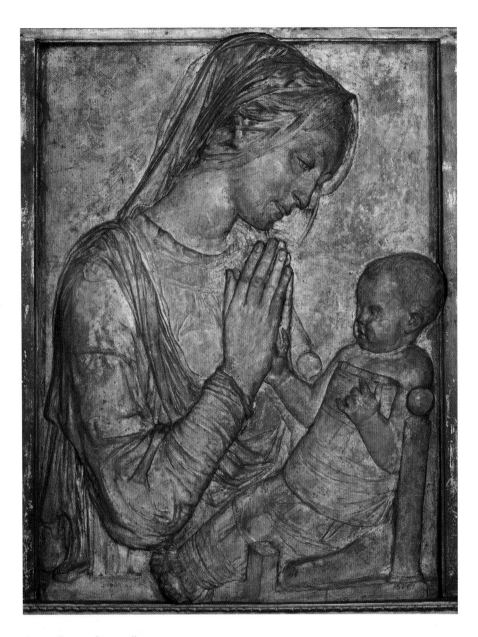

14.4 Follower of Donatello,
The Virgin and Child,
Florence *c*.1455–60
(cat.170)

prominent Florentine family, on the back.[20] The much abraded painted decoration on the exterior faces of the Courtauld diptych may imitate a *cuir-bouilli* (hardened 'boiled leather') covering. In April 1390 Francesco Datini, the merchant of Prato, received a leather case to accompany an image of Christ that he had ordered from an unnamed Florentine painter, so that he could carry the picture with him wherever he travelled without it getting wet.[21] Other devotional images could be much larger and were evidently permanent and immovable fixtures within the interior. The gilded terracotta relief of the Virgin and Child by a follower of Donatello (*c*.1455–60; plate 14.4) is over 130 cm high with its present, sixteenth-century frame.[22] The popular, colourful and relatively inexpensive, tin-glazed terracotta relief images of the Virgin and Child produced by the Della Robbia workshop must often have been set into interior walls.[23] Fifteenth-century Florence saw the emergence of a new category of religious image, which seems to have been specific to the domestic interior: the circular tondo (see plate 2.8).[24] The larger examples of this format, which could be painted, sculpted or moulded, measured well over a metre in diameter and were set within elaborately carved and gilded frames.

An array of prescriptive literature and diary accounts can shed some light on how Renaissance Italians interacted with the devotional images in their homes. In his memoir the Florentine merchant Giovanni Morelli gave a detailed description of his son Alberto's mortal illness in 1406.[25] On his deathbed Alberto had clutched a 'tavola' of the Virgin, evidently a small devotional panel.[26] One year later, haunted by his failure to arrange his son's final confession, Giovanni returned to another image, this time a panel of the Crucifixion, to which Alberto had often prayed. In an attempt to expurgate his error and to retrospectively grant his son a good death, Giovanni undertook a sequence of ritualized meditations. He kissed and embraced the image, praying to each of the figures in turn – first Christ crucified, then the Virgin and finally St John the Evangelist.[27] The sentiments he describes are a mixture of empathy and guilt, for through the image Giovanni was 'looking into myself at my sins'.[28] After a lengthy sequence of prayers, he apologised for not

14.5 Woodcut from
Girolamo Savonarola's
Predica dell'arte del ben morire,
Florence, 1496–7
(British Library, London
IA.27320, fol.6r)

Questa cogitatione della morte lhãno hauuta tucti li sancti
buomini & sancte donne; & in ogni opera che efanno i tucta

published later in the same year.[32] In the first the skeletal figure of Death confronts a young, well-dressed Florentine man with a choice between paradise and the torments of hell; 'Look carefully where you want to go,' Savonarola tells his audience: 'Up there [in paradise]? Or down there [in hell]?' ('O quasu? O quagiu?'; plate 14.5).[33] In the second, Savonarola describes a man who is sickening but putting off making his confession, while his wife and doctor encourage him not to think about death.[34] The anonymous illustrator has set the scene within a well-appointed interior, and the woodcut is famous for its representation of a *lettuccio*, or daybed, and a tondo of the Virgin and Child (see plate 19.5).[35] The patient has not yet retired to bed but lies on the *lettuccio* while his wife and doctor examine a beaker of his urine. They are unaware of the demons that surround them and the figure of Death knocking at the door. In the third woodcut the patient is on his deathbed, with Death now sitting at his feet (plate 14.6).[36] For Savonarola this scene was to serve as a

addressing the image with due reverence and proper language. He had, however, consciously presented himself before the painting, dressed only in a nightgown and wearing a rope or halter around his neck, a traditional mark of penitence and humility.[29]

Giovanni's testimony is remarkable, and there is no way of knowing whether his behaviour was typical, even within a Florentine context. But it is likely that he structured his devotions around practices and prayers that he was familiar with, both from the liturgy of the church and from the practices of lay confraternities (where images of the Passion were commonly used as aids to prayer).[30] In his sermon on the 'Art of Dying Well' delivered on the 2 November 1496 – the feast of All Souls – Savonarola urged his Florentine followers to keep a series of images of death and dying in their *camere*, to encourage them to contemplate their own end and to prepare themselves for it.[31] The vivid images he described were graphically visualized in the woodcut illustrations to the printed edition of the sermon

14.6 Woodcut from
Girolamo Savonarola's
Predica dell'arte del ben morire,
Florence, 1496–7
(British Library, London
IA.27321, fol.11r)

warning to those who put off confession to the last moment, and the text describes how family and relatives continue to urge the sick man to concentrate on getting better, while the Devil encourages his despair in the hope of God's mercy. The woodcut may present a more optimistic reading than the accompanying sermon, with a confessor at the bedside and the patient's wife now praying fervently to an apparition of the Virgin and Child above. The man's bedroom is equipped with a crucifix in a niche above a *cassone* (chest), with the artist making a play on the latter's resemblance to an altar or a tomb.[37] Savonarola's sermon fell within an established medieval tradition of treatises on dying well, but the integration of moral instruction and devotional imagery reflected a dynamic new visual culture. Savonarola doubtless foresaw the potential of print to realize the domestic images that he urged his listeners to acquire, for cheap devotional woodcuts, sometimes hand-coloured, had been available in Italy from the early years of the fifteenth century.[38]

The devotional image was only one strategy by which Renaissance Italians sought to sacralize their domestic surroundings. For the pious, prayer could be a constant activity. Manuals for household devotion recommended prayers for numerous daily actions and chores, from getting up to going to bed.[39] Prayer was often understood as talismanic, as was the common gesture of making the sign of the cross.[40] Devotional objects could also satisfy the widespread desire for apotropaic charms. Many Italians owned an Agnus Dei, a small medallion of wax mixed with oil bearing the image of the Lamb of God, which had been blessed by the Pope or his acolytes on Easter Saturday.[41] Agnus Dei were set within mounts of gold, silver, brass or copper and suspended on chains for wearing around the neck.[42] These containers reflected the church's requirement that Agnus Dei be set within appropriate receptacles, both to protect the wax and to prevent direct contact with the wearer's body.[43] They served as personal phylacteries with a wide variety of perceived powers, from protection from fire to easing childbirth. On account of this last association Agnus Dei were frequently given as dowry or wedding gifts.[44] Containers of holy water were acquired and retained for similar ends, while the fifteenth-century Veronese merchant Bartolomeo dal Bovo believed that the

slips of paper he had placed under the altar cloth in church and then tied around the clapper of the campanile bell were infused with the power of the mass.[45]

By the fifteenth century strings of beads known as paternosters or rosaries were ubiquitous aids to prayer, allowing devotees to calculate and recite complex combinations of the Our Father (Paternoster), Hail Mary (Ave Maria) and the Creed.[46] The Franciscan friar Cherubino da Spoleto, in one of the most popular early pamphlets on the spiritual life printed in the vernacular in the late 1470s, prescribed twenty-five Our Fathers, or seventy Hail Marys with an Our Father after every tenth Ave.[47] Prayer beads were often divided into decades by larger beads to keep count of these lengthy sequences. Other cycles of prayer carried indulgences for those who recited them, and Cherubino reminded his readers of the many miracles the Virgin had conceded to those who revered her through such structured devotions.[48] At the same time, the power of incantations could be easily misunderstood, and San Bernardino condemned those who recited the Passion of Our Lord during the fashioning of rings and amulets.[49] By the early sixteenth century the use of prayer beads was consolidated in the official cult of the rosary, with the repetition of 150 Hail Marys interspersed with Our Fathers providing a mnemonic structure for meditation on the joys and the sorrows of the Virgin.

Paternosters were produced in a wide range of materials, the most basic having beads of turned boxwood or bone (plate 14.7).[50] The very poorest in society used knotted cords.[51] The 1483 inventory of the house of the Sienese physician Bartolo di Tura recorded strings of paternoster beads made from white and black paste.[52] Venice exported large quantities of paternosters made of glass, crystal and Baltic amber.[53] Customs accounts from Rome show that thousands of paternosters with beads of enamel or coloured glass, sometimes packed in barrels, were being imported into the city in the 1470s and 1480s for sale to visiting pilgrims.[54] To judge from their low price, these must have been comparatively simple objects. For the better off, rosary beads could be fashioned from precious materials and embellished with devotional imagery. Luxury paternosters attracted the attention of sumptuary legislation: in

14.7 Wooden rosary,
probably Genoa,
17th century
(cat.174)

1449 the Genoese forbade women from wearing paternosters made of gold (silver gilt was acceptable) or set with pearls or gems.[55] Paternosters were often carried ostentatiously, and could be worn around the neck, on the wrist or attached to a girdle.[56] The 1428 inventory of the workshop of the Florentine goldsmith Dino di Montuccio recorded a set of coral beads with small silver crosses suitable for a woman ('da donna'), although it is difficult to know what made this paternoster gender specific.[57] A particularly intricate sixteenth-century rosary survives in the Museo Civico in Turin, where the rock crystal beads encapsulate verre eglomisé (gilded on glass) images of saints and New Testament scenes (plate 14.8).[58]

14.8 Rosary, Italy,
16th century
(cat.175)
The thirteen beads are formed from pairs of rock crystal hemispheres, with the internal faces painted and gilded with New Testament scenes and pairs of saints. The attached cross, also made of crystal, bears an image of the Crucifixion on one side, and the Virgin in glory on the other.

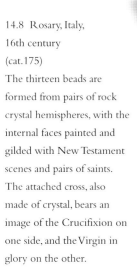

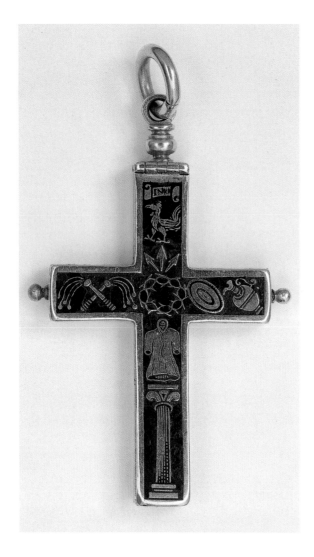 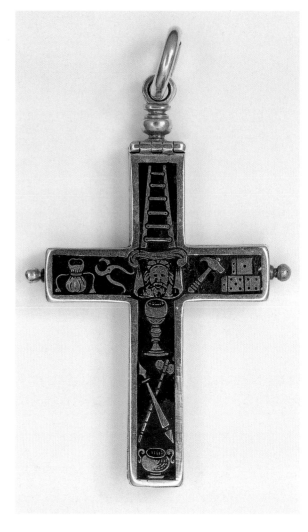

14.9 Reliquary cross,
Italy, *c.*1600
(cat.176)
The instruments of the
Passion are reserved on black
enamel, while internal
compartments hold relics and
names of saints are engraved
on the inside of the lid.

Much Renaissance jewellery was devotional in sentiment and apotropaic in function. Crosses were frequently worn as pendants around the neck – a gold pendant cross of *c.*1600 in the V&A with the instruments of the Passion picked out against black enamel represents a particularly fine example of this type of object (plate 14.9).[59] The cross opens to reveal a set of compartments containing relics of the Apostles Peter and Paul, of the Virgin's milk and – most importantly – a tiny fragment of the True Cross (each relic being identified by an engraved inscription on the underside of the lid). The inherent power of these relics and their proximity to the owner's body would have rendered this an extremely powerful prophylactic object in the eyes of Renaissance Italians. Materials as well as relics could possess

protective powers, and coral was especially prized for its medicinal and protective qualities.[60] Unworked branches were commonly worn as charms, especially by children (see plate 8.7), and, as we have seen, paternoster beads were often fashioned from coral.[61] A small gold and enamel pendant depicting the Crucifixion and Resurrection from the late sixteenth century now in the V&A retains its carved coral setting (plate 14.10).[62]

Religious images and their accoutrements structured devotion around particular points in the Renaissance home, usually, although not always, situated within the *camera*. Some larger *palazzi*, however, incorporated chapels with consecrated altars that allowed the celebration of the mass within the home.[63] The chapel dedicated to the Holy Trinity in

14.10 Pendant with the
Crucifixion (obverse) and
the Resurrection (reverse),
Italy, late 16th century
(cat.177)

the Palazzo Medici frescoed by Benozzo Gozzoli between 1459 and 1462 is the most famous and the best-preserved example.[64] Other chapels were certainly less ornate, but Philip Mattox's research suggests that they were a more common feature of Renaissance *palazzo* design than has traditionally been thought, at least in Florence.[65] For laymen the right to have an altar depended on a papal or episcopal licence, which was usually for a portable altar, a relatively small, consecrated stone (*pietra sagrata*) that could be placed on any suitable surface to transform

it into an altar table (or *mensa*).[66] The wealthy Tornabuoni family, for example, seem to have placed their consecrated altar stone on a wooden trestle table.[67] Every altar, whether permanent or portable, required a chalice, crucifix and two candlesticks for the celebration of mass, although often they were equipped with a much wider range of objects: silk or wooden altarfrontals, linen altar cloths, predellas, paxes, missals, cushions, benches, bells and vestments.[68] In this respect, well-funded domestic chapels could share substantially the same material

14.11 (*opposite*) Andrea del Brescianino, winged tabernacle with a later bronze crucifix, Siena, *c.*1516 (cat.169)

culture as ecclesiastical foundations, and devotional and liturgical objects commissioned for them were often willed to religious institutions.[69] Sometimes the crucifix could be set within a tabernacle, and the painted triptych with the arms of the Sienese Sozzini family attributed to Andrea del Brescianino (*c.*1516) with a later bronze crucifix was probably designed to accompany a portable altar in a domestic setting (plate 14.11).[70]

Genuine chapels for communal worship and the celebration of mass in the home, however, remained the exception, and were generally the preserve of the wealthy.[71] A more typical view of individual domestic piety is provided by the Venetian artist Leandro Bassano's remarkable portrait of a widow at her devotions from the end of the sixteenth century (plate 14.12).[72] This unidentified woman kneels at a prie-dieu (or *inginocchiatoio* in Italian) situated in a

14.12 Leandro Bassano, *Portrait of a Widow at her Devotions*, oil on canvas, north-east Italy, *c.*1590–1600 (Private collection)

small oratory or a corner of a room that has evidently been set aside for devotional exercises. She has placed her prayer book on the prie-dieu, which is set before an image of the Birth of the Virgin, similar in scale to surviving examples of devotional painting by Bassano.[73] The widow, however, does not look at the painting, but gazes blankly into space, her hands raised in meditation. Here the artist reminds us that, according to St Bernard, higher levels of prayer were imageless, and should rise above pictures and other aide-memoires.[74] But the material prompts for the widow's devotions are conspicuously gathered around her – the image on the wall, the prayer book on the prie-dieu and the rosary that she counts in her hands.

Inginocchiatoi have been identified in domestic inventories from the early sixteenth century, but more simple pieces of furniture were already being used for kneeling at prayer in the fifteenth.[75] Cherubino da Spoleto, in the aforementioned pamphlet, describes how a devotee, when reciting the Our Father, should kneel at 'Blessed be Thy name' using a 'banchecto', a low bench one 'palmo' (about 30 cm) high.[76] Similarly, he or she should kneel at the 'The Lord is with you' ('Dominus tecum') of the Hail Mary, repeating the line three times in reverence to the Virgin.[77] Cherubino does not mention images in his text, but representations of the Virgin and Child (plate 14.13), often with the text of the Hail Mary inscribed on the Virgin's halo, the hem of her mantle or the picture's frame, must have often provided a visual focus for this type of ritualized devotion. Individuals were encouraged to decorate these ensembles as if they were altars, even though they were not consecrated. The Dominican preacher Giovanni Dominici exhorted one Florentine mother to make her son tend and light a domestic altar, mimicking the actions of the priests and acolytes in church by saying mass, ringing bells and lighting candles.[78] This altar could not have been a consecrated *mensa*, nor a portable altar, but Dominici's pedagogical advice does demonstrate the extent to which the liturgical rituals of the church provided a model for lay piety, to the extent of acting as a devotional primer for young children.

In many respects, Renaissance Italy marked the apogee in the proliferation of lay devotional practices that had its origins in the thirteenth century with the foundation of the Franciscan and Dominican orders of friars. Lay devotion could be communal and participatory – most male Italians of any standing were members of a religious confraternity – but could also be intimate and domestic. Relations with the Deity were mediated and personalized by guardian angels and patron saints.[79] The expanding material culture of lay spirituality reflected both this specification of the sacred and a growing array of extra-liturgical devotions, some of which were endorsed by the church through indulgences. The religious images and objects found in Italian interiors were veiled, touched, knelt on, kissed and worn by their owners. In an era of relatively weak episcopal control, the laity could also appropriate and manipulate the instituted power of the Church's liturgy by acquiring relics and sacramentals – consecrated objects like Agnus Dei – for their homes. Only in the later sixteenth century, in the wake of the pastoral reforms of the Council of Trent (1545–63), would the clergy reassert their authority over holy images, relics, the sacraments and sacred space.[80] Before the Counter-Reformation mendicant preachers and vernacular texts were more significant stimuli for lay piety than bishops or parish priests, and the laity themselves enjoyed considerable latitude when constructing their own patterns of devotion. But in a society where everything from war to the weather could be attributed to divine agency, all but the most impious Italians acknowledged the presence of the sacred within the home through images, objects, spaces and prayer.

14.13 Carlo Crivelli, *Virgin and Child*, Ascoli Piceno, *c*.1480 (cat.126)
This is the type of Venetian composition for which Carlo Crivelli was known.

OPVS·CAROLI·CRIVELLI·VENETI

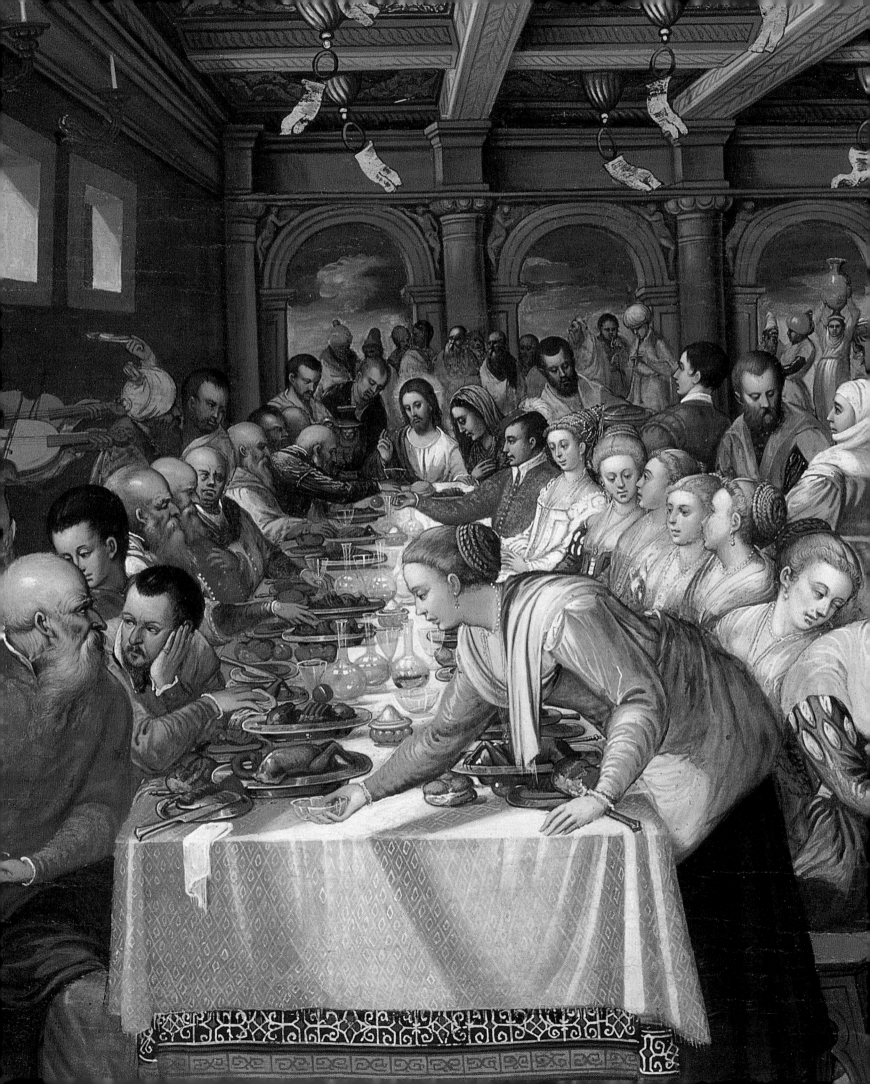

SOCIABILITY
AND
ENTERTAINMENT
IN THE *CASA*

SOCIABILITY

MARTA AJMAR-WOLLHEIM

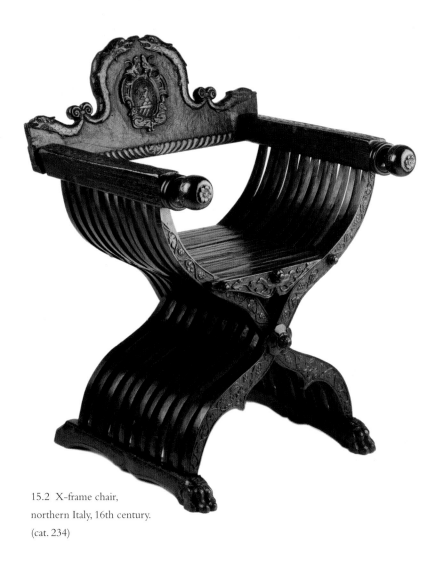

15.2 X-frame chair,
northern Italy, 16th century.
(cat. 234)

ON 22 FEBRUARY 1561 the Paduan writer Sperone Speroni wrote a letter to his daughter Giulia in which he expressed his concerns about the frequency of her social engagements: 'I realize that you are very young, and in better shape than ever, so that the parties that you give at home are not enough, and you have to go to all the others.'[1] This letter – part of a dense correspondence between Speroni and his network of family and friends – is of great interest because it allows us to cast doubts on two dominant historical assumptions: that the house was not an important setting for sociability and that Renaissance women (particularly from the elites) did not enjoy much of a social life.

Various factors suggest that the role of the house as a setting for sociability was in the process of expanding. Over the course of the Renaissance the look and character of interiors changed dramatically: new types of spaces and a plethora of new kinds of furnishings were introduced. There was also a noticeable increase in quantity: houses included more rooms and contained more objects than ever before. As household expenditure on domestic goods grew rapidly, the symbolic value of the house increased: its look and character now mattered more in terms of social prestige.[2] New conduct books providing guidance on a wide range of domestic matters, from how to entertain guests at the table to what 'parlour' games to play, also emerged, showing a tangible concern about the social perception of the household. Little is known about the role of the urban house in the development of social interaction, since scholarship has rather concentrated on how public institutions and spaces fostered it. Sociability in courtly contexts and at public festivities, for example, has attracted a high degree of scholarly attention, leaving the city dwelling as a relatively unexplored microcosm. And yet it is clear from a wide variety of sources that the Italian *casa*, far from being secluded and peripheral, was in fact a central locus of social exchange. As has been pointed out,

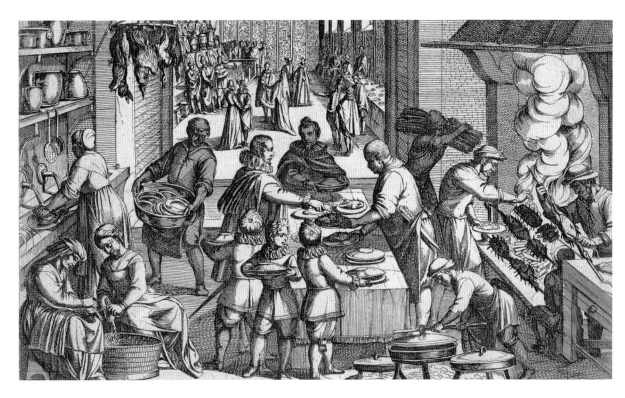

15.1 Detail from Antonio Tempesta, *Gennaio* (January), engraving, Italy, 1599 (V&A: 29283A) Servants prepare a meal in the kitchen in the foreground for the guests in the *sala* beyond.

sociability resists the categories of 'public' and 'private', for its very function is to integrate the two.[3] The Renaissance *casa* became a stage bridging these two spheres. Sociability in domestic contexts had a 'public' function: there is a wealth of evidence showing that upper-class houses in different Italian cities were opened up to host dinners and banquets, literary games, theatrical performances, as well as balls, music and other forms of entertainment. Although all this points to a heightening of sociability within the Renaissance home, given the current state of the research it is only possible to provide a preliminary outline (plate 15.1).[4]

Home-based sociability covered a wide spectrum of practices, ranging from high-profile hospitality, on behalf of the local government for the benefit of official visitors, to seasonal parties or low-key entertainment among friends. As well as being deeply involved in the conspicuous rituals marking rites of passage such as births and marriages, the house was heavily concerned with everyday exchanges such as 'courtesy' (*di cortesia*) visits or transactions with neighbours and suppliers (see p.151).[5] Domestic spaces and objects were set aside for these practices, enhancing and fostering sociability. The emergence of new rooms designed for medium-scale entertainment, such as the *salotto*, and the impressive increase in numbers of objects at the heart of sociability, like

chairs and tableware, can all be associated with these new demands of domesticity. These various forms of interaction could mix men and women, separate them or be sexually exclusive. Different age groups could also participate in some of these encounters, and be banned from others. Domestic sociability could be aimed at supporting the 'horizontal ties of friendship' among social peers or designed to nurture the 'vertical relationships within the community'.[6] Whatever form it took, it placed the house, its inhabitants and its contents centre stage in the performance of the social virtues that exemplified Renaissance notions of civility, such as *cortesia* and *domestichezza* (domestic friendliness).

Many of these social events saw women playing a central role. Female identity was inextricably linked to the house and household, as the expression *donna di casa* (housewife) suggests, but now it acquired new connotations (see pp.152–5). As women more clearly took on the responsibility of entertaining guests as hostesses, they could actively participate in home-based recreation, and in the process develop social, intellectual and even management skills to a greater degree than is usually acknowledged. Because of their ephemeral nature, the large majority of these events have left little or no trace, but scattered evidence can assist in the attempt to conjure up their manifold settings and players.

HOME VISITS

> We can see minute distinctions or gains being made
> within groups of people, in letting this person sit
> on the arm-chair (*seggiola a braccioli*), that person on
> the stool (*scabello* [sic]), and that other person on
> the small bench (*banchetta*); [we can see] that the
> person who is invited to rest his legs, to show
> himself humble and self-effacing, rejects the chair
> and the stool and goes to sit on the small bench. At
> that point the host and friend is forced to run and
> get him [the guest] up immediately and physically
> take him to the big chair, but he [the guest] first
> places his arse pronto on the stool, and it is a pain
> to move him so that [only] at the end he sits where
> he was supposed to be in the first place.[7]

This spirited passage from a mid-sixteenth-century
conduct book by the Sienese Girolamo Bargagli
about how to pay and receive a visit (*Discorso intorno
al fare et al ricevere le visite che occorrono infra le private
persone*) re-enacts the moment at which, during a
home visit, a group of male guests are invited to take
their seats. As they deliberately invert the socially
determined seating order designed by their host,
chaos builds up. Although Bargagli depicts the scene
with some degree of parody, it is also clear that he
supports the complex code of conduct that enables
social hierarchy to become visible at such social
events. He proceeds to enumerate the specific
requirements for visits by peers, relatives or friends,
and by inferiors and superiors. A long list is then
provided of all the different circumstances that
demand visits: in case of illness, to present condo-
lences for a death or congratulations for a marriage,
a newly acquired dignity or fortune, or to greet
someone on their return after a long journey or a
military campaign. He also advises foreigners on
how to pay visits to the locals. The frequency of
visits is crucial – neither too often, nor too seldom –
and they should not be carried out for pecuniary
reasons. Most of all, since visiting is 'a form of con-
versation among people', Bargagli is keen to point
out that the topics addressed and the modes of talk-
ing have to suit the circumstances.[8]

What emerges clearly from this and other conduct
books of the time is that visiting had become a
subtle art, demanding refined social skills. What is
equally noticeable, however, is that domestic furnish-
ings played a key role too, supporting and enforcing
these rituals and even coming to embody the social
hierarchies and the players involved in the scene.
Chairs emerge as specialized enough to enable social
distinctions to take material form. With its wrapping
shape, support for the back and the arms and gener-
ous seating surface, the armchair, traditionally
denoting authority, represented the highest and most
desirable form of seating (plate 15.2). The *sgabello* –
a stool that often featured a backrest – came second,
while the backless bench, echoing past fashions
and denoting collective as opposed to individual
seating, was at the bottom of the ladder. The same
types of seating mentioned in Bargagli's text emerge
prominently from contemporary household invento-
ries. In the Genoese house of the noblewoman
Battina Centurione a comparable range of seats is
listed in 1568, with many of the chairs with backs for
men (*carregha da homo con le spalle*) being described in
some detail: they might, for example, be covered with
velvet or leather, and come from Spain or Naples.[9]
Stools and benches for the *sala* are mentioned too,
but no details are provided, suggesting that they were
of less importance. Interestingly, women's chairs are
simply described as good (*bone*) or bad (*cattive*).[10]
Arguably, specialization in the seating available in the
house, far from being the result of purely decorative
or utilitarian concerns, actively contributed to regu-
late and support sociability.

Visiting and being visited was at the heart of
the lives of not just the male but also the female
members of affluent households, as can be seen in
the correspondence between Speroni and his three
daughters, spanning over nearly thirty years (from
the early 1550s to *c*.1580).[11] While living in Rome,
Speroni kept in constant touch with his family,
particularly with his third daughter Giulia, married
to the nobleman Alberto Conti and the mother of
many children, often writing to her more than once
a week. Guests came and went from their houses,
and in turn Giulia engaged in visiting acquaintances
and relations on a regular basis, usually travelling
by coach. Sometimes the visitors were her father's
friends. On 19 March 1557, for example, Speroni
wrote a short letter to Giulia announcing his
imminent visit in the company of two unnamed *gran
gentiluomini* ('great gentlemen'):

Make sure that the house is set up as I wrote to you, with the Bassano hangings in the *sala* and downstairs, and with the tapestries in the *camera* ... I am sending you a basket with a few things to be kept aside for my stay, which will be needed by the two gentlemen.[12]

15.3 Dish with fruit and vegetables, Faenza, *c*.1540 (cat.74)

This kind of decorative ceramic imitating real food played on the expectations of the diner and could suggest colourful produce out of season.

Although the house was set up for the arrival of guests with tapestries and other furnishings, there is a sense of routine in these quite minimal preparations, implying that the household was accustomed to such visits. Giulia appears as the welcoming hostess, capable of taking care of Speroni's friends with suitable *domestichezza*. This emerges also from a letter dated 30 September 1563, when Speroni wrote to her asking whether she could receive the nephew of his friend, the humanist Annibal Caro: 'This young man is called Messer Ottavio. Treat him with honour ... and if you can, let him stay in your house and treat him with homely affection.'[13]

Domestic sociability – whether in the form of visits or parties – was a subject dear to the moralist Speroni, as it combined social aspirations with delicate issues of decorum. Keen to instruct Giulia on how to move within the small but influential world of the Paduan elite, he points out the benefits and dangers of social networking:

I am not forbidding you to go to parties and visits. But as you cannot go without good company, I am giving you these instructions. With some company it is dishonourable for you to go; in some places it is dangerous ... I would like you to get acquainted with the wife, or daughters, or daughters-in-law of the *Podestà*; because through these social practices it is often possible to solve the ill fates that may occur to a family.[14]

This picture of an intense social life in which the home was fully involved also emerges powerfully in the *Institutione della sposa* (1587) by Pietro Belmonte, a small conduct book dedicated to his daughter Laudomia. This booklet containing guidelines directing married women through the many social practices demanded by upper-class society provides us with an intriguing window from which to view attitudes to sociability. Visiting emerges as a ritualized activity taking place largely under women's control and commanding careful codification in line with perceived social and gender boundaries. If guests are male and of similar social standing as herself, the gentlewoman is expected to be polite, but cautious, making sure that the conversation remains within the limits of decorum: 'In your conversation you will not lower yourself [to talk about] weaving and sewing, nor you will raise yourself [to talk about] negotiating alliances or matters to do with war: the one subject is not suitable for men to discuss, and the other not suitable for women.'[15] The rules governing sociability with other women are more relaxed and with them she will be able to 'proceed with less sense of restraint and more freedom, as among peers it is possible to talk better and more widely about one's own affairs'.[16] When other women come to visit, she will be an exemplary hostess, open her house to them and use domestic spaces and possessions to strengthen her social relations. Refreshments were considered important in the display of hospitality and they brought domestic objects such as tableware to the forefront: 'Then you will offer them refreshment and recreation with *confetti* [sugarcoated almonds], fruits, or other foods which you will have had prepared for them' (plate 15.3).[17] Most importantly, the house and its contents should be 'offered' to her guests as a way of demonstrating her heartfelt sociability:

Take them [the guests] by the fire, or the window, or the garden, according to the seasons, and times, and guide them around the house, and in particular show them some of your possessions, either new, or beautiful, but in such a way that it will be received as a sign of your politeness and domesticity, and not arrogance: something that you do as if showing them your heart.[18]

PARTYING IN THE HOME

One of the biggest tests of domestic sociability was the party (*festa*). Although parties could take many different forms, and vary enormously in character, they often opened with a lavish meal. In charge of preparations, the hostess was expected to organize them in a suitable way and in the spirit of welcoming hospitality:

> You should not behave as I have seen some women do, who make such a din, with banging and moving about of tables and chairs, and so much noise of plates, and knives, that the guest expects a sumptuous meal, and at the end realizes that the mountain has brought forth a mouse; instead, you will issue your orders quietly, and will set everything up, and ensure that everyone is well looked after according to their standing, not disdaining to take care of what happens in the kitchen more than usual, distributing not just excellent foods with largesse, but a cheerful face and warm hospitality.[19]

The *sala* was the designated setting for entertainment around the table, especially during the winter months. In the *sala* represented in Antonio Tempesta's *Gennaio*, or 'January' (1599; plate 15.1), the association between hospitality and food consumption is emphasized. Servants are busy preparing a sumptuous meal, while in the background the *sala* is densely populated with guests. The *festa* is in full swing, with musicians, dancing couples, and men and women engaged in conversation. The *sala* has been transformed into a sociable setting thanks to the versatility of its furnishings: the beautifully laid-out table has been put near the wall to free up space, while a sumptuous stepped *credenza* (sideboard) has been covered in vessels and the walls lined with lavish hangings.

15.4 (*left and opposite*)
Oil cruet, plate and *coppa* (bowl) with the arms
of the Salviati family of Florence, Faenza, *c.*1531
(cats 82, 84 and 83)
This set has been attributed to the workshop
of Pietro Bergantini.

This picture of domestic spaces and objects supporting hospitality is echoed by contemporary household inventories, showing the proliferation of tableware, ranging from ceramics to pewter and, in the most affluent households, silver. By the mid-sixteenth century the maiolica 'service' (known as *fornimento* or, again, *credenza*), which included plates of different shapes and sizes, serving dishes, bowls and jugs, was a relatively common asset among the affluent (see p.262). As both its craftsmanship and its functional refinement made the service suitable for display as well as use, it often carried the family arms. This is the case in the matching set from the early 1530s owned by the prestigious Salviati family of Florence, of which at least six pieces have survived (plate 15.4).[20] Decorated with a deep blue glaze painted over with fine white and blue decorations of masks, dolphins and cherub heads, this set would have been ideal for display, but was also perfectly appropriate for use. Of the surviving pieces, the plates, the oil cruet and the fruit bowl are highly functional. The Salviati went on to commission larger and larger maiolica sets over the course of the sixteenth century. Around 1559 they acquired an armorial service bearing landscape designs (*paesi*) of nearly 180 pieces, probably designed for twenty-four diners and comprising items ranging from jugs to

cooling vessels, and from serving dishes to plates for individual use, thus satisfying the requirements of the different courses of a meal. By 1583 they also had services of 272 Faenza whites (plate 15.5) and of 201 pieces of Ligurian blue pottery.[21] These spectacular displays of tableware were undoubtedly designed to impress visitors and guests, and to be used when relatively large numbers of people gathered at the table.

15.5 Whiteware plate, Faenza, 1560–1620 (cat.69)
This plain white dish is an unusual archaeological survival of a type very common at the time.

The quantity, the refined decoration, the variety of shapes and the often prominent presence of the family arms all point to the use of this ware at social occasions, as opposed to just household consumption.

Pewter, too, could assist in the rituals of sociability at the dining table. In 1545 the Florentine merchant Matteo Botti ordered from London a service of 180 pieces of English pewter 'per in casa' (for use at home).[22] This was not a phenomenon limited to Florence. A service of over 180 pieces of pewter,

including 69 small plates for individual use, 104 dishes of four different measures and the box designed to contain them, was listed in 1567 among the possessions of the Marquis Squarciafico's household in Genoa.[23] In 1581 Francesco Sansovino pointed out the spectacle of the 'endless silver *credenze*, and other *fornimenti* of ceramics, pewters, coppers and damascened bronzes' in the *sale* of Venetian palaces.[24] At the high end of 'hospitality ware' was silver, not an unusual feature of wealthy households, but one that has survived in extremely small numbers, since it was susceptible to being melted down and restyled in line with changes in fashion. Part of a hoard, the simply styled items illustrated in plate 15.6 represent the kind of silver tableware that might have been found on a wealthy Venetian table in the early 1500s. Of exceptionally elaborate design are a late sixteenth-century gilt silver ewer and basin attributed to Venetian craftsmen and encrusted with intricate *all'antica* motifs and cartouches (plate 15.7). These showpieces, designed for maximum visual impact by the table or on a *credenza*, would have symbolized the conspicuous consumption and high fashionability of the household.[25] In Genoa silver was especially popular: the Brignole family, for example, acquired entire silver services and by 1594 they had over 150 items of silver tableware, including 115 plates of different sizes.[26]

Dining was seen as the quintessential arena for the display of civility, where good table manners met polite conversation, but it is clear that play was also a key part of this. Tableware designed to accompany drink-related games gained popularity in the sixteenth century. The famous etiquette bestseller of the Cinquecento, Della Casa's *Galateo* (1558), discusses drinking competitions and their popularity in antiquity, making a distinction between the Italian habit of drinking for fun and the northern European custom of getting drunk as a matter of prestige: 'I thank God that, with other plagues which have come to us from beyond the mountains [the Alps], this infamous one has not reached us yet: to get drunk not just for fun [*gioco*], but as an honour.'[27] Drinking and playing went hand-in-hand, as suggested by a song in a northern Italian wine-making treatise (*c*.1570–80), which referred to drinking games played on St Martin's day (11 November), where dice were used to decide who should start

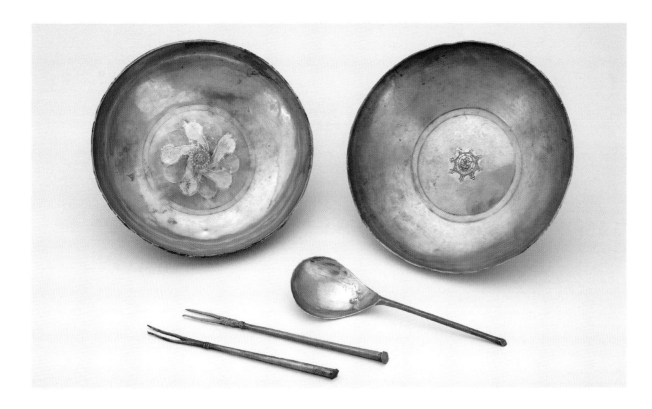

15.6 Silver bowls, spoon and forks, Venice or Venetian dominions, early 16th century (cat.63)

15.7 Ewer and basin, Venice, c.1580 (cat.85)

15.8 *Tazza da inganno* (puzzle-cup), Deruta, 1520–30 (cat.48)

drinking and how many drinks each participant should have.[28] This text also contains recipes for drink-related tricks, such as concoctions designed to glue the vessel to the mouth of the unlucky drinker.[29] Drinking vessels designed to amuse and challenge the diners in drink-inspired games became popular on Italian tables, as suggested by the mid-sixteenth-century writer on pottery Cipriano Piccolpasso, who called them 'unruly vessels'.[30] Among them were puzzle-cups (*tazze da inganno*), vessels designed to frustrate or soak the drinker.[31] They came in different shapes, suggesting a lively market ready to embrace novelty. The example illustrated in plate 15.8, made in the Umbrian town of Deruta (*c.*1520–30), contains an inscription on the inner edge saying: 'CHI.DELACOLODA.PASSA. LASECONDA.RIGA.DELVINO.NO(N)BEVERAMIGA' (Whoever goes beyond the second mark on the column will not drink the wine).[32] In fact it was almost impossible to drink from. A puzzle-cup with the same inscription bears the arms of the Ranieri family of Perugia, suggesting that such objects were not disdained by the upper classes.[33] A white Faenza-ware puzzle-cup made by the workshop of Virgiliotto Calamelli (*c.*1575) carries the arms of the Emilian Garzoni family.[34] The mouth of the cup has two openings connected to an internal conduit that

ends inside the body of a frog sitting on the bottom of the cup. When liquid is poured in, the frog croaks, and when the cup is raised to drink, the liquid spills out of the holes cut around the upper rim and over the drinker. Other eccentric drinking vessels found their way onto Italian tables. Made in Faenza in the second half of the sixteenth century, the drinking boot illustrated in plate 15.9 was inspired by classical precedents.[35] A similar one now in Hamburg carries the coat of arms of the noble Lapini family of Florence, suggesting again that such objects played a role in elite households.[36]

While food and drink often opened and set the pace of a *festa*, the range of forms of recreation on offer was impressive: from conversation and play to music, dancing and even theatrical performances. An engaging picture of the many entertainments featuring at Genoese *feste* emerges from Giulio Pallavicino's chronicle, *Inventione di scriver tutte le cose accadute alli tempi suoi, 1583–89*, describing in detail the many banquets, balls, plays and other entertainments taking place in the houses of the nobility throughout the year.[37] Some of these social occasions were connected to the celebration of weddings, which were large public events, with numbers of guests occasionally surpassing one hundred. The most diverse reasons, however, were given for throw-

ing a large party: the arrival of an important guest, the celebration of a religious feast, or the reconciliation between a father and a daughter. These events are 'classified' in different ways: *ritrovo* is used as the most general term for social gathering; *tempi meglio* ('better times') tends to refer to social occasions throughout the year which lasted for more than one day; and *veglie* is the name for those extending into the early morning hours and taking place mostly in the cold season (from November to February), but summer *veglie* are also recorded.[38] They can also be referred to in more specific terms: *banchetto* (banquet), *disnare* (meal), *comedia* (comedy). A typical entry, written on Wednesday 23 November 1583, reads: 'Giovan Battista Spinola [Giulio's uncle] organized a banquet for all his relatives, and there was dancing all day and until the evening with much participation.'[39]

What is especially striking about Pallavicino's 'diary' is the frequency of the social events '*a casa*'

15.9 Vessel in the shape of a boot, Faenza, 1550–1600 (cat.49)

recorded. Hardly a week went without one, and in some periods, such as Carnival or 2 November (the day commemorating the dead), there was more than one a day. Typically, the number of guests varied from about seventy down to twenty, a scale of entertainment that fitted with the Genoese custom of having both large and medium-sized reception rooms (*sale* and *salotti*), where guests could be suitably entertained. The average size of the *sala* in the *palazzi* of Strada Nuova was between 200 and 150 square metres, with a height of between 9 and 12 metres, while *salotti* were considerably smaller.[40] The Pallavicino palace had two *salotti* on the ground floor as well as on the *piano nobile*. Occasionally, Giulio mentions the precise location of a social event within the house. For example, on 13 February 1584 he records a 'festa in sala' (party in the *sala*) in the house of Giovanni Spinola which turned out particularly well: thanks to the diligence of his sons, 'servants' and *bravi* (mercenary soldiers) were kept out.[41] Women were heavily involved in such events, both as hostesses and as active participants, and some commentators warned against women's licence during them. For example, the Bishop of Novara, Francesco Bosio, wrote back to the *Signoria* in Milan on 4 December 1582 after an extended stay in Genoa as apostolic visitor: 'It would be very appropriate to moderate women's excessive freedom, and strictly enforce that law that was issued last year, and prohibit *veglie* in which people stay up to behave in an unruly way and sinfully.'[42] Several parties described by Giulio ended 'in commotion, with women falling on the floor in the attempt to flee'.[43]

At the core of domestic sociability was the art of conversation (*conversare*). Perfecting civil verbal exchange was a subject of great literary interest during the Italian Renaissance, culminating in Baldassare Castiglione's epoch-making *Cortegiano* (1528). All sixteenth-century conduct books placed *conversare* high on the list of social virtues that any gentleman or gentlewoman ought to possess. Conversation also became closely intertwined with mixed-sex entertainment, as shown by famous collections of intellectual games, such as Innocenzio Ringhieri's *Cento giuochi liberali et d'ingegno* (1551), addressing 'generous ladies' and 'brave gentlemen' gathering to spend their time together 'merrily and pleasurably'.[44] In another collection of games, the

Ueglia villanefca : Com
pofta p el difcreto giouane. M. Francefco Fonfi.
Caftiglionefe . Interlocutori :
Saluadore : Berna : Bartoccio : Symonaccio : & Mer-
lino uillani. La Sandra : la Baptifta : & la Bia-
gia giouane contadine.
Et prima Merlino cõ la Cetara cãta q̃fti Strãbotti:

15.10 Francesco Fonsi,
Veglia villanesca, Siena, 1521
(British Library, London,
11426.b.26)

Trattenimenti (1587), the author describes the scene of a *veglia* held in Siena during the siege of 1555 and recounts how the hostess guided her female guests into an 'honourable *salotto*' removed from the clamour of the street and invited in some gentlemen. The group was then made to sit down in a circle by the fire and the playing started (as in plate 15.10).[45]

The insistence on the *sala* or *salotto* as the most socially appropriate space for this form of polite entertainment, however, might betray quite a different state of affairs. In his 1561 comedy *Ortensio* the Sienese Alessandro Piccolomini draws a colourful distinction between the virtuous games played in the *sala* with the gentlewomen and the licentious ones carried out in parallel in a 'kitchen *veglia*' with the maids, 'those chunky servants, better stuff'.[46] 'Parlour' games designed to be played exclusively at *veglia* gatherings are explained in detail in Girolamo Bargagli's *Dialogo de' giochi che nelle vegghie sanesi si usano di fare* (1572).[47] This text had an impressive popularity at the time: it was reprinted eight times

by 1609 and was soon translated into various languages. These games, based on the spoken word and on a familiarity with literature, were central to home-based entertainment: 'Become familiar with the verses of Petrarch, Ariosto and Dante; and it is good to learn many by heart, not just to play the game of verse-making, but also for many other games which may take place', suggested Bargagli to the players keen to shine (see plate 11.19).[48] But, as well as being symbols of civility, 'parlour' games had to fulfil the principle of *diletto* (delight), which allowed for a surprising degree of salaciousness. Under the heading 'game no.52' Bargagli explains in some detail the *giuoco della lettiera* (game of the bed):

> When grooms bring their brides home they
> usually take great care in adorning the *camera* and
> especially in setting up a rich and suitably
> dignified bed. The game master must pretend that
> the groom, a person of poor culture, has provided
> everything except for one thing, which he has
> been unable to come up with, a verse or a motto
> to be written in golden letters on the cornice of
> the bed, as it is customary.[49]

To come to the groom's rescue, every player must come up with a suitable verse or motto for him to write on the bed. Bargagli can remember a few good ones proposed during such games, all of which are double entendres. For example, one suggestion is 'The spirit is ready, but the flesh is tired', a verse taken from Petrarch, and ultimately from the Gospel, but clearly open to a sexual reading.[50]

Although it was seen as inappropriate to play cards, table games or chess at *veglie* – such pastimes had to be 'kept away from our thoughts'[51] – it is clear that they were a common aspect of domestic sociability, too. Gambling also thrived in spite of decrees attempting to limit the amounts of money involved. In Genoa Giovan Battista Imperiale lost 500 scudi 'in casa Lomellino' in 1583, and a gambling session at a house in the Albaro district on 29 April 1586 ended with a confrontation.[52] In his dialogue set among a group of six Genoese noblewomen (*Ragionamento di sei nobili fanciulle genovesi*, 1588) Cristoforo Zabata praises playing as a pleasurable pastime, but condemns the habit of engaging in it 'for avarice and to strip your partner of his

15.11 Filippo Succhielli,
Biribissi, Siena,
late 16th century
(cat.44)
This game of chance was
very popular for domestic
gambling.

possessions'.[53] Card games were very popular, but new board games involving gambling emerged at around this time. Among the most common 'games of chance' was the *biribissi*, a type of lottery, but without the latter's institutional connotations.[54] The example illustrated in plate 15.11 features 63 squares corresponding to the same number of tickets below, which are ready to be cut up. The players bet a sum of money on a figure in the hope that it would be extracted. Outlawed in all Italian states, it maintained its popularity well into the eighteenth century.[55] The *pela il chiù* (literally 'pluck the owl'), similar to

15.12 Two dice, Florence,
late 15th century
(cat.46)

the English 'snakes and ladders', was another fashion-
able gambling game (see plate 22.7). Played with
dice (plate 15.12), it involved progressing round a
given circuit, with many hazardous stops and penal-
ties. 'Games of skill', such as chess (*scacchi*), with its
chivalric and military associations, also had deep
roots in patrician leisure. In the 1554 edition of his
advice book, the *Ricordi*, aimed at the gentleman, Fra
Sabba da Castiglione praised chess for being a game

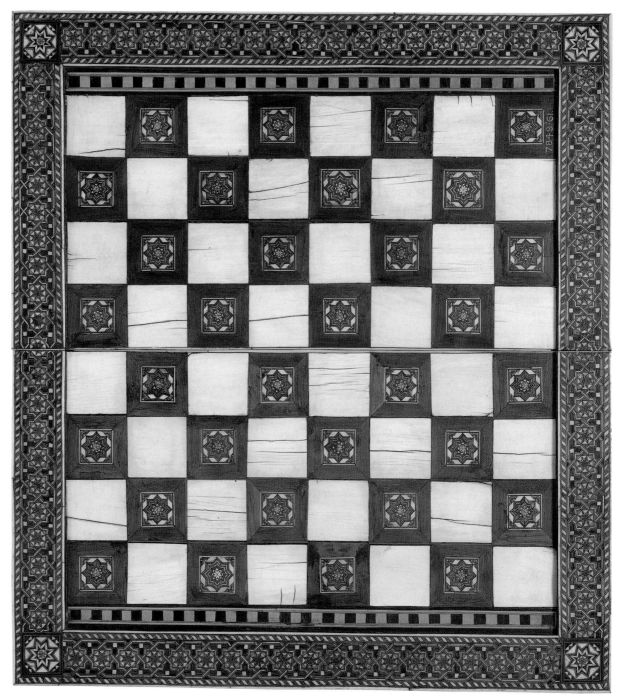

15.13 Games board,
Spain, 16th century
(cat.43)

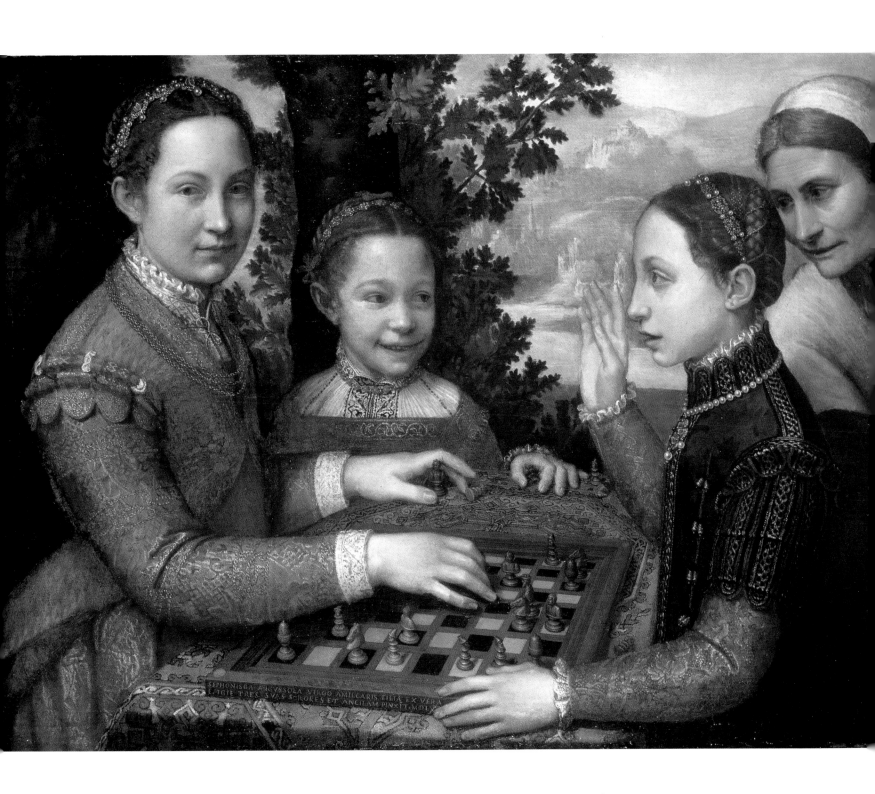

15.14 Sofonisba Anguissola, *Sisters Playing Chess*, Cremona, 1555 (cat.41)

of 'brains, skill and memory' but went on to condemn the anger that it could generate in those who lost at it.[56] Luxury chess boards became common possessions among the elites (plate 15.13) and could even be incorporated into the design of gaming tables, thus making them a permanent feature of a

room.[57] The gentility and intellectual quality of chess made it more socially acceptable than other pastimes for educated women, as suggested by a picture by the renowned Cremonese painter Sofonisba Anguissola, which portrays her sisters engaged in a game of *scacchi* (plate 15.14).

Some aspects of domestic entertainment were bought in, but participants did not shy away from taking on key roles as musicians, dancers or actors. Music could be written especially for parties, raising important questions about the role of domestic sociability in actively fostering musical composition (see pp.238–42). For example, on 2 November 1589 Giulio Pallavicino reports that after a public tournament and dinner in the house of the Salvago family, 'songs made for this purpose' were sung, and later on the same evening they were repeated in the houses of Fabrizio and Maddalena Pallavicino, Giulio's uncle and aunt.[58] Dancing was also very common, emerging as a standard type of recreation often remarked upon as the highlight of a *festa*. It was not unusual for children to be taught to dance as part of their upbringing, as exemplified by the entries in the account books of the Brignole-Sale family recording payments for a dancing tutor.[59] French and Spanish dances were very fashionable, but a particularly popular dance in the sixteenth century was the *gagliarda*, the first Italian dance in which one couple danced at a time, before the scrutinizing eyes of the others.[60] The *gagliarda* (plate 15.15) was also distinctive for its acrobatic character, involving various elaborate jumps, and was included in the most successful dance books of the time.[61] 'If you are invited to the dance which we usually call the *gagliarda*, I want you to avoid it as much as you can,' warned Belmonte.[62] But in 1575 Ascanio de' Mori, describing an evening of entertainment in the *sala* of Beatrice Gambara in Brescia during which the *gagliarda* was followed by games, suggests that this dance was not unusual.[63]

15.15 Fabritio Caroso,
'Gagliarda' from *Nobiltà di dame*
(later edition of *Il ballarino*),
Venice, 1600 (V&A: 86.U.84)

Whether improvised or programmed, the theatre also played a central part in home-based recreation. Only pleasurable, lightweight theatre was accepted, thus comedy thrived, while tragedy could be ruled out as inappropriate for a domestic setting. Girolamo Bargagli suggests that all participants at a *veglia*, including women, must be prepared for the eventuality of acting in a *comedia all'improviso* (improvised comedy).[64] This scenario of informal theatre comes into sharp relief thanks to a rare document of a Sienese magistrate, the *Balia*. In it we find a list of twenty-five Sienese noblemen and women arrested on 9 February 1541 at a private performance of a comedy 'in the house of Buoncompagno della Gazzaia'.[65] According to the legal records, this gathering took place some time after the local authorities had forbidden such nocturnal events. For this infringement of the law the men who were caught acting were banished from Siena for six months, while those who were watching were fined. All the women present were forbidden to wear jewellery and finery for two months. The three women who were caught acting – Eufrasia and Lisabetta Borghesi and Francesca Petroni – suffered this prohibition for an even longer period, and in the case of Eufrasia, who performed in the comedy dressed as a servant, the sentence lasted a whole year.[66] Theatrical performances were also typical of the Genoese social scene. On Monday 4 March 1585 Giulio Pallavicino wrote: 'In the evening a comedy was performed by some young gentlemen in Strada Nuova in the house of Giulio Spinola … it was very beautiful and with a large company of gentlewomen.'[67] Giulio could also be critical of the quality of the entertainment, especially if not performed by members of the upper classes. For example, on 12 October 1589 he records: 'Tonight a pastoral [play] was performed in the house of Giovan Francesco Benigasi. It was carried out by non-noble youths and it turned out rather clumsy.'[68]

Like a piece of theatre, every aspect of domestic sociability was carefully staged, even the goodbyes. When it was time for visitors to take their leave, the hosts had to: 'Accompany [the guest] to the top or the bottom of the stairs, depending on his standing, asking him to send your regards to his close family.'[69]

★ ★ ★

Thus the inhabitants of the house as well as its domestic spaces, furnishings and objects were called on to support sociability, whether at the table, by the fireplace, on the dance floor or on the stage. As the house became a centre of social activity, men and women could mix more, and women, by virtue of their role as hostesses, could develop a stronger grip over the household. Although home-based entertainment could allow informality and even the breaking of rules of behaviour, it is clear that a code of civility was also a major force. The evidence presented here can only begin to penetrate the complex character of domestic sociability and to help us understand its impact on culture more broadly. It undeniably suggests, however, that, far from being a minor player, the household made a crucial contribution to the development of Renaissance sociability.

BATHING IN GENOA

STEPHANIE HANKE

I n no other Italian town in the second half of the sixteenth century did the installation of private baths play such an important role as in Genoa.[1] Existing buildings and original archival documents provide evidence of at least thirteen palaces and villas in which bathing facilities were installed during this period. The usually small but luxuriously decorated rooms with their stucco, frescoes and marble inlays were part of the splendour of Genoese noble residences so greatly admired by foreign visitors. During his stay in Genoa in the early seventeenth century Peter Paul Rubens certainly enjoyed the lavish bathrooms as an important element of the comfort he so admired in the local private palaces.[2] A fresco by Luca Cambiaso in the Palazzo Spinola Pessagno (plate 15.16) provides a contemporary view of such a bathing room, giving us an impression of these small, hidden spaces.

The prevalence of baths in Genoa and their typological similarity indicate that they were a fashionable feature within the palaces of the local ruling classes. They usually consisted of a main octagonal space serving as a sweating room, with niches on the diagonal sides and a tub inserted into the wall (plates 15.17 and 15.18). Adjacent were a changing room (*antibagno*) and other rooms for resting (plate 15.19). The low ceilings and small dimensions of these spaces, often less than 2 by 2 metres, allowed instant heating through steam pipes incorporated in the walls and floors.

15.16 Luca Cambiaso, bathing scene, fresco, Genoa, *c.*1565 (Palazzo Spinola Pessagno, Genoa)

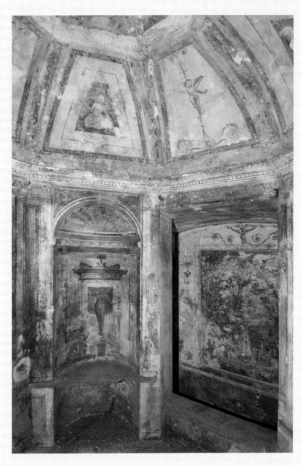

15.17 (*far left*) The bathroom of Villa Pallavicino delle Peschiere, Genoa, *c*.1560

15.18 (*left*) The bathroom of Villa De Mari Grüber, Genoa, second half of the 16th century

15.19 Peter Paul Rubens, ground floor plan of Villa Grimaldi La Fortezza, detail of bathing complex, etching, Genoa, 1622

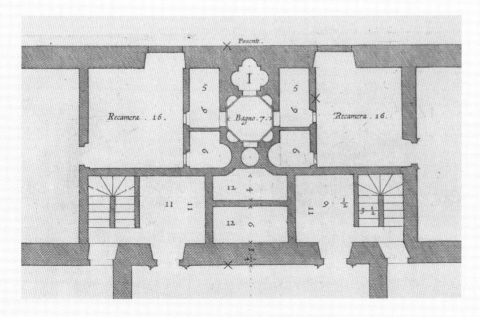

Unlike the Roman palace baths of the early Cinquecento, the distinct Genoese bathing culture cannot simply be explained as a revival of antique bathing customs, inspired by Vitruvius' description of baths in antiquity.[3] The popularity and appearance of Genoese bathrooms seems to have been influenced by Turkish baths, which were well known to the Genoese through close trade links with Constantinople as well as through contemporary literature on the Middle East. It is even likely that the Genoese, when building their baths, relied on the expertise of the city's Turkish population and profited from centuries of Islamic experience with building this kind of structure.

Descriptions of Genoese baths in travel literature, as well as Giorgio Vasari's account of the large bath of the Grimaldi family, which was built by Galeazzo Alessi around 1550 and had space for eight to ten bathers in its water basin, indicate that these rooms were not only reserved for the patron and his family. As in antiquity and the Islamic world, the Genoese bath was a place for sociability. The city had devised a particular system in which the owners of private palaces were obliged to accommodate high-ranking state guests in their houses. The baths would have been available for the use of these guests, which suggests that the conventional notion of the bath as a strictly private area of the house, at least in Genoa, should be revised. On the contrary, their sophisticated decoration and recurring form in numerous buildings indicate that these rooms were considered emblems of luxury and status symbols, with which the competitive oligarchic families tried to impress their foreign guests.

TABLES AND CHAIRS

FAUSTO CALDERAI AND SIMONE CHIARUGI

The adjustable folding table in plate 15.20, considered by some to be a nineteenth-century piece in the Renaissance style perhaps because of its excellent surface condition, is in fact an original sixteenth-century object. It is composed of a folding stand, equipped with two iron chains with hooks which regulate the opening, and a flat leaning surface, hinged in the middle, which opens out like a book. It is made entirely of a very compact variety of solid oak, and decorated with a technique of intarsia known as *buio*, using small bone tesserae in different shapes, mainly triangular. These are arranged in geometric designs consisting of circles, squares and ribbons, in the style traditionally described as *alla certosina*. Originally, the corners of the stand were reinforced with specially forged iron caps.

Now lost, they have been substituted with modern ones. Even though this furniture type is well known, and was very popular at the time, very few examples survive in such excellent condition.

The Medici inventory of 1553 describes two folding tables that belonged to Eleonora of Toledo; one listed 'with its chains' (*con sue catene*) had walnut legs and was probably not dissimilar to the example shown here.[1] Various suggestions have been proposed regarding the dating and place of production. It is generally thought that this technique and type of decoration was most popular during the fifteenth century in the Veneto, due to the popularity of Islamic goods in this region. In fact, demand for these objects continued into the sixteenth century, both in central and northern Italy including Genoa. Objects with intarsia in the same style have been attributed with certainty to this city, which was particularly receptive to the influence of contemporary Spanish furniture.[2]

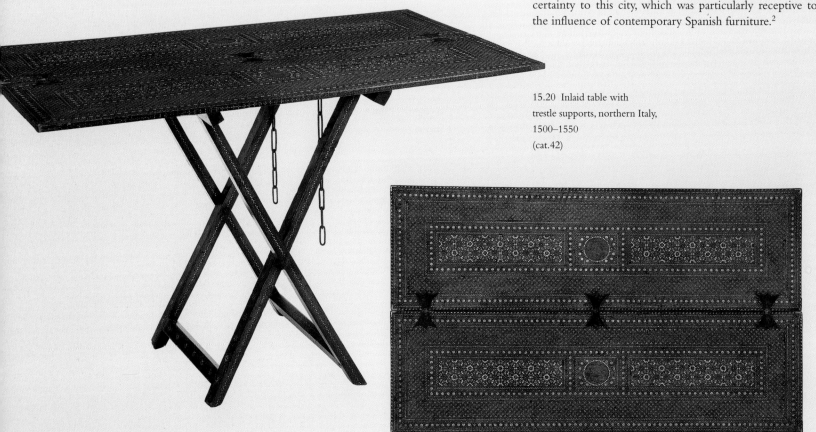

15.20 Inlaid table with
trestle supports, northern Italy,
1500–1550
(cat.42)

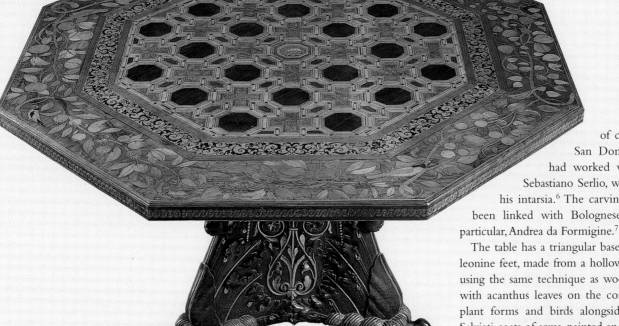

15.21 Fra Damiano Zambelli da Bergamo after a design attr. Giacomo Vignola, octagonal table, Bologna, early 1530s (cat.110)

of constructing the choir of San Domenico in Bologna and had worked with Vignola as well as Sebastiano Serlio, who supplied cartoons for his intarsia.[6] The carving of the table's base has been linked with Bolognese workmanship and, in particular, Andrea da Formigine.[7]

The table has a triangular base, resting on three strong, leonine feet, made from a hollowed-out trunk of walnut, using the same technique as wooden statues. It is carved with acanthus leaves on the corners and with scrolling plant forms and birds alongside the Guicciardini and Salviati coats of arms, painted and highlighted with gold.[8] The large octagonal top is reversible. It has a walnut frame, intarsia on both sides and along its edge, and is 4.5 cm thick. The veneers are composed of an impressive range of Italian and exotic precious woods, approximately 0.4 cm thick. The central composition of both sides is similar, with some variations, comprising black octagons in ebony, inserted within geometric grids composed of box wood, stained green wood, thuya root and perhaps also the so-called ironwood (Caesalpinia ferrea). The border of what is usually considered the underside has a simple design with large geometric panelling made of maple root, thuya root and ribbons of walnut and ironwood. The obverse surface is much richer, characterized by a large band of intarsia with scrolling plants, fruit and animals in different coloured woods against a walnut ground. The central decoration consists of a further, narrower ring, made of streaked maple and decorated with a black arabesque. This is not, however, genuine intarsia, but rather a deeply engraved design filled with black stucco. The centre of the table is attached to the foot with an iron baton. This baton is covered by an octagonal, iron boss decorated with scrolls etched with acid. At the centre is a silver plaque, slightly in relief, chased and enamelled, depicting a bipartite shield with the arms of the Guicciardini and Salviati between volutes.[9] The combination of the black arabesque with a maple background is particularly notable, as it is almost identical to the borders framing the intarsias by Zambelli for San Domenico.[10] The consistent use of exotic woods, highly unusual for the 1530s, makes this table an extraordinary object.

In contrast, the octagonal table in a private collection (plate 15.21) is a display piece, to be shown to visitors to the house.[3] This example, of excellent workmanship, is remarkably well documented. It is cited in the will of the historian Francesco Guicciardini as early as 1540,[4] which records that it was a gift from the monks of the monastery of San Michele in Bosco in Bologna. It probably dates from the period when the illustrious historian was the apostolic legate in that city on behalf of Clement VII (June 1531–November 1534). The presence of the Guicciardini arms linked with those of the Salviati, a reference to Francesco's wife, Maria d'Alamanno di Averardo Salviati, has led to the mistaken suggestion that it was a wedding gift. This hypothesis, however, can be ruled out, given that their marriage was celebrated in Florence many years earlier, in 1508. According to Vasari, Giacomo Vignola created 'beautiful and whimsical fantasies in various designs, mainly made at the request of Messer Francesco Guicciardini, at the time governor of Bologna, and some of his friends: these designs were then executed in wood worked and dyed like intarsia by Fra Damiano Zambelli da Bergamo of the order of San Domenico in Bologna.'[5] The design of the object could therefore be attributed to the early work of Vignola, who entrusted its production to the famous master of intarsia, Fra Damiano. At the time Zambelli was occupied with the monumental project

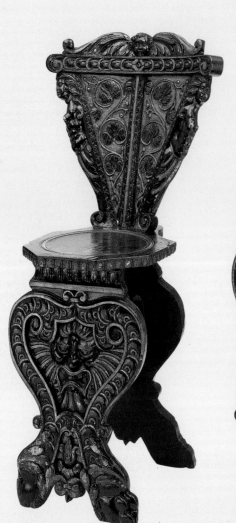
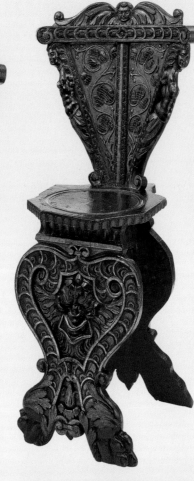

The pair of carved chairs from the Horne collection in Florence (plate 15.22), the two *sgabelli* (stools) from the V&A (plate 15.23) and the set of five X-shaped, folding chairs from the Bagatti Valsecchi Museum in Milan (plate 15.24) represent only a selection of the many types of chairs available during the Renaissance. Nevertheless, their proven authenticity makes them particularly significant. The two examples from the Horne, made in walnut and deeply carved, are models that were already in use at the end of the fifteenth century and became the basic proto-type of the modern chair.[11] In contrast, the high-backed *sgabelli* enjoyed little popularity beyond the Renaissance period. This gilded pair is carved from walnut, with bases in the shape of large, expressive masks and imposing, fan-shaped backs, decorated with caryatids and scrolling foliage. Identical ornament can be found on examples that have traditionally been linked with Venetian production from the second half of the sixteenth century.[12]

15.23 Pair of *sgabelli* (high-backed stools), Veneto, 1580–1600 (cat.130)

15.22 Pair of chairs, Tuscany, 16th century (cat.23)

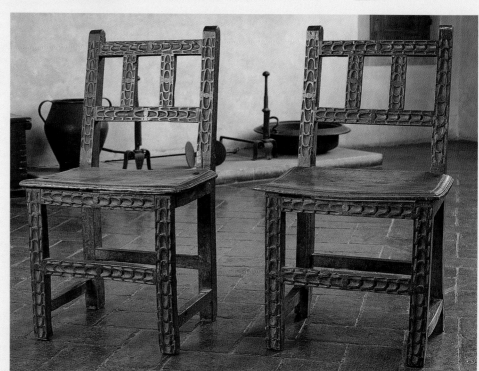

15.24 Set of five chairs,
Italy, 16th century
(cat.28)

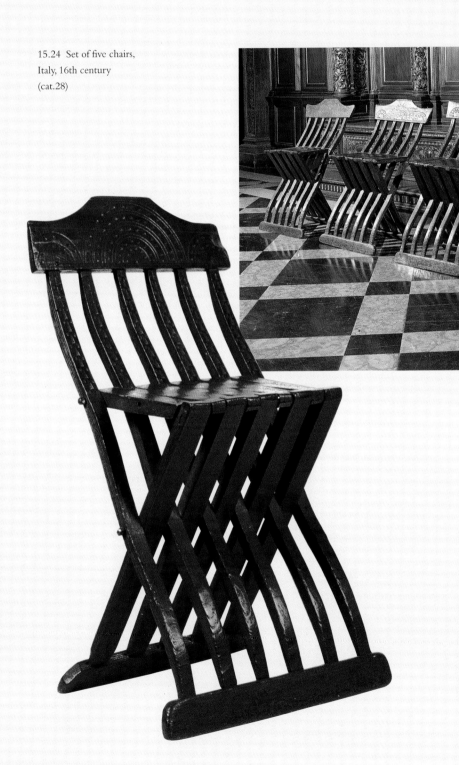

The five beech-wood chairs with folding slats form the largest surviving group of their kind. Their design allowed them to be stored when not in use. In the past their authenticity has been doubted on the grounds that beech was not refined enough for this type of object. However, recent analyses have shown that there is no reason to doubt their originality. Indeed, it is increasingly apparent that during the Renaissance, in both central and northern Italy, beech wood was widely used for the construction of jointed seats and was presumably prized for its solidity as much as the more prestigious walnut.[13]

MUSIC

FLORA DENNIS

DOMESTIC MUSIC-MAKING underwent an extraordinary transformation between 1400 and 1600. New types of musical instruments were developed, while existing instruments were produced in ever greater numbers. The invention of printing also had a profound effect: the first printed music book appeared in Italy in 1501 and by the 1540s music was being published on an unprecedented scale, much of it directed at an amateur audience (plate 16.1). New music appropriate for domestic performance emerged, ranging from the sung madrigal to instrumental music for lute and keyboard. Few non-courtly households would have owned a musical instrument at the beginning of the fifteenth century; by the end of the sixteenth even artisans might possess a lute or small keyboard instrument.

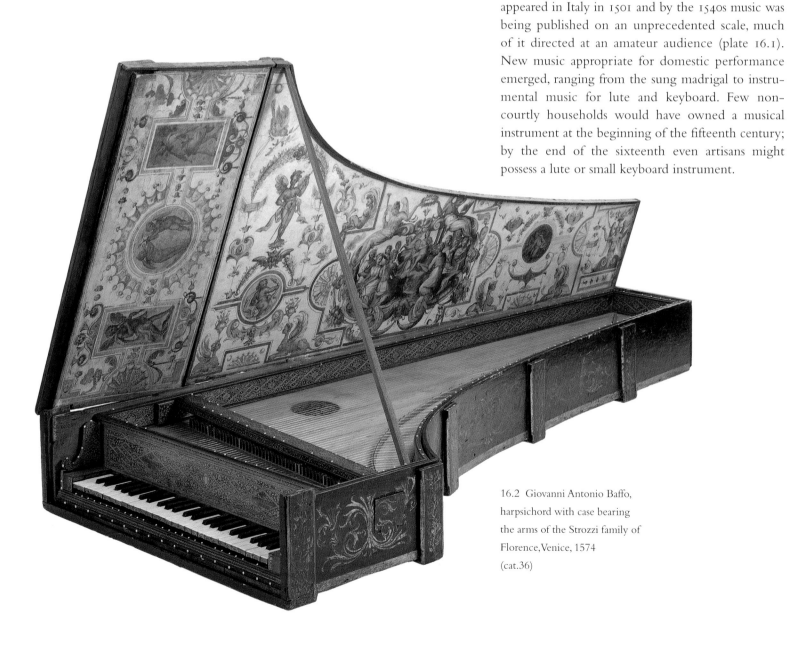

16.2 Giovanni Antonio Baffo, harpsichord with case bearing the arms of the Strozzi family of Florence, Venice, 1574 (cat.36)

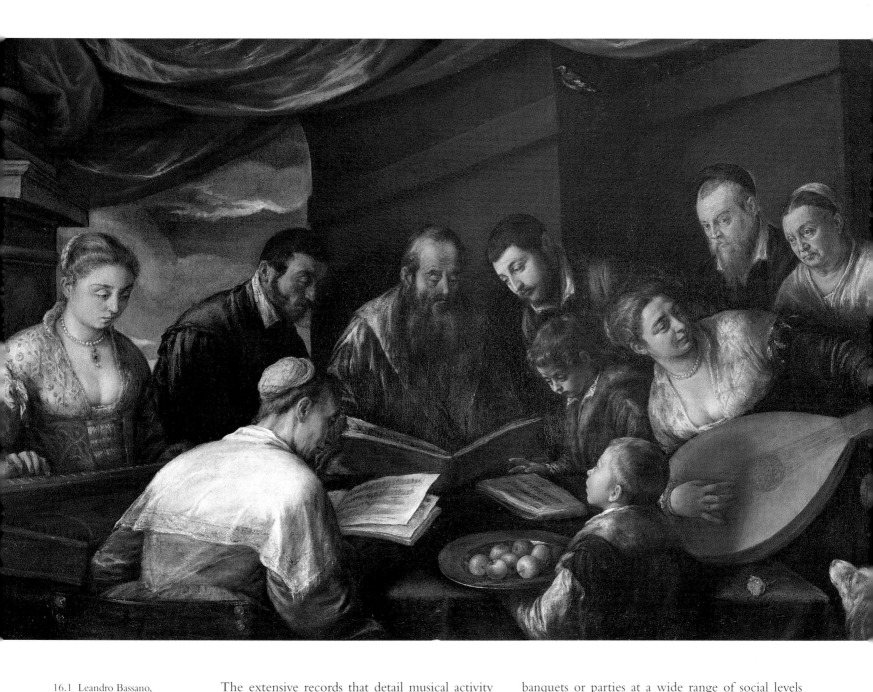

16.1 Leandro Bassano,
The Concert, Venice, 1592
(cat.35)
The family gathering
together to play and sing
becomes a metaphor for
domestic harmony.

The extensive records that detail musical activity in churches or courts do not exist for the domestic sphere, making it difficult to present a detailed picture of the nature of music in the home. This scarcity of documentation has meant that a wide array of sometimes surprising sources, including inventories, fictional writing, paintings and even domestic objects themselves, has become the best way to tease out the rich variety of domestic music-making. Payment records, diaries and other written descriptions indicate that professional singers and instrumentalists were hired to perform at wedding banquets or parties at a wide range of social levels (see, for example, the group of musicians in the background of plate 17.1). But it would be wrong to assume that all domestic music was 'bought in'. The Renaissance house also had its own lively musical culture, from children learning and practising instruments, mothers soothing their babies with lullabies, to the singing and playing that formed a vital part of domestic sociability. Growth in the availability of books and instruments brought the pleasures of music-making into the domestic sphere to an unprecedented degree.

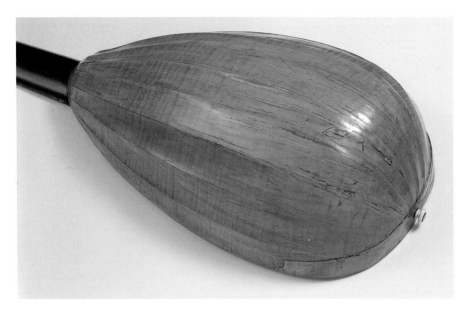

16.3 Laux Maler, lute back,
Bologna, early 16th century
(cat.38)

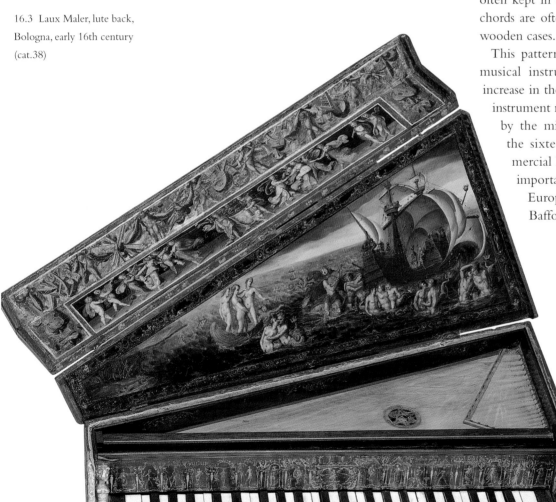

16.4 Spinet,
Italy, *c*.1600
(cat.37)

INSTRUMENTS AND BOOKS

In general, the number of musical instruments listed in household inventories increased from the 1520s and continued to grow into the second half of the sixteenth century.[1] Most commonly found are lutes (plate 16.3) and keyboard instruments – harpsichords (plate 16.2) and spinets (plate 16.4), the strings of which were plucked, and clavichords, the strings of which were struck by small metal blades.[2] Stringed instruments played with a bow, such as members of the viol family and the *lira da braccio*, and wind instruments, mostly in the form of recorders, became more frequent from the mid-sixteenth century onwards. Certain types of instruments are frequently listed in groups or sets, such as groups of four or five viols or between two and ten recorders, often kept in one large case. Both lutes and harpsichords are often also described as having protective wooden cases.

This pattern mirrors the growing availability of musical instruments in Italy, largely due to the increase in their local manufacture. Although Italian instrument makers were constructing harpsichords by the mid-fifteenth century, it was not until the sixteenth that production reached commercial levels. Venice became one of the most important centres of harpsichord building in Europe, with craftsmen such as Giovanni Baffo enjoying widespread reputation.[3]

L bianco e dolce cigno cantádo more et io piangédo giung'al fin del uiuer mio et io piágendo

giung'al fin del uiuer mio stran'e diuersa sorte ch'ei more sconsolato et io moro bea

to morte che nel morire m'empie di gioia tutto e di desire se nel morir' altro dolor non sen

to di nulle morte il di sarei contento di mille morte il di sarei contento.

16.5 Jacques Arcadelt,
Il primo libro di madrigali,
Venice, 1541
(cat.39)
This madrigal, 'Il bianco
e dolce cigno', was one
of the most popular in
16th-century Italy.

Lute-making also increased dramatically in Italy during the sixteenth century, with manufacture dominated by a small number of German families, such as the Tieffenbruckers or the Malers, living in Venice, Padua and Bologna.[4] Consistent evidence for the cost of instruments is hard to find, but they were available at a wide range of prices: an old lute was valued at 1 *lira* 4 *soldi* in Venice in 1552, while a new harpsichord in Florence in 1569 cost 120 *lire*. In 1581 a large Venetian lute-making shop contained 532 lutes at various stages of completion, listing many inexpensive instruments (called *dozenali*) alongside a smaller number of expensive lutes (*liuti da prezio*), constructed from precious materials such as ivory or even custom-made with coats of arms.[5] By the late 1500s musical instruments were possessed at a surprisingly broad range of social levels, from members of the Venetian and Florentine nobility to barbers, wool merchants and cheese-sellers.[6]

Inventories provide much less information about the music books people owned. Gioseffe Zarlino, renowned music theorist, composer and chapel-master of St Mark's in Venice, possessed a famous library, described by Francesco Sansovino as one of the most impressive in the city.[7] An inventory taken of his house in 1590 tells us he owned 1144 books, a good proportion of which must have been volumes of music, but not a single title is recorded. Instead, typically for inventories in this period, the books are listed according to their size – 290 in folio, 244 in quarto, 354 in ottavo and 106 in duodecimo.[8] Occasionally, inventories might note that one of the volumes listed is a music book (*libro di canto* or *di musica*) or that its format is oblong, the standard design for most books of music.[9] Usually, however, documents only record the titles of such books in exceptional cases, such as the records of the Venetian Inquisition's investigation for heresy in 1560 of the Paduan music teacher Francesco Scudieri, who owned twenty-three music books, mostly popular, much-reprinted works,[10] or the Paduan music enthusiast Marc'Antonio Genova, who left specific instructions in his will for the disposal of his collection of fifty-nine books of vocal and instrumental music.[11]

From the fifteenth century until the 1540s most notated music in circulation in Italy was written by expatriate Franco-Flemish composers. The earliest madrigals, a new 'serious' form of vocal music that drew on Petrarchan poetry, were written by northern Europeans such as Philippe Verdelot and Jacques Arcadelt, in the 1520s and 1530s.[12] Arcadelt's first book of madrigals (plate 16.5), first published in 1538, became one of the most popular and reprinted books of music of the period.[13] From the 1540s onwards, as the madrigal's popularity intensified, music by native Italian musicians became more prevalent.

CFROTTOLE INTABVLATE DA SONARE ORGANI.
LIBRO PRIMO.

16.6 Andrea Antico, *Frottole intabulate da sonare organi,* Rome, 1517 (Josef Dobrovsky collection, National Museum, Prague)

Printed music consisted largely of vocal pieces. Secular songs, such as madrigals and *frottole* (plate 16.6), and motets (settings of usually sacred Latin texts) could be sung at home. Four-part music was most common until the mid-sixteenth century, when pieces for five or six voices upwards became more popular. This music came in sets of partbooks, each devoted to a separate voice and, although madrigals and motets were written as vocal pieces, individual voice parts could also be played on instruments, such as the viol, allowing for flexible combinations of voices and instruments. By the mid-sixteenth century numerous volumes of basic music theory were available to teach novice readers how to play and read all forms of musical notation. Books for the lute often included simple instructions on how to play and tune the instrument, while the survival of a densely printed folio sheet crammed with information on both practical and theoretical aspects of music hints at a wider range of more ephemeral didactic materials.[14]

Surviving stocklists of booksellers' shops and printers' workshops suggest the range of books available for the sixteenth-century musical enthusiast, and provide an indication of their prices (usually approximately 1 *lira* for a set of partbooks, a price that remained consistent throughout the sixteenth century).[15] Purchases of music books, however, are recorded only very rarely. The account book of the Florentine widow Maria Ridolfi Strozzi, records a payment of 3 *lire* 10 *denari* in 1553 for 'six songbooks from which to learn music' for her son Filippo.[16] In October 1592 the customs inspector Piero Concini bought a bound copy of music for 6 *lire* from a Florentine bookseller, Piero di Giulio Morosi.[17] Four years later, the leather-worker Giovanni d'Ippolito Libanori purchased a second-hand volume for three voices from the same shop; this, together with a dictionary, cost 3 *lire*.[18]

Exactly where instruments and books were kept and played in the house is difficult to establish. Not all inventories list objects according to which room they were in. While instruments occasionally turn up in unexpected places (for example, the small organ in a Venetian kitchen in 1546),[19] some general patterns can be discerned for Florence and Venice.

In Venice keyboard instruments are usually listed in the *portego* and the important *camere* leading off it (often described as *grande* or *d'oro*). Lutes are also frequently found in smaller *camere*. In Florence instruments mostly appear in *camere* and *anticamere*. In both cities significant numbers of instruments were kept in attics and are often described as old or broken.

But inventories are problematic as they record the place of objects at the specific moment when the inventory was taken. Their evidence hides a vital aspect of even large instruments during this period: their portability. Instruments were easily moved from one part of the house to another, even from inside the house to outside, depending on the occasion. Here, literary evidence provides a more dynamic picture of domestic musical activity. In a sixteenth-century tale by the Sienese author Pietro Fortini a servant carries out into the garden 'a beautiful keyboard instrument, which Constansio kept in his *camera* to entertain himself with'.[20] An adulterous wife in a story by Matteo Bandello spends an hour or two practising the lute alone in her *camera* during the day, but in the evenings plays in a dark corner of the *sala* with her amorous music *maestro*.[21] In Pietro Aretino's play *Il filosofo* (1546) one character asks another to 'go and get my lute from my *camera* and bring it to me'.[22] Instruments were not static objects within the home; where they were played and when depended on the type of music-making required. As Leonello d'Este says in a fifteenth-century literary discussion of objects appropriate to a library, 'it is not unseemly to have … even a lute if your pleasure ever lies that way: it makes no noise unless you want it to'.[23]

As numbers of instruments grew during this period, they became a part of everyday domestic material culture. Their importance in the home can be traced through the increasing number of references to their presence alongside household objects in another useful source of evidence: contemporary riddles and games. Church bells and bagpipes are the only 'instruments' to be the subjects of riddles (*indovinelli*) published in the early sixteenth century, but by the late 1500s lutes, harpsichords, flutes, the *lira da braccio* and even the *lira*'s bow are featured.[24] On board games instruments were depicted beside candlesticks, scissors, jugs and hats: a violin, drum and guitar appear in the *biribissi* (see plate 15.11), and

an early seventeenth-century game includes a violin, drum and lute.[25] Books of domestic magic tricks include instructions on 'how to make hens dance to the sound of a lute, or indeed the sound of other instruments'.[26]

Musical instruments had strong visual and physical relationships with other domestic furnishings. They could be highly ornamental: carved, gilded or painted, or made of precious materials such as ebony or ivory. The backs of lutes were often the focus of decoration, visible only when they were hung against the wall, out of use. The outer cases of keyboard instruments were frequently elaborately painted inside and out (see plates 16.3 and 16.4). Cases could be unfolded in a series of stages, each of which revealed a certain amount of inner decoration. Above the keyboard, mottoes often added a literary aspect: 'I make the eyes and the heart happy at the same time'[27] or 'There is dancing when I sing'.[28] Fra Sabba da Castiglione recommended furnishing the house with musical instruments, 'because such instruments as these greatly delight the ears … and they also greatly please the eye'.[29] This view accords with the Paduan writer Sperone Speroni's late sixteenth-century account of a German merchant's room in Venice that contained 'one hundred types of varieties of musical instruments, plucked, wind and stringed … at first sight, every object appeared … to have been put there for purely ornamental reasons'.[30]

Playing these instruments depended on functional household furniture. All sorts of seating were used: paintings, prints and drawings show stools, chairs with and without arms, and even chests being employed. The inventory of a Venetian lute-maker's shop in 1571 lists a number of 'stools for lute'.[31] Even large harpsichords did not necessarily have legs, but could be rested on tables, stools or trestles (see plate 16.6 and the background to plate 3.10). Temporary installations were set up and dismantled according to the occasion. Fifteenth- and early sixteenth-century inventories record instruments and furniture separately, providing no sense of a fixed relationship between them. From the middle of the sixteenth century, however, as harpsichords grew in size, they are listed with 'their stools' (*con li suoi scagni* or *scagnelli*) or 'feet' (*piedi*). This more fixed relationship contributed to an increasingly static placement of larger instruments within the house.

MUSIC ROOMS

16.7 Francesco Salviati,
Portrait of a Man with a Lute,
oil on panel, probably
Florence, *c.*1527 (Musée
Jacquemart André, Paris)

This decrease in mobility was one of several elements that resulted in the Renaissance 'music room' (*stanza de' suoni, studio di musica*), part of a general tendency towards room specialization during this period. Another driving factor was the increasing numbers of musical instruments owned by people at the highest social levels, which required a designated space at least for storage and rehearsal, if not for playing. An exaggerated, early sixteenth-century fictional account of a vast collection, including huge numbers of precious gems, sculpture and weapons, describes a densely displayed group of musical instruments. In 'a beautiful *sala*, not very large', sixty different types of instrument are listed, ranging from conventional lutes, harpsichords and flutes to obscure classical instruments and small everyday whistles and Jew's harps.[32] In the mid-sixteenth century the Venetian Cipriano Moresini was described as having created a room at his *villa* 'in which there were instruments, viols, lutes … books of every sort of music'.[33] An inventory of the possessions of the Florentine Niccolò Gaddi at his death in 1591 lists a *stanza de' suoni* on the ground floor of his house in Florence, containing thirty-eight instruments. He kept 130 books of music 'of various types' (*di più sorte*) separately in his library.[34] The palace of the Ferrarese nobleman Antonio Goretti in the late sixteenth century was described as a 'home of music': 'he keeps not only every sort of instrument both ancient and modern … but also, in another beautifully ordered room, all the music, old and new, sacred and secular, that it is possible to find';[35] another commentator described Goretti owning 'a study full of as many of the excellent works as have ever appeared, and of precious instruments'.[36]

The word 'study' was also applied to music rooms in Venice. Francesco Sansovino's account of notable sights within private Venetian *palazzi*, first published in 1581, contains a list of 'music studies' (*studi di musica*) with exceptional collections, including large numbers of 'ancient' and modern instruments, as well as music books.[37] The report by the Englishman Fynes Moryson of his stay in Venice in the 1590s suggests that it was indeed possible for people to visit these collections: 'Sigr. Nicolao Vendramini … most curteously shewed mee and my friends, though being altogether unknowne to him, some rare clockes, admirable carved Images, and a paire of Organs having strange varieties of sounds.'[38] The description of certain items as 'ancient' or as producing 'strange varieties of sounds' indicates that they could be collected as curiosities, prized for their antiquity,[39] their prestigious associations (such as the organ in the collection of the Venetian nobleman Caterin Zen that supposedly once belonged to Matthias Corvinus, King of Hungary),[40] their bizarre appearance or the noises they made. These collections represented a theoretical, antiquarian interest in music, which existed alongside the pleasures of playing and appreciating instruments.

PLAYING AND SINGING

With the exception of a surprisingly large number of instruments described as broken, without strings or generally 'in a bad state', inventories give no sense of whether or not the instruments listed were being played. Domestic account books enliven this picture by recording payments for their regular upkeep. Lutes and harpsichords are mended and restrung. Harpsichords and spinets are equipped with new quills, tuned on a regular basis and have their cases repainted.[41]

Domestic account books also record payments for music lessons, usually for the young sons of the family, which appear alongside instruction in dancing, writing, arithmetic and, in one case, swimming.[42] Prescriptive literature recommended that musical education for boys should start at the age of seven.[43] Endless literary sources indicate the social esteem musically capable young men were given: heroes of innumerable tales or *novelle* are described as 'a good musician and most learned on all instruments'.[44] Music's physically improving effects at any age are stressed, but its particular benefits for libidinous youths are often noted: 'I find nothing calms me and cheers up the perturbed harmony of the soul better … it softens the ardour of anger, and reforms degenerate customs', writes one author.[45]

Alongside this belief in music's chastening properties sat an equally strong, contradictory association with lasciviousness. Music was thought to inflame the passions and could carry powerful connotations of excessive luxury. Savonarola consigned 'musical instruments and music books'[46] to the famous bonfires of the vanities in the late fifteenth century, while a sixteenth-century dialogue 'In disfavore della Musica' cited classical examples of musicians who were 'for the most part delicate, lascivious and effeminate'.[47] Sources suggest similar reasons for the disapproval of the participation of the elderly in domestic entertainments. In Sambuci's emblem treatise of 1564 an older man plays the lute in a domestic setting under the heading 'Degenerate', while in Ripa's *Iconologia* of 1618 an elderly man is pictured holding playing cards and surrounded by a lute, a flute and an open music book. 'It is most scandalous', condemns Ripa, 'for an old man to attend lascivious activities, gatherings, games, parties, songs, and other vanities.'[48]

The fact that many courtesans were musically trained meant that women's musical ability could have problematic connotations.[49] Courtesans' musical skill was seen as part of their repertory of seductive charms, as vividly demonstrated in a letter of Pietro Aretino: 'the things which Franceschina sang yesterday to the tune of her lute, penetrated my heart with so sweet a sort of musical persuasion, that I must needs come to the point of amorous conjunction.'[50] Musical instruments could form a part of a sexual economy. A courtesan in one of Aretino's dialogues tells her daughter 'nobody would dare refuse you a little instrument; therefore ask one for a lute, another for a harpsichord, this one for a fiddle, that one for flutes, another for a little organ, and somebody else for a *lira*; it is so much gained.'[51] Court records indicate that instruments such as fifes, drums and lutes were commonly among the presents given to sodomized youths by their older sexual partners.[52]

These associations made the musical education of daughters troublesome, all the more so because music teachers, in both fiction and documentary sources, had a dangerous habit of turning into seducers.[53] Unsurprisingly, then, there are fewer records of music lessons for girls. Pietro Bembo's comment to his daughter that learning a musical instrument was a pursuit for 'vain and frivolous' women represents a typical view,[54] and recommendations for a musical education for women are usually qualified in some way. In his *Libro della bella donna* (1554) Federico Luigini advises that young women be permitted to learn the lute only after first presenting several pages of justification listing classical precedents.[55] As with other kinds of learning, it was feared that too much musical knowledge would interfere with a daughter's ability to run the house. In his *La civil conversazione* (first published in 1574) Stefano Guazzo proposes that a girl's education should vary according to the sphere she is intended to occupy. If destined to serve a noblewoman at a court, she should be instructed in the things that will please her patron, including singing, playing and dancing: 'all that which adorns the women of a palace … but a private gentleman has no need in his house of these songs and dances'.[56] He concludes: 'If fathers wish to marry their daughters to those who are not consumed by the smoke of music or the odour of poetry, they

16.8 Attr. Bacchiacca,
*Portrait of a Woman with a
Book of Music*, oil on panel,
Italy, *c*.1540 (The J. Paul
Getty Museum, Los Angeles)

would be advised to keep them occupied with the wool-winder and household goods, rather than musical instruments.'[57]

One clear piece of evidence that musical knowledge was becoming a desirable social virtue in this period is the increase in the number of portraits of sitters with music books and instruments.[58] Sixteenth-century portraiture placed great emphasis on including objects that reflected people's character and interests; being painted with a lute or an open music book was a deliberate choice that advertised the sitter's musical ability or literacy (plates 16.7 and

16.8). While some surviving examples of 'musical' portraits may represent professional musicians, a painting such as *Two Boys of the Pesaro Family* by Titian and workshop (plate 16.9) indicates that the visual declaration of musical talent was a more widespread phenomenon. Furthermore, group portraits, such as Giovanni Antonio Fasolo's painting of the Valmarana family, in which the children hold music books, or Leandro Bassano's depiction of several generations grouped around a table playing together (plate 16.1), powerfully associate family music-making with domestic harmony.

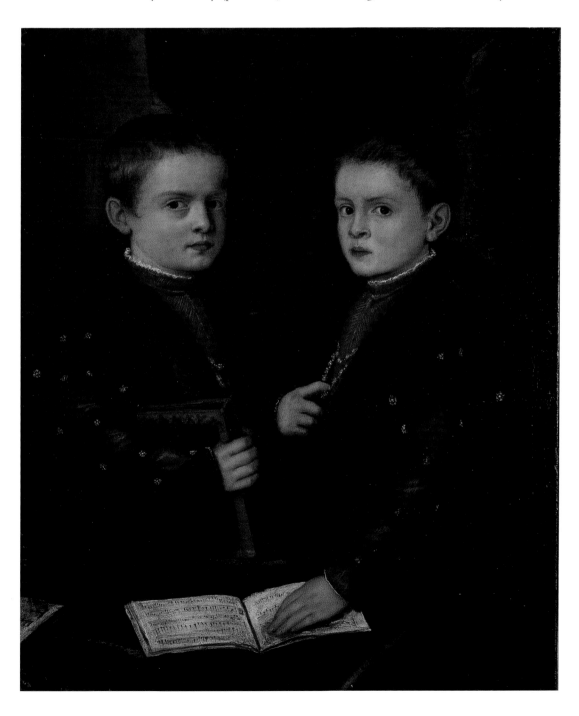

16.9 Titian and workshop,
Two Boys of the Pesaro Family,
oil on canvas, Venice,
c.1540–45 (Private collection)

MUSIC AND SOCIAL GATHERINGS

Many patrician men maintained the interest in music encouraged in their youth into adulthood. From surviving letters we know that members of the Florentine Strozzi family, brothers Filippo and Lorenzo, as well as Filippo's son Ruberto, were great musical enthusiasts, avidly collecting and jealously guarding madrigals for their own private use.[59] Filippo and Lorenzo are described as having enjoyed singing madrigals, carnival songs and lamentations publicly 'without shame'.[60] The crescent moons from the Strozzi coat of arms feature on the binding of a music manuscript and in the decoration of the harpsichord in plate 16.3; both testify to the family's musical activities.[61] Music made an important contribution to the social life of many patrician men: gatherings at which music was performed by a combination of professional and elite amateur musicians were common and could also include discussions of theoretical aspects of music – the relationship between music and poetry, for example, or conjectures as to the nature of music of the classical past. Functioning as informal academies, musical gatherings of this type took place in the mid-sixteenth century in the palaces of the Venetian nobleman Domenico Venier and the exiled Florentine Neri Capponi in Venice,[62] and in the Florentine home of the Bardi family at the end of the century.[63]

At non-patrician levels of society people also met in each others' houses to play and discuss music. One of the most extraordinary fictional accounts of two such evenings, written by Anton Francesco Doni in 1544, involved a combination of proficient amateurs and professional musicians and is presented as a dialogue into which actual pieces of music – madrigals, motets and French chansons – are interspersed.[64] Discussion centres around the pieces sung, and a sense of dramatic realism is injected through the inclusion of mistakes in the music ('This bass is wrong, or you are singing it wrong; look: ut, sol – two rests are missing. Put six where there are four') or comic touches such as a bored participant humming to himself ('ut, ut, mi, re, mi, fa, sol, fa, mi').[65] A letter from Doni asking a singer friend to come with a group of fellow musicians and bring 'a case of viols, a large harpsichord, lutes, flutes, crumhorns and part books for singing' for a comedy they were to perform at his house suggests that Doni himself

hosted musical entertainments on a moderately elaborate scale.[66]

Music at social gatherings was not necessarily provided by professional performers. Those with ability could be paid for their services regardless of their main profession, such as the peasant Niccolò Lori, who played the rebec, a bowed string instrument, at several parties given by Niccolò di Luigi Capponi in 1575.[67] Most frequently, however, musical contributions came from guests. A reputation of musical proficiency could result in a plethora of invitations, such as the youth in one of Fortini's *novelle* who was often 'invited to supper and to gatherings, because he sang very well and played all types of instrument'.[68] Similarly, the popularity of social gatherings at a particular home could be due to the frequency and quality of music-making that took place there: 'In Cinzia's house there were always many gentlemen … because there one played, one sang and there was always some pleasant discussion.'[69] A poem by Giulio Cesare Croce shows how this participation might not always have been willing or enthusiastic. A host eager to have music and dancing at his party asks those who play to fetch their instruments, but meets with reluctant responses:

'Signor Oratio, get your lute.'
'I'm not very in tune, Signore …'
'Signor Ottavio, bring your viola.'
'I don't have it here, it's locked up in the school …'
'And you Signor Ortensio, your little spinet …'
'I will do as you wish,
Although I'm not an excellent player.'[70]

False modesty seems to have played no part in their protests, as during the dancing later on they are told:

'Oh musicians, it's as if you're sleeping:
Play a little more strictly,
As the next dance
Goes with much more vigour.'[71]

Even children could be pressed into entertaining visitors. In another text by Croce an uncomfortable host says to his son:

'Come now, well, so as not to be idle, little Camilla will play the spinet a bit, and you will sing some small song.'
'What would you like me to sing, father?'
'Sing whatever song you like, as long as it's short.'[72]

16.10 Giulio Grotto, pseud. [Giulio Cesare Croce (?)], *La Violina*, Ferrara, 1590 (cat.40)
In the 'Violina', a young girl protests that she would rather marry a handsome youth than a rich old man.

SONGS AND POETRY

A lack of music books or instruments did not necessarily indicate a lack of musical activity: there existed a strong tradition of transmitting melodies and texts orally and performing without musical notation. Occasionally, it is possible to retrace the echoes of the music that people sang casually to themselves as they went about their daily business. Children were first exposed to song as lullabies; prescriptive literature recommends that parents or wet nurses could 'prevent children from having long, loud bouts of crying with sweet and delightful songs'.[73] But references to this sort of singing are rare and usually captured only incidentally. In one poem a mother is suspicious of her daughter continually singing the *Diridon* (a popular song also known as the *Tirindon*), which she does all day long, 'with and without accompaniment'.[74] In self-defence, the daughter says she sings because she is young and enjoys the song, but this does not assuage the mother's qualms that her daughter is surreptitiously communicating with a young man who hangs about outside their house. In another example a diary records the death of 'a jocular man', seventy-five-year-old Jaco de Colavabbo: 'He was at home after dinner by the fireside; he was singing to himself the prophecy of St. Bridget with great festivity and joy. He felt a sudden pain and suffered a stroke and he died of it.'[75]

Many 'popular' songs were based on the performances of *cantimbanchi* or *cantastorie* who sang poetry publicly in city *piazze*. We know from numerous sources that Ariosto's epic poem *Orlando Furioso* (1532) was performed across Italy in this way, to stock melodies that were subsequently sung by all: 'loved by the old, the young, women, the most learned of men; they resound through the city and travel to the country'.[76] Certain songs, such as the *Franceschina* or the *Girometta*, enjoyed particular popularity during the sixteenth century, and their melodies were written down and incorporated into standard musical repertories.[77] Scipione Ammirato writes of the *Girometta* that 'it was sung by children and adults day and night, in *piazze* and streets, in such a way that everyone had this song continually thundering in their ears.'[78] So common was the *Girometta* that in this novella even dogs started to bark its tune. Other songs, such as the *Violina* (plate 16.10) and the *Gobbo Nan*, were evidently well

16.11 *Vilanesche opera bella*
et dilettevole, Venice, 1585
(Biblioteca Universitaria
Alessandrina, Rome
XIII.a.58.74)

known, but their melodies have not survived.[79]
'Everyone's singing the *Violina*' states the 'reply' to
the *Violina*:

> From the evening until the morning
> In the houses and the streets
> At banquets and *mattinate* [nocturnal street-
> singing].[80]

Texts of these songs were often printed in small
books of poetry. Although they contained no music,
their title pages often state that the contents were to
be sung (see plate 16.10), to melodies that were
presumably transmitted orally.

MUSIC AND OBJECTS: FANS AND PLATES

Books of poetry were not the only repositories of
song texts. One surprising domestic object that
recorded verses to be sung is the paper fan, known as
the *ventola* or *ventarola* (plates 16.11 and 16.12).[81]
Used in summer to cool oneself down and drive
away insects, and in winter to protect oneself from
sparks from the fire, these fans were often elaborately
decorated on both sides. 'Most of them are very
elegant and prety things,' writes the Englishman
Thomas Coryat: 'the paper … is on both sides most
curiously adorned with excellent pictures, either of
amorous things tending to dalliance, having some
witty Italian verses or fine emblems written under
them or of some notable Italian city.'[82] A fan-seller in
a contemporary poem cries:

> Here you see beautiful sonnets
> Verses, rhymes and learned sayings
> Madrigals and *villanelle*, and *capricii* and lovely
> things.[83]

Sold by ambulant pedlars, they were popular from
the 1520s onwards and seem to have been available
to a wide range of people: one poem opening
Mi chiamo ventarola ('My name is fan') states 'I serve
everyone / Men, women and children',[84] while
another, 'In praise of fans', declaims that they are
loved and respected 'By the low, by those in the
middle, and by Heroes'.[85]

Once existing in large quantities, only a very small
number of these fans have survived, preserved bound
up into books as poetry or collected as prints.[86] They

16.12 Paper fan with
rebus puzzle and poem
(*Alle bellissime, e virtuose
gentildonne bolognese*)
by Giulio Cesare Croce,
Bologna, late 16th century
(Biblioteca Comunale dell'
Archiginnasio, Bologna,
BCAB, A.V.G.I.X., 1412)

are either decorated with woodcuts, many depicting some form of music-making, or have a poem on one side with a woodcut illustration on the other. An examination of their content reveals remarkably strong connections between fans, poetry, music and domestic theatrical games. Poetry appearing on fans ranges from the texts of popular songs, such as the *Violina*, to verses known as *mascherate*. A frequent ingredient of sixteenth-century sociable gatherings, the *mascherata* was a type of musical 'turn' in which participants were required to impersonate one of a range of stock characters. In a fictional description of a late sixteenth-century party, or *veglia*, the person in charge of the games instructs the others present to perform *mascherate* as a range of characters, from wet nurses and French cooks to the well-known comic characters Gratian and Pantalone. One guest has to sing a peasant girl's song; another is told: 'Marino, / I want you to be a chimneysweep.'[87] *Mascherata* texts identical to those given in this account are found not only in books but also on fans, often with woodcut illustrations. In a handful of cases musical settings

for these verses also survive. Marino's response at the Bolognese party, 'Oh, oh, chimneysweeps, / who, lovely ladies, has a chimney to sweep?',[88] is almost indistinguishable from the text set to music and published by the Bolognese composer Filippo Azzaiolo.[89] Fans, it seems, could function as prompts for the singing of poetry, playing an active role in domestic theatrical performances.

Fans were also used as a basis for sociable play in other ways. A late sixteenth-century Bolognese fan has a rebus puzzle on one side and its solution in poetic form on the other (plate 16.12); its riddle could therefore be posed as a teasing challenge.[90] Popular in Italy during the sixteenth century, rebus puzzles are discussed in the numerous books of *imprese*, or emblems, published during the period.[91] These puzzles often visually expressed the syllables 'ut', 're', 'mi', 'fa', 'sol' or 'la' using musical notation. The first examples appeared in the late fifteenth century in France, but the written rebus seems to have come to Italy in the late fifteenth or early sixteenth century via the Milanese court. Seven

leaves of one of Leonardo da Vinci's manuscripts include more than 150 puzzles, many of which use musical notation.[92] The earliest printed Italian examples appear in editions of a poem, *Filogine*, by the writer Andrea Baiardo, who also had close links with Milan: one whole verse is presented visually as a rebus (plate 16.13). In his treatise on the art of writing (1540), Giovambattista Palatino discusses the rebus (calling it *sonetto figurato*) and gives instructions for its composition:

16.13 Andrea Baiardo, *Filogine*, Venice, 1535 (British Library, London, 1073.f.2)

The figures should be clearly and distinctly set out using as few letters as possible. One need not be too careful with spelling, or use ornate or Tuscan language; neither is it important that the same figure serves for the middle or end of one word and the beginning of the next.[93]

Four examples of poems in rebus form follow, each of which includes musical notation. For all of these puzzles a certain amount of musical literacy was vital to be able to decode successfully the musical clues alongside the pictograms.

Less enigmatic musical inscriptions are found on maiolica ware throughout the sixteenth century. Motifs of open books containing sketchily drawn musical notes, suggesting the idea of written music, can be found in many examples of maiolica from the first half of the sixteenth century, while others are decorated with legible music that does not seem to have any inherent meaning. Cipriano Piccolpasso's treatise on the art of the potter, which discusses the production and decoration of maiolica, contains an example of classically inspired *trofei* (trophies), including an open book decorated with a clearly visible two-part piece with the words 'Armati cor mio'.[94] A few surviving dishes include intelligible musical inscriptions with texts that appear to be the opening phrases of particular songs.[95] Not all of these can be identified with extant pieces of music, but they presumably represent the openings of songs recognizable at the time,[96] and may therefore have acted as prompts for the performance of the piece, giving the opening phrase of a single voice with the expectation that it would be continued and joined by others. A rare example of a plate exists, however, from which an entire piece of music could once have been performed (plate 16.14). This bears the alto voice of a four-part *frottola*, attributed to Giacomo Fogliano in the printed sources from which the music was clearly copied.[97] Both the cartouche on which the music appears and the reverse of the dish bear the name 'Altus', which implies the existence at one point of similar dishes bearing the three other parts ('Cantus', 'Tenore' and 'Bassus'). When the dishes were brought together at the table, the piece could be performed in its entirety.

★ ★ ★

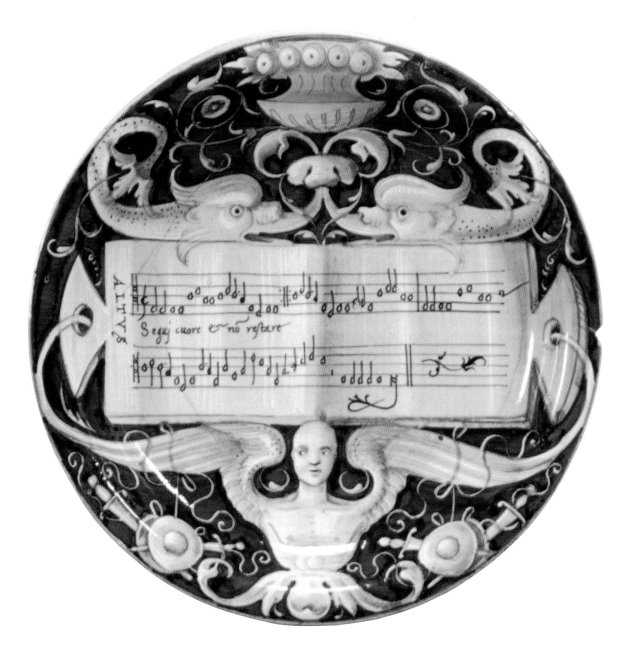

16.14 Dish with musical inscriptions, tin-glazed earthenware, Casteldurante, 1525–30 (Museo Internazionale delle Ceramiche, Faenza, 21036)

Contributing to the daily lives of people at all levels of society, music became, as one contemporary writer put it, 'the condiment of our happiness'.[98] The increase in production and availability of instruments and books led to more widespread musical activity, recorded in letters, diaries and domestic account books, as well as paintings of the period. Traces of the rich tradition of popular song can be partially recaptured through literary sources and the material evidence of fans. Inscriptions on maiolica ware reveal a further interweaving of music and the domestic material world.

In prescriptive literature the sound of the house was deemed to reflect the nature of the household. Recommending that guests be lodged 'far from the noise of the family', Giacomo Lanteri notes that visitors will otherwise 'judge the head of the family either negligent or believe the whole house to be in chaos'.[99] Another writer warns that the husband who cannot keep discipline in his house faces a lack of domestic peace and lasting conjugal love, leading to 'fights, discords, noises, with great disorder of the care of the family'.[100] In this context Bassano's family group harmoniously playing and singing together represents the epitome of domestic bliss: a metaphor for a happy and well-ordered household.

MEALS

ALLEN J. GRIECO

17.3 Purple glass beaker, Venice, 1480–1510 (cat.53)

IT SEEMS TO BE AN UNWRITTEN LAW of history that the more we are interested in common and everyday occurrences, the harder it is to find the documents to help us in our task. The problems we encounter when speaking about meals provide a case in point. To begin with, most meals, and especially those eaten every day, did not normally give rise to archival sources worth speaking of, whereas the more one moves to upper-class meals, to rich meals, to 'special' meals and to banquets (plate 17.1), the more documents are available. The reason for this phenomenon is, quite simply, that the considerable expenses incurred on these occasions had to be documented. These records included printed descriptions of banquets, possibly the first of which was published in 1475 to commemorate Costanzo Sforza's marriage to Camilla Marzano.[1] Such documents are an important source and testify to how banquets were meant to communicate to a wider audience than just the people who attended these occasions. However, although documents of this type are interesting, they should be considered predominantly as models for festive occasions or for the meals of the rich and powerful, rather than a basis for generalizations about eating during this period. Only scant evidence survives for simple meals. This can be supplemented by literary sources, which, despite requiring careful interpretation, do provide at least some idea of what such meals might have been like (plates 17.2 and 17.3).

17.2 Knife and two-pronged fork, Italy, c.1500 and 16th century respectively (cats 58 and 59)

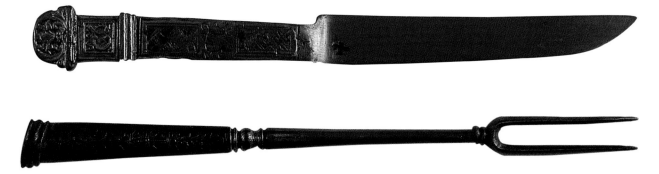

17.1 Greek-Venetian artist
after Tintoretto, *Marriage
Feast at Cana*, Venice,
c.1561–70
(cat.50)

Insofar as the more exceptional meals are concerned, there is varied and plentiful documentation. In fact, it is possible to obtain data on meals from such diverse sources as the accounts of top level banquets (for example, state marriages, visits of potentates and meals celebrating a newly acquired knighthood), the sumptuary laws bent on curbing excessive luxury in the Italian city states, cookbooks (mostly designed for an upper-class clientele) and even a variety of medical texts on diets. Even more precise are the account books for both families and institutions, which help us to understand what people ate and to a lesser degree how they ate.

MEALS OF THE WEALTHY AND THE EVOLVING MERCHANT-CLASS FOOD ETHIC

From the very outset it must be said that it would be illusory to try to define what the medieval and Renaissance Italian meal was like. Even a cursory glance at the sources confirms that there were then, as now, many different types of meals depending on a number of variables. This variability can, in fact, also be observed in the meals that were offered by inns of the time. For example, the meals available in the Albergo della Stella in Prato in the early fifteenth century could range from the simplest 'egg and some bread for the slave' to at least two different fixed price menus, but also included what we would today call 'a la carte' meals, which could be ordered by the wealthiest clients. The most obvious of these variables is, of course, the one connected to the social class of the consumer. In a society where social distinctions were manifested in a variety of ways, food was an important distinguishing element, not only between the different classes but also between urban and rural cultures. Literary texts are particularly sensitive to this aspect of meals and allow us to penetrate, at least to a certain extent, the social code that was behind these occasions.

In the 1430s Leon Battista Alberti, the author of the *I libri della famiglia*, reminds his readers that the household should be served meals that are both abundant and consist of 'good' but not 'elect' food (in Italian he uses the term *elettissimi*). He points out that the food for the household should not include 'peacocks, capons and partridges, nor other such refined foods that are usually served to those who are sick, but rather make sure that you serve a meal for city dwellers'.[2] Excessive luxury is thus condemned and the code to be followed is explicitly associated with urbane city living. It was, however, also possible to go too far in the opposite direction. There was a fine line between what was considered to be sufficiently good food but not lavish and, conversely, food that was considered excessively poor. The idea that one had to serve food that was appropriate to the occasion and to the status of those at the table seems to have been deeply rooted. Although it is possible to find endless condemnations of how food occasioned excessive spending and luxury, it must not be forgotten that one could be at fault for exaggerated parsimony. For example,

in *La civil conversazione* by Stefano Guazzo, begun in the 1560s, this concern surfaces explicitly at the end of a long passage in which gluttony and excessive expenditure are dealt with in some detail. The reader is reminded that

> just as we feel that condemnation must be heaped on those whose gluttony causes them to never be satisfied with the food they eat and who spend excessively to satisfy their appetite, so do I feel that one can hardly hold up as an example those whose miserliness keeps them from living properly according to their rank in society.[3]

This 'upper-class' statement of the dilemma, whereby expenditure had to be enough but not too much, might well have been seen differently by the merchant classes. It is worth drawing attention to a mid-fifteenth century text, *Il libro dell'arte di mercatura* by Benedetto Cotrugli (first published in Venice in 1573), which discusses the conduct of the ideal merchant and devotes part of a chapter on temperance to the issue of how they should behave when it came to eating. According to this text, great restraint should be exercised with both food and drink: 'Eat only in order to sustain your body'. The author's reasons included the fact that the public role of a merchant's life demanded sobriety at all times, otherwise he would run the risk of making a mistake when adding up what he owed or was owed. Too much food was seen as being dangerous because it provoked slothfulness, sleepiness, slow wits and other undesirable effects. The author lists the five different signs of gluttony, quoting Thomas Aquinas:

> first of all, when you eat earlier than is wont; secondly, when after one kind of food you desire another; thirdly, when you desire precious foods; fourthly, when you want great quantities of food; fifthly, when you are not careful to be clean, but rather eat avidly and without any order.[4]

That such a statement was not a hollow prescriptive maxim can be seen if we examine the rare accounts that have survived and that shed some light on the diet of a merchant. A study of the food outlay incurred by Italian merchants working in the Datini office in Valencia in the first decade of the fifteenth

century suggests that the restraint called for in pre-scriptive texts was matched in reality by an equally parsimonious behaviour.[5] This is apparent if one considers that bread and wine alone accounted for over 51 per cent of the total expenditure for food-stuffs, a proportion close to the lower-class diets of the same period. Further confirmation comes from the extremely limited use of spices (1.36 per cent of the food budget) and a meat consumption that, while relatively high (a little more than 26 per cent), is revealingly limited to buying butcher's meat. In fact, fowl, the mainstay of upper-class diets and a strong social marker in the fifteenth and sixteenth centuries, is served only on very special occasions (thirteen times in the course of a whole year).

The general increase in the level of wealth over this period seems to have had an influence on the meals and food that the urban and merchant classes consumed. Eustacchio Celebrino's *Refettorio*, first published in 1526, is a unique document in more than one way.[6] Although clearly a piece of prescriptive prose, and thus subject to all of the caveats of this kind of source, it does provide us with an opportunity to look at a social milieu that is usually hidden from the historian's gaze. Unlike the didactic literature of the period that was produced in and for court audiences (whether lay or ecclesiastical), this small octavo booklet of no more than fifteen pages was clearly aimed at a more 'middle-' and merchant-class readership. It is not only the formal aspect of this document, however, that suggests a relatively simple readership, but also its content. The tone of the book is set from the very beginning, since the full title specifies that it will explain how to carve 'all kinds of meats' and how to serve dishes 'according to the order in which a *scalco* [literally 'carver'] would do it'.[7] Clearly the book is meant for houses where there was no resident *scalco*, a position of great prestige in the fifteenth- and sixteenth-century courts and in the palaces of the wealthiest members of society. Celebrino's text must be seen as an attempt to disseminate the specialized knowledge of these high-level professionals, knowledge that is often detailed at great length in the much more ambitious and complete treatises published in the sixteenth century.

The first part of the volume is devoted to the description of eight different types of meals to be served: from a 'sumptuous meal' to a simple one. After the elaborate meal the author lists an everyday dinner, a lunch during Lent, a lunch in periods of the year when fruit is available, and lunch and a dinner for an 'intimate friend' (*amico domestico*). All of the meals follow the same basic grammar in which there are four distinct courses. In all cases the meal begins with a first course, what we might call today an entrée; for the formal meals it can consist of two, three or more dishes and can be varied according to the importance of the meal. The dishes, often quite unlike what is served at present to begin a meal, can range from expensive prestigious candied fruit (such as lemons, walnuts, ginger) or sweet wine such as malmsey (*malvasia*) and biscuits to much simpler dishes such as mixed salads, fresh cream (*cavi di latte*) and liver with a red sauce. Then follow two distinct courses, a boiled and a roasted one (sometimes the order is inverted) usually consisting of different meats, which during Lent were replaced by fish. Here again the dishes can be increased and varied by choosing the meats, fowl and fish in such a way as to modulate the importance of the meal. All the meals mentioned by Celebrino end with a last course, which on the fanciest occasions is made up of a kind of marzipan cake (*marzapan*) and for the simpler meals consists of cooked or raw fruit and cheese. It should be added that all these meals, no matter how simple, are clearly one step up from the common everyday meal, for which it remains almost impossible to find records. They are, however, interesting because they show that middle-class meals (and I use this term for lack of a better one) had not only become more complex since the beginning of the fifteenth century but also mirrored the evolution that upper-class meals and banquets had undergone.

To go back to upper-class meals, the opposition between public occasions, in which the food had to meet certain standards in order to uphold the honour of those who were offering it, and private meals, where one ate in a very modest if not down-right parsimonious way, seems to be a fundamental divide that runs through the history of Italian food consumption. The excesses that public meals could entail, inspired by a wish to display both the wealth and power of a family were, above all, associated with the magnate class. They were not, however, entirely

restricted to this social group. These concerns were an important part of life for the merchant classes as well, especially as the late medieval and Renaissance ruling class in central and northern Italy was often recruited from the ranks of the wealthier merchants. Conspicuous consumption was dealt with by town authorities who promulgated sumptuary laws. From the late thirteenth century to the end of the sixteenth century practically every Italian city state had its own sumptuary legislation that was regularly updated. Although most of this legislation dealt with the even more sensitive issue of clothing, almost without exception it included a set of laws devoted to curbing excessive alimentary luxury displayed in public. These laws were ultimately quite ineffective in containing such displays, but they do tell us something about how lavish meals were structured and, incidentally, about what was considered to be the maximum luxury allowable.

In Florence, for example, the banquet regulations of 1473 allowed only two courses (one of boiled meat and one of roasted meat), but they appear more liberal than earlier laws since a greater number of meats were allowed in each course. The course of boiled meats could include up to three different kinds of meat, while that of roasted meats could be served with as many as four different types. This law also mentions that anything made with eggs, cheese or milk, as well as blancmange (*biancomangiare*), pies of different kinds, soups, *maccheroni*, pork, salted meats or fish, gelatine and many other items, need not be considered an extra course and therefore could be served without incurring sanctions.[8] This loophole in the law is interesting because it confirms and explains the impression that festive meals had become increasingly complex affairs in the fifteenth century and sixteenth centuries. The wording allowed for any number of side dishes to be added to the main courses, something that presumably was fully taken advantage of without incurring the wrath of the civil authorities.

Festive banquets, for which we have abundant accounts, respected in most cases the sumptuary laws, but it must also be pointed out that these

laws could be broken. If, for some reason, it was decided that a banquet was to transgress the terms of the law, all that was needed was to pay the fine, a punishment that in some cases might well have added to a family's display of wealth and power, thus ultimately turning the law against itself. It must not be forgotten that sumptuary laws were aimed above all at conspicuous display, as indicated by the Florentine law of 1473 which stated that a private meal at home with only family members attending did not need to observe any of the rules and regulations decreed for public meals.

Turning away from sumptuary laws and looking at some of the festive banquets that were recorded in the late fourteenth century, it becomes apparent that the structure of these meals was already very similar to the one we inferred from the sumptuary laws. For example, the structure of the meals celebrating Giovanni Panciatichi's knighting in 1388 in Pistoia and Florence was very similar to the banquet served more than sixty years earlier in honour of Francesco di Messer Sozzo Bandinelli's knighting in Siena.[9] Both banquets began with sweetmeats (such as candied fruit, ginger), went on to a dish of boiled meats, continued with a course of roasted meats and ended with yet more sweetmeats. Although the source does not specify whether the sweetmeats at the end of the meal were different to the ones at the beginning, it is likely that such postprandial food adhered to the dietary norms of the period and consisted of candied seeds of various kinds. Along with the meat dishes, there were also some pies, blancmange and a variable number of other side dishes. These relatively simple festive meals of the fourteenth century, which remained the rule in the fifteenth century, tended to disappear during the following century in favour of increasingly elaborate meals in which the number of courses increased exponentially. The festive gatherings mentioned in the cookbook published by Cristoforo Messisbugo, a high official (first a *spenditore* – in charge of buying provisions – and then a *scalco*) of the Este court, show that by the 1540s and 1550s the two-, three- or four-course meal had become a distant memory. Not only had the number of courses increased to

17.5 Pastry cutter, Italy, 17th century (cat.96) Pastry-cutting tools like this were used to make shapes out of all sorts of doughs, from pasta to pie-crusts, as can be seen in the illustrations to Scappi's *Opera*.

17.4 Bartolomeo Scappi,
Opera, Venice, 1570
(cat.89)
The scenes at this opening
show pastry being prepared
and sauces filtered (left), and
dishes being washed and
knives sharpened (right).

as much as seventeen, but the number of dishes in each course could vary from seven to nine.[10] This profusion of courses and dishes served at the Este court is more or less confirmed by the festive meals that Bartolomeo Scappi, the cook of Pope Pius V, mentions in his *Opera* published in 1570 (plates 17.4 and 17.5). The meals he recounts were made up of anywhere from six to at least eight courses, which he refers to as either *servizi di cucina* or *servizi di credenza* depending on whether they were hot dishes from

the kitchen or cold ones prepared at the *credenza*. Each of these courses was, in itself, composed of as many as eight to sixteen dishes.[11]

The vast increase in courses during the sixteenth century is partially due to the fact that the *servizi di credenza* doubled the number of courses in a meal. The *credenza*, quite literally the sideboard, referred to a piece of furniture where the more prestigious serving platters were exposed, but also had other functions that are too often forgotten. The *credenza*

was, in fact, also where sweetmeats were kept and where all the food was prepared and transferred from the platters arriving from the kitchen to the plates to be served up. The *credenza* became an important institution during the late fifteenth and early sixteenth century, most probably in conjunction with the growing popularity of 'salads' that constituted a whole class of new dishes.[12] Quite unknown in the late Middle Ages, these salads (*insalate*), unlike today, included cold meats, fish, and shellfish of all kinds. They had in common the fact that they all were salted (which explains the etymology) as well as being dressed with vinegar and oil. Together these dishes constituted the so-called *servizio di credenza*.

It would be quite wrong, of course, to think that meals designed for princes, courtiers or popes resembled in any way the daily fare of the upper classes. Even a table such as that of the *mensa della signoria* (the table of the highest executive body in the city of Florence) in the fifteenth century[13] did not come close to the luxury encountered in courts at the same time. The detailed daily shopping list of this governing body does not allow us to determine the exact menu provided at their table, but the limited amount of items bought for these meals suggests that they were nowhere as grand and varied as the festive meals served in courts. In most cases the Signori ate two or three different meats every day (usually veal, mutton and fowl of various kinds) with side dishes like blancmange but also salad, vegetables of various kinds and fruit. The shopping list became more varied when an important visitor had to be honoured (such as an ambassador or a prince) or for special occasions (including Christmas and the last day of carnival).

That festive meals were altogether exceptional and therefore hardly indicative of a simpler way of eating is also born out by Domenico Romoli in his little-studied treatise on the different aspects of the princely table and its management in the early sixteenth century. Book four of his treatise is devoted to the menus he prepared and served from 10 March 1546 to 9 March 1547. These meals, which he carefully points out from the outset are 'ordinary meals day by day',[14] appear restrained when one considers that they were meant to be the fare of a prince. While showing a certain amount of variety, these 'ordinary' meals confirm once again that the basic

structure of the repast was not very different from the one described by sumptuary laws. The main meal of the day was lunch, which was made up of three courses on normal or 'fat days' and four courses on 'lean days'. Lean days were the ones in which religious prescriptions required the entire population to forego any kind of meat, fowl and eggs and substitute such fare with fish or vegetables (Fridays, Saturdays and during the forty days of Lent). Each one of these courses included some four or five different dishes. Thus, on lean days the meal began with an *antipasto*, which was followed by a second course referred to as *allesso* (boiled) and a third course referred to as *fritto* (fried), and finally ended with *frutte* (fruit), which also included vegetables and candied fruit. On normal days the *fritto* course was simply dropped. Supper, on the other hand, was almost invariably made up of four or five different dishes, but was not subdivided into courses.

The tendency in this period towards increasingly large meals, at least on festive occasions, did not mean that people ate vast amounts of different foods. There is ample evidence to suggest that individuals chose suitable foods from what was served (according to their constitution) and avoided the many other available dishes. The abundance and luxury of these occasions were condemned by some. The advocates of moderation were, presumably, among the many who bought and read Alvise Cornaro's treatise on sober life, something of a bestseller, which was first published in 1558 and remained popular well into the nineteenth century. Cornaro lamented the fact that in Italy 'excessive eating is seen as a virtue and an honourable thing to do, while a sober way of living is seen not only as a dishonourable custom, but also one becoming only the miserly'.[15]

The criticism that Cornaro levelled at those who ate and drank excessively must have been intended primarily for people who routinely ate a lot at public banquets, since private meals seem, on the whole, to have been much more restrained affairs. Beyond the princely 'everyday' meals mentioned by Romoli, one could add other examples of how 'domestic' meals were comparatively modest. Guazzo, for example, a contemporary of Cornaro, opposes the noise and confusion of public banquets with the more moderate, simple and satisfying meals in which family and friends ate together.[16]

The clear distinction that must have existed between public and private meals can also be inferred from the comments of the Englishman Sir Robert Dallington regarding a trip he made to Tuscany in 1596. Although accounts of festive meals clearly underline the conspicuous consumption of meat, Dallington soon came to the conclusion that meat was not served very often on a daily basis. He noticed that 'for every horse-load of flesh eaten, there is ten cart loades of herbes and rootes, which also their open Markets and private tables do witness'. For someone used to eating much more meat, the surprising consumption of vegetables (a recent phenomenon among the upper classes) was explained by Dallington in the following way:

Concerning Herbage, I shall not need to speake, but that it is the most generall food of the Tuscan, at whose table a Sallet [salad] is as ordinary, as Salt at ours; for being eaten of all sorts of persons, & at all times of the yeare: of the riche because they have to spare; of the poor, because they cannot choose; of many Religious, because of their vow, of most others because of their want.[17]

FOOD AND THE LOWER CLASSES

Poor meals are not usually described in any detail and most accounts are limited to mentioning what was eaten. The most commonly described meal in literary sources, especially autobiographical accounts,[18] consisted of onion or garlic and bread, probably representing the most basic type (plate 17.6). Although well known and even overused in books on food history, *The Bean Eater* (Rome, Galleria Colonna), painted by Annibale Carracci in 1585, is a pithy statement of a typical lower-class meal. In front of the diner on the table, the bowl of beans sits beside all the most basic elements of such a meal: bread, onions, salad and a glass of wine. The lack of meat or any other source of animal proteins is conspicuous but quite usual for lower-class meals of the period. This kind of poor repast is not encountered only in paintings and literary sources, but was also the fare, at least two or three days a week, of the North African slaves who built Florentine fortifications in the sixteenth century.[19]

It is quite certain that both the food that some-body chose to eat (or, in some cases, was obliged to eat) and table manners were considered fundamental elements in determining an individual's social class. An interesting example of this can be found in one novella by the early fifteenth-century Sienese author, Gentile Sermini. The whole story is an elaborate joke (a *beffa*) played on Mattano, a well-to-do young man from the countryside who thinks that he should be eligible for the highest political offices in Siena just because he has some money.[20] During a plague year he takes refuge in Abbadia a Isola, a small town just outside Siena, where he apes the way of life of a group of young men from the urban upper classes. He spends money in much the same way as them, but it is obvious that his spending is not legitimized by his social rank as theirs is. This group of young men, born within the city walls, a key condition for holding office, decide to play a trick on Mattano and, in doing so, make him understand that his lowly birth and his bad manners will always exclude him from this public role. One of the judges of his eligibility is none other than a bishop's cook who, from the vantage point of the kitchens, can tell the social extraction of his customers simply by observing what they eat and how.

According to the cook, Mattano will never hold office in Siena because he has no table manners and eats what are considered revolting dishes fit only for country dwellers. The list of his transgressions is interesting because, although the intent is obviously satirical, it gives an idea of the code that allowed people to distinguish the city people from the less dainty inhabitants of the countryside. Crucially, Mattano is guilty of breaking rules of etiquette that are essentially urban. The bishop's cook also judges Mattano negatively for eating unrefined food such as goose, warmed-up cabbage and soup with vast amounts of garlic.[21] This love of garlic was thought to be an almost innate quality of the poor and rural populations (to the extent that it is often referred to as the 'spice of the poor'). It was therefore hardly surprising that he ate garlic even with the most delicate meats. The cook was scandalized that 'he would eat that powerful garlic even with capons, pheasants and partridge, just as he had done with the rancid lard he fed on when he lived in the countryside'.[22] Mixing unrefined foods with refined ones demonstrated that his taste was not discerning.

This story shows that even the timing of Mattano's meals betrayed his lowly social origins. Eating in the mid-morning had typically lower-class associations with the break of the working man known as the *panberare*, a conflation of *pane*, meaning 'bread', and *bere*, meaning 'drink', which in some cases was part of their daily pay. Similarly, the mid-afternoon or evening meal called the *merenda* was associated with the habits of rural people eating in the fields. The cook in Sermini's story seals his condemnation of Mattano's eating habits by criticizing the timing of his meals: 'he is wont to take *panberare* breaks to eat and drink something, no less than two or three times a day not counting the break he takes to eat his snack (*merenda*) and then having his dinner'.[23] In short, his uncouth manners were also underlined by the number of times he ate every day, a defect that was considered to be a clear sign of being closer to animal behaviour than that of human beings.

★ ★ ★

At the end of this brief look at Italian Renaissance eating habits it seems important to reiterate that the closer one looks at meals, the more difficult it becomes to make generalizations that are valid in all cases. The most fitting conclusion might well be to quote Eustachio Celebrino, who at the end of his booklet reminds his readers:

> Although I have described to you the types of meals observed in Venice, this does not mean that you can practice and know the universal order of meals; for this reason it is said that every region has its own way of doing things and every house has its own customs.[24]

17.6 Oil and vinegar cruet, probably Venice or Padua, 1530–40 (cat.102); dish, northern Italy or Tuscany, *c*.1500 (cat.100); jug, probably Bologna, *c*.1510–20 (cat.101); bowl, possibly Padua, 1475–1500 (cat.103)
Everyday ceramics combined traditional decorative motifs with innovative shapes. This cylindrical oil and vinegar cruet is inscribed 'OIO' (for oil) on one end and 'ASE' (for vinegar) on the other.

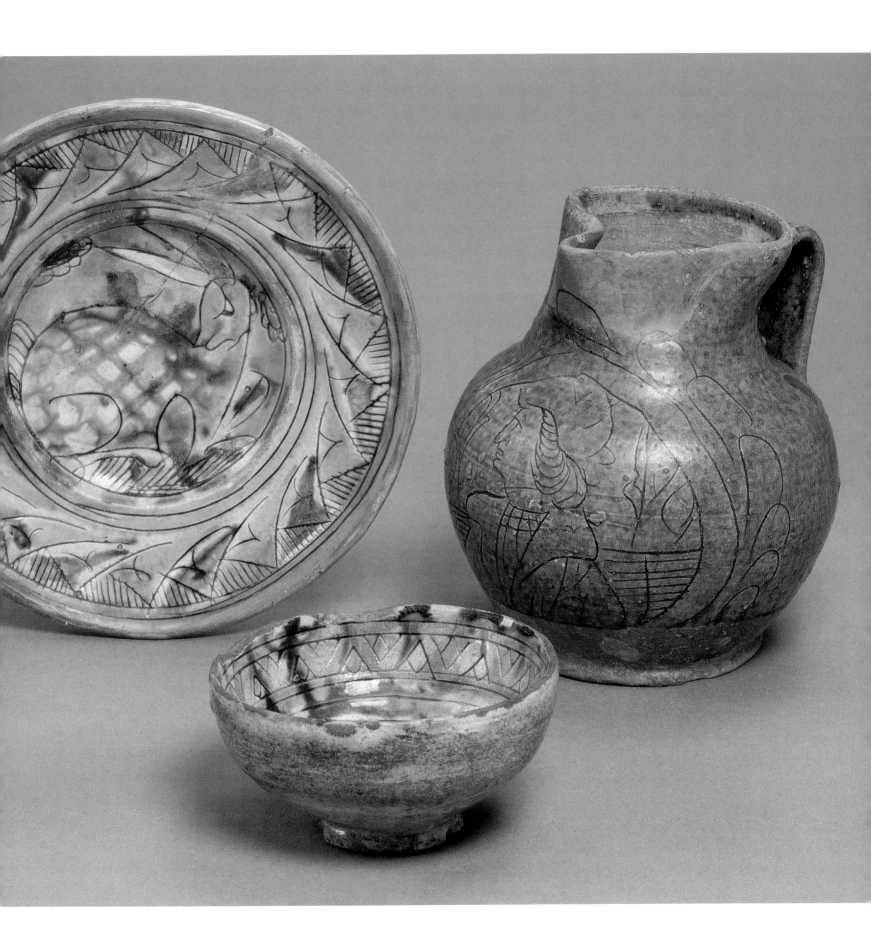

TABLEWARE

REINO LIEFKES

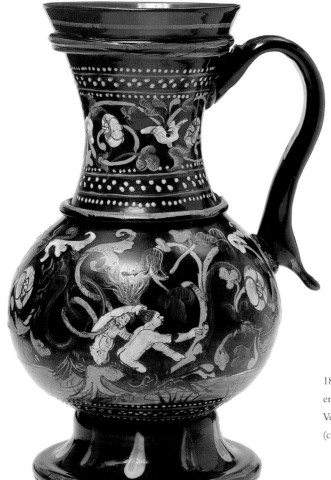

18.1 Blue glass jug with enamelling and gilding, Venice, 1500–1525 (cat.52)

IN THE 1490S THE HUMANIST Giovanni Pontano wrote a treatise about the five virtues associated with spending money, in which he identifies dining as one of the most important social activities. He used the term 'conviviality' for the virtue of coming together in an atmosphere of familiarity to enjoy a meal.[1] Perhaps, with the exception of clothing and personal adornment, there was no context more suitable for expressing social aspirations, civility and splendour than dining (plate 18.1).

During this period Italy saw rapid changes in dining practices and in the material culture of food and cooking. In the aftermath of the Black Death in the fourteenth century, a heavily reduced population enjoyed a relative abundance of food. The introduction of new foods went hand in hand with an unprecedented development of tableware. From a relatively sparse range around 1400, objects for the table reached a peak of sophistication by 1600 with growing numbers of ceramics, each with its own specific function, such as the eggcup (plate 18.11). During the first half of the sixteenth century ensembles of tableware emerged, most notably the matching ceramic 'service'.

A large literature on Renaissance ceramics and, to a lesser extent, glass and metal artefacts exists, and in recent years an increasing interest in the history of food and cookery has developed (see pp.244–52). The material culture of eating, however, remains notoriously difficult to study. Inventories inevitably capture a very specific moment in time, often listing items as they were stored away, rather than ready for use, and are normally not very specific about low-value objects such as simple wooden bowls, spoons and trenchers (see plate 23.7). Contemporary accounts tend to illustrate exceptional events rather than day-to-day practice. The same is true for contemporary pictorial sources, which are difficult to interpret because of their layered iconographies. Printed cookery books give a good sense of how the tastes and consumption habits of mostly courtly

elites stood as a model for broader social circles, but give tantalizingly little detail about the material culture of eating and dining. Whereas museum collections usually contain the rarest and most highly treasured objects, archaeology provides us with a much more reliable picture of daily life (see pp.332–41).[2] But this source material is patchy and also needs to be interpreted very carefully.

As in medieval times, precious metalwork remained a dominant feature of elaborate meals. Stepped sideboards, or *credenze*, placed against a wall near the table, displayed an abundance of precious objects ranging from the utilitarian to the elaborate, including large dishes, bowls, vases, basins and ewers. Dishes were used for serving, shallow bowls for drinking wine, and ewers and basins for washing hands at the dining table before the start of the banquet and between courses. In his *Banchetti* of 1549 Cristoforo Messisbugo, the famous *scalco* who worked at the court of Ferrara, gives a detailed description of everything needed for a grand banquet or special occasion such as a wedding feast.[3] He prescribes silver ewers and basins for the most important tables and bronze ones for the other tables.

Owning a small number of objects in silver, alongside larger quantities of tableware in other materials, was widespread in wealthy households throughout the Renaissance period. Apart from ewers and basins for washing hands, almost any type of object could be made out of silver, including cups, bowls, dishes, square trays, salts, buckets and cutlery. Silver forks in particular, often in sets of twelve, can be found in many inventories, including those of middle-class households. Probably intended for eating fruit and sweetmeats, they were a symbol of sophistication.[4] When the Florentine silk merchant Jacopo di Giannozzo Pandolfini purchased a set of twelve silver forks and spoons in 1475, he paid the princely amount of over 20 florins.[5] In his account books this amount is only surpassed by a set of beautifully gilded wedding chests costing nearly 40 florins, which he bought in the year of his marriage, two years earlier. Even in elite circles the host's own possessions – and his status – could be bolstered for special occasions such as wedding banquets by hiring or borrowing silverware.[6] But silver was not only intended for the occasional lavish banquet: a Flemish merchant living in Venice had a selection of silver plate in his kitchen – a ewer and basin, a set of twelve spoons, fifteen forks and another four spoons, various sets of knives and two salts – which was specifically described in his inventory as 'for use in the house'.[7]

Despite the occasional sumptuous *credenza* display, precious metalware did not dominate the *sala* as in other European countries such as France and England.[8] In Italy status accrued not so much from the value of the material itself but from the added value of craftsmanship, novelty and rarity. In 1437 the merchant humanist Niccolò Niccoli used to eat 'from the most beautiful antique dishes, and he drank from cups of crystal or some other fine stone. To see him, old as he was, gave one a sense of refinement.'[9] Imported luxury goods such as Spanish lustred pottery, Chinese porcelain and enamelled glass from Syria could contribute a rare and novel element to the table. Imported goods, however, could not supply all the demand for sophisticated food and tableware. In this dynamic market local craftsmen responded by producing goods in line with fashion requirements. The glass industry of Venice witnessed an explosive development and by the middle of the fifteenth century Murano had become the world's main producer of fine glass for the table. A similar pattern of growth can be seen in the manufacture of ceramics, where a handful of relatively rural places became famed for the quality of their wares.[10] By 1568, in the second edition of his *Lives of the Artists*, Vasari praised the local painted pottery from Casteldurante, comparing it favourably with that produced by the ancient Romans.[11]

A dining table in the late fourteenth or early fifteenth century would have held relatively few objects made from a variety of materials. In a late fourteenth-century manuscript copy of *Theatrum Sanitatis* one illustration depicts a typical well-to-do table of the period laid out for a meal, and another shows a more humble dining scene set in a kitchen (plate 18.2). In the picture on the left the table, set up for the occasion in a *sala* or loggia, is a long rectangular wooden board supported by trestles and covered by a white linen 'Perugia' tablecloth, decorated at the two narrow ends with bands of geometric shapes (see plate 24.3, p.342). Red wine is poured from a long-necked decanter bottle, or *inghistera*,

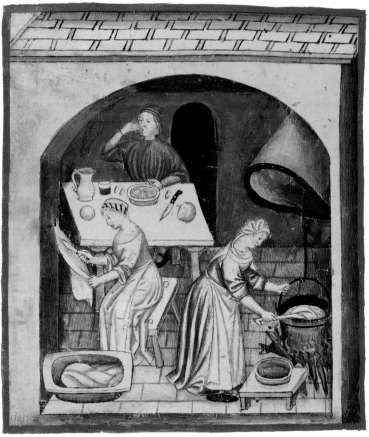

18.2 Miniature illuminations of dining scenes from Ububchasym de Baldach's *Theatrum Sanitatis*, Lombardy, late 14th century (Biblioteca Casanatense, Rome)

while in the kitchen scene an earthenware jug serves the same purpose. In both cases simple, slightly conical glass beakers are used for drinking. Such glass bottles and beakers were the staple output of Renaissance glasshouses and were intended for everyday use as well as for grand banquets, at which they featured in large quantities. In the picture on the left each diner has a knife and a bread roll, while the food is placed on a communal wooden trencher, or *tagliere*. The term *tagliere*, from the Italian for cutting (*tagliare*), is also used for almost flat dishes in ceramics or pewter.[12]

The diners have no individual plates and some of the food is visible in front of them, placed straight onto the tablecloth. Two small receptacles can be seen on the table: one is a salt, while the small dish with a wide rim is probably for condiments. A servant is approaching from their left with a wooden *tagliere*, holding what is probably a cut of meat. Recipe books from the same period frequently refer to solid food being placed on a *tagliere* for serving, while food containing sauces or liquids was put in a

bowl (*scodella* or *scodellino*).[13] The kitchen scene on the right shows such a bowl in the shape of a straight-sided basin.

The habit of sharing dishes with other diners was well established during the Middle Ages. In a long prescriptive poem, *De quinquaginta curialitatibus ad mensam*, written in the second half of the thirteenth century by Bonvesin de la Riva, a lay brother and doctor of grammar from Milan, there is a set of rules about how to behave at the table, many of which are directly related to this practice of sharing a plate.[14] Sometimes a slice of bread could serve as a personal plate,[15] but in around 1400 individual trenchers were introduced, of which only fragments have survived.[16] Bowls and dishes (*piatti* and *piattelli*) were most commonly made from ceramics, but the more well to-do households also had pewter. Almost all inventories list them. In the 1402 inventory of Lotterio di Nerone's Florentine house we find middle-sized and large bowls and dishes, both in maiolica and in pewter, with five large pewter bowls for serving.[17]

Maiolica is the term used now for Italian tin-glazed earthenware, but in the early fifteenth century it referred specifically to highly decorated, lustred pottery imported from Spain.[18] The Spanish agents of Italian merchants sometimes requested a bespoke decoration, including the coat of arms of the family for whom the wares were made (plate 18.2). The lustre decoration, which is prone to rubbing off and scratching, makes such pots extremely vulnerable, but documentary evidence clearly points to its practical use at the table. The famous 'merchant of Prato', Francesco Datini, ordered considerable quantities of Spanish pottery on more than one occasion.[19] The inventory of his Florentine house, compiled in 1400, includes a basin for

18.3 Bowl and two jars with the arms of the Gondi family of Florence, Valencian region, 1486–7 (cats 81 and 80)

hand washing, three cooling vessels for fruit, six small dishes for fish and nineteen bowls from which to eat.[20] His close friend and notary, Ser Lapo Mazzei, asked if he might have copies made of one of Datini's Spanish plates, 'like the one we had, the evening we ate the swifts'.[21]

In 1475 the banker Filippo Strozzi ordered a service of 155 pieces from Valencia.[22] Nothing has survived from this set, but similarly datable examples with the arms of the Gondi or the Martelli family give an idea of their likely appearance. Several different objects bearing the Gondi arms have almost identical decoration, indicating that they were part of a larger matching set. Two tall jars in the British Museum (plate 18.3) demonstrate that the ensemble was not strictly confined to tableware and had a display function. High-quality ceramics continued to be imported from Spain until the second half of the fifteenth century, but this practice came to a gradual end.[23]

While the use of fine imported ceramics is documented, it seems that this was probably restricted to special occasions. The 1450 inventory of Giovanni di Pietro di Fece's modest house in Siena shows that he kept his best tableware in his *camera*.[24] This included a bronze ewer and basin; a Milanese knife-holder

containing three large knives with white handles; and, in a chest close to his bed, a tablecloth, large quantities of maiolica and pewter, including bowls, dishes and nine salts. He kept less-treasured objects in his *camera del pane* (room for bread-making), such as brass candlesticks and two small maiolica jugs, and there was more tableware in the kitchen, including a small brass basin, more pewter salts and a dish, as well as a trestle table, all obviously for regular use. Quite typically, his *sala* was almost empty, containing not much more than a dining table on trestles, two benches and a 'sad old' chair.[25]

When studying a range of domestic inventories of the Renaissance period, it becomes clear that certain kinds of dining-related objects often occur in the same quantities. This pattern becomes even clearer when looking at contemporary invoices and orders for matching dinner sets. Large objects not directly intended for the table, like large jugs and cooling vessels, most commonly came in sets of four, while candlesticks in inventories of the *sala* – mostly made of bronze – often number eight. All other plates, bowls and dishes tend to come in multiples of six or twelve, although the quantities sixteen and forty also occur. It is not clear if these numbers had a symbolic meaning, relating for instance to the twelve disciples present at the Last Supper. Twelve was also the number of members of the Compagnia del Paiolo, an exclusive society of food-loving artists, among them Andrea del Sarto, who regularly came together for dinner parties, following a medieval tradition of the 'twelve gluttons'.[26] Many dishes in recipe books

of the period, such as the *Libro per cuoco*, are intended for twelve people.[27] In recipes twelve people were deemed to need either six or twelve chickens between them. Whatever the symbolic significance of the numbers six and twelve might be, they were of course also standard quantities used in counting and trade. Datini ordered ceramics from Valencia in dozens.[28]

In 1475 Filippo Strozzi ordered 400 glass beakers and 60 glass bottles directly from the furnaces of Murano. This seems like a high number, but it was probably not unusual considering how breakable they were. Simple beakers and bottles were also made at smaller local production centres such as Gambassi near Florence.[29] In inventories such glass might be referred to as 'ours' (*nostrale* or *di nostro*).[30] Filippo ordered at the same time from Murano a small number of exceptional glass objects, including milky white opaque glass made in imitation of Chinese porcelain, marbled 'chalcedony' and blue enamelled glass (plate 18.1).[31] Venice had by now established a complete monopoly of the luxury market. Its glass furnaces had become well known not only for coloured and enamelled glass but above all for a beautifully clear and almost colourless type of glass called *cristallo* or *cristallino*, referring to its similarity to natural rock crystal. Bowls for drinking, plates with and without a low foot, standing cups with covers, salts and cooling vessels, mostly footed, all occur in inventories from the 1490s onwards both in colourless and blue glass and sometimes worked with gilding (plates 18.4 and 18.5).

18.5 Enamelled and gilded glass-footed cooling vessel and serving dish on a low foot, Venice, *c.*1480 and *c.*1500–1520 respectively (cats 19 and 65)

18.4 Enamelled and gilded
glass goblet, Venice, *c.*1480
(cat.64)

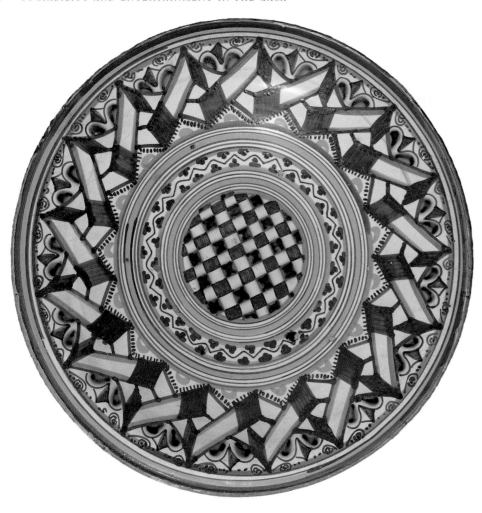

18.6 Serving dish,
probably Montelupo,
early 16th century
(cat.55)
Montelupo tin-glazed
earthenware was appreciated
for its intricate geometric
decoration.

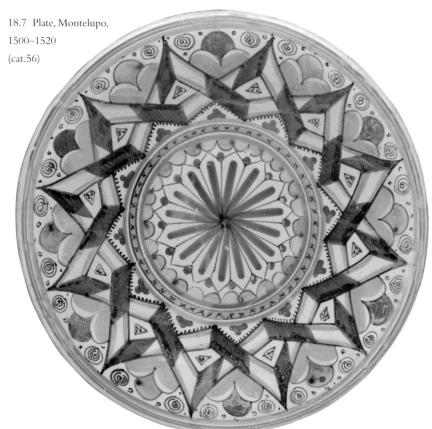

18.7 Plate, Montelupo,
1500–1520
(cat.56)

The development of high-quality ceramic production in Italy was equally dramatic, but the picture is much more complex. Many different production centres, often with their own specialities and traditions, catered for local as well as wider markets. Incised slipware – pottery decorated with a thin layer of clay in a contrasting colour, through which a decoration could be scratched to reveal the underlying colour – was predominantly produced in northern Italy, especially in the Veneto and in Emilia-Romagna (see plate 17.6).[32] With its white surface, maiolica provided an ideal ground for fired, painted decoration. Montelupo, a small village in the mountains near Florence, became one of the city's major suppliers of tin-glazed pottery (plates 18.6, 18.7, 18.8 and 18.9).[33] The second half of the fifteenth century saw a development from 'closed', bowl shapes to more open, plate shapes.[34] Everyday pottery was mostly decorated with geometric patterns, but animal figures and human faces became increasingly popular.

18.9 Serving dish with a stag motif, Montelupo, 1480–90 (cat.54)

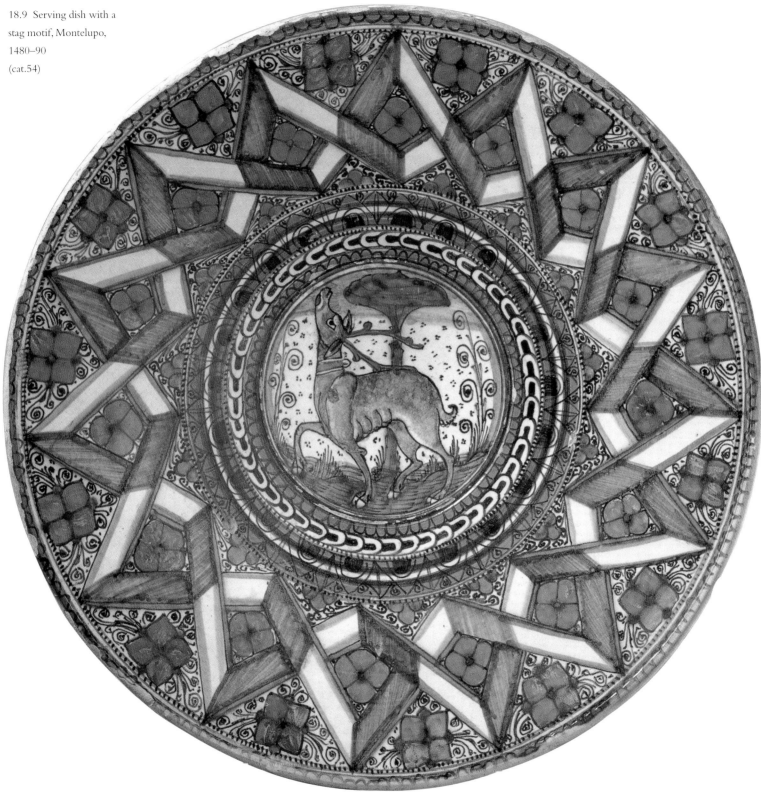

18.8 (*left*) Salt or condiment dish, Florentine area, Italy, *c.*1520 (cat.57)

18.10 Whiteware plates,
one with a deep well,
Faenza, 1550–1620
(cats 69 and 70)

The decorative vocabulary of tin-glazed pottery reached its peak between the late fifteenth and the mid-sixteenth century. The entire outer surface of a dish or a pot could be covered with highly colourful narrative scenes. The stories depicted, often derived from ancient mythology or classical history, gave this kind of pottery its popular name of *istoriato* (historiated or story-painted) maiolica.[35] At the top end of the market whole sets of *istoriato* pottery were ordered by wealthy Italian families, often featuring their own coat of arms. The most famous example is a set of Urbino earthenware, ordered by Eleonora Gonzaga as a gift for her mother Isabella d'Este in 1524.[36] Urban inventories include substantial quantities of maiolica, but they do not give us any clues about the level of decorative refinement of the pottery listed. Given that almost no *istoriato* maiolica has emerged from excavations, it must be assumed not only that its production was relatively small, but also that its use was probably mostly confined to special occasions.[37] In a much quoted letter of 1528 the ducal agent of Urbino wrote to Eleonora della Rovere about the dining habits of the pope: 'Seeing Our Lord eat off earthenware decorated with white on white, I asked his steward why his Holiness didn't eat from ware painted with figures. I got the answer that he ate off nothing else, reserving the other kind for the use of cardinals …'[38]

Various dining sets can at least be partly reconstructed from surviving pieces scattered in collections around the world. It is interesting to compare the dimensions of these objects with a contemporary manuscript source. Cipriano Piccolpasso's account of the manufacture of maiolica, based on his knowledge of the potteries of Casteldurante, was written in 1559, exactly the same date as a surviving set ordered from Urbino by the Salviati family, the so-called *paesi* service (see pp.211–12).[39] In this manuscript there is a scale diagram showing the actual diameters of the standard assortment of bowls, plates and dishes produced in Casteldurante. There are six different dimensions for at least fifteen different sorts of specific objects, and the sizes are standardized to fit the fireproof cylinders or 'saggars' in which they were fired. Large cups (*tazzoni*), dishes (with or without a rim), dishes called 'for meat' (*piatti detti da Carne*), baskets for fruit and raised salvers (*aborchiati*) are all of the same diameter at 27.3 cm, which falls within the range of sizes for the *paesi* ordinary bowls (*scodelle ordinarie*). Plates for salad are 21.5 cm in diameter, the same size as 'dishes for soup derived from silver models'. Plates for napkins and for condiments or sauces are also the same size at 18.8 cm, which corresponds with the small curved plates (*piattetti cuppi*) from the *paesi* service. It is rarely possible to match these sizes with surviving museum objects in

18.11 Tripod egg cup,
Faenza, 1550–1600
(cat.71)

a meaningful way. An exception is a dish in the Bowes Museum (Barnard Castle, Co. Durham), dated 1577, which bears the inscription 'for placing a piece of boiled veal' (*per meter uno pesco* [sic] *di vitello alleso*) which is the same size as Piccolpasso's 'piatti detti da Carne'.[40] As the Casteldurante sizes provided by Piccolpasso are directly linked to the size of saggars, it becomes clear that different pottery centres probably used different standard sizes, reflecting local manufacturing techniques.

Production of Faenza ware in the second half of the sixteenth century is relatively well documented. The passion for all-over decoration waned during this period in favour of clean, whiter services and a greater variety of shapes (plates 18.10, 18.11, 18.12 and 18.13). From about 1540 Faenza (near Bologna) specialized in the manufacture of high-quality pottery with a thick white layer of glaze, which was left either completely blank or partially painted in a sketchy style (*stile compendiario*), mostly in blue and yellow.[41] This Faenza whiteware (*bianchi di Faenza*) became much appreciated among discerning patrons. Considerations of hygiene might have played a part in this: unlike metal objects, glazed ceramics do not retain any odours.

18.12 (*right*) Calamelli workshop, whiteware salt, Faenza, *c*.1590
(cat.72)

18.13 (*far right*) Pouring vessel in the form of a shell, Faenza, *c*.1560–80
(cat.73)

With the passion for white came a greater appreci-ation of the quality of the glaze and shapes of ceramics. Whereas plates could be completely plain, new types of fanciful objects, such as open-worked fruit-baskets and elaborately shaped jugs and cups, became popular. The 1556 factory inventory of the Faentine potter Virgiliotto Calamelli includes no less than fifty different kind of objects, the vast majority intended for use at the table.[42] Different object types were also subdivided into different sizes according to their specific functions. This inventory additionally contains a wide range of unspecified wares listed as 'pieces of work' or 'things of different forms', ranging from boats and drinking fountains to figures of Hercules. Surviving Faenza white vessels in the shape of a boat or Hercules fighting the Nemean lion fit these descriptions.[43]

The variety of types and fanciful shapes of vessels produced by the potters of Faenza was matched by the glassblowers of Murano and Florence. Design drawings by late sixteenth-century artists such as Jacopo Ligozzi and Bernardo Buontalenti show an endless variety of ingenious forms of pouring and drinking vessels.[44] Decoration was mostly confined to filigree glass – a colourless glass into which fine parallel opaque white stripes were incorporated – emphasizing the complex mould-blown shapes (plate 18.14). Goblets could take the shape of ani-mals, musical instruments or human forms. The most extreme vessel was perhaps a very shallow type of drinking bowl (*tazza*) on a high stem, which is often depicted in contemporary dining scenes (plate 18.15). It is very difficult to drink from it without spilling, doubtless a test of the manners and sophisti-cation of its user.

★ ★ ★

During the sixteenth century basic tableware became available to a wider section of society than ever before. At the top end of the market dining habits of unprecedented sophistication were devel-oped. This is reflected in increasing quantities of tableware, and in the development of completely new object types, often with highly specialized functions and shapes. The predominance of ceramics and glass as materials suitable for tableware became firmly established, and this situation was to last for centuries to come.

18.14 Filigree glass cooling bowl, Venice, 1575–1600 (cat.78)

18.15 *Tazza* (wine glass),
probably Venice, 1550–1600
(cat.75)

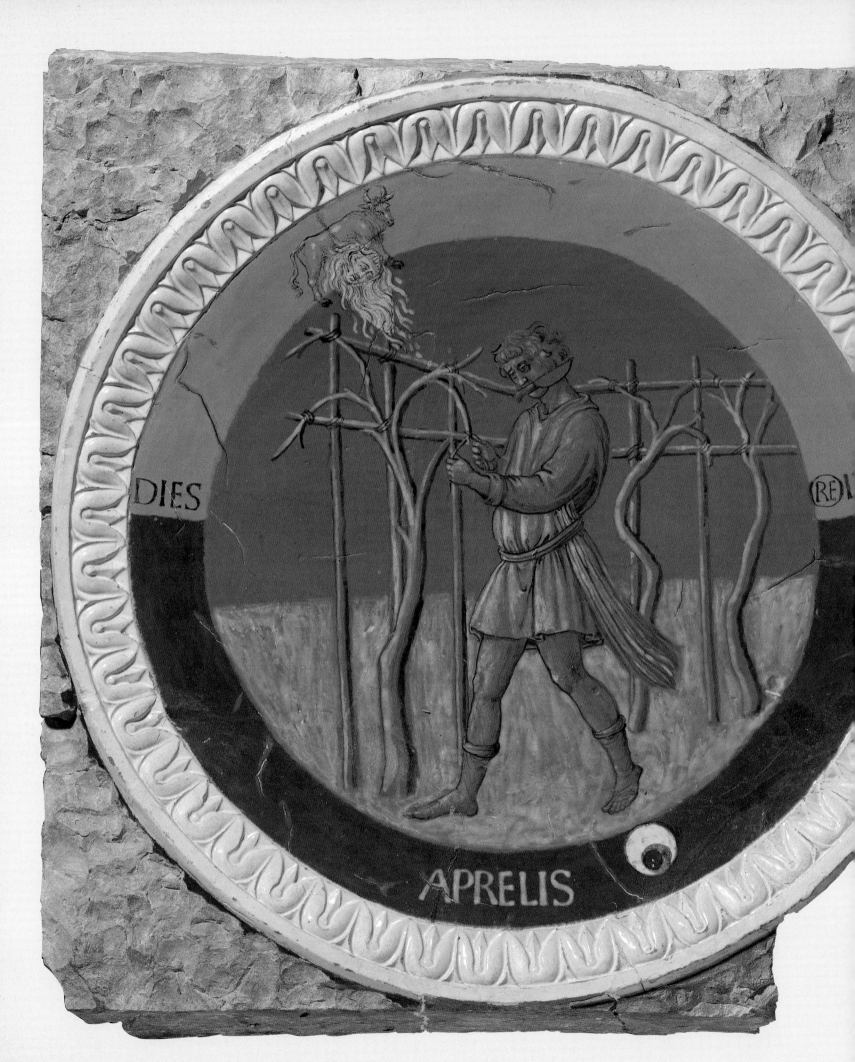

DIES (R)E

APRELIS

PART

V

ART
AND OBJECTS
IN THE *CASA*

ART IN THE *CASA*

PETA MOTTURE AND LUKE SYSON

OUR NOTION OF 'ART' has changed considerably since the Renaissance. In recent years it has sometimes been stated, however, that it was precisely in the period around 1500 that a conceptual quantum shift occurred: the dawning of the so-called 'age of art' that continues to the present day.[1] According to this view, this was the moment when paintings, sculptures and other crafted objects ceased to be valued primarily for the function they performed (devotional or instructive, commemorative or ornamental), but were instead appreciated as something more akin to our modern idea of the 'work of art'. Who painted a picture, it is argued, started to matter more than what was depicted, and paintings became 'Bellinis' or 'Raphaels' rather than Virgins or Christs, just as we expect today. But was there really a substantive change in attitude towards, and in the perception of, painting and sculpture, and if so, is this when it took place? This phenomenon is analysed in this chapter, to show that these new considerations overlaid and augmented, rather than completely superseded, earlier priorities but that, while the process was gradual, the home was a key site for the emergence of these new attitudes. By the end of the sixteenth century modes of display that took account of the desire to view more closely works by individual artists were fully established.

19.1 Vincenzo and Gian Matteo Grandi,
fireplace, Padua, *c*.1510–30
(cat.123)
This grand fireplace would have dominated the room, due to both its scale and its intricate sculptural decoration. The supporting columns are formed of tritons, and the high-relief frieze around the upper section shows hunting scenes with peasants, and fashionable noblemen and women on horseback. The fine shallow relief underneath would only have been revealed in the flickering light of the fire.

THE FUNCTIONAL TRANSFORMED

These issues require some teasing out. This was a period when what we would now see as 'artistic' design was applied to an astonishing range of objects, from portable items to architectural features.

palazzo or casa, the visitor would
ith an array of artefacts that had
but were also contrived to convey
ges to those invited to enter. The
begin with the houses' imposing,
r cases, often with elaborate door-
late 20.5). In Venice the bronze
the task of feeding (and possibly
market by producing distinctive
both functional and aesthetic needs.
omprised intertwining animals and
blematic of the republic and her
the sea: lions (of St Mark, Venice's
e sea-god Neptune, dolphins and
ell as mermaids and mermen.[2] The
mained practical, in that curled
ften formed the grip and were the
ccommodate fingers, but were also
;.

embellishments were matched by
ght likewise be highly ornate. These
ge and complex stone architectural
as wall fountains and fireplaces,
n and warm. But practical though
re, they also became the focus for
ll and were frequently executed by
workshops. Fireplaces, which could
ture of a room, became increasingly
la Settignano, brother of the more

famous Desiderio, is credited, for instance, with carving the enormous fire surround from the Palazzo Boni in Florence (see plate 19.12),[3] while Vincenzo and Gian Matteo Grandi (the workshop active around 1510–70), who ran important sculpture and bronze workshops in Padua and Trent, were probably responsible for an impressive fireplace decorated with hunting scenes (plate 19.1).[4] Classical inspiration is evident in the naked putti and the herm-like supporters of this Paduan fireplace, as well as in the decoration and simplified architectural form of the Boni fire surround, its scale and grandeur making up for the lack of hood, or *padiglione*.[5]

Within the fireplaces were the utensils required for tending the fire, notably the firedogs (or andirons) that supported the logs. The appearance and status of firedogs are not always evident from inventories. Several pairs are listed in the 1492 inventory of the Palazzo Medici in Florence, but their material and form are unspecified. Those placed in the fireplace in the *saletta rimpetto alla sala grande* (the little *sala* next to the great *sala*) are recorded only as 'large', weighing about 45 kilograms and, together with the fork, shovel and fire irons, they formed a set.[6] In contrast, Venetian firedogs were frequently sculptural *tours de force*.[7] Made up of several sections, inspired both in form and decoration by the antique, they were crowned by classical gods and goddesses or by other mythological beings. On occasion, Venetian fireplaces and their andirons may have been conceived as a unit, suggesting a new coherent approach to design.[8] The Barbaro firedogs (*c.*1590–1620) were apparently made to order, with the coat of arms being cast with the main body of the objects rather than attached subsequently (plate 19.2). Functional bronzes, however, were commonly bought directly from the foundry or shop, sometimes personalized by the addition of a coat of arms at that stage. A handbell for calling servants, which has unidentified arms, is a case in point (see plate 20.6). As with the small figurative bronzes produced by Severo da Ravenna and his shop (see p.300), clients could create a personal variation on a theme by choosing from a range of stock items that could be combined in new ways to create a unique work.

Though occasionally designed by well-known sculptors, the majority of Venetian functional bronzes, including the intricate doorknockers, were probably created by foundrymen. These artisans were lower in the social pecking order than sculptors and were generally acknowledged for their skill, or *arte*, but rarely for their inventive talent, or *ingegno*.[9] These two terms are key to this discussion. *Arte* – or, in Latin, *ars* – is a word that can best be translated as 'craft', encapsulating the learnt mechanical skills and techniques required to transform natural materials into objects beautiful and useful to man. This word underpinned popular medieval concepts of beauty[10] and had no derogatory overtones in the fifteenth or sixteenth centuries. Objects such as doorknockers and fireplaces could perhaps be classified mostly as

PAINTINGS FOR FLORENTINE PALACES

By the middle of the fifteenth century, the production and display of luxury goods, including paintings, was a way of life for wealthy Florentines.

The several hundred clans who made up the city's elite – called patricians – lived in palaces which housed multiple individual families and generations. When a patrician man married, he was generally given an inter-connected suite of rooms for his personal use. The most opulently furnished space in this suite was the *camera*, or chamber. Here he and his wife would conceive their children, as well as entertain honoured guests.

Chambers were small rooms, but they were full of valuable things, textiles, clothing, furniture, sculpture and paintings. Much of the furniture – including chests (*cassoni*) and wainscotting or backboards (*spalliere*) – was painted. These paintings, most now separated from their original contexts, included non-religious stories, often drawn from ancient Greek and Roman mythology. They are among the earliest examples of secular pictures to survive from Medieval and Renaissance Europe. These rooms, however, often additionally contained circular paintings of Christian subjects, called *tondi*.

National Gallery

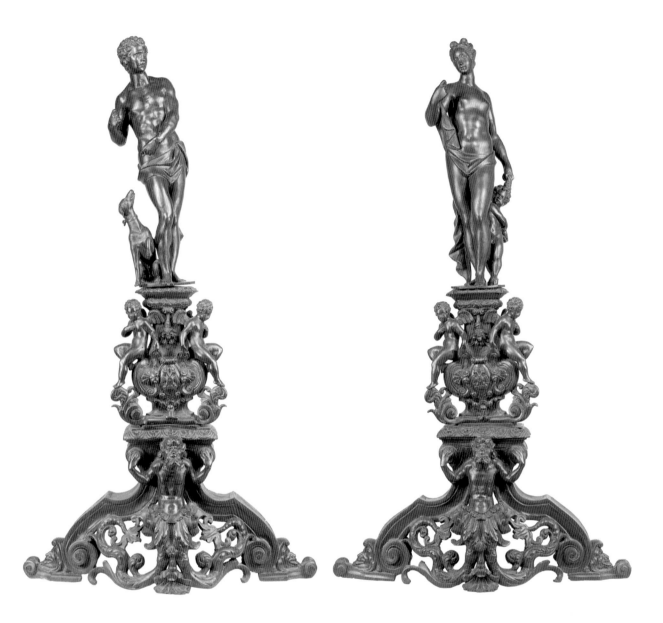

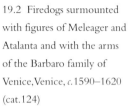

19.2 Firedogs surmounted with figures of Meleager and Atalanta and with the arms of the Barbaro family of Venice, Venice, *c.*1590–1620 (cat.124)
These imposing andirons would have stood within a large fireplace to support the logs for the fire. Placed at the focal point of the room, they were both functional and decorative. While often more modest in scale, Venetian firedogs were typically made up of a number of separate sections, and topped by a god and goddess or another pair of mythological figures. The crowning statuettes here are based on marble statues by the Veronese sculptor, Girolamo Campagna.

'works of *arte*', but not usually 'works of art' in the complete sense that was established during this period. For in the Renaissance 'art', as we understand it today, demanded the additional element of *ingegno* (the Latin *ingenium*). This word signalled the inborn talent required for invention, inspiration and novelty.[11]

It is not surprising therefore that many foundrymen aimed at producing their own complex designs, to raise the status of their works (and their commercial value) by adding *ingegno* to their *arte*. To do so, however, they often took inspiration for their figures from marble and bronze sculptures created by others – works that appeared on civic buildings and altars by the leading sculptors of the day.[12] Those

surmounting the Barbaro firedogs, for instance, imitate the style of Girolamo Campagna, a Veronese sculptor also active in Venice, whose marble figures of Venus Marina on the balustrade of the Biblioteca Marciana (1588-90) and of the patron saint of the church of San Lorenzo (1615-17) seem both to have provided models for similar bronzes. Many other domestic objects were transformed in this way: Venetian painted glass utensils imitated the pictures of Vittore Carpaccio; Florentine painted chests looked to celebrated works by Lorenzo Ghiberti or Paolo Uccello; 'historiated maiolica', made all over Italy, combined print sources taken from engravings designed by Raphael and his successors. *Ingegno*, even at one remove, was a crucial element in the messages

these objects were intended to convey. Beyond the honour of spending well, visibly declared,[13] beyond even the much vaunted social virtue of magnificence, it was important that the owners' and commissioners' aesthetic discernment and civility – *gentilezza*, which was required to appreciate properly the inventive quality of possessions – should itself be recognized by others. The talents of artists were believed to reflect the talents of their patrons. And the visible inclusion of this element was moreover one of the strategies by which conspicuous expenditure, which might otherwise be condemned as overly luxurious, could be appropriately tempered.[14]

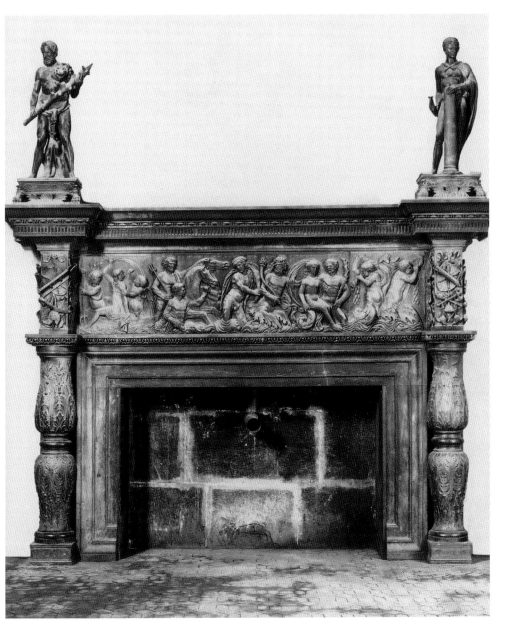

19.3 Giuliano da Sangallo, fireplace from the Gondi palace, Florence, *c*.1501

DISPLAY

It might be thought that these ideas would have had special import for the reading of objects, notably figurative works, made or designed by artists whose individual *ingegno* was already a matter of celebration. However, the issue of accessibility – the degree to which the works of famous artists could be closely inspected and their talents more fully appreciated – was only gradually addressed, and, at least initially, the scope for seeing works by celebrated masters was often surprisingly limited.[15] Giuliano da Sangallo, for example, in *c*.1501 incorporated two fired terracotta statuettes of Hercules and Samson onto the mantel of a fireplace in the *sala grande* of the Gondi palace in Florence, painted to look like stone or bronze (plate 19.3).[16] These are among the very few pieces of domestic sculpture of this period to remain *in situ*. Their position (about 3.2 metres above the floor) may give a clue as to the placement of other sculptural works that these statuettes imitate, whether ancient or executed during the period in bronze and stone. The fact that they cannot be studied close-up has led commentators from Giorgio Vasari (who called them 'carvings' in 1568) onwards into the excusable error of thinking that they were truly carved from *pietra forte*. They are pieces of considerable antiquarian ambition, beautifully, if economically, modelled with a strong feeling for anatomy, and the figures have heads of impressively classical nobility. Like the medium, these aspects are not at all easy to appreciate given the location of the pieces.

These works are exceptional, since it is not usually easy to determine exactly where things were first seen. Some paintings may have been placed at about eye level, as they are in public galleries today. The three Sienese panels attributed to Guidoccio Cozzarelli of the exemplary heroines, Hippo, Camilla and Lucretia (*c*.1495–1500), are seemingly the only such works to survive with their frame more or less intact. The fictive marble frame resembles that of an altarpiece,[17] and the panels may therefore have been placed at a similar height to an altar, perhaps positioned on an *armadio*, or cupboard.[18] In that case, their location may have been similar to the full-length figures seen in intarsia schemes such as the ones above the *armadi* on the east wall of the sacristy at Florence cathedral.[19]

19.4 Fra Filippo Lippi,
The Annunciation and *Seven
Saints*, Florence, *c.*1450–53
(cats 214 and 215)
The *Seven Saints* panel
represents male members
of the Medici family.

This suggestion remains necessarily speculative, but inventories, especially the 1492 inventory of the Medici palace made after the death of Lorenzo, do provide more (albeit scattered) information about the locations of individual objects.[20] There is some evidence, especially from the first half of the Quattrocento, that figurative or narrative paintings on panel were incorporated within individual items of furniture, set into bedheads, for example, or used as the fronts of chests. Other records, from the later fifteenth century onwards, indicate, however, that particular paintings were sometimes situated immediately above particular pieces of furniture, belonging with them but not physically part of them, signalling a change of emphasis. In the sixteenth century two framed paintings on canvas belonging to the Medici and attributed to Domenico

Ghirlandaio could apparently be seen above an old *armadio*,[21] but their textile supports prove that they could not have been integral to it. Pictures that were situated above low cupboards in this way (possibly including the Sienese heroines) could be viewed relatively easily. The panel paintings that we know were on occasion hung above chests were probably even lower on the wall, and the painted chests themselves were of course lower still, but the interested viewer could still crouch or kneel to inspect them.

While these categories of picture were hung at about eye level or below, this was certainly not the case for a very large number of paintings and sculptures of the period. Many works in the *camera* were displayed at more lofty levels. Busts and pictures were placed, for example, above high bedheads and *lettucci*.[22] Perhaps the most famous painting

THE FUNCTIONAL TRANSFORMED

These issues require some teasing out. This was a period when what we would now see as 'artistic' design was applied to an astonishing range of objects, from portable items to architectural features. On entering the *palazzo* or *casa*, the visitor would be confronted with an array of artefacts that had specific functions but were also contrived to convey additional messages to those invited to enter. The experience would begin with the houses' imposing, richly carved door cases, often with elaborate door-knockers (see plate 20.5). In Venice the bronze industry rose to the task of feeding (and possibly even creating) a market by producing distinctive handles that met both functional and aesthetic needs. These generally comprised intertwining animals and figures, often emblematic of the republic and her association with the sea: lions (of St Mark, Venice's patron saint), the sea-god Neptune, dolphins and hippocamps, as well as mermaids and mermen.[2] The doorknockers remained practical, in that curled foliage or shells often formed the grip and were the ideal shapes to accommodate fingers, but were also visually appealing.

Such exterior embellishments were matched by interiors that might likewise be highly ornate. These could include large and complex stone architectural elements, such as wall fountains and fireplaces, for keeping clean and warm. But practical though these features were, they also became the focus for the display of skill and were frequently executed by major sculptural workshops. Fireplaces, which could be the major feature of a room, became increasingly elaborate. Geri da Settignano, brother of the more famous Desiderio, is credited, for instance, with carving the enormous fire surround from the Palazzo Boni in Florence (see plate 19.12),[3] while Vincenzo and Gian Matteo Grandi (the workshop active around 1510-70), who ran important sculpture and bronze workshops in Padua and Trent, were probably responsible for an impressive fireplace decorated with hunting scenes (plate 19.1).[4] Classical inspiration is evident in the naked putti and the herm-like supporters of this Paduan fireplace, as well as in the decoration and simplified architectural form of the Boni fire surround, its scale and grandeur making up for the lack of hood, or *padiglione*.[5]

Within the fireplaces were the utensils required for tending the fire, notably the firedogs (or andirons) that supported the logs. The appearance and status of firedogs are not always evident from inventories. Several pairs are listed in the 1492 inventory of the Palazzo Medici in Florence, but their material and form are unspecified. Those placed in the fireplace in the *saletta rimpetto alla sala grande* (the little *sala* next to the great *sala*) are recorded only as 'large', weighing about 45 kilograms and, together with the fork, shovel and fire irons, they formed a set.[6] In contrast, Venetian firedogs were frequently sculptural *tours de force*.[7] Made up of several sections, inspired both in form and decoration by the antique, they were crowned by classical gods and goddesses or by other mythological beings. On occasion, Venetian fireplaces and their andirons may have been conceived as a unit, suggesting a new coherent approach to design.[8] The Barbaro firedogs (*c.*1590-1620) were apparently made to order, with the coat of arms being cast with the main body of the objects rather than attached subsequently (plate 19.2). Functional bronzes, however, were commonly bought directly from the foundry or shop, sometimes personalized by the addition of a coat of arms at that stage. A handbell for calling servants, which has unidentified arms, is a case in point (see plate 20.6). As with the small figurative bronzes produced by Severo da Ravenna and his shop (see p.300), clients could create a personal variation on a theme by choosing from a range of stock items that could be combined in new ways to create a unique work.

Though occasionally designed by well-known sculptors, the majority of Venetian functional bronzes, including the intricate doorknockers, were probably created by foundrymen. These artisans were lower in the social pecking order than sculptors and were generally acknowledged for their skill, or *arte*, but rarely for their inventive talent, or *ingegno*.[9] These two terms are key to this discussion. *Arte* – or, in Latin, *ars* – is a word that can best be translated as 'craft', encapsulating the learnt mechanical skills and techniques required to transform natural materials into objects beautiful and useful to man. This word underpinned popular medieval concepts of beauty[10] and had no derogatory overtones in the fifteenth or sixteenth centuries. Objects such as doorknockers and fireplaces could perhaps be classified mostly as

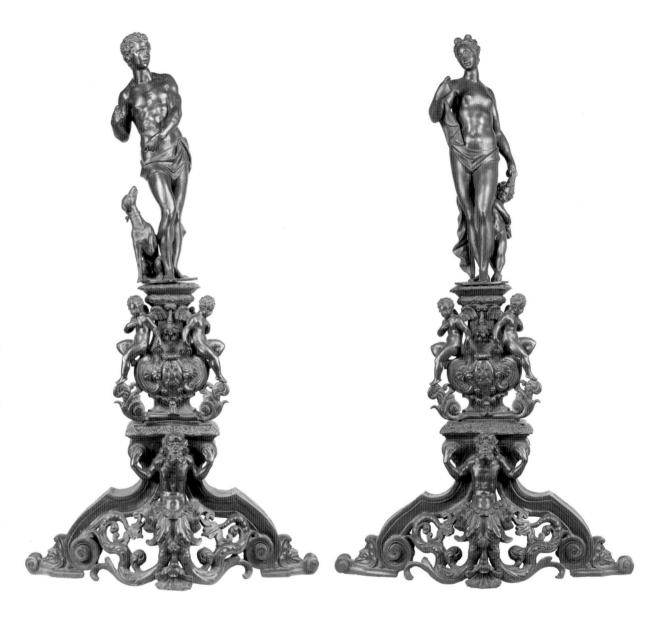

19.2 Firedogs surmounted with figures of Meleager and Atalanta and with the arms of the Barbaro family of Venice, Venice, *c.*1590–1620 (cat.124)

These imposing andirons would have stood within a large fireplace to support the logs for the fire. Placed at the focal point of the room, they were both functional and decorative. While often more modest in scale, Venetian firedogs were typically made up of a number of separate sections, and topped by a god and goddess or another pair of mythological figures. The crowning statuettes here are based on marble statues by the Veronese sculptor, Girolamo Campagna.

'works of *arte*', but not usually 'works of art' in the complete sense that was established during this period. For in the Renaissance 'art', as we understand it today, demanded the additional element of *ingegno* (the Latin *ingenium*). This word signalled the inborn talent required for invention, inspiration and novelty.[11]

It is not surprising therefore that many foundrymen aimed at producing their own complex designs, to raise the status of their works (and their commercial value) by adding *ingegno* to their *arte*. To do so, however, they often took inspiration for their figures from marble and bronze sculptures created by others – works that appeared on civic buildings and altars by the leading sculptors of the day.[12] Those

surmounting the Barbaro firedogs, for instance, imitate the style of Girolamo Campagna, a Veronese sculptor also active in Venice, whose marble figures of Venus Marina on the balustrade of the Biblioteca Marciana (1588-90) and of the patron saint of the church of San Lorenzo (1615-17) seem both to have provided models for similar bronzes. Many other domestic objects were transformed in this way: Venetian painted glass utensils imitated the pictures of Vittore Carpaccio; Florentine painted chests looked to celebrated works by Lorenzo Ghiberti or Paolo Uccello; 'historiated maiolica', made all over Italy, combined print sources taken from engravings designed by Raphael and his successors. *Ingegno*, even at one remove, was a crucial element in the messages

these objects were intended to convey. Beyond the honour of spending well, visibly declared,[13] beyond even the much vaunted social virtue of magnificence, it was important that the owners' and commissioners' aesthetic discernment and civility – *gentilezza*, which was required to appreciate properly the inventive quality of possessions – should itself be recognized by others. The talents of artists were believed to reflect the talents of their patrons. And the visible inclusion of this element was moreover one of the strategies by which conspicuous expenditure, which might otherwise be condemned as overly luxurious, could be appropriately tempered.[14]

19.3 Giuliano da Sangallo, fireplace from the Gondi palace, Florence, *c.*1501

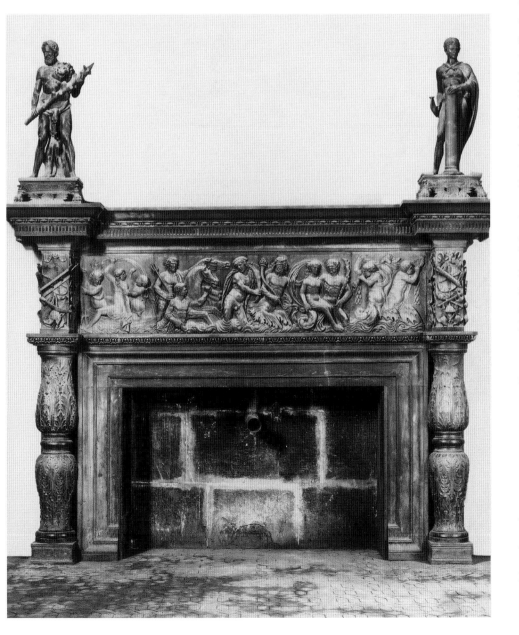

DISPLAY

It might be thought that these ideas would have had special import for the reading of objects, notably figurative works, made or designed by artists whose individual *ingegno* was already a matter of celebration. However, the issue of accessibility – the degree to which the works of famous artists could be closely inspected and their talents more fully appreciated – was only gradually addressed, and, at least initially, the scope for seeing works by celebrated masters was often surprisingly limited.[15] Giuliano da Sangallo, for example, in *c.*1501 incorporated two fired terracotta statuettes of Hercules and Samson onto the mantel of a fireplace in the *sala grande* of the Gondi palace in Florence, painted to look like stone or bronze (plate 19.3).[16] These are among the very few pieces of domestic sculpture of this period to remain *in situ*. Their position (about 3.2 metres above the floor) may give a clue as to the placement of other sculptural works that these statuettes imitate, whether ancient or executed during the period in bronze and stone. The fact that they cannot be studied close-up has led commentators from Giorgio Vasari (who called them 'carvings' in 1568) onwards into the excusable error of thinking that they were truly carved from *pietra forte*. They are pieces of considerable antiquarian ambition, beautifully, if economically, modelled with a strong feeling for anatomy, and the figures have heads of impressively classical nobility. Like the medium, these aspects are not at all easy to appreciate given the location of the pieces.

These works are exceptional, since it is not usually easy to determine exactly where things were first seen. Some paintings may have been placed at about eye level, as they are in public galleries today. The three Sienese panels attributed to Guidoccio Cozzarelli of the exemplary heroines, Hippo, Camilla and Lucretia (*c.*1495–1500), are seemingly the only such works to survive with their frame more or less intact. The fictive marble frame resembles that of an altarpiece,[17] and the panels may therefore have been placed at a similar height to an altar, perhaps positioned on an *armadio*, or cupboard.[18] In that case, their location may have been similar to the full-length figures seen in intarsia schemes such as the ones above the *armadi* on the east wall of the sacristy at Florence cathedral.[19]

19.4 Fra Filippo Lippi,
The Annunciation and *Seven
Saints*, Florence, *c.*1450–53
(cats 214 and 215)
The *Seven Saints* panel
represents male members
of the Medici family.

This suggestion remains necessarily speculative, but inventories, especially the 1492 inventory of the Medici palace made after the death of Lorenzo, do provide more (albeit scattered) information about the locations of individual objects.[20] There is some evidence, especially from the first half of the Quattrocento, that figurative or narrative paintings on panel were incorporated within individual items of furniture, set into bedheads, for example, or used as the fronts of chests. Other records, from the later fifteenth century onwards, indicate, however, that particular paintings were sometimes situated immediately above particular pieces of furniture, belonging with them but not physically part of them, signalling a change of emphasis. In the sixteenth century two framed paintings on canvas belonging to the Medici and attributed to Domenico

Ghirlandaio could apparently be seen above an old *armadio*,[21] but their textile supports prove that they could not have been integral to it. Pictures that were situated above low cupboards in this way (possibly including the Sienese heroines) could be viewed relatively easily. The panel paintings that we know were on occasion hung above chests were probably even lower on the wall, and the painted chests themselves were of course lower still, but the interested viewer could still crouch or kneel to inspect them.

While these categories of picture were hung at about eye level or below, this was certainly not the case for a very large number of paintings and sculptures of the period. Many works in the *camera* were displayed at more lofty levels. Busts and pictures were placed, for example, above high bedheads and *lettucci*.[22] Perhaps the most famous painting

known to have been sited above a *lettuccio* is Sandro Botticelli's *Primavera* (*c*.1478; 203 x 314 cm), now in the Uffizi.[23] Its large dimensions imitate the size of the backrest of the *lettuccio* and might perhaps be taken as indicative for *lettuccio* paintings: Botticelli took account of its low viewpoint in the large scale of the figures. Other pictures set above pieces of furniture seem to take their shape from the items they accompanied. In 1532 Marcantonio Michiel recorded seeing a reclining female nude by Giovanni Girolamo Savoldo above the bed of Andrea Odoni in Venice, and once again this fact may give a clue to the positioning of surviving paintings of similar subjects that are the size and shape of bedheads but were probably not actually set within them.[24]

Works of art are most frequently recorded above doors;[25] paintings situated in this way include the *Annunciation* and *Seven Saints* panels by Fra Filippo Lippi (plate 19.4) thought to have come from the Palazzo Medici in Florence, while panels of Saints Peter and Paul by Masaccio (no longer known) in the *sala* on the ground floor of the Medici palace were 'above the chimney piece'.[26] Moreover, the position of a tondo of the Virgin and Child with Angels, which appears in an often reproduced woodcut illustration in the 1496–7 edition of Girolamo Savonarola's *Predica dell'arte del ben morire* (plate 19.5), shows that even works that were not expressly associated with an architectural element or a piece of furniture could be hung well above head height.[27] This image may well be of more documentary use than many others, since it was designed to guide devotional practice at the time. It also gives an idea of how very tall the *lettuccio* might be, with the

paintings and other objects placed on and above it even higher up.

A famous passage describing such pictures in Vasari's 1568 life of the mysterious artist Dello Delli mentions painted wedding chests and goes on to say, in reference to other forms of painting that, significantly, he considered outmoded:

And what is more, *cassoni* were not the only things painted in such a manner, but also *lettucci* [daybeds], *spalliere*, and the *cornici* [mouldings] that provide the ornament around [the rooms], and other similarly made ornaments of the *camera* that were used in those times magnificently, as can be seen in numerous examples throughout the city. And these kinds of things were in use for so many years that even the most excellent painters exercised themselves in such works, without shaming themselves, as many would today, by painting and gilding such things. And it is true, and that, among many other things, several *cassoni*,

19.5 Woodcut from Girolamo Savonarola, *Predica dell'arte del ben morire*, Florence, 1496–7, (British Library, London, IA.27321 fol.biv)

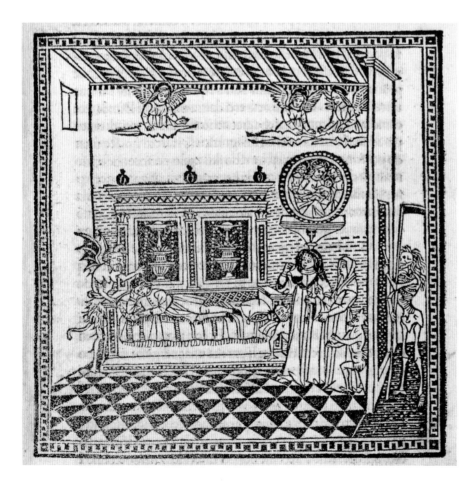

spalliere and *cornici* can be seen in our day in the *camere* of the Magnificent Lorenzo de' Medici the Elder, in which are painted by the hands not of common painters but of excellent masters, all the jousts, tourneys, hunts, feasts and other spectacles of his times, with judgement, with invention and with marvellous craft. Such things are to be seen … in the palace and old houses of the Medici.[28]

This passage takes us to the heart of the thorny problem of so-called *spalliera* paintings, one that can only be touched on here.[29] It is very difficult to find a consistent definition for the word *spalliera*.[30] It is normally thought that *spalliera* paintings, executed in the period *c.*1470-1515, can be characterized by their long horizontal format, usually about 60-80 by 140-70 cm, and by their narratives taken from the Old Testament, ancient history, fable or myth, and more rarely from the lives of the saints, depicting small figures within elaborate architectural and landscape settings. At its most literal, the word referred to elements that supported the shoulders: *spalle*. The backrests of *lettucci*, for example, are often called *spalliere* in inventories. So too were the long, horizontal tapestries that hung above benches or from their backrests and could be leaned against for comfort.[31] The word was also used to mean 'wainscoting', fixed marquetry wooden panelling up to the height of a dado at about shoulder height. It has often been assumed, therefore, that paintings of this shape (much the same dimensions as *spalliera* tapestries) occupied a similar position, installed within panelling at the same height and using a method similar to the intarsia panels in the *studiolo* of Duke Federico da Montefeltro at his Urbino palace.

Thus it is held by many commentators that these pictures formed a kind of 'middle register' at shoulder level in a room, usually a bedroom. In fact, according to Vasari's account and other documentary evidence, it seems that some such pictures were displayed rather higher. Many, as we have seen, were set at about 2 metres high, in the space between the top of panelling – or major pieces of furniture such a *lettuccio* – and the ceiling. *Spalliera*-shaped panels are also documented higher still, above doors on the *piano nobile*. These heights may have been at about 3 metres in the cases of doors in the *camera* that led from the *sala* and at about 2.5 metres for

19.7 Workshop of Benedetto da Maiano, portrait bust of a man, Florence, 1475–1500 (cat.22) This type of bust would commonly have been placed above a doorway or a fireplace.

Height was also an issue for the display of portrait busts (plate 19.7). Developed in Florence in the mid-fifteenth century, the portrait bust carried a number of associations. It combined elements of the medieval reliquary bust – most particularly in its distinctive form, truncated across the chest – and the classical portrait bust.[34] And its form, placement and meaning were clearly informed by readings of classical texts, in addition to surviving antique examples. Pliny the Younger made a direct connection between the display of a portrait, knowledge of an individual's renown and the preservation of his memory.[35] And this text and others formed the basis for Leon Battista Alberti's discussions of portraiture in *De pictura* (1435) and his belief that such effigies would immortalize the artist, as well as the sitter.[36]

The practice of displaying portrait sculpture may have begun with the making of life and death masks. This was not a novelty, since casting from life is described by the Florentine Cennino Cennini in *Il Libro dell'Arte* of about 1400.[37] A number of leading artists in the later Quattrocento utilized this technique, including Andrea del Verrocchio, whose 'twenty masks taken from nature' were noted by his brother Tommaso.[38] It is arguable that producing a bust in clay or stucco directly from a life-cast mould was a mechanical process, even if skill was required to make the necessary adjustments to any distortions and in applying naturalistic paint, as was customary. Mino da Fiesole's marble busts of the Medici family of 1453-4 and Antonio Rossellino's 1456 bust of Giovanni Chellini (see plate 2.13), however, utterly transformed the genre. Although Rossellino's bust appears to have been based on a life cast, the sculptor demonstrated his extraordinary talent by translating Chellini's sober but vivid likeness into the unyielding and costly medium of marble.

doors leading from the *camera* to the *anticamera* or the *scrittoio*.[32] The Ghirlandaio workshop painted two pictures almost certainly for the Palazzo Spannocchi in Siena in *c.*1493, at the time of the wedding of Antonio and Giulio Spannocchi; these works are mentioned by Vasari, and until recently were thought either to have been invented by him or lost.[33] They depict episodes from the lives of Alexander the Great and Julius Caesar (plate 19.6). They are taller than most so-called *spalliera* panels, and the closeness of their dimensions to Botticelli's *Primavera* suggests that the larger of the two with the story of Alexander may have been placed above a *lettuccio*. But otherwise they are typical in their mixture of instruction and entertainment, and also in their format – crammed with figures and incident in highly elaborated landscapes. This small figure scale would have made them difficult to view from a distance and much of their inventive detail would have been lost.

19.6 Workshop of
Domenico Ghirlandaio
(Bastiano Mainardi and
Davide Ghirlandaio?),
*The Magnanimity of Alexander
the Great*, and Workshop of
Domenico Ghirlandaio
(Francesco Granacci?), *Julius
Caesar and the Crossing of the
Rubicon*, Siena, *c.*1493–5
(cats 111 and 112)

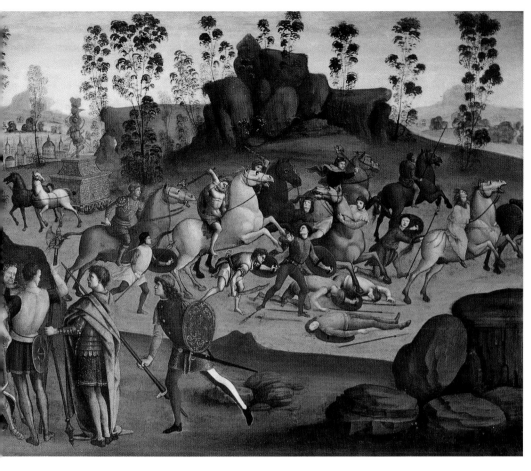

19.8 *Virgin and Child*,
Florence, *c.*1425–50
(cat.115)
The elongated form of this
stucco Madonna suggests
that it would have been
placed high on a wall and
viewed from below.

in line with the notion that these objects stood in for their subjects), could not be easily seen.[41] In other words, while artists might invite the close inspection of their works, their perceived original functions often rendered such appreciation difficult or impossible. There was a gap in perception of such works between maker and owner, but one that increasingly narrowed as owners recognized the qualities of what they had in their possession.

Painted portraits evolved in a similar manner. Many of the earliest appear to have been designed in the first instance to be portable – the equivalent of medals or small works for private devotion. Several have faux-marble or porphyry backs or are painted with emblems and coats of arms. Fra Filippo Lippi's *Portrait of a Woman* in Berlin (early 1440s; see plate 6.9), for example, has just such a 'stone' verso.[42] The care with which their backs were decorated indicates that they were to be handled and seen from both sides.[43] When not in use, they were probably stored rather than permanently displayed on walls. By the 1470s this situation had substantially changed, and we read in Florentine inventories of several painted portraits hanging permanently on walls, sometimes as overdoors.[44] It should come as no surprise that it was precisely during this period that portraits grew in size. Their growth continued, particularly in Venice, with the ever-greater dimensions of pictures by Titian, Veronese and Tintoretto that were hung – often high like other categories of painting – in Venetian palaces.

It is possible that high settings for certain objects were intended physically to convey an elevated status, that these were positions of honour and power. Certainly, that is suggested by the place of the Virgin tondo in the Savonarola woodcut, and indeed of the Madonna and Child painting in Carpaccio's image of the *Arrival of the English Ambassadors* (1490-96) from his St Ursula cycle.[45] The Virgin presided over her space, and some painters and sculptors may have taken account of this foreshortened view in their designs (plate 19.8).[46] If, as Vasari indicates with regard to *spalliera* painting, certain categories became outmoded, the practice of displaying works of art high up did not cease. But, as we shall see, the fact that certain objects were physically shifted down denotes a significant change of attitude.

Most of these early busts were displayed above fireplaces, windows, cornices and especially doorways,[39] a practice that continued into the sixteenth century. The position in which they were meant to be exhibited was sometimes taken into account in their design. For example, the forward-jutting head of the bust of Cardinal Giovanni de' Medici, attributed to Antonio de' Benintendi, of around 1512 – which was cast from life and naturalistically painted, complete with five o'clock shadow – appears to have been designed for a high position.[40] The placement of some particularly beautiful examples at doorway height was, however, at odds with their full appreciation. The talents displayed by the sculptors in capturing expression or indicating personality as well as the skilful level of detail, with the busts sometimes sculpted fully in the round (their backs and the tops of their heads as completely resolved as their fronts,

ART FOR ART'S SAKE

It is certainly the case that authorship became an increasingly important factor during this period in choosing, commissioning and showing certain works for the home. New types of work were produced and, perhaps just as importantly, old categories were collected. A radically different attitude to the art of the past can be demonstrated by the end of the fifteenth century.

These are shifts that can be located, above all, in the activities of Lorenzo de' Medici and by his connection with some very famous works. Lorenzo was not alone in collecting antiquities, Greek and Roman gems, hard-stone vases and statuary, some of which could be found in the living spaces of his palace, as well as in his more secluded *studiolo*. These were artefacts that derived their sometimes immense value from their rarity and, in particular, from their challenging and exquisite craftsmanship and the inventive powers of their makers – their combined *arte* and *ingegno*. This exercise of artistic discernment can be seen in his collecting of works that we can

assume are unlikely to have been commissioned by him or his forebears in the first place. Buying paintings from the Netherlands, lauded for their startling naturalism, was in some ways a similar activity to amassing antiquities, but here the perceived value of the works was almost entirely predicated on their craft and their authors' talent, rather than their association with a glorious past. Lorenzo owned a portrait of a 'French woman' by Petrus Christus, which he kept in his *scrittoio*.[47] The fact that she is not identified more precisely may simply indicate that her name had been forgotten, in contrast with most of the other portraits in the palace. It is, however, more plausible that Lorenzo prized this painting for the reasons that we today enjoy looking at a similarly anonymous female portrait by Petrus, now in Berlin – for its beauty. Less expected is Lorenzo's acquisition of native Florentine paintings in the same spirit. The recent discovery however that the three panels of Paolo Uccello's *Battle of San Romano* (*c.*1438-40; plate 19.9), in Lorenzo's ground-floor *camera*, were not originally installed in any palace belonging to

19.9 Paolo Uccello,
Battle of San Romano, Florence,
probably *c.*1438–40,
tempera with oil on poplar
(National Gallery, London)

the Medici, as was always supposed, has fascinating implications.[48] In 1484 Lorenzo essentially sequestered the pictures from two of the sons of Lionardo di Bartolomeo Bartolini-Salimbeni, for whose town house they had been painted. Here we have an unprecedented example of the acquisition of 'second-hand' goods because of their aesthetic appeal. They were hung high on the walls in accordance with late fifteenth-century practice and were not therefore displayed in the way they are today. However, it is worth pointing out that Lorenzo, when he acquired them, ordered the carpenter who had removed them from the Bartolini-Salimbeni to cut off their curved tops (their original lunette shapes had been conceived so that in their first setting they could fill the spaces where ceiling vaults met the

walls). New corners were made up at the same time, converting them into oblong works, thus changing paintings that had once formed part of a decorative scheme into something much closer to gallery pictures. It has also recently been shown that the pictures probably hung slanting forward of the vault corbels, no longer precisely vertical and taking better account of the needs of the viewer.

These events give a context for the much noted fact that the 1492 Medici inventory is one of the very first in Italy to specify the names of many of the artists.[49] A work was often no longer just a Virgin and Child, but a Virgin and Child 'by the hand of Donato'. And the discovery that Uccello's masterpieces were 'collected' by Lorenzo rather than commissioned by his father or grandfather gives us leave to think that he may have garnered other authored works in the same manner. It is notable, for example, that three of Donatello's reliefs were gathered together in the *anticamera* of Lorenzo's first floor *camera grande* (main *camera*).[50] There they could be

19.10 Attr. Moderno, *The Virgin and Child in a Niche, between St Jerome and St Anthony* and Moderno, *Hercules and the Oxen of Geryon*, northern Italy, *c.*1490
(cats 256 and 257)
Often kept in the study, plaquettes could be used to decorate objects such as writing desks and inkstands, but became prized as works of art in their own right.

seen with other works, such as small paintings by artists including Giotto (whom Lorenzo publicly commemorated), Fra Angelico, and (jointly) Fra Filippo and Pesellino, a physical record of the glories of Florentine Trecento and early Quattrocento art. In all, the room contained three images of the Virgin, in a period when, for obvious devotional reasons, it was unusual to have more than one.[51] It seems that Lorenzo had created a little *galleria* or picture cabinet near his *scrittoio*, and therefore that we can begin to think of him as one of the key progenitors of the art gallery as we understand the concept today.

GOD-GIVEN TALENTS

Here it is appropriate to return to the ownership and exhibition of devotional images, the very objects whose meaning is held to have changed in the years around 1500. Images of the Virgin and Child were recommended for the bedrooms of every Italian house, not just to ensure proper Christian devotion but also as the ideal exemplars for new wives and expectant mothers.[52] It is clear that the development of technologies for replication, both in cheaper materials, such as terracotta and stucco, and in costly bronze, played a key role in feeding an expanding market (plate 19.10). Donatello even designed a bronze roundel depicting the *Virgin and Child with Four Angels* to act as a mould for reproducing the image in glass (plate 19.11 and see plate 2.14), although it is not known if it was ever used for that purpose before he gave it to his doctor, Giovanni Chellini. This bronze tondo mould was probably

19.11 Reverse of Donatello,
The Virgin and Child with Four Angels
(Chellini Madonna),
probably Padua, *c*.1456
(cat.14)

executed while Donatello was in Padua (1443–53), where he also designed the so-called *Verona Madonna* specifically for replication, suggesting a north Italian market for such pieces.[53] It is Lorenzo Ghiberti, however, who is generally credited with instigating the flourishing trade in terracotta Virgin and Child reliefs in Florence at the beginning of the fifteenth century. These may have been cast successively in a number of workshops, enabling the images to be widely disseminated.

Certainly, by 1523 the virtually unknown 'sculptor of statuary', Sandro di Lorenzo di Sinibaldo, had made *terra secca* (unfired clay) statuettes that included a *bambino* – the Christ Child – after a work by Desiderio da Settignano, as well as a Judith after Andrea del Verrocchio. Verrocchio, who had died in 1488, was described in the 1523 document as 'a man of great reputation and a big name in this art'.[54] By the early sixteenth century works by famous artists were therefore clearly seen as worth copying, and their authorship worth noting. Numerous Florentine terracotta statuettes of this kind were produced, including groups of the Virgin and Child, of Charity and of lively, squabbling boys, as well as small figures of David and of St John the Baptist, both representative of the city itself.[55] The David statuettes often hint at a source in Donatello's bronze *David* (*c.*1450), and they are also closely related to Verrocchio's bronze of the same subject (*c.*1465), both of which first stood in the Palazzo Medici. Similarly, the della Robbia workshop produced colourful reduced versions of the now lost sculpture by Donatello of *Dovizia* (or *Wealth*; *c.*1430), which stood in the middle of the main trading area of Florence. The adaptation of public sculptures for use in the home happened both in Florence, from the late fifteenth century into the first half of the sixteenth century, and in sixteenth-century Venice. These sculptures had important talismanic or political associations. In both Florence and Venice such sculpted works could personify the city. But, as well as their subject matter, their authorship, whether actual or at one remove, is likely to have been of consequence. It seems possible that the authorship of the originals may have played a role in the taste for these works of art within the home. There can be little doubt that versions of Ghiberti's *Virgin and Child* relief, with the figure of Eve on the console, would have been recognized

as his, whether actually produced in his studio or later in another imitative workshop, just as copies of the *Dovizia* would presumably have evoked the name of Donatello.[56]

The motivation behind these copies and variations is important when we come to consider the many images of the Virgin and Child painted or sculpted for the *casa* by artists of extraordinary renown. The concept of *ingenium* is usually discussed as a feature of Renaissance attempts to revive the spirit and customs of the ancient world. The secular mindset of the twentieth century has, however, caused the religious implications of the idea to be significantly underestimated. There can be little doubt that, in a Christian context, if talent was deemed innate, then it was also seen as God-given. It was not usually necessary to state this theme explicitly, but Vasari's introduction to his biography of Leonardo sums up an attitude that would have informed readings of works such as his 1470s *Benois Madonna*, almost certainly made for a domestic context:

> The greatest gifts are often seen, in the course of nature, rained by celestial influences on human creatures: and sometimes, in supernatural fashion, beauty, grace and talent are united beyond measure in one single person, in a manner that to whatever such a one turns his attention, his every action is so divine, that surpassing all other men, it makes itself clearly known as a thing bestowed by God (as it is), and not acquired by human art. This was seen by all mankind in Leonardo da Vinci … [57]

The powers of individual artists therefore became paramount and signatures appeared ever more regularly on works of art; several of Raphael's images of the Madonna or Holy Family painted for the domestic sphere in the first decade of the sixteenth century are discreetly signed.[58] Raphael's *Madonna del Cardellino* was kept in the house of the Florentine Lorenzo Nasi, 'who had taken a wife at about that time', according to Vasari,[59] suggesting that this was commissioned at the time of his marriage to Sandra di Matteo Canigiani before 23 February 1506. His *Canigiani Holy Family* was also connected with the marriage between Domenico Canigiani and Lucrezia di Gerolamo Frescobaldi in 1507. Therefore both of these works almost certainly fall into the

category of bedchamber Madonnas, but they also take the representation of the Virgin to a brilliant new artistic height.

It is especially important to realize, in addressing the theme of this chapter, that during the course of the Cinquecento some Virgin and Child paintings were moved out of bedrooms into spaces that should be understood as proto-art galleries. By the early seventeenth century, at least, Lorenzo de' Medici's model had proved potent. We can follow this trend above all in Venice, with displays of pictures in the *portego* (see p.56). These were long, well-lit rooms, in which paintings were a common feature. The 1538 inventory of the *portego* of the courtesan Elisabetta Condulmer may be regarded as typical for elite houses of this date.[60] It contained pictures with largely secular subject matter and a high proportion of paintings by artists from the north of the Alps. By the time the collection of Andrea Vendramin was catalogued in 1627, the primary method of classification was by artist (see pp.63-4).[61] By then the compiler made a clear distinction between, on

the one hand, Vendramin's collection depicted in the catalogue and, on the other, the older, smaller paintings that filled gaps in the studies and the 'diverse portraits that are for the adornment of the house'.[62] The catalogue includes small pictures by Andrea Schiavone that were probably once attached to chests or other pieces of furniture and a *Virgin and Child* by Giovanni Bellini.[63]

★ ★ ★

It seems that we can trace a three-stage process during the course of the fifteenth and sixteenth centuries: firstly pictures that were painted as intrinsic to items of furniture, secondly paintings that were no longer actually parts of utilitarian objects but that might pertain to them and imitate their shapes and, finally, these and other such works that were converted into or executed specially as gallery pictures. By this transformation, which would have rendered more visible some at least of the paintings and sculptures discussed above, we can trace the roots of what we see in so many public galleries today.

THE *ACQUAIO* (WALL FOUNTAIN) AND FIREPLACE IN FLORENCE

BRENDA PREYER

The *sala principale* of a Florentine palace always had a large fireplace and, in the later fifteenth and early sixteenth centuries, often a wall fountain, or *acquaio*, a built-in basin with an elaborate frame (see pp.38-9). Both of these major elements were customarily made of *pietra serena*, the grey limestone widely used for architectural decoration. Many texts (such as Vasari, sixteenth-century documents and nineteenth-century descriptions) refer to the fireplace and the *acquaio* as a pair, with the implication that the same artists designed and executed both. No pieces survive together *in situ*, and the two illustrated here (plates 19.12 and 19.13) come from palaces separated in time by fifty years.

The Boni fireplace (plate 19.12) probably corresponds to the one mentioned, together with an *acquaio*, in an 1803 sale document describing the *sala* of the Boni palace, torn down shortly afterwards. Its whereabouts remained a mystery until 1859, when it was seen in a villa outside Florence and bought for the V&A.[1]

In 1859 the *acquaio* was in the Girolami palace, owned then by a member of the Molini family.[2] An *acquaio* and fireplace in this palace were mentioned by Leopoldo Cicognara in the early nineteenth century as examples of the ornate style that Benedetto da Rovezzano brought to this type of domestic sculpture.[3] Herbert Horne's investigations in the *sala principale* at the Corsi-Horne palace which he bought in 1911, show the *acquaio* to have been on the inner long wall and the fireplace at right angles to it on the short entrance wall. The same scheme is presented in the section drawing of the Gaddi houses (see plate 2.5), where one also sees a second *acquaio* on the ground floor next to the courtyard. Indeed, these fixtures were sometimes installed in courtyards and *camere*, as well as in kitchens, though the elaborate decoration of the Girolami *acquaio* certainly indicates that it was for a *sala*.

The frames of these architectural constructions were covered with ornamentatation of the most varied sort adorning the surfaces of the strong vertical supports, the friezes and, on the *acquaio*, above the basin itself. References to the family were standard: for example, the fireplace features the Boni coat of arms in the centre, and the idealized heads to either side may evoke the deceased parents of the three brothers who built the palace, if the shells against which they are set have a funerary significance.[4]

19.12 Geri da Settignano (?), fireplace from the Boni Palace, Florence, *c.*1458
(cat.21)

19.14 'Beaver' tearing off its
testicles, detail from the frieze of
a fireplace, *c*.1500
(Private collection, United States)

19.13 *Acquaio* from
the Girolami palace,
Florence, *c*.1500
(cat.16)

In the centre of the *acquaio*'s frieze is another enigmatic image: a beast tearing off its testicles. Despite its long legs and neck and its fish-like tail, this is meant to be a beaver. According to a tradition going back to Pliny, beavers saved their lives through this act because they were hunted for their testicles, which had prized medicinal properties.[5] The same creature, better preserved, appears on the frieze of a fireplace that is now in a private collection in the United States[6] and may also come from the Girolami *sala* (plate 19.14). Unfortunately, nothing has come to light to explain the use of the beaver by the owner of the palace, Francesco di Zanobi Girolami, who was a prominent banker in Florence and in Rome. Another problem concerns the marble heads of a young man and a young woman once inserted in the roundels near the top and shown in old photographs of the *acquaio*. Reported by Pope-Hennessy in his catalogue of 1964 to have disappeared,[7] they are close but not identical to two pieces published recently.[8]

Numerous accoutrements were associated with fireplaces and *acquai*. Inventories sometimes list benches, chairs and tables near the fireplace. In addition to fire tools and andirons (often appearing as prized items in inventories), the mantlepiece – well above eye level on the Boni fireplace – may have provided a surface for the display of sculpture and other three-dimensional objects. Vasari

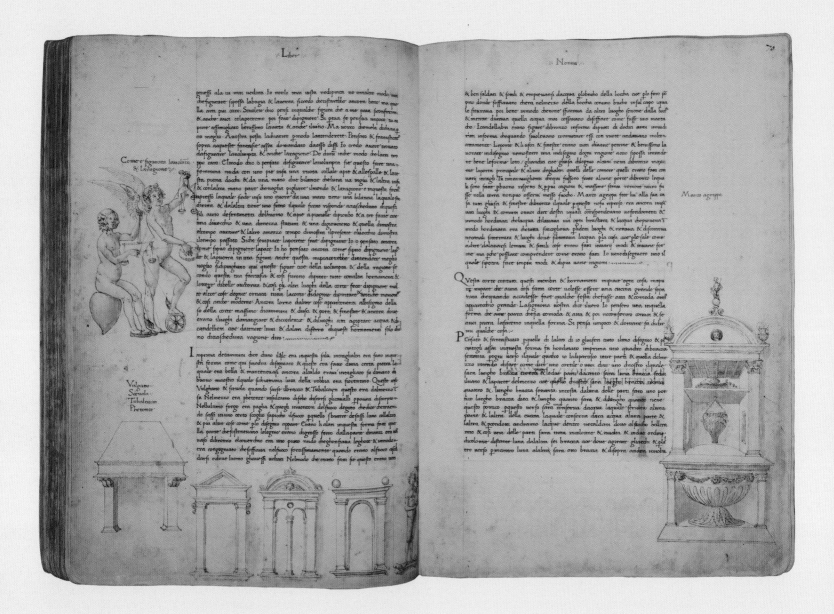

19.15 Filarete, *Trattato di architettura*, Milan, *c*.1460–64 (cat.10)

Filarete's treatise is written as a dialogue between the architect and his patron. This copy was produced for Piero de Medici and includes a chapter praising the Medici as patrons.

stated that busts adorned 'fireplaces, doorways, windows, and cornices'.[9] Paintings, or even a bronze relief in a *saletta* of the Medici palace, could be placed on the wall above the fireplace. In the fresco by Andrea del Sarto at the church of Santissima Annunziata (see plate 2.9) vigorous putti, seemingly made of stone, are depicted above the fireplace flanking the emblem of the order of Servites to which the church belonged. The Girolami *acquaio* once had a shelf at the second level above the basin: the supports' metal stubs remain on the sides, while the panels behind were left plain in anticipation of being screened by objects resting on the shelf. The drawing by the architect Antonio Averlino, known as Filarete, shows such a shelf, and documents indicate that they were common on *acquai* (plate 19.15) On the shelves and basin of the *acquaio* compilers of inventories found a variety of vessels of copper

and brass, and of terracotta, maiolica and glass (plate 19.16). There were also towels and, perhaps more surprising, a proliferation of candlesticks. The sculptures, often heads, mentioned occasionally in inventories *all'acquaio* were probably above the cornice (plate 19.17).

Some *acquai* acted as drains and Filarete's text refers to 'places where the water of the house, that is, of the *sale*, was thrown out'. The Girolami example, however, and all those that can be found in religious contexts in sacristies and outside refectories, were connected to a plumbing system and had running water. The ceremony of washing hands could take place before the meal, and also during it; as a servant poured water over the guest's hands, it was caught in a basin and the hands were dried with a towel. The elegant brass ewer and basin from Fucecchio (plate 19.18) help us visualize this.

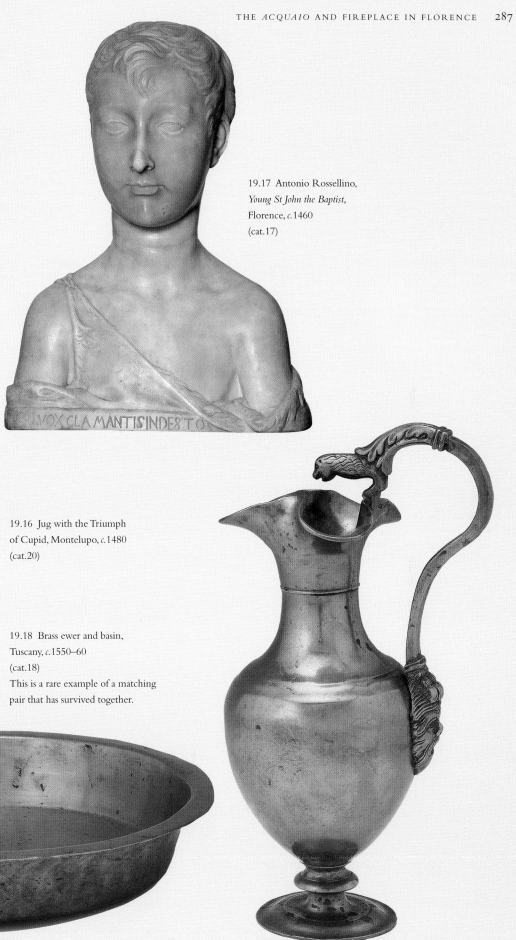

19.17 Antonio Rossellino,
Young St John the Baptist,
Florence, *c.*1460
(cat.17)

19.16 Jug with the Triumph
of Cupid, Montelupo, *c.*1480
(cat.20)

19.18 Brass ewer and basin,
Tuscany, *c.*1550–60
(cat.18)
This is a rare example of a matching
pair that has survived together.

THE MEDICI STUDY

LUKE SYSON

19.20 Bertoldo di Giovanni, medal of the Pazzi Conspiracy, Florence, 1478 (cat.218)

I n August 1480 Cardinal Giovanni of Aragon was led through the Palazzo Medici by Lorenzo de' Medici. The visit, which included the other key sites of the chapel and sculpture gardens, was reported in copious detail by the Ferrarese Antonio da Montecatini to his ducal master, Ercole I d'Este:

> Then he entered the *studio*, the chamber that had belonged to Piero, and there he examined the said *studio* with copious quantities of books, all worthy, written with a pen – a stupendous thing. Then we returned to the little loggia opening off the *camera*. And there on a table, he had brought his jewels [out of the *studio*] … vases, cups, hardstone coffers mounted with gold, of various stones, jasper and others. There was a crystal beaker mounted with a lid and a silver foot, which was studded with pearls, rubies, diamonds and other stones. [He also showed] a dish carved inside with diverse figures, which was a worthy thing, reputed to be worth 4,000 ducats [the famous Tazza Farnese, so-called after a subsequent owner]. Then he had brought two large bowls full of ancient coins, one of gold coins and the other full of silver, then a little case with many jewels, rings and engraved stones [plate 19.19].[1]

The Medici *scrittoio* and its contents had become a focus for the many ceremonial visits that grandees coming to Florence expected,[2] which in some ways seems surprising. In theory, at least, this was a study space created by Piero de' Medici, Lorenzo's father, to conduct his business – a space that was standard for merchants and bankers in Florence and elsewhere in Tuscany. In practice it had become a treasury, a *Kunstkammer*, a library, even a proto-

museum, which could proclaim a whole set of messages about the Medici, the head of the family, his wealth and his cultural interests (plate 19.20).

Piero is thought to have commissioned the fitting-out of this room in the early 1450s. Certainly, by 1456 it had been seen by Filarete, who described it in some detail in his celebrated architectural treatise, *Trattato di architettura*, presenting it as a model for others to follow. Filarete's account is one of the key pieces of evidence for the study's appearance and function, as it was destroyed in 1659. Describing a space full of books and 'other worthy objects', he stated that 'the floor as well as the ceiling [was] enamelled with most worthy figures, so that whoever enters is filled with admiration. The master of this enam-elling was Luca della Robbia.'[3] Miraculously, Luca's twelve, glazed terracotta, vault tiles, all concave and con-taining white-framed roundels showing the Labours of the Months, survive in the V&A (plate 19.21). These were an extraordinary, unprecedented and never to be repeated technical and artistic achievement. Ceramic paints and glazes were used to achieve works that resemble drawings on blue-prepared paper. The borders show how much daylight there would be in every month, and they are astrologically well informed. Even the choice of labours seems to have been based on a learned treatise by the first-century Spanish author, Columella: the *De re rustica*.

Their arrangement, however, is very hard to reconstruct. Though the corners are badly damaged, enough of their colour survives to suggest that the individual scenes were originally framed by fictive dark purple-red porphyry and green serpentine spandrels. But it is not clear how these colours met – whether they were supposed to match or to contrast at the corners, and thus although they are likely to have been placed in three rows of four, their order cannot be established with certainty. Their sizes (each *c*.59.7 cm in diameter) and their curvature (eight curve around a horizontal line and four round a vertical) have been used to estimate their positioning. We can be fairly sure that they were set into a barrel vault, but we have no evidence of the mouldings that are likely to have been employed as ribs for the vault or of the cornice that must have supported the whole structure. It is, however, likely, as we shall see, that the walls were lined with inlaid wood

19.19 Coin (*aureus*) of Trajan, Rome, AD 112–14 (cat.245); coin (*sestertius*) of Trajan, Rome, AD 105 (cat.246)

19.21 Luca della Robbia,
The Labours of the Months,
Florence, *c*.1450–56
(cat.216)
This layout reflects the most
convincing disposition of the
roundels as they originally
appeared in the vaulted ceiling
of the Medici study.

19.22 (*right*) Illumination by
Ricciardo di Nanni from
St Augustine, *De Civitate Dei*,
Florence, *c.*1460–63
(cat.224)

19.23 (*far right*) Illumination
by Francesco d'Antonio del
Chierico from Pliny, *Historia
Naturalis*, Florence, 1458
(cat.225)

cupboards, of the kind employed by Federico da Monte-
feltro, Duke of Urbino, in his later *studioli* in Urbino and
Gubbio, presumably recessed beneath the cornice.

It is already clear that this was no ordinary *studiolo*.
Recent research has established that such spaces were
built first and foremost as places to conduct business, and
were filled with papers, accounts and memoranda.[4] The
objects used to decorate them were primarily functional,
including inkwells, sandboxes and the like (see p.170), but
the emphasis in Piero's *scrittoio* was very different. Filarete
gave a verbal portrait of Piero de' Medici ensconced in his
scrittoio, describing objects that range from the academic
and inspirational to the aesthetically pleasurable.[5]

Piero had effigies and images of all the emperors and
worthies that there ever were, some made of gold, some
of silver, some of bronze, of precious stones [*pietra fine*]
and of marble or other materials that are marvellous
things to behold. Their worth [*dignità*] is such that to
look at these portraits carved in bronze alone ... is
enough [to appreciate] their excellence, which fills his
soul with delight and pleasure in their sight. These give
pleasure in two ways to those who understand and
enjoy them as he does; first for the excellence of the
image represented; secondly for the worthy mastery of

ancient and angelic spirits who, through their sublime
talent, have made such base things as bronze, marble and
suchlike prized so greatly ... He takes pleasure first
from one thing and then from another, praising one for
the dignity of the image because it was made [by the
hand of man] and another that reveals even greater skill
because it seems to have been done by nature rather
than man. When we see things made by the hand of
Phidias or Praxiteles, we say that it does not seem to
have been fabricated but to have come from heaven.[6]

By deliberately ignoring the more practical side of the
space, Filarete was promoting Piero as a man of antiquarian
knowledge and outstanding good taste – with the ability
to distinguish between one master's skills and another's,
and indeed to separate the inspired from the mundane.

Two inventories of Piero's goods have come down to
us and both contain many objects of just the kind that
Filarete lists. The cupboards containing them are not
mentioned, showing that they were built-in. In 1456 his
'gioie e simile cose' (jewels and similar things) included
hardstone vases, coins, cameos and jewellery to be worn.
Piero already possessed a 'unicorn' horn, which was to
become one of most highly valued objects in Medici
ownership by the last decade of the century (worth an

astounding 6,000 florins),[7] and had acquired a substantial library.[8] In the inventory his books are carefully classified into sections: sacred subjects (as in plate 19.22); followed by books by ancient authors (plate 19.23) on grammar, poetry, history, *arte*, philosophy and other smaller sections, including architecture; and books in Italian. By 1465, when the second inventory was taken, the list had grown, with the addition of intaglio gems (plate 19.24) and, perhaps more unexpectedly, a number of 'tavole alle greca' – Byzantine micro-mosaics of sacred subjects.[9] The library, too, had considerably expanded.[10]

In 1492 the contents of the *scrittoio* were listed again in the celebrated inventory of the goods belonging to Lorenzo made after his death.[11] Many of his gems and hardstone vessels (plates 19.25 and 19.26) – some inherited from his father, others purchased through an elaborate community of representatives stretching from Venice to all-important Rome – can still be identified.[12] Lorenzo's practice of having his name carved on some pieces raised their status and allowed viewers to identify them as some of his most treasured possessions. These gems and vessels had become the most celebrated objects in the Medici study and, apart from the unicorn horn, were also the most highly valued. But the study's contents were more wide-ranging and were intended to reflect his real and symbolic interests in a range of fields. The inventory

19.24 Ancient and medieval cameos and intaglio documented in the Medici study in the 15th century: (*top left*) *Centaur*, Rome, 2nd century BC (cat.219); (*top right*) *Three Carpenter Erotes*, Roman workshop (?), 1st century BC (cat.221); (*above left*) *Hermaphrodite with Three Erotes*, Roman workshop (?), 1st century BC (cat.220); (*above right*) *Poseidon and Amphitrite* workshop employed by the court of Frederick II, Holy Roman Emperor (1215–50?) (cat.222)

19.26 (*right*) Jasper beaker with lid, silver gilt mounts and pearl, Fatimid, 10–12th century, or France or Burgundy, 1400–1450 (cat.227)

19.25 (*far right*) Double cup in jasper, Italian with Florentine mounts, late 15th century, foot added in the early 16th century (cat.228)

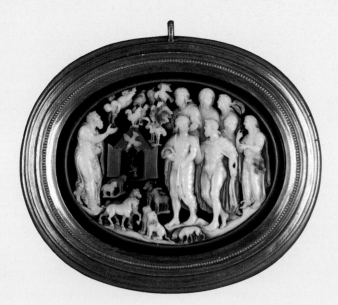

19.27 Cameo depicting Noah and his family emerging from the ark, probably Sicily or southern Italy, *c*.1200–1250 (cat.230)

19.29 Illumination by Francesco Rosselli from Aratos, *Phaenomena*, Florence, *c*.1490 (cat.226)

19.28 Medal of Cosimo de' Medici (il Vecchio), Florence, *c*.1450–75 (cat.217)

mentions at least two other areas listed as *scrittoi*, one of which, half way up the stairs from the main courtyard, was almost certainly the place for practical business. The principal study had become a showroom, lined with cupboards which, when open, functioned not unlike modern museum cases. From these all sorts of marvels could be taken down and examined, sometimes in other spaces such as the loggia.

The list starts, as might be expected, with the hardstone vessels and reaches a pinnacle with the Tazza Farnese, which was now worth a hefty 10,000 florins. The inventory suggests that individual cupboards were devoted to objects of particular types: the vessels were followed by mounted cameos, all elaborately detailed with the number, sex and age of the figures carved onto them (plate 19.27). Then came rings set with ancient intaglios. These were succeeded by a section of precious metal pieces grouped for their enamels and then other examples of modern goldsmiths' work – among them a gold medal of Lorenzo's grandfather, Cosimo (plate 19.28). Other crafts were celebrated in the next sections. The micro-mosaics were grouped with a painting by Giotto, seemingly meant to show that Florentines could match the pictorial skills of the Byzantine works in their own chosen medium, painting. It may be no coincidence, if this was indeed a celebration of Florentine identity, that the Giotto, a *Deposition of Christ*, heralded an assembly of books in the Tuscan *volgare*: books by Dante and Petrarch, classical authors and religious texts (plate 19.29). Other technical marvels were also prized: paintings by Netherlandish masters in oils (plate 19.30), carved ivory and bone, and bronze casting, ancient and modern. A collection of maps publicized Lorenzo's global interests, and ranged from world atlases to a plan of the Castello Sforzesco in Milan. The inventory comes to a glittering climax with a list of jewellery of the kind worn by the Medici and their consorts – an expression of pride in the women of the family and of the advantageous marriages of the men.

In Milan the Sforza, who as dynastic rulers had no need to temper their displays of wealth, took embassies to their court on tours of their treasury. In the Florentine republic where the Medici had to show off their power and wealth with some discretion the *scrittoio* functioned in the same way. That is not to say that Piero and Lorenzo did not have a genuine fascination for the arts of the ancients and a real capacity to appreciate the technical skills of the moderns, but this was a treasury nevertheless. The total contents of the *scrittoio* in 1492 were considered to be worth an astonishing 60,866 florins, more than all the rest of the family possessions put together, and certainly more than the palace itself. These were precisely the kind of objects that were regularly held by the Medici as the security for loans they made to many of the most powerful men and women in Europe. The Medici genius lay in accumulating and demonstrating this wealth in a form that spoke of their education and civility. The *scrittoio* was not only the intellectual and material core of the palace, it was the heart of their mercantile empire. This, as Luca della Robbia's roundels demonstrate, was a miniature cosmos, showing off all the miracles of man and nature, with the Medici at its centre.

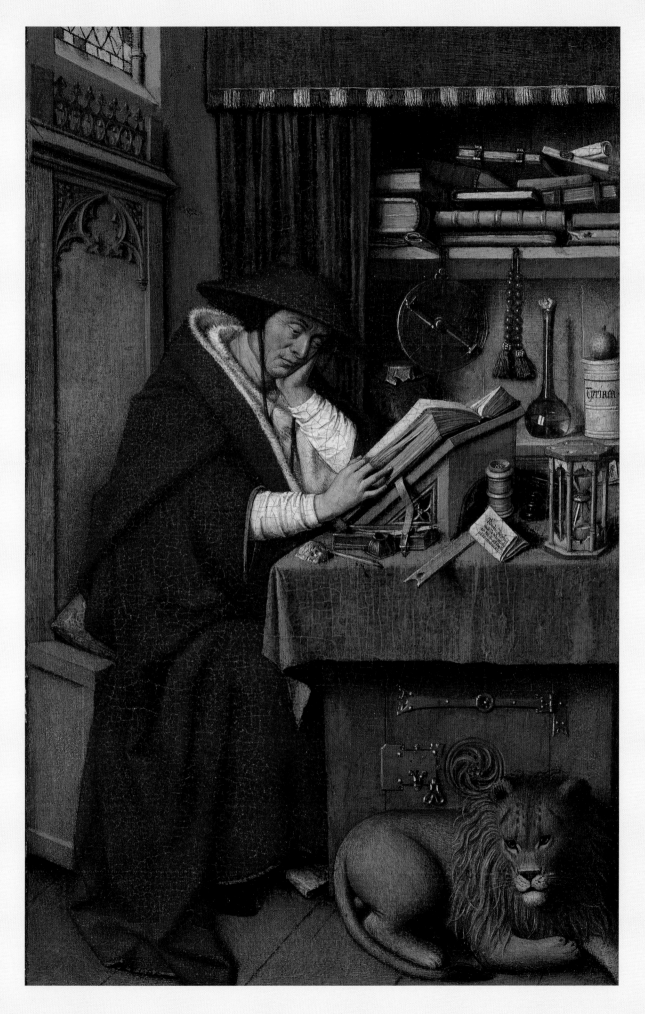

19.30 Attr. Jan van Eyck and
assistant, *St Jerome in his Study*,
Bruges, 1442
(cat.223)
This painting has sometimes
been identified with the 'small
panel from Flanders with
St Jerome on it' described in
the Medici inventory of 1492.
It is more likely, however, that
the picture that belonged to
Lorenzo was an earlier version
of the same composition.

BRONZES

JEREMY WARREN

20.1 (*opposite*) Workshop of Severo da Ravenna, inkstand with the *Spinario*, Ravenna, *c.*1510–30
(cat.253)
The *Spinario* was one of the best-known pieces of antique sculpture in Renaissance Rome and was frequently copied by artists. The life-cast shell held ink, while quills could be stored in the hollow tree-trunk on which the *Spinario* is seated.

20.2 Riccio, *The Shouting Horseman*, Padua, *c.*1510–15
(cat.258)
The horseman is loosely modelled on contemporary Venetian light cavalry who rode bareback wearing simply helmet and breastplate, armed with a sword or light lance.

THE SMALL BRONZE has come to be regarded as one of the characteristic expressions of the Italian Renaissance. It was a highly successful means by which Renaissance man could translate his love affair with the world of antiquity into a contemporary idiom. Latin texts helped to remind well-educated Renaissance men and women of the huge attraction small bronzes had held for their Roman predecessors, such as the Emperor Nero who, according to Pliny, carried a bronze figure of an Amazon everywhere with him.[1] It was perhaps in this spirit that Cardinal Francesco Gonzaga ensured that, among some of his other special treasures, his bronze figures always travelled with him.[2] Whether conceived as miniature versions of ancient sculptures, such as the so-called *Spinario* (plate 20.1), a late Roman small monumental bronze of a boy plucking a thorn from his foot, or as independent creations in a consciously classicizing style (plate 20.2), many bronzes provided tangible modern echoes of that golden age. Cosimo de' Medici gave expression to a more intangible sense in which modern people might, through the possession of *all'antica* works of art, aspire to the ancient virtues when in 1434 he wrote: 'If the painters, sculptors and architects of our time can in some part emulate the temples, the gates, the columns, the paintings, the marble figures and bronze statues of the ancients … shall we not imitate those ancients whom … we follow far after, and whose traces we adore?'[3]

Such deliberate but subtle emulation may very well have been in the mind of the Bolognese gentleman, Gaspare Fantuzzi (*c.*1465/70-1536), when he commissioned a remarkable bronze figure of the *Sleeping Hercules* (plate 20.3), proudly including an inscription with his name on the underside of Hercules' wineskin pillow. Although as a design it appears to have no recognizable classical sculptural prototype, the concept of Fantuzzi's bronze probably derives from a model known through literary descriptions, the *Hercules Epitrapezios*, a bronze

statuette of the drunken hero, which in ancient Greece and Rome would be placed on the table to preside over drinking sessions. Such an idea seems particularly appropriate to Fantuzzi who, as well as his passionate interest in the classical world, was evidently a notable *bon viveur*.[4]

Whilst Fantuzzi's bronze *Hercules* might have appeared from time to time on the dining table, it is quite possible that it would normally have been kept in a more private space such as his study (*studiolo*). Bronzes were evidently conceived as works of art for a more intimate context, since they seem commonly to have been kept in the more private spaces in the house, such as the bedroom and, above all, the study, a room that often led off the *camera*. Most educated and well-off men (and sometimes women) in the Renaissance aspired to a studio, an often tiny private space to which its owner could retire for quiet study or reflection,[5] and where many of his most precious treasures would be kept. Within studies bronzes might be displayed on wall shelves, safe from accidental damage, or they might be placed on tables for display or, perhaps more commonly, for practical use (see plate 20.4).

The great majority of bronzes produced during the Italian Renaissance were in fact made for use, so-called 'functional bronzes', which, however beautiful in their own right, nevertheless had some practical use beyond simple ornament. Most research into bronzes over the past 150 years has tended to focus

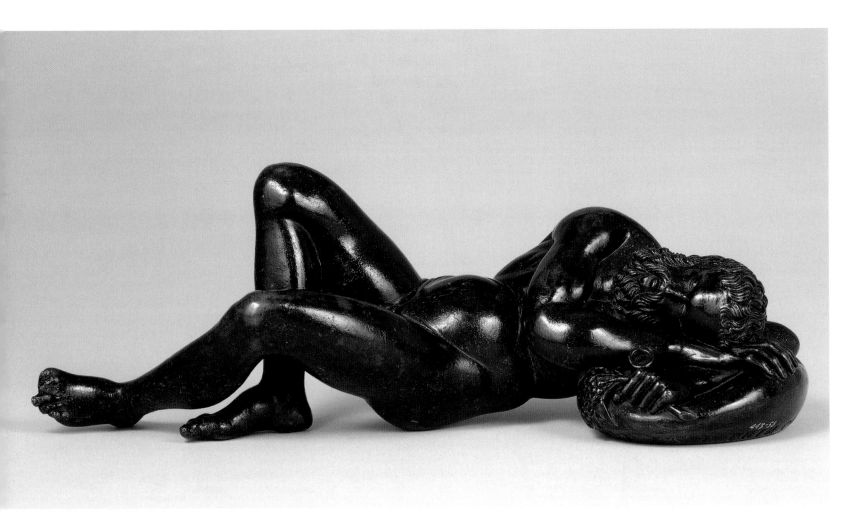

20.3 *Sleeping Hercules*, possibly Bologna, *c*.1490–1500 (cat.255)
Hercules is shown asleep in a drunken stupor, his head resting on an empty wineskin.

20.4 Vittore Carpaccio,
Vision of St Augustine,
tempera on canvas, Venice,
*c.*1502 (Scuola di San
Giorgio degli Schiavoni,
Venice)

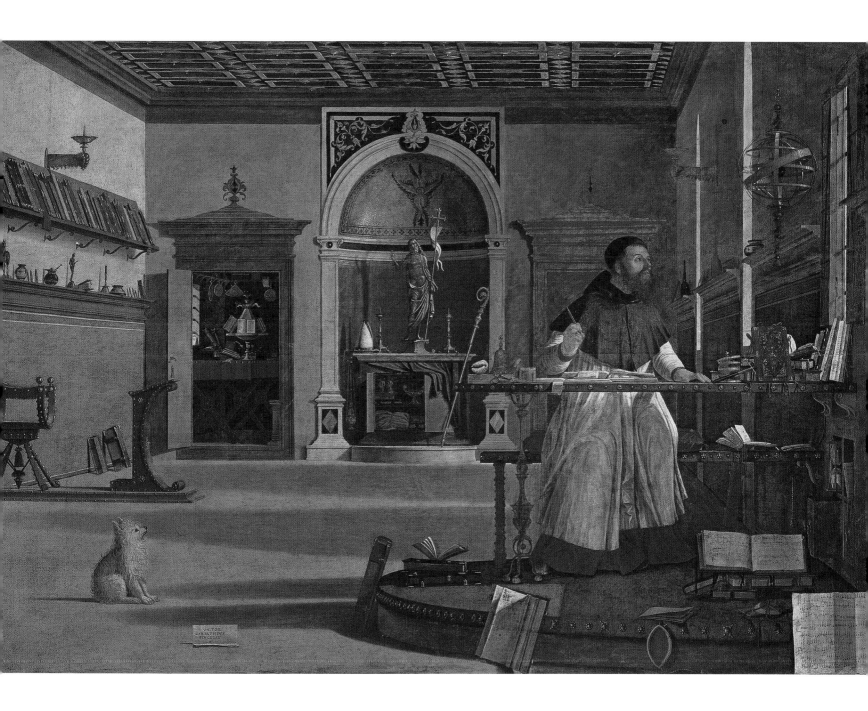

20.6 Handbell, probably
Venice, *c*.1550
(cat.252)
This handbell, which has lost
its handle, is inscribed
'PVLSV MEO SERVOS
VOCO' (with my ring
I call my servants),
confirming that it was
made for use in households
for summoning servants.

20.5 Doorknocker,
Venice, 1550–1600
(cat.3)

are usually photographed – does it also become
clear that the conjoined animal heads form a handle,
making it convenient to pick up and, thus, emi-
nently suitable for use as a paperweight, its probable
original function. Understanding better how these
objects were used increases our pleasure in them
and our ability to relate to them as works of art. It is
also a salutary reminder that concepts such as good
design and practicality were no less important to
many sculptors of the Renaissance than they are to
any designer working today.

Compared to an important category of works of
art that has almost completely disappeared – secular
functional objects in precious metal – Italian Renais-
sance bronzes have survived in reasonable numbers.
This encourages a misleading impression that
bronzes were common in Renaissance households,
when in fact they were quite rare, certainly more so

on issues of attribution or provenance, often over-
shadowing the practical roles that these works of art
played in the lives of their first owners. Often, as
with a candlestick, a doorknocker (plate 20.5), bell
(plate 20.6) or even a pair of wafer irons (see plate
7.12), this role is very obvious, at other times less so.
An extraordinarily intricate lead group, cast from
life, of two lizards fighting a snake (plate 20.7) is at
first sight simply a virtuoso demonstration of the
caster's skill, as well as evidence of the Renaissance
fascination with the natural world. It is of course
both these things, but only once it is examined
closely – and not simply from above as such groups

20.7 *Two Lizards Fighting a*
Snake, northern Italy, *c*.1550
(cat.254)

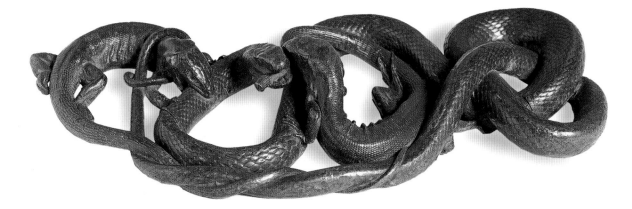

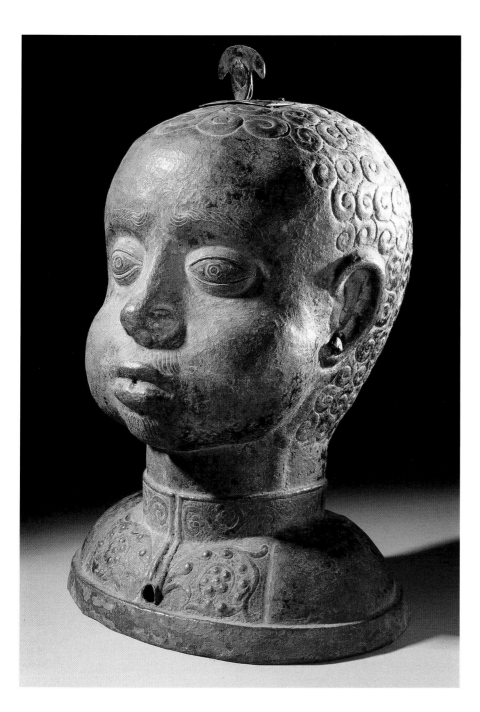

20.8 *Aeolipile* (fire-blower),
Venice, *c.*1500
(cat.251)

goldsmith's work, bronzes, especially if antique, were nevertheless expensive objects. Although, when reading his diatribes against the customs and morals of his contemporaries, due allowance must be made for exaggeration and, in this case, for the higher values attaching to antiquities, Fra Sabba da Castiglione's scathing criticism, in the 1549 edition of his *Ricordi*, of people who, he thought, wasted their money on works of art nevertheless gives some sense of the relative scale of values:

> And what can we say about the vanity of that other man who will fork out 1500 ducats for a statue of metal or stone, which serves no useful purpose and which can render no service whatsoever; and yet he will not pay 25 ducats for a real living servant, who could serve and assist him in many ways? And the other who will go on foot so as not to have to spend 10 ducats on a horse, and yet will then go and pay 500 for a little antique horse in bronze, which not only cannot carry him but has itself to be borne around?[7]

Further evidence of the value placed on bronze sculpture is the frequency with which inventories record objects as 'simulated bronze' (*finto di bronzo*), sculpture made from a lesser material such as terracotta and provided with a bronze-coloured patina. To take just one example from many, the inventory of the Florentine Lodovico di Gino Capponi, drawn up in 1534, listed one group of three and another of seven clay figures coloured to imitate bronze ('fighure di tera colore di bronzzo').[8] Among the most treasured possessions of Sabba da Castiglione, who did not himself own a single bronze, was just such a terracotta relief depicting *St Jerome*, made by his friend the sculptor Alfonso Lombardi.[9] The effect was evidently so realistic that the relief was even described as cast in bronze (*ex brongio conflatum*) in Sabba's first will, drawn up in 1546.[10] A remarkable Venetian 'aeolipile', or fire-blower, in the form of a head of a black man (plate 20.8) almost certainly originally imitated bronze. Aeolipiles were filled with water and heated, forcing a jet of steam through the small hole in the mouth which, when directed into the fire, helped it to burn more brightly. Made in fact of humble sheet copper, the aeolipile carries traces of black patination and gilding, suggesting that

than silver. It is unusual to find more than a couple of bronzes in domestic inventories, even in those of the so-called urban elites. The wealthy Bolognese humanist Bartolomeo Bianchini (1471–1510) had just three in his study at the time of his death, a horse's head, a man's head and a little figure.[6] Even in princely households the majority of such workaday objects as candlesticks would have been made from cheaper materials such as iron or latten (a brassy alloy of copper and zinc). If not as costly as the finest

when new it would have appeared like a black-patinated bronze with gilded highlights. A fascinating image of a black man in fashionable and expensive dress, it must have looked spectacular when new. Aeolipiles were described by the architect Filarete as part of the equipment for fireplaces, together with fire-dogs (see plates 10.3 and 19.2).[11] Fire-dogs appear relatively frequently in inventories, but these fire-blowers by contrast seem to have been exceptionally rare, although one was sent from Rome to King René of Anjou in 1448.[12]

Although they remained expensive luxuries, as techniques for reproducing multiple versions from a single model improved in the course of the sixteenth century,[13] the market for bronzes nevertheless seems to have broadened to a considerable extent, to judge from the number of surviving versions of such popular models as Severo da Ravenna's *Spinario* (plate 20.1). Severo, who worked in Padua for around a decade in the early sixteenth century, on his return to his native Ravenna set up one of the most productive foundries in sixteenth-century Italy, which may have continued to operate under his son Niccolò until well into the century.[14] Severo's many bronzes range from autograph work of the highest quality to mass-produced and progressively debased pieces based on a limited range of models. This gradual decline in quality can clearly be seen in two double candlesticks in the form of a singing siren mounted on an eagle's claw, possibly made as many as fifty years apart from one another.[15] The siren candlesticks are an excellent demonstration of Severo's concern with functionality. In what seems to be the earliest type, made around 1510–30 (plate 20.9, left), the siren's arms are sharply bent, her tails held upright and the candleholders separately cast with integral screws, with which they are fixed into holes in the siren's hands. Although beautiful, the design is a little too vertical, making the candlestick unstable and easy to knock over. Because of the position of the siren's arms, it has to be picked up by the eagle's leg, not necessarily the most stable solution when lighted candles are in the holders. Another problem is that the candleholders themselves are all too easy to break off, as has indeed occurred in all four known versions of this variant. These problems seem to have been addressed in two subsequent variants, before the workshop arrived at what was probably its final solution (plate 20.9, right). By lowering and spreading out the siren's arms, the candlestick has been made much more stable, while it can now be easily picked up and carried by the siren's waist. It is, however, notably cruder when compared to the earlier version, suggesting that in this case aesthetic quality has run in inverse proportion to improvements in functionality.

Severo da Ravenna seems to have invented what must have appeared at the time a revolutionary system of using integrally cast, thick tapering screws to fasten together the separately cast components of his utensils. Made to a standard size, these screws allowed interchangeability of components and thus a huge variety of solutions around a basic model such as the *Spinario*, which could be used on inkstands, small boxes or simply as an independent decorative statuette.[16] Although the workshop of Severo da Ravenna seems to have operated on a semi-industrial basis, components being produced in multiples from a single mould, the wax models so produced could be modified before being cast in bronze. This seems to have happened frequently and thus it is surprisingly rare to find bronzes that are absolutely identical. These variations can sometimes be related to the particular functions that a bronze utensil might have been expected to perform. Even tiny, apparently insignificant, details may in fact be conscious design choices on the part of the sculptor. For example, unlike some freestanding versions of the *Spinario* in which the fingers of the boy's right hand are gracefully splayed outwards, in the inkstand version, where the hand is close to the inkwell and the delicate fingers might therefore be vulnerable to damage from quill pens, they are closed tight around the thorn.

Although many inventories refer to functional bronzes, most references turn out to be disappointingly vague – all too typical is 'an inkstand of bronze' in the 1555 inventory of the study of the Venetian collector Andrea Odoni.[17] Only rarely can an inventory description be matched to a surviving model with any confidence; thus inventories will often tell us little more than the bare facts and statistics of ownership. Although they must, like documents, be approached with a degree of caution, paintings and other visual representations can be helpful in the information they provide about bronzes, how they

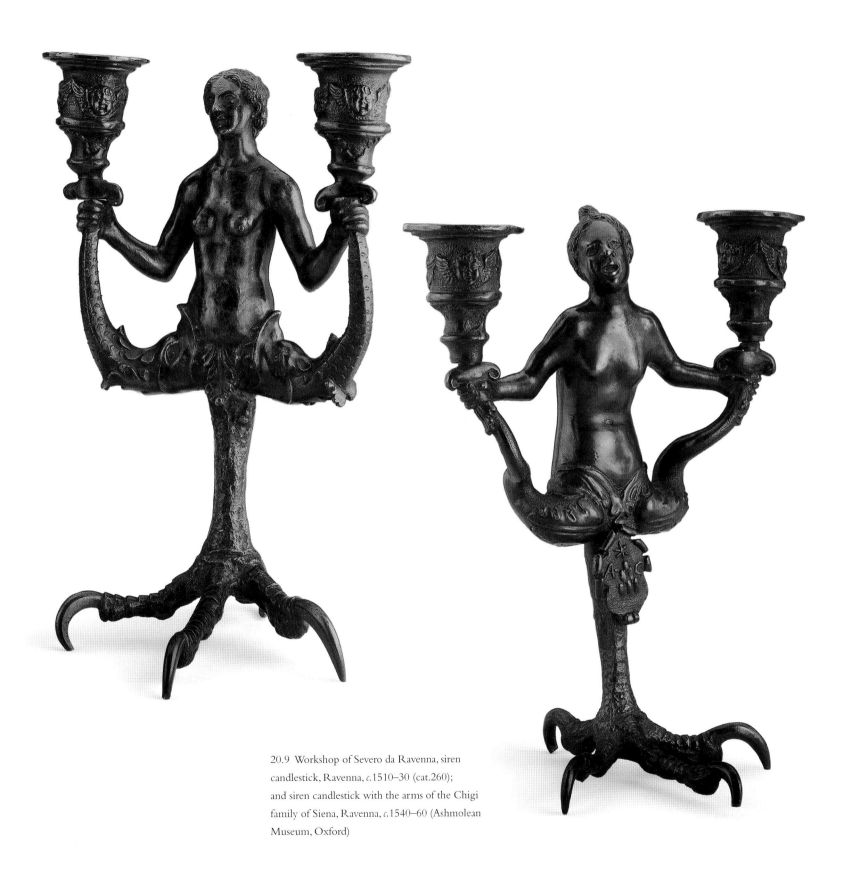

20.9 Workshop of Severo da Ravenna, siren
candlestick, Ravenna, c.1510–30 (cat.260);
and siren candlestick with the arms of the Chigi
family of Siena, Ravenna, c.1540–60 (Ashmolean
Museum, Oxford)

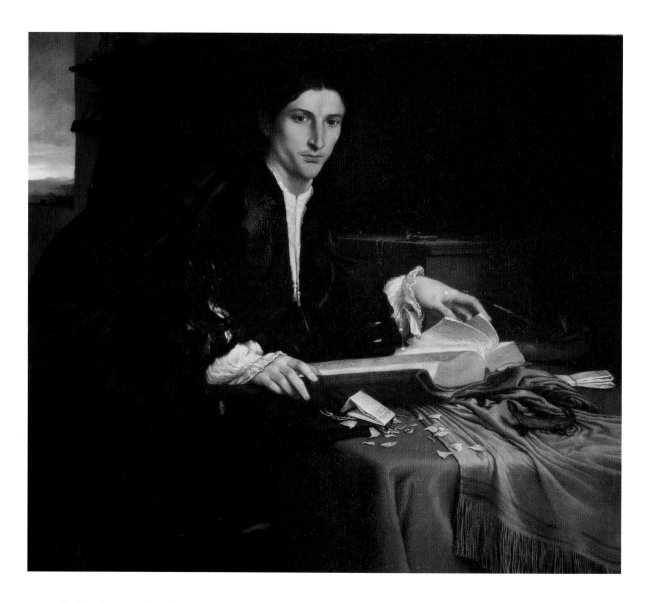

20.10 Lorenzo Lotto, *Portrait of a Young Man*, oil on canvas, Venice, *c.*1530 (Galleria dell'Accademia, Venice) Although apparently set in an open loggia, this painting shows a young man surrounded by the apparatus of a study, including a large ceramic inkstand and a high shelf for the display of precious objects.

were displayed or used and even what they originally looked like. The lizard on the table in Lorenzo Lotto's portrait of a young man of *c.*1530 (plate 20.10) is almost certainly not supposed to be a living animal, as has often been assumed, but is instead probably a lead cast painted from life, which would have served as a paperweight, like the two lizards fighting a snake. Paintings also confirm the evidence from inventories that bronzes were often displayed high, on specially constructed cornices running along a wall, high enough to protect these expensive objects from casual damage, but low enough to allow them to be taken down and handled (plate 20.4). While the interior space in Gian Antonio Corona's *Birth of the Virgin* of *c.*1508 is certainly imaginary (plate 20.11), there is no reason to suppose that the placing above

a door of a version of the well-known figure of *Marsyas*, the original model of which was probably made in Florence in the fifteenth century (plate 20.12), does not also represent contemporary practice.

Bronze artefacts can also often be seen in portraits and other pictures containing depictions of studies, thus confirming evidence from inventories that in many houses this was the space where any bronzes would be kept. Very often bronzes in studies would be objects for writing, such as inkstands and pounce pots containing sand for drying ink. Inkstands in particular appear more frequently in inventories than other types of bronze and also point us towards the type of people who most typically commissioned and collected such works of art. These were not necessarily princes and members of their courts but

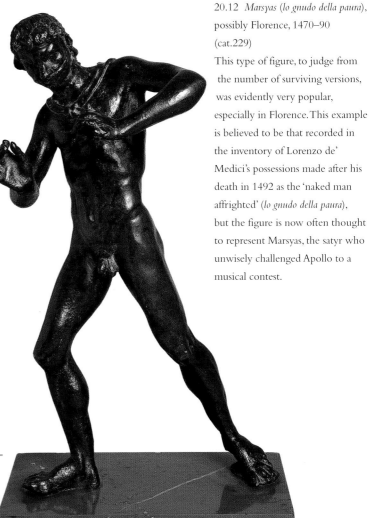

20.12 *Marsyas* (*lo gnudo della paura*), possibly Florence, 1470–90 (cat.229)

This type of figure, to judge from the number of surviving versions, was evidently very popular, especially in Florence. This example is believed to be that recorded in the inventory of Lorenzo de' Medici's possessions made after his death in 1492 as the 'naked man affrighted' (*lo gnudo della paura*), but the figure is now often thought to represent Marsyas, the satyr who unwisely challenged Apollo to a musical contest.

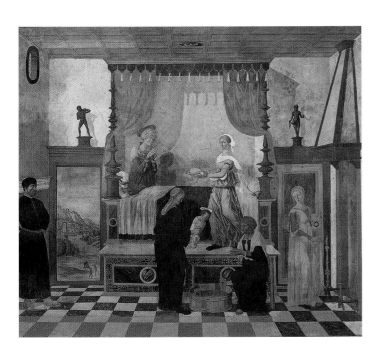

20.11 (*above*) Attr. Gian Antonio Corona, *The Birth of the Virgin*, fresco, Padua, *c.*1508 (Scuola del Carmine, Padua)

very often learned and intellectual professionals, for whom utensils such as inkstands were the daily tools of their occupation. Thus it is no coincidence that Padua, the city generally credited with the leading role in the development of the small bronze in early Renaissance Italy, had no princely court. Instead, as the home of one of Europe's oldest and greatest universities, the city was packed with doctors, teachers and scholars, the intellectuals for whom the small bronze seems to have held the greatest fascination and for whom, with their complex, often consciously learned iconography, many bronzes seem to have been tailor-made. Inkstands have come to be seen as almost symbolic of that crucially important reserved, private space for intellectual contemplation and endeavour, the Renaissance scholar's study.[18] Indeed it is difficult to imagine in any other context than a scholar's preserve delightful inkstands and sanders created from life casts of a variety of living creatures. Although we cannot be certain where such life-cast bronzes were made, the fascination with naturalism that they demonstrate is characteristic of much Paduan work in the early sixteenth century and reflects the interests of Paduan patrons, among whom were many physicians and scientists.[19]

The Paduan elites were equally fascinated by the classical world, which excited a more imaginative response on the part of artists and patrons alike. In 1504 the Neapolitan humanist Pomponius Gauricus (Pomponio Gaurico), writing in Padua, complained that sculptors were 'now so taken up with representing satyrs, hydras, chimeras and other monsters that they have never actually seen, that they give the impression there is nothing else to be sculpted'.[20] This statement should be seen in the context of the small humanist world in which Gauricus moved and for which he was writing his dialogue on sculpture

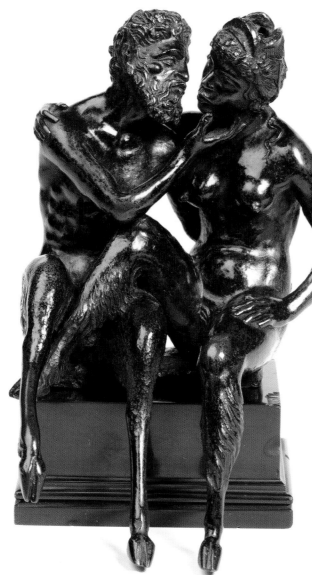

20.13 Riccio, *Satyr and Satyress*, Padua, *c*.1510–15 (cat.259) One of the most beautiful and intimate representations of a theme of perennial interest to Renaissance artists, Riccio's sculpture adds an extra dimension to the common topos of satyrs and satyresses as creatures enslaved by their base passions. The group, certainly conceived as a collector's piece, was probably originally mounted on a naturalistic bronze base, now lost.

De sculptura, so does not necessarily imply that such sculptures were made in vast numbers. Indeed, the bronze sculptor most indelibly associated with the Paduan bronze, Andrea Briosco (*c*.1470-1532), called 'il Riccio', seems on the evidence of his surviving autograph work to have made no more than a hundred or so independent small bronzes in the course of his career.[21] Several of these are indeed representations of satyrs. In the best of them, such as the *Satyr and Satyress* of *c*.1510-15 (plate 20.13), Riccio succeeds to a greater degree than almost any other single artist of the Renaissance in evoking a sense of human empathy with figures emblematic of the wild and savage side of paganism. Riccio's will is almost a pagan document in itself; exceptionally for the age, it contains not a single invocation of Divine Mercy,

and Riccio specified that he was to be buried outside the church of San Giovanni in Verdara, effectively in the space for non-Christians.[22]

Most of Riccio's bronzes were produced for a small circle of intellectuals associated with the University of Padua, who were Riccio's main patrons and with whom he appears to have been on intimate terms. One of these, the philosopher Giambattista de Leone, was responsible for securing for Riccio the commission for his masterpiece in bronze, the enormous *Paschal Candelabrum* made between 1507 and 1516 for the basilica of St Anthony of Padua.[23] Riccio's well-known oil lamp in the form of a stylized boat exemplifies the sophisticated intellectual milieu in which the artist and his patrons worked. Classicizing in form and subject matter, it nevertheless resembles no surviving lamp from the ancient world, the form of the boat in fact suggesting a Venetian war galley of *c*.1500. Its iconography is complex, one of the reliefs on the sides illustrating the theme 'ignorance is always opposed to virtue', with the rest of the decoration appearing to act as a commentary on this topos.[24] The iconographical programmes on bronzes such as this lamp are likely to have been essentially private affairs, often conceived between artist and patron and accessible only to a tiny circle of close intimates. Notwithstanding its sophisticated form, which implies it must have cost its first owner a great deal, this is a fully functional oil lamp.

Unlike his contemporary Severo Calzetta, Riccio seems to have made few functional bronzes, concentrating instead on reliefs and independent statuettes, among which the masterpiece is perhaps the so-called *Shouting Horseman* (plate 20.2).[25] Just as Riccio's oil lamp alludes to contemporary Venetian maritime power, the *Shouting Horseman* shows Riccio observing at first hand the Venetian Republic's *stradiot*, or light mobile cavalry, whose headquarters were in Padua. At the same time the rider and his horse show equal awareness of classical prototypes, so are emphatically not merely contemporary figures. In its naturalism allied to knowledge of classical literary sources, *The Shouting Horseman* reflects remarkably closely Riccio's friend Pomponius Gauricus's discussion of equestrian sculpture.[26] As such, it is a rare case in which an identifiable surviving bronze can be placed more fully in its contemporary context.

Riccio's work spawned many imitators. One foundry in particular seems to have specialized in functional bronzes utilizing Riccio's imagery and may even have inherited his workshop models after his death in 1532. This may have been the workshop of Desiderio da Firenze, a mysterious figure active in Padua and Venice in the 1530s and 1540s, whose most important documented work is a large bronze, the *Voting Urn*, made for the Council of the Commune of Padua in 1532-3.[27] The most spectacular work in this group of functional bronzes is a large perfume burner of cylindrical shape, profusely decorated and surmounted by a figure of a reclining satyr

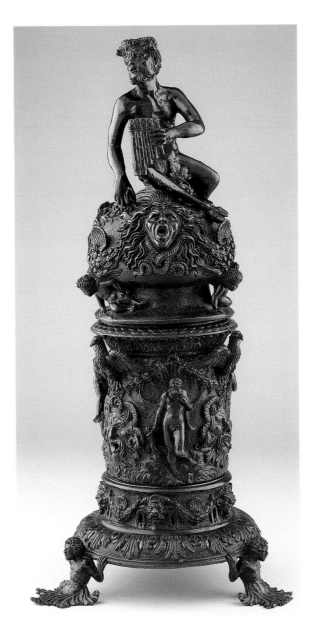

holding pan pipes (plate 20.14). Like the British Museum aeolipile (plate 20.8), the perfume burner was originally partly gilded, so its decorative features would have stood out with even greater intensity. It consists of three separate parts, held together by bayonet fittings; in the bottom section charcoal was burnt, and this activated scent and smoke from the pastilles, which were placed on a perforated grille at the bottom of the central drum section. Sweet-smelling smoke then issued from various apertures in the central and upper sections, the circular shape ensuring that the scent emanated in as many directions as possible.

Smells, in both their positive and more negative connotations, played a more important part in people's consciousness than they do today. In the sixteenth century they were thought to be material – food odours, for example, were regarded as not just appetising but actually nourishing.[28] Foul odours were considered to be carriers of disease, but at the same time it was believed that disease could be kept at bay by sweet smells (see pp.184-6). By no means all scent had to be burnt; the botanist Pietro Andrea Mattioli described in 1539 how the Torre Aquila in the Castello del Buonconsiglio in Trent, at this time fitted up as a place to receive ladies, was sweetened by the scents of musk, amber, orange-flower water and civet, all issuing from various perfume containers and burners (*profumiere*).[29] Of these substances, only amber had to be burnt to release its scent. *Profumiere* in bronze came in various shapes and sizes, the burner in plate 20.14 being one of a small group of large, exceptionally grand vessels. Despite the fact that such bronzes must have been immensely costly, not a single contemporary inventory reference to this type of large burner has yet been identified. It demonstrates how vitally important it is, when considering the place of bronzes in the Renaissance interior, to study not simply documentary and pictorial records but also the surviving art objects themselves.

20.14 Attr. Desiderio da Firenze, perfume burner, Padua, *c*.1540–50 (cat.250)

Its circular shape suggests this magnificent perfume burner might have stood in the middle of a room, where it would have had the maximum effect, with wreaths of scented smoke swirling out through carefully positioned holes.

SPLENDOUR

JAMES LINDOW

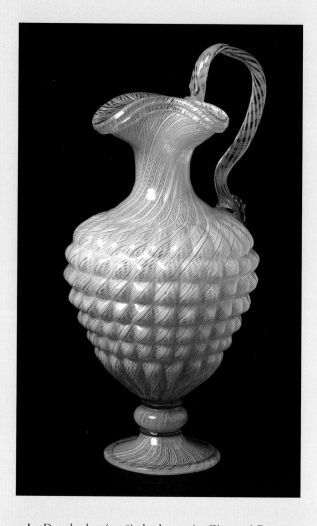

During the Renaissance the terms 'splendour' (*splendor*) and 'magnificence' (*magnificentia*) were both perceived as virtues sharing the common attributes of expenditure on a grand scale. Their definitions were taken from the writers of antiquity: magnificence became intrinsically connected to the art of building, while splendour was interpreted as a desirable quality governing appropriate domestic expenditure and display. The classical usage of the term splendour derived from the verb *splendeo*, meaning 'to shine, be bright' or 'to gleam', and had appeared in the prose of Cicero and others to praise the 'polished' or 'splendid' character of individuals or classes of citizens, as well as define a particular style of living synonymous with magnificence.[1]

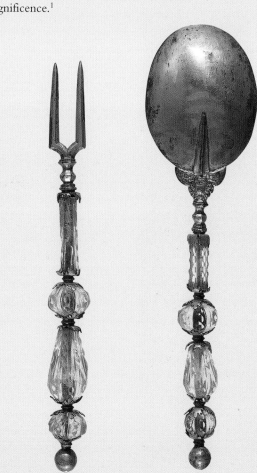

In *De splendore* (1498) the humanist Giovanni Pontano, writing at the Neapolitan court, focused his discussion of the term splendour on the interiors and furnishings of the private house, defining it as a virtue related to, but separate from, magnificence.[2] For Pontano splendour represented an entirely appropriate extension of magnificence into the domestic interior. In his discussion of the domestic objects suitable for the splendid man, Pontano created two principal categories: household furnishings (*supelectiles*) and ornamental objects (*ornamenta*). Whereas furnishings were defined as 'all domestic objects, such as vases, plates, linen, beds and other objects of this category, without which it would not be possible to live comfortably', ornamental

20.15 (*left*) Silver and rock crystal knife, fork and spoon, Venice, 16th century (cat.76)

20.16 (*above*) Filigree glass ewer, Venice, 1550–1600 (cat.77)

objects were broadly characterized as 'seals, paintings, tapestries, divans, ivory seats, cloth woven with gems, cases and caskets variously painted in the Arabic manner, little vases of crystal and other things of this type'.[3] In broad terms, the discussion of displaying furnishings and decorative goods within the interior in a decorous manner encompassed the suitability of specific domestic objects for particular rooms as well as the manner in which they were to be displayed (plate 20.15).

The sensory impact of the Renaissance interior was achieved by the inclusion of diverse materials, colours and textures, ranging from the tactile qualities of tapestries, hangings and fabrics to the fragility of glass and ceramics (plates 20.16 and 20.17), and from the aromas of woods and incense to the visual intensity and gem-like quality of coloured glassware. The shine, polish and luminosity of furnishings and ornamental goods accorded closely with the classical definition of splendour (plate 20.18).[4]

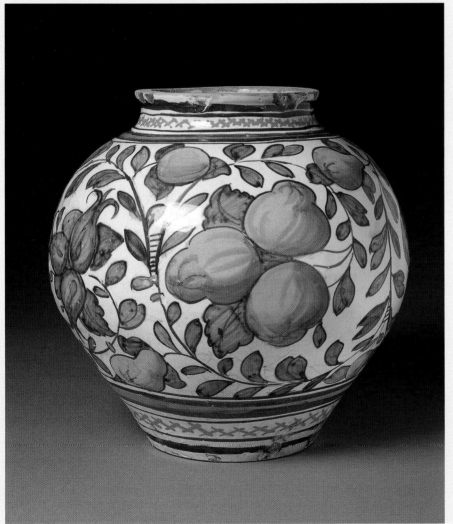

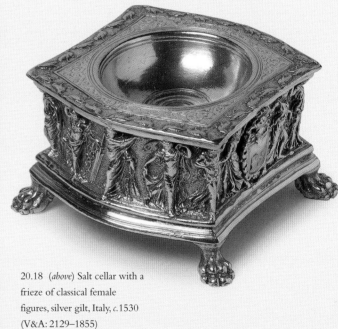

20.18 (*above*) Salt cellar with a frieze of classical female figures, silver gilt, Italy, *c.*1530 (V&A: 2129–1855)

20.17 Jar with depictions of fruits, nuts and pods, Venice, mid-16th century (cat.262)

MIDDLE-EASTERN OBJECTS

ANNA CONTADINI

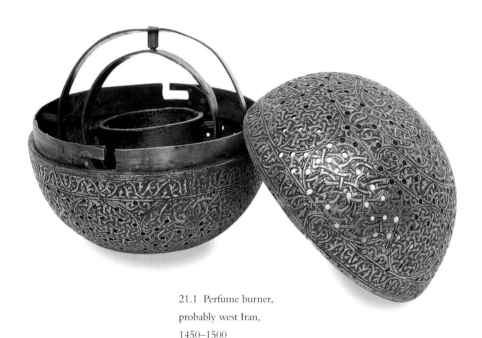

21.1 Perfume burner,
probably west Iran,
1450–1500
(cat.195)

APPRECIATION OF ISLAMIC ARTEFACTS in Italy began during the medieval period, as is abundantly demonstrated by gifts made to the Church now held in religious treasuries. This pattern of acquisition was continued and developed during the period 1400-1600, with maritime republics providing one of the main routes for the activity. Middle-Eastern influences were thus transmitted not only through Sicily and southern Italy but also through Genoa, Pisa, Lucca, Siena, Florence, Amalfi and, of course, Venice. We know from documents in the Venetian archives that one of the biggest yearly expenses of the republic from the thirteenth century was the import of precious textiles from the Middle East. Carpets were to remain staples, but the trade in textiles, glass, ceramics and metalwork was also significant, despite market fluctuations.

Trade with the Near East was first conducted mainly with the major cities in Egypt and Syria, which were ruled by the Mamluks – the terms 'damask' (from Damascus) and 'muslin' (from Mosul) bear witness to this connection. But under the Mamluks' successors, the Ottomans, Anatolian centres of production came to the fore, and after 1453 the newly dominant position of Ottoman Constantinople attracted a strong Venetian, Florentine and Genoese mercantile presence. An alternative early source was Mongol-controlled Persia, where the Florentines and the Sienese were active by the end of the thirteenth century, with contacts continuing until the early fifteenth century. The result was a massive import of textiles, especially silks, from China and Turkestan – the 'Tartar and Turkish cloths' mentioned by Dante.[1]

Imported Islamic wares reflected the flourishing mercantile activities that lay behind so much of Italy's success in this period. Moreover, they were luxury commodities affordable only by the upper strata of society. They were therefore markers of economic status, but they also indicated aesthetic discernment, for both their 'exotic' appearance

and the superlative quality of their workmanship revealed the refined taste of their owners. The admiration they inspired provoked Islamicizing tendencies within Italian art itself, as well as the production of local imitations. It is possible to distinguish partially overlapping phases of acquisition, assimilation and imitation in this process and, through the diffusion of decorative motifs and techniques of production, trace the ways in which Islamic artefacts enriched the material culture and aesthetic horizons of Renaissance Italy. Consequently, we are able to understand something of how they were perceived within the context of the Italian Renaissance interior.

Islamic artefacts could be purely decorative, display pieces designed to impress and convey status as well as give pleasure. But they were often functional at the same time, serving, for example, to make fashionable and expensive clothing, or being used as ostentatious utensils at banquets. They also served other, more intimate functions in the house, finding their place in the bedroom or in the *studiolo*, where they might even give practical aid to the attempts of a humanist scholar to grapple with the religious and cultural environment from which they originated. It is important to note that engagement with the Islamic Middle East was by no means confined to trade, diplomacy or conflict: it also included an intellectual aspect. The printing press gave a new impetus to the dissemination of knowledge, with an Arabic font being created in Venice to produce both religious and scientific texts. The need for more accurate translations was felt, the first Arabic grammars appeared and, along with Hebrew, Arabic was viewed as a desirable addition to the university syllabus. Alongside classical texts, new Latin editions were printed of works such as Avicenna's *Canon* on medicine, indispensable to the library of a humanist scholar.

METALWORK

The complexity of artistic interaction between Italy and the Middle East is well illustrated by the numerous brass vessels, inlaid with silver and, less frequently, with gold and a black organic compound, that are traditionally dubbed 'Veneto-Saracenic'. Stylistically and technically,[2] the ornamentation of these objects is Islamic, and certain pieces bear the signatures of Muslim craftsmen. Yet many are European in form, their decoration frequently includes Western coats of arms,[3] and the vast majority are found in European – and in particular Italian – collections. It has been suggested, in fact, that they were made in Italy, first by refugees from the defeated crusader kingdoms and later by Muslim craftsmen in Venice (whence the term 'Veneto-Saracenic').[4] But there is no documentary evidence to support the 'Veneto-Saracenic' hypothesis, and it has been largely abandoned.[5] That fine inlaid metalwork was imported from the Levant is noted by Vasari,[6] and it is now generally agreed that these pieces date from the second half of the fifteenth and the early sixteenth century and, European imitations excepted, were made in the Islamic world for the Western market.[7]

They do not, however, form a unified group, and there is uncertainty as to their provenance. They can be divided into three types.[8] One comprises metalwork produced in the closing decades of the Mamluk Empire, which fell to the Ottomans in 1517. These pieces are decorated in a recognizably Mamluk manner, with a preponderance of geometric interlace in the inlay work, but are distinguished by the absence of inscriptions and, often, by a distinctly European shape.[9]

One such piece is the perfume burner in plate 21.1.[10] Europe imported many such spheres, generally inlaid in the Veneto-Saracenic style. In the Islamic world, as in China where they originated, they were used for burning incense,[11] and two that belonged to the Medici (both today in the Bargello) are listed in an inventory of 1553 as 'profumieri damasceni'.[12] But if some retained this function,[13] others were employed as hand warmers, by clerics during Mass and by wealthy laypeople in the home:[14] two merchants from Prato and Pistoia, who were in Avignon in 1360, are recorded in an inventory as owning 'one sphere of gilded silver for warming the hands'.[15] When used as perfume burners they were sometimes hung, as in the 1532 portrait of Georg Gisze by Holbein which shows one of the larger spheres hanging by a chain from a hook on a shelf of the gentleman's study. The two Bargello spheres also have a chain,[16] and further visual evidence of these objects being hung from the ceiling can be found in Persian miniatures.[17]

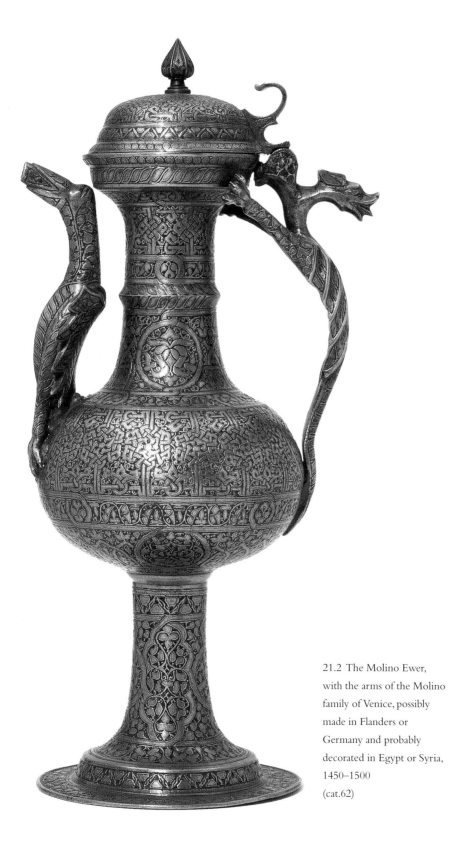

21.2 The Molino Ewer,
with the arms of the Molino
family of Venice, possibly
made in Flanders or
Germany and probably
decorated in Egypt or Syria,
1450–1500

(cat.62)

The example in plate 21.1 is of standard construc-
tion, with two brass hemispheres pierced with small
round holes and decorated with engraving and inlay.
Housed within is a receptacle mounted in a gimbal
device to keep it level and prevent spillage, even if
the ball was rolled. The sphere was thus also some-
thing of a mechanical curiosity, and as such would
have held considerable appeal. Although portable,
it would probably have been kept in the *camera* or
studiolo, where it could be appreciated at close range.

Another splendid, if enigmatic, vessel belonging to
this group is the so-called Molino Ewer (plate 21.2).[18]
Executed by means of engraving and inlays of silver
and a black compound, the Mamluk design of its
decoration comprises a profusion of geometric
interlace and vegetal scrollwork. Notable features
are the broad register of interlace circumscribing the
globular body that is rendered as a pseudo-inscrip-
tion (derived from the early Arabic script known as
Kufic), and the two roundels with inverted lotus
blossoms on the neck. But particularly remarkable
is a medallion on the lid bearing the coat of arms
of the Molino, a patrician Venetian family that had
mercantile links with the Levant.[19] What, then, is
to be made of its shape, which is that of a type pro-
duced in Germany and Flanders during the second
half of the fifteenth century?[20] We know that
Middle-Eastern craftsmen could imitate occidental
shapes, as demonstrated by an Iranian candlestick
mentioned below,[21] but the likely explanation is that
the ewer is a vessel of North European manufacture
ornamented by Islamic craftsmen for a Western
market,[22] and many Veneto-Saracenic pieces may
likewise have been European-produced brasses sent
to the East to be decorated.[23] A similarly shaped
ewer in Naples has a blank shield on its neck,[24] sug-
gesting a trade in stock products to be customized
on their arrival in (or return to) Europe.

Regarding function, two main possibilities – both
connected to the *sala* – suggest themselves: to pour
drink[25] or to pour water in the elaborate hand-
washing practice that took place before and after
dining,[26] interestingly mirroring a similar type of
ablution ritual in the Islamic world.[27] In his descrip-
tion of a rich gentleman's villa written between 1460
and 1464, the architect Filarete details this ceremony
with six servants 'who looked like angels', each 'with
a silver basin in one hand' and 'a ewer filled

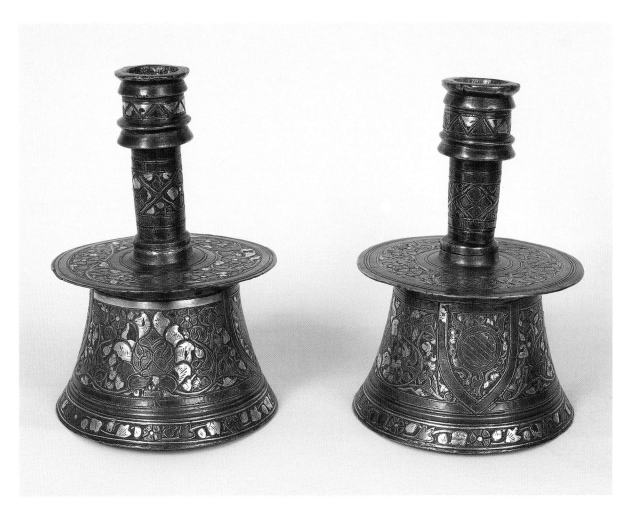

21.3 Candlesticks with the arms of the Contarini family of Venice, brass, engraved and inlaid with gold and silver, Egypt or Syria, early 15th century (Museo Correr, Venice CIXII nn. 22, 23)

with water in the other',[28] dextrously pouring the liquid over the diners' hands and into the basins beneath; and the 1474 inventory of the trousseau of Caterina Pico, daughter of the Lord of Mirandola, records 'four brass basins with accompanying ewers [commonly dubbed *bronzini*] bearing in their centre silver coats of arms painted in enamel'.[29] The Molino Ewer is certainly too richly ornamented to have been a workaday object: it was probably proudly exhibited on a *credenza* (sideboard)[30] and only employed during grand banquets for its ostentatious display of the Molino coat of arms.

Also belonging to this group is a pair of mid-sixteenth-century Mamluk-produced candlesticks which were in the possession of another leading Venetian family (plate 21.3).[31] They have a short stem and a bell-shaped base carrying a flat drip-tray, and are decorated in a typically Mamluk manner with vegetal, floral and geometric designs. The base bears a shield of European shape that frames a

roundel containing diagonal stripes, the Contarini coat of arms.

Candlesticks of this type could have been used anywhere in the home, but paintings of religious scenes with contemporary domestic settings suggest that they were particularly favoured in the *camera*. Many examples of the Annunciation and the Birth of the Virgin include a candlestick – often of Islamic shape – placed on a shelf, mantelpiece or even headboard.[32] Another common context appears to have been the *studiolo*, as illustrated by numerous pictures of scholar-saints in their studies.[33] A calligrapher's *studiolo* represented in a Venetian woodcut published in 1525 includes just such a candlestick,[34] which with its single, small flame would have been well suited to the more confined spaces of the home. On the other hand, the Contarini pieces, being a pair and ornamented with the family's arms, might well have been intended for display in the more public areas.

The second group in the 'Veneto-Saracenic' cate-gory is typified by the use of silver wire inlays to create an expansive curvilinear network of medal-lions and scrolls. The effect is somewhat freer, for whereas the surfaces of the Mamluk pieces are divided into distinct zones, the patterns of this group are not as rigidly organized. Their fluidity and the minute detail of the decorative elements strongly recall Iranian metalwork of the late fifteeenth and early sixteenth century, which remains the most convincing attribution. However, certain features of form and decoration serve to distinguish them from mainstream Persian production and suggest that they

may have been designed for export, possibly with Western sensibilities in mind.[35]

Among this second group are the famous pieces signed by Mahmud al-Kurdi ('the Kurd') and Zayn al-Din,[36] including a large bucket in the V&A produced by the latter master.[37] Made of brass intri-cately inlaid with silver and engraved, its walls are straight and almost perpendicular, curving at the bottom to form a flat base. A semicircular handle, the greater part of which is modelled as two serpents, rises from the walls of the bucket by means of two brackets, the inner faces of which are inscribed with the signature of Zayn al-Din. We know that buckets

21.4 Salver, probably western Iran, late 15th to early 16th century (cat.61)

21.5 Pair of candlesticks, Italy (probably Venice), mid-16th century (cat.135)

of such form were used in the West as washbasins,[38] and it is not unlikely that this piece was exported to Europe and used in such a capacity.

Another impressive piece belonging to this group is a large salver (late fifteenth/early sixteenth century; plate 21.4).[39] Made of engraved and inlaid brass, it is shallow, with a wide, splayed rim. The inlay work is of silver and a black compound, and may originally have included gold. The striking focal point of the design is a central circular medallion containing a European coat of arms, in this case unidentified. From it radiates a rich network of lobed, scrolling and intertwining vegetal stems, rendered in silver against a ground of minute arabesques; the complexity and detail of the pattern make this dish an especially fine example. Such dishes could be used in several different ways and contexts. Some have a form with a central depression that appears to have been favoured for liturgical use in the Mass.[40] However, the piece illustrated, with its flat base and shield, belonged to the secular sphere and most probably to the *sala*, where it would have been exhibited on a *credenza* and employed for serving food during banquets or, once again, as part of the hand-washing ritual. As this custom

was largely for display, the amount of liquid poured was small and, as demonstrated by paintings of the period, would have posed no problem for a shallow dish.[41]

The third group comprises European imitations, which, because of their stylistic fidelity, may not have been previously distinguished from Islamic pieces. Aesthetically, they differ in having a more clearly compartmentalized organization of the decoration,[42] and technically by never being inlaid with the black organic compound.[43] A fine example is the pair of early fifteenth-century brass candlesticks in plate 21.5,[44] engraved and inlaid with silver. With a baluster stem that rests on a drip-tray carried on a broad and bulbous foot, the shape appears to have been developed in Renaissance Italy[45] and may be related to a type of Cinquecento Venetian wine-glass.[46] Its Italianate form does not preclude it from having been decorated or even manufactured in the Middle East, but a Western origin is confirmed by the ornamentation that is palpably different from that on Islamic metalwork: the lines appear comparatively disjointed, and the patterns they describe have a decidedly *all'antica* feel to them. Nevertheless, these candlesticks clearly strive towards a Middle-Eastern

typology and provide evidence of the prestige and desirability of Eastern metalwork in Renaissance Italy. Also in the V&A is a remarkable west Iranian candlestick of analogous form dating from the late sixteenth or early seventeenth century. Evidently copied from an Italian model, it demonstrates that stylistic transfer could be a two-way process.[47]

As well as producing imitations, Italian metalworkers responded creatively to Middle-Eastern types. Take, for instance, the sixteenth-century gilt brass object here described as a perfume burner but elsewhere considered to be a lamp (plate 21.6).[48]

Conceived as a *tholos* (a classical temple of circular plan), it has a cylindrical body marked by *all'antica* pilasters and a domed lid resting on an architrave-like moulding. Three lion-paw-shaped legs support this little temple, which is profusely decorated with relief work against a polychrome enamelled ground, with areas of filigree openwork between the pilasters and on the lid. Some of the ornamentation – particularly that on the pilasters and architrave – accords with the shape of the burner and is similarly classical, but the greater part is Islamic in derivation: the relief of arabesques on the lid, the panels between the pilasters, and the web of openwork formed by piercing the ground, are typically Islamic. What is remarkable is that these elements have been integrated with an otherwise classical idiom with surprisingly happy results, largely because the Islamic arabesque is not too far removed in nature from the scrollwork of antiquity. Objects of this type were evidently popular in Renaissance Italy, as several

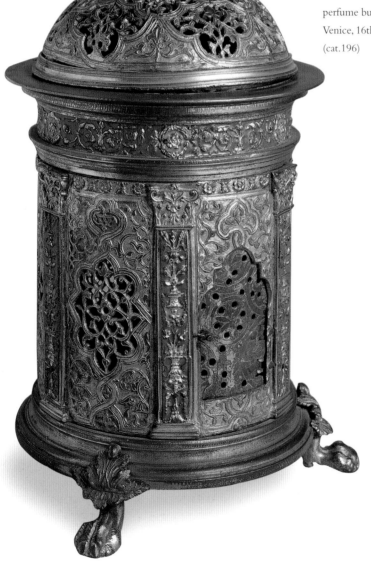

21.6 Domed perfume burner, Venice, 16th century (cat.196)

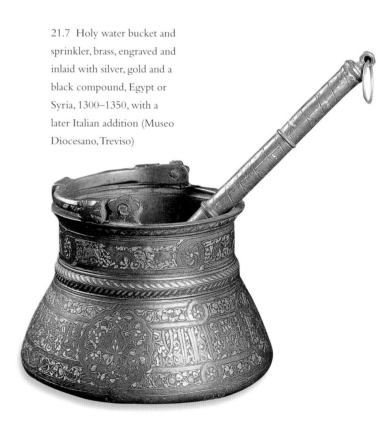

21.7 Holy water bucket and sprinkler, brass, engraved and inlaid with silver, gold and a black compound, Egypt or Syria, 1300–1350, with a later Italian addition (Museo Diocesano, Treviso)

survive, almost all with Islamicizing decoration.[49] They may most probably be ascribed to sixteenth-century Venice, where the Islamic influence in metal-work was at its most pronounced. Three are almost identical to this burner and were probably made in the same workshop.[50]

The function of these objects is disputed. Some scholars consider them night lamps – that is to say, a sort of bedside light, and with its limited open-work our example could have provided a suitably subdued light. But it would have been equally apt for diffusing sweet fragrances, and the likelihood that it was used in this capacity is strengthened by its correspondence to a variety of Islamic incense burners that also took the form of a domed cylindrical vessel on three lions' feet. Examples of this type – which was first made in Mosul in the early thirteenth century, with production continuing in Syria in the fourteenth and fifteenth centuries[51] – must surely have made their way to Italy, and may have served as inspiration.

A particularly interesting case of re-use is the transformation of an extraordinary Mamluk brass bucket, with silver and gold inlay, into a vessel for holy water to which was later added a sprinkler (plate 21.7). It can be dated to the first half of the fourteenth century and, according to the diocesan inventories, was already in Treviso in 1592.[52] The overall shape of the vessel, including the handle, presumably original, is almost identical to another bucket now in the Correr Museum in Venice.[53] Although much of the inlay is lost, it is in very good condition and is richly decorated on all surfaces, including the outer base, with six wonderful flying phoenixes, while the inner base has a decoration of vegetal motifs and rosettes. The secular decorative scheme includes a band of running animals and a predatory bird attacking a duck, with a poetic inscription in the middle band of the body. Conversion to sacred use may have taken place in the home, before its transfer to the church, and an indication of how it might have been used, in particular in the devotional context of the *camera*, comes from a painting by Carpaccio, *The Dream of St Ursula*, of 1490–95 (see plate 14.3): beside her bed is a religious image and, hanging from the bottom of its frame, a bucket of almost identical shape to the one in Treviso, with a handle and sprinkler.[54]

CARPETS

We know from the Venetian archives that precious textiles from the Middle East were one of the Republic's biggest yearly expenses from the thirteenth century and that the most popular type of import was the knotted carpet. Carpet-making was extensively cultivated in the Muslim world, and the West eagerly consumed its products.[55] The trade dates back at least to the fourteenth century,[56] and although demand sometimes exceeded supply Western merchants were generally able to ensure a steady flow. Venetian merchants were in the vanguard of this enterprise, and they may even have been involved in carpet production, for we know of at least one case of a sixteenth-century Venetian trader resident in Egypt, Francesco da Priuli, who sponsored looms and oversaw their output.[57] Most imported carpets came from Turkey, some from Egypt, but few before the seventeenth century from Iran, which was less accessible than the Levantine regions.[58] Venice and the other Italian states dominated trade throughout the Renaissance, but from the sixteenth century onwards they faced increasing competition from north European – and particularly Dutch – merchants.[59]

The popularity of Eastern carpets is attested by the frequency with which they are depicted in Renaissance paintings.[60] These show the various ways in which they were employed, and have provided scholars with invaluable evidence for dating surviving examples. In the Islamic world carpets were generally intended for the floor, but in Europe they had several other functions besides: as chest covers, as items of display hung from windowsills, and, notably, as luxurious tablecloths.[61] Here visual evidence is corroborated by contemporary inventories, which refer far more often to 'carpets for writing desks' and 'tables' than to 'carpets for floors'.[62] These various uses – which quite literally elevated the carpet from its position as a floor covering – reflected the high status given to rugs in the ornamentation of the Renaissance interior.

Among the most common imported varieties is a group commonly dubbed 'Lotto' carpets.[63] But Lorenzo Lotto was neither the first nor the only artist to represent such carpets: from the beginning of the sixteenth century to the middle of the seventeenth there are at least a hundred depictions,[64] suggesting a lengthy period of popularity peaking in

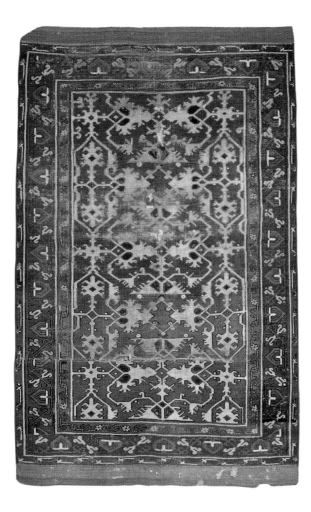

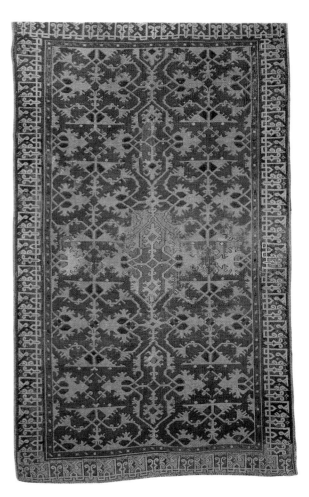

21.8 (*right*) Lotto carpet, western Turkey (probably Ushak), 16th–17th century (cat.137)

21.9 (*far right*) Lotto carpet, hand-knotted woollen pile on a woollen warp and weft, western Turkey (probably Ushak), probably 1500–1550 (V&A: 904–1897)

the second quarter of the sixteenth century.[65] In technique and appearance these woollen carpets are unmistakably Turkish, and there is general agreement that most if not all were made in and around the west Anatolian town of Ushak, whence they could be exported through Izmir on the Aegean coast.[66] Like most other categories of Turkish carpet, the Lotto carpets are strikingly conservative in design: the main fields seldom vary much, and it is apparent that the weavers used cartoons from which to repeat patterns.[67]

Two of the three Lotto carpets in the V&A (plates 21.8 and 21.9) are known to have been purchased in Italy, while the third is also probably of Italian provenance.[68] Typically, they have main fields decorated with variants of the same design, based essentially on the alternation of staggered rows of hexagonal and cross-shaped forms. Also standard is yellow on a red ground, with blue used sparingly as an accent colour.[69] Greater variation occurs in the decorative borders, as these three examples demonstrate. Two are

edged with interlace ultimately derived from Kufic, an early Arabic script, indicating that they probably date from the first half of the sixteenth century, while the stylized foliate meander of the border of the third points to a slightly later date.[70] Geometric patterns were also common to other kinds of Turkish carpet, in particular the 'Small Pattern Holbeins', which characteristically have a pattern of small octagons alternating with crosses, both surrounded by angular interlacing ornament. Named after Hans Holbein, who depicted this type in his paintings, they appear a half-century or so before the Lottos, which are commonly presumed to be a later variant.[71]

European buyers appear to have been generally happy with stock products,[72] but there are cases of works being customized for the European market, often in response to individual commissions. For example, a letter to Lorenzo de' Medici about a table carpet, dated 28 March 1473, and the 1492 list of carpets that he owned, provide evidence of Medici commissions.[73] Adaptations of this nature seem to

have occurred more commonly in another group of carpets, extensively imported to Italy. Most are of wool and are distinguished by colouring, technical characteristics, and superlative quality. They share a limited but rich palette, consisting primarily of deep red, blue and green.

There are two contrasting styles within this category, the first characterized by the use of kaleidoscopic geometric designs.[74] Some of these have Mamluk blazons,[75] but their place of production remains a subject of controversy. Because Italian inventories up to the sixteenth century mainly distinguish between carpets from Turkey and carpets from Damascus,[76] it was once thought that they were produced in Damascus, but there is hardly any supporting evidence.[77] Cairo, however, is documented as a site of carpet manufacture from as early as the fourteenth century, and most scholars now agree on this city as the source.[78]

Technically indistinguishable from the first, the second type follows the quite different Ottoman floral tradition. It is largely agreed that these carpets

were also produced in Cairo, the shift in style being the result of the conquest of Egypt by the Ottomans in 1517.[79] Supporting this view is the discovery in 1983 of two grand carpets in the storeroom of the Pitti Palace, one in the geometric Mamluk style, the other in the Ottoman floral mode, but both described in Medici inventories as 'Cairino' carpets.[80]

A remarkable cruciform carpet, woven in a single piece, can also be assigned to Ottoman Cairo (plate 21.10).[81] Decoratively, its surface is divided by bands into a large central square from which emanate four rectangular flaps. The main elements of the design stand out in yellow, while the secondary motifs are in more muted shades of green and blue; the ground is a rich red. Stylistically Ottoman, its decoration draws on the vocabulary of Iznik pottery and tile work of the second half of the sixteenth century, to which period it can accordingly be attributed. Furthermore, its ornamentation resembles that of another, rectangular example in the Bardini Collection, which is also thought to have been produced in Ottoman Cairo.[82]

21.10 Table carpet, probably Cairo, mid-16th century (cat.233)

The makers of these carpets were aware of European taste and adapted their output accordingly.[83] Although the V&A carpet was thought to have been a canopy for use in processions when it was bought in 1883, its cruciform shape – known also from another example in San Gimignano[84] and a fragment in Berlin,[85] both likewise Cairene – indicates that it was intended as a cover for a small square table, a use quite alien to the Islamic world but common in the West.[86] It was with the same purpose in mind that the Cairene ateliers also produced square and circular rugs.[87] With its Cairene technique, Turkish ornamentation and European purpose, the cruciform carpet represents a striking convergence of cultural forces, demonstrating the thirst of Europeans for Eastern carpets and the eagerness of Islamic craftsmen to supply their needs.

21.11 *Nihale* (floor covering), cut and voided velvet, compound satin and velvet, Turkey, late 16th or early 17th century (Detroit Institute of Art, 48.137)

FABRICS

Islamic woven silk fabrics, too, were traded westwards, although with a far more limited impact. Ottoman Turkey, once again, was the main source,[88] production being centred on the west Anatolian town of Bursa, which was also an entrepôt for raw silk from Iran.[89] Italian merchants traded there throughout the fifteenth and sixteenth centuries, purchasing raw silk for the thriving Italian weaving industries, particularly in Venice, Florence and Genoa.[90] Because of the increasing output of these local manufactories, demand in Italy for worked silk from the Middle East dwindled.[91] Thus although Ottoman fabrics were exported in large numbers to Eastern Europe and Russia,[92] comparatively few came to Italy, while Italy itself was a major supplier of silk fabrics to the Ottoman court and upper strata.[93] Many of these Italian fabrics had a distinctly Western appearance, but there was frequent reliance on Ottoman models, even down to loom width. These imitative textiles were once thought to indicate the popularity of Ottoman fabrics in Italy, but it is now agreed that they were made chiefly for export to Turkey rather than for domestic consumption.[94] A wonderful example is a sixteenth-century velvet in the Bargello Museum which, although Ottoman in style, seems to have been produced in Italy, possibly Venice.[95]

In a further twist, Ottoman weavers began making copies and adaptations of fashionable Italian fabrics.[96] It was the great demand in Turkey for Italian patterned silk velvets that probably prompted the establishment of velvet-weaving looms in Bursa about the middle of the fifteenth century, and in Istanbul a century later.[97] Some of the pieces they produced are so close to their Italian counterparts as to be stylistically indistinguishable, and only on technical grounds can they be tentatively identified as Turkish.[98]

If not of quite the same standard as their Italian counterparts, which were twice as expensive on the Ottoman market,[99] the Bursa and Istanbul velvets – or *kadife* – were of fine quality and much admired. The industry quickly developed its own characteristic style and excelled in the production of *çatma*: velvets brocaded with silver or gold thread.[100] Although few were imported, these Ottoman velvets were also esteemed in Italy. One famous example is

the floor covering (*nihale*) produced in the late sixteenth or early seventeenth century that was for many years a prized element in the furnishing of the Villa Doria Pamphilj, Rome (plate 21.11).[101] It is known that Ottoman fabric traders were allowed to settle in Venice[102] and that Italian merchants imported Turkish silks.[103] Indeed, the influx of Levantine brocades was substantial enough to cause the Venetian Signoria to place embargoes on their importation.[104]

As well as floor coverings, such fabrics would have been used for the tailoring of costumes and for upholstery, their main functions in Turkey.[105] In 1501 Giovanni Maringhi, resident in the Istanbul mercantile quarter of Pera, reported to his patron in Florence that he had ordered in Bursa four dress lengths of a kind that he had previously sent,[106] indicating a sustained interest in such materials.

GILDED LEATHER SHIELDS

The decorative patterns of the three shields in plates 21.12, 21.13 and 21.14 are extremely close to the Turkish style. Indeed, if one did not know that Islamic shields use different materials, have a different shape and are not normally dressed in leather, it would be difficult at first glance to recognize that they are European imitations produced in Venice.[107] They belong to a collection of twenty-three gilded leather shields (oval and convex) and bucklers (small round shields with a buckle, i.e. a central conical, metallic point) in the armoury of the Palazzo Ducale in Venice. Similar pieces are held in various museums and private collections all over the world, some bearing the coats of arms of aristocratic Venetian families. A particularly important set comprising twenty shields was ordered from Venice by Wolf Dietrich von Raitenau, the Archbishop of Salzburg from 1587 to 1611, for his horsemen,[108] and as the three shown here are virtually identical to them in decoration and technique, it is likely that they are contemporary, a dating further supported by similarities to Islamic examples of the period.

They were produced by the technique used for wall hangings made of gilded leather, called *cuoridoro* (the Venetian dialectal equivalent of *cuoi d'oro*, golden leathers). During the sixteenth century there were over seventy *cuoridoro* workshops, but wall leathers went slowly out of fashion and by 1760 only seven

remained.[109] Trade patterns were complex, with skins and gold coming from different oriental and Western regions, and the import of both crude and tanned leathers was one of the major expenses of the Venetian Republic.[110] But once decorated, the finished product might be re-exported: in 1569 an order was placed by Ibrahim Bey, who had been impressed by a previous batch of Venetian gilded leathers.[111]

The production process of the shields was quite complex. The base frame consisted of horizontally and vertically overlapping curved thin laths of wood. The thin leather mostly had a relief decoration, but sometimes the pattern was painted on a flat background. The skin was divided into six triangles so as to be easily stretched and stuck onto the round surface. A thin layer of glue was then applied, onto which the silver or the pure gold leaf was stuck, gold always being used on the central medallion. This and the lateral medallions were separately decorated pieces of leather glued over the leather background. The gold or silver leaf was subsequently coated with coloured transparent varnishes, mostly red, but also green and blue, which are brightened by the gold or the silver underneath. These varnishes, sometimes together with opaque tints, were laid on the empty spaces among the relief decorations, functioning as a multicoloured background. The relief design was underlined by various coloured tints (which unfortunately in most cases have disappeared), and contoured and highlighted freehand with liquid gold. The entire surface was then given a final thin preservative coat of colourless varnish. The same technique is adopted in a number of Venetian bookbindings, some of them in Islamic style, which clearly must have been produced in the same *cuoridoro* workshops.[112]

The pattern is usually of a central round medallion with twelve points, surrounded by a sunburst decoration of six oval medallions, repeated and interrupted on the border. The field has a multitude of interlaced scrolls, leaves and small flowers with five petals. There is an evident parallel with contemporary medallion carpets, as in the central decoration of the famous Ardabil carpet in the V&A, dated 1539.[113] A few shields have peony medallions, another decorative element commonly employed in the Islamic world. This appears on one of the three shields

(plate 21.12), which also shows another common motif in Islamic art: the so-called 'cloud pattern'. Again, this decoration is used in a way very similar to that found on Turkish and Persian carpets of the same period.

Apart from their splendid decoration, two of these shields show the initials and coat of arms of well-known Venetian families. One (plate 21.13) has a central medallion with St Mark's lion and the initials 'A C', making it very likely that it belonged to the Contarini family, owners of the pair of Veneto-Saracenic candlesticks (plate 21.3). The other (plate 21.14) has the coat of arms (with black lozenges) of the Foscarini family, and the initials 'A F'. Both families were major powers within the republic's oligarchy, contributing also – significantly in the context of the shields – to its military endeavours. For example, the likely owner of the Foscarini shield, Antonio Foscarini (1570-1622), was *capitano da mar*, Venice's Admiral of the Fleet and, as such, an important figure in the struggle against the Ottomans.

21.12 Gilded leather shield, leather on a wooden frame with gold and silver leaf, coloured varnishes and liquid gold, Venice, 1550–1600 (Ameria del Palazzo Ducale, Venice, Inv. J20)

Both shields are fully worthy of such illustrious owners. The medallions are remarkable for their internal decoration in relief, obtained by punching the reverse of the skin. Little flowers are part of the decoration, and the background is covered by little gold dots grouped in threes, another typical Islamic decorative element, found in bookbindings and also in miniature paintings, where it is used to represent stars in the sky.

Only the most important and noble personages in the Venetian army possessed shields with their own coats of arms and even initials. These were objects of display rather than practical tools of warfare, paraded on special occasions and exhibited in the home as symbols of power. Indeed, an important feature of any patrician house in Venice was a display of weapons known as the *lanziera dell'arme*, which was put up on the walls of the *portego*, the palace's main public space. These displays, recorded in inventories, would typically comprise a fanlike configuration of spears, called a *restelliera*, arranged behind a central shield.[114] For example, an inventory of goods belonging to the Magnifico Michele Memo, compiled in 1573 soon after his death, lists a *lanziere dell'arme* the centrepiece of which was a gilded shield with a helmet decorated with the Memo arms.[115] Sometimes these displays might include items taken in battle: a late sixteenth-century inventory of the patrician De Lezze family, for instance, lists a Turkish bow among other such trophies (although it was kept in a *camera* on the upper floor rather than the *portego*).[116]

Despite their peculiarly Venetian character, these shields are a product of the taste for Turkish design in the decorative arts that was widespread in Europe during the sixteenth and seventeenth centuries, as demonstrated, for example, during the festivities organized for the entry of the future Philip II of Spain into Milan in 1548, when members of the local nobility dressed in Turkish garb to symbolize 'ancient heroes'.[117] The similarity of the shields' decoration to things Turkish is such that we can regard them as one of the best examples of ostentatious Western objects being produced in the 'Turkish manner', taking 'an exotic object as a prototype to be imitated'.[118]

★ ★ ★

The range of objects that has been considered above bears testament, above all, to the vitality of trade and cultural contacts between Renaissance Italy and the Islamic world. Although imported to other parts of Europe, where they inspired further imitation, objects from the Near and Middle East enjoyed greatest favour and were most influential in Italy. As well as being the result of Italy's strong mercantile presence in the Middle East, this phenomenon reflected certain aesthetic and artistic commonalities between the cultures of Italy and Islam, as demonstrated most clearly in the case of textiles. Whether displayed as indicators of status or beautiful exotica, Middle-Eastern artefacts constituted an important element in the decoration and enrichment of the homes of wealthy Italians during the Renaissance.

21.13 Gilded leather shield, Venice, 1550–1600 (cat.32)
The large central medallion of this shield depicts the Lion of St Mark, and beneath this are the initials 'A C', probably indicating that the shield belonged to a member of the Contarini family of Venice.

21.14 Gilded leather shield with the arms of the Foscarini family of Venice, Venice, 1550–1600 (cat.33)

PRINTS

ELIZABETH MILLER

22.1 *Madonna del Fuoco* (Madonna
of the Fire), woodcut coloured
by hand, Italy, before 1429
(Cathedral, Forlì)

ON THE NIGHT OF 4 FEBRUARY 1428 a woodcut depicting the Madonna and Child with saints survived a fire that gutted a school in the house of Brusi da Ripetrosa in the northern Italian city of Forlì. The survival of this highly combustible object was hailed as a miracle, and the image became known as the *Madonna del Fuoco* (Madonna of the Fire). On the following Sunday it was carried in procession to Forlì cathedral where it remains to this day, the focus of a religious cult (plate 22.1). A mid fifteenth-century fresco in Forlì cathedral, possibly by Giovanni di Pedrino, depicts the miraculous event and its immediate aftermath (plate 22.2).[1]

While the fresco must not be taken at face value as an exact representation of what happened, the way the artist chose to depict the scene is nevertheless instructive. The detached building in the centre of the fresco is relatively modest with one room occupying the whole of the first floor. The front wall of this room has been destroyed by the fire, revealing a coffered ceiling and two small windows on the back wall of the room. Seven men are tackling the fire. To the amazement of three men standing in front of the ground floor of the building, they can see the undamaged print on the first floor. The fresco tells us that in the early fifteenth century, just a few decades after woodcuts were first produced in Italy, a school-teacher was able to own an elaborate and powerful woodcut image. The actual print has survived to the present day because of its very special history. It stands as a representative of all those prints that have perished but that once hung on the walls of Italian Renaissance interiors – domestic or otherwise – pasted on wood, stuck straight onto the wall with sealing wax, or, more grandly, placed in a frame.[2]

Another fifteenth-century Italian woodcut that has also survived is now in the V&A, *The Virgin with the Infant Christ on her Knee* (plate 22.3). The scale of this print suggests that it was also intended for display, rather than preservation and contemplation, stuck into an album or inside the cover of a book, and it

22.2 Giovanni di Pedrino (?), *The Miracle of the Madonna del Fuoco*, fresco, Forlì, c.1450 (Cathedral, Forlì)

shares some similarities of pose with the *Madonna del Fuoco*. The very poor condition of the V&A print can be explained by the fact that it was pasted onto wood, which was later planed down from the back.

In the Renaissance the kind of glass suitable for use in picture frames, which might have offered protection from dirt, dust, attack by insects and all the other things that cause prints to deteriorate, did not exist. A good idea of how prints were treated is given by a northern European panel painting of *The Annunciation* by The Master of Flémalle of *c*.1415–25. This includes a hand-coloured woodcut, stuck up over a fireplace with red sealing wax, depicting St Christopher carrying the Christ Child.[3] It is showing signs of becoming torn and tattered. The effects of smoke, soot and grease on a print in such a position can be easily imagined.

The period 1400 to 1600 extends from the beginnings of the history of European printmaking to a time when prints were produced and marketed on a huge scale, and widely traded across Europe and beyond. Before the later thirteenth century Italian homes would have been entirely paperless environments. The earliest reference to papermaking in Italy dates from 1268,[4] while the earliest woodcuts printed on paper date from just before 1400; the earliest Italian engravings on paper followed a few decades later. The study of prints in the Italian

Renaissance domestic interior is thus the study of the arrival and integration of a new commodity into household practices and routines.

Prints are mass-produced images. Printmaking differs from drawing and painting in that it makes possible the production of hundreds, sometimes thousands, of essentially identical examples of the same picture. Some sense of the scale of fifteenth-century print retailing is suggested by the example of a Paduan merchant who signed a contract for the sale of 3500 prints in 1440.[5] It is this volume of sales that made printmaking an extraordinarily powerful medium of communication.

The surviving body of Italian Renaissance prints is only a proportion of what must have existed at the time. Whole classes of Italian Renaissance prints, including popular satirical prints, have scarcely survived and in at least one case the existence of a particular print can be inferred only from a Renaissance inventory and a ceramic plate that used it as a design source.[6]

In the Renaissance period people bought prints new, from street pedlars, at fairs, from artists or specialist retailers, and when travelling away from home on pilgrimage[7] or business. In Florence prints could be bought on the second-hand market.[8] A collection put together over a lifetime, comprising forty-eight woodcuts, four engravings and one metal-cut, was

evidently within the budget of a notary, Jacopo Rubieri, born in Parma around 1430.[9] Consumers brought prints into their houses, where they were displayed or stored. In the period between their acquisition and their eventual destruction or disposal, prints were, of course, meaningful possessions to their owners and users. As with other types of objects in the Italian Renaissance, the owners of prints could use them to 'seek sensation, novelty, creativity or religious verification', as well as to 'day-dream and fantasize', rather than being mere 'passive consumers'.[10]

Around AD 600 Pope Gregory I wrote 'Pictures are used in churches so that those who are ignorant of letters may at least read by seeing on the walls what they cannot read in books'.[11] Gregory also stated on another occasion that pictures were the books of the illiterate (although this time he did not specify pictures in churches), and this remained a very influential doctrine at least until the Reformation in the early sixteenth century. In AD 787 a conclave of bishops, known as the Second Nicene Council, had ruled that the crucifix and other images of Christ and the saints, could be displayed and venerated in churches and homes since 'the honour shown to the image is transferred to the prototype, and whoever honours an image honours the person represented by it'.[12]

A strong influence from the thirteenth century onwards was the use of images by members of the mendicant Franciscan and Dominican orders, which was emulated by the local communities with whom they were closely involved.[13] These circumstances provided very favourable market conditions for the makers of prints of Christian subjects when they introduced this novel commodity into Italian society around 1400. The lay community's use of prints for private devotion in their own houses was part of a larger phenomenon. New forms of lay piety diminished the need for the clergy's services and created a demand for 'paraliturgical apparatus', of which religious prints were only one example (see pp.190-202).[14] The function of devotional prints was to act as a focal point for strengthening the relationship between the owners of devotional prints and the holy persons depicted in them, so that the holy persons could act as a conduit between them and God.[15]

By the time of the Catholic Counter-Reformation in the late sixteenth century a manual of good parenthood was offering advice on the placing of religious prints in the home:

> And as to pictures of saints, one must begin by saying it is very expedient to have them in one's own home, for those who cannot have them made with colour and with greater skill it is sufficient to have prints which can be very beautiful and can be had for a small price; and it is good to place them according to the size of the house, not in a disorderly way, but in certain principal positions, although in some parts of the house such as a small oratory or loggia it is good to have many images together arranged in order and consequence of the subject, for example the fifteen mysteries of the blessed rosary of the Madonna and such like, and in this way to make a place like a spiritual garden for the recreation of the soul.[16]

This quotation suggests how the judicious positioning of prints could either enhance an existing sacred space, such as a place set aside for private prayer in the form of an oratory, or through their very presence create sacred space in a part of the house chiefly associated with non-devotional activities such as a loggia, which was designed for outdoor summer dining or recreation.

A late sixteenth-century Italian drawing of the interior of a poor household may actually depict a print in a domestic interior (plate 22.4).[17] In the top left corner of the composition is the corner of a bed above which a Madonna and Child image is shown suspended from a central fixing. The apparently somewhat floppy quality of this picture within a picture seems to suggest that it is meant to depict a print. The relative poverty of the surroundings with a family cooking, eating and sleeping in one room, without even a proper hearth, also increases the probability that this devotional image is an inexpensive print, rather than a more costly painting. Just as paintings and reliefs of the Madonna and Child would have been placed in a *camera,* the room where sleeping took place, in a wealthy household, in this poor interior the Virgin and Child image is positioned close to the bed.[18] Also depicted in the room is a large two-handled vessel standing on the floor by

22.4 Attr. Annibale Carracci,
Interior of a Poor Household,
drawing, probably Bologna,
late 16th century
(whereabouts unknown)

the bed; it closely resembles surviving ceramic wares that served as chamber pots (see plate 13.12). This reminds us that, while we are accustomed to seeing Italian Renaissance prints in the context of museums and print rooms, in the period 1400–1600 they shared the same space as a vast range of other domestic objects.

At the right-hand edge of this drawing of a sparsely furnished interior is the corner of a long, low, storage chest or *cassone*, an item of furniture often associated with marriage (see pp.120–21). A *cassone* could range from an elaborately painted, carved and gilded example for the very rich, to a plainer, much less costly piece of furniture appropriate to further down the social scale. One surviving *cassone* dating from the start of the sixteenth century, and originating from Venice or Lombardy (plate 22.5),

22.5 *Cassone*, pine and poplar decorated with woodcuts printed in black and red, northern Italy, 1500–1520 (Civiche Raccolte d'Arte Applicata, Castello Sforzesco, Milan inv. n.45)

has a curved front decorated with four, square wood-cuts pasted onto it. The two woodcuts placed at the centre have a star-shaped geometrical pattern. This motif, which is printed in black and red, simulates the earliest type of intarsia (decorative wood inlay), known as *tarsia a toppo*, made in Italy from the early fourteenth century onwards and derived from Islamic woodwork.[19] The two woodcuts at either end of the *cassone* front both depict the same room[20] and have a cut-out figure of a dog glued onto one and a hare onto the other. This woodcut decoration simulates pictorial perspective inlay, which was a speciality of

Italian intarsia workers around 1440–1500.[21] Both *tarsia a toppo* and pictorial perspective intarsia were extremely time-consuming and labour-intensive, as well as requiring a high level of skill from the maker in comparison to pasting a paper print onto wood. Woodcut decorations enabled the less well-off to own an ingenious imitation of a type of luxury furniture that only the wealthy could afford. *Cassoni* now in Berlin and Turin, which are decorated with the very same woodcuts as those pasted on the Milan example, suggest production on a commercial scale.[22] It was not just intarsia makers whose work was being imitated by the makers of woodcut-decorated furniture. The regulations of the guild of Venetian painters specified penalties for the passing-off of chests and boxes decorated with coloured woodcuts as painted furniture.[23] Just such an early sixteenth-century, small Florentine *cofanetto* (casket), measuring 27 x 16 x 18 cm and decorated inside and out with woodcuts including a hunting scene, is in the collection of the Museo Bardini in Florence.[24]

Prints in the Italian Renaissance interior were not always fixed in one position, to be appreciated only by the sense of sight. They were also handled and understood through the sense of touch. The individual sheets of paper used for prints would have had qualities of surface roughness or smoothness, weight and flexibility, depending on factors relating to the papermaking process, such as the quality of the linen rags from which the paper was made. Printing a woodcut creates an embossed effect on the paper, while engraving produces a series of inked ridges – both effects that are tangible to the fingertips.

The most obvious example of the handled print was the printed playing card. Card games arrived in Europe in the early fourteenth century when the first playing cards were hand-painted. The earliest reference to printed playing cards in Italy comes from a tax declaration made in Florence in 1430 by the printer, Antonio di Giovanni di Ser Francesco, of printing blocks of saints and of playing cards valued at 20 florins, which he used in his craft.[25] Among the

earliest surviving Italian playing cards are partially uncut sheets of forty-four woodcut cards with suits of Cups, Coins, Swords and Clubs and court cards consisting of King, Knight and Valet dating from 1462 (plate 22.6).[26] As the cards passed from person to person in the game, depictions of high-value or highly wrought objects changed hands. These cards contributed to a shared visual culture based on courtly models and deriving ultimately from literary traditions. This shared visual culture is also present on a ceramic dish possibly from Ferrara dating from 1450-1500, which depicts a game of cards played by men and women on a folding trestle table set up in a fenced garden.[27]

These cards are examples of the phenomenon of material culture in the home being both an appropriation of the larger world and a representation of that wider world within the home.[28] An even more striking example of this is provided by printed board games, such as *pela il chiù* ('pluck the owl'; plate 22.7). The game was played with three dice, and the numbers thrown dictated which square the player's token landed on; the square instructed the player to either pay or take a certain number of small coins from the pot.[29] A square on the outer circuit of the board shows one of the potentially most expensive household purchases: a canopied bed hung with curtains. Many of the other squares on the board feature the sale of goods and provision of services which flowed in and out through the household: street-sellers offering hats, combs, fans (*Berettaro, Petinelle, Ventarole*), terracotta pots, drinking glasses (*Testi*,[30] *Bicchieri*), vegetables, baked goods, lemons, tripe (*Ortolana, Fornaro, Limone, Trippe*), water and grappa (*Acquarola* and *Aquavit*). Also on offer is rat poison (*Pasta per topi*). The suppliers of services for the smooth running of the household include a locksmith, chimney-sweep and wine-carrier (*Magnano, Spazacamin, Brentador*), and a collector of human excrement (*Cagarola*) shown with a high-sided chamber pot.

As all the preceding examples make clear, within the house different prints fulfilled different functions. They could be devotional objects, a form of surface decoration on furniture, a recreational tool or, indeed, art objects, sometimes recording compositions by other artists or collected in their own right. The Italian writer Fra Sabba da Castiglione wrote an entire chapter, originally published in 1546, on those things that lend distinction to the house. He deals with, in order, musical instruments, antiquities, painted stories and portraits, and intarsia work, before arriving at prints and going on to medals, Flemish tapestries, Turkish carpets and leather hangings.

And some adorn them [houses] with prints, engraved on copper and on wood, either from Italy or elsewhere, mostly those from Germany and especially those from the hand of Albrecht

Dürer, certainly not only the most excellent but divine with the burin, or by Lucas [van Leyden] his pupil, who closely follows his great master.[31]

One person who conformed to Sabba da Castiglione's notions of gentlemanly decor as incorporating prints was Francesco Baiardo (died 1561), a patron and collector of the work of the artist, Parmigianino.[32] The artworks with which Baiardo chose to surround himself are recorded in a posthumous inventory. At the time of his death his collection included 557 drawings and one painting by Parmigianino, as well as a large quantity of prints both for display and assembled in two albums.[33] The first album of prints included a Passion of Christ by Dürer and the second consisted entirely of German prints. Whoever drew up the inventory took what was for the sixteenth century an unusually high level of care to

22.7 Ambrogio Brambilla, *Pela il chiù*, Rome, 1589 (cat.45) As well as showing archetypes and theatrical characters like Time or Pantalone, this game, which could have been stuck onto a board, has many squares decorated with the providers of goods and services that make the household run smoothly.

differentiate between prints, drawings and paintings in the various rooms. As well as making a distinction between sketches and finished drawings, the unknown inventory-maker mentions drawings on both sides of a single sheet of paper, and often gives one or more of the dimensions of paintings. Prints are indicated by the expressions *stampato* (printed) or *un quadro in stampa* (a printed picture). In most cases the subjects of the prints and the creator of the composition are mentioned.

Three small rooms were listed (*primo camerino*, *secondo camerino* and *terzo camerino*). Of these, the first room housed one print out of a total of nine pictures, the second, four prints out of twenty-nine pictures, and the third, twelve prints out of thirty pictures. Thus the proportion of prints to works in other media varied from room to room, indicating that each space would have had a distinct character. There is insufficient information in the inventory to reconstruct exactly how the pictures were displayed in these rooms, but both the overall scattering and, within that, the apparent grouping of some prints in the inventory seems to reflect a hanging arrangement.

Of the first small room's pictures, five are described as by, or after, Parmigianino; an image of Christ, is attributed to another artist from Parma, and two are Flemish landscapes. The last item in the inventory of this room is the only print: the *Burning of Troy* after Giulio Romano. In the second small room thirteen pictures are by, or after, Parmigianino, one is by Correggio, another is by the Parma artist Mazzola Bedoli, another is a Flemish landscape and nine are unattributed. The remaining four pictures are prints. Of the four prints, three are grouped together in the list: a print of Michelangelo's Sistine Chapel, a print described as a Battle of Horses after Raphael and a portrait of Emperor Charles V. Also in the inventory of this room, listed between a St Roch by Parmigianino and a landscape by an unknown artist, is Albrecht Dürer's engraving of *Fame*.

In the third small room the inventory records that twelve of the thirty pictures are prints. Dürer's engravings of *St Eustace* (plate 22.8) and *Knight, Death and the Devil* are together, as are prints after Raphael: *Parnassus*, *The Judgement of Paris* and *The Massacre of the Innocents*. It is not surprising that the

largest and most visually striking of Dürer's and Raphael's prints were those selected to be hung. The experience to be gained by viewing prints while turning the pages of a book is very different from viewing them displayed on the wall. A print hung on the wall is visible to everyone – resident, visitor or servant – entering the room, while a print within a volume is only seen by selected viewers at the discretion of the owner.

Although work by artists from Parma dominated Francesco Baiardo's collection, a print reflecting a major fresco painting in Rome such as *Parnassus* brought Raphael's work into Baiardo's home. Additionally, the prints of Albrecht Dürer – art from north of the Alps – joined Flemish landscape paintings in the collection to provide foreign novelties. To Italians in Italy the engravings of Dürer were like other imports, such as Middle-Eastern carpets and damascened metalwork (see pp.308-21), for which there was also a strong market at this time.

The Baiardo inventory enables us to see prints in relation to paintings and drawings. Prints also need to be perceived in relation to all the other objects of special significance with which people might chose to surround themselves. 'A small version on paper of Michelangelo's *Last Judgement* in a wooden frame', which was doubtless a print, appears in the February 1571 inventory of an *anticamera* (antechamber) belonging to the sculptor Benvenuto Cellini.[34] This same room housed valuable goods such as the sculptor's clothes and twelve pairs of sheets in a chest, two pistols, two swords, a Turkish knife, a silver inlaid dagger and a spear or javelin (*zagaglia*). The importance of the room to its owner is confirmed by the fact that it contained the privileges awarded to Cellini by the king of France.[35]

★ ★ ★

Some of the meanings invested in prints by their owners, such as expressing religious faith or their art-collecting preferences, are relatively easy to conjecture, while others remain obscure. Intriguing questions, such as whether certain types of print appealed across class boundaries or if particular prints were more usually owned by men or by women, require much further research.

22.8 Albrecht Dürer, *St Eustace*, Nuremberg, *c.*1501 (cat.249)

The prints of the German artist Albrecht Dürer were popular among Italian Renaissance print connoisseurs. On receiving a new example from Germany, Sabba da Castiglione wrote: 'with delight and great pleasure I admired and considered the figures, the animals, the perspectives, the buildings, the distant landscapes and the other marvellous descriptions …'[36]

EVERYDAY OBJECTS

HUGO BLAKE

23.2 Marble mortar, Liguria,
early 17th century
(cat.97)

SINCE THE 1960S ARCHAEOLOGISTS have probably unearthed many times more fifteenth- and sixteenth-century objects than those that have survived above ground. But this evidence has not always been recognized by mainstream Renaissance scholarship. The merits of archaeological evidence lie in the contexts in which it is found, its apparent lack of bias in its disposal, and in its quantity. However, like other sources, it has its limitations. Nearly all excavated material is secondary rubbish, often forming landfills and sometimes disposed of in cesspits, which can only occasionally be associated with particular houses. It is very unusual to find items in the room in which they were used.

Among the everyday objects that have survived, some categories are much better represented than others. Metals and glass were recycled; and wood was put on the fire.[1] Of what was thrown away, only inorganic and some bone items are likely to have remained, although waterlogged ground may conserve wood and leather. Iron is likely to have corroded and glass to be fragmentary. Pottery survives in greater numbers than anything else, since it had no secondary use once broken.

Most of the smaller portable objects displayed in museums of fine and decorative arts would not have been used on a daily basis in the Renaissance. Inventories of domestic possessions show that silver, porcelain, maiolica, worked glass, brass and pewter were locked away with textiles in chests in the *camera*.[2] A few brass or copper objects may have been out in the *sala*. The most frequently used items were in the kitchen (plate 23.1), which was the source of food, light and heat and where clothes were washed.

The range of materials that constituted everyday objects was limited. Silver was too valuable to be used regularly, except on the tables of the wealthy. It became more common in the sixteenth century, when even workers might possess the odd silver spoon or fork. Along with jewellery and textiles, silver bolstered status and was a way of storing

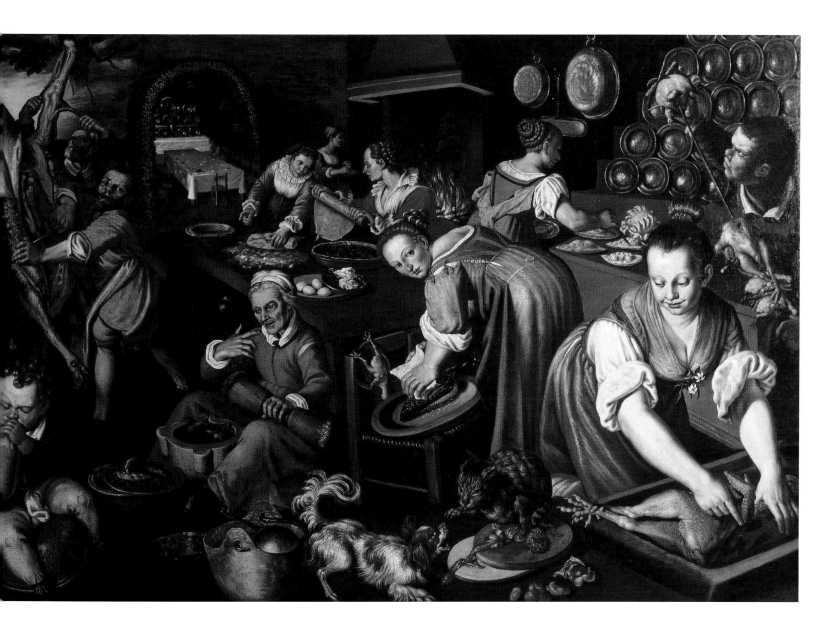

23.1 Vincenzo Campi, *Cucina (Kitchen Scene)*, Cremona, 1580s? (cat.87) This lively and salacious kitchen scene shows many aspects of food preparation, from the mixing of ingredients and grating of parmesan to the rolling and cutting of pastry for making pies (*torte*).

wealth: it could be sold or serve to guarantee loans.[3] Similar wares were made from base metals whose colour aped that of precious metals. Polished tin and its alloy pewter resemble silver, and brass – a mixture of copper and zinc – gilt silver. Copper vessels, sometimes tinned, were used for cooking. Other implements placed on the fire were made from a stronger material, iron, as were handles or supports.[4] Stone was also used for cooking pots, and for other mundane items like mortars. Ceramic, glass and wood items, which were employed for preparing and eating food as well as for storing and transporting it, were mentioned less often in the inventories, perhaps because they were of little intrinsic value.

This essay will draw attention to the few remaining objects, especially metalwork, that once formed the bulk of everyday possessions in most households. It will examine the archaeological record to show what small items were common and the form they took. For example, the hoard discovered near Feltre in 1912 appears to be the only group of ordinary domestic metalwork from Renaissance Italy (plate 23.3). Feltre's recalcitrance in the war between Venice and the League of Cambrai provoked Emperor Maximilian I to raze the city in 1510. This cache of thirty-six pewter, bronze and copper valuables was probably buried by refugees or looters at that unhappy time.[5] Written and pictorial evidence will

23.3 Mughnai Hoard, Italy and Germany, 15th and early 16th century (cat.107) The hoard includes candlesticks, a small cauldron, vases, plates, basins, a food warmer (also illustrated separately on the right) and tableware. Pewter was popular on the table and was often imported from England.

be deployed to illuminate the purpose and ownership of these hitherto relatively little-known everyday objects and show where they were used or kept in the home. Although material from all over northern Italy has been considered,[6] this essay will focus on objects from Genoa. Unpublished inventories of Genoese homes – unlike most of those published – will demonstrate the range of movable goods used by the socio-economic and cultural group who could be described as the 'artisanal classes'.[7]

THE RELATIVE VALUE OF EVERYDAY OBJECTS

Metal objects were often listed by weight, and when they are valued, we can discover their relative worth. In a 1451 Genoese inventory silver was ten times more expensive than tin. According to another drawn up in 1453, each piece of tableware in tin was worth about fifteen times as much as a wooden trencher, estimated at 4 *denari*. The 1451 valuations show that metal cooking and water vessels cost from 15 *soldi* to 1 *lira* each, a brazier 12 *soldi*, a mortar and pestle 8 *soldi*, and a carving knife and bronze candlestick 4 *soldi* each. These are in the same range as the wood furniture, with an intarsia chair at 6 *soldi*, tables from 12 *soldi* to 1 *lira* 10 *soldi*, intarsia chests at 1 *lira* 5 *soldi* and 2 *lire*, and bed frames at 2 *lire* and 2 *lire* 10 *soldi*.

Bedding and clothing were, however, in a different league. The mattress and pillow of Gerolamo de Ricobono's slave were in 1451 worth 5 *lire*, his servants' sheets about 1 *lira* each, and his best quilt over 18 *lire*. His wife's clothes ranged from 4 to 15 *lire* per

item, which are comparable to the 'togas' valued at 14 and 16 *lire* left in 1453 by the shoemaker. Thirteen items of jewellery lumped together work out at nearly 5 *lire* an item.[8] These valuations are credible, because they were made not by notaries but by second-hand dealers. Buying and selling used goods was common and practised by all social groups.[9]

KITCHEN

The goods left by a fisherman from Portofino near Genoa in 1498 give us an idea of the basic equipment of a simple kitchen: a bread chest, one copper cooking pot, another in stone with an iron suspension chain, a copper pail for drawing water from a well, and a stone mortar.[10] Most townsfolk stocked at least six months' supply of food.[11] The inventory of a six-bedroom furnished house, let in 1419 by a Genoese innkeeper to a painter from Milan, constitutes a rich source to explore the contents of the kitchen. Storage was provided by one oil jar and five 'white' terracotta 'barrels'. Wooden barrels, casks and ceramic jars for flour, oil, wine and vinegar were usually stored in the cellar of large owner-occupied houses. Lesser quantities were presumably kept in the small and medium-sized jars featured in a few kitchens, which may not have been thought worth listing in other inventories.[12] Seven earthenware *orci*, or large storage jars, over two feet (60 cm) high, stand in the *orciaia* store of the Palazzo Vecchio (plate 23.4). They have the single beaked spout that is typical of Florence.[13]

23.4 *Orciaia* (jar store), terracotta, Florence, *c.*1520–50 (Palazzo Vecchio, Florence)

23.5 Cooking pot or *acquaio* pail, copper, northern Italy, mid-15th century (Soprintendenza per i Beni Archeologici, Milan, 147320)

In his cookery book of 1570 Bartolomeo Scappi (see p.249) shows bronze mortars and their pestles, with which to pound spices. They may have been used to crush herbs and spices such as thyme, mint, basil and cloves, which, mixed with rose vinegar, formed the *sapor verde* or green sauce eaten with meat. All kinds of fruit, nuts and cooked food, like, for example, boiled crayfish, were mixed together in mortars to prepare *torte*, or pies (plate 23.1).[14] Small bronze mortars were also often owned by the wealthier households. Mortars of marble and other stones with solid wood pestles were more commonly recorded in kitchens (plate 23.2).

The cooking equipment in the house rented by the Milanese painter included a pair of firedogs, an iron chain, two spits of different sizes for roasting, an iron grate for grilling fish, a frying pan and its spatula, a smaller copper one and five cooking vessels for stews or soups (two large soapstone and two earthenware cooking pots and a copper cauldron). Gaspare Aleardi kept in his kitchen in Verona three sizes of copper cooking vessel, described respectively as being able to hold a half, two and four buckets.[15] A hemispherical copper bowl with two lug handles and a reinforcing strip riveted to the rim, excavated

from a fifteenth-century context in Milan (plate 23.5), together with the copper cooking pot found at Feltre, may correspond with the smallest size. The one from Feltre, still with its handle from which it could be hung on a chain over the fire, has instead a convex base like surviving soapstone cooking pots.[16]

Pietra ollare, or cooking-pot stone, was quarried and turned in the western and central Alps, from where it was distributed throughout the Po plain and Liguria. Soapstone vessels retain heat better than copper or ceramic and were less likely to break than the latter. When they did, they were sufficiently

valuable to be mended. A Genoese baker's stone cooking pots were valued at 12 *soldi* and 10 *soldi* each, in comparison with 1 *lira* for his copper *pairolium*, or cauldron, and 1 *soldo* for a Spanish ceramic plate. Two of the seven stone cooking pots left by Brigida Lomellini in 1458 were repaired.[17] A finely turned complete example, found at the bottom of a well near Forlì and probably dating to the fourteenth or fifteenth century, still has its iron handle attached to two hooks folded around an iron band that embraces the vessel just below its rim. An old repair of four cramps supports the base. Another soapstone cooking pot, excavated in Liguria, consists of fragments from at least three separate vessels – including a former lid incorporated as the base – which had been sewn together with copper wire. As the holes through the stone may have been drilled, an artisan would have been employed to put together this extreme instance of recycling and reuse.[18] Presumably an inner sealant of congealed food rendered it impermeable.

For the same reason glaze was applied to the inside of earthenware cooking pots (plate 23.6).[19] Although many bear traces of burning on their outsides, it is unlikely they were strong enough to withstand the

flames of the fire and were instead rested, as recipe books indicate, on embers. Traces of sooting on one side confirm, as recipe books and images show, that some pots – and even metal jugs and glass flasks – were placed near the fire and warmed by radiant heat. Illustrated and excavated earthenware jars, with a flat bottom and a single handle on the side, would have suited this purpose.[20]

Food was also kept warm on chafing dishes. Wealthier families possessed brass food-warmers, many of which were kept in the kitchen.[21] The holes in the side and the notches in the rim of the particularly fine bronze one in the Feltre hoard would have allowed warm air to circulate under a dish or pan (plate 23.3). The example illustrated by Scappi shows two discs, which would presumably have separated the heating element (possibly charcoal) from the food receptacle.[22]

While liquid foods were cooked in vessels suspended from a chain, more solid ingredients were placed in well-greased pans on a tripod over the fire. Scappi listed and illustrated in his treatise iron tripods of triangular, square and round shapes.[23] Copper cauldrons were used to heat water and in the Florentine house of Francesco Inghirrami were supported on their own iron tripods weighing about 2½ and 5 kilograms. Scappi listed and illustrated a range of cauldrons (*caldari*), including a massive one which stood on a ring with four feet.[24] Tripods were often mentioned in inventories and were still in use until recently.[25] Depictions of the Miracle of the Desecrated Host, for example Uccello's painting dating from the 1460s, show a shallow pan with a long handle on a tall round tripod stand. Pans like this may correspond to Scappi's frying pan (*padella*) for eggs or Benedetto Vivaldi's iron griddle for pies. They could also be used for frying fowl as an alternative to roasting on the rotated spit.[26] The double-handled earthenware pans (*tegami*) are the nearest

23.6 Terracotta cooking pot,
Ferrara, end of 15th century
(cat.94)

23.7 Wooden bowl and
spoon, probably Liguria,
17th century
(cats 98 and 99)

23.9 Wooden bucket,
northern Italy, 16th century
(cat.105)

surviving equivalent to the metal pans. Eighteen small ones dating to the early seventeenth century were recovered from a shipwreck off the Ligurian coast at Varazze.[27]

Food and water were doled out with copper, iron or wood ladles or serving spoons (plate 23.7). Some were perforated and oval in shape and had a hooked end for suspension.[28] Bartalo di Tura di Bandino had a wooden ladle for pasta.[29] Images of cooks stirring and trying food, waving spoons in the air and with ladles tucked into the back of their belts give the impression that these tools may have symbolized the cook and cooking. When not in use, they could be left in jars by the fire.[30]

Basins were multifunctional objects. The wood and earthenware examples in the Milanese painter's kitchen in Genoa could have been used for washing, mixing or serving foods.[31] Plain, flanged bowls like those from Ferrara, which were glazed brown or green on the inside, would have been suited to these tasks (plate 23.8). It has been suggested that terracotta bowls distinguished by mould-made relief decoration on their outside were, despite their porous nature, used for various small-scale washing activities (see plate 11.5).[32]

Copper buckets were also kept in the kitchen. In his top-floor kitchen in Verona Gaspare Aleardi had both copper- and iron-bound wood buckets and four wooden lids to cover them. The ladle accompanying the bucket in a Genoese house implies it was used to store water.[33] The Milanese painter's wooden bucket may have resembled the one found in a well in Genoa (plate 23.9).[34] Losing

23.8 Bowl for food
preparation, Ferrara,
end of 15th century
(cat.95)

23.10 *Mezzina*
for carrying water,
Montelupo, *c.*1480–90
(cat.106)

pails in wells must have happened often, as a
Florentine inventory listed a pair of hooks to retrieve
them. In an altarpiece predella (*c.*1470), now in the
Galleria Nazionale at Perugia, Piero della Francesca
depicted a set used to rescue a baby from a well.[35]
Water was also kept and carried around the house
in earthenware containers (plate 23.10). The basket-
handled jars characteristic of Florence were also used
for pouring water into jugs (plate 23.11).[36] Although
unglazed porous earthenware is not the ideal
medium for storing liquids, evaporation through the
body of the pot cools the water.

SALA

Inventories of *sale* commonly list a brass ewer and
basin, and a copper water pitcher.[37] A jug and dish
are often represented together in paintings.[38] Many
basins were described as 'for giving water to the
hands'.[39] Boccaccio's *Decameron* and later literary
accounts show how hand washing was a routine
event before diners were seated at the table and at
the end of the meal.[40] In his guide to manners, *Gala-
teo* (1558), Giovanni Della Casa advocated a public
demonstration of hand washing to assure fellow
diners that the fingers that would dip into the
common serving bowl were clean.[41] In descriptions
of banquets the 'water given to the hands' was
odorifera, or perfumed with rose, orange or cedar
flower essence, which served to purify and protect
the individual.[42] As hands were 'washed' over rather
than in the basin, the latter served to catch the
residue, only a small amount of which could have
been held in the salver or dish used.[43]

 Shallow hammered brass basins with embossed
gadroons around the centre, similar to the one in the
painting by the Ghirlandaio workshop (plate 19.6),
are preserved in museums and churches all over Italy.
Some are decorated with German inscriptions in
gothic letters, embossed relief scenes and punched
decoration. They are believed to have been made in
Germany and perhaps copied in Italy.[44] Three basins
included in the Feltre hoard correspond to this type.
One shows Adam and Eve on either side of a tree
encircled by an inscription and resembles other
examples attributed 'probably' to Nuremberg.[45]
Although some were displayed in the home on
mantelpieces and over doorways, most were probably
hand-washing salvers.[46] If indeed all these beaten

brass dishes were originally used in the home, they would form the largest category of domestic metal-work surviving from Renaissance Italy. Northern European brass, however, was rarely recorded in inventories.[47]

The Ghirlandaio workshop painting (plate 19.6) shows a servant holding a lidded jug with an elegant baluster profile, a tubular spout and a narrow neck and foot.[48] The brass one of *c.*1550-60 from Fucecchio (see plate 19.18) has instead an open trefoil mouth resembling the ewers illustrated by Scappi and probably like the one in Francesco Inghirrami's inventory described as a 'big brass jug with an open mouth'.[49] Small jugs with no spouts could have served as mugs, with their flared mouths more suitable for sipping than quaffing.[50] These may also have had a role as ladles or scoops on an *acquaio* (wall fountain).[51]

The basin with which the Fucecchio jug is now associated is deep, straight sided and plain with a narrow brim. In some paintings of banquets similar deep basins were depicted on a stand alongside the *credenza* on which they were also displayed.[52] The loop handle riveted to the rim of the deep Feltre

basin suggests that it was probably stored hanging against a wall, base outwards (as represented in plate 23.1), and was thus unlikely to have been a show item. Large brass basins on pedestals could be used for hand washing, but also for washing dishes.[53] A mid-fifteenth-century panel painting by the Apollonio di Giovanni workshop shows a freestanding basin with dishes in it, ready to be washed up by a servant who is bringing two more.[54] Basins 'for washing bowls' were inventoried in Florentine *sale.*[55]

Pedestalled stands could allow a pail to be suspended in order to pour water over a basin.[56] Round-bottomed pails were also suspended in this way on *acquai*, hung on a hook or from a short chain.[57] In Tuscany these pails could be called *secchia da acquaio.* They were sometimes distinguished from those used to draw water (*da tigniere aqua*) or for the well (*da pozo*). Some were made of copper and a few of brass, and could weigh about 2 kilograms. In the 1492 Lorenzo de' Medici inventory two *secchie* are described as round, one with a spout and the other with two taps. In the *saletta* in front of the great *sala* he kept a bronze damascened spouted cup to use as an *acquaio* pail, and a large copper bowl that belonged underneath it.[58]

In Venice small brass buckets (*secchielli de latton*) may have served as *acquaio* pails. An example in the Correr Museum in Venice, embossed with foliage and the Barbarigo coat of arms, has a tap attached to the rounded base and its handle has a kink to accommodate a hook.[59] The punched decoration of a star on the base and of oblique strokes on the side and rim of the copper bowl from Milan – described with the cooking pots in the kitchen (see p. 335; plate 23.5) – suggests that it may instead have had a more visible role as an *acquaio* water pail.[60] In Genoese inventories copper pails were often paired with tin jugs. Where no basin and ewer were mentioned, a pail and pitcher may have fulfilled the same role for less formal hand washing.[61]

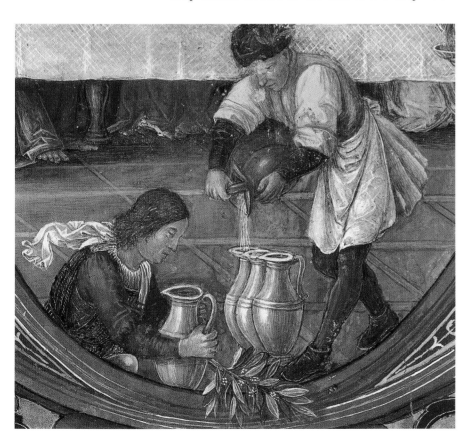

23.11 Illuminated initial showing a detail of the *Marriage of Cana*, Florence, mid-15th century (Opera di Santa Maria del Fiore, Florence, ms.C.n.11, c.87)

CAMERA

Everyday objects also fulfilled important functions within the *camera*. Rituals of personal hygiene were carried out using a wide range of domestic artefacts, from shaving bowls to ear cleaners and ointment jars. Della Casa advised that washing hands – except before dining – and combing should be conducted in private in the *camera*.[62] Gerolamo de Ricobono's basin for bathing would have been employed in this more personal washing.[63] Illustrations of the birth of the Virgin and of St John the Baptist show metal basins and ewers placed on the floor to wash the newborn. The most common form of basin depicted in these scenes resembles the wide and relatively deep one in the Feltre hoard.[64] Feet were washed in similar basins (*bacini da lavare i piè*), as described by the author Sacchetti recounting how a wife washed her husband's feet.[65]

A brass basin for shaving or hair washing was listed in some of the wealthier houses. Lorenzo de' Medici kept one, together with hand- and foot-washing vessels, in his *camera*'s lavatory.[66] A sixteenth-century print of a *commedia dell'arte* scene shows a pail with a tap suspended over a bent bearded man whose head is being washed and combed with a short version of a garden fork. The man has placed his hands on a low table either side of a tapering straight-sided bowl.[67] Lorenzo had a case containing four razors, which he kept with a silver mirror in his downstairs *anticamera* and *scrittoio*. In the mid-sixteenth century a razor case containing a stone (possibly a hone), a comb and 'other knick-knacks' was recorded in the second *camera* of a Tuscan glassmaker.[68]

Inventoried combs were made of elephant ivory and less commonly of wood or horn. Elaborate ivory examples like the one owned by the Venetian Giovanni Venturini and described as worked and painted in gold are displayed in museums.[69] Those excavated from waterlogged contexts are plain, double-sided and carved from a single piece of wood, and one has been identified as made from boxwood.[70] Similar combs were portrayed in the hands of women at their toilet.[71] Whereas Francesco Inghirrami kept his painted ivory comb in the study attached to his *camera*, many formed part of the bride's trousseau and are listed with other toilet and dress accessories.[72] Inghirrami also had a silver ear cleaner which can be matched with a bone example dug up in Piedmont.

Bronze tweezers have also been found there and at Ferrara (see plates 13.4 and 13.8).[73]

Small drug-jars or pots containing ointments and lotions were popular in households. They range from glass phials and jars (plate 23.12) to wooden cylindrical boxes. The imprecise turning of the latter and the broken-off tops of the phials dug up at Lugo show that they were treated as throw-away containers.[74] Their contents served as medicaments and cosmetics. Contemporary representations depict the infirm being tended and women being groomed beside tables bearing small jars and bottles.[75] In one of Bandello's stories, published in the sixteenth century, a man takes from a vase belonging to his master a perfumed unguent to rub into his hair and beard.[76]

Chamber pots were more likely to be recorded in *camere*, but were not kept exclusively there: inventories list examples in the *sala* and the cellar. The Venetian Maria Pollani had ten buckets for 'filth' and eight for clean water.[77] Earthenware chamber pots (*pitali*), current in Liguria from the sixteenth century, have a slightly splayed cylindrical body with two opposed strap handles under a sloping brim and are internally glazed (see plate 13.12).[78] These bucket-shaped items could be boxed into purpose-made wooden stools. The 'little seat' and the cylindrical 'urinal' case, both illustrated by Scappi, may have been covered with fine cloth.[79]

SEWING AND SPINNING

Cesare Vecellio's famous book on Italian dress, *Habiti antichi*, which was first published in 1590, shows boxes hanging from Genoese women's girdles, which may have been the silver needle cases listed in inventories.[80] More common than needles among excavated material are 'bronze' pommel-headed pins. The pins, which could be used to fasten veils to the hair, are about 1 mm in diameter and vary in length from 2.5 to 10 cm (see plate 7.16).[81] Along with pairs of scissors, a thimble, ivory combs, wood mirrors and a cypress box of perfumes, the Florentine Maria di Piero Bini brought to her marriage in 1493 200 *spilletti*, or small pins.[82] More common than any other surviving metal item relating to female domestic activity are 'bronze' thimbles (see plate 11.11). Two sorts are known: the tapering type culminating in a dome and the ring band, both used for sewing.[83] They were covered with regular

punched or drilled indentations. The only remaining silver gilt thimble is decorated with a castle, while another fifteenth century example features a bird and the word 'DIO'.[84]

In the same chest containing a silver ring thimble in Francesco Inghirrami's house was a bag of glass spindle whorls, designed to weigh and rotate the spindle as it fell to the floor drawing out and spinning the wool. Examples in maiolica, earthenware and stone survive (see plate 11.7). These globular or bi-conical objects were pierced to hold a spindle, wooden examples of which have been retrieved at Ferrara and Genoa.[85]

LIGHTING AND HEATING

Objects for lighting were plentiful in Renaissance houses. Braziers and bed warmers, as well as candlesticks, lamps and lanterns, may have been fuelled in the kitchen and lit before being taken to other rooms.[86] Candlesticks (*candelabri* or *candelieri*) provided the commonest form of illumination and were usually made of brass or bronze, although some were of iron or wood.[87] The fine pair of bronze candlesticks with a broad conical base from the Feltre hoard (see plate 23.3) closely resembles those depicted in countless contemporary paintings, shown in niches and on shelves in *camere* and studies, on *acquai*, and on display *credenze*.[88]

A candelabrum incorporating an oil lamp is listed in a Genoese *camera*, while the 'merchant of Prato' Francesco Datini kept small lamp-holders (*lucernieri*) in his study.[89] These could be made of wood and even marble, whereas lamps were commonly made of brass, iron and, occasionally, glass.[90] The open iron lamps and the spikes from which they hung could be dangled from the hand, suspended from the ceiling or mantelpiece, or fixed to the wall.[91] Lamps could be more substantial and decorative, as in a shallow bronze example, which has bands of circles incised inside, an iron tongue and traces of a movable lid.[92] At the other end of the scale were cheap pottery hand-held lamps (*lumammani*), consisting of a bowl perforated with a spout for the wick and with a pointed handle sticking out of the other side.[93]

★ ★ ★

In this essay we have seen how earthenware was used to store foodstuffs, to carry water, to serve as an inadequate cooking vessel and to contain ointments; but, although the largest class of material by far from archaeological sites is ceramic, pottery was for most people a cheap substitute for other more appropriate or desirable materials. Despite the ease with which metals could be recycled, everyday household items of middling value survive more abundantly than once thought. That north European brass basins do so is because they found a second home in churches. Although a small pail or cauldron and a north European basin have been excavated, the chance discovery of a hoard like that at Feltre is the best source for complete base-metal items to match those listed in inventories and depicted.[94] Archaeology is good at turning up small objects like thimbles and pins. Waterlogged earth has preserved a remarkable range of wooden artefacts, such as bowls, combs, spindles, spoons, spinning tops, gaming pieces and exceptionally a complete bucket. Even small bottles and jars of the most easily broken material, glass, can be found intact. Examination of archaeological finds shows that more types of everyday objects were in use than those described in inventories and literary works or illustrated in paintings and prints. By studying all three sources of information together we can form ideas about how they were used and consider what this may tell us about the way people lived.

23.12 Glass ointment jar, probably northern Italy, 1500–1550 (cat.192)

TEXTILES AND CLOTHING

ELIZABETH CURRIE

24.3 Woven linen and
cotton towel ('Perugia' towel),
Italy, 15th or 16th century
(cat.51)

A HOUSEHOLD INVENTORY taken in 1600, after the death of the husband of the Florentine noblewoman Camilla Magalotti, underlines the central role played by textiles within the domestic interior. In addition to the existing furnishings, the inventory lists a collection of no fewer than 929 *braccia* (about 540 metres) of various kinds of fabric stored within the house inhabited by Camilla and her four sons. Some of the lengths of textile were destined to be made into items of clothing, for example linens for shirts, while others were intended for hangings and other furnishings, such as the 'three pieces of gold and turquoise "false" velvet' and the 27 *braccia* (about 16 metres) of blue linen and wool 'to make a cloth for a baldachin over a bed'.[1] Evidently, surviving examples can only convey a very partial idea of the great variety of textiles used to decorate the home and clothe its occupants. These textiles ranged from the extremely functional to the highly ornamental and were sometimes made or embellished in the home as well as by professionals, using both local and foreign goods. As will be seen, the choice of textile itself not only affected where it was displayed in the house but also how, when and where it was acquired.

However, as the textile industry developed over the course of the fifteenth and sixteenth centuries, the basic raw materials – mainly cotton, linen, wool and silk – were woven in more imaginative combinations in order to create a range of new products, sometimes mixing cheaper fibres with more expensive ones and thereby lowering the cost of goods that were previously only within the reach of the wealthiest. To a certain extent, this enabled individuals in different social spheres to re-create similar interior decorations, using the same types of furnishings and colours, in more affordable materials.[2] Imitations and the reciprocal borrowing of motifs and techniques across different textile types, such as stamping patterns with hot tongs rather than weaving them into the fabric, contributed to this phenomenon.

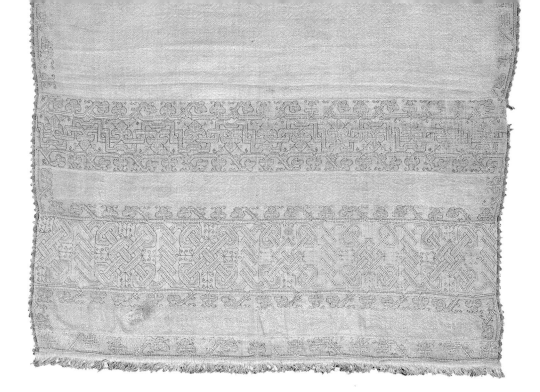

24.1 Linen diaper cover embroidered with silk, Italy, 1500–1550 (cat.60)

LINENS AND COTTONS

Of these two types of textile woven from plant fibres, linen was the more durable. The Italian cotton industry did not attempt to imitate high-quality Islamic products and consequently the use of cotton was mainly limited in wealthy homes to pillow and mattress stuffing, or mixed cloths such as fustian.[3] Linen, on the other hand, often took up such a substantial portion of a family's annual expenditure that it was sometimes allotted its own separate category in account books, entitled *panni lini*. It was common to purchase linen fibre in bulk by weight and then have it spun and woven into cloth, sometimes by female family members and servants. The Florentine Niccolò di Luigi Capponi, for example, ordered 58 kilograms of linen to be shipped from Pozzuoli, near Naples, in the 1570s.[4] A small notebook recording the personal expenses of the Roman noblewoman Virginia Orsini demonstrates her role in organizing different stages of the production of linen goods for various household uses. It lists payments 'to the gardener's wife for spinning strong linen', 'to the weaver for a narrow piece of cloth', for 'spinning linen yarn', 'sewing the shirts of Signor Alessandro [her husband]', and 'cloth for the babies' cradles'.[5] Although local fibres were used primarily, more valuable finished linen cloths were also imported from specialist centres in Flanders, northern France and southern Germany. However, as with many other categories of goods, it is not always easy to establish from written sources whether individual textiles were in fact foreign or simply copies made in Italy.

The shift from imports to the development of locally produced imitations is often reflected in contemporary textile terminology: by the sixteenth century, names such as *perpignano*, *damasco*, *ormisino* and *tabi*, were used to refer to types of cloth rather than fabrics actually produced in Perpignan, Damascus, Ormus and the Attabi quarter of Baghdad.

The versatile nature of linen meant that it could be worked in many different ways to produce heavy canvas as well as linen damasks and fine fabrics for underwear, thereby fulfilling a variety of highly specialized functions. The most basic linens were used for very practical purposes, such as mosquito nets or for window coverings in place of glass panes. In 1576 the Odescalchi family from Como invested in quantities of linen for precisely this purpose, which they treated with oil and wax in order to make them waterproof.[6] From 1525 to 1538 the household purchases made by the Genoese silk merchant and nobleman, Giovanni Brignole, included linen tablecloths and sheets from Flanders and Holland, and large quantities of linen quilts, cushions and bedcovers stuffed with cotton.[7] Indeed, large households often possessed remarkable amounts of towels, bed and dining linen, often decorated with fine embroidery, suggesting that families were prepared for entertaining on a large and elaborate scale (plates 24.1 and 24.2, on p. 350). While these items were not in use, inventories record that they were stored in a variety of receptacles, in chests or drawers under or next to beds and in different rooms

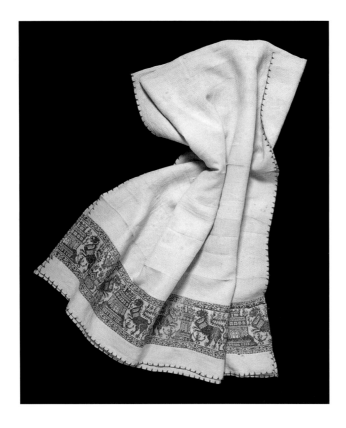

24.4 Woven silk and
linen napkin, Italy,
16th century
(cat.67)

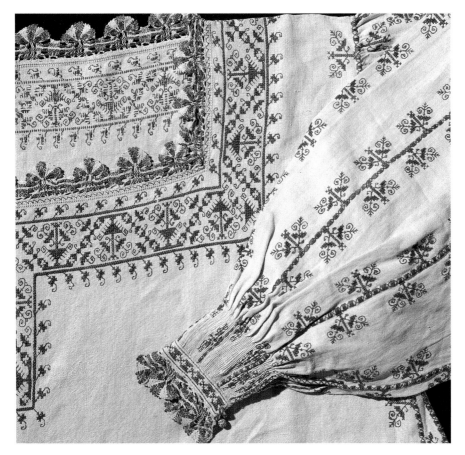

throughout the house. In the 1460s the Florentine Alessandra Macinghi Strozzi was hard at work finding high-quality linens to send to her exiled sons. Her letters refer to large linen towels 'to hang on a hat holder', small ones 'to put round your shoulders when you comb your hair' and round ones 'for wiping the sweat off your face' (see p.181).[8] Unlike the practical items sent to Filippo and Lorenzo Strozzi, many examples of more decorative towels, made of linen damask or of the type now known as 'Perugia towels', have survived to this day (plates 24.3 and 24.4). The latter were in fact mostly made in Lucca or Tuscany, although they continued to be produced in Umbria well into the sixteenth century. Made of linen, or linen and cotton mixes, they had brightly coloured figurative borders, often depicting animals and architectural motifs.[9]

In addition to these ongoing purchases, many linen items entered the household as part of a bride's wedding trousseau. Again, a striking number and range of garments were often assembled for such occasions. The Florentine Cassandra Covoni, who married into the Guicciardini family in 1526, brought with her numerous linen, as well as a few cotton items, including 148 handkerchiefs, 31 aprons, 29 shirts, 25 coifs and 6 pairs of sleeves, plus 50 *braccia* (roughly 29 metres) of fine linen.[10] Many of these goods, such as shirts (plate 24.5) and partlets (pieces of fabric, often decorated with embroidery or lace, used to cover low necklines), would have been worn next to the skin as underwear, while others, such as coifs (close-fitting caps), were intended mainly for use indoors. While it was typical for family members to be involved in the production of the trousseau, it is likely that several of Cassandra's more important linen garments, for example those embroidered in black silk threads, a popular technique known in England at the time as 'blackwork', were carried out by a professional. In 1569 the Brignole family, for example, employed Janetta Magnasca, 'known as the

24.5 Embroidered woman's
shirt with lacework,
Italy, 1550–1600
(cat.182)

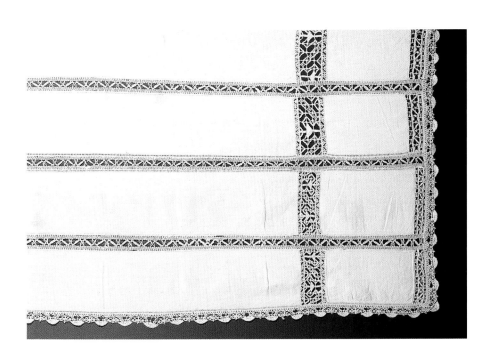

Greek woman and mistress of embroideries', to embroider linen garments in preparation for the birth of Maddalena Brignole's first daughter, both for the mother to wear after the birth as well as for the baby.[11] It is precisely these more ornate linen items that have survived today, prized by successive generations primarily for their embroidery or other forms of surface decoration, rather than the basic textile from which they were made.

The taste for decorated linens was an important factor in the rapid development of lace production, both in terms of variety of techniques and applications. One of the first written references to lace-making appears in a sumptuary law issued in Venice in 1476,[12] and although other Italian cities, such as Milan and Genoa, also developed into production centres, Venetian needle-lace was particularly sought after throughout the sixteenth century. Borders and inserts of cutwork and lace, sometimes of silk but mainly linen, were added to the collars and cuffs of undershirts as well as pillow and table covers (plates 24.6 and 24.7).

24.6 (below) Embroidered cushion cover with bobbin lace insertions, Italy, 1550–1600 (cat.121)

24.7 (above) Linen and lace tablecloth, Italy, 1550–1600 (cat.66)

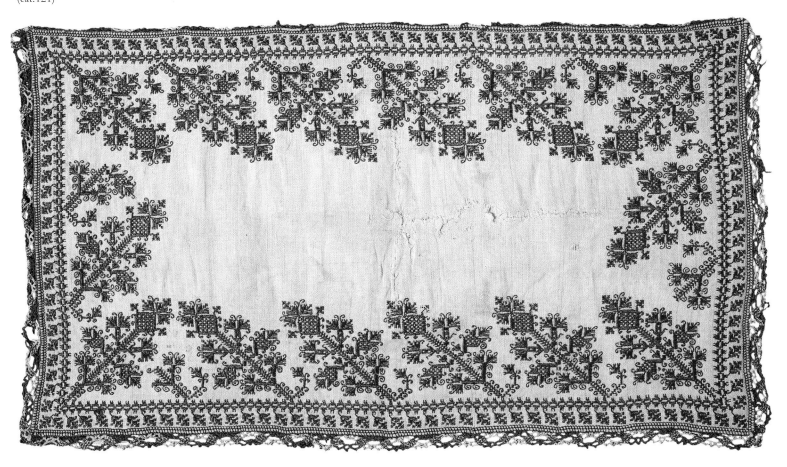

WOOL, LEATHER AND FUR

The warmth and hardwearing nature of woollen cloth made it a popular choice for both household furnishings and clothing. Although the most important textile furnishings in patrician interiors were often made of silk, tapestries were an exception to this. Woven mainly in wool, sometimes using silk and metal thread highlights, tapestries were chiefly imported from the Low Countries during the fifteenth century, before attempts were made to establish production in Italy. The 1496 inventory of Francesco di Angelo Gaddi, Florentine politician and close associate of Lorenzo de' Medici, lists in his bedroom three tapestries described as *panni d'arazzo*, worth 12 florins, followed by four red serge, painted cloths worth 10 florins.[13] The size of such hangings obviously significantly affected their value. Although, as a rule, only the wealthiest could afford to decorate an entire room with a large series of tapestries, smaller, individual pieces were more reasonably priced. Due to their prestigious nature, tapestries gave rise to many cheaper imitations and it is not always clear whether inventories and other contemporary sources refer to the more common worsted woollen hangings decorated with painted images, or tapestries with woven ones.

24.8 (*below and opposite*) Suede leather hat and jerkin, Italy, late 16th to early 17th century (cats 181 and 180)

As well as wall hangings, wool was used for covers and bed furnishings. Francesco Gaddi's house contained several brightly coloured serge bed valances, some of them painted with his family's coat of arms.[14] Geometrically patterned, woollen, knotted-pile carpets were rarely used to cover floors but were hung instead over tables, chairs and window seats (see p.315). Imported from Near Eastern countries such as Turkey from the fourteenth century onwards and subsequently copied in Italy, their vivid colours can often be seen in the foreground of portraits or other images of interiors (see plate 1.1).[15] While many of the furnishings referred to above would have been relatively permanent features within the domestic interior, it was also customary to temporarily drape the interior and exterior of a house with black woollen cloths following the death of a family member. According to contemporary theories on mourning dress, the matt surface of wool was considered more suited to the solemnity of these occasions than the sheen of silk textiles. The expense of such public displays of honour was substantial and as a consequence even wealthy families often hired woollen hangings rather than purchasing them outright. The Odescalchi, for example, rented roughly 105 metres of black cloth in 1601 for this purpose.[16]

Even during the height of summer household interiors with stone walls could be cold. In August 1544 the Duchess Eleonora of Toledo urgently requested some woollen clothing from Florence to be made and sent to her children in the country at Camaldoli, as they were 'dying of cold, with nothing else to wear but silk sarcenet'.[17] Two months later she ordered a pair of gowns lined with wolf fur for herself, specifying that the good furs were to be reserved for the shorter gown for outdoor wear, while the other gown, for use indoors, was to be longer and lined with the remaining, poorer quality furs.[18] Like fur, leather also provided warmth and was a frequent choice for men's jerkins, doublets and hats (plate 24.8). The majority of clothes designed specifically to be worn inside the house were full-length, dressing-gown-type garments, often made of wool and in addition lined with leather or fur. In 1573, for example, the Florentine senator Domenico Bonsi received a visit in his home from a Spanish Knight of St Stephen. Bonsi was unwell and so he remained in bed for the occasion but it is recorded

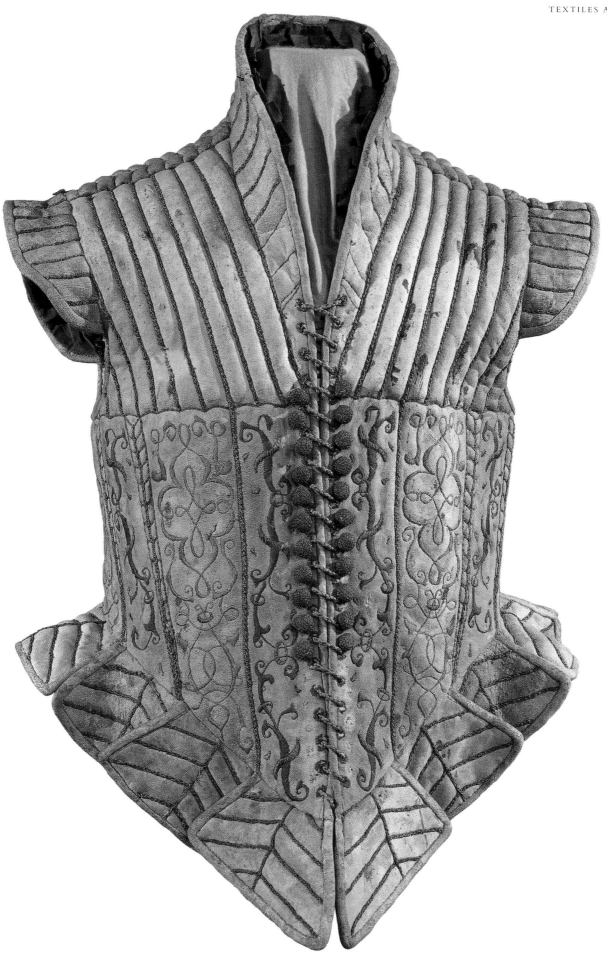

24.9 Silk velvet bed valance with padded appliqué, Italy, 16th century (cat.132)

that he 'threw on a *zimarra*' before his guest arrived.[19] The *zimarra* was a loose robe that reached to the floor, generally fastening down the front with rows of buttons or frogging. It was far removed from the increasingly tailored, outdoor male dress fashionable in Italy and was inspired by the flowing, less restrictive lines of eastern Mediterranean garments such as the Turkish kaftan.[20] Some sixteenth-century Florentine household accounts refer to clothing purchased 'for the house' and 'for the villa', and from the beginning of the following century the distinction between indoor and outdoor clothing in archival sources increases, as clothing became more codified and the descriptions necessarily more involved.[21] Clothing worn in a rural rather than an urban interior setting differed primarily in terms of colour and textiles. For example, cheap, locally produced woollens, such as those made in the Casentino valley to the north-east of Florence, were adopted by wealthy Florentines who would not have worn them in their town residences, and for men a brighter range of colours was considered more acceptable for villa life.

SILKS

Silk was initially imported from the Ottoman Empire, but by the late fifteenth century silk-weaving had been established in several Italian cities, even though the raw materials sometimes still hailed from more distant regions. Due to its expense, silk was used more frequently for dress fashions than domestic furnishings, but in wealthy households it was employed to make bed hangings, such as curtains, testers and valances, bed covers or cushions and usually required a far greater financial outlay than the wooden furniture it was intended to decorate. To enhance the prestige of silk furnishings, they were often embellished with metal threads in the form of appliqué work, embroidery or fringing, such as the cushions emblazoned with her own family's coat of arms that accompanied Caterina Pico della Mirandola to her marital home or this velvet bed valance embroidered with grotesques (plate 24.9).[22] For her marriage to the Genoese nobleman Fregosino da Campofregoso in 1489, the dowry of Chiara Sforza, the illegitimate daughter of Lucrezia Landriani and Galeazzo Maria Sforza, Duke of Milan, unusually included a large number of domestic furnishings, as well as personal clothing and jewellery.[23] Most of the belongings listed were made of silk. No fewer than eighteen wooden bed frames are described in the inventory, complete with mattresses and pillows, followed by a variety of silk hangings that could be used to cover them when necessary. These included baldachins and matching bed covers, which were mostly made of velvet but also some sheerer silks, such as sendal. A further indication of their value is the fact that the majority of the hangings were crimson, as the dye for this, obtained from the pregnant

kermes beetle, was one of the most costly. After the beds a variety of chairs were listed, covered with gold and silver silk cloths or crimson and green velvets.

Complex, multi-coloured brocaded velvets and damasks were reserved for the most important rooms or pieces of furniture in an interior but plain, shot or watered silks, such as tabbies or taffetas, were also particularly prized for their light-reflective qualities. Genoese inventories from the late sixteenth and early seventeenth centuries show that the bedrooms and *sale* of noble households were often decorated with moveable soft furnishings and wall hangings in co-ordinating colours.[24] Yellow was a popular choice, presumably as it gave the impression of an interior suffused with gold. Silk was also used to equip chapels within domestic settings, from embroidered silk bags to store the paraphernalia of the mass to altar frontals and curtains to protect the altarpiece, thereby mirroring on a more modest scale contemporary ecclesiastical interiors and vestments.

Unlike linens, which were replaced more regularly and consumed through use, due to their expense silk furnishings were often assembled in connection with important family occasions, such as a marriage, and

24.10 Santi di Tito, *Portrait of a Lady*, oil on wood, Florence, c.1600 (The Baltimore Museum of Art)

were used over a long period of time. Standard motifs, most notably pomegranates, pine cones or thistles, surrounded by elaborate, scrolling foliage, continued to be produced over many decades. The rare exceptions to this were lengths of fabric commissioned especially by an individual family during the late fifteenth and early sixteenth centuries, such as the highly costly brocaded velvets woven with the coats of arms of the Medici and the Soderini.[25] As a rule, therefore, patterned silks for the interior were not swiftly responsive to changes in fashion. During the fifteenth and early sixteenth centuries this was also true to a certain extent for clothing, given that silks used for dress and domestic purposes were mostly indistinguishable. This facilitated the practice of recycling goods, which was widespread at all social levels, from clothing to furnishing and vice versa. Traces of wax and faded patches on many surviving garments suggest that the textile was originally used for other purposes, as do the numerous items made from smaller fragments pieced together. This cycle of re-use is highlighted in the inventory of the Milanese widow Livia Tollentina, taken in 1580 after the death of her husband Giovanni Pietro Visconti. Many of the clothes Livia wore as a married woman were re-made into ecclesiastical hangings, upholstery for her coach and, in the case of a gold and turquoise gown, 'unpicked for the needs of my household'.[26] However, from the mid-sixteenth century onwards there was a growing production of velvets and lighter, cheaper silk fabrics for clothing, decorated with smaller motifs that were more suited to contemporary dress patterns (plate 24.10).[27] In contrast, textiles for domestic, as well as ecclesiastical, purposes were generally made of longer-lasting, high-quality silks and continued to employ the traditional motifs with large-scale repeats (plates 24.11 and 24.12).

Silk was occasionally also used for special garments intended to be worn indoors. The Milanese noblewoman Barbara Fagnami owned a silk gown 'for the house', made of green sarcenet embroidered with gold threads and valued for the very substantial sum of 150 imperial ducats in 1600.[28] Camilla Magalotti possessed a pink damask maternity cassock decorated with silver bows, presumably worn during pregnancy and when receiving visitors after the birth of her children.[29]

24.2 Embroidered linen
sheet or coverlet, Italy,
1575–1600
(cat.120)

Throughout the fifteenth and sixteenth centuries wooden surfaces and cold stone walls were draped with fabric, often in vivid, contrasting hues, transforming the appearance of interiors. It was possible to find a range of textiles in all rooms of the house, used not just for decoration, but also for the purposes of cleanliness, insulation and protection. The arts of dining, etiquette and sociable living were all complemented by the invention or refinement of suitable textile accessories. The great majority of goods were produced in Italy and developments in local textile industries meant that by the end of the sixteenth century there was an abundance of fabric types and motifs. Medium-cost products began to fill the gap between high-quality, extremely expensive silks and cheap cloths. Towards the end of this period, while some aspects of the designs for domestic and dress textiles differed, they increasingly converged in their use of elaborate combinations, dense embroideries and applied ornament.

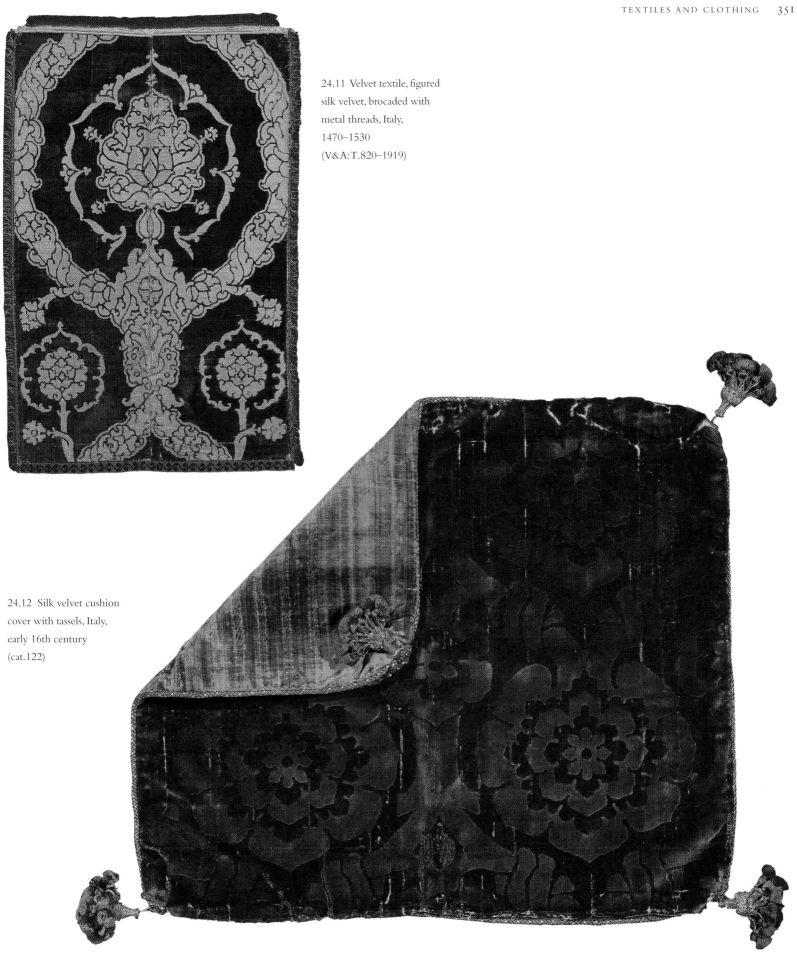

24.11 Velvet textile, figured silk velvet, brocaded with metal threads, Italy, 1470–1530 (V&A:T.820–1919)

24.12 Silk velvet cushion cover with tassels, Italy, early 16th century (cat.122)

SUMMARY CATALOGUE

The following summary catalogue entries have been prepared by a wide range of specialist scholars, curators and conservators consisting of Marta Ajmar-Wollheim, Peter Barber, Andrea Bellieni, Jim Bennett, Sarah Bercusson, Hugo Blake, Clare Browne, Fausto Calderai, Simone Chiarugi, Anna Contadini, Donal Cooper, Stephanie Cripps, Elizabeth Currie, Daniela degl'Innocenti, Flora Dennis, Patricia Fortini Brown, Nick Humphrey, Katherine Hunt, Reino Liefkes, Giorgia Mancini, Noreen Marshall, Ann Matchette, Elizabeth Miller, Peta Motture, Claudio Paolini, Brenda Preyer, James Robinson, Guia Rossignoli and Nicola Salvioli, Katy Temple, Dora Thornton, Jeremy Warren, Rowan Watson and Robert C. Woosnam-Savage, to whom the editors and summary catalogue editor would like to extend their warmest thanks.

Note: The following list is correct at the time of going to press.

Introduction

1. Portrait of a Lady, known as 'Smeralda Bandinelli'
PLATE 1.3

Sandro Botticelli, Florence, 1470s
Tempera on poplar panel, h 65.7 cm, w 41 cm
Inscr. 'Smeralda di … Bandinelli moglie d … Bandinelli' on the ledge (apocryphal; probably added in the 17th century by a member of the Bandinelli family)
V&A: CAI 100

Provenance
Pourtalès Collection, sold Paris, March 1865; Colnaghi, sold Christie's 23 March 1867, lot 1970; Howell for D. G. Rossetti; 1880 sold by Rossetti to Constantine Alexander Ionides, by whom bequeathed in 1900.

Bibliography
Kauffmann 1973, I, pp.37–9; Lightbown 1978, II, B15, pp.28–9; Campbell 1990, p.115; Rubin and Wright eds 1999, pp.326–7, no.83; Brown 2001, pp.172–5; Weinberg 2004, pp.20–26.

2. Model for the Strozzi Palace, Florence
PLATE 2.1

Giuliano da Sangallo, Florence, 1489–90?
Wood, h 73.7 cm, w 147.5 cm, d 117 cm
Museo Nazionale del Bargello, Florence, Inv. 71 V

Provenance
Strozzi Palace, Florence; acquired 1938.

Bibliography
Millon and Lampugnani eds 1994, p.519 with reference also to previous literature.

3. Doorknocker with a merman and a mermaid embracing
PLATE 20.5

Venice, 1550–1600

Bronze, h 30.5 cm, w 23.5 cm
V&A: A.76–1956

Provenance
Dr W. L. Hildburgh by 1948 (loaned to V&A); bequeathed by Dr W. L. Hildburgh, FSA, 1956.

Bibliography
Krahn ed. 1995, pp.306–7.

4. Iseppo da Porto and his Son Adriano
PLATE 9.2

Paolo Veronese, Venice, c.1551
Oil on canvas, h 207 cm, w 137 cm
Galleria degli Uffizi, Florence, inv. Contini Bonacossi no.16

Provenance
Palazzo Da Porto, Vicenza; Count Alessandro Contini Bonacossi.

Bibliography
Rearick 1990, pp.352–3; Gregori 1994, pp.280–81; Pignatti and Pedrocco 1995, I, pp.57–8; Priever 2000, p.20.

5. Livia da Porto Thiene and her Daughter Porzia
PLATE 9.2

Paolo Veronese, Venice, c.1551
Oil on canvas, h 208.4 cm, w 121 cm
The Walters Art Museum, Baltimore, Maryland, 37.541

Provenance
Palazzo Da Porto, Vicenza; private collection, Vicenza; acquired by Henry Walters from Paolo Paolini, Rome, 1921.

Bibliography
Piovene and Marini 1968, p.92; Pignatti 1976, pp.106–7, no.21; Zafran 1988, p.62; Rearick 1990, pp.353–4; Pignatti and Pedrocco 1995, I, pp.58–9; Priever 2000, p.20.

6. Rapier
PLATE 1.12

Italian, c.1600–1630

Steel, wood, l 135.9 cm, blade 119.7 cm
Inscr. 'IN TE DOMINI' in the fuller (groove), on one side of the blade, and 'SPERAVIT' on the other (In te Domini speravi: In thee, O Lord, I have hoped, Psalms 30 and 70). The ricasso (the blunt part at the base of the blade) bears on both sides a punched 'Maltese' cross.
Lent by the Board of the Trustees of the Armouries, Leeds, IX. 111

Provenance
Possibly from the old armoury of the Knights of Malta.

Bibliography
Unpublished.

7. Marten head
PLATE 8.11

Venice (?), mid-16th century
Enamelled gold, rubies, garnets and pearls,
l 8.4 cm
The Walters Art Museum, Baltimore, Maryland, 57.1982

Provenance
Unknown.

Bibliography
Hunt 1963; Randall 1967; Weiss 1970; Schiedlausky 1972; Garside 1979, pp.201–2, no.540; Musacchio 1999, p.136; Musacchio 2001, pp.183–4.

8. Plan of houses belonging to the Gaddi family of Florence
PLATE 2.5

Unknown draftsman, Florence, c.1560
Brown ink with brown, green, red, yellow and blue wash on white paper, h 42.3 cm, w 45.7 cm
Inscr. with many notes, including measurements, names of the component houses and of the spaces inside.
Uffizi, Gabinetto dei Disegni e Stampe, Florence, n.4301 A

Provenance
Unknown.

Bibliography
Ferri 1885, p.44; Bucci and Bencini 1971, p.12 and pl.XIII; Brucker 1984, p.60; Davis 1996, p.112, note 53.

9. Cross-section of houses belonging to the Gaddi family of Florence
PLATE 2.5

Unknown draftsman, Florence, c.1560
Brown ink with brown, green, red, yellow and blue wash on white paper, h 28.3 cm, w 43.5 cm
Inscr. with many notes, including measurements, comments about relative floor levels, names of the component houses and of the spaces inside.
Uffizi, Gabinetto dei Disegni e Stampe, Florence, n.4302 A

Provenance
Unknown.

Bibliography
Ferri 1885, p.44; Bucci and Bencini 1971, p.12 and pl.XIII; Brucker 1984, p.60; Davis 1996, p.112, note 53.

10. *Trattato di architettura* (Treatise on Architecture)
PLATE 19.15

Antonio di Piero Averlino, called Filarete, Milan, c.1460–64
Ink, wash, some colour and gold on paper in original binding, h 40 cm, w 29 cm
Biblioteca Nazionale Centrale, Florence, II, I, 140

Provenance
Piero de' Medici.

Bibliography
Filarete 1965; Filarete 1972; Giordano 1998.

11. *Regole generali di architettura* (General Rules of Architecture)
PLATE 3.1

Sebastiano Serlio, printed by Francesco Marcolini da Forlì, Venice, 1537
Paper. 76 fols, h 33.7 cm, w 23 cm
Royal Institute of British Architects, London, E.e.457

Provenance
Frederick R. Hiorns by whom presented around 1950.

Bibliography
Mortimer 1974, p.651, no 471; Serlio 1982, Book IV, Chapter 6, fol.31; Savage et al. 1994, p.1797, no.2966; Serlio 1996, p.156.

12. Inventory of Francesco Nori's house, Florence
PLATE 2.11

Unknown scribe, Florence, 1478
Paper, in recent binding, h 43 cm, w 30.5 cm
Archivio di Stato, Firenze, Magistrato dei Pupilli avanti il Principato, 174, fols.228–33v

Bibliography
Preyer 1983, pp.398–400; Lydecker 1987a, p.169; Apfelstadt 1987, pp.103–4; McKillop 1992, pp.708–11.

13. Bust of Giovanni di Antonio Chellini da San Miniato
PLATE 2.13

Antonio Rossellino, Florence, 1456
Marble, h 51.1 cm
Inscr. 'MAGR IOHANES MAGRI. ANTONII DE STO MINIATE DOCTOR ARTIVM ET MEDICINE./ MCCCCLVI' (within hollowed base); 'OPVS ANTONII' (in the centre)
V&A: 7671–1861

Provenance

Said to have been obtained by an unrecorded vendor from the palace of the Pazzi family in Florence in 1860, then purchased in Florence for the Museum.

Bibliography

Pope-Hennessy 1964, I, pp.124–6, no.103, fig.121; Avery 1970, pl.90, p.119; Pope-Hennessy 1970, pp.137, 139, 141 n.4; Schuyler 1976, pp.152–4, 155, 221, 237, figs 42, 82; Schulz 1977, pp.14, 16, 72, 81, 88, 126, figs 218, 219; Fusco 1982, p.184; Poeschke 1990, pp.137, 139, 144, pl.190.

14. The Virgin and Child with Four Angels
PLATES 2.14 and 19.11

Donatello, probably Padua, *c*.1450 (before 1456)
Bronze, diam 28.2 cm
V&A: A.1–1976

Provenance

Giovanni Chellini di San Miniato (1456); sold from the Gaddi collection lot 31, 21 March 1764; Marquis of Rockingham 1775–80; art market in London in 1975. Purchased with the aid of public subscription, with donations from the National Art Collections Fund and the Pilgrim Trust, in memory of David, Earl of Crawford and Balcarres.

Bibliography

Pope-Hennessy 1976, pp.172–91, figs 21–5; Radcliffe and Avery 1976, pp.377–87, figs 24–5, 29; Darr ed. 1985, pp.131–2, no.28; Pope-Hennessy 1986, pp.222–3; Baker 1989, pp.174–94; Poeschke 1990, pp.117, 137, pl.130; Dale 1995, pp.3–9; Williamson 1996, p.78.

15. Accounts and Family Chronicle (*Ricordanze*) Book G
PLATE 2.15

Giovanni Chellini, Florence, 1425–57
Paper bound in parchment, h 31 cm, w 21.5 cm
Inscr. 'Libro G'.
Istituto di Storia Economica, Università 'L. Bocconi', Milan, Archivio Saminiati-Pazzi, Sezione 1, vol.2

Provenance

Chellini (later called Saminiati) family, then Pazzi family, Florence; purchased 1936–7.

Bibliography

Lightbown 1962, pp.102–4; Janson 1964, pp.131–8; Chellini 1984, p.218; Groppi 1990, pp.30–34; Rubin 2006, ch.2.

Sala

TUSCAN *SALA*

16. *Acquaio* (wall fountain) from the Girolami Palace, Florence
PLATE 19.13

Unknown craftsman, Florence, *c*.1500
Pietra serena, h 426.7 cm, w 304.8 cm
V&A: 5959–1859

Provenance

Girolami, then Molini Palace, Florence.

Bibliography

Cicognara 1813–18, II, p.299; Pope-Hennessy 1964, II, pp.405–6 with reference also to previous literature; Preyer 1993, pp.85–6.

17. Young St John the Baptist
PLATE 19.17

Antonio Rossellino, Florence, *c*.1460
Marble, h 38 cm, w 29 cm, d 13 cm
Inscr. 'Ego vox clamantis in deserto' (I am the voice of one crying in the wilderness [John I: 23])
Museo Nazionale del Bargello, Florence, Inv.91

Provenance

Vittoria della Rovere, Urbino, 1631.

Bibliography

Planiscig 1942, pp.28–9, 53.

18. Ewer and basin
PLATE 19.18

Italian, Tuscany, *c*.1550–60
Copper alloy, ewer h 29.5 cm, basin diam 28.3 cm
Chiesa Arcipretura di S. Giovanni Battista, Fucecchio, on loan to Museo di Fucecchio, inv.24–5

Provenance

Collegiata, Fucecchio.

Bibliography

Dal Poggetto 1969, nos 26–7; Bianchi 1988, nos 197–8; Proto Pisani 2004, nos 24–5.

19. Footed bowl (cooling vessel)
PLATE 18.5

Venice, *c*.1480
Glass, mould-blown, enamelled and gilt, h 13.5 cm, w 31 cm
V&A: 5240–1901

Provenance

Transferred from the Museum of Practical Geology.

Bibliography

Unpublished.

20. Jug depicting the Triumph of Cupid
PLATE 19.16

Italian, Montelupo, *c*.1480
Tin-glazed earthenware, h 38.5 cm, diam 29 cm
V&A: 1568–1855

Provenance

Purchased from Delange, Paris.

Bibliography

Rackham 1940, cat.96; Cora 1973, tav 153, no.153a; Berti 1997–9, I, no.136; Berti 2002, cat.22, pp.123–7.

21. Fireplace with the arms of the Boni family of Florence
PLATE 19.12

Geri da Settignano?, Florence, *c*.1458
Pietra serena, h 259.5 cm, w 365.8 cm
V&A: 5896–1859

Provenance

Boni Palace near via dei Pecori, Florence; Dr Pietro Masi in villa 'Il Barduccio', Florence, *c*.1847.

Bibliography

Pope-Hennessy 1964, I, pp.135–8; Darr and Preyer 1999, pp.726–8 with reference also to previous literature.

22. Bust of a man
PLATE 19.7

Workshop of Benedetto da Maiano, Florence, 1475–1500
Marble, h 55.2 cm
V&A: 974–1875

Provenance

Purchased in Italy in 1875 from Aylmer, Stamp & Co.

Bibliography

Pope-Hennessy 1964, I, pp.160–61, no.135, fig.161; Schuyler 1976, pp.235–6, fig.115.

23. Pair of chairs
PLATE 15.22

Italian, Tuscany, 16th century
Carved walnut, h 85 cm, w 47 cm, d 38 cm
Museo della Fondazione Herbert Percy Horne, Florence, inv. nos. 152 and 696

Provenance

Probably acquired from a private collection in 1909.

Bibliography

Gamba 1961, p.51, no.59; Rossi 1966/7, p.162; *Il Museo Horne* 2001, p.72; Paolini 2002, pp.96–7.

24. Parade shield with the arms of the Villani family of Florence.
PLATE 2.6

Unknown craftsman, Florence, *c*.1450–1500
Painted and gilt gesso on wood, lined with leather, h 111.8 cm, w 55.9 cm
V&A: 3–1865

Provenance

Villani house, Florence; Guadagni Palace, Florence; Spence, Florence.

Bibliography

Hayward 1951, p.15; Curtis ed. 2004, no.20, p.83.

VENETIAN *SALA* (PORTEGO)

25. Four sections of cornice from the Benci palace, Venice
PLATE 3.5

Venice, 1581–1621
Pinewood (*Pinus cembra*)
8441: C–1863 l 194 cm, h 56 cm, d 29.5 cm
8441: D–1863 l 263 cm, h 55 cm, d 30 cm
8441: I–1863 l 209 cm, h 56 cm, d 29 cm
8441: N–1863 l 254 cm, h 55.5 cm, d 29 cm
V&A: 8441:C–1863; 8441:D–1863; 8441:I–1863; 8441N–1863

Provenance

Zuan Antonio and Lorenzo Tentor-Girardi-Zecchini at Palazzo Benci alla Madonna dell'Orto, Venice; Soulages Collection.

Bibliography

Pollen 1874, p.324; Pollen 1875 ill. p.68; Bassi 1980, pp.308–13.

26. Tapestry with the arms of the Contarini family of Venice: A Woodland Park with Palace and Pavilions
PLATE 3.4

Brussels, before 1589
Wool and silk, h 233.7 cm, w 402.8 cm
Marks: Brussels, and 'I.V. H.' attributed to the tapestry workshop of Joost van Herzeele.
V&A: 129–1869

Provenance

Purchased from Signor Gagliardi, 1869.

Bibliography

Wingfield Digby 1980, p.59; Brown 2004, pp.84–5. For the weavers' mark see Delmarcel 1999, p.366, no.31.

27. Tapestry with the arms of the Contarini family of Venice: A Woodland Glade with Horsemen
PLATE 3.4

Brussels, before 1589
Wool and silk, h 224.7 cm, w 134 cm
Marks: Brussels, and 'I.V. H.' attributed to the tapestry workshop of Joost van Herzeele.
V&A: 130A–1869

Provenance

Purchased from Signor Gagliardi, 1869.

Bibliography

Wingfield Digby 1980, p.59; Brown 2004, pp.84–5. For the weavers' mark see Delmarcel 1999, p.366, no.31.

28. Set of five chairs
PLATE 15.24

Italian, 16th century
Carved beech, h 87 cm, w 39 cm, d 27 cm

Museo Bagatti Valsecchi, Milan, inv. nos. 233–7

Provenance
Probably acquired around 1885.

Bibliography
Toesca 1918, pl.LIX; Ragghianti Collobi 1951, p.58; Gonzales-Palacios 1969, I, p.44; Pavoni 1994, p.70; Chiarugi 2003, p.134.

29. Lantern
PLATE 3.8

Venice, *c*.1570
Carved wood, partly gilt and painted, and iron, h 213.4 cm, diam 86.4 cm
V&A: 7225–1860

Provenance
Purchased from the Soulages Collection, 1860.

Bibliography
Pollen 1874, pp.171–2; Schottmüller 1928, p.XXXI; Thornton 1970, pp.124–5; Burns, Boucher and Fairbairn 1975, no.82.

30. The Virgin and Child (The Madonna of the Pomegranate)
PLATE 3.14

Giovanni Bellini and workshop, Venice, probably 1480–90
Oil on poplar, h 90.8 cm, w 64.8 cm
Signed on a *cartellino* (small piece of paper) on the parapet 'IOANNES / BELLINVS.P[INXIT]'
The National Gallery, London, NG 280

Provenance
Purchased from Baron Francesco Galvagna, Venice 1855.

Bibliography
Davies 1961, pp.56–7; Baker and Henry 1995, p.32.

31. Portrait of a Gentleman, probably of the Soranzo family of Venice
PLATE 3.6

Paolo Veronese, Venice, 1575–87
Oil on canvas, h 184 cm, w 113 cm
By kind permission of the Earl and Countess of Harewood, and the Trustees of the Harewood House Trust

Provenance
Reinst Collection in Venice in 1648 (in a pair with a painting portraying the sitter's wife); 1666 sale of Niccolò Renier's Collection, Venice (no.G.14); Sir Charles Robinson; 6th Earl of Harewood.

Bibliography
Hadeln 1924, p.209, n.1; Pallucchini 1939, pp.180–81; Martineau and Hope 1983, p.238; Pignatti and Pedrocco 1995, I, pp.431–2.

32. Gilded leather shield
PLATE 21.13

Venice, 1550–1600
Leather, glued to a wooden frame and decorated with gold and silver leaf, coloured varnishes, and liquid gold, h 57.3 cm
The central medallion has in its middle the Lion of St Mark, and beneath the initials A C, possibly indicating that it belonged to a member of the Contarini family.
Armeria di Palazzo Ducale, Musei Civici Veneziani, Venice, inv. J 14 (formerly inv. 122/Sala E)

Provenance
Probably Contarini family.

Bibliography
Grube ed. 1989, p.238 and figs 9–10B; Franzoi 1990, no.121, p.83 and fig.36.

33. Gilded leather shield with the arms of the Foscarini family of Venice
PLATE 21.14

Venice, 1550–1600
Leather, glued to a wooden frame and decorated with gold and silver leaf, coloured varnishes, and liquid gold, h 53.5 cm
Below the central medallion the coat of arms of the Foscarini family of Venice, flanked by the initials A F, probably in reference to Antonio Foscarini.
Armeria di Palazzo Ducale, Musei Civici Veneziani, Venice, inv. J 13 (formerly inv. 65/Sala E)

Provenance
Probably Foscarini family.

Bibliography
Grube ed. 1989, pp.237–8 and figs 4–5B; Franzoi 1990, no.109, p.82 and col. pl.25.

34. Sconce
PLATE 3.3

Italian, 16th century
Wrought iron, gilded, h 17.8 cm, w 30.5 cm
V&A: 5812–1859

Provenance
Unknown.

Bibliography
Unpublished.

ENTERTAINMENT

Music

35. The Concert
PLATE 16.1

Leandro Bassano, Venice, 1592
Oil on canvas, h 114 cm, w 178 cm
Uffizi, Florence, inv. 1890 n.915

Provenance
Entered the Uffizi in 1704.

Bibliography
Arslan 1960, I. p.241, II, fig.304; *Gli Uffizi* 1979, p.152; Gregori 1994, p.272.

36. Harpsichord
PLATE 16.2

Giovanni Antonio Baffo, Venice, 1574
Coniferous softwood, cypress, sycamore and pear wood decorated with ivory, rosewood, boxwood, ebony and parchment
Harpsichord: l 217 cm, w 83.9 cm, d 18.7 cm
Case: l 221.7 cm, w 89.8 cm, d 25.2 cm
Inscr. above the keyboard: 'IOANES ANTONIVS BAFFO VENETVS MDLXXIIII'. The case bears a coat of arms with three crescent moons, probably belonging to the Florentine Strozzi family.
V&A: 6007–1859

Provenance
Purchased in Florence from William Blundell Spence by Henry Cole.

Bibliography
Russell and Baines 1968, I, pp.33–5; Barnes 1971, pp.1–10; Wraight 1997; Schott, Baines and Yorke 1998, I, pp.32–5; Wraight 2000.

37. Octave spinet
PLATE 16.4

Italian, *c*.1600
Cypress, sycamore, pearwood, beech, ebony and ivory, painted inner lid of the case depicting Arion and the Dolphin and decorated with crescent moons, l 75.6 cm, w 38.5 cm, h 10 cm
V&A: 218–1870.

Provenance
Purchased in Florence from William Blundell Spence.

Bibliography
Russell and Baines 1968, I, pp.37–5; Schott, Baines and Yorke 1998, I, pp.46–7.

38. Lute back
PLATE 16.3

Laux Maler, Bologna, early 16th century
Sycamore, l 56 cm, w 33 cm
V&A: 194–1882

Provenance
Carl Engel.

Bibliography
Russell and Baines 1968, II, pp.29–30; Schott, Baines and Yorke 1998, II, p.30.

39. Jacques Arcadelt, *Il primo libro di madrigali* (The First Book of Madrigals)
PLATE 16.5

Printed by Antonio Gardano, Venice, 1541
Paper, four vols, each of 28 fols, h 15 cm, w 22 cm
Dedication in Bassus part-book from Gardano to Leone Orsino
The British Library, London, K.2.h.3

Provenance
Henry Fitzalan, Earl of Arundel; John Lumley, Baron Lumley.

Bibliography
Bridges 1982; Lewis 1988–97, I, pp.182–207, 255–60; Fenlon and Haar 1988, pp.240–44; Milsom 1993, pp.146–82; Fenlon 1995a, pp.69–70.

40. Giulio Cesare Croce [?] (pseud. 'Giulio Grotto'), *La Violina*
PLATE 16.10

Printed by Vittorio Baldini, Ferrara, 1590
Paper, 4 fols, h 15 cm, w 10 cm
The British Library, London, c.95.b.37

Provenance
Unknown.

Bibliography
Dennis 2002, pp.120–21. On the poem: Ferrari 1883; Ferrari 1888; Dursi 1966.

Games

41. Sisters Playing Chess
PLATE 15.14

Sofonisba Anguissola, Cremona, 1555
Oil on canvas, h 72 cm, w 97 cm
Inscr. 'SOPHONISBA ANGVSSOLA VIRGO AMILCARIS FILIA EX VERA EFFIGIE TRE SVAS SORORES ET ANCILAM PINXIT MDLV'.
Muzeum Narodowe, Poznan, The Raczynski Foundation

Provenance
Odoardo Farnese 1600; purchased in Naples by Luciano Bonaparte; purchased in Paris by Count Athanasius Raczynski in 1823.

Bibliography
Sofonisba Anguissola e le sue sorelle 1994, pp.190–91, with reference also to previous literature.

42. Inlaid table with trestle supports
PLATE 15.20

Northern Italian, 1500–1550
Walnut with inlay of bone and other woods, the trestle support with iron chains

The top (open) l 154.3 cm, w 92 cm, h 1.9 cm, height on stand (adjustable) 80–100 cm
V&A: 236–1869

Provenance
Purchased from Giuseppe Baslini of Milan.

Bibliography
Pollen 1874, p.294; Burns, Boucher and Fairbairn 1975, cat. no.88, p.57.

43. Games board
PLATE 15.13

Spanish, 16th century
Chestnut wood with ivory marquetry, l 53.5 cm, w 48 cm
V&A: 7849–1861

Provenance
Unknown.

Bibliography
Pollen 1874, p.169; Stanley, Rosser-Owen and Vernoit, 2004, p.130, pl.159.

44. Printed board game: *Biribissi*
PLATE 15.11

Filippo Succhielli, Siena, late 16th century
Etching and engraving h 41.7cm, w 32.5 cm
Lettered with inscriptions and 'Il nuovo gioco del ocha il quale serve per il Biribissi'
Civica Raccolta delle Stampe A. Bertarelli, Castello Sforzesco, Milan, Cart.m.8–1

Provenance
Achille Bertarelli

Bibliography
On the game see *Legni incisi della Galleria Estense* 1988, pp.167-68

45. Printed board game: *Pela il chiù* (pluck the owl)
PLATE 22.7

Ambrogio Brambilla, Rome, 1589
Etching and engraving, h 40.4, w 52.3 cm
Inscr. Brambilla's monogram and *'Romae Baptiste Parmensis formis 1589'*
The British Museum, London, 1869–4–10–2460 ★

Provenance
Purchased from Mr Daniell.

Bibliography
Ehrle 1908, p.62; Bertarelli 1929, p.61; Bury 2001, pp.152–3, no.103.

46. Two dice
PLATE 15.12

Florence, late 15th century
Bone, h 0.9 cm, w 0.4 cm
Museo Archeologico Nazionale Firenze, inv.225176

Provenance
Excavated in Via de' Castellani, Florence, 1982.

Bibliography
De Marinis 1997, no.99.

47. *Orlando furioso*
PLATE 11.19

Lodovico Ariosto, printed by Vincenzo Valgrisi, Venice, 1556
Paper. 529 fols, h 19 cm, w 11 cm
V&A: L.85–1868

Provenance
Purchased 1868.

Bibliography
Pollard 1914, p.299; Hofer 1945, pp.27–40; Bellocchi and Fava 1961, pp.18–19; De Simone ed. 2004, pp.165–6.

48. Puzzle cup (*tazza da inganno*)
PLATE 15.8

Italian, Deruta, 1520–30
Lustred tin-glazed earthenware, h 6.6 cm, w 22.5 cm
Inscr.'CHI.DELACOLODA.PASSA.LAS ECONDA.RIGA.DELVINO.NO(N)BE VERAMIGA' (Whoever goes beyond the second mark on the column will not drink the wine)
Museo Internazionale delle Ceramiche, Faenza, no.6151

Provenance
Bequeathed by Marquis Paolo Mereghi in 1953.

Bibliography
Ravanelli Guidotti *c*.1987, pp.133–4.

49. Vessel in the shape of a boot
PLATE 15.9

Italian, Faenza, 1550–1600
Tin-glazed earthenware, h 24.4 cm, w 21.3 cm
Museo Internazionale delle Ceramiche, Faenza, 21163

Provenance
Galeazzo Cora, given 1979.

Bibliography
Ravanelli Guidotti 1996, cat.140, pp.492–3.

DINING

50. Marriage Feast at Cana
PLATE 17.1

After Tintoretto, Greco-Veneto artist (Michele Damaskinos?), Venice, *c*.1561–70
Tempera and oil on wood panel, h 80 cm, w 118 cm
Museo Correr, Musei Civici Veneziani, Venice, Cl. I, n.255

Provenance
Unknown.

Bibliography
Mariacher 1957, p.140.

Table setting: Tuscany, *c*.1500

51. Towel, known as 'Perugia' towel
PLATE 24.3

Italian, 15th or 16th century
Woven linen and cotton, l 212 cm, w 66 cm
V&A: 487–1884

Provenance
Purchased in 1884 from the estate of W. Buller.

Bibliography
Endrei 1987.

52. Jug
PLATE 18.1

Venice, 1500–25
Blue glass, enamelled and gilt, h 20 cm, w 13 cm
V&A: 273–1874

Provenance
Webb Collection.

Bibliography
Honey 1946, p.60, plate 22B; Brooks 1975, p.25; Barovier Mentasti 1982, p.71, fig.50; Lanmon 1993, p.19, fig.3.1.

53. Glass beaker
PLATE 17.3

Venice, 1480–1510
Purple glass, blown in a dip-mould, h 7 cm.
Venice, NAUSICAA (Soprintendenza dei Beni Archeologici) 232

Provenance
Teatro Malibran excavation: found with later 15th-century pottery.

Bibliography
Unpublished.

54. Serving dish
PLATE 18.9

Italian, Montelupo, 1480–90
Tin-glazed earthenware, diam 33.5 cm
V&A: C.2065–1910

Provenance
Salting Bequest.

Bibliography
Rackham 1940, cat.130; Berti 1997–9, II, p.264, fig.69; Berti 2002, cat.33, pp.163–5.

55. Serving dish
PLATE 18.6

Italian, probably Montelupo, early 16th century
Tin-glazed earthenware, diam 35 cm
V&A: C.657–1909

Provenance
Given by Mr J. H. Fitzhenry.

Bibliography
Rackham 1940, cat.354; Cora 1973, fig.245a.

56. Plate
PLATE 18.7

Italian, Montelupo, 1500–1520
Tin-glazed earthenware, h 4.4 cm, diam 27.8 cm
Museo Archeologico e della Ceramica di Montelupo, Montelupo, A373

Provenance
Montelupo, 'Pozzo dei lavatoi' excavation.

Bibliography
Berti 1997–9, II, cat.71, p.265; Berti 2002, cat.34, pp.166–7.

57. Salt or condiment dish
PLATE 18.8

Italian, Florence area, *c*.1520
Tin-glazed earthenware, diam 13 cm
V&A: 695–1894

Provenance
Formerly in the wall over the south door of the Greek Chapel of the old monastery near the fortress of Kantara, Cyprus.

Bibliography
Rackham 1940, cat.357.

58. Knife
PLATE 17.2

Italian, *c*.1500
Silver and gilt bronze, l 15.7 cm
The Worshipful Company of Cutlers of London, Inv. 23

Provenance
Zschille Collection.

Bibliography
Masterpieces of Cutlery 1979, pp.24–5.

59. Fork
PLATE 17.2

Italian, 16th century
Gilt steel, l 15 cm
The Worshipful Company of Cutlers of London, Inv. C.1.1.5

Provenance
Acquired from Howard Smith in 1962.

Bibliography
Masterpieces of Cutlery 1979, pp.24–5.

Table Setting: Veneto *c*.1500

60. Cover
PLATE 24.1

Italian, 1500–1550
Linen diaper embroidered with silk, with silk braid and fringe, l 119 cm, w 54 cm
V&A: 940–1897

Provenance
Purchased from Messrs Howard and James, London, in 1897.

Bibliography
Unpublished.

61. Salver
PLATE 21.4

Probably Western Iran, late 15th–early 16th century
Brass, engraved and inlaid with silver, a black compound, and possibly once with gold, diam 49.5 cm
In the centre of the dish, an unidentified coat of arms.
V&A: 2061–1855

Provenance
Unknown.

Bibliography
Kühnel 1925, p.151 and fig.120; Mayer 1959, p.57, no.V (where it is mistakenly categorised as one of the pieces signed by Mahmud al-Kurdi); Huth 1970, p.4, pl.4 (where the piece is again misattributed to Mahmud al-Kurdi); Auld 2004, p.235, no.5.27.

62. Ewer with the arms of the Molino family of Venice
PLATE 21.2

Possibly Flanders or Germany and probably decorated in Egypt or Syria, 1450–1500
Brass inlaid with silver and a black compound, h 34.3 cm, d 12.7 cm
V&A: M.32–1946

Provenance
Presented by Dr. W. L. Hildburgh in 1946.

Bibliography
Hildburgh 1941, pp.18, 21 and fig.F; *Fifty Masterpieces of Metalwork* 1951, pp.56–7, no.27; Haedeke 1970, p.ix, no.72 and fig.72; Sievernich and Budde 1989, p.601, no.4/97 and col. pl.692; Auld 2004, p.294, no.8.3; Stanley, Rosser-Owen and Vernoit 2004, p.127 and col. pl.152.

63. Bowl, spoon and fork
PLATE 15.6

Venice or Venetian dominions, early 16th century
Silver, punched and chased, bowl: diam 12.1 cm; spoon: l 17 cm; fork: l 16 cm. Bowl and spoon with Venetian hallmarks (the Lion of St Mark, the

letter V and a cross). Spoon and fork with slip-top finials.
The British Museum, London, MLA 1986, 10–9, 2–4

Provenance
Part of a hoard from Cyprus, judging by coin evidence, hidden around 1570.

Bibliography
Unpublished.

64. Goblet
PLATE 18.4

Venice, *c*.1480
Glass, mould-blown, enamelled and gilt, h 15.8 cm, diam 9.6 cm
V&A: 7536–1861

Provenance
Unknown.

Bibliography
Nesbitt 1878, p.62.

65. Serving dish on low foot
PLATE 18.5

Venice, 1500–20
Glass, mould-blown enamelled and gilt, h 6.5 cm, w 25 cm
V&A: 5495–1859

Provenance
Soulages Collection.

Bibliography
Nesbitt 1878, p.73.

Table Setting: Bianchi di Faenza, *c*.1600

66. Lace tablecloth
PLATE 24.7

Italian, 1550–1600
Tabby linen with lacework, h 87 cm, w 204 cm
Museo del Tessuto, Prato, i. n.76.01.12

Provenance
Leopold Bengujat, Carlo Bruscoli and donated by Riccardo Bruscoli.

Bibliography
Unpublished.

67. Napkin
PLATE 24.4

Italian, 16th century
Woven silk and linen, l 133.5 cm, w 72.5 cm
V&A: 234–1880

Provenance
J. C. Robinson Collection; purchased in 1880.

Bibliography
Unpublished.

68. Plate
PLATE 15.5

Italian, Faenza, 1560–1620
Tin-glazed earthenware, h 4.7 cm, diam 23.5 cm

Museo Internazionale delle Ceramiche, Faenza, 17190

Provenance
Excavated in Faenza.

Bibliography
Ravanelli Guidotti 1996, cat.100, pp.410–11.

69. Serving dish
PLATE 18.10

Italian, Faenza, 1560–1620
Tin-glazed earthenware, h 4.4 cm, diam 33.5 cm
Museo Internazionale delle Ceramiche, Faenza, 18347

Provenance
Unknown.

Bibliography
Unpublished.

70. Plate with deep well
PLATE 18.10

Italian, Faenza, 1560–1620
Tin-glazed earthenware, h 6 cm, diam 21.3 cm
Museo Internazionale delle Ceramiche, Faenza, 28219

Provenance
Excavated in Faenza.

Bibliography
Ravanelli Guidotti 1996, cat.100, pp.410–11.

71. Egg cup
PLATE 18.11

Italian, Faenza, 1550–1600
Tin-glazed earthenware, h 9.8 cm, w 6.5 cm
Museo Internazionale delle Ceramiche, Faenza, 15158

Provenance
Gift of Sesto Menghi, 1966.

Bibliography
Ravanelli Guidotti 1996, cat.173, pp.552–3.

72. Salt
PLATE 18.12

Italian, Faenza, Calamelli workshop, *c*.1590
Tin-glazed earthenware, h 13.5 cm, w 18 cm
V&A: C.27–1923

Provenance
The Alfred Williams Hearn Gift.

Bibliography
Rackham 1940, cat.1024; Gennari 1956, pp.57–60 (workshop). Similar examples Ravanelli Guidotti 1996, pp.140–41, fig.26 and p.236, fig.3 and Ravanelli Guidotti 1998, pp.450–52.

73. Pouring vessel
PLATE 18.13

Italian, Faenza, *c*.1560–80
Tin-glazed earthenware, h 19 cm, w 21.5 cm
V&A: 353–1908

Provenance
Given by Mr J. H. Fitzhenry.

Bibliography
Rackham 1940, cat.1094; Ravanelli Guidotti 1996, cat.141, pp.494–5.

74. Dish with fruit and vegetables
PLATE 15.3

Italian, Faenza, *c*.1540
Tin-glazed earthenware, diam 23.5 cm
The Ashmolean Museum, Oxford, Fortnum C479

Provenance
Purchased by Fortnum in Paris in 1856; presented by C. D. E. Fortnum.

Bibliography
Unpublished. A similar marked dish attributable to the workshop of Virgiliotto Calamelli is Wilson 1987, no.115.

75. Wine glass (*tazza*)
PLATE 18.15

Probably Venice, 1550–1600
Glass, applied and tooled decoration, h 13.5 cm, w 16 cm
V&A: 188–1879

Provenance
Robinson Collection.

Bibliography
Mariacher 1959, p.44; Liefkes 1997, pp.50–53, fig.58.

76. Knife, spoon and fork
PLATE 20.15

Venice, 16th century
Silver and rock crystal, knife: l 21 cm
Museo Correr, Musei Civici Veneziani, Venice, classe XXXI, no.264

Provenance
Unknown.

Bibliography
Pazzi 1993, p.238.

77. Ewer
PLATE 20.16

Venice (Murano), 1550–1600
Glass, moulded and blown, with twisted opaque white canes (*vetro a retorti*) and plain canes, h 27.5 cm
The British Museum, London, MLA 1869, 6–24, 45

Provenance
Sir Felix Slade, FSA; given by the executors of his estate in 1869.

Bibliography
Tait 1979, cat.158.

78. Cooling bowl
PLATE 18.14

Venice, 1575–1600
Filigree glass, mould-blown, h 10 cm,
diam 27 cm
V&A: 5221–1901

Provenance
Transferred from the Museum of
Practical Geology.

Bibliography
Unpublished. Similar-shaped bowl with
a different filigree pattern and cold-
painted decoration in the Museo Civico,
Turin, Barovier Mentasti 1982, p.80,
fig.64. Similarly shaped bowl from the
Hermitage Museum, St Petersburg
Lanmon 1993, p.86, fig.25.9.

Sets and Display

79. *Credenza*
PLATE 1.10

Florence?, end of the 16th century
Carved walnut with gilding, poplar
and fir lining, h 134 cm, w 223 cm,
d 51.5 cm
Museo Nazionale del Bargello, Florence,
Inv. n.223

Provenance
Confraternity of Pieve di San Michele
in Carmignano; donated by Giovanni
Bruzzichelli in 1983.

Bibliography
Mostra Mercato Internazionale 1963,
pp.294–5, n.63; *Il Museo del Bargello*,
1984; Gaeta Bertelà, Paolozzi Strozzi and
Spallanzani eds 1988, pp.90–91,
nn.240–41; Massinelli 1993, p.162,
pl.XLIX.

**80. Two jars with the arms of the
Gondi family of Florence**
PLATE 18.3

Spanish, Valencian region, probably
Manises, 1486–7
Tin-glazed earthenware with lustre
decoration, jars with four handles
and covers in shape of miniature jars,
h approx 54 cm.
The British Museum, London, MLA G
552–3, 554–5

Provenance
Frederick Du Cane Godman;
bequeathed by Miss Edith Godman in
1983.

Bibliography
Frothingham 1951, p.190; Wilson 1987,
cat.15; Spallanzani 2006, pp.68–9, 195,
498 (Doc. 379), pls 102–3.

**81. Bowl with the arms of the
Gondi family of Florence**
PLATE 18.3

Spanish, Valencian region, probably
Manises, 1486–7

Tin-glazed earthenware with lustre
decoration, h 6.1 cm, w 24 cm
V&A: 2047–1910

Provenance
Hôtel Drouot, Paris, 8 May 1894, lot 9;
Salting Bequest.

Bibliography
Ray 2000, p.86, cat.186, pl.23;
Spallanzani 2006, pp.68–9, 195, 498
(Doc. 379), pl.104.

**82. Cruet with the arms of the
Salviati family of Florence**
PLATE 15.4

Italian, Faenza, 1531
Tin-glazed earthenware, painted
on blue-tinted ground (*berettino*),
h 25 cm, w 15.5 cm
Inscr. 'OLLIO', and dated '1531'.
V&A: C. 2123–1910

Provenance
Spitzer Collection; Salting Bequest.

Bibliography
Rackham 1940, cat.290; Ravanelli
Guidotti 1990, no.143, pp.280–81;
Wilson 2003, pp.177–8, fig.95.

**83. *Coppa* (basin) with the arms
of the Salviati family of Florence**
PLATE 15.4

Italian, Faenza, possibly made in the
workshop of Pietro Bergantini, 1531
Tin-glazed earthenware, painted on
blue-tinted ground (*berettino*), h 12 cm,
diam 31.5 cm
Dated '1531'
Museo Civico, Turin, 2725/c

Provenance
Riccardo Gualino Collection; purchased
from Accorsi, Turin.

Bibliography
Mallé 1974, no.19; Pettenati 1982, p.110,
cat.42; Ravanelli Guidotti 1988, p.216,
Tav. V; Ravanelli Guidotti 1990, no.143,
pp.280–81; Wilson 2003, p.184, note 8.

**84. Plate with the arms of
the Salviati family of Florence**
PLATE 15.4

Italian, Faenza, probably 1531
Tin-glazed earthenware, painted on
blue-tinted ground (*berettino*); diam
37.3 cm Unidentified mark in foot.
The British Museum, London, MLA
1855, 12–1,100.

Provenance
Ralph Bernal; acquired at the Bernal
Sale, 1855.

Bibliography
Wilson 1987, no.113.

85. Ewer and basin
PLATE 15.7

Venice, *c*.1580
Silver gilt, ewer: h 43.6 cm, diam 17.6

cm; basin: diam 67.6 cm
Marks W and SB in monogram.
V&A: M.237 and 237A – 1956

Provenance
Dr. W. L. Hildburgh bequest.

Bibliography
Oman 1962, pls 9–14; Taylor 1964, p.83;
Pazzi 1993, pp.54–5.

**86. Set of twelve knives and
serving knife**
PLATE 1.4

Italian, Milan, *c*.1460
Iron blades with parcel gilt silver
handles, l 26.5, 27, 27.3, 28.5, 23.5, 22,
24, 24, 22, 23.5, 23, 23.5 cm, serving
knife l 33 cm
Inscr. 'FINCHE VIVO – E DA POI LA
MORTE'; 'PER AMARTE – CHOM
FEDE'; 'SPERO LVCEM'; 'FIN CHE
VIVO P[ER] – AMARTE'; 'SPERO
TVO BENE'; 'IN TI SOLA – DVM
VIVAM'; 'NIVIS AMOR DVRAT';
'FIDELITAS ET AMOR'. ('While I live
– and after death'; 'To love you – with
faith'; 'I hope in light'; 'While I live – to
love you'; 'I hope for your good'; 'In you
alone – while I live'; 'Love endures the
snow'; 'Faith and Love')
Civiche Raccolte d'Arte Applicata e
Incisioni, Castello Sforzesco, Milan,
Bronzi 12–24

Provenance
Acquired from the sale of Prince Gian
Giacomo Trivulzi's collection, Milan,
1935.

Bibliography
Alberici 1978; Zastrow 1993, nos 62–74.

KITCHEN

87. *Cucina* (kitchen scene)
PLATE 23.1

Vincenzo Campi, Cremona, 1580s
Oil on canvas, h 145 cm, w 220 cm
Accademia di Brera, Milan, no.297
(1980)

Provenance
Listed (with four other paintings,
including the San Martino, see cat.
no.263) in the will of Elena Luciani,
Campi's widow, in 1611; acquired by the
monastery of San Sigismondo in
Cremona in 1623; from 1809 in the
collection of the Accademia di Brera,
Milan.

Bibliography
Paliaga 2000a, pp.152–4, with reference
also to previous literature.

88. Apron
PLATE 11.1

Italian, 1550–1600
Tabby linen with lacework, h 90 cm,
w 90 cm, belt 87 cm
Museo del Tessuto, Prato, in. n.76.01.18

Provenance
Leopold Bengujat; Carlo Bruscoli and
donated by Riccardo Bruscoli.

Bibliography
Palazzo Vecchio 1980, p.361, n.733.

89. *Opera*
PLATE 17.4

Bartolomeo Scappi, printed by Michele
Tramezzino, Venice, 1570
Paper, 436 fols, h 22 cm, w 17 cm.
Bound in a mid-16th century pigskin
binding, blind stamped with the Four
Evangelists, with a bookplate lettered
'C.W.G.V.N', and with the stamp of the
Patent Office Library.
The British Library, London, 1651/431

Provenance
Probably the Augustinian monastery at
Klosterneuburg; Christoph Wenzel Graf
von Nositz (1643–1712); Patent Office
Library [founded 1855]; British Museum
1966.

Bibliography
Haebler 1928–9, p.220; Simon 1953,
p.128; *Et coquatur ponendo* 1996,
pp.304–5.

**90. *I secreti de la signora Isabella
Cortese* (The Secrets of Signora
Isabella Cortese)**
PLATE 13.1

Written anonymously under the
pseudonym Isabella Cortese; printed by
Giovanni Bariletto, Venice, 1561
Paper, 88 fols, h 16 cm, w 11 cm
Full title: 'I secreti de la signora Isabella
Cortese. Ne' quali si contengono cose
minerali, arteficiose, & alchimiche, &

molte de l'arte profumatoria, appartenenti a ogni signora.' (The secrets of Signora Isabella Cortese. In which are included mineral, man-made and alchemical things and many [things] concerning the art of perfumery, suitable for any lady). With additional manuscript recipes in Italian possibly in a 16th century hand. Bound with two other works, the first insr. by Sloane in code '1689.6d'.
The British Library, London, 1038.c.4.(2)

Provenance
Sir Hans Sloane 1689; Foundation collection of the British Museum, 1753.

Bibliography
Eamon 1994, pp.135–7, 164, 194, 290.

91. Wooden fireplace hood
PLATE 10.2

Italian, Veneto carver, Treviso, c.1450
Carved larch wood, h 24.5 cm, w 199 cm, d 104.5 cm
Museo della Casa Trevigiana Ca' Da Noal, Treviso, inv. M 451

Provenance
Acquired from Luigi Bailo at the end of the nineteenth century.

Bibliography
Unpublished.

92. Firedogs
PLATE 10.3

Italian, 16th century
Wrought iron, brass, h 69.2 cm, l 48.2 cm, w 24.7 cm
V&A: 56 and 56A–1905

Provenance
Received from A. Johnson & Sons.

Bibliography
Unpublished.

93. Trivet
PLATE 10.4

Northern Italian, 1535–40
Iron, h 17.5 cm, diam 21 cm
Museo Archeologico e della Ceramica di Montelupo, Montelupo, MET003

Provenance
From the area of Castello di Montelupo.

Bibliography
Unpublished.

94. Terracotta cooking pot
PLATE 23.6

Italian, Ferrara, end of the 15th century
Ceramic, inside glazed, h 11.2 cm, rim diam 12 cm
Museo Nazionale Archeologico, Ferrara, inv. 66866

Provenance
Excavated from the convent of Sant' Antonio in Polesine, Ferrara, 1994–5.

Bibliography
Guarnieri 2005.

95. Bowl for food preparation
PLATE 23.8

Italian, Ferrara, end of the 15th century
Ceramic, inside glazed green, h 8 cm, rim diam 22.2 cm
Museo Nazionale Archeologico, Ferrara, inv. 68393

Provenance
Excavated from the convent of Sant' Antonio in Polesine, Ferrara, 1994–5.

Bibliography
Guarnieri 2005.

96. Pastry cutter
PLATE 17.5

Italian, 17th century
Iron, l 12.3 cm
Inscr. 'Allerina'.
V&A: 105–1884

Provenance
Given by Mr. G. Baslini.

Bibliography
Unpublished.

97. Mortar
PLATE 23.2

Italian, Liguria, early 17th century
Marble, h 13.2 cm, rim diam 20.5 cm
Soprintendenza per i Beni Archeologici della Liguria, Genoa, inv. RCGE 80827

Provenance
Excavated from a shipwreck off Varazze (prov. Savona) (excavation inv.178), 1991–4.

Bibliography
Martino and Bracco 1999, p.211, fig.14.

98. Wooden bowl
PLATE 23.7

Italian, probably Liguria, 17th century
Wood, h 7.9 cm, rim diam 17 cm
Soprintendenza per i Beni Archeologici della Liguria, Genoa, inv.93030

Provenance
Excavated in the old port, Genoa (US 5037), 1995–6.

Bibliography
Bandini 1999, pp.90–91; Bulgarelli 2001, p.128.

99. Wooden spoon
PLATE 23.7

Italian, probably Liguria, 17th century
Wood, handle: l 12.4 cm; bowl: l 4.7 cm, w 3.7 cm
Soprintendenza per i Beni Archeologici della Liguria, Genoa, inv. 92980

Provenance
Excavated in the old port, Genoa (US5037), 1995–6.

Bibliography
Bandini 1999, pp.91–2; Bulgarelli 2001, p.128.

100. Dish
PLATE 17.6

North Italian or Tuscan, c.1500
Incised slipware, diam 21 cm
V&A: 1225–1901

Provenance
Found in excavations in Florence; purchased from Giuseppe Salvadori, Florence.

Bibliography
Rackham 1940, cat.1389.

101. Jug
PLATE 17.6

North Italian, probably Bologna, c.1510–20
Earthenware, incised, green glaze, h 17 cm, diam 15.5 cm
V&A: 1187–1901

Provenance
Purchased from G. Brauer, Florence.

Bibliography
Rackham 1940, cat.1395.

102. Oil and vinegar cruet
PLATE 17.6

North Italian, probably Venice or Padua, 1530–40
Incised slipware, h 13.5 cm, w 16.5 cm
Inscription: 'OIO' (for *olio*) and 'ASE' (for *aceto*)
V&A: C.35–1923

Provenance
The Alfred Williams Hearn Gift.

Bibliography
Rackham 1940, cat.1407. Similar example in the British Museum, dated 1525, Fortnum 1896, p.118.

103. Bowl
PLATE 17.6

Italian, Veneto, possibly Padua, 1475–1500
Glazed earthenware with incised decoration, h 6 cm, diam 11.8 cm
V&A: 380–1889.

Provenance
Purchased from Mr Fairfax Murray, London.

Bibliography
Unpublished.

104. *Conca* or washing bowl
PLATE 11.5

Italian, Montelupo, 1540–1570
Ceramic, h 16 cm, rim diam 35.5 cm
Museo Archeologico e della Ceramica, Montelupo, inv. R 104/94

Provenance
From the area of Castello di Montelupo.

Bibliography
Berti 1997–9, III, pp.222, 439.

105. Bucket
PLATE 23.9

Northern Italian, 16th century
Wood and iron, h 24 cm, opening 22.3 by 26.3 cm
Soprintendenza per i Beni Archeologici della Liguria, Genoa, inv. 99757

Provenance
Excavated from the former Pammatone Hospital, Genoa, 1965.

Bibliography
De Floriani 1978, pp.120–23.

106. *Mezzina* (water pail)
PLATE 23.10

Italian, Montelupo, c.1480–90
Ceramic, h 38 cm, max diam 27 cm
Museo Archeologico e della Ceramica, Montelupo, Montelupo, inv. 207119

Provenance
Excavated in Palazzo Podestarile (cess pit B), Montelupo.

Bibliography
Berti 1997–9, III, pl.404.

107. Four bowls, a basin, a food warmer, a handled vessel and a cooking pot from the Mugnai Hoard
PLATE 23.3

Italian, 14th–16th century
Bowls: pewter; basin, food warmer and handled vessel: bronze; cooking pot: copper
Bowls: h 4.2 cm, diam 16 cm; basin: h 5 cm, diam 34 cm; food warmer: h 9.5 cm, diam 17.3 cm; handled vessel: h 17.5 cm (handle raised), diam 9 cm; cooking pot: h 9.5 cm, diam 15.6 cm
Museo Civico di Feltre, Feltre, Inv. n.10

Provenance
Excavated at Riva Bellata, Mugnai in 1912.

Bibliography
Pianca and Velluti 2002, p.109.

Camera

INTRODUCTION

108. Birth of the Virgin
PLATE 1.1

Vittore Carpaccio, Venice, *c*.1504–8
Oil on canvas, h 126 cm, w 129 cm
Inscr. 'VICTOR. CARPATIVS V.
FACIEBAT' on lower right (apocryphal;
probably added in 1811 when the work
was transferred to Milan).
Accademia Carrara, Bergamo, n.731
(155)

Provenance
Scuola di Santa Maria degli Albanesi,
Venice; after the Napoleonic suppression
in 1808, passed to the Pinacoteca di
Brera in 1811; Teodoro Lechi in Brescia;
Guglielmo Lochis of Bergamo, by
whom bequeathed in 1859.

Bibliography
Lauts 1962, pp.33–4, 234–5; Rossi 1979,
p.44; Sgarbi 1979, no.29; Pignatti 1981,
pp.94–5; Brown 1988, pp.290–91;
Borean 1994, pp.21–72; Aikema and
Brown eds 1999, pp.220–21;
Heimbürger 1999, pp.36–8; Brown
2004, pp.100–101.

109. Bed
PLATE 1.8

Central Italian, 16th century
Walnut, h 252 cm, w 163.5 cm, d 214
cm
Palazzo Davanzati, Florence, Inv. n.204

Provenance
Donated by Mrs Matilde Colman
Loeser in 1959.

Bibliography
Berti 1971, pp.203–4, pl.77.

**110. Octagonal table with the arms
of the Guicciardini and Salviati
families of Florence**
PLATE 15.21

Fra Damiano da Bergamo from a design
attributed to Giacomo Vignola, Bologna,
early 1530s
Carved walnut, painted and highlighted
with gold, veneered with walnut, ebony,
box, ironwood, maple root, thuja root
and other coloured woods, silver and gilt
iron boss, h 82.5 cm, w 139 cm
Private collection

Provenance
Private collection by descent.

Bibliography
Tinti 1928, pls CXXVI and CXXVII;
Gregori 1960, p.75 n.200, fig.127;
Bandera 1972, p.12, figs 37–8; Manni
1986 p.131, fig.64; Thornton 1992,
(1991) p.212.

TUSCAN *CAMERA*

**111. The Magnanimity of
Alexander the Great**
PLATE 19.6

Workshop of Domenico Ghirlandaio
(Bastiano Mainardi and Davide
Ghirlandaio?), Siena?, *c*.1493–5
Tempera on wood, h 76 cm, w 229.5 cm

**112. Julius Caesar and the
Crossing of the Rubicon**
PLATE 19.6

Workshop of Domenico Ghirlandaio
(Francesco Granacci?), Siena?, *c*.1493–5
Tempera on wood, h 73.5 cm, w 170 cm
Both accepted by HM Government in
lieu of Inheritance Tax and allocated to
the Victoria and Albert Museum, 2005

Provenance
Palazzo Spannocchi, Siena; Alexander
Barker [d. 1873], London, by 1854
(his sale, Christie, Manson & Woods,
London, 6th, 8th–11th June 1874,
nos 82 and 83, as by Pinturicchio);
purchased by John Alexander Thynne,
4th Marquess of Bath, Longleat House.

Bibliography
Berenson 1968, p.252; Santi and Strinati
eds 2005, pp.201–3.

113. St Jerome in the Wilderness
PLATE 2.8

Piero di Cosimo, Florence, *c*.1495–1500
Oil on panel (frame carved from the
same panel), diam 74 cm
Museo della Fondazione Herbert Percy
Horne, Florence, inv. no.31

Provenance
Purchased in 1906 by Herbert Percy
Horne.

Bibliography
Bacci 1966, pp.72–3; Rossi 1966/7,
pp.142–3; Bacci 1976, pp.87–8; Fermor
1993, pp.201–3; Forlani Tempesti and
Capretti 1996, p.114, no.21; Olson 2000,
p.251.

114. Bust of Pietro Mellini
PLATE 2.12

Benedetto da Maiano, Florence, 1474
Marble, h 52 cm, w 62 cm, d 36 cm
Inscr. inside 'Anno 1474' (In the year
1474) 'Petri Mellini Francisci Filii Imago
Hec' (This [is] the image of Pietro
Mellini the son of Francesco), and on
the underside 'Beneditus Maianus Fecit'
(Benedetto da Maiano made [this])
Museo Nazionale del Bargello, Florence,
Inv.52s

Provenance
Mellini Palace, Florence; bought for
'Galleria delle Statue' from unrecorded
vendor, 1825.

Bibliography
Lavin 1970, p.217; Barocchi and

Gaeta Bertelà 1985, p.79; Carl 1994,
pp.158–61; Carl (forthcoming).

115. The Virgin and Child
PLATE 19.8

Florence, c.1425–50
Painted stucco, h 92.7 cm, w 72.4 cm,
d 21 cm
V&A: A.11–1932

Provenance
Purchased in London, 1932.

Bibliography
Pope-Hennessy 1964, I, p.61, no.53,
fig.65; Johnson 1997, pp.4, 6, figs 1.7–8;
Curtis ed. 2004, p.95, no.36.

116. Birth tray (*desco da parto*)
PLATE 8.1

Domenico di Bartolo?, Tuscany,
before 1445
Tempera on panel, diam 57 cm
Birth scene on the front; two nude boys
with sashes, one wearing a coral amulet,
in a garden, on the back.
Galleria G. Franchetti alla Ca' d'Oro,
Venice, D.85

Provenance
Unknown.

Bibliography
Berenson 1932, p.171; Fogolari 1965,
p.10; Valcanover 1986, p.40; De Carli
1997, no.26, pp.122–3; Musacchio 1999,
pp.27–8, 131–2; Däubler-Hauschke
2003, no.8, pp.191–3.

**117. Wedding chest with the arms
of the Rossi (?) and Pitti families
of Florence**
PLATE 7.18

Attributed to the workshop of Lorenzo
da Credi, Florence, *c*.1480
Poplar wood painted with tempera,
h 43 cm, w 153 cm, d 43 cm
Museo della Fondazione Herbert Percy
Horne, Florence, inv. n.148

Provenance
Unknown.

Bibliography
Paolini 2002, pp.77–80.

118. Flower vase
PLATE 6.7

Spanish, Valencia, probably Manises,
1435–75
Tin-glazed earthenware with lustre
decoration, h 52.8 cm, w 39 cm,
d 20.3 cm
V&A: 8968–1863.

Provenance
Soulages Collection.

Bibliography
Ray 2000, pp.84–5, cat.180, pl.21.

**119. Box with the arms of the
Buondelmonte family of Florence**
PLATE 5.2

Florence, *c*.1460
Hardwood, covered with gilt gesso
decoration and partly painted in glaze,
lined with silk, h 13.4 cm, diam 33.4 cm
V&A: 5757–1859

Provenance
Unknown.

Bibliography
Pollen 1874, pp.29–30; Lorenzelli 1984,
p.112.

120. Sheet or coverlet
PLATE 24.2

Italian, 1575–1600
Tabby linen embroidered with silk,
h 220 cm, w 184 cm
Museo del Tessuto, Prato, i. n.76.01.13

Provenance
Leopold Bengujat; Carlo Bruscoli and
donated by Riccardo Bruscoli.

Bibliography
Unpublished.

121. Cushion cover
PLATE 24.6

Italian, 1550–1600
Linen embroidered with silk, with
bobbin lace insertions, l 27 cm,
w 48.5 cm
V&A: Circ.7–1913

Provenance
Purchased from M. Fulgence, Paris,
in 1913.

Bibliography
Unpublished.

122. Cushion cover
PLATE 24.12

Italian, early 16th century
Pile on pile silk velvet, with plain velvet
back, edged with silk cord, and silk and
metal thread tassels, l 60.5 cm, w 51 cm
V&A: T.238–1965

Provenance
Purchased from a private collection in
1965.

Bibliography
Unpublished.

CAMERA D'ORO

123. Fireplace
PLATE 19.1

Vincenzo and Gian Matteo Grandi, Padua, c.1510–30
Tufa, h 231.8 cm, w 236.2 cm
V&A: 655–1865

Provenance
Soulages Collection; purchased in 1865.

Bibliography
Pope-Hennessy 1964, II, pp.508–10, no.538, figs 534–5; Warren (forthcoming) in which the fireplace is newly attributed to Vincenzo and Gian Matteo Grandi.

124. Firedogs surmounted with figures of Meleager and Atalanta and with the arms of the Barbaro family of Venice
PLATE 19.2

Venice, c.1590–1620
Bronze, 8413–1863 (Meleager) h 116 cm, w 64 cm, d 86 cm; 8413A–1863 (Atalanta) h 117.5 cm, w 66 cm, d 86 cm
V&A: 8431, 8431A–1863

Provenance
Soulages Collection; purchased 1863.

Bibliography
Robinson 1856, p.109; Burns, Boucher and Fairbairn 1975, p.16, no.III; Motture 2003, fig.8, pp.282, 296, no.3 with reference also to previous literature.

125. Bellows with the arms of the Giustiniani and Rossi families of Venice
PLATE 10.5

Italian, c.1530
Walnut partly gilded, with bronze, leather and silk velvet, h 70.5 cm, w 26 cm, d 7 cm (closed)
V&A: 7698–1861

Provenance
Possibly commissioned for a member of the Giustiniani and Rossi families of Venice; Soulages Collection.

Bibliography
Pollen 1874, p.8; Bode 1902, p.22.

126. Virgin and Child (The Jones Madonna)
PLATE 14.13

Carlo Crivelli, Ascoli Piceno, c.1480
Tempera on panel with gilded stucco, h 48.5 cm, w 33.6 cm
Inscr. 'OPVS.CAROLI.CRIVELLI. VENETI'
V&A: 492–1882

Provenance
Bought probably in Italy in the early 1860s by collector John Jones, by whom bequeathed in 1882.

Bibliography
Kauffmann 1973, pp.78–9; Lightbown 2004, pp.266–8 and pl.108.

127. Lamp with the arms of the Tiepolo family of Venice
PLATE 3.7

Venice, early 16th century
Glass, enamelled and gilt, h 28.5 cm, diam 7 cm
Museo del Vetro-Murano, Musei Civici Veneziani, Venice, Cl.VI, n.2

Provenance
Teodoro Correr Collection, left to the city of Venice in 1830.

Bibliography
Mariacher 1959, p.36; Barovier Mentasti 1982, cat.107, pp.100–101; Dorigato 2003, pp.20–24.

128. Venus in her Bedchamber
PLATE 3.10

Attributed to Lambert Sustris, Venice or Padua, c.1548
Oil on canvas, h 116 cm, w 186 cm
Rijksmuseum, Amsterdam, inv. A3479

Provenance
Villa Borghese, Rome (until the end of the 18th century); Rundell; W. Young Ottley; W. Willet (before 1824); W. Buchanan; L. W. Neeld (after 1829); sold by L. Neeld, Grittleton House, London, Christie's 13 July 1945, lot 42 to Fenouil; acquired by Rijksmuseum through Thomas Harris, Garden Lodge Studio, London, 1946.

Bibliography
All the Paintings of the Rijksmuseum in Amsterdam 1976, p.529; Martineau and Hope eds 1983, p.211; Reist 1988, pp.256–67; Aikema and Brown 1999, pp.532–3; Brown 2004, pp.172–4.

129. Leather panel
PLATE 3.12

Florence?, 16th century
Tooled, polychromatic, silver and gold painted, lacquered leather, h 268.4 cm, w 265.5 cm
Museo Stefano Bardini, Florence, inv. 858

Provenance
Bequeathed by Stefano Bardini.

Bibliography
Palazzo Vecchio 1980, p.158; Scalia *et al.* eds 1982, pp.117–19; Scalia *et al.* eds 1983, p.90; L. E. Veronesi ICCD, Sopr. of Florence, OA report n.09/00282397, 1988.

130. Pair of chairs (*sgabelli*)
PLATE 15.23

Italian, Veneto, 1580–1600
Walnut, partly gilded, h 107 cm, w 49.5 cm
V&A: 7179–1860 and 7183–1860

Provenance
Soulages Collection.

Bibliography
Pollen 1874, pp.103–4; Bode 1902, p.22.

131. Wedding chest
PLATE 3.13

Venice?, 15th or early 16th century
Fir wood, gilded pastiglia and tempera with iron handles, h 60 cm, w 172 cm, d 56 cm
Museo Stefano Bardini, Florence, inv. n.1220

Provenance
Bequeathed by Stefano Bardini in 1922.

Bibliography
Pignatti 1962, p.40; Gregori 1966, p.35, fig.18.

132. Valance
PLATE 24.9

Italian, 16th century
Silk velvet with padded appliqué of silver tissue embroidered in coloured silks and couched metal thread, h 31 cm, w 278.5 cm
V&A: 37–1903

Provenance
Purchased from M. Fulgence, Paris, in 1903.

Bibliography
Unpublished.

133. Cover
PLATE 24.9

Italian, late 16th century
Linen with cutwork and needle lace in 42 alternating squares, each of different pattern, l 180 cm, w 160 cm
V&A: T.116–1959

Provenance
Purchased from a private collection in 1959.

Bibliography
Browne 2004, pl.4.

134. *Restello* (framed mirror with pegs)
PLATE 13.16

Italian, 1500–1550?
Carved poplar, gilded and painted, h 98.5 cm, w 105 cm, d 16 cm
Museo Stefano Bardini, Florence, Inv. n.990

Provenance
Bequeathed by Stefano Bardini in 1922.

Bibliography
Unpublished.

135. Pair of candlesticks
PLATE 21.5

Italian, probably Venice, mid-16th century
Brass, engraved and inlaid with silver, h 19.1 cm, diam 18 cm
V&A: 553–4–1865

Provenance
Soulages Collection.

Bibliography
Mackay Thomas 1942, Pl.I, F; Auld 2004, p.261, no.6.26.

136. Dressing case
PLATE 3.11

Venice, c.1580
Beechwood with panels of painted bone, and bronze handles, h 17 cm, w 13 cm, d 13 cm
V&A: 217–1866

Provenance
Purchased from Farrer of London.

Bibliography
Pollen 1874, p.31; Thornton 1972, pp.9–12, 50–57, 108–110.

137. 'Lotto' carpet
PLATE 21.8

Western Turkey, probably Ushak, 16th–17th century
Hand knotted woollen pile on a woollen warp and weft, later horizontally cut and rejoined, l 178 cm, w 114 cm
V&A: T.348–1920

Provenance
Purchased in 1920 from Harold Wallis of Purley.

Bibliography
King, Franses and Pinner 1984, pp.354, 366–7, 381, fig.11; Wearden 2003, p.36 and col. pl.115.

LIFE CYCLE

138. Family Portrait
PLATE 5.1

Cesare Vecellio, Venice, 1550s
Oil on canvas, h 113 cm, w 180 cm
With an unidentified coat of arms on
the background wall
Museo Correr, Musei Civici Veneziani,
Venice, Cl. I n.254

Provenance
Correr bequest, 1830.

Bibliography
Mariacher 1957, pp.225–7; Davanzo Poli
1980, p.231; Conte 2001, pp.178–9.

139. The Steps of a Man's Life
PAGE 102

Cristoforo Bertelli, Venice, c.1580
Engraving, h 41.5, w 54.5 cm
Inscr. with various texts and the name
and address of the printmaker
Civica Raccolta delle Stampe
A.Bertarelli, Castello Sforzesco, Milan,
SPP m. 10E-1

Provenance
Achille Bertarelli.

Bibliography
Bertarelli and Novati 1911, p.XVIII,
n.20; Rigoli *et al.* 1995, p.384, no.508.

140. The Steps of a Woman's Life
PAGE 102

Cristoforo Bertelli, Venice, c.1580
Engraving, h 39, w 52 cm
Inscr. with various texts and the name
and address of the printmaker
Civica Raccolta delle Stampe
A.Bertarelli, Castello Sforzesco, Milan,
SPP m. 10E-2

Provenance
Achille Bertarelli.

Bibliography
Bertarelli and Novati 1911, p.XLIII,
n.21; Rigoli *et al.* 1995, p.385, no.509.

Getting Married

141. Portrait of a Woman and a Man at a Casement
PLATE 6.8

Fra Filippo Lippi, Florence, c.1436-38
Tempera on panel, h 64.1 cm,
w 41.9 cm
Inscr. 'lealt[a]' (loyalty) on the edge of
the woman's cuff
The Metropolitan Museum of Art,
Marquand Collection, Gift of Henry G.
Marquand, 1889 (89.15.19)

Provenance
Revd John Sanford, Nynehead Court,
Wellington, Somerset, and London
(bought in Florence; about 1829–d.
1855; inv., n.d., no.167, as by Masaccio;
cat., 1847, no.1; bequeathed to
Methuen); Frederick Henry Paul, 2nd

Baron Methuen, Corsham Court,
Chippenham, Wiltshire (1855–83; sold
to Marquand); Henry G. Marquand,
New York (1883–9).

Bibliography
Pope-Hennessy and Christiansen 1980,
pp.56–9; Jansen 1988; Tietzel 1991,
pp.17–38; Ruda 1993, pp.85–8, 385–6;
Mannini and Fagioli 1997, pp.92–3;
Dalli Regoli 2000, pp.28–9; Brown
2001, pp.106–7; Christiansen 2005,
pp.150–53.

142. Sculptural Group from an Inkstand
PLATE 7.2

Italian, Urbino, Fontana workshops,
1575–1600
Tin-glazed earthenware, h 23 cm,
w 22.5 cm, d 19 cm
Musei Civici, Pesaro, Inv. N.4363

Provenance
Acquired from Collezione Mazza
Domenico in 1857.

Bibliography
Mancini Della Chiara 1979, cat.223;
Giardini 1996, fig.268, p.90.

143. Goblet with double portrait
PLATE 7.15

Venice, 1475–1500
Green glass, the foot blown in a dip
mould, with enamelled and gilt
decoration, h 17.1 cm, w 11.3 cm
(bowl), 10.9 cm (foot).
V&A: 409–1854

Provenance
Purchased from Mr Warren, Wardour
Street, London.

Bibliography
Honey 1946, plate 22C and p.60; Brooks
1975, p.22; Barovier Mentasti ed. 1982,
cat.73; Liefkes 1997, p.43, fig.48.

144. Dish on a low foot
PLATE 7.14

Italian, Deruta, probably workshop of
Giacomo Mancini detto il Frate, mid-
16th century
Tin-glazed earthenware, diam 26.5 cm
Inscr. 'DVLCE.EST.AMARE' (It is sweet
to love)
V&A: C.2116–1910

Provenance
Delsette Collection; Salting Bequest.

Bibliography
Rackham 1940, cat.755; Fiocco and
Gherardi 1984, p.409.

145. Handkerchief
PLATE 7.1

Italian, c.1600
Linen with cutwork, needle lace and
embroidery, l 45.5 cm, w 45.5 cm
V&A: 288–1906

Provenance
Purchased from Samuel Chick in 1906.

Bibliography
Doran ed. 2003, no.61; Browne 2004,
pl.6.

146. Linen tablecloth with amorous inscriptions
PLATE 7.9

Italian, Lombardy or Piedmont,
1450–1500
Linen embroidered with silk thread of
various colours, l 160 cm, w 96 cm
Inscribed with lines of amorous poetry
With a motif possibly representing
the coat of arms of the Provana family
from Piedmont
Museo Civico d'Arte Antica e Palazzo
Madama, Turin, 1849/T

Provenance
Purchased in 1921 from Dr C. Carbonelli.

Bibliography
Viale 1939, p.156, pl.381.

147. *Fede* ring
PLATE 7.6

Italian, 15th century
Silver, diam 2.5 cm, h 1.2 cm
V&A: 848–1871

Provenance
Acquired by Edmund Waterton in
Rome, 1857.

Bibliography
Oman 1930, p.102; Bury 1982, p.190.

148. Ring
PLATE 7.7

North Italian, early 15th century
Gold, with circular bezel cut to a quatre-
foil and set with cut diamond, w 1.9 cm
Inscr. in enamel in black letter on
shoulders: 'Lorenso★ a Lena Lena'
(From Lorenzo to Lena Lena)
The British Museum, London, MLA AF
1090

Provenance
Castellani Collection; bequeathed by
Augustus Wollaston Franks, 1897.

Bibliography
Dalton 1912, cat.984; Ward *et al.* 1981,
cat.197; Syson and Thornton 2001,
p.65, fig.45.

149. Dish
PLATE 7.13

Italian, probably Gubbio, 1500–1510
Tin-glazed earthenware with lustre
decoration, h 5 cm, diam 29 cm
V&A: 8900–1863

Provenance
Soulages Collection.

Bibliography
Rackham 1940, cat.440. Similar
example, Fiocco and Gherardi 1995,
p.29, fig.3.

150. Wafering irons
PLATE 7.12

Italian, Umbria, 1481
Iron, diam of plates 17.3 cm
Inscr. when reversed (i.e. on the wafers)
'ELSERVIRE · MAI · SE · PERDE · EVNO
· PERFECTO · AMORE · SEMPRE · E ·
PIVVERDE' (Service is never lost and a
perfect love is ever more green) on the
three-towered castle plate; 'RENZO ·
PACCA · M · CCCC · LXXXI · LVC[I]A ·
PACCA' (Renzo Pacca 1481 Luc[i]a Pacca)
on the plate with the mortar and pestles.
V&A: M.443–1924

Provenance
Given by Dr W. L. Hildburgh, FSA.

Bibliography
Hildburgh 1915, pp.183–4, no.8, fig.3;
Curtis ed. 2004, p.87, no.25.

The Trousseau

151. Christ Child
PLATE 8.8

Workshop of Andrea della Robbia,
Florence, c.1490–1510
Polychrome enamelled terracotta,
h 45.7 cm
V&A: 7702–1861

Provenance
Given by Mr George H. Morland.

Bibliography
Pope-Hennessy 1964, I, pp.225–6, no.217
with reference also to previous literature.

152. Book of hours with the arms of the Serristori family of Florence
PLATE 11.8

Written in Florence, c.1500
Illuminated by Monte di Giovanni and
Mariano del Buono
Parchment. 189 fols, h 21.5 cm,
w 14.5 cm
Frontispiece with the arms of the
Serristori family but lacking the Medici
device granted in 1515 by Leo X.
V&A: MSL/1921/1722

Provenance
Made for a member of the Serristori
family; bequeathed by David Currie,
1921.

Bibliography
D'Ancona 1914, pp.860–61, no.1674;
Harthan 1977, pp.154, 156; Garzelli 1985,
II, pp.451, 613, figs 764, 994; Watson
2003, pp.116–17.

153. Pastiglia box with scenes from Roman history
PLATE 7.3

Italian, Ferrara or Venice, 1500–1550
Softwood (probably poplar) with
pastiglia decoration and water-gilding,
lined with (later) red baize, h 19 cm,
w 31 cm, d 22.5 cm
V&A: W.23–1953

Provenance
Given by Dr W. L. Hildburgh.

Bibliography
Hildburgh 1946, pp.125–8.

154. Necklace
PLATE 7.5

Italian, *c*.1540
Gold enamelled in black and white,
l 59.8 cm
Inscribed: 'VBI AMOR IBI FIDES'
(Where there is Love, there is also
Fidelity).
V&A: M.117–1975

Provenance
Given by Dame Joan Evans, PPSA.

Bibliography
Princely Magnificence 1980, pp.51–2; Bury
1982, p.64.

155. Girdle
PLATE 7.4

Italian, 15th century
Cloth of gold, gilt metal, enamel and
nielloed silver, w 6.6 cm, l 158.7 cm
Inscr. 'AMOR.E.VOL'; 'SPERA.IN
DIO' (Love wants [?]; Hope in God) and
with an unidentified coat of arms
V&A: 4278–1857

Provenance
Unknown.

Bibliography
Bury 1982, p.243.

156. 199 pins
PLATE 7.16

Northern Italian, 1500–1550
Bronze, l 2 to 7 cm
Museo di Antichità, Turin, inv.71742

Provenance
Excavated from Montaldo di Mondovì
castle (prov. Cuneo) (US 168), 1983–4.

Bibliography
Cortelazzo and Lebole Di Gangi 1991,
pp.222–3, fig.128.

157. Woman's long shirt
PLATE 7.10

Italian, 1550–1600
Embroidered tabby linen with lacework,
l 118 cm, w 131 cm (hem)
Museo del Tessuto, Prato, i. n.76.01.16

Provenance
Leopold Bengujat; Carlo Bruscoli and
donated by Riccardo Bruscoli.

Bibliography
Unpublished.

Childbirth and Childhood

158. Portrait of Lucina Brembati
PLATE 8.10

Lorenzo Lotto, Bergamo, *c*.1518
Oil on panel, h 51 cm, w 42 cm
Inscr. 'CI' in the crescent moon (*luna*), a

rebus of the subject's name: lu-ci-na.
Accademia Carrara, Bergamo, inv. 900

Provenance
Countess Grumello Albani, Bergamo;
Accademia Carrara, Bergamo, 1882.

Bibliography
Pignatti 1953, p.97; Gentili 1980,
pp.418–19; Zampetti 1983, no.18; Rossi
1988, pp.176–9; Gentili 1989, pp.174–7;
Humfrey 1997, pp.66–70, 171; Brown
and Lucco 1997, pp.114–16, no.15;
Musacchio 2001, p.176; Rossi 2001,
pp.94–5; Penny 2005, pp.581–2.

**159. The Birth and Naming of
St John the Baptist**
PLATE 2.7

Benedetto da Maiano, Florence, *c*.1477
Terracotta, h 30.5 cm, w 45.7 cm.
V&A: 7593–1861

Provenance
Marchese Ottavio Gigli by 1855; Gigli-
Campana collection; purchased 1861.

Bibliography
Pope-Hennessy 1964, I, pp.159–60,
no.134, fig.155; Darr ed. 1985, pp.195–6,
no.65; Bule, Darr and Gioffredi eds 1992,
pp.117–23; Butterfield 1997, pp.105–25;
Boucher ed. 2001, no.15.

**160. The Naming of St John the
Baptist birth bowl (*tafferia da parto*)**
PLATE 8.2

Jacopo Carucci, called Il Pontormo,
Florence, *c*.1525
Oil on panel with gilding, diam 59 cm
Inscr. 'iohannes' on the paper where
Zacharias writes. The Della Casa and
Tornaquinci coats of arms on the back.
Galleria degli Uffizi, Florence, inv.1890
n.1532

Provenance
Della Casa family (?); Galleria degli
Uffizzi, 1704.

Bibliography
Clapp 1916, pp.57, 140–41; Cox-Rearick
1964, I, no.290, pp.273–4, II, figs 282–3;
Berti 1973, pp.100–101;
Gli Uffizi 1979, p.431; Bruschi 1992, n.p.;
Costamanga 1994, no.A30, pp.281–2; De
Carli 1997, no.53, pp.186–7; Musacchio
1999, pp.83–5; Olson 2000, pp.27, 276;
Däubler-Hauschke 2003, no.10,
pp.197–202.

**161. Broth bowl and trencher from a
childbirth set**
PLATE 8.3

Probably painted by Nicola da Urbino,
Casteldurante, 1525–30
Tin-glazed earthenware, diam 19 cm
V&A: 2258&A–1910

Provenance
Mr Matthew Uzielli; Salting Bequest.

Bibliography
Rackham 1940, cat.551; Cioci 1982,
p.255; Bandini 1996, p.75, fig.21;
Musacchio 1999, pp.95, 116, figs 78,
106.

162. Swaddling band
PLATE 8.5

Italian, 1590–1600
Linen with cutwork, needle lace and
embroidery, l 302 cm, w 24.5 cm
V&A Museum of Childhood, London,
B.878–1993

Provenance
Estate of David Knight.

Bibliography
Kevill-Davies 1991, p.27; Buck 1996,
pp.24–35; Marshall (forthcoming).

163. Baby walker
PLATE 9.4

Italian, Lombardy?, 16th–17th century
Carved and turned walnut, h 40 cm,
diam 54.5 cm
Museo Bagatti Valsecchi, Milan,
inv. n.314.

Provenance
Arrigoni Collection.

Bibliography
Malaguzzi Valeri 1913; Toesca 1918, pls
XVII, LXV; Terni De Gregory 1957,
p.38; Pavoni 1994, pp.42, 78; Chiarugi
2003, pp.188–9.

**164. Portrait of a Young Girl of
the Redetti family of Bergamo**
PLATE 9.1

Giovanni Battista Moroni, Bergamo,
1566–70
Oil on canvas, h 40 cm, w 32 cm
Accademia Carrara, Bergamo, n.658 (71)

Provenance
Bergamo, Redetti family; Crocetta di
Mozzo (Bergamo), Pinacoteca Lochis;
Lochis bequest to the Municipio di
Bergamo, 1866, transaction with the heir
Carlo Lochis for transmission to the
Pinacoteca.

Bibliography
Rossi 1979, p.178; Gregori 1979,
pp.227–8; Rossi and Gregori eds 1979,
pp.180–81; Rossi 1991, fig.12; Milesi
1991, pp.68–9; Humfrey 2000,
pp.50–51.

165. Portrait of a Youth
PLATE 1.13

Attributed to Mirabello Cavalori,
Florence, 1560–70
Tempera on panel, h 92 cm, w 82 cm
Museo Stefano Bardini, Florence,
inv.784

Provenance
In the Bardini collection since 1923.

Bibliography
Weigelt 1926, p.191; Lensi 1929, p.78;
Scalia and De Benedictis 1984,
pp.240–41.

**166. *Esemplario di lavori* (needlework
pattern-book)**
PLATE 11.16

Giovanni Andrea Vavassore, Venice, 1540
Paper, h 21.6 cm, w 15.5 cm, d 2 cm
Full title: 'Esemplario di lavori che
insegna alle donne il modo e ordine di
lavorare e cusire e recammare, e
finalmente far tutte quelle opera degne
di memoria: la quale po fare na donna
virtuosa con laco in mano …' ([Book
of] examples of work which teaches
women the way and order of making
[textiles] and of sewing and
embroidering and finally to do all those
works which deserve to be remembered:
and which a virtuous woman can do
with a needle in her hand …)
Biblioteca Nazionale Centrale, Florence,
B.R.142.1

Provenance
Biblioteca Palatina (Palat. 13.7.5.15).

Bibliography
Sander 1942, 6462; Lotz 1933, p.124;
Ajmar 2004, pp.213–16.

**167. *Luminario, seu de elementis
litterarum libri IV* (Luminario,
concerning the elements of letters
book four)**
PLATE 9.5

Giovanbattista Verini, probably printed
in Toscolano by Alessandro Paganini,
c.1527
Paper, 64 fols, h 20 cm, w 14 cm
V&A: 347–1891

Provenance
Hippolyte Destailleur (1822–
1893)[printed bookplate H. Destailleur];
possibly a member of the Dundas family
[19th century printed bookplate with
initials DD and the motto 'Essayez'];
Sir Antonio Panizzi(?); purchased 1891.

Bibliography
Verini 1947; Bonacini 1953, pp.352–5;
Morison 1953, pp.41–5; Casamassima
1966, pp.27–30; Osley 1972, pp.43–7;
Morison 1990, pp.67–9.

168. Spinning top
PLATE 9.6

Italian, probably Genoa, 17th century
Wood, h 5.5 cm, max diam 4.4 cm
Soprintendenza per i Beni Archeologici
della Liguria, Genoa, inv. RCGE 93005

Provenance
Excavated in the old port, Genoa (US
5037), 1996.

Bibliography
Bandini 1999, fig.6:21.

DEVOTION

169. Winged tabernacle with a later bronze crucifix, and with the arms of the Sozzini family of Siena
PLATE 14.11

Andrea del Brescianino, Siena, *c*.1516 (tabernacle); Pietro Tacca? (crucifix); circle of Domenico Beccafumi (exterior of shutters)
Oil on panel, h 73.1 cm, w 52.3 cm (closed); bronze crucifix, h 23.8 cm, w 19.3 cm
Inscr. 'TANTO REDENPTI PRETIO / HVIVS LIVORE SANATI SVMVS' (Redeemed by so great a price / We were healed by His wounds) on the cornice and base of the frame.
The tabernacle has the coat of arms of the Sozzini family of Siena on both sides of the base.
Chigi Saracini Collection property of Banca Monte dei Paschi di Siena, Inv. 25

Provenance
Sozzini family Siena; Chigi Saracini Collection, Siena.

Bibliography
Salmi 1967, pp.112–15; Sricchia Santoro 1988, pp.78–80; Bagnoli, Bartalini and Maccherini 1990, pp.300–303; Santi 1998, pp.28–9.

170. The Virgin and Child
PLATE 14.4

Follower of Donatello, Florence, *c*.1455–60
Gilded terracotta, h 74.3 cm, w 55.9 cm
V&A: 57–1867

Provenance
Purchased in Florence, 1867.

Bibliography
Pope-Hennessy 1964, I, pp.64–5, no.64, fig.80; Pope-Hennessy 1986, pp.230–33; Kecks 1988, p.101; Avery 1991, no.50, pp.90, 92; Avery 1994, pp.84–5; Jolly 1998, no.32.3, pp.35, 129–31, pl.59.

171. The Virgin with the Infant Christ on her Knee
PLATE 22.3

Northern Italian, 1450–75
Woodcut coloured by hand, stuck down on wood, h 65 cm, w 45.7 cm
V&A: 321a–1894

Provenance
Purchased from Stefano Bardini, Florence.

Bibliography
Schreiber 1926–30, p.62, no.1058n; Hind 1935, pp.160–62; Lambert 1987, p.184, fig.189.

172. The Virgin and Child
PLATE 14.2

After Donatello (painting and gilding probably by Paolo di Stefano, also

known as Paolo Schiavo), Florence, late 1430s
Painted and gilded stucco, h 36.5 cm, w 20.2 cm, d 5.3 cm.
Inscr. 'AVE MARIA GRATIA PLENA' (Hail Mary full of grace).
V&A: A.45–1926

Provenance
Collection of Lord Carmichael of Skirling by 1926; bought at the Carmichael sale (Sotheby's, 10 June 1926). Presented by the National Art Collections Fund with the aid of a body of subscribers in memory of Lord Carmichael of Skirling.

Bibliography
Pope-Hennessy 1964, I, pp.83–4, no.68, fig.94; Avery 1991, p.49, no.30; Radcliffe, Baker and Maek-Gérard 1992, pp.18–19; Johnson 1997, pp.2, 13 n.10, fig.1.1; Jolly 1998, no.43.2, pp.39, 44, 45, 47, 144, pl.76; Curtis ed. 2004, p.82, no.15.

173. *Psalmista secundum ordinem biblie* (The Psalms following the order of the Bible)
PLATE 11.3

Printed in Venice by Lucantonio Giunti, *c*.1515
Paper. 206 fols, h 7.5 cm, w 5 cm
V&A: 308–1894

Provenance
Purchased 1894.

Bibliography
Unpublished. Printer's mark: Zapella 1986, II no.620.

174. Four portions of a wooden rosary
PLATE 14.7

Italian, probably Genoa, 17th century
Wood beads, iron (?) rings, combined l 61.8, diam 1 and 1.4 cm
Soprintendenza per i Beni Archeologici della Liguria, Genoa, inv.99756

Provenance
Excavated in the old port, Genoa (US 7390A), 1996.

Bibliography
Unpublished.

175. Rosary
PLATE 14.8

Italian, 16th century
Rock crystal beads and cross, with painted and gilded images, silver gilt mounts, decorated with pearls, l 38 cm
Museo Civico, Turin, V.O. 97–2984

Provenance
Bequeathed by Marquis Emanuele d'Azeglio in 1890.

Bibliography
Marquet de Vasselot 1914, p.72; Pettenati 1978, p.47.

176. Reliquary cross
PLATE 14.9

Italian, *c*.1600

Gold, the Instruments of the Passion reserved on black enamel, h 6.9 cm, w 4 cm, d 0.7 cm
V&A: M.77–1979

Provenance
Given by Miss L. M. Pacy.

Bibliography
Princely Magnificence 1980, p.79; Bury 1982, p.64.

177. Pendant
PLATE 14.10

Italian, late 16th century
Carved red coral set with enamelled gold, h 6.2 cm, w 3.7 cm, d 1.2 cm
V&A: 105–1865

Provenance
Received from M. Van Cuyck, Paris.

Bibliography
Bury 1982, p.72.

CARING FOR AND DRESSING THE BODY

178. Venus at the Mirror
PLATE 1.14

Titian and workshop, Venice, 1560s
Oil on canvas, h 117 cm, w 89 cm
Private collection

Provenance
Rudolph II at Prague, inventory 1598 and 6 December 1621 (no.1037); Queen Christina of Sweden as war booty from the capture of Prague in 1648 (inventory 1652), until 1689; Marquis Pompeo Azzolino until 1692; Prince Livio Odescalchi until 1721; Orléans collection in Paris until 1798; purchased by the Earl of Darnley in 1798; purchased by Karl Bergsten, Stockholm, in 1925.

Bibliography
Wethey 1969–75, III, pp.202–3.

179. Man's shirt
PLATE 13.10

Italian, 1550–1600
Embroidered tabby with linen lacework, h 92.5 cm, w 62.5 cm (without sleeves)
Museo del Tessuto, Prato, i. n.76.01.19

Provenance
Leopold Bengujat; Carlo Bruscoli and donated by Riccardo Bruscoli.

Bibliography
Palazzo Vecchio 1980, p.360, n.732.

180. Jerkin
PLATE 24.8

Italian, late 16th–early 17th century
Suede leather, probably deerskin, lined with brown taffeta and embroidered with yellow and brown silk and metal threads, front h 69 cm, back h 52 cm, w 84 cm
Museo Stibbert, Florence, Inventory no.193

Provenance
Unknown.

Bibliography
Cantelli ed. 1974, n.1776; Arnold 1985, pp.21, 72–3; *L'abito per il corpo* 1998, pp.74–5, 163.

181. Hat
PLATE 24.8

Italian, late 16th–early 17th century
Suede leather, probably deerskin, with yellow ribbon and embroidered with cord made of metal threads and cream coloured silk, h 17 cm, diam 29 cm
Museo Stibbert, Florence, Inventory no.13.693

Provenance
Unknown.

Bibliography
Cantelli ed. 1974, n.2146; *L'abito per il corpo* 1998, pp.78, 163.

182. Woman's shirt
PLATE 24.5

Italian, 1550–1600
Embroidered tabby with linen lacework,
l 110 cm, w 132 cm (hem)
Museo del Tessuto, Prato, i. n.76.01.15

Provenance
Leopold Bengujat; Carlo Bruscoli and
donated by Riccardo Bruscoli.

Bibliography
Palazzo Vecchio 1980, p.359, n.731.

183. Corset
PLATE 1.11

Italian, mid-16th century
Steel, front h 43 cm, chest circumference
65 cm
Museo Stibbert, Florence, Inventory
no.14.147

Provenance
Unknown.

Bibliography
L'abito per il corpo 1998, pp.106–7, 165.

184. *Pianelle* (shoes)
PLATE 7.11

Italian, probably Venice, late 16th
century
Wood, covered with velvet, with gilded
stamped leather inner sole, and silver gilt
braid and bobbin lace, each, l 20.5 cm,
w 10.7 cm, h 9 cm
V&A: 929&a–1901

Provenance
Purchased from M. Vitall Benguiat,
London, in 1901.

Bibliography
Pratt and Woolley 1999, pp.19–20.

185. Mirror frame
PLATE 13.6

Workshop of Neroccio dei Landi, Siena,
*c.*1475–1500
Painted *cartapesta* (papier mâché),
h 45.7 cm, w 40.6 cm, d 5.5 cm
V&A: 850–1884

Provenance
Purchased in Florence, 1884.

Bibliography
Pope-Hennessy 1950, pp.288–91, fig.16;
Pope-Hennessy 1964, I, pp.270–71,
no.284, fig.285; Curtis ed. 2004, p.78,
no.8.

186. Casket
PLATE 13.5

Venice, 1575–1600
Softwood with veneers inset with
mother of pearl plaques, painted and
with gilt embellishments, inside, a glass
mirror and a later red velvet lining;
bronze handles, h 23.5 cm, w 43.5 cm, d
30.5 cm
With an unidentified coat of arms.
V&A: 7901–1861

Provenance
Unknown.

Bibliography
Huth 1971, p.5, pl.9; Thornton 1972,
pp.9–12, 50–57, 108–110.

187. Mirror
PLATE 13.5

Venice, *c.*1590
Glass, hardwood painted with gilt
embellishments, inset with mother-of-
pearl plaques, h 58.5 cm, w 31.5 cm,
d 12.5 cm
V&A: 506–1897

Provenance
Bought from Bonnaffé sale (lot 139),
Paris.

Bibliography
Schottmüller 1928, p.199; Huth 1971,
p.6, pl.13; Thornton 1972, pp.9–12,
50–57, 108–110; Alberici 1980, p.90;
Doran ed. 2003, p.114.

188. Ewer and dish
PLATE 13.13

Italian, Deruta, early 16th century
Tin-glazed earthenware, finished
in lustre, ewer h 16.7 cm, dish diam
32.7 cm
The British Museum, London, MLA
1878, 12–30, 361 and 1885,0508.37

Provenance
Ewer bequeathed by John Henderson
in 1878. Dish given by A. W. Franks.

Bibliography
Ewer: Wilson 1987, cat.143; ewer and
dish: Ajmar and Thornton 1998, p.143,
fig.3.

189. Iznik-style shaving bowl
PLATE 13.7

Italy, possibly Padua, 17th century.
Tin-glazed earthenware, painted in
polychrome over a white, opaque glaze
and coated with a final transparent glaze,
h 15 cm, diam 37 cm
Museo Correr, Musei Civici Veneziani,
Venice, inv. no.Cl, IV, 97

Provenance
Unknown.

Bibliography
Curatola ed. 1993, cat. no.301.

190. Towel, known as 'Perugia' towel
PLATE 13.11

Italian, 15th or 16th century
Woven linen and cotton, l 150 cm,
w 56 cm
V&A: 1017–1900

Provenance
Given by Dudley Myers in 1900.

Bibliography
Endrei 1987.

191. Comb
PLATE 13.9

Northern Italian, *c.*1400
Ivory, h 11.5 cm, w 16.5 cm, d 1.2 cm.
V&A: 227–1867

Provenance
Soltikoff collection until 1861; John
Webb; purchased 1867.

Bibliography
Longhurst 1929, p.68, pl.LVI; Curtis ed.
2004, p.79, no.13.

192. Ointment jar
PLATE 23.12

Probably northern Italian, 1500–1550
Glass, h 3.5 cm, rim diam 4.2 cm
Museo Nazionale Archeologico, Ferrara,
inv.67768

Provenance
Excavated from Sant'Antonio in
Polesine convent, Ferrara, 1994–5.

Bibliography
Guarnieri 2005.

193. Tweezers
PLATE 13.4

Northern Italian, mid- or later 15th
century
Bronze, l 7.2 cm
Museo di Antichità, Turin, inv.26/98

Provenance
Excavated at Verrone castle (prov. Biella)
(US 26), 2001.

Bibliography
Pantò 2001, p.24, fig.12c.

194. Earcleaner
PLATE 13.8

Northern Italian, mid- or later 15th
century
Bone, incomplete l 6 cm
Museo di Antichità, Turin, inv.26/97

Provenance
Excavated at Verrone castle (prov. Biella)
(US 26), 2001.

Bibliography
Pantò 2001, p.24, fig.12e.

195. Perfume burner
PLATE 21.1

West Iran?, 1450–1500
Brass, pierced and inlaid with silver and
a black compound, most of the inlay
having disappeared, diam 13.4 cm
Museo Correr, Musei Civici Veneziani,
Venice, inv. no.Cl. XII, 11

Provenance
Unknown.

Bibliography
Curatola ed. 1993, p.488, no.305 and
col. pl.; Auld 2004, p.122, no.1.14.

196. Domed perfume burner
PLATE 21.6

Venice, 16th century
Gilt bronze, pierced and enamelled,
h 23 cm, diam 14 cm
Museo Nazionale del Bargello, Florence,
inv. 786 C

Provenance
Bequeathed by Louis Carrand in 1888.

Bibliography
*Catalogo del R. Museo Nazionale di
Firenze* 1898, p.148, no.786; Gerspach
1904, p.32 and fig.40; Grigaut 1958,
p.155, no.417; Mariacher 1981, p.86,
fig.B.

197. Pomander
PLATE 13.14

Italian, 14th century
Nielloed silver, silver-gilt, h 6.5 cm,
w 4 cm
Latin inscriptions relating to the
Judgement of Paris run around the edge
of each section.
V&A: M.205–1925

Provenance
Francis Reubell Bryan Bequest.

Bibliography
Church 1886, p.166, fig.2; Cook 1904,
pp.97–8; Cook 1925, lot 434; Lightbown
1992, pp.529–30.

198. Ring
PLATE 13.15

Italian, setting 15th century, intaglio
2nd or 1st century BC
Silver, onyx, diam 2 cm; h 1.9 cm
V&A: 724–1871

Provenance
Waterton Collection; received from
Mr. J. M. Whitehead.

Bibliography
Oman 1930, pp.97–8; Bury 1982, p.189.

199. Chamber pot
PLATE 13.12

Italian, Liguria, early 17th century
Ceramic, slipped and glazed inside,
h 24.5 cm, rim diam 20 cm
Soprintendenza per i Beni Archeologici
della Liguria, Genoa, inv. 99767

Provenance
Excavated from a shipwreck off Varazze
(prov. Savona) (excavation E.12.15.19
VAR 91 120), 1993.

Bibliography
Gardini and Benente 1994, p.53;
Martino and Bracco 1999, pp.224–5.

HANDIWORK

200. Sewing scene
PLATE 11.12

Jacopo or Francesco Bassano, Bassano, 1587
Brown watercolour, white lead, traces of black pencil on pale blue paper, h 27.5 cm, w 38.1 cm
Inscr. lower left corner 'vecchio' (old) in pen and brown ink in a seventeenth-century hand; on the back 'x. 6 [?]. 0/1587' in blue watercolour in an old hand.
Gabinetto Disegni e Stampe degli Uffizi, Florence, 1892 F

Provenance
Fondo Mediceo, possibly from the collection of Cardinal Leopoldo de' Medici.

Bibliography
Disegni italiani della Galleria degli Uffizi 1984, no.25; Ballarin 1995,II, pl.292 and p.502; Matthews-Grieco and Brevaglieri 2001, p.68.

201. *Gli universali de i belli recami* (The universal [models] of beautiful embroideries)
PLATE 11.14

Nicolò D'Aristotile (Lo Zoppino), Venice, 1537
Paper, 20 fols. h 16.2 cm, w 11.7 cm
Full title: 'Gli universali de i belli recami antichi, e moderni: ne i quali un pellegrino ingegno, si di huomo come di donna, potra in questa nostra eta con l'ago vertuosamente esercitar si.' (The universal [models] of beautiful embroideries, ancient and modern, with which a roving intellect either of a man or a woman would be able to practice with the needle in a virtuous way.)
V&A: L.177-1918

Provenance
Purchased from the Fairfax Murray sale, Christie, Manson and Wood, London, 21 March 1918.

Bibliography
Lotz, 1933, pp.145–6.

202. *Vaghi lavori dille done* (Fine Women's Works)
PLATE 11.15

Lunardo Fero, Venice, 1559
Manuscript volume containing a title page and sixty-four designs on thirteen leaves. Pen, ink and watercolour on paper, h 19.4 cm, w 15 cm
Full title: 'Vaghi lavori dille done da mi Lunardo fero disegnati e presentati alla Vertuosa et Nobile ELENA FOSCARA Degna et Ingenosa Persona de ingegno pronto et porta pore in opera secondo el suo bisogni.' (Fine women's works drawn by me Lunardo Fero and presented to the virtuous and noble Elena Foscara, worthy and ingenious person of ready intellect which she will be able to put into practice according to her need.)
The last design the coat of arms of the Foscari family of Venice.
V&A: E.1940–1909

Provenance
Purchased from T. de Marinis & Co., Florence, 1909.

Bibliography
Unpublished.

203. Cover
PLATE 11.13

Italian, 16th century
Linen embroidered in coloured silks, l 146.5 cm, w 87.5 cm
V&A:T.307–1920

Provenance
Purchased from a private collection in 1920, the vendor having acquired it in Bagni di Lucca in 1875.

Bibliography
Unpublished.

204. Spindle whorls
PLATE 11.7

Italian, possibly Faenza, early to mid 16th century
White tin-glazed earthenware with blue inscriptions, max. diam 2.25 cm, max. d 1.81 cm
Inscr. with women's names: MARGARITA; CHASANDRA; ANTONIA BE[lla]; AGNOLA BELLA; ANTONIA B[ella]; GEMMA BELLA; BEATRICE B[ella]; S.LENA; CHRIOFE; MED[e]A BE[lla]; LORENSA BELLA; DIRVTEA BELLA 1564; VIOLANTE; PANTA BELLA; LAISA BELLA; …CIA BELLA; NESTASIA BELLA
V&A: C.29 to Q–1960

Provenance
Purchased from H. Longden in 1960.

Bibliography
Unpublished.

205. *Tombolo* (lace pillow)
PLATE 11.8

Venice, late 16th or early 17th century
Carved wood with textile inserts, diam 24 cm, w 15 cm
Museo Correr, Musei Civici Veneziani, Venice

Provenance
Unknown.

Bibliography
Davanzo Poli 1984–6, p.279.

206. Border
PLATE 11.9

Venice, late 16th century
Bobbin lace, in linen thread, l 38.5 cm, w 7.5 cm
V&A: 1249–1893

Provenance
Purchased from Julius von Kaan Albest in 1893.

Bibliography
Unpublished.

207. Domed thimble
PLATE 11.11

Northern Italian, 16th century
Ivory or bone, h 2.5 cm, diam 2 cm
Museo Nazionale Archeologico, Ferrara, Inv. 68367

Provenance
Excavated from Sant' Antonio in Polesine convent, Ferrara, 1994–5.

Bibliography
Zappaterra 2005.

208. Ring thimble
PLATE 11.11

Northern Italian, 16th century
Bronze, h 1.6 cm, diam between 1.5 and 2.6 cm
Museo di Antichità, Turin inv.62665

Provenance
Excavated at Brignano Frascata (San Giorgio, prov. Alessandria) (US 212), 1986.

Bibliography
Subbrizio 1993, p.245, fig.181.9.

209. Needle
PLATE 7.16

Northern Italian, 1500–1550
Iron, l 3.7 cm
Museo di Antichità, Turin, inv.54/41

Provenance
Excavated from Montaldo di Mondovì castle (prov. Cuneo) (US 54), 1983–4.

Bibliography
Cortelazzo and Lebole Di Gangi 1991, p.227, fig.134.2.

210. Button
PLATE 11.11

Northern Italian, 1500–1550
Bronze, diam 1.2 cm
Museo di Antichità, Turin, inv.54/38

Provenance
Excavated from Montaldo di Mondovì castle (prov. Cuneo) (US 54), 1983–4.

Bibliography
Cortelazzo and Lebole Di Gangi 1991, p.226, fig.131.2.

211. Shears
PLATE 11.10

Italian, 16th century
Iron with incised decorations and gilding, l 18.3 cm
Museo Nazionale del Bargello, Florence, Carrand 885

Provenance
Carrand collection.

Bibliography
Salvatici 1999, p.141.

212. Handkerchief press
PLATE 11.6

Italian, possibly Venice, early 15th century
Carved cypress wood, h 24 cm, w 31 cm, d 15.5 cm
Museo Correr, Musei Civici Veneziani, Venice, Cl.XXIV.n.119

Provenance
Purchased by the Musei Civici Veneziani in 1962.

Bibliography
Mostra del costume nel tempo 1951, p.13; *Bollettino dei Musei Civici Veneziani* 1962, p.30.

INTRODUCING THE MEDICI

213. The Medici–Tornabuoni birth tray (*desco da parto*)
PLATE 8.12

Giovanni di Ser Giovanni (Lo Scheggia), Florence, 1449
The Triumph of Fame depicted on front; the device of Piero de' Medici with the Medici and Tornabuoni coats of arms on the back
Tempera, silver, and gold on wood, diam 92.7 cm
Inscr. 'SEMPER' (forever) in the banderole of the device on the back.
The Metropolitan Museum of Art, Purchase in memory of Sir John Pope-Hennessy: Rogers Fund, The Annenberg Foundation, Drue Heinz Foundation, Annette de la Renta, Mr. and Mrs. Frank E. Richardson, and The Vincent Astor Foundation Gifts, Wrightsman and Gwynne Andrews Funds, special funds, and Gift of the children of Mrs. Harry Payne Whitney, Gift of Mr. and Mrs. Joshua Logan, and other gifts and bequests, by exchange, 1995 (1995.7)

Provenance
Lorenzo de' Medici, Florence (b. 1449–d. 1492); inv. 1492; confiscated by the Florentine government; Medici family sale, Orsanmichele, Florence, summer 1495, for 3.6.8 fiorini to Bartolomeo di Bambello, Florence (1495–d. 1543); his widow, Lucrezia di Bambello (from 1543); their son, Jacopo di Bambello (until d. 1579); Abbé Rimani, Florence (in 1801); Alexis-François Artaud de Montor, Paris (by 1811 d. 1849; his estate sale, Place de la Bourse, Paris, 16–17 January, 1851, no.57, as by Giotto, to Bryan); Thomas Jefferson Bryan, New York (1851–67; cat.1852, no.4; given to New York Historical Society); New York Historical Society, New York

(1867–1995; sale, Sotheby's, New York, January 12, 1995, no.69, as by Giovanni di Ser Giovanni di Simone); Metropolitan Museum of Art, 1995.

Bibliography
Ahl 1981, pp.160, 172; De Carli 1997, no.28, pp.126–9; Thornton 1997, pp.5–6; Musacchio 1998; Musacchio 1999, pp.73–9; Däubler-Hauschke 2003, pp.85–124, no.32, pp.262–6; Musacchio 2003, pp.317–18.

214. The Annunciation
PLATE 19.4

Fra Filippo Lippi, Florence, *c.*1450–53
Egg tempera on wood, h 68.6 cm,
w 152.7 cm
The National Gallery, London, NG 666

215. Seven Saints
PLATE 19.4

Fra Filippo Lippi, Florence, *c.*1450–53
Egg tempera on wood, h 68 cm,
w 152.8 cm
The National Gallery, London, NG 667

Provenance
Both acquired from the Palazzo Riccardi (formerly Palazzo Medici) by the Metzger brothers shortly before 1848; acquired by Sir Charles Eastlake about 1855; by whom presented, 1861.

Bibliography
Davies 1950; Marchini 1975, pp.26–7, 206–7, nos. 29–30; Ames-Lewis 1979, pp.126–31; Edgerton and Steinberg 1987; Edgerton 1991, pp.88–107; Ames-Lewis 1993, pp.209–17; Ruda 1993, pp.199–205, 444–6; Ames-Lewis 1995, pp.119–20; Gordon 2003, pp.142–56.

The Study

THE MEDICI STUDY

216. Twelve roundels with the labours of the months
PLATE 19.21

Luca della Robbia, Florence, *c.*1450–56
Enamelled terracotta, diam 59.7 cm
V&A: 7632–7643–1861

Provenance
Palazzo Medici, Florence, *c.*1450–56 (in the *scrittoio* of Piero de' Medici); Palazzo Medici purchased by the Riccardi 1659, the roundels later moved to decorate a fountain in a garden in Florence belonging to the Riccardi family; acquired by the Marchese Campana by 1859; Gigli-Campana collection; purchased 1861.

Bibliography
Pope-Hennessy 1964, I, pp.104–12, nos 82–93, figs 99–110; Pope-Hennessy 1980, pp.42–5, 54, 240–42, pls X–XIII, pls 63–71; Gentilini 1992, p.65; Williamson 1996, p.79; Thornton 1997, pp.49–51, figs 32a and b; Christiansen ed. 2005, pp.198–9, no.25, illus. pp.200–201.

217. Medal of Cosimo de' Medici (*il Vecchio*)
PLATE 19.28

Italian, Florence, *c.*1450–75
Cast bronze, diam 7.7 cm.
Inscr. obverse: 'MAGNVS COSIMVS MEDICES P P P' (The great Cosimo de Medici. First / Governor[?] Father of the Country); reverse: 'PAX LIBERTASQVE PVBLICA FLORENTIA' (Peace and public freedom. Florence)
V&A: A.284–1910

Provenance
Salting bequest.

Bibliography
Hill 1930, no.909; Avery 1991, no.83, p.146; Avery 1994, pp.108–9.

218. Medal of the Pazzi Conspiracy
PLATE 19.20

Bertoldo di Giovanni, Florence, 1478
Bronze, diam 6.5 cm
Inscr. obverse: 'LAVRENTIVS' and 'MEDICES'(Lorenzo de' Medici) either side of the colossal head of Lorenzo, 'SALVS PVBLICA'(the public health) below rail of choir screen; reverse: 'IVLIANVS' and 'MEDICES' (Giuliano de' Medici) either side of the colossal head of Giuliano, 'LVCTVS PVBLICVS' (public mourning) below rail of choir screen.
V&A: 7139–1860

Provenance
Purchased 1860.

Bibliography
Hill 1930, p.240, cat. no.915. Other versions, Hill and Pollard 1967, p.49, cat. no.252; Pope-Hennessy 1989, pp.29, 30, fig.28; Draper 1992, pp.86–95, 216; Scher ed. 1994, pp.129–32, cat. no.41; Rubin and Wright eds 1999, pp.128–9; Attwood 2003, I, pp.37, 54; Syson 2004, pp.100–101, 125, fig.28 with reference also to previous literature.

219. Cameo showing a centaur
PLATE 19.24

Roman workshop, 2nd century BC
Sardonyx, h 5.1 cm, w 4.2 cm
Inscr. 'LAV. R. MED.'(Lorenzo de' Medici)
Museo Archeologico Nazionale, Naples, inv. 25889

Provenance
Lorenzo de' Medici, by 1492; Margherita of Austria, widow of Alessandro de' Medici and wife of Ottavio Farnese; Farnese collections; Borbone collections.

Bibliography
Pesce 1935, p.76, no.20, pl.III, 20; Giuliano 1973, pp.62–3, no.35, pl.VIII; Giove and Villone 1994, p.73, pl.95, p.140, no.52.

220. Cameo showing Hermaphrodite with three Erotes
PLATE 19.24

Roman workshop (?), 1st century BC
Glass paste, h 2.2 cm, w 1.6 cm
Inscr. 'LAV. R. MED.'(Lorenzo de' Medici) on the verso
Museo Archeologico Nazionale, Naples, inv. 26997

Provenance
Lorenzo de' Medici, by 1492; Margherita of Austria, widow of Alessandro de' Medici and wife of Ottavio Farnese; Farnese collections; Borbone collections.

Bibliography
Pesce 1935, p.64, no.13, pl.II, 13; Giuliano 1973, pp.47–8, no.12, pls 4–5; Giove and Villone 1994, p.140, no.35.

221. Cameo showing three carpenter Erotes
PLATE 19.24

Roman workshop (?), 1st century BC
Sardonyx, h 2 cm, w 1.7 cm
Inscr. 'LAV. R. MED.' (Lorenzo de' Medici)
Museo Archeologico Nazionale, Naples, inv. 25853

Provenance
Cardinal Pietro Barbo, by 1457; bought by Lorenzo de' Medici in Rome in 1471; Margherita of Austria, widow of Alessandro de' Medici and wife of Ottavio Farnese; Farnese collections; Borbone collections.

Bibliography
Pesce 1935, p.62, no.9, pl.I, 9; Giuliano 1973, pp.60–61, no.31, pl.23; Giove and Villone 1994, p.114, pl.160, p.140, no.49.

222. Cameo showing Poseidon and Amphitrite
PLATE 19.24

Workshop working for the court of Frederick II (1215–50) (?)
Chalcedony, h 2.5 cm, w 1.9 cm
Inscr. 'LAV. R. MED.'(Lorenzo de' Medici)
Museo Archeologico Nazionale, Naples, inv. 25955

Provenance
Lorenzo de' Medici, by 1492; Margherita of Austria, widow of Alessandro de' Medici and wife of Ottavio Farnese; Farnese collections; Borbone collections.

Bibliography
Pesce 1935, p.58, no.2, pl.I, 2; Wentzel 1953–6, p.256, pl.17; Giuliano 1973, pp.64–5, no.38, pl.XIV; Giove and Villone 1994, p.29, fig.27, p.140, no.53.

223. St Jerome in his Study
PLATE 19.30

Attributed to Jan van Eyck and assistant, Bruges, 1442
Oil on linen paper on oak panel, h 19.9 cm, w 12.5 cm
The Detroit Institute of Arts, Detroit, Michigan, City of Detroit Purchase (25.4)

Provenance
Mantua 1531?; Ferdinando Carlo, Duke of Mantua (d.1708); Johann Mattias von der Schulenberg by 1738; Pierre Stevens, Antwerp?; Paul Bottenwiser, Berlin 1924; Detroit Institute of Arts 1925.

Bibliography
Panofsky 1953, I, pp.189–90; Friedländer 1967, p.104; Hall 1968; Garzelli 1984; Täube 1993, pp.260–61; Ainsworth 1994, pp.68–71; Rohlmann 1994, pp.96–7; Hall 1998; Borchert 2002, p.327; Campbell 2002, pp.367–71; Nuttall 2004, pp.107–8; Evans 2006.

224. *De civitate dei* (The City of God)
PLATE 19.22

St Augustine. Manuscript written out by Messer Piero Strozzi; illuminated by Ser Ricciardo di Nanni, Florence, *c.*1460–63
Parchment. 356 fols, h 39 cm, w 27.8 cm
Biblioteca Medicea Laurenziana, Florence, ms 12, 19

Provenance
Made for Lorenzo de' Medici.

Bibliography
D'Ancona 1914, no.268; Ames-Lewis 1984, pp.233–4, cat. no.1; Garzelli 1985, I, p.127.

225. *Historia naturalis* (Natural History)
PLATE 19.23

Pliny the Elder. Manuscript written out by a scribe named Ser Benedetto; illuminated by Francesco d'Antonio del Chierico, Florence, 1458
Parchment. 425 fols, h 41.8 cm, w 27.7 cm
Biblioteca Medicea Laurenziana, Florence, MS 82, 3

Provenance
Made for Piero di Cosimo de' Medici.

Bibliography
Alexander and De la Mare eds 1969, p.40; De la Mare 1971, p.193; Ames-Lewis 1984, pp.330–31, cat. no.84; Garzelli 1985, pp.101, 118, 134, 428, 570, figs 386–8, 390; Alexander ed. 1994, p.120, no.50.

226. *Phaenomena*
PLATE 19.29

Aratos. Greek manuscript written out by Demetrios Damilas; illuminated by Francesco Rosselli, Florence, *c*.1490
Parchment. 73 fols, h 25 cm, w 15.7 cm
The British Library, London, Add.MS 11886

Provenance
Copied for Lorenzo de' Medici.

Bibliography
Martin 1956, pp.251–3; Canart 1977–9; Garzelli 1985, I, 178, II, pl.524–6; Fryde 1996, p.96.

227. Beaker with lid
PLATE 19.26

Fatamid, 10th-12th century, or, France or Burgundy, 1400–1450
Jasper, pearl, silver-gilt mounts of the 15th century, h 17.8, w 8.6 cm (beaker), w 10.7 cm (lid)
Inscr. 'LAV. R. MED'. (Lorenzo de' Medici)
Museo degli Argenti, Palazzo Pitti, Florence, 1921, no.553

Provenance
Inventory of Lorenzo de' Medici 1492; between 1532 and 1785 in Michelangelo's *Tribuna delle reliquie* in the church of San Lorenzo in Florence; Uffizi (Gabinetto delle Gemme) until 1921, when it entered the collections of the Museo degli Argenti.

Bibliography
Holzhausen 1919–32, p.120; Piacenti 1967, p.135; Heikamp and Grote 1972, pp.61–2, pl.107–9; Fusco and Corti 2006, pp.92-93, pl.VII.

228. Double cup
PLATE 19.25

Cups: Italian, late 15th century; mounts: probably Florentine, late 15th century;

foot added in the early 16th century
Jasper with silver-gilt mounts, h 30.5 cm, w 14.2 cm
Inscr. 'LAV. R. MED.' (Lorenzo de' Medici)
Museo degli Argenti, Palazzo Pitti, Florence, 1921, no.800

Provenance
Initials of Lorenzo de' Medici; between 1532 and 1785 in Michelangelo's *Tribuna delle reliquie* in the church of San Lorenzo in Florence; Uffizi (Gabinetto delle Gemme) until 1921, when it entered the collections of the Museo degli Argenti.

Bibliography
Holzhausen 1919–32, pp.120, 122; Morassi 1963, p.43, n.227; Heikamp and Grote 1972, pp.148–9, pl.VIII; Fusco and Corti 2006, pp.92–3, pl.VIII.

229. *Marsyas*, also known as *Lo gnudo della paura* (naked man affrighted)
PLATE 20.12

Florence, 1470–90
Bronze, h 32 cm
Museo Nazionale del Bargello, Florence, 1879 no.82

Provenance
Lorenzo de' Medici.

Bibliography
Massinelli 1991, pp.31, 35, fig.29; Spallanzani and Gaeta Bertelà 1992, p.52 (c.26v in original inventory). Other versions: Ebert-Schifferer ed. 1985, pp.388–92.

230. Cameo showing Noah and his family emerging from the Ark
PLATE 19.27

Probably Sicily or southern Italy, *c*.1200–1250
Mount probably Burgundy, late 14th–early 15th century
Onyx and gold, h 6.4 cm, w 7.2 cm
Inscr. 'LAVR MED'. (Lorenzo de' Medici)
The British Museum, London, MME 1890, 9–1,15

Provenance
Piero de' Medici; Lorenzo de' Medici.

Bibliography
Tait 1986, p.218, pl.541; Jenkins and Sloan 1996, p.197; Fusco and Corti 2006, pp.97–100,173–4, 292, 293, pl.V and fig 103.

THE STUDY: WORK AND CONTEMPLATION

231. St Jerome in his Study
PLATE 1.6

Antonello da Messina, Venice, *c*.1475
Oil on lime wood, h 45.7 cm, w 36.2 cm
The National Gallery, London, NG 1418

Provenance
Antonio Pasqualino, Venice, by 1529; Thomas Baring by 1835; William Coningham, 1848; Thomas Baring; Earl of Northbrook, from whom purchased by the Gallery in 1894.

Bibliography
Frimmel 1888, pp.98–100; Davies 1961, pp.40–41; Fletcher 1981, p.453; Howell Jolly 1982, pp.152–259; Howell Jolly 1983; Puppi 1987; Arbace 1993, pp.52–7, no.18; Thornton 1997, pp.53–60; Aikema 1999, pp.214–17; Aikema 2000.

232. Agostino della Torre with his Son Niccolò
PLATE 12.2

Lorenzo Lotto, Bergamo, *c*.1513–16
Oil on canvas, h 88 cm, w 71.3 cm
Inscr. 'L. LOTVS. / P. . / [1515]' on the chair; 'Medicorum Esculapio / Joani Augustino Ber/gomatij' on the letter held by Giovanni Agostino; 'Dno Nicolao de la Tur/re nobili bergom … / amico singmo / Bg.mj' on the letter on the table.
The National Gallery, London, NG 699

Provenance
General Teodoro Lechi, Brescia, by 1812; sold to Count Samuel von Festetits in 1847; his sale, 12 May 1859, where bought by 'Henking'; Giovanni Morelli by September 1859; purchased by the National Gallery, October 1862.

Bibliography
Gould 1966; Gould 1975, pp.133–4; Cortesi Bosco 1981, pp.315–19; Bonnet 1996, pp.64–6; Humfrey 1997, p.66; Humfrey 2001, pp.90–91; Penny 2004, pp.52–64.

233. Table carpet
PLATE 21.10

Probably Cairo, mid-16th century
Hand-knotted woollen pile woven to a cruciform shape on a woollen warp and weft, l 231 cm, w 251.5 cm
V&A: 151–1883

Provenance
Purchased in 1883 at a sale by the firm Bon Marché, Paris.

Bibliography
Kendrick and Tattersall 1931, pp.23–4; Erdmann 1940, pp.55–81 and fig.15;

Erdmann 1962, p.65 and fig.15; Erdmann 1970, p.199; Ettinghausen 1974, p.301 and fig.40; King, Franses and Pinner 1981, pp.36, 47, 50 and fig.11; Curatola 1983, p.169; King 1983, p.81, no.52; Baker and Richardson eds 1997, p.256, no.103 (inc. col. pl.); Bier 1998, p.96 (inc. col. pl.); Wearden 2003, p.32 and col. pl.83.

234. X-frame armchair
PLATE 15.2

Northern Italian, 16th century
Walnut, h 80 cm, w 61 cm, d 54 cm
V&A: 7196–1860

Provenance
Soulages Collection.

Bibliography
Pollen 1874, p.102.

235. Case for documents and writing materials
PLATE 12.4

Italian, 1500–1550
Wood with cut and embossed leather, with a tinned iron pierced plate, h 39 cm, diam 8 cm
V&A: 480–1899

Provenance
Purchased from Stefano Bardini in Florence.

Bibliography
Unpublished.

236. Set of drawing instruments
PLATE 12.12

Italian, early 16th century
Steel, damascened in gold and silver, box w 20.5 cm, d 7.1 cm, h 4.3 cm
Museum of the History of Science, University of Oxford, 52444

Provenance
Presented by Lewis Evans, 1924.

Bibliography
www.mhs.ox.ac.uk/epact

237. Spectacles frame
PLATE 12.7

Probably Florence, end 14th–mid-16th century
Horn, h 6.8 cm, diam 4.2 cm
Museo Archeologico Nazionale Firenze, inv.225174

Provenance
Excavated in Via de' Castellani, Florence, 1982.

Bibliography
De Marinis 1997, no.97.

238. Signet ring
PLATE 12.6

Italian, 15th century
Gold, diam 2.3 cm
Inscr. 'Petrus Novarino' [in reverse] and

with a coat of arms on the bezel.
V&A: M.276–1962

Provenance
Given by Dame Joan Evans, PPSA.

Bibliography
Taylor and Scarisbrick 1978, p.51; Bury 1982, p.194.

239. Fountain pen
PLATE 12.8

Italian, probably Tuscany, mid- or late 14th century
Bronze with felt inside, l 9.7 cm
Museo Archeologico Nazionale Firenze, inv.225193

Provenance
Excavated in Piazza della Signoria, Florence, 1987.

Bibliography
De Marinis 1997, no.55.

240. Inkstand
PLATE 12.5

Italian, Urbino, dated 1584
Tin-glazed earthenware, h 16.5 cm, w 33.5 cm
V&A: 1681–1855

Provenance
Bernal Collection.

Bibliography
Rackham 1940, cat.897; *The Rival of Nature* 1975, p.92, cat.243.

241. Astronomical compendium
PLATE 12.11

Ulrich Schniep, Munich, 1566
Gilt and silvered brass, diam 4.3 cm
Inscr. 'Horologio Generale Fatto monaco per maistro Vdalricus Schniepp anno.1566' (Universal dial made in Munich by master Ulrich Schniep in the year 1566), with many other inscriptions and instructions in Italian.
Museum of the History of Science, University of Oxford, 48219

Provenance
Presented by J. A. Billmeir, 1957.

Bibliography
www.mhs.ox.ac.uk/epact

242. A Venetian compendium of sea charts
PLATE 1.16

Unknown scribe, Venice, *c*.1490
Ink and coloured washes on vellum
79 fols; h 44.5 cm, w 32 cm. Late 17th-century (?) plate with the arms of the Cornaro family on fol.1; original late 15th century, leather, blind-stamped binding with metal corners and bosses.
The British Library, London, Egerton MS 73

Provenance
By *c*.1700 Cornaro family, Venice; Library of San Marco, Venice;

Vendramini; Rev. Charles Yonge; acquired by British Museum, Rev. Yonge's sale, 1 March 1832 (lot 928); British Library 1973.

Bibliography
Zurla 1818, II, pp.353–8; *Catalogue of the Manuscript Maps, Charts and Plans and Topographical Drawings in the British Museum. Volume 1*, 1844 pp.17–21; D'Avezac Macaya 1845, p.217; Campbell 1987, pp.376, 391–2, 398–9, 401, 413–15, 423, 432–3, 435, 440, 442, 444; Martineau and Hope eds 1983, p.398, H.11.

243. 'Modern' Ptolemaic world map on a cordiform projection
PLATE 12.3

Bernardus Sylvanus, printed by Jacopo Pencio, Venice, 1511
Black and red ink printed on vellum
h 41.5 cm, w 56.5 cm
From *Claudio Ptholemei Alexandrini liber geographiae* (Book of Geography by Claudius Ptolemaeus of Alexandria)
The British Library, London, G.8176

Provenance
Bequeathed to the British Museum by Thomas Grenville, 1848.

Bibliography
Harrisse 1892, p.85; Nordenskiöld 1889, pp.18–19 and pl.xxxiii; Sabin 1868–1936, 66477; Skelton 1969; Woodward 1983; Shirley 1984, p.35 no.32 and pl.35.

244. Astrolabe
PLATE 12.10

Giovanni Domenico Fecioli, Trento, 1558
Brass, diam 16.2 cm
Inscr. 'Io:Dom:Feciolus Trident: faciebat' and 'Astrolabum hoc ex tabulis Bergensibus construendum sibi curauit Julius Caesar Luchinus Bononiae anno 1558' (Giovanni Domenico Fecioli of Trent made [this]. Giulio Cesare Luchino of Bologna supervised the construction of this astrolabe for himself according to the Tabulae Bergenses in the year 1558)
Museum of the History of Science, University of Oxford, 50257

Provenance
Constructed under the instruction of Giulio Cesare Luchino of Bologna; the d'Hauteville family of Salon, Provence; bequeathed by Mrs A. M. Billmeir.

Bibliography
www.mhs.ox.ac.uk/epact

245. Coin (*aureus*) of Trajan
PLATE 19.19

Roman, AD 112–14
Gold, diam 1.9 cm
Inscr. obverse: 'IMP TRAIANO AVG

GER DAC P M TR P COS V I P P' (To the Emperor Trajan Augustus Germanicus Dacicus, High Priest, Holder of Tribunician Power, in his sixth year as Consul, Father of the Country.); reverse: 'S P Q R OPTIMO PRINCIPI' (The Roman Senate and People to the best leader.)
V&A: A.680–1910

Provenance
George Salting, London by whom bequeathed, 1910.

Bibliography
Unpublished. Other examples: Cohen 1880–92, p.77, no.575; Mattingly 1936, p.96, pl.17 no.3; Christol and Lassalle 1988, pp.22–4, no.52.

246. Coin (*sestertius*) of Trajan
PLATE 19.19

Roman, AD 105
Brass, diam 3.4 cm
Inscr. obverse: 'IMP CAES NERVAE TRAIANO AVG GER DAC PM TR P COS V PP' (To the Emperor Caesar Nerva Trajan Augustus Germanicus Dacicus, High Priest, Holder of Tribunician Power, in his fifth year as Consul, Father of the Country.); reverse: S P Q R OPTIMO PRINCIP/SC (The Roman Senate and people to the best leader. By decree of the Senate.)
V&A: A.708–1910

Provenance
George Salting, London, by whom bequeathed, 1910.

Bibliography
Unpublished. Other examples: Cohen 1880–92, p.71, no.525; Mattingly 1936, pp.168–9, pl.28, no.8.

247. Binding on an edition of Thucydides in Greek
PLATE 11.20

Italian, 16th century

Morocco, with panel and ornament tooled in gold, a central medallion lettered QOUKU / DIDHS, with metal clasps and corner-pieces, on Thucydides [Works], Venice: Aldus Manutius, 1502.
h 29.8 cm, w 21 cm
V&A: A.M.34–1865

Provenance
Purchased 1865.

Bibliography
Unpublished.

248. Binding with the device Giovanni Battista Grimaldi of Genoa
PLATE 11.21

Bound in Rome, mid-16th century
Red morocco, ornament tooled in gold, with an impression of a cameo (Apollo driving a chariot and Pegasus on Mount

Helicon), the device of Giovanni Battista Grimaldi, on Girolamo Malipiero, *Il Petrarcha spirituale ristampato nuovamente*, printed by Francesco Marcolini da Forlì, Venice, 1538, h 15.8 cm, w 10.5 cm
V&A: A.M.93–1866

Provenance
Giovanni Battista Grimaldi (*c*.1524–*c*.1612); purchased 1866.

Bibliography
Weale 1894, p.57, no.238; Hobson 1975, p.167, no.92; Harthan 1985, p.43, no.24.

249. St Eustace
PLATE 22.8

Albrecht Dürer, Nuremberg, *c*.1501
Engraving, h 35.7 cm, w 26 cm
V&A: E.4652–1910

Provenance
Sir J. St Auybn; Salting Bequest.

Bibliography
Bartsch 1803–21, no.57; Bartrum 2002, pp.141–2, no 74 with reference to other literature.

250. Perfume burner
PLATE 20.14

Attributed to Desiderio da Firenze, Padua, *c*.1540–50
Bronze, with gilding, h 51.2 cm, diam at base 18.7 cm
The Ashmolean Museum, Oxford, WA 2004.1

Provenance
Sir Julius Wernher by 1911; Sir Harold Wernher, Bath House and then Luton Hoo; Christie's, London, 5 July 2000, lot 65; Daniel Katz Gallery, London; bought in 2004 with the assistance of the National Heritage Memorial Fund, National Art Collections Fund, Friends of the Ashmolean, Elias Ashmole Group, Central Purchase Fund and with further donations from Mr Philip Wagner, the France, Madan, Russell, Bouch and Miller Funds, and other private donations.

Bibliography
Bode 1980, p.24, pl.60; *Works of Art from the Wernher Collection* 2000, no.65; *Donatello e il suo tempo* 2001, p.183, no.43; Warren 2001a, p.93; Leithe-Jasper and Wengraf 2004, pp.92–5, fig.4.

251. Aeolipile (fire-blower)
PLATE 20.8

Venice, *c*.1500
Sheet copper, partially gilded, h 25.4 cm
The British Museum, London, P&E OA 2624 (Sloane 4.c.1112)

Provenance
Mr Dupuy, from whom acquired by Sir Hans Sloane, probably in the 1720s; acquired with the Sloane Collection in 1753.

Bibliography
Hildburgh 1951, p.49, pl.XVc; Warren 2004, pp.34–6, fig.11.

252. Handbell
PLATE 20.6

Northern Italian, probably Venice, *c.*1550
Bell-metal, h 9 cm, diam 8.7 cm
Inscr. 'A.M.' on the crown, 'PVLSV MEO SERVOS VOCO' (With my ring I call the servants) on the body.
V&A: M.199–1938

Provenance
Given by Dr W. L. Hildburgh, FSA.

Bibliography
Burns, Boucher and Fairbairn 1975, p.63; Motture 2001a, no.41, pp.146–7.

253. Inkstand with the *Spinario*
PLATE 20.1

Workshop of Severo Calzetta (Severo da Ravenna), Ravenna, *c.*1510–30
Bronze, h 26.4 cm, l of base 14 cm
The Ashmolean Museum, Oxford, WA 1899.CDEF.B1078

Provenance
Acquired in Rome in 1851 by C. D. E. Fortnum, by whom bequeathed in 1899.

Bibliography
Bode 1980, p.96, pl.89; Lloyd 1980, no.14; Ebert-Schifferer ed. 1985, pp.350–51, no.49; Thornton 1997, pp.151–2, fig.96; *Donatello e il suo tempo* 2001, pp.135, 139–142, figs 3, 8–9.

254. Two Lizards Fighting a Snake
PLATE 20.7

Northern Italian, *c.*1550
Lead, patinated to look like bronze, w 23.5 cm, h 9 cm
Museo Nazionale del Bargello, Florence, 1873 no.23

Provenance
Medici Collection, 1624–38 Inventory.

Bibliography
Massinelli 1991, pp.74–5, 80, fig.64.

255. Sleeping Hercules
PLATE 20.3

Northern Italian, possibly Bologna, *c.*1490–1500
Bronze, l 37 cm, h 12 cm
Inscr. 'GASP.FANT.PRIM.CAROLI. ANT.F.VIRT.CVLT.' (Gaspare Fantuzzi, the first-born son [?] of Carlantonio, a promoter of virtue).
English Heritage/Wernher Collection, Rangers House, London, EE 58

Provenance
Sir Julius Wernher.

Bibliography
Warren 2002, pp.25–36, figs.11–12.

256. Plaquette: The Virgin and Child in a Niche, between St Jerome and St Anthony
PLATE 19.10

Galeazzo Mondella, called Moderno, northern Italian, *c.*1490
Bronze, h 11 cm, w 6.5 cm
Inscr. 'HOC HOPVS [sic] MODERNI', and 'S G'(irolamo) and 'S A'(ntonio) on the reverse (St Jerome and St Anthony)
V&A: A.425–1910

Provenance
George Salting, London by whom bequeathed, 1910.

Bibliography
Maclagan 1924, p.28; Pope-Hennessy 1965, fig.189, p.42. Other versions: Pope-Hennessy 1989; Lewis 1989, fig.12, pp.115–16; Toderi and Toderi 1996, pp.88–9, no.155, 156.

257. Plaquette: Hercules and the Oxen of Geryon
PLATE 19.10

Galeazzo Mondella, called Moderno, northern Italian, *c.*1490
Bronze, h 7.3 cm, w 5.4 cm
Signed in raised letters, near the top, 'O. MODERNI'
V&A: A.440–1910

Provenance
George Salting, London by whom bequeathed in 1910.

Bibliography
Maclagan 1924, p.21. Other versions: Pope-Hennessy 1965, pp.43–4, no.137, fig.156; Lewis 1989, fig.3, p.110–11.

258. The Shouting Horseman
PLATE 20.2

Andrea Briosco, called Riccio, Padua, *c.*1510–15
Bronze, h 33.5 cm
V&A: A.88–1910

Provenance
Fréderic Spitzer, Paris; George Salting, London by whom bequeathed, 1910.

Bibliography
Planiscig 1927, pp.203–7, 480, no.62; Radcliffe 1983, pp.376–7, no.S22; Ebert-Schifferer ed. 1985, pp.382–4, no.78; Krahn ed. 1995, pp.202–3, no.30; Motture 2001b, pp.42–61; Motture 2004, pp.1425–7 with reference also to previous literature.

259. Satyr and Satyress
PLATE 20.13

Andrea Briosco, called Riccio, Padua, 1510–15
Bronze, h 23.2 cm
V&A: A.8–1949

Provenance
Charles Holden White, London;
purchased by Alfred Spero at Charles Holden White's sale, Christie's, London, 2 December 1948 (lot no.109); purchased by the National Art Collections Fund and presented to the V&A, 1949.

Bibliography
Planiscig 1927, pp.261–2, 483, no.135; Stone 1981, pp.111–13; Martineau and Hope eds 1983, p.377, no.S23 (with previous literature); Ebert-Schifferer ed. 1985, pp.463–5, no.166; Radcliffe 1997, p.91, fig 5.8; Warren 2001a, p.87; Krahn 2003, p.114.

260. Siren candlestick
PLATE 20.9

Workshop of Severo Calzetta (Severo da Ravenna), Ravenna, *c.*1510–30
Bronze, h 28.2 cm
The Ashmolean Museum, Oxford, WA 1888.CDEF.B1025

Provenance
Acquired in Bologna in 1857 by C. D. E. Fortnum, by whom given in 1888.

Bibliography
Lloyd 1980, no.9; Warren 1999, pp.26–7, fig.17.

261. Armillary sphere
PLATE 12.9

Italian, *c.*1500
Brass, diam 16.6 cm
Museum of the History of Science, University of Oxford, 12765

Provenance
Purchased in 1955.

Bibliography
www.mhs.ox.ac.uk/epact

262. Jar
PLATE 20.17

Venice, mid-16th century
Tin-glazed earthenware, h 27 cm, diam 27.5 cm
V&A: C.330–1930

Provenance
Purchased in 1930 with the John Webb Trust Fund.

Bibliography
Rackham 1940, cat.812.

Conclusion

263. *San Martino* (St Martin's Day) also known as *Trasloco* (Moving Home)
PLATE 1.17

Vincenzo Campi, Cremona, 1580s
Oil on canvas, h 142 cm, w 216 cm
Inscr. 'CASA DA VENDERE O FITAR' (House for sale or to rent).
Museo Civico, Cremona, Inv. 2051

Provenance
Listed (with four other paintings, including the kitchen scene, see cat.87) in the will of Elena Luciani, Campi's widow, in 1611; acquired by the monastery of San Sigismondo in Cremona in 1623; from 1809 in the collection of the Prefettura of Cremona.

Bibliography
Paliaga 2000a, pp.152–4; Marubi 2003, pp.132–3, fig.94.

NOTES

References to the Archivio di Stato in various Italian cities have been abbreviated as follows:
ASF (Florence)
ASG (Genoa)
ASM (Milan)
ASP (Prato)
ASS (Siena)
ASV (Venice)

1. Introduction

1. Grieco, Rocke and Superbi, eds (2002); Brown and Davis (1998).
2. Goldthwaite (1993), p.61.
3. Filarete (1972), I, p.26: 'Lo edificio sotto forma e similitudine umana essere fatto… Tu non vedesti mai niuno dificio… che totalmente fusse l'una come l'altra… chi è grande, chi è piccolo, chi è mezzano, chi è bello e chi è men bello, chi è brutto e chi è bruttissimo, come ne l'huomo proprio.'
4. Scamozzi (1615), bk1, p.255: 'Nelle facciate, e nel di dentro [le case de'gentilhuomini di terraferma] tenghino qualche cosa del bello e gratioso … accio da questi segni esteriori: come dalla faccia dell'huomo si possi comprendere, che sia casa da gentil'huomo.'
5. Lanteri (1560), p.14: 'non convenevole cosa sarebbe, che un mercante habitasse in un sontuosissimo palagio, et con magnificenza fabricato, ove un feudatario ricco d'entrata, in un picciolo habitasse'.
6. Goldthwaite (1993), p.61.
7. Clarke (2003).
8. Lando (1999), pp.178–82: 'Niuno dubitò mai che le case picciole con minor spesa non si fabricassero, et in minor spazio di tempo fabricate, molto piu utilmente non si godessero. S'è anchora sempre creduto che dentro vi fusse maggior proportione, et per conseguente, piu vaghe et vistose appariscero: sono meno soggette alle insidie de ladroni, ne anche parmi che per la bassezza loro, possano si agevolmente essere dalle celesti saette percosse: ed oltre che meglio si habitano, meglio anchora, et con minor spesa si adornano. L'huomo per quelle è iscusato di far feste, et di albergare principi per la strettezza della casa.'
9. Welch (2002), p. 222.
10. Welch (2002), p. 223.
11. Goldthwaite (1993), pp. 24–5; Syson and Thornton (2001).
12. Michiel (2000), p.56.
13. Frigo (1985).
14. Bec (1967).
15. Cicchetti and Mordenti (1982–91);

Cherubini (1989); Pezzarossa (1980).
16. Matchette (2005).
17. Machiavelli (1954).
18. Burckhardt (1995), p.227.
19. Burckhardt (1995), p.243.
20. Belgrano (1875), Molmenti (1905), Schiaparelli (1908) and Frati (1900).
21. Schiaparelli (1983), I, p.ix: 'Ben poche reliquie vi restano ormai del buon tempo antico, e anche queste, disperse come sono, e staccate da quel tutto di cui erano parte, hanno perduto ogni potere suggestivo. Porgere agli spiriti amanti del passato un qualche aiuto a rievocare nella sua interezza l'ambiente domestico in cui vissero i contemporanei di Dante e del Boccaccio, del Brunelleschi e del Botticelli, ecco lo scopo di questo libro'.
22. Schiaparelli (1983), I, p.x: 'Per via scopriremo l'origine di talune costumanze tuttora in vigore, e di non pochi oggetti di cui anche oggi facciamo uso senza sapere donde ci vennero e quando furono introdotti fra noi: così, studiando uno dei lati meno conosciuti della vita degli avi, getteremo qualche luce pur sulla nostra. E poichè quella vita era tutta penetrata di elementi estetici, molto spesso ci si offrirà l'occasione di discorrere d'arte, specialmente d'arte decorativa e applicata all'industria.'
23. Bode (1902).
24. Pavoni (1997); Penny (2005b).
25. One exception was the exhibition held at Palazzo Strozzi in 1948. See *La casa italiana nei secoli* (1948).
26. Lydecker (1987a); Thornton (1991).
27. Goldthwaite (1993).
28. Sarti (2002); Cohen and Cohen (2001-2002).
29. Thornton (1997); Musacchio (1999); Syson and Thornton (2001); Brown (2004).
30. Callmann (1999); Mazzoni (2004).
31. These issues were discussed at 'Renaissance Furniture', the Furniture History Society Annual Symposium, held at the V&A, 4 March 2006.
32. Botticelli (1997); Callmann (1980), pp.66–7. We are particularly grateful to Wolfram Koeppe, Associate Curator in the Department of European Sculpture and Decorative Arts at the Metropolitan Museum for allowing us to examine this bed in detail and for his invaluable insights.
33. Blair St George (1998); Miller (1987).
34. Johnson (1997); Klapisch-Zuber (1985b).
35. Goldthwaite (1993), pp. 227–37
36. Della Casa (2000), p. 84: 'Non si dèe alcuno spogliare, e spezialmente scalzare, in pubblico, cioè là dove onesta brigata sia; ché non si confà quello atto con quel luogo e potrebbe anco avvenire che quelle parti del corpo che si ricuoprono

si scoprissero con vergogna di lui e di chi le vedesse. Né pettinarsi né lavarsi le mani si vuole tra le persone, ché sono cose da fare nella camera e non in palese'.
37. Knox (2000).
38. *L'abito per il corpo* (1998), p.107.
39. Boggero and Simonetti (1991); Grossi Bianchi (1995); Kruft (1971); *La pittura a Genova e in Liguria* (1987); Gonzalez-Palacios (1996); Varaldo (1994).
40. Spallanzani (1997).
41. Lillie (2005).
42. Glassie (1976), pp. 293–95.
43. Didi-Hubermann (2002), p. 219: 'ein wahrer Übergang aus dem Leben in die Kunst'.
44. Schlereth (1982), p.xvi; Findlen (2002).
45. Belmonte (1587), p. 58: ' et cosi o al fuoco, ò alle finestre, ò al giardino condurle, secondo le stagioni, et i tempi: mostrandole le casa, et a proposito alcuna tua cosa, ò di nuovo, ò di bello, che tu habbia, ma però con maniera tale, che sia accettato per tua gentilezza ò domestichezza, et non per alterezza di animo: il che sarà in vece di mostrarle il cuore'.

2. The Florentine *Casa*

1. See the important observations by Amanda Lillie in Millon and Lampugnani (1994), p.519.
2. For some of these themes, see Preyer (1998).
3. See Bulst (1970) and Bulst (1990), Spallanzani and Gaeta Bertelà (1992), pp.1–131. In general, see Thornton (1991).
4. Pellecchia (forthcoming).
5. The paintings were made for Leonardo Bartolini, and they were acquired by the Medici only in 1484; see Caglioti (2000), I, pp.265–81, and Caglioti (2001), pp.37–54.
6. Even in the sixteenth century the *anticamera* usually followed the *camera* in Tuscany; statements that two *anticamere* preceded the *camera* in Cosimo I's quarters in the Palazzo Vecchio are based on a misinterpretation by the editor of the inventory, where the word *anticamera* does not appear (Conti 1893, pp.33–4). In Rome the *anticamera* occasionally had the significance of 'antechamber' ('ante' meaning 'before'), but sometimes it followed the *camera*: Frommel (1973), I, pp.72–3. Pius II's description of the main floor in his palace in Pienza mentions *anticamere* first, with the sense that they led to the other rooms, presumably reflecting Roman usage: Piccolomini (1972–6), III, p.219.
7. Bulst (1990), pp.115–16. The words *saletta* and *salotto* are used for the same

rooms in the construction documents for the houses of the Loggia of Santissima Annunziata and in various documents for the Gianfigliazzi palace. See Andreatta and Quinterio (1988), pp.266, 271; Preyer (2004), pp.75, 80.
8. Malquori (1993), pp.80–81.
9. Examples of early buildings about which there is ample written testimony are the palaces of Benedetto degli Alberti, built in the 1370s and described in 1468 (Preyer 2005, pp.89–92); of Giovanni di Bicci de' Medici (inventory of 1417: Spallanzani 1996, pp.3–48; Saalman and Mattox 1985, pp.336–41; and of Agnolo and Niccolò da Uzzano (inventory of 1424: Bombe 1928, pp.1–29).
10. Cf. Thornton (1991), pp.300–312. Lydecker (1987a) and Goldthwaite (1993) also endorse the idea that the Medici palace had an innovative interior and that the sixteenth century brought dramatic changes to Tuscan houses.
11. Schiaparelli (1908), pp.141–50; Schiaparelli (1983), I, pp.37–45; Orefice (1986), pp.90–93, 96–9, 142; Sframeli (1989), *passim*.
12. Thornton (1991), pp.44–8, states that walls were painted, or covered with fabric or with panelling. Herbert Horne's journal of the restoration of his palace does not mention frescoes, or holes, hooks, etc. for attaching decoration (Preyer 1993); nevertheless, I concur with Thornton's assessment, though I would broaden the range of materials.
13. See Preyer (1998).
14. Darr and Preyer (1999), pp.726–8; Davis (1996), pp.94–6.
15. Mazzi (1897), p.362; ASF, Carte Strozziane, V series, vol.1430 (1611 inventory); Lingohr (1997), pp.82–3: 'uno piedistallo con il bacino d'ottone e sechia'.
16. Pope-Hennessy (1964), II, pp.405–6. The palace has no courtyard, and the *sala* on the main floor has been divided into two rooms and a corridor, the latter probably the 'dark anteroom of the house' where Robinson saw the *acquaio* in 1859. See, for *acquai* in general, Schiaparelli (1908), pp.80–86.
17. Preyer (1993), pp.85–6.
18. Cicognara (1813–18), II, p.299; Vasari (1878–85), IV, p.531; VI, p.58. Neither author specifies that the pieces were in the *sala*, but it is hard to imagine where else they could have been.
19. Andreatta and Quinterio (1988), pp.266, 271.
20. Darr and Preyer (1999), p.728: 'un cammino ed un acquaio fra di loro opposti, e riccamente architettati con cornice intagliate con ornate e figure a basso rilievo.'
21. Vasari (1878–85), VI, p.58. That this

indeed was Giovanni Gaddi's house can be deduced from the census of 1561 (ASF, Decima Granducale, vol.3783, no.950). Charles Davis misinterpreted Vasari's words regarding the Gaddi 'fireplace and acquaio' ('un camino ed un acquaio') and, I believe, the Bindo Altoviti set as well, stating that the two elements in these sets were combined into a new form; the drawing plainly shows them as the two traditional fixtures (Davis 1996, pp.98–9 and 112, nn.53–4).

22. Lydecker (1987b).
23. See, for England, Roberts (1995), p.328.
24. Boucher (2001), pp.134–5. For the many questions regarding depictions of *camere*, see Kwastek (2001).
25. See Aquino (2005), p.85, for a remarkable document that states the specific spatial relationships envisioned for the wooden components of a *camera*.
26. Benporat (2001), pp.237–40.
27. Lydecker (1987a), pp.65–6; Olson (2000).
28. What follows is a brief summary of recent research that will be presented soon in a detailed study. My reconstruction has many points in common with that of Braham (1979), although I opt for a different room in the palace, and I give more prominence to the *lettuccio*.
29. A tondo of *The Trinity* by Granacci was probably not part of the room's original decoration. Vasari did not mention it in Pierfrancesco's *camera* in the first edition of the *Lives* of 1550, while a tondo of this subject appears in the inventory of Pierfrancesco's brother Giovanni in 1558; when Giovanni's family moved to Pierfrancesco's palace, they must have added the work to the *camera,* where Vasari mentioned it in his second edition of 1568.
30. For the three rooms see Haines (1983), Cheles (1986), and Raggio and Wilmering (1999).
31. ASF, Magistrato dei Pupilli avanti il Principato, vol.174, ff.229v–30. For Nori and his palace, see Preyer (1983), pp.398–400 and Lydecker (1987a), p.169.
32. For Mellini and his palace, see Carl (1994), pp.158–61, and the forthcoming monograph by the same author.
33. ASF, Notarile Antecosimiano, vol.10586, f.176v:'la testa del marmo di maestro Giovanni'.
34. For example, at the Gianfigliazzi, Boni-Antinori and Pazzi palaces. For the first of these, see Preyer (2004), pp.80–81.
35. In general, see Musacchio (1999).
36. I have not found corroborating evidence for the idea of the *anticamera* as the wife's room, which was put forward

in Bulst (1970), pp.389–90, and Bulst (1990), p.114, and followed by Thornton (1991), p.295.
37. Work with the plans of 1650 and the modern measured drawings in Cherubini and Fanelli (1990), pp.332–5, yields these dimensions, slightly different from those given in Pope-Hennessy (1980), p.241.
38. Milan, Università Bocconi, Istituto di Storia Economica, Archivio Saminiati-Pazzi, I, 14 (Giornale di Bartolomeo di ser Bartolomeo da Saminiato), f.xxxviiii.
39. Chellini (1984), p.218; Rubin (2006), ch.2.
40. For the latter, see Thornton (1997), p.77.
41. I owe this observation to Fabrizio Nevola.

3. The Venetian *Casa*

1. Schulz (2004), pp.5–10.
2. Mazzi (2000), pp.192–217.
3. Zumiani (2000), pp.307–25.
4. Smith (2000), pp.134–53.
5. Brown (2004), pp.195–200; Sarti (2002), pp.75–80.
6. Brown (2004), p.64; Howard (2002), pp.96–110; see also Thornton (1991), pp.284–300.
7. Cited by Brown (2004), p.67.
8. Schulz (2004), pp.10–21.
9. Sansovino (1663), I, p.382:'si chiamano Altane, per uso di distendere i panni al Sole, dalle quali si scuopre anco per lungo tratto di acqua, tutto il paese all'intorno'.
10. Brown (2004), p.53; Davies and Hemsoll (2000), pp.252–66.
11. Brown (2004), pp.53–62.
12. ASV, Cancelleria Inferiore, Miscellanea Notai Diversi, B.39, no. 59, inventory of Piero Gritti q. Marco (22 March 1557), f.33v; ibid., B.42, no. 66, inventory of Donato da Lezze q. Michael (19 October 1582), f.13v.
13. Sansovino (1663), I, p.384:'Ogni luogo commodo ha cortile col pozzo in mezzo scoperto, perche l'acque dolci si fanno più perfette all'aria che al buio: attento che il Sole le purga, & s'esala perciò da loro ogni difetto.'
14. Howard (2002), pp.66–8; Wolters (1976), p.252, cat.184.
15. Sansovino (1663), I, p.384:'tutte le finestre si chiudono, non con impannate di tela incerata, ò di carta, ma con bianchissimi & fini vetri, rinchiusi in telaro di legno, & fermati con ferro, & con piombo … con maraviglia de forestieri'.
16. Goy (1992), pp.240–43.
17. Sanudo (1980), p.21:'sono tanti li veri che li maistri continuamente conza, et mette in opera … che per ogni contra' vi è una bottega de verieri'.
18. Sansovino (1663), I, p.384:'l'occhio,

oltre alla bella veduta, corre per tutto liberamente, & i luoghi sono chiarissimi & pieni di Sole'; Chambers and Pullan (2001), p.24. See also Thornton (1991), pp.27–30; and Howard (2002), p.62.
19. Hills (1999), pp.111–13; Crovato (2002).
20. Hills (1999), pp.130–31; Thornton (1991), pp.234–9.
21. Thornton (1991), p.245.
22. Sansovino (1663), I, p. 384:'secondo le stagioni de i tempi'; Brown (2004), pp.84–5; Digby (1980), pp.59–61.
23. Brown (2004), pp.16–19, 95–6.
24. Brown (2004), pp.73, 83–5; ASV, Cancelleria Inferiore, Miscellanea Notai Diversi, B.34, no.3 (3 November 1507: Paolo Morosini q. Ursati [= Orsato]); ibid., B.36, no.17 (16 September 1535: Alvise Bon); ibid., B.40, no.45 (30 January 1566 m.v. [= 1567]: Zuan Alvise Bragadin); ASV, Giudici de Petition, B.44 (10 November 1592: Alessandro Ram).
25. Smith (2000), pp.134–53.
26. Sansovino (1663), I, pp.383–4:'Tutte le camera hanno i camini … Et certo con giudicio, percioche quando si esce di letto, si hà il fuoco vicino, il quale non solamente a prò asciugando lo humido, che si tira à se per lo dormir della notte, ma riscalda le stanze, & purga i cattivi vapori che si lievano ò per aria, ò per altro.'
27. Attardi (2002), pp.1–104.
28. Sartori (2001), p.47:'la camera spazada dove de inverno eremo soliti manzar'.
29. Brown (2004), pp.77–8. Commynes (1747), I, p. 481:'ont pour le moins, pour la pluspart, deux chambres qui ont les planchez dorez, riches manteaux de cheminées de marbre taillés, les chalitz des litz dorez, & les ostevens peints & dorez, & fort bien meublées dedans'.
30. Newett (1907), pp.339–40. Casola (1855), p.109:'Haveva uno camino tutto de marmoro de Carrara lucente come l'auro, lavorato tanto subtilmente che figure e fogliame, che Prassiteles ne Fidia le potrebbero adjungere. El celo della camera quanto fosse ben lavorato de auro e de azuro ultramarino, et la pariete tanto bene lavorata che io non lo posso riferire … tanto belle figure e naturali e tanto auro per tutto che non so se al tempo de Salomone … in el qual l'argento era reputato più vile che le prede, se ne facesse tanta labundantia quanto se demonstrava lì.'
31. Bistort (1912), pp.239 and 352–9:'le immoderate et excessive spexe che si fano in questa terra … in apparati, sì de lecti, come de camere, cum grande offension del nostro signor dio et universal danno de nostri zentilhomeni et citadini'.
32. Bistort (1912), pp.369–70:'al tuto vane e superflue, le qual exciedeno el

privato … i rastelli et chasse dorate, molto sumptuose et de valuta'.
33. Brown (2004), pp.123–5.
34. Cited in Brown (2004), p.67:'dare ordini mentre, che sono sani, e sumministrare a' loro bisogni quando fussero amalati'.
35. For example the eighteenth-century bedchamber with alcove, removed from Palazzo Sagredo, now in the Metropolitan Museum in New York.
36. Brown (2004), pp.100–109; Thornton (1991), pp.192–204.
37. Brown (2004), pp.77, 112–18. ASV, Cancelleria Inferiore, Miscellanea Notai Diversi, B.42, no.4: 17 January 1577 m.v. [= 1578]: Melchior Michiel q. Andrea: 'un tavolin tondo da lavorar suso'.
38. ASV, Cancelleria Inferiore, Miscellanea Notai Diversi, B.42, no.66, inventory of Donato da Lezze q. Michael (19 October 1582), ff.7v–8r: 'Un altaretto et sopra un christo di rilevo in croce di legno'.
39. ASV, Cancelleria Inferiore, Miscellanea Notai Diversi, B.44, [no number], inventory of Nicolo Padovano (3 April 1594), f.4:'un scrittor de noghera con scritture et sacheti pien di scritture'. See also Thornton (1997), pp.1–88 and *passim*.
40. Brown (2004), pp.217–50; Thornton (1997), pp.99–126.
41. Brown (2004), pp.235–40; Lauber (2002), pp.41–3.
42. Lauber (2002), p.42:'un honoratissimo adornamento e stima'.
43. Logan (1979), pp.67–75. Borenius (1923), p.20:'Quadri mezani, e picoli nelli studij, che non sono stati deliniati, perche sono vecchi, et sono posti in alcuni luoghi per adanpire il compartimento … diversi altri di retratti, et che sono per adornamento della Casa.'
44. Thornton (1991), pp.99–100.
45. Moryson (1971), p.88.
46. Lanteri (1560), pp.102–3:'senza passare pel rimanente della casa, ove possano esser vedute'.
47. Brown (2004), pp.67–8 and 91: Serlio – 'uno andito segreto pel quale si passa di camera in camera senza passar per lo portico';'loggietta segreta … in questa per non esser veduta da nessun lato stavano le figlie'; Scamozzi – 'I servi non vano mai ne gli appartamenti delle donne: intanto che non fano di certo, se in quella casa vi siano le figliuole dongelle: e parimente le serve giovani non comparono, se non di rado alla presenza de' loro padroni; ma servono ne gli appartamenti delle loro padrone … e vi si và per scale secretissime.'
48. Romano (1996), pp.85–99 and *passim*.
49. Sansovino (1663), I, p.381:'noi chiamamo case per modestia … Ma in

questa se ne contano poco meno di cento, & tutti, cosi antichi come moderni, magnifichi & grandi, cosi nella compositura, come ne gli ornamenti, ne partimenti, & ne luoghi utili per habitare';'edifici, ne più agiati, ne più raccolti, ne più acconci per lo uso humano di questi'.

4. The Artisan's *Casa*
My thanks to Dr Tonia Banchero, Dr Claudia Cerioli and Dr Valentina Ruzzin who have identified and transcribed the inventories used in this essay, and to Dr Assini of the Archivio di Stato, Genoa, for facilitating their work.

1. Although historians of work do devote some attention to the issue, to date the only specific study remains Isabella Palumbo Fossati's pioneering work on Venice, which is largely based on evidence from the late sixteenth century: Palumbo Fossati (1984).
2. For a synthesis of the studies, see Franceschi (1993), pp.290–300.
3. Here the term 'artisan' covers all those who produced goods directly with their own hands or supervised the work of others, and who traded in manufactured goods. The distinction between production and retail is frequently anachronistic in relation to this period: the shop was often a place of both productive work and commercial trading.
4. Although sending newborns to a wet nurse has often been described as a custom exclusive to the patriciate, diaries indicate this practice among artisans: Nadi (1969), pp.42–3, 51; Neri di Bicci (1976), entries 140, 198.
5. Dini (1990), p.438.
6. Neri di Bicci (1976), entries 201, 202.
7. Nadi (1969), pp.89, 97–8, 101, 110, 136.
8. All the artisans whose diaries are mentioned in this chapter owned a house or apartment at some point in their life but they then sold it after a few years.
9. Romano (1987), p.60.
10. Nadi (1969), pp.57, 110.
11. On the range of living patterns found in households of the Venetian labouring classes, see also Chojnacka (2001), ch.1.
12. Grossi Bianchi and Poleggi (1979), pp.137, 275; Pandiani (1915), p.67.
13. The quotation is from Pedro Tafur, cited in Heers (1984), p.46. See also the chronicle of Jean Marot d'Anton, who was in Genoa in 1502: *Croniques de Jean d'Anton* (1835), II, p.209.
14. Grossi Bianchi and Poleggi (1979), p.140.
15. Gianighian and Pavanini (1984), pp.63–5.

16. Gianighian and Pavanini (1984), p.94; Grossi Bianchi and Poleggi (1979), p.150; Pagliara (2001).
17. Gianighian and Pavanini (1984), pp.84–7.
18. My reconstruction is based on the biographical details provided by Bruno Dini in his *ricordanze*.
19. This view was established in Hughes (1984).
20. Nadi (1969), pp.97–8, 109. His daughter Tagia and her husband also left against his wishes and so did his son Antonio: Nadi (1969), pp.107, 113.
21. Nadi (1969), p.57.
22. Nadi (1969), p.93.
23. Nadi (1969), p.118:'e io andai a casa de la madre e mia compagnia a pianzere e lamentare del nostro grandissimo dano, me fiastri non volsero me partissi di casa, disse che voleano fossi il loro padre fino alla morte, lì andà a stare'.
24. Nadi (1969), p.230:'Chatelina andò a dormire con el fiolo Zanbatista e io rimasi con li garzoni … sto a dormire con i garzoni quando è fato el leto e quando non è fo come posso, messer Iddio me dia bona pazienza'.
25. Nadi (1969), pp. 213–14, 311, 325.
26. Bianchi and Grossi (1999), p.34.
27. The operations of wool production were largely concentrated in workshops, but even in this case the spinning, warping and weaving were carried out in the home, with women making a substantial contribution. Franceschi (1993), p.66.
28. Ghiara (1991), p.14.
29. Ghiara (1983), p.138. The spooling was usually done in the home by young women who worked under the supervision of a female overseer.
30. Franceschi (1993), pp.167–79.
31. One example is offered by Neri di Bicci, who had his own painter's workshop separate from his dwelling, while his sons were respectively apprenticed to a silk worker and a banker, and Neri's mother worked on wool and silk cloth from home. Neri di Bicci (1976), entries 286, 288, 32, 109.
32. Gatti (1986), pp.23, 50.
33. Dini (1990).
34. Gatti (1986), p.61; see also pp.62–3 for examples of similar agreements.
35. Grendi (1975), p.265.
36. Belgrano (1871, 1872); Pandiani (1915), pp.174, 179–80.
37. Grendi (1975), pp.260, 269.
38. Grendi (1975), pp.284–5.
39. Among others Kent and Kent (1982), Romano (1987), Eckstein (1995).
40. Davis (1994).
41. For example,'the gown of crimson velvet lined with red cloth with a pattern of three fruits, and a necklace of real pearls, the sleeves lined with thick

fur' found in the house of a cheesemonger: ASG, Notai Antichi, 496, inventory of Simone di Bargagli, 31 August 1413.
42. Vecellio (1590), pp.178–9.
43. The inventory of Everaldo Egre, for example, includes one woman's belt with a pomander and one *clavacuore* with its little knife, needle-case and little scissors: ASG, Notai Antichi, 661, doc. 474, inventory of Everaldo de Egre, 28 December 1450. *Clavacuori* can also be found in ibid., 1402, doc. without number, inventory of Geronimo Bianchi, 24 April 1501; 2437, inventory of Giovan Battista Bottino, 18 January 1556; 668, inventory of Francesco di Uncio, 13 November 1464; 2437, inventory of Francesco Cavallerio, 21 May 1566.
44. A portion of Andrea di Bicci's dowry was paid with 'lengths of wool, linen and other things': Neri di Bicci (1976), entry 279. For examples of debts paid in kind, see Dini (1990), p.426.
45. Inventory of Giovan Battista Bottino, ASG, Notai Antichi, 2437, 18 January 1556.
46. Examples include the inventories of Domenico Troti, shoemaker (ibid., 661, doc. 196, 25 December 1453), of Francesco Cavallerio, silk-weaver (ibid., 2437, 21 May 1566), and of Francesco di Uncio (ibid., doc. 668, 13 November 1464).
47. Neri di Bicci (1976), entries 8, 33, 39, 55, 64, 68, 69, 70, 71, 128, 152.
48. Neri di Bicci (1976), entries 17, 25, 40, 73, 89, 90, 91, 99, 115, 141.
49. Pandiani (1915), pp.97, 353. See, for example, the inventories of Giovanni Agostino Marchi, silk-worker, who had 'a cielo da letto' in a basket kept in his mezzanine, and of Simon de Amigdola, draper, who had two 'camere dipinte' in his house in Genoa and one in his rural house (ASG, Notai Antichi, 2445, 5 March 1583; 1402, document with no number, 19 May 1568). 'Camere' do not seem to correspond to bed curtains, for these are listed separately.
50. Examples of such visits are recorded in Gaspare Nadi's diary (Nadi 1969, pp.174, 282–3).
51. Nadi (1969), pp.26, 41, 73–4, 155, with further examples on pp.222, 329.
52. ASG, Notai Antichi, 544, inventory of Giovanni Ricci, 'lanaiolo', 30 August 1408.
53. Ibid., 1402, doc. without number, inventory of apothecary Geronimo Bianchi, 24 April 1501.
54. Ibid., 1402, doc. with no number, inventory of Simone de Amigdola, draper, 18 May 1568.
55. Ibid., 661, doc. 474, inventory of Everaldo de Egre, 28 December 1450.
56. Ibid., doc. 668, inventory of

Francesco di Uncio, 13 November 1464.
57. Ibid., 2445, inventory of Giovanni Agostino Marchi, 'setaiolo', 5 March 1583. For inventory of apothecary Bianchi, see n.53.
58. Ibid., 544, inventory of Antonio di Pavia, baker, 25 February 1417.
59. In the home of the gem-cutter Everaldo de Egre, for example (see n.55), one of the rooms in the mezzanine is filled with garments and shoes belonging to the master of the house, while the *camerotto* contains several items of clothing and jewellery of the mistress along with some household tools.
60. As suggested by the regulations for bakers issued in Genoa. Rebora (1987), pp.1514–16, nos 1–2.

5. People and Property in Florence and Venice
1. See Chojnacki (2000), Chabot (2005) and Bellavitis (2005).
2. For a more general background to the relationship between house and family in European history, see Sarti (1999).
3. Herlihy and Klapisch-Zuber (1978).
4. ASF, Carte Strozziane, V series, 12, f.25r:'voglio che la casa la quale habito posta nel corso degli Strozi sia di mia figliuoli e discendenti chon questo che mai si possa vendere né per altro modo alienare se none ne' mia disciendenti per linea masculina, i quali manchando a' disciendenti di Filippo di messer Lionardo, i quali manchando ai disciendenti di messer Iachopo dello Stroza.'
5. Cited in Brown (2004), pp.37–40.
6. ASV, Avogaria di Comun, Matrimoni, reg.142, f.384v, 6 June 1542:'per valore ducati 700 la casa da stazio a S. Apostoli sul rio dei Crosechieri che sia libera del ditto messer Gerolamo per conto di dota, la qual casa ha tutte queste condixion infrascritte, cioè: corte discoverta, pozo proprio, magazen, caneva, sotoportego, luogo da liscia, riva propria, do soleri con soffitta et tuto adornamento che sono al momento in sopradetta casa, con condition ch'el mezado soto dita casa romagna al prefato messer Nicolò.'
7. The house in San Raffaele, Venice, part of the dowry of Valeria, the natural daughter of Boniforte Dosio, was paid by her widowed mother (ASV, Notarile Atti, folder 377, no.304, 9 November 1543).
8. ASF, Corporazioni religiose soppresse, 102, 82, f.3r.
9. ASV, Avogaria di Comun, Matrimoni, reg.144, f.254, 18 February 1567.
10. Ibid., reg.141, f.81v, 1 June 1514, the inventory included:'due casse depente', 'una casseleta depenta fornida de oro', 'un letto fornido con le coltrine d'oro'.

11. Ibid., reg.144, f.95v, 22 October 1599: 'un letto con due cussini e due cavazzali'.
12. Klapisch-Zuber (1994b).
13. Mazzi and Raveggi (1983).
14. Alberti (1980), p.266.
15. Herlihy and Klapisch-Zuber (1978), Chojnacka (2001).
16. Bellavitis (2001), pp.296–303.
17. Cf. Romano (1996).
18. ASV, Notarile Testamenti, folder 782, no.679, 21 March 1556: 'mia fia che ho lattado madonna Andriana Barbaro relitta de messer Zuan Agustin Moro et sua sorella madonna Maria Barbaro'.
19. ASV, Scuola Grande di S. Maria in Valverde o della Misericordia, reg.129, 28 July 1503: 'per l'anema de Franceschina Morato fo mia compagna et massera'.
20. ASV, Notarile Testamenti, folder 193, no.174, 27 February 1561: 'Se lassasse un maschio o più voio che preditto mio marido sia usufruttuario de tuti li mei beni preditti portandose ben con ditti miei fioli et non faxando diferentia dalli miei ad altri chel ne avesse in caso el tornase a maridarsi, la qual bona compagnia son certa il farà a ditti miei fioli per l'amor è stato tra noi.'
21. Ibid., folder 196, no.904, 20 February 1544.
22. Ibid., folder 1258, no.19, 25 January 1578: 'la sopraditta mia consorte Camilla, la qual con affettuosisime parole mi ha raccomandato … esso Carletto dicendomi con parole piene di amorevolezza verso il detto Carletto allora fantolin che lassando a me la sapeva che io haverei per raccomandato Carlo et el beneficiarei dicendomi se vi maridate non voglio che alcun el batta.'
23. Ibid., folder 193, no.141, 5 May 1547: 'Itam volgio che la libraria ne la quale sono molti libri latini et greci et hebraici sia commune a tuti diti miei fioli, ma però in governo de Alexandro mio fiol.'
24. Ibid., folder 196, no. 870, 28 July 1569.
25. Ibid., folder 192, no.138, 1538: 'le opere et el retratto in stampa de Luter: non so dove le sia ma trovade nei miei libri sia subito brusade'.
26. ASF, Carte Strozziane, II series, 2, f.34v.
27. Dati (1869), p.31.
28. ASV, Notarile Testamenti, folder 79, no.393, 5 August 1537: 'mi ho personalmente conferito in la casa del habitation de messer Andrea Pegoloto mio fratello', 'dechiarando che io non lasso cosa alcuna a mio marido perché io non ho habudo cosa alcuna da lui'.
29. ASF, Notarile Antecosimiano, 10516, ff.49v–51v, 20 November 1410.
30. Ibid., 10518, ff.285r–288v, 20 November, 1423.

31. ASF, Corporazioni religiose soppresse, 102, 84, ff.17r–19v, 104r.
32. ASV, Avogaria di Comun, Matrimoni, reg.141, f.225v, 18 July 1519: 'perché son vecchio et per non andar ramingo in altre contrade'.
33. Ibid., reg.141, f.190v, 1 December 1519.
34. Ibid., reg.146, f.84v, 16 June 1537: 'la casa da statio in contrà e confin de San Cancian, soler de sopra, per ducati 2.500, con questa tamen condition che non se possi né spegazzar de ditta casa l'arma da ca' Marin si dentro come fora, né per li ditti novizi, né discendenti, né per nessun'altra persona nel tempo a venir'.
35. Klapisch-Zuber (1985a), pp.117–31.
36. Chabot (1986), pp.7–24: 'Non ho né casa, né masserizie', 'Non ò maserizia però che rimasi vedova e sanza maserizia', 'Una chasa … con le maserizie assai istrette che a noi vedove si richiede'.
37. ASV, Notarile Testamenti, folder 1185, f.54, 28 December 1508: 'et voglio che la ditta Maria mia moier in vita sua de tutto la sia dona et madona tutta via vedovando perché la tengo savia et de Dio serva ormai per esser in qualche etade di prepararse per l'anima sua et mia et non attender più ale vanità del mondo né sottomettersse più a persona alcuna salvo a l'onipotente Idio'.
38. Ibid., folder 1185, f.142v, 26 June 1528, will of Natale Garzoni.
39. ASF, Carte Strozziane, V series, 12, f.25r, 12 October 1429: 'voglio che all'Alexandra mia donna, rimagniando dopo di me e vivendo cho' mia figliuoli, non possa essere tracta di casa e debba avere, non adomandando le sue dote, le spese per se e per una che la serva. E se a lei non piacessi stare cho' mia figliuoli e tenesse vedovile vita e honesta e non volesse stare nella dicta chasa, voglio che oltre alle sue dote abbia gl'usufrutti del podere di Pozolaticho tutto il tempo della sua vita'.
40. ASF, Manoscritti, 84, ff.27v–28r.
41. Ibid.: 'pigliare la tenuta della detta camera et antichamera et chamera terrena e de' beni predetti e quelli tenere, usufructare a suo piacere mentre ch'ella viverà stando vedova sanza molestia o contradictione dell'erede del detto testatore e sença licentia, auctorità o divieto d'alchuno giudice o corte'.
42. ASF, Carte Strozziane, V series, 12, f.25r: 'che tute le discendenti di messer Iacopo dello Stroza degli Strozzi che fussino o che saranno v'abino su [la casa] la ritornata in caso della viduità'.
43. ASF, Manoscritti, 84, f.25r–v: 'E più volle che lle dette sue figliuole ne' detti chasi di viduità e necessità nella detta chasa e fortezza da Uzzano, per l'erede del detto testatore s'assegni a lloro uso

quelle masserizie e chose chome a lloro piacerà sì veramente che le dette sue figliuole domandino chose ragionevoli e giuste et non cose che no' potessono essere riprese, stando a lloro detto se l'aranno avute o no.'
44. ASF, Catasto, 31, f.111 r–v.
45. Fachard (1986), pp.171–2: 'ad ciò si vedessi quello era suo libero et quello si havea ad preservare alle heredi'.
46. Crabb (2000).
47. Velluti (1914).
48. Fachard (1986), p.182.
49. ASV, Notarile Testamenti, folder 66, no.246, 12 January 1503: 'Item perché el dito messer Sebastian vene a star in chaxa mia al mio maridar et sta e porto' e a el suo mobele, pero' voio che l'abia tuto el suo mobile e che non li vegna fato molestia alguna de dir chel non sia suo tuto quelo chel dirà eser suo.'
50. Dini (1990), p.439: 'Quella donna è venuta a sciorinare e' sua panni e maseritie!'
51. Braunstein (1985).
52. Bellavitis (2001), pp.296–303; Grubb (1994).
53. Bellavitis (2001), p.309.

6. Representing Domestic Interiors

1. However, it is sometimes forgotten that inventories of moveable goods were taken for particular reasons, often connected with the deaths of their owners. Thus we should not see these lists as records of houses whose rooms had been casually vacated. Instead, the rooms may have been carefully prepared so that the inventory could be taken. It is likely, for example, that some objects that were openly displayed during their owners' lifetimes were stored for security at such a time.
2. See especially Thornton (1997).
3. Norman (1999), pp.82–93.
4. Kwastek (2001). Although it is aware of the paintings' subject matter, this account remains problematic because of the way in which it compares images of the bedchamber to pieces of furniture which have been catalogued in the past as Quattrocento, but whose status now seems distinctly dubious.
5. See Constable (1990), pp.49–70
6. Cadogan (2000), pp.2, 85.
7. Christiansen (1998), esp. p.39; Nuttall (2004), pp.36–8
8. For this discussion, see Ames-Lewis (1979) and (1989); Ruda (1984) and (1993), pp.127–8; Nuttall (2004), pp.20–22, 107, 157, 164. For Filippino's tondi, see Krohn (1994); Zambrano and Nelson (2004), pp.28, 344–5, cat.30. For their relationship with the Portinari Altarpiece, see Christiansen (1998), p.49.
9. Christiansen (1998), pp. 49–53; Nuttall (2004), pp.133–6.
10. Panofsky (1953), pp.140–44.

11. Lorne Campbell in his account of Jan van Eyck's Arnolfini Double Portrait in the National Gallery: Campbell (1998), pp.198–204.
12. This is essentially the approach in Bergström (1957) and Rice (1988), pp.105–11.
13. Olson (2000), p.247.
14. Thornton (1991), p.17.
15. Origo (1963), p.52.
16. Ruda (1993), pp.159, 428–9, cat.38.
17. Lydecker (1987a), pp.46–8.
18. Wright (2005), pp.300–306. Nevertheless, as Wright points out, the setting is specifically Florentine (if also paradisiacal), as the distant view of the city indicates.
19. Thornton (1991), p.182, pl.200.
20. Ladis (1992).
21. Reynolds (1996).
22. Christiansen (1982), p.131, cat. XLIII, pl.102; De Marchi (1992), p.172, pl.67, fig.91.
23. Panofsky (1953), p.142.
24. See the many examples included in Prampolini (1939).
25. See Edgerton (1977).
26. Gospel of the Birth of Mary 9: 1–2; Ragusa and Green (1961), p.16. See also the Protevangelium of James 10: 1.
27. This literature is very large, and this is not the place to analyse it in full (I may therefore stand justly accused of oversimplifying an immensely complicated issue). But see Bernard of Clairvaux (1976–9); Scheper (1971); Duby (1976); Astell (1990), esp. pp.61–4; Zlatohlávek (1995), esp. pp.34–73.
28. Steinberg (1996), p.5 n.2.
29. Ruda (1993), pp.88–98.
30. Blum (1992).
31. Carruthers (1998), pp.171, 216, 239–40, 249.
32. Pardo (1991); Kemp (1991); Kent (2000), p.92.
33. See Arasse (1999), p.28. He draws on the arguments in Didi-Huberman (1990), pp.186–7, 190, in which he posits the Virgin's garden as a memory locus.
34. Yates (1966), esp. pp.57–63.
35. Bacci (1907); Sheridan (1960); Yates (1966), pp.108–9; Bolzoni (1992), esp. p.59; Kent (2000), pp.91–3. Michele del Giogante wrote: 'Here I Michele di Nofri di Michele di Maso del Giogante, accountant, will show the principle of learning the art of memory, which was explained to me by Maestro Niccholò Ciecho [the blind Marchigian improviser of popular poetry] of Florence I December 1435 when he came here, beginning by allotting places in my house according to the way he told me to …'
36. See Bolzoni (1985).
37. Ziliotto (1937); Yates (1966), pp.106–7; Yates (1976).

38. See Yates (1966), pp.83, 108, 117. Romberch used the *Ars memorativa* by Jacobus Publicius, published in Toulouse in 1475/6 as a source (later published as part of the *Oratoriae artis epitome* in Venice in 1482); the author styled himself, possibly misleadingly, 'of Florence'. See Carruthers and Ziolkowski (2002), pp.226–7.

39. Cadogan (2000), pp.320–21, cat. Davide 3, which follows Lisa Venturini in her view that it is not by the hand of the sixteen-year old Mainardi and re-assigns it to Davide Ghirlandaio, working to his brother Domenico's design.

40. Didi-Huberman (1990), p.190, for the manifold identification of Mary with objects and natural phemomena.

41. Ruda (1993), p.191. Here he builds on ideas explored by Baxandall (1972), p.48.

42. These sometimes included works of art. See Debby (2002).

43. For some of the well-known texts that would have informed the viewing of images of the Annunciation, see Liebrich (1997), pp.17–41.

44. See Bolzoni (1985) and (2003).

45. A good example of this approach is Geiger (1981).

46. Cadogan (2000), p.214.

47. Sprinson de Jesus in Ainsworth and Christiansen (1998), p.118, cat.12 (Hans Memling, *The Annunciation*).

48. De Voragine (1993), I, p.149.

49. Panofsky (1953), p.126

50. Panofsky (1953), pp.143, 415. The identification of textual sources by Panofsky and his followers remains extremely useful, as long as contemporary popular knowledge of the text can be demonstrated, and it is recognized that the identified text is likely to be one among several that would have informed a reading of the image, and it does not provide the only solution.

51. Bolzoni (1984), Delcorno (1980).

52. Ilgner (1904), pp.158–78, 223–7; Jarrett (1914); Tawney (1926), pp.31–32, 40–41; Rinaldi (1959), p.89; De Roover (1967), pp.1–17; Picciani (1972).

53. Brucker (1967), p.121.

54. Ruda (1993), p.520, doc.6.

55. Origo (1963), p.57.

56. Leon Battista Alberti, *I libri della famiglia*, Liber tertius familie: economicus, Gianozzo: 'La masserizia nuoce a niuno, giova alla famiglia. E dicoti, conosco la masserizia sola essere sofficiente a mantenerti che mai arai bisogno d'alcuno. Santa cosa la masserizia!'

57. Debby (2001), p.129.

58. Baldwin (1985–6); Brown (2001), pp.106–8, cat.3; Christiansen (2005), pp.150–52, cat.4 (which compares the image to Lippi's *Annunciation* in the Galleria Nazionale d'Arte Antica, Rome, but only from a formal point of view).

59. Canticles 2: 9.

60. Syson (1997), esp. p.52; (Brown) 2001, pp.110–11, cat.4 (in which it is dated slightly too late). She lacks the ring on her fourth finger that would indicate that she was already married.

61. Lefebvre (1991).

62. In the *Zardino de Oration* of 1454 (published in Venice in 1494). See Baxandall (1972), p.46.

63. Syson and Thornton (2001), p.38.

64. Lydecker (1987a), pp.63–7, 69, 263, 279; Musacchio (1999), pp.159, 160, 162, 164.

65. Musacchio (2000), pp.147–59. San Bernardino mounted a defence of the practice of attaching arms to sacred paraphernalia mainly to guard against theft. See Trexler (1980), p.92, n.23.

66. Trexler (1972).

67. Randolph (1998), esp. p.196.

68. Musacchio (2000), esp. pp.153–4.

69. Ray (2000), pp.69–72, cats 144, 146 and see p.108.

70. Bettoni (1997), esp. pp.58, 64, 76, cats 24, 31, 48.

71. Liefkes (1997), p.38, fig.40. For the association of clear glass and the Virgin's purity, see Meiss (1976); Sandström (1963), pp.64–5.

72. Mentasti *et al.* (1982), p.18.

73. Mentasti *et al.* (1982), p.100, cat.106 (in the Metropolitan Museum or Art, New York, inv.1483 Class II).

74. This has been suggested as the function for the Annunciation lunette by Fra Filippo Lippi in the National Gallery, London. See Gordon (2003), I, pp.149–55, who however points out that the absence of scratches and dents makes it unlikely that it was ever as vulnerable to damage as it would have been if incorporated into a bed. Nevertheless, the bed painted with the Virgin and Child and a donor and dated 1337 in the Ospedale del Ceppo in Pistoia, which was made as a votive object, may reflect contemporary and subsequent domestic practice.

7. Marriage and Sexuality

Special thanks are due to the many friends and colleagues who contributed to the research for this essay. I would like to especially recognize the contributions made by Eve Borsook, Christiane Klapisch-Zuber, Alexandra Korey and the editors of this volume, Marta Ajmar-Wollheim and Flora Dennis.

1. Syson and Thornton (2001), ch.2, 'Betrothal, Marriage and Virtuous Display', pp.37–77. On the many similarities between Christian and Jewish uses of objects in courting, betrothal and marriage in Renaissance Italy, see Weinstein (2004).

2. Brucker (1986).

3. On reproduction theory in Renaissance Italy, see Bell (1999), Berriot-Salvadore (1993) and Jacquart and Thomasset (1988).

4. On marriage before and after Trent, see Fazio (1996) and Lombardi (1996).

5. Ferrante (2001), pp.354–5: 'Perché non voglio Andrea!'

6. Lombardi (2001), p.208: 'Quante volte per comperare le nappe, i nastri, e le scarpe alla innamorata, si ruba da' giovani parte della raccolta ne' loro poderi?'

7. Lombardi (2001), pp.208–9.

8. Meek (2001). For traditional marriage rites and gestures in central and northern Italy, see Eisenach (2004), Ferraro (2002), Lombardi (2001), Merzario (1981), Seidel Menchi and Quaglioni (2001).

9. Lombardi (2001), p.213.

10. Cavallo and Cerutti (1990), p.74.

11. Frigo (1985).

12. Klapisch-Zuber (1985a), pp.178–212.

13. An example of a commemorative inkwell is a small maiolica polychrome sculpture from Faenza representing the Judgement of Paris and inscribed with date '1505 ad 6 di junij'; Ravanelli Guidotti (1998), pp.230–32, fig.50a.

14. Syson and Thornton (2001), p.64, fig.44.

15. Schutte (1980). On the variety of betrothal boxes in this period and their iconography, see Lorenzelli and Veca (1984); Brown (2004), pp 108–10; Miziolek (2003).

16. Randolph (1998) and Simons (1988).

17. Altieri (1995), p.53: 'lo zaffiro di color celeste, ce denoti la anima nostra, qual da quello se deriva; e'l balascio poi, come de ignea material, denoti lo corpo, receptaculo del core, infocato da amorevil fiamma, et per questo demostrase dunarli la anima ello core'. On the wider cultural significance of the colours blue and red, see Pastoureau (2000).

18. On the meaning of stones in the Renaissance, see Sberlati (1966) and Magnus (1967).

19. Italian, fifteenth century, listed in Dalton (1912), p.158, no.986, and p.164, no.1019a. On finger rings, see also Lightbown (1992).

20. I thank Christiane Klapisch-Zuber for having shared with me her forthcoming article on the wedding of Francesco de' Medici, 'Les noces Florentines du XVe siècle'. On the circulation of rings as gifts, see Klapisch-Zuber (1994a) and Bestor (1999).

21. On nuptial chests, see Baskins (1998), Faenson (1983b), Hughes (1997), Miziolek (1996), Tinagli (1997), ch.1, pp.21–46.

22. Sachs (1983).

23. Sachs (1983), p.26: 'calzoni di tabì bianco con cordoncini foderati di ermesino bianco'.

24. Sachs (1983), pp.22–3.

25. Sachs (1983), p.28.

26. Baldwin (1986).

27. Ajmar and Thornton (1998); Ravanelli Guidotti (2000), plates 52, 62; Ravanelli Guidotti (1998), p.195, figs 14, 15.

28. Ravanelli Guidotti (1986). This article cites several sets of maiolica made specifically for weddings.

29. Owing to their greater fragility, nuptial goblets made of glass are much more rare than commemorative maiolica. A magnificent example is a green glass goblet, enamelled and gilded, featuring portraits of the bride and groom and pairs of putti, attributed to Giovanni Maria Obizzo, Murano, Venice, *c*.1490–1510, and reproduced in Syson and Thornton (2001), p.53, fig.33.

30. See Murphy (2001), figs 26, 27.

31. Chambers and Pullan (1992), p.265.

32. Strozzi (1877), pp. 5–6 (24 August 1447): 'E come si maritò [findanzò], gli tagliò una cotta di zetani vellutato chermisi; e così la roba di quello medesimo; ed è'l più bel drapppo che sia in Firenze; che se lo fece'n bottega. E fassi una grillanda di penne con perle, che viene fiorini ottanta; e l'acconciatura di sotto, è sono duo trecce de perle, che viene fiorini sessanta o più: che quando andrà fuori, arà in dosso più che fiorini quattrocento. E ordina di fare un velluto chermisi, per farlo colle maniche grandi, foderato di martore, quando n'andrà a marito; e fa una coppa rosata, ricamata di perle.'

33. Randolph (1998), p.193.

34. On the counter-dowry, see Klapisch-Zuber (1985a), pp.213–46; Bestor (1999); Allerston (1998).

35. For the fifteenth century, see Simons (1988). For the sixteenth century, see Brevaglieri (1995) and Murphy (1997).

36. Randolph (1998), p.189 and n.34: 'Anchora possino portare collari o collane, vezi, e due brocchette, [sic] una per in capo et una per la spalla: et queste sopra dette cose le possino portare tre anni da dì che ne saranno ite a marito, così per quelle che per lo passato sono ite a marito come per quelle che per l'avenire andranno: Et finiti i detti tre anni, possino portare la collana o vero collare solo et una brochette sola per insino in altri tre anni, et di poi sia vietato interamente loro el potere portare qualunque delle sopra dette cose.' See also Hughes (1986).

Chests

1. On this typology, see Paolini (2004), containing an appendix with a bibliography of roughly seventy titles on *forzieri* and *cassoni*. In this context the essential contribution made by Peter Thornton in his *Italian Renaissance Interior 1400–1600* (1991) should be noted.
2. On this issue, see the arguments put forward in Thornton (1984).
3. In particular, Vasari notes that in his time 'everyone had these chests painted, and in addition to the stories depicted on the front and sides, they included coats of arms, the symbol of the family line, in the corners and elsewhere. And the stories illustrated on the sides were generally fables taken from Ovid or other poets, or else episodes from Greek and Latin histories: and equally hunting scenes, jousts, tales of love and other similar things, according to preference. The inside could then be lined with silk or cloth, according to the status and power of the commissioner, in order to keep silk clothes and other precious things better.'
4. See Lydecker (1987a).
5. Paolini 2002, pp.77–80, with bibliography. The attribution to Lorenzo di Credi was first suggested by Umberto Baldini (in Paolini 2002, p.11).
6. On this typology, see Bruschi (1994).
7. Museo Poldi Pezzoli (1983), p.312, with bibliography, to which should be added Balboni Brizza (1995), pp.24–9.
8. The chest, acquired by Giuseppe Bertini in 1884 and the subject of an unspecified intervention by Luigi Cavenaghi in 1890, was restored first in 1974 and then again in 1985, focusing mainly on consolidating the structure and materials, given the object's overall integrity.
9. Pollen (1924), pp.136–7; Henneberg (1991), pp.115–32.
10. Various chests of this type at the Kaiser Friedrich Museum in Berlin, despite the fact that they have survived in the form of carved panels remounted on modern, Renaissance-style structures, have been identified by Frida Schottmüller as the products of artists gravitating around the circle of Polidoro da Caravaggio and dating from *c.*1540 (Schottmüller 1921, figs 138–42; Schottmüller 1922, pp.viii–ix, fig.7).
11. See, for example, those in the Robert Lehman collection at the Metropolitan Museum of Art in New York (Szabó 1975, figs 136–7), those in the Frick Collection (*Frick Collection* 1992, in particular nos 16.5.117 and 16.5.118), and also those mainly from the Mikhail Botkin collection and now at the Hermitage (see Faenson 1983a, figs 165–92).
12. Gonzàlez-Palacios (1984), pp.22–3.

The *Lettuccio* and *Cappellinaio*

1. See, in particular, the contributions in Trionfi Honorati (1981) and Thornton (1992), pp.149–153. An updated and complete bibliography on the subject can be found in Paolini (2004), pp.29–34 and 73–81. See, also by the same author, a study of the *lettuccio* in the Horne Museum in Florence, one of the few accessible examples: Paolini (2002), pp.70–72.
2. This was the case for the wedding chamber created in 1508 for the Sienese nobleman Girolamo di Francesco Guglielmi by the Florentine carpenter residing in Siena, Bastiano di Salvadore di Bindo. The contract for the work is preserved in the Archivio di Stato, Siena. In addition to the *lettiera* with its headboard, truckle bed, chest at the foot of the bed and the usual chests at the sides, the carpenter was also commissioned to supply a *lettuccio* with predella that was as long and as high as the *lettiera* (4 by 4 Sienese *braccia* – equal to 238 by 238 cm, 1 Sienese *braccio* being 59.5 cm) and a 'quadro per ritto, fra la sedia e la lettiera, co'lo medesimo ordine di regolami e intagli di sopra a detto quadro, chome sta nella lettiera e la sedia' (vertical picture, between the chair and the *lettiera*, with the same specifications and carving as the chair and the *lettiera*). See Corti (1985).
3. ASS, Conservatori riuniti, folder 611 (*623 vecchio*), insert 16. The *lettuccio* was sold in 1883 for 3,200 *lire*.
4. ASS, Conservatori riuniti, filza 604 (*204 vecchio*) 'Inventario dei mobili e attrezzi esistenti nell'I. e R. Conservatorio del Rifugio di Siena questo di 31 dicembre 1818', nos. 107, 108, 109 and 110. The *lettuccio*, together with a small number of other pieces of furniture, was estimated at the very modest figure of 17 *lire*.
5. ASS (A.S.C.S., Archivio Postunitario – Comune di Siena XXV), A sezione storica: Inventario generale degli oggetti mobili (compilato dal mese di febbraio a giugno 1897). 'Sala delle Biccherne, no.209, Cappucciaio intarsiato e intagliato all'antica. Sec. XV. Condizione buona. Valore L. 800,00.' (*Cappucciaio* with intarsia and antique-style carving. Fifteenth century. Good condition. Value *Lire* 800.00.)
6. Mengozzi (1904). The term *cappucciaio* is still used today by many Sienese conservators, and historians also refer to it. Perhaps it derives from an old local expression indicating the maker or seller of hoods and hats.
7. The official catalogue of the exhibition records that the *lettuccio*, described here also as a 'cappucciaio', was displayed, together with two sixteenth-century chests, on the first floor of the Palazzo Pubblico in room VI, located between the Map Room and the Consistory Room: *Mostra dell'antica arte senese* (1904), p.138, no.10134. The photograph (Istituto Italiano Arti Grafiche) appears in Ricci (1904), pp.61, 140 fig.131. A reproduction of the object was also available from the Sienese photographer Lombardi, perhaps already in the 1884 catalogue, as recorded in two publications: Ferrari (n.d. [1910]), table XXIV, and (n.d. [1916]), p.296, table IV. Anna Maria Massinelli rediscovered the *lettuccio*, presenting it in its current state in Massinelli (1993), fig. 130, table IX.
8. The work was carried out between 1924 and 1926 entirely by the brothers Giuseppe and Tito Corsini, who were at the time undisputedly the best local wood-carvers and cabinet-makers. In the documents discovered there is no mention of the *lettuccio* or *capellinaio*, but it is possible that the restoration was carried out by this firm. A.S.C.S, Archivio Postunitario, folder 0021, lavori pubblici dal 1815 al 1924, and folder 0031, lavori pubblici dal 1925 al 1929.

8. Conception and Birth

1. For wooden birth trays, see De Carli (1997); Musacchio (1999), esp. pp. 59–83; Däubler-Hauschke (2003); and Randolph (2004), pp.538–62.
2. For wooden birth bowls, see Musacchio (1999), esp. pp.83–9.
3. There are two versions of this bowl, the main difference being the heraldry; see Ferrazza and Bruschi (1992). For drawings associated with them, see Cox-Rearick (1964), pp.273–4; and *Art Treasures and Antiquities from the Famous Davanzati Palace* (1916), lot 996.
4. For maiolica birth wares, see Crainz (1986); Bandini (1996); and Musacchio (1999), especially pp.91–123.
5. Astrology was an important part of Renaissance society, and indeed an important part of childbirth; many homes had astrology texts. See, for example, ASF, Magistrato dei Pupilli avanti il Principato (henceforth MPAP) 187, 341v; and Lemay (1984), pp.83–4.
6. Piccolpasso (1980), I, ff.10v–11r.
7. For these sources, see, among others, Lydecker (1987a); Anselmi (1980), pp.93–149; Strozzi (1877); and Thornton (1991).
8. For poultry, see Musacchio (1997); for a gift of two silver salts, see Castellani (1992), p.75.
9. There is a vast literature on ex-votos; see Masi (1916); Turchini (1992); and Freedberg (1989), pp.225–9.
10. Lemay (1990), p.197. In England churches assembled relics to loan to pregnant women (Thomas 1971, p.28),
while a fifteenth-century Florentine estate included a crystal, a reliquary ampule and relics, all for women to wear during childbirth (ASF, MPAP 173, f.266v).
11. Henschenius and Patebrochius (1737), I, pp.332–3 and 348–9; and Cassidy (1991).
12. ASP, Archivio Datini 1103, 23 April 1395.
13. Vernon (1909), II, p.208; and Sacchetti (1993), pp.514–16. For examples, see ASF, MPAP, 2653, f.353r; and ASF, Acquisti e doni 21, f.16r.
14. D'Afflito (1994) and Musacchio (2005), 139–56. Further information on charms can be found in Borghini (1981), pp.167–8. I am grateful to Richard Goldthwaite for this reference.
15. For example, in 1472 the Florentine Niccolo Strozzi bought ninety pieces of coral to make a necklace for his six-month-old son Carlo (ASF, Carte Strozziane, IV series 71, f.27v). Further information on coral is found in Alexandre-Bidon (1987) and Borghini (1981), pp.169–71.
16. ASF, MPAP 177, f.77r; and Schnapper (1988), VI, pp.36–7. My thanks to Katharine Park for this reference.
17. Altieri (1992), pp.62–3.
18. Schnapper (1988), I, pp. 26–7. See also Bromehead (1947) and Barb (1950). A collection of remedies from 1364 recommended that pregnant women carry aetites on their right sides; see Bernardi (1898), p.71.
19. Luzio and Renier (1893), p.70.
20. ASF, MPP 2668, f.531v; and MPAP 4, f.8r. For additional birth charms, see Lightbown (1992), pp.23–32; and Kieckhefer (1989), p.102.
21. For Margaret's life and martyrdom, see De Voragine (1941), pp.351–4.
22. Lemay (1990), p.197, and Burke (1987), p.122.
23. My thanks to Timothy Wilson for drawing this bowl to my attention. This term was not particularly common; for its use in reference to a pregnant pig, see Lotto (1969), p.214.
24. Brucker (1971), pp.181 and Rainey (1985), p.479.
25. Trexler (1973).
26. Alberti (1988), p.299; Varchi (1859), II, p.669; and Paré (1982), pp.38–9.
27. Klapisch-Zuber (1985a), pp.310–29.
28. Ovid, *Metamorphoses*, 9.273: 434–574.
29. For further discussion, see Musacchio (2001).
30. Gentili (1989); and Brown and Lucco (1997), pp.115–16.
31. Much of his wealth came from his involvement in the Medici bank; see De Roover (1963), pp.17, 71–2 and 235. See Musacchio (1999), pp.158–73, for a

transcription of this inventory.

32. Musacchio (1998) and Musacchio (2003).

33. By the late fourteenth century artists and artisans regularly displayed objects for purchase by an eager and acquisitive public. In 1461 the painter Neri di Bicci made a birth tray at his own expense for this purpose; see Neri di Bicci (1976), pp.167–8. An anonymous fifteenth-century carnival song of the Florentine sculptors also referred to this type of production; see Singleton (1936), p.10.

34. ASF, MPAP 2650, f.153v.

35. ASF, Carte Strozziane, V series 1751, f.125r. For more information on this case, see Musacchio (1997), pp.7–8.

36. ASP, Ceppi 211, f.32 right.

37. In 1388 Jacopo Bombeni's heirs noted that a striped and lined birth mantle had been loaned to Tommaso Sacchetti (ASF, MPAP 1, f.234r). In 1471 Niccolo Strozzi bought a wooden birth tray and a nightshirt for his pregnant wife, as well as a mantle for their not-yet-born child, from a used goods dealer (ASF, Carte Strozziane, IV series 71, f.22v). In 1463 Giovanni Strozzi sent a chest to the monastery of San Piero Martero in Florence, containing five birth mantles among the linens and accessories (ASF, Carte Strozziane, III series 275, f.76v).

38. See, for example, ASF, MPAP 166, f.97v ('uno mantiletto tristo da donna di parto').

39. On sumptuary legislation in the Italian city states, see, among others, Hughes (1983), Rainey (1985) and Kovesi Killerby (1994). Florentine laws regarding gifts at birth and baptism underwent changes in 1373 (Rainey 1985, p.256), 1388 (Dominici 1860, pp.234–5), 1402 (Rainey 1985, p.65), 1415 (Statuta populi et communis Florentiae 1778, pp.381–2), 1473 (ASF, Consigli della repubblica, provvisioni registri, 164, f.38r), 1546 (Cantini 1800–1808, I, p.320), and 1562 (Cantini 1800–1808, IV, p.405).

40. On the Florentine attitude toward wealth, see Goldthwaite (1993), pp.204–12.

41. Bonnaffè (1895), pp.56–7; further references are Sansovino (1581), p.402, and Lotto (1969), p.237.

42. Luzio (1912), p.73; Cantini (1800–1808), V, p.71; and ASF, Consigli della repubblica, provvisioni registri, 164, f.38r.

43. ASF, Corporazione religiose soppresse dal governo francese (102), 356, f.28 right.

44. On baptism, see Haas (1995) and, more generally, Coster (2000) and Cramer (1993).

45. For the importance of this iconography in Florence, see Hatfield (1970a) and Trexler (1978).

46. Vasari (1878–85), VII, pp.20–21; and Schaefer (1988), p.14.

47. ASP, Archivio Datini, 1092, 31 July 1390 and 20 January 1391.

48. Perosa (1960), p.35; Klapisch-Zuber (1985a), pp.213–46; and ASF, Carte Strozziane, IV series, 418, f.9v. The silverware recalls the English practice of gifting apostle spoons; see Jackson (1892) and Shakespeare's Henry VIII (Act V, Scene ii), where the king taunts a hesitant sponsor with, 'Come, come, my lord, you'd spare your spoons.'

49. ASF, Carte Strozziane, IV series 418, f.8v; and ASF, Carte Strozziane, II series 16 bis, f.4r.

50. Klapisch-Zuber (1985a), pp.213–46.

51. Herlihy and Klapisch-Zuber (1985), p.277.

52. Chojnacki (1975), p.587.

53. Alberti (1969), pp.54–5.

54. For Giovanni's letter describing the tragedy, see ASF, Mediceo avanti il Principato 35, 746; the tomb is discussed in Egger (1934).

55. For the demographic crisis, see Carmichael (1986), pp.60–61; and Herlihy and Klapisch-Zuber (1985), pp.60–92.

56. For the plague and its impact, see Biraben (1975–6), Park (1985), Cohn (1992) and Herlihy (1997).

57. Meiss (1951).

58. Strocchia (1992), p.64.

9. Children and Education

1. Alberti (1960), p. 107: 'figliuoli … sieno come pegno e statici della benivolenza e amore congiugali e riposo di tutte le speranze e volontà paterne'; Alberti (1969), pp.112–13.

2. Palumbo Fossati (1984), 109–53.

3. Ariès (1962), pp.35–8; Becchi (1996), 115–53; Dempsey (2001); Cortese (1999), 235–40.

4. Cadogan (2000), pp.93–101, 230–36.

5. Coonin (1995), pp.61–71.

6. Campbell (1990), pp.178–9, 196–7, 214; Cortese (1999), pp.235–47; Zuffi (2000), p.269.

7. Pignatti and Pedrocco (1995), pp.57–9; Priever (2000), p.20.

8. Sansovino (1565), f.6r: 'rinovò & dhuomini, & di donne la maggior parte de gli antenati & se stessa'; Brown (2004), p.16.

9. Harprath (1984), pp.6, 20.

10. Heywood (2001), pp.64–71; Shahar (1983), pp.138–82.

11. Davanzo Poli (1999), p 196

12. Serlio (1978), text to Plan LII.

13. Alberti (1960), pp.32–3: 'Stimo tutta quella età tenerina più tosto devota al riposo delle donne, che allo essercizio degli uomini … Adunque sia questa prima età in tutto fuori delle braccia de' padri, riposisi, dorma nel grembo della mamma'; Alberti (1969), pp.49–50.

14. Dominici (1927a), pp.34, 37: 'La prima si è d'avere dipinture in casa di santi fanciulli o vergini giovinette, nelle quali il tuo figliuolo, ancor nelle fascie, si diletti come simile e dal simile rapito, con atti e segni grati alla infanzia. E come dico di pinture, così dico di scolture. Bene sta la Vergine Maria col fanciullo in braccio, e l'uccellino o la melagrana in pugno. Sarà buona figura Gesù che poppa, Gesù che dorme in grembo alla Madre; Gesù le sta cortese innanzi, Gesù profila ed essa Madre tal profilo cuce … É tale età come disposta cera, e piglia quella impronta vi s'accosta …'; Dominici (1927b), pp.101–2, 106.

15. Stighelen (2000), p.33.

16. Grendler (1989), pp.142–54, 276–8.

17. Cunningham (1995), pp.34–5.

18. Alberti (1960), p. 33: '[I figliuoli] cominciano a proferire e con parole in parte dimonstrare le voglie sue. Tutta la casa ascolta, tutta la vicinanza riferisce, non manca ragionarne con festa e giuoco, interpretando e lodando quel fece e disse'; Alberti (1969), p.50.

19. Grendler (1989), pp.42–101; Cunningham (1995), pp.79–99.

20. Tagliente (1524): 'insegna a ciascheduno che sappia leggere, ad insegnare al suo figliuolo et figliuola, o vero amico, che niente sapino leggere, talmente che ciascheduno potra imparare et etiam le donne grandi, et piccole, che niente sanno potranno imparare a leggere'; Grendler (1989), p.100.

21. Grendler (1989), pp.87–9.

22. Antoniano (1926), pp.336, 343: 'il buon padre di famiglia si contenti che la sua figliuola sappia recitare l'Ufficio della Santissima Vergine, e leggere le vite de' Santi, ed alcun libro spirituale, e nel rimanente attenda a filare, e cucire, e ad occuparsi negli altri esercizj donneschi … [e] devono essere adorne di modestia di silenzio'; Grendler (1989), p.89.

23. Dominici (1927b), pp.113, 117: 'cavallucci di legno, vaghi cembali, uccellini contraffatti, dorati tamburelli, e mille differenze di giocucci … uno altaruzzo o due in casa … parinsi a dir messa'; Dominici (1927a), pp.42–5.

24. Dolce (1547), ff.8v–9r: 'debbono essere i suoi primi giuochi con le fanciulle della sua et, sempre trovandosi a quelli presente o la madre, o la Balia, o altra femina grave di anni & da bene … sciocche imagini … dove l'uso di quelle insegna alle fanciulle prezzar gli ornamenti & le pompe … che esse impareranno con diletto & il nome, & l'ufficio di ciascheduno.'

25. Citolini (1561), pp.481–2: 'le puppe, giucar a le comari, è a le scodelle'.

26. Heywood (2001), pp.103–6.

27. Alberti (1969), pp.62–3.

28. Heywood (2001), p.103.

29. Fiorin (1999), pp.209–19; Becchi (1996), p.115.

30. Klapisch-Zuber (1997), pp.167–8.

31. Ariès (1962), p.38 and passim.

32. Heywood (2001); Cunningham (1995).

33. Dominici (1927b), p. 117: 'Or come ben guadagni e lavori, tutto'l dì tenergli in collo, baciargli, e con la lingua leccare, cantare lor canzone, narrare bugiarde favole, far paura con trentavecchie, ingannare, con essi fare a caponascondere, e tutta sollecitudine porre in fargli belli, grassi, lieti, ridenti e secondo la sensualità in tutto contenti'; Dominici (1927a), p.45.

34. Antoninus (1959), I, ch.2, 'De amore', col.432: 'O quot sunt, qui eis [filios] quasi idolis inserviunt!'; cited in Herlihy (1991), p.12.

35. Della Casa (2000), p. 27: 'Errano parimente coloro che altro non hanno in bocca giammai che i loro bambini e la donna e la balia loro. – Il fanciullo mio mi fece ieri tanto ridere! Udite … Voi non vedeste mai il più dolce figliuolo di Momo mio!'; Della Casa (1958), p.42.

10. Servicing the Casa

1. Palladio (1570), II, p.3: 'nella parte più bassa della fabbrica, la quale io faccio alquanto sotterra'.

2. Schiaparelli (1983), I, p.5: 'cinque o sei stanze erano sufficienti ad alloggiare una famiglia agiata, e le abitazioni maggiori non ne avevano più di tredici o quattordici, nel XV secolo i palazzi ove abitavano i grandi mercanti fiorentini erano così comodi e vasti da vincere al paragone le dimore di più di un sovrano … e quello che i fratelli Da Uzzano s'eran fatto costruire nella via de' Bardi, pur non essendo dei maggiori, contava al terreno nove, al primo piano dieci e al secondo undici locali'.

3. Broise and Maire Vigueur (1983), p.146.

4. For example, the credenze or dispense (stores containing foodstuffs): a frequent source of errors of interpretation.

5. The excellent essay by Pier Nicola Pagliara (2001) is a welcome exception.

6. See Pagliara (2001), pp.41–3.

7. Pontano (1518), in particular 'De liberalitate liber', ff.97r–117v.

8. See Sigismondi Sigismondo (1604), pp. 67–98.

9. See, for instance, Adami (1657), Assandri (1616), Buonpigli (1569) and Vizani (1609).

10. Goldthwaite (1987) and (1993).

11. Antoniano (1821), II, lib.II, ch.107, p.27: 'le suppellettili … sono giunte a tanto eccessivo lusso, che quelle che

oggidì si usano nelle ville, oltrepassano assai in valore quelle che i nostri maggiori, anche de' più nobili, e benestanti cittadini, adoperavano, non sono già molti anni, nelle città capitali'.

12. Rosello (1549), f.5v: 'occhi molto grandi et grossi, overo incavati, la faccia picciola et stretta, le ciglie a guisa di volpe congionte e piegate verso il naso, la voce grossa e sottile … segni evidentissimi di ebbrezza e di sfrenata ira'.

13. Fusoritto (1593), p.627: 'dalli trenta fino alli sessanta anni … che, molto giovane, saria di poca autorità, e manco esperienza, troppo vecchio non potria resistere alla fatica si dello scrivere, come nell'andar per casa, e dove sia necessario'.

14. Frigerio (1579), pp.77–8: 'conforme che suona l'istesso nome è il principal ministro dell'Economia in tutte le case, dove si ritrova, subintrando immediatamente in luoco del patrone, che, per essere supremo ministro, gli deve anco dar con l'uffitio somma potestá, et autoritá, altrimenti saria inutile, e poco gli giovería il voler, e saper disporre tutte le cose, se gli mancasse poi il poter eseguirle.'

15. Giegher (1639).

16. Scappi (1643), p.4: 'il primo fondamento hà da essere la cognitione et prattica di diversi modi di cose … hà da conoscere ogni sorte di carne, e di pesce, e di qualunque altra cosa … e compartire ogni sorte d'animali quadrupedi e volatili, e discernere tutti i pesci marittimi, e di acqua dolce, e li lochi, e membri più appropriati per fargli arrosto, overo alessati … e in buona parte pratico di ogni sorte di spetiarie … la qualità d'ogni liquore tanto di grasso quanto di magro, e tutte le sorte di frutti, e d'herbe, e le loro stagioni' and 'presto, patiente, modesto, sobrio … pulito e netto nella sua persona … non deve in tutto riposarsi nè fidarsi de suoi aiutanti, et altri a lui soggetti, tenendo à memoria l'antico detto; che chi molto si fida rimane ingannato'.

17. In this context, see Frigo (1985).

18. Romoli (1560), ff.3v–4r: 'di natura ladri, et l'avaritia per managgiar il denaio gli scanna … che se nei pasti ordinari robbano a decine, in tempo di convito o banchetto grande robbano a centinaia'.

11. Housework

I would like to thank Flora Dennis and Liz Miller for their comments and insights on earlier drafts of this chapter.

1. Guazzo (1587), p.380: 'Ma à questa donna non sarà giunta all'eccellenza della virtù, se oltre alla conservazione della robba non procurerà ancora d'aumentarla con la sua industria, et di

far, che tutta la servitù di casa s'affatichi insieme con lei del continuo in qualche utile essercizio, et ciò si faccia senza querele … Non aspettate hora, ch'io discenda alle particolari minutezze de'fili, e delle tele per l'uso, e per l'ornamento della casa, nè della politezza de' mobili, dell'essercitio dell'ago, della conocchia, dell'arcolaio, dell'allevare i Cavalieri da seta, del visitar la cantina, il granaio, la dispensa, l'horto, il pollaio, e gli animali della corte rustica, del tener conto de'bucati, e di tutte le stoviglie, del cucinar le vivande ordinarie, e delle conserve per tutto l'anno, perche sarebbe un voler ammaestrare le donne nel governo della casa, il che non appartiene à noi.'

2. Brown and Davis (1998), p.14; Wiesner-Hanks (2001), pp.3–16.

3. Brown (1986b), pp.206–24. See also Brown and Goodman (1980), pp.73–80.

4. Grafton and Jardine (1986), pp.29–57.

5. Wiesner-Hanks (2001), pp.6–7.

6. Ajmar (2004), pp.135–230.

7. Goldthwaite (1993) pp.176–255; Ajmar (2004), pp.231–59.

8. 'La Donna è quella, che governa, e regge / La casa, e tien unita, la famiglia; / E che mantien la roba, e che corregge, / E dà creanze, al figlio, et alla figlia, / E l' honor del Marito ama, e protegge / Nè mai dal suo voler torce le ciglia; / Ma secretaria d' ogni suo conseglio / Di giorno in giorno và di ben in meglio.' See Matthews-Grieco (2000), p.306.

9. 'Contentarsi del Marito che Iddio gli ha dato' and 'Nutrisca i figliuoli con il propio latte'. See Matthews-Grieco (2000), p.306.

10. Published in Matthews-Grieco (2000), p.308.

11. Speroni (1740), I, p.79: 'Perocchè l' uomo naturalmente è più forte e di maggior cuore che la donna non è: ed in ciò discretamente ha Iddio operato, acciocchè dentro e fuori di casa nostra, parte cauti parte animosi acquistando, e l' acquistato salvando ne meniamo la vita.'

12. Giovanni di Dio da Venezia (1471), ff.41r–42r: 'subito che ve desvegiate dicete Benedictus es domine … Poi subito attendete a gli facti de casa, zoè chiamar le fantesche se non sonno levate, et subito far et ordenar lo foco, scovar la casa, metter el disnar al foco, vestir gli puti, far gli lecti, et facte tutte le altre cosse che a quelle hore apertiene … Poi per lo spacio de più o meno de meza hora secundo le vostre commodità state in oratione. … Subito che [è] l' hora del disnar solicitamente vui istesse faciando et ordenando drizar la tavola cum tutte le cose che a quella apertiene. Se poi avanti dinar avanza qualche tempo per uno poco tornar al[l'] oratione in zenochiono.'

13. Rummel (1996).

14. Speroni (1740), V, pp.200–201.

15. Paleario (1983), p.98: 'ma perché conservar le cose che in casa vengono appartiene alla donna, vogliamo che ella senza schifeltà alcuna del tutto pigli il governo, né senza suo commandamento alcuna cosa si comperi o venda che al vivere della famiglia faccia mestiere'.

16. Lanteri (1560), pp.166–7: 'Io per prima andai investigando alla giornata se cosa alcuna all' ornamento della casa mancava … Ma la prima, et più importante provisione ch' io feci, fu, l' ornamento delle stanze, cioè delle tapezzarie che mancavano, overo che per non essere così a proposito voleano essere mutate. Delle biancherie feci il medesimo.'

17. Paolin (1996), p.52: 'la matina la casa nete, bene paregiato il disinarre, li puti bene vestiti e bene governati, e non sentir: vien … il teser, il coltrer, e sartori'.

18. Paolin (1996), p.45: 'Con gran faticha ò cominciatto lavare né si pol catar n'omen né done per dinari'.

19. Paolin (1996), p.39: 'Non m'ha giovato far ogni diligentia e averlo fato fenire, adeso non speto altro che sole.'

20. Paolin (1996), p.44: 'Partirvi da vostro marito per far una lissia et lassarlo alli pericoli della vita'.

21. I secreti (1561), p.30; Giegher (1639), pp.1-8. See Eamon (1994).

22. Lanteri (1560), p.169: 'ma le damigelle … servono poi ancora pel cucire, et per tenere addobbata la casa di biancherie di tutte le maniere'.

23. Smith (1998), pp.375–91.

24. Dolce (1545), f.13r: 'due cose di grande utile alla conservatione delle famiglie, hoggidì sono ambedue rimase alle femine di basso grado'.

25. For spinning wheels in Genoese houses in the fifteenth and sixteenth centuries, see ASG, Fondo Notai Antichi, Notaio Branca Bagnara, no.667, 274, inventory of Cassano Lauri, 22 June 1452; ASG, Fondo Notai Antichi, no.2501, inventory of Battista Grimaldi, 15 July 1567.

26. Musacchio (1999), pp.94–5.

27. Molà (2000), pp. 423–59.

28. Molà (2000), pp. 423–59.

29. Levey (1983), pp.11–20; Mottola Molfino (1986), pp.277–93; Davanzo Poli (1998).

30. Klapisch-Zuber (1984), pp.12–23.

31. Giovanni Di Dio da Venezia (1471), f.57r : 'forse per zocho de schachi … charte, … over de dadi, forse per saper cantar et sonar come meretrice.'

32. Giovanni di Dio da Venezia (1471), ff.53v–54r.

33. Dolce (1545), f.12v: 'all' huomo la penna, et alla donna s' acconviene l'aco'.

34. See Mottola Molfino (1986),

pp.277–93 and Ajmar (2004), pp.204–16.

35. See Lotz (1933).

36. Urbani de Gheltof (1876) proposes, without producing any evidence, the existence of home-based needlework schools in sixteenth century Venice.

37. Matthews-Grieco and Brevaglieri (2001), p.67.

38. Piccolomini (1862), p.7: 'mai si stanno coteste mani, chè sempre ti trovo a lavorare e ricamar qualche cosa'.

39. Antoniano (1584), p.163: 'Ma sopra tutto la valente madre di famiglia tenga le figliuole bene occupate, e lontane dall' otio, maestro come tante volte s' è detto di molti peccati … Lavorino adunque le nobili zitelle, rallegrinsi di vestire con le mani loro i padri, e i fratelli.'

40. Vavassore (1530), p.1: 'da poi di queste cose pulite haverete lettere antique per poter scriver con l'aco: et raccamar li nomi di ciaschuno sì come vi acaderanno'.

Books

1. For further reading see Nuovo and Sandal (1998), Nuovo (2003) and Richardson (1999).

12. Business Activities

1. The definition is taken from Roux (1982), p.20: 'le case urbane sono anche strumenti di lavoro'; the concept has subsequently been applied with specific reference to Italy by Sarti (2003), pp.89–92.

2. Grazzini (1976), supper 1, novella 1; supper 1, novella 5; supper 2, novella 2.

3. For an overview of this subject see, for example, Tenenti (1988), pp.225–6.

4. Crouzet-Pavan (1992), pp.509–14; Palumbo Fossati (2004), pp.448–51.

5. Paciolo (1878), ch.3, p.39: 'Item mi trovo di mercanzie in casa, ovvero in magazzeni'.

6. Quoted in Tucci (1981), p.31: 'ricchezze e mobile precioso'.

7. Corazzol (1994), p.786.

8. Tucci (1981), pp.86–7.

9. Ait and Vaquero Piñeiro (2000), pp.137–9.

10. Scotti Tosini (1983), pp.71–5.

11. Politi (2002), pp.391–2 (cited on p.391: 'fondeghetto delle robbe' and 'fondico alla porta'), p.420.

12. Lanteri (1560), p.21; Serlio (1994), bk VI, esp. pp.119–42; Palladio (1980), bk II, ch.1 ('Del decoro o convenienza che si deve osservar nelle fabriche private'), pp.95–6.

13. Frigo (1985), p.140.

14. Lanteri (1560), esp. p.16 ('il mercante … dee sopra tutto cercar il sito dell'albergo suo, in quella parte della città, che all'essercitio suo essere più commoda potrà sperare'), pp.21, 30–31.

15. Goldthwaite (1995), VII, p.4; and also Valtieri (1988), pp.XIII–XIX.

16. Cotrugli Raguseo (1990), bk IV ('Della casa. Capitolo primo'), p.230: 'Et primo, vuole essere sita in loco piano et propinquo a luogo de negotiationi et ricepto de mercanti, il che è grande commodità, perché molte volte li acade andare o mandare a casa et per essere presto fa il facto suo … Secondo, de' havere onorato introito per li forestieri che non li cognoscono se non per fama, et molto t'atribuisce bella presentia et residentia di casa. Tertio, havere nel primo solaro uno scriptoio habile alle facciende tue, et dextro che d'ogni banda si possa sedere et separato, senza dare impaccio alla famiglia di casa per li forestieri che vengono a contare teco.'

17. Thornton (1997), p.77.

18. Thornton (1991), p.296.

19. Liebenwein (1992), esp. chs 3 and 4; Thornton (1997).

20. Hayez, conference paper delivered at *A Casa: People, Spaces and Objects in the Renaissance Interior*, V&A, London, 7-8 May 2004; Hayez (2005), esp. pp.139–56.

21. Cotrugli Raguseo (1990), bk IV, p.231: 'Et chi si dilecta di lectere non debbe tenere libri nello scriptoio commune, ma havere scriptoio separato in camera sua o almeno apresso d'essa, per potere studiare quando tempo t'avanza.'

22. Liebenwein (1992), pp.43–4.

23. Quoted in Palumbo Fossati (2004), p.478: 'per scrivere'.

24. Rovida (2003), pp. 5 ('bella e comoda casa'), 9–10.

25. Thornton (1997), p.77; Bona (2000), p.176; Politi (2002), pp.391–2; Palumbo Fossati (2004), pp.477–8 ('per contar denari'); Hayez (2005), pp.139–40 and *passim*.

26. Thornton (1997), p.77; for the objects used by Francesco Datini to read and write, see Hayez (2005), pp.139–40.

27. See Branca (1986), p.XVII.

28. Alberti (1969), bk III, p.253: 'stava così bene al mercatante sempre avere le mani tinte d'inchiostro'.

29. Della Casa (1990), p.50, para 328: 'Ora, che debbo io dire di quelli che escono dello scrittoio fra la gente con la penna nell'orecchio?'

30. Tucci (1989), p.561; Branca (1986), p.XVII.

31. Cotrugli Raguseo (1990), bk I, p.175: 'Debbi … tenere il tuo scriptoio ordinatamente, et a tucte le lectere che ricevi debbi notare donde le ricevi et l'anno, mese et dì, et metterle a uno luogo, et a tutte fare risposta et notare di sopra: risposta. Poi ogni mese fa mazzi di per sé et conservali, et così tucte le lectere di cambio che paghi infilza, et le lettere d'importantia. Overo scripte di

mano o strumenti, conserva come cosa necessarissima. Et habbi sempre il capo intro le tue scripture …'.

32. Machiavelli (1989), Act II, Scene iv, pp.194–5.

33. *Le lettere* (1990), pp.144 no.72, 154 no.78, 168 no.85. Nigro (1994), docs II, p.179, and III, p.180 ('vita di cane'). See also the comments by Hayez (1997), p.43 n.13.

Scientific Knowledge
1. Park (1985), Porter (1997).
2. Turner (1987).

13. Health, Beauty and Hygiene
1. In fifty years the work had more than seventy editions and was translated into seven languages. Eamon (1994), p.139.

2. First published in Venice, the work was reprinted several times and translated into different languages. Eamon (1994), p.127; Levecque-Agret (1987).

3. An example is represented by Pietro Bairo's *Secreti medicinali* (1561), another successful commercial operation. It was the shortened, vernacular version of the *Veni Mecum*, published fifty years earlier in Latin by the same author, personal physician to the Dukes of Savoy, as a portable compendium of treatments for travelling doctors; Camillo (1986).

4. For example, the immensely popular *Regimen sanitatis salernitanum,* also known as *Schola salernitana*, takes the form of short, memorable verses; Sigerist (1956), ch.2.

5. Flandrin (1987), p.16.

6. For example, some of the recipes in the *Secreti Medicinali di Magistro Guasparino da Venexia* (ed. C. Castellani, Cremona 1959) are taken from works by Taddeo Alderotti and by Anselmo da Incisa. Likewise, the late fifteenth-century manuscript 'Medicinialia quam plurima' includes sections from famous medieval medical texts, such as Pietro d'Abano's *De venenis*. See *'E io je onsi le juncture'* (1997), pp. 5, 10, 12.

7. 'Medicinalia quam plurima', ff.334v, 368–70v: 'la medica di Montogio', 'frate Pietro dell'ordine di S.Agostino', 'uno speziale genovese che lo ha avuto da un frate milanese carmelitano che lo ha avuto a sua volta da una strega milanese in confessione'.

8. Sforza Riario (1972); *I secreti della signora Isabella Cortese* (1561).

9. Green (2000), pp.1–7, 46–7.

10. 'Cronaca de' Freschi'.

11. The Bardi family, for example, owns three such manuscripts, one datable to the sixteenth century, another that incorporates the transcription of an earlier recipe collection and a third compiled in the first decades of the

seventeenth century; Torresi (1994), p.10.

12. Three different authors, writing respectively at the end of the fourteenth century, in the first half of the sixteenth and in the second half of the same century, seem to have contributed to the production of the recipe collection entitled 'Libro per ricette bone per li corpi humani et altri rimedi boni per cavalli' and kept by the Ubaldini family of Urbino. The sixteenth-century section of the manuscript has been published in Aromatico and Peruzzi (1997).

13. Palmer (1985).

14. Pennell, forthcoming.

15. Phan (1987), p.119.

16. Pennell, forthcoming and 2004, Introduction.

17. *'E io je onsi le juncture'* (1997), p.54; *Opera nuova* (1534), f.18: 'parerano li homini de diversi colori', 'far che la carne cotta parerà in tavola vermigiata'.

18. 'Medicinialia quam plurima', ff.106r and 374v.

19. Piemontese (1603), p.85.

20. Three of such hats 'to make girls blonde' (*da ribiondire le fanciulle*) are found for example in the inventory of Francesco Inghirami, published in Musacchio (2000), p.171.

21. Matthews-Grieco (1991); Laughran (2003), pp. 47–61; Pancino (2003).

22. Medicinalia quam plurima, ff.143r, 222v, 277v, 279r.

23. Paschetti (1602), p. 211.

24. Paschetti (1602), pp.132–3.

25. Fonseca (1603), p.102.

26. Venturelli (1996), p.137. Two silver *stuzicatoi da orecchi*, one of them with a coat of arms, are found in the inventory of Francesco Inghirami: Musacchio (2000), pp.162, 168.

27. Piemontese (1603), p.64: 'A far stiletti perfetti da nettare i denti'.

28. Fonseca (1603), p.143; Traffichetti (1585), p.170; Bruno (1569), pp.126–7.

29. Frommel (2001), pp.26–7, 33, 35.

30. Pediconi (2003), ch.3.

31. Fonseca (1603), p.123.

32. Fonseca (1603), p.18: 'Taccino hora gli antichi quelle lor tante lavande fregagioni e unzioni perché oltre all'essere superflue sono ancora di gran fatica'.

33. *Scuola salernitana* (1587), p.67: 'Molte cose nuocciono agli occhi, la prima è la stufa overo bagno, offendendo il caldo la loro complessione che naturalmente è fredda … e per questa cagione molti ciechi si ritrovano intorno al fiume Rheno dove comunemente si frequentano i bagni e le stufe.'

34. Fonseca (1603), pp.16, 18, 19, 23; Gropetio (1560), ch.1.

35. On thermal baths, see Palmer (1990); Chambers (1992); Nicoud (2002).

36. Paschetti (1602), p. 202: '[il bagno] fu trovato dagli antichi per tenere i corpi netti e mondi perciò che non avendo quelli in uso le vesti di lino o se pur le usavano pochi adoperandole, si riempivano generalmente tutti d'ogni sporchezza … ma a nostri tempi usando tutti universalmente così i poveri come ricchi le camiscie e perciò tenendo più facilmente netti i corpi non è tanto in uso né così frequente come era né tempi antichi.'

37. Vigarello (1985).

38. Frick (2002), pp.39–42; Sekules (2001).

39. Pagliara (2001), p.55; Piana (2001), p.95.

40. Pagliara (2001), p.57.

41. Ruggiero (1993), pp.89, 113.

42. Pagliara (2001), p.65.

43. Palmer (1993); Jenner (2000).

44. From Garzia dell'Horto, *Due libri dell'historia de' semplici …*, Venice (1582), cited in Torresi (1994), p.16.

45. Venturelli (1996), p.95. Precious necklaces containing amber and musk are found in the inventories of Milanese patricians in the sixteenth century and are repeatedly banned, without success, by the sumptuary laws of 1565 and 1584.

46. See, for example, the sixteenth-century recipe collection 'Adunanza di ricette' published in Passerini (1912), p.40.

47. Mancino (1995). *Opera nuova* (1534), p.22 ('A far osselletti di cipro').

48. Mancino (1995), p.160.

49. Ambergris is a grey-black, solid, greasy and spongy substance released from the intestine of the sperm whale. Musk is the glandular secretion of a small deer that lives in China, Nepal and Tibet; it takes the form of reddish grains. Civet is the glandular secretion of a wild cat that lives in Africa and Asia.

50. Torresi (1994), c.15–16.

51. *Opera nuova* (1534), f.23 ('A fare una pasta da far paternostri odoriferi').

52. The specific powers of each stone are described in works called 'lapidaria', and among the most famous were *Speculum Lapidum* by Camillus Leonardus (Venice 1502) and *Libri tre di M. Ludovico Dolce nei quali si tratta delle diverse sorti di pietre che produce la natura* (Venice 1565).

53. Venturelli (1996), pp.133–5.

54. From 'Libro per ricette bone' (see n.12): Aromatico and Peruzzi (1997), p.96.

55. *Secreti Medicinali di Magistro Guasparino*, recipe nos 268–71; Torresi (1994), c.27.

The *Restello*: Furniture for Beauty
1. Thornton (1990), pp.174–82; Thornton (1991), pp.234–41.

2. Robertson (1954), pp.7–8; Goffen

(1989), pp.226–37.

3. For a summary of the various interpretations, see Tempestini (1999), pp.146–7.

14. Devotion

1. For Moroni's picture, probably painted in the late 1550s for a Bergamo patron, see Rossi and Gregori (1979), pp.51, 118–19; Humfrey (2000), pp.19, 61–2, who agree that the composition is indebted to St Ignatius of Loyola's *Spiritual Exercises*, first published in Italian translation in 1551, especially the saint's invocation to imagine the physical space ('il luogo corporeo') of the sacred event or figure that one wished to contemplate.

2. Lillie (1998), p.32; on the importance of street Madonnas, see Muir (1989). For reasons of space, it has not been possible to discuss here the devotional life of the significant Jewish communities in Renaissance Italy: for an introduction and further bibliography, see Bonfil (1994), pp.215–37. In addition, scattered congregations of Greek Orthodox Christians did not follow the Latin rite, especially in Venice and southern Italy: for an overview, see *La Chiesa greca in Italia* (1972–3).

3. For Florence and a comprehensive guide to depictions of devotional images in contemporary Italian paintings, see Kecks (1988). For the range of religious subjects recorded in Venetian interiors, see Palumbo Fossati (1984), pp.131–2. For the presence of religious images in the *sala* and bedchamber of the Palazzo Sanuti in Bologna in 1505, see Frati (1928), p.18.

4. For Florentine images referred to as 'da camera' or 'da tenere in camera', see Thomas (1995), pp.60, 286; for Marian reliefs, see Johnson (1997), p.7. In Venice, the *portego* also seems to have been important as a setting for religious images, see Palumbo Fossati (1984), p.144.

5. See, for example, the concentration of devotional images, together with an Agnus Dei and a pax, in the study of the Florentine humanist Andrea Minerbetti in 1493; see Schiaparelli (1908), I, p.184 n.2; Thornton (1997), pp.21–3.

6. Neri di Bicci (1976).

7. Zuraw (2001), p.106. For the prevalence of Madonnas *di stilo greco* in Venetian inventories, see Aikema (1999), p.83; many Flemish devotional images are also recorded, see p.84. On the relationship between traditional icon types and Giovanni Bellini's images of the Virgin intended for private devotion, see Goffen (1975).

8. For the trade in second-hand devotional images, see Lydecker (1987a),

pp.214–16. For Andrea Minerbetti's purchase of devotional images from a second-hand dealer, or *rigattiere*, in 1516, see Schiaparelli (1908), I, p.187 n.1.

9. In 1506 the Florentine patrician Alessandro Gondi valued a marble Madonna at 100 *lire*, compared to 2 *lire* for one of gesso; see Musacchio (2000), p.148.

10. On the high cost of frames, see Thomas (1995), pp.286–7.

11. V&A: A.45-1926; for the gesso squeeze and the plaquettes on which it depends, see Pope-Hennessy (1964), I, pp.83–84, no.68; Johnson (1997), p.2; the frame has been dated to between 1430 and 1450. The iron ring at the top indicates that the image was designed to hang from a hook.

12. For Florentine examples of veiled images see Musacchio (2000), p.150; for 'Ave' inscriptions see Johnson (1997), pp.7–8.

13. The 1418 Medici inventory included two tabernacles of the Virgin with wings ('sportelli'), one of which also had a silk veil ('con uno vello di seta dinanzi'), cited by Lydecker (1987a), p.210 n.2. Another image of the Virgin was provided with a veil and a fourth described simply as 'closable' ('da serare'). The 1400 inventory of Francesco Datini's house in Florence records an ivory panel of the Virgin with 'sportelli' in Francesco's bedchamber and an image of Christ with a curtain of green taffeta embroidered with gold; see Piattoli (1926), p.113.

14. For the analogy between circular images of the Virgin and Child and contemporary convex mirrors and their circular frames, see Olson (2000), pp.95–101.

15. Drill holes for jewellery and (with x-ray analysis) embedded jewels have been identified by Johnson (2000), p.221.

16. Trexler (1980), pp.68–9.

17. For the Florentine experience of miraculous cult images see Trexler (1972); the comparison with domestic practice is made by Musacchio (2000), p.150. For the veiling of altarpieces, see Nova (1994).

18. On the illumination of a domestic painting to mark the birth of a child, see this publication, p.132.

19. For similar ensembles in Genoese bedchambers, see Pandiani (1915), pp.100–101.

20. Courtauld Gallery: P.1966.GP.213; the right valve measures 20.3 x 14.4 cm, the left 20.2 x 14 cm; reproduced in Christiansen (2005), pp.188–9 (cat.21), who suggested a date in the early 1450s for the diptych. I am grateful to Caroline Campbell and Graeme Barraclough of the Courtauld Gallery for sharing with me the conclusions of

their recent examination of the panels.

21. Published by Piattoli (1930), p.232 ('una guaina di chuoio chotto'), with further discussion in Thomas (1995), p.102; a devotional triptych of carved horse bone made by the Embriachi workshop around 1400 survives with its *cuir-bouilli* case in the Kunstgewerbemuseum, Berlin; see Schmidt (2005), pp.96, 100, and figs 54, 55.

22. V&A: 57-1867; the terracotta Madonna measures 74.3 x 55.9 cm without its frame, see Pope-Hennessy (1964), I, pp.77–8, no.64, who suggests a date in the 1450s and observes that the relief is modelled rather than moulded.

23. In 1493 Andrea Minerbetti described a 'nostra donna della robia murata' in his memoirs, cited by Thornton (1991), p.268.

24. Olson (2000), pp.83–105.

25. Trexler (1980), pp.172–86.

26. For the importance of touch in the reception of domestic images, see Wilkins (2002), p.376.

27. Trexler (1980), p.176.

28. Morelli (1956), pp.476–7: 'Dinanzi alla figura del crocifisso Figliuolo di Dio … incominciai prima a immaginare e ragguardare vi me i miei peccati'; translation by Trexler (1980), p.177.

29. Trexler (1980), p.176.

30. For the use of *tavoluccie* of the Passion and Crucifixion by Florentine and Roman confraternities to console condemned criminals, see Trexler (1980), p.200; Edgerton (1985), pp.172–9. For an anthology of recent studies on Italian confraternities, see Wisch and Cole Ahl (2000).

31. Polizzotto (1989), pp.27–87; Weinstein and Hotchkiss (1994), pp.24–9.

32. The sermon had gone through fifteen editions by 1540; see Polizzotto (1989), p.28.

33. Weinstein and Hotchkiss (1994), pp.24–9.

34. Weinstein and Hotchkiss (1994), pp.27-8

35. The relatively high placement of the tondo in the woodcut seems to reflect Florentine practice, see Lydecker (1987a), p.66; Olson (2000), p.79.

36. Weinstein and Hotchkiss (1994), pp.27, 29.

37. Both San Bernardino and Savonarola urged their audiences to keep crucifixes in their bedchambers; see Lydecker (1987a), p.180.

38. Saffrey (1984), pp.4–7.

39. Trexler (1980), pp.100–101.

40. Origo (1963), p.64.

41. On the pre-Tridentine history of this practice, see Lightbown (1992), pp.228–30; Cantini Guidotti (1994), I, pp.57–61.

42. In 1430 Paolo Guinigi, Lord of Lucca, owned what must have been a particularly fine Agnus Dei of gold, set with pearls, sapphires and spinnels, which seems to have been decorated with an enamel of the Annunciation; Lightbown (1992), p.230.

43. Cantini Guidotti (1994), I, p.58; Venturelli (1996), p.135.

44. See Venturelli (1996), p.135. In his book of *ricordanze* the Florentine patrician Alamanno Rinuccini described the gold Agnus Dei case set with a sapphire and pearl he commissioned for his new wife in 1504; see Syson and Thornton (2001), p.62.

45. For the various charms that Dal Bovo recorded, including the use of slips of paper with holy scripture to expel bed lice, see Grubb (1996), pp.187–8.

46. On the development of the rosary, see Winston-Allen (1997).

47. Cherubino da Spoleto (*c*.1477–80), ff.14r–15v.

48. Cherubino da Spoleto (*c*.1477–80), f.14v, advised his readers that those who read the Office of the Cross gained a large indulgence ('che la persona che lo dice guadagnia grande indulgentia') and, on f.15r, that the Virgin had conceded many favours and miracles ('a chi questa corona have dicta').

49. Lightbown (1992), p.97.

50. Lightbown (1992), pp.342–54; Cantini Guidotti (1994), I, pp.143–5.

51. St Catherine of Siena (1347–80) used a knotted cord as a paternoster; see Lightbown (1992), pp.345, 352, although it incorporated a small silver cross.

52. Lightbown (1992), p.345.

53. Lightbown (1992), p.348.

54. Esch (1995), pp.83–4 n.95. Dedicated paternoster shops are documented around St Peter's from the fourteenth century; see Lightbown (1992), p.344.

55. Cited by Lightbown (1992), p.351.

56. Venturelli (1996), p.140.

57. Cantini Guidotti (1994), II, p.24.

58. Pettenati (1978), p.47, fig.77.

59. V&A: M.77-1979; published in *Princely Magnificence* (1980), p.79 (no.94).

60. For coral and its qualities, see Venturelli (1996), pp.130–31; its resonance with the blood of Christ also led to coral being used extensively to decorate reliquaries.

61. In 1456 Piero de' Medici possessed a branch of coral on a silver gilt chain; see Lightbown (1992), p.207. See Ciardi Duprè *et al* (1977), pp.330–32, for depictions of the Christ Child wearing a coral pendant, and pp.268–71 for similar pendants recorded in Florentine household inventories.

62. V&A: 105-1865; for coral paternosters, see Lightbown (1992), pp.346–7. A typical coral rosary

('corona') with larger beads of silver gilt and a cross of silver is described in the 1567 workshop inventory of the Flemish goldsmith Ermanno di Lodovico Foghet, resident in Florence; see Cantini Guidotti (1994), II, p.72.
63. Francesco di Giorgio included chapels in his projects for palaces for lords and princes ('signori o vero prencipi'), Martini (1967), II, pp.351–2.
64. For the concession of altar rights to Cosimo de' Medici and his sons Piero and Giovanni, see Saalman and Mattox (1985), pp.344–5; Böninger (2000), pp.335–7. For the chapel and its decoration, see Kent (2000), pp.305–28.
65. Mattox (1996). Private chapels were more common in the patrician villas of the Florentine *contado*, where the nearest church could be several miles away; see Lillie (1998), pp.21–2. In 1505 the oratory within the Palazzo Sanuti in Bologna was equipped with silver gilt chalices, suggesting the presence of at least a portable altar; see Frati (1928), p.19.
66. For the legal distinctions between a portable altar and a chapel, see Böninger (2000), p.335; for the position of oratories and chapels in canon law, see Schmidt (2005), pp.90–91. In 1524 the Florentine patrician Luigi Martelli purchased a 'pietra sagrada', presumably to act as a portable altar for a household chapel; see Lydecker (1987a), p.32 n.32.
67. Musacchio (2000), p.154.
68. See Lillie (1998), pp.35–8 and, for the contents of a modest villa chapel in the *contado*, p.45 n.65. For the contents of the chapel in the Palazzo Medici and its accompanying sacristy as recorded in the 1492 inventory, see Spallanzani and Gaeta Bertelà (1992), pp.23–5; for the contents of the chapels at the Medici villas at Cafaggiolo and Castello, see Shearman (1975), pp.22–7.
69. In 1396 the Venetian widow Margarita Luciani bequeathed 'a decorated altar of mine that I have at home' to the monastery of Corpus Domini; see Bornstein (1998), p.191, although this may not have been a consecrated altar. For the very well-documented Florentine case of Francesco Pugliese's 1503 bequest of his private chapel of Sant'Andrea at Sommaia to the Dominican friars of San Marco, see Horne (1915), pp.44–6; Burke (2004), pp.155–87.
70. The bronze crucifix is later in date, and probably replaced a polychrome wood original; see Sricchia Santoro (1988), pp.78–80; Santi (1998), pp.28–9.
71. For one thing, the owner had to support a priest to officiate at the altar, although this may not have been so difficult to arrange in Florence, where the clergy were dominated by the

wealthy patrician families; see Brucker (1985), pp.17–28. Gratian's Decretals (the standard manual of canon law) allowed anyone to build an oratory for prayer but required episcopal authorization for the celebration of Mass; see Schmidt (2005), pp.90–91.
72. See Humfrey *et al.* (2004), p.199 and Wilkins (2002), pp.372–4.
73. Humfrey *et al.* (2004), pp.198–9.
74. Ringbom (1969), p.163; Johnson (1997), pp.5–6.
75. Lydecker (1987a), p.59, notes that the earliest reference to an *inginocchiatoio* in the Florentine inventories he consulted dates from 1517.
76. Cherubino da Spoleto (c.1477–80), f.15v: 'Questa corona si fa in questo modo per farela devotamente a gi uno banchecto alto uno palmo che se possa la persona ingenochiare sopra isso acconzamente.' The Florentine *palmo* measured 29.18 cm: see Zupko (1981), p.184.
77. Cherubino da Spoleto (c.1477–80), f.15v.
78. Klapisch-Zuber (1985a), pp.320–22. Dominici's text is often quoted, but Musacchio (2000), p.147, has questioned how widely known it was in fifteenth-century Florence.
79. For San Bernardino's belief in guardian angels, see Origo (1963), p.162.
80. Tanner (1990), II, p.737.

15. Sociability
I would like to thank Dottoressa Francesca Mambrini for identifying and transcribing the Genoese inventories used here and Flora Dennis and Bruno Wollheim for their many suggestions.

1. Speroni (1989), V, p.83: 'Intendo che tu sei più giovine, e più sulla gamba che mai, e che non ti bastano le feste di casa vostra, ma vai a tutte le altre.'
2. Goldthwaite (1993), pp.150–255.
3. Vickery (1998), pp.195–7.
4. Goldthwaite (1993), pp.232–43; Preyer (1998), pp.357–74.
5. For birth-related rituals in the home, see Musacchio (1999).
6. Vickery (1998), pp.202–3.
7. Bargagli, 'Discorso intorno al fare et al ricevere le viste': 'si veggon fare di minute differenze o vantaggi fra le brigate, nel far posar questi nella seggiola a braccioli, quegli nello scabello, e quegli nella banchetta, ovvero, che chi giugne invitato a posare le gambe per mostrarsi humile e modesto, rifiuta la seggiola e lo scabello e vassi nella banchetta a riporre. Onde il padrone ed amico è forzato a correre a levarlo subito quindi e nel condurlo con le braccia alla sedia grande, egli prima pone il culo quanto prima nello scabello, ed è uno stento a

rimuovermelo perch'ei si conduce alla fine al luogo dove dovea fermarsi la prima volta.'
8. Bargagli, 'Discorso intorno al fare et al ricevere le viste': 'Perche le visite sono una specie di conversazione tra gli huomini'.
9. ASG, Notai Antichi, 2502, inventory of Battina Centurione, 20 May 1568.
10. ASG, Notai Antichi, 2502, inventory of Battina Centurione, 20 May 1568
11. Speroni (1989), V.
12. Speroni (1989), V, p.52: 'Fa che la casa sia apparecchiata, come t' ho scritto, delle spalliere del Bassan in sala e da basso, e di razzi nella camera … Ti mando in un cesto certe robe da salvar alla mia venuta, perchè bisogneranno per li gentiluomini.'
13. Speroni (1989), V, p.261: 'e questo giovane ha nome M. Ottavio. Falli fare onore, che bene il merita per se, e per suo zio: e se in casa vostra può alloggiare, alloggialo, e domesticamente accarezzalo.'
14. Speroni (1989), V, pp.103–4: 'Non ti vieto l'andare alle feste ed alle visite; ma perchè non vi puoi andar senza compagnia bona, però ti do questi ricordi. Con alcune non ti è onore andare, ed in qualche loco ti saria pericoloso …Vorria io che sempre tu praticassi con le mogliere, o figliole, o nuore del Podestà; perchè per tali pratiche si rimedia molte volte a gran mali, che sogliono occorrere alle case.'
15. Belmonte (1587), p.57: 'nel tuo favellare non ti abbasserai d' intorno al filato, et al cucito, nè meno ti alzerai a i negocii delle leghe, et delle imprese della guerra: che l'uno non è da huomo, et l'altro da donna ragionamento.'
16. Belmonte (1587), p.57: 'potrai procedere con men rispetto, et più libertà, perche fra simili, et simili, meglio, et più largamente si può ragionare de loro affari'.
17. Belmonte (1587), pp.57–8: 'Et indi le farai rinfrescare e ricreare con confetti, ò frutte, od altro, che in quel mentre le haverai fatto apprestare.'
18. Belmonte (1587), p.58: 'et cosi o al fuoco, ò alle finestre, ò al giardino condurle, secondo le stagioni, et i tempi: mostrandole la casa, e a proposito alcuna tua cosa, ò di nuovo, ò di bello, che tu habbia, ma però con maniera tale, che sia accettato per tua gentilezza ò domestichezza, et non per alterezza di animo: il che sarà in vece di mostrarle il cuore.'
19. Belmonte (1587), p.52: 'non farai come hò veduto fare ad alcune donne, che dovendo ricevere appena un povero peregrino, fanno tante parole, tanti ravolgimenti, tanto dibattimento di scanni, scranne, et tanti romori di piatti, et di coltelli, che colui si prepara di

dover veder un solennissimo pasto, et alla fine s'accorge che che i monti han partorito i topi: onde appena ha tanto da cibarsi, che li basta: et di quel poco, senza ordine, et malamente cucinato: ma tu con silentio ordinerai, et disporrai ogni cosa, et farai che secondo il lor grado vengon tutti ben trattati, non ti sdegnando dar di volta un poco più del solito in cucina, perche le vivande riescano ben cotte, et stagionate: facendogli non men copia di ottimi cibi, che di allegro viso, et di grata accoglienza.'
20. Ravanelli Guidotti (1990), pp.279–80; Wilson (1987), pp.78–9.
21. Brody (2000), pp.30–46.
22. *Et coquatur ponendo* (1996), p.389.
23. ASG, Notai Antichi, 2501, inventory of Stefano Squarciafico, 21 October 1567.
24. Sansovino (1581), p.142: 'Le credentiere d'argento, et gli altri fornimenti di porcellane, di peltri, et di rami, ò bronzi lavorati all'azimina, sono senza fine'.
25. Hayward (1976), p.371.
26. Tagliaferro (1995), pp.187–8 and nn.14–16.
27. Della Casa (1977), p.133: 'io ringrazio Dio che, con molte altre pestilenze che ci sono venute d'oltra monti, non è fino a qui pervenuta a noi questa pessima: di prender non solamente in giuoco ma eziandio in pregio lo inebriarsi'.
28. Carboni (2003), pp.80–81.
29. Carboni (2003), p.8.
30. Piccolpasso (1980), f.6v: 'per che se io cominciai a stendarmi ne gli Vasi senza bocca, alle Tazze da inganno, che sono cose che non ha regula, mi alungarei troppo'.
31. Piccolpasso (1980), f.6v.
32. Ravanelli Guidotti (1987), pp.133–4.
33. Ravanelli Guidotti (1987), pp.133–4.
34. Ravanelli Guidotti (1996), pp.152–3.
35. Rasmussen (1984), pp.256–7; Ravanelli Guidotti (1996) pp.492–93.
36. Rasmussen (1984), pp.256–7.
37. Pallavicino (1975).
38. For *veglie*, see Belgrano (2003), pp.260–63.
39. Pallavicino (1975), p.21: 'Il Giò Batta Spinola … ha fatto un banchetto a tutti li suoi parenti, e vi si è ballato tutto il giorno e così fino a sera con molto concorso'.
40. Poleggi (1978).
41. Pallavicino (1975), p.34: 'vi fu ballo con quiete grandissima essendo stato usato gran diligenza dalli figli che servitori ne bravi intrasero a far festa in sala'.
42. Belgrano (2003), pp.260–61: p.260: 'Sarebbe molto espediente … moderare la troppa larga libertà delle donne, et conservare strettamente quell'ottima

legge che fu fatta … l'anno passato, di proibire le veglie, nelle quail si vigila per far mille disordini e peccati.'

43. Pallavicino (1975), p.67: 'ma la veglia andò tutta in rumor, le Donne che cascavano in terra volendo fuggire'.

44. Ringhieri (1551), p.1: 'generose madonne', 'huomini prodi', 'per trapassare in festa, et in Leticia, il tempo'.

45. Bargagli (1587) p.20: 'honorato salotto'.

46. Piccolomini (1574), p.53: 'quelle servotte meglior robbe'.

47. Bargagli (1982).

48. Bargagli (1982), p.159, 'conviene farsi famigliari il Petrarca, l'Ariosto e Dante rispetto a' versi, de' quali fa di mestieri il sapene molti, non solo per cagione del giuoco del Versificare, ma per molti altri che occorrer possono'.

49. Bargagli (1982), p.107: 'gli sposi, allor che deono menar la moglie a casa, sogliono molto la camera adornare a particolarmente un ricco e orrevol letto porre in assetto, il rettor del giuoco finge che lo sposo si sia di tutte le altre cose proveduto fuor che d'una sola, perché come persona idiota, non ha saputo trovar mai un verso, o ver un motto per metter nella cornice della lettiera a lettere d'oro, come s'usa.'

50. Bargagli (1982), p.107: 'Lo spirto è pronto, ma la carne è stanca' (Petrarch, *Rime*, CCVIII, v.14). This verse originally comes from the Bible: 'The spirit indeed is willing but the flesh is weak' (Matthew 26: 41 and Mark 14: 38).

51. Bargagli (1982), pp.68–9: 'Né ancho di quelli altri, che o colle tavole, o colle carte, o co gli scacchi si fanno, perciò che questi, non pur da' ragionamenti, ma da' nostri pensieri hanno da esser lontani'.

52. Pallavicino (1975), pp.2, 120.

53. Zabata (1588), p.68: 'Onde se il giuocare sarà per fine di passare il tempo con piacere, come lecito diporto si potrà concedere, ma per fine di avaritia et di spogliare il compagno delle facultà, all'hora per vitio, non che per vanità si deve dannare'.

54. *I legni incisi della Galleria Estense* (1986), pp.167–8.

55. *I legni incisi della Galleria Estense* (1986), pp.167–8.

56. Sabba da Castiglione (1554), f.88r ; 'Alcuna fiata, come realaccio ch'egli è, giuoca con esso noi alle carte, et s'el vince non si altera, non corruccia, non bestemmia, ma se perde, ancora che che non fosse se non un soldo, si adira, rinega, et rinegando esce di san Puccio'.

57. Brown (2004), p.132.

58. Pallavicino (1975), p.245: 'certe canzoni fatte per questo effetto, e furno cantate in diverse veglie e fra l'altre in casa di Madalena Pallavicina e in casa di Fabritio Pallavicino'.

59. Tagliaferro (1995), p.20.

60. Baldacci (2004), pp.120–23.

61. Arcangeli (2000), pp.24–5.

62. Belmonte (1587), p.83: 'Et se danzando avverrà che tù sia invitata al ballo, che noi sogliam chiamare la gagliarda, vogliò che tù lo fugga piu che puoi … mà posto che tù sia sforzata pur d'andarvi, vuò che tù vi vada di rado, et quelle poche volte con atto tutto Donnesco, non saltando, et volteggiando à guisa di giuocogliera, nè men stando tanto continente che paia che tù lo faccia per dispetto; mà come à dietro t'ho descritto, con avveduta, et misurata maniera, coprendo con disprezzo ogni studio, et ogni arte che vi porrai.'

63. De' Mori (1989), pp.62–3.

64. Bargagli (1982), p.113.

65. ASS, Deliberazioni della Balìa, 123, 10 February 1542, ff.39v–40r. See Mazzi (1882), I, pp.260–2 and nn.1–3.

66. ASS, Deliberazioni della Balìa, 123, 10 February 1542, ff.39v–40r. See Mazzi (1882), I, pp.260–62 and nn.1–3.

67. Pallavicino (1975), p.68: 'Si fece alla sera una comedia in strada nova in casa del Signor Giulio Spinola … fu assai bella e con gran compagnia di Dame.'

68. Pallavicino (1975), p.241: 'Questa sera si fece una pastorale in casa di Gio. Francesco Benigasi e fu fatta da giovani non nobili, riuscì molto goffa.'

69. Belmonte (1587), p.57: 'Nel suo partir poi, li renderai tutte quelle gratie che per te si potranno, accompagnandolo fin al sommo, ò all'imo della scala, secondo meritarà: pregandolo salutare à tuo nome la sua piu cara famiglia.'

Bathing in Genoa

1. A further exploration of Genoese baths and their furnishings is provided in Hanke (2004) and (2006).

2. Several of the buildings published in Rubens's compendium of etchings, *Palazzi di Genova*, (1622) include baths, as for example the ground plan of the Villa Grimaldi La Fortezza, a detail of which is shown in plate 15.19.

3. Examples of Roman Cinquecento baths include Cardinal Bibbiena's in the Vatican and that of Clement VII in the Castel Sant'Angelo. For Roman baths in the early sixteenth century see Frommel (1973), I, pp.75–8; *Quando gli dei si spogliano* (1984); and Edwards (1983).

Tables and Chairs

1. Thornton (1992), p.214 and also fig.246. Another folding table with intarsia, thought to be from the Veneto area, from a private English collection, is illustrated in Alberici (1980), pp.32–3, figs 41–2.

2. Toesca (1918), tables XII and LIX; and Chiarugi (2003), I, p.135, notes 91–2.

3. See Thornton (1992), pp.209–14, and in particular p.212 for a specific reference to the Guicciardini table.

4. Guicciardini Archive, Florence, folder of wills, 'Testamento di Francesco di Piero di Jacopo, 21 maggio 1540. Rogato da Ser. Pier Francesco Maccalli', with annotations by his brother Jacopo. The table, incorrectly described as 'round', was part of the inheritance of another brother, Gerolamo.

5. Vasari (1906), VII, p.105: 'Belle e capricciose fantasie di vari disegni, fatti per la più parte a requisizione di messer Francesco Guicciardini, allora governatore di Bologna, e da alcuni altri amici suoi: i quali disegni furono poi messi in opera in legni commessi e tinti a uso di tarsie da fra Damiano da Bergamo dell'ordine di San Domenico in Bologna.' There is little to confirm Danti's account that Vignola's designs were sent to Florence 'to have them made up by excellent masters of intarsia'; see Danti (1583).

6. On this subject and also the work of Serlio, see Tuttle (2002), p.115; and Ricci (2002), p.124.

7. Bandera (1972), pp.12, figs 37–8; and Manni (1986), p.131, fig.64.

8. Various painted and gilt areas have been retouched and a corner of one of the feet has been repaired. All these interventions probably date back to the second half of the nineteenth century. It seems likely that there was a renewed interest in the table during this period, demonstrated by a print by Professor Giuseppe Marrubini depicting Francesco Guicciardini seated at the table reading the sermons of Savonarola (held in the Guicciardini Archive, Florence).

9. The enamelled plaque is described and reproduced as a print in Guicciardini (1932), p.31.

10. See Venturino (2002).

11. Paolini (2002), pp.96–7.

12. Cf. Schottmüller (1921), p.171, fig. 383; and Alberici (1980), p.71, fig.93.

13. Chiarugi (2003), I, p.134, nos 82–6.

16. Music

I would like to thank Marta Ajmar-Wollheim, Iain Fenlon, Liz Miller and Alexander Masters for their invaluable comments on earlier drafts of this chapter.

1. The analysis of this section is based on a selection of approximately 400 published and unpublished inventories. Published inventories include those listed in Thornton (1991), pp.363–5, and Thornton (1997), pp.210–20, together with references cited by Palumbo Fossati (1984), Vio and Toffolo (1987–8) and Toffolo (1995). Unpublished inventories were consulted in the Archivio di Stato of Florence (mostly from the archives of the Strozzi, Capponi and Guicciardini Corsi Salviati families) and the Archivio di Stato of Venice (mostly from the *fondo* Cancelleria inferiore, Miscellanea notai diversi, Inventari). I am grateful to Caroline Anderson, Lizzy Currie and Ann Matchette for having generously shared with me a considerable quantity of unpublished references to material held in the Archivio di Stato of Florence.

2. On these instruments, see 'Lute', 'Harpsichord', 'Spinet' and 'Clavichord' in Sadie (2001).

3. 'Baffo, Giovanni Antonio' in Sadie (2001).

4. Schott *et al.* (1998), pp.33–5; Cervelli (1968) and Ongaro (1991).

5. Ongaro (1991), p.49.

6. Palumbo Fossati (1984).

7. Palumbo Fossati (1986), p.639.

8. Palumbo Fossati (1985), p.636, and Fenlon (2002), p.137, n.63.

9. Palumbo Fossati (1985), p.489.

10. Ongaro (1994).

11. Fabris (1934).

12. Fenlon and Haar (1988).

13. Bridges (1982).

14. Carrara (1972).

15. Lewis (1988–97), I, p.89; Fenlon (1995a), p.86; Bernstein (1998), pp.127–37, Dennis (2002), pp.182–93.

16. ASF, Libri di Commercio e di Famiglia, 4402, f.106v: '6 canzonieri de imparar musica'.

17. Carter (1989), p.495.

18. Carter (1989), p.495.

19. Toffolo (1995), n.61.

20. Fortini (1988), p.781: 'un bello strumento, quel Constansio per suo spasso teneva in camera'.

21. Bandello (1992), p.329.

22. Aretino (1546), Act IV, Scene iv: 'va' per il mio liuto in camera, e recamelo'.

23. Leonello d'Este, as characterized in Angelo Decembrio's dialogue *De politia litteraria*, quoted in Thornton (1997), p.121.

24. For example, *Indovinelli, riboboli, passerotti et farfalloni* (n.d. [16th century]), and Croce (1611).

25. Ghisi (1620).

26. Panelli (n.d.), f.3v. For music and games generally, see Haar (1962), Fabris (1996) and Stras (2005).

27. McGeary (1981), p.6: 'Rendo lieti in un tempo gli occhi e'l core'.

28. McGeary (1981), p.31: 'Saltatur me canente'.

29. Sabba da Castiglione, *Ricordi*, quoted in Barocchi (1978), III, p.2919: 'questi tali instrumenti dilettano molto alle orecchie … ancora piacciono assai all'occhio'.

30. Speroni (1596), p.68: 'cento varietà di stromenti di musica dà penna, dà fiato, & dà corda … nel primo aspetto niuna cosa vi si scorgeva … che ad altro, che à puro ornamento del suolo … esser posta si riputasse'.

31. Ongaro (1991), p.49.

32. Achillini (c.1510), ff.3v–4r: 'una belissima sala, non molto grande'. See Franzoni (1990).

33. Doni (1928), p.199: 'alla sua villa aveva per ridotto de' virtuosi fatto una stanza, chiamata Apolline, e in quella v'erano stromenti, viole, leuti … libri d'ogni sorte musica'.

34. Acidini Luchinat (1980), pp.153 and 163. I am grateful to Brenda Preyer for bringing this article to my attention.

35. Piccinini (1620), Introduction: 'ha in una camera ogni sorte di stromenti antichi e moderni … ma tiene ancora con ordine bellissimo in un'altra stanza tutta la musica antica e moderna, così da camera come da chiesa, che sia possibili ritrovarsi'.

36. Superbi (1620), p.130: 'un Studio pieno di quante opere eccellenti sono mai uscite, & d'instrumenti preziosi'.

37. Sansovino (1581), ff. 138v–139r, and Thornton (1997), p.114.

38. Moryson (1907–8), I, p.192.

39. Silva (1984).

40. Sansovino (1581), f.138v, and Silva (1984), p.368.

41. For example, ASF, Libri di Commercio e di Famiglia, 4402, f.20v, 15 April 1551: '2 lire 10 denari, per … corde de liuto et altro'; ASF, Capponi, 146, f.57r, 25 Settembre 1570: '10 denari, per haver incordato parte d'un liuto'; f.63v, 20 February 1576: '1 lira 12 denari, per corde da liuto e fiaschetti d'inchiostro'; ASF, Guicciardini Corsi Salviati, Libri di amministrazione, 446, 15 February 1612: '18 lire, per avere rimesso tutte le corde e penne a uno stromento, e tre accordature d'un altro'. I am grateful to Lizzy Currie for having brought the Capponi and Corsi account books to my attention.

42. ASF, Guicciardini Corsi Salviati, Libri di amministrazione, 446.

43. Gozzi (1589), p.65.

44. Fortini (1988), I, p.227: 'buon musico e di tutti li strumenti dottissimo'.

45. Lando (1550), f.4r: 'non ritrovo cosa che meglio mi acqueti & rasereni la conturbata harmonia dell'animo … ch'ella ammollisci l'ardor dell'ira, & riformi le depravate usanze.'

46. Ginori Conti (1937), pp.130–31: 'strumenti di suoni di musica con li suoi libri'. I am grateful to Ann Matchette for this reference.

47. Lando (1550), f.2v: 'per la maggior parte dilicati, lascivi, & effeminati'.

48. Cesare Ripa, Nuova iconologia (1618), quoted in Guidobaldi (1990), pp.57–9:

'Nel vecchio è di molto scandolo attendere alle lascivie, conviti, giuochi, feste, canti et altre vanità.'

49. Brown (1986a) and Newcomb (1986).

50. Quoted in Santore (1988), p.58.

51. Aretino (1889), pp.110–11. Italian original in Aretino (1975), pp.202–3: 'Pippa, niuno è atto a negarti uno stormentino; e perciò a uno chiedi il liuto, a l'altro l'arpicordo, a colui la viola, a costui i fiuti, a questo gli organetti e a quello la lira: che tanto è avanzato'.

52. Rocke (1996), p.166.

53. Bandello (1992), pp.316–37; and Cohen and Cohen (1993), pp.103–33 (ch.3, 'Ottavia and her Music Teacher').

54. Ferrero (1948), p.56: 'il sonare è cosa strana e leggera'.

55. Luigini (1554), pp.107–16.

56. Guazzo (1993), II, p.237: 'tuto ciò che adorna le donne di palazzo … Ma un privato gentiluomo non ha già bisogno in casa sua di queste canzoni e di questi balli.'

57. Guazzo (1993), II, p.237: 'se i padri avranno a maritare le figliuole in persone che non si pascano di fumo di musica nè d'odore di poesia, saranno avvertiti di essercitarle intorno all'arcolaio e alle massarizie di casa, più tosto che agli istromenti da sonare'.

58. Fenlon (1995b), and Slim (2002).

59. Agee (1983) and (1985).

60. Quoted in Feldman (1995), pp.29–30: 'Dilettavasi oltre modo della musica, cantando con modo e ragione; nè si vergognò insieme con Lorenzo suo fratello e altri suoi simili, cantare ne' giorni santi pubblicamente nelle Compagnie di notte, le Lamentationi. Similmente fece per carnevale in maschera per le case le canzoni. Dilettossi anche di comporre nella nostra lingua in prosa e in versi, come per più sue traduzioni e madrigali, che oggi in musica si cantano, puossi conoscere.'

61. Brown (1966) and (1968).

62. Feldman (1991) and (1995).

63. Palisca (1989).

64. Doni (1544) and Haar (1966).

65. Haar (1966), p.28: 'Quel Basso sta male, o voi dite male; mostrate: ut, sol, gli mancan due pause. Fateli se, dove le son Quattro.'

66. Letter from Doni to the singer Luigi Paoli (1552), cited in Feldman (1995), p.19: 'Voi havete à venire Domenica sera da noi con tutta la vostra compagnia, & portrate la Cassa con le Viole, le Stromento grande di penna, i Liuti, Flauti, Storte, & libri per cantare, perche Giovedì si fa la nostra Comedia.'

67. ASF, Capponi, 146, f.34v: 'per esser venuto à sonar con un ribecchino à più veglie Niccolò Lori contadino'.

68. Fortini (1988), II, p.511: 'e spesse

fiate era da que' giovini invitato a cena e a' loro ritruovi, perché egli molto bene cantava e sonava di tutti li strumenti.'

69. Bandello (1993), p.360: 'Ne la casa di Cinzia sempre v'erano di molti gentiluomini … perchè quivi si sonava, si cantava e sempre v'era alcun piacevol ragionamento.'

70. Croce (1620), ff.2r–v: 'Signor Oratio prendete il Liuto. / Io non son troppo in tono il mio Signore … / Signor Ottavio la vostra Viola. / Non l'hò qui, che serrata è ne la scuola … / E voi Signor Ortensio la Spinetta … / Farò quel che volete, / Bench'io non sia eccellente sonatore.'

71. Croce (1620), ff.4r–v: 'O Sonatori, par che voi dormiate: / Sonate un pò più stretto, / Perche questo balletto / Va fatto con assai più gagliardezza.'

72. Croce (1609), p.10: 'Horsù dunque, per non stare in otio, la Camillina sonarà un poco la spinetta, e tu canterai qualche canzoncina in essa, acciò che non vi venghi sonno; suona un poco Camilla / Qual volete voi, ch'io canti, Signore padre? / Canta, che canzone tu vuoi, pur ch'ella sia corta.'

73. Gozzi (1589), p.60: 'vietasi ancor'alli fanciulli il grande, & lungo pianto, con soavi, e dilettevoli canti.'

74. Vincenzo (n.d. [1600?]), f.1v: 'col suono, e senza suon'.

75. Journal of Tommaso di Silvestro, quoted and translated in Niccoli (1990), p.18.

76. Giovanni Bardi, In difesa dell'Ariosto, lecture delivered to the Accademia degli Alterati, Florence, 1583, quoted in Haar (2004), p.183: 'tenuto caro da vecchi, da giovani, dalle donne, da' dotti giuditiosi, stante per la città, andante in villa'. See also Haar (1981).

77. Kirkendale (1972).

78. Scipione Ammirato, Del maraviglioso avveddimento d'un cane del Re Francesco di Francia, Opuscoli (Florence, 1637), quoted in Kirkendale (1972), pp.210–11: 'et cantavasi da piccoli, et da grandi di giorno, et di notte per le piazze, et per le vie sì fattamente, che ciascuno havea del continuo gli orecchi intronati dal tuono di questa canzone.' The story must have been told between 1548 and 1582.

79. Ferrari (1883) and (1888); Dursi (1966); and Dennis (2002), pp.120–21.

80. Croce [?] (1590), f.2r: 'Ogn'un canta la Violina / Da la sera à la mattina / Per le case, per le strade / Ai banchetti, e mattinade.'

81. Milano (1987) and Milano and Villani (1995).

82. Milano (1987), p.3.

83. Milano (1987), p.6.

84. Croce (1639), f.4r: 'Di me si servon tutti / Huomini donne e putti.'

85. Croce (1639), f.3v: 'Da bassi, da mezani, e da gli Heroi.'

86. The largest collections are in the Civica Raccolta delle Stampe Achille Bertarelli in Milan (see Milano and Villani 1995) and in the Biblioteca Universitaria and the Biblioteca Comunale dell'Archiginnasio, Bologna.

87. Croce (1601), f.3v: 'Marino, / Voglio ch'ei faccia da Spazzacamino.'

88. Croce (1601), f.3v: 'oh ohi Spazzacamì / Chi ha belle Donn' cami da fa spazzà.'

89. Azzaiolo (1557).

90. Bellettini et al. (2000), pp.236–7.

91. Baratta (1905), Marinoni (1954) and Céard and Margolin (1986).

92. Baratta (1905) and Marinoni (1954). On the use of Rebus puzzles in 16th-century music, see Stras (2005).

93. Palatino (1953), p.211: 'le figure siano accommodate alle materie distinte, & chiare, & con manco lettere che sia possible. Ne si ricerca in esse di necessita molta orthographia, o parlar Toscano, & ornato, ne importa che una medesima figura serva per mezzo, o fine d'una parola, & principio dell'altra.'

94. Piccolpasso (1980), I, f.66v.

95. Ravinelli Guidotti (2004), pp.39 and 40.

96. For example, Bartolomeo Tromboncino's frottola, 'Audi cielo il mio lamento', which appears on a dish dated c.1515 in the V&A. See Slim (1984), reprinted in Slim (2002).

97. Ravinelli Guidotti (2004), p.58–9.

98. Lando (1550), f.5r: 'il condimento delle nostre contentezze'.

99. Lanteri (1560), p.18: 'Et le stanze dove i forastieri si vorranno alloggiare; saranno in luogo che dal romore della famiglia sia lontano … che il romore della famiglia, non si oda così facilmente.'

100. Gozzi (1589), pp.40–41: 'le risse, le discordie, i romori, con grandissimi disordini della cura familiare'.

17. Meals

1. Apparato de le nozze di Costanzo Sforza (Vicenza, 1475).

2. Alberti (1969), p.234: 'paoni, capponi e starne, ne simili altri cibi eletissimi, quali s'apparecchiano agl'infermi, ma pongasi mensa cittadinesca' (all translations, including this one and unless otherwise specified, are my own).

3. Guazzo (1993), p.226: 'sì come vogliamo che meritino gran biasimo quei che per crapula non finiscono mai di saziarsi de' cibi e di spendere soverchiamente nel diletto della gola, così istimo che meritino poca lode quei che per avarizia restano di vivere sconvenevolmente secondo il loro grado'.

4. Cotrugli (1990), p.226: 'prima, quando mangi innanzi tempo; secondo, quando di poi uno cibo vuoi l'altro; terzo,

quando vuole cibi preziosi; quarto, quando ne vuole in quantità; quinto, quando non serva politia nel mangiare, ma mangia avidamente et senza hordine.'
5. Garcia Marsilla (1997), pp.831–9.
6. Celebrino (1526).
7. Celebrino (1526), title page: 'Opera nova che insegna apparechiar una mensa a uno convito et etiam a tagliar in tavola de ogni sorte de carne et dar li cibi secondo l'ordine che usano gli scalchi per far honore a forestieri.'
8. For a study of Florentine sumptuary laws and a transcription of some of the relative documents, see Rainey (1985).
9. The festivities celebrating Giovanni Panciatichi are published in Passerini (1858), pp.245–67, and those celebrating Francesco di Messer Sozzino Bandinelli in *Rerum Italicarum Scriptores* (1934), pp.443, 445, 450.
10. Messisbugo (1557): above all the first part, where various meals are described in detail.
11. Scappi (1570), bk IV, pp.169–327.
12. On what was meant by salads, see the treatise composed in the 1560s by Costanzo Felici (Felici 1986, esp. pp.24–30). See also the very interesting comments on salad in Massonio (1627), esp. ch.3.
13. ASF, Camera del Comune, Mensa dei Signori, nos 13, 15, 17, 26.
14. Romoli (1560), f.32v: 'Del mangiare ordinario di dì in dì'.
15. Cornaro (1993), p.29: 'è sentita la crapula per cosa virtuosa e onorevole, e la vita sobria disonorevole e da uomo avaro'.
16. Guazzo (1993), p.175.
17. Dallington (1605), p.34.
18. Examples are abundant but see, among others, Gherardi da Prato (1975), pp.227–8, and, for a travel account, Piccolomini (future Pope Pius II; 1972–6), p.93.
19. Daniela Lamberini, pers. comm.
20. Sermini (1874), novella XXV, pp.295–304.
21. Concerning the lowly status of geese and aquatic birds, as well as the whole problem of what was considered to be rich food or simple fare – too long to be discussed here – see Grieco (1999).
22. Sermini (1874), p.300: 'e così vorrebbe il forte aglione con capponi o fagiani o starne, come col vieto lardo che usava in contado'.
23. Sermini (1874), p.299: 'e dipoi è uso di panberare la mattina duo o tre volte, e merendare, e poi cenare la sera'.
24. Celebrino (1526), p.38: 'Ben ch'io te habbia scritto questo ordene al modo proprio de Venetia, el non è che tu possi far e saper l'ordene universale; perché si dice: ogni terra la sua usanza et ogni casa ha il suo costume.'

18. Tableware
I want to express my gratitude to Paola Cacciari, who has assisted me in my research of contemporary texts, and to Professor Marco Spallanzani, for letting me read parts of his forthcoming book on Spanish lustrewares and for pointing out some archival references.

1. Goldthwaite (1989), p.24 (quoting Giovanni Pontano, *I trattati delle virtù sociali*); Benporat (2001), p.94 (quoting Giovanni Pontano, *De conviventia in opera*, Venice, 1518).
2. At the recent excavations of the pottery workshop at Cafaggiolo, for instance, hardly any evidence of the production of *istoriato* maiolica was found: Valeri (2002), pp.213–16; Vannini et al. (2005).
3. Faccioli (1966), pp.265–75 (quoting Messisbugo, *Banchetti composizioni di vivande e apparecchio generale arte della cucina*, Ferrara, 1549).
4. Thornton (1991), p.106, quotes Giovanni Batista Barpo, who wrote in Venice in 1634 that 'at your villa you should have – according to your means – several spoons and forks of silver and some plates of beautiful maiolica in order always to retain a measure of civility and to show that you are well born (per conservar sempre certa civiltà, e dimonstratione d'esser ben nato).
5. Lydecker (1987a), p.104, n.48.
6. Benporat (2001), pp.16–17.
7. Brulez (1965), p.808: 'argenti per uso di casa'.
8. Goldthwaite (1989), p.20.
9. Spallanzani (1997), p.49, and Goldthwaite (1989), p.25: 'quando era a tavola mangiava in vasi antichi e bellissimi, e così tutta la sua tavola era piena di vasi di porcellana, o di altri ornatissimi vasi. Quello con che egli beveva erano coppe di cristallo, o di altra pietra fine. A vederlo in tavola, così antico come era, era una gentilezza.'
10. Goldthwaite (1989), p.5.
11. Syson and Thornton (2001), p.214.
12. Lindow (2004), p.211, note 220: 'taglieri da maiolicha'. Brulez (1965), p.808; the 1606 inventory of a Venetian merchant lists 82 'tagliere de peltre picoli, diversi', obviously for individual use.
13. For instance in one of the earliest Italian recipe books *Anonimo Toscano* dating from the late fourteenth or late fifteenth century. Faccioli (1966), pp.17–57, has published parts of this book, but a full version can be found on the Web at the URL <http://staff.uni-marburg.de/~gloning/an-tosc.htm>.
14. Contini (1937).
15. Faccioli (1966), p.42; 'De la Suppa', a recipe from *Anonimo Toscano*, refers to bread cut in the fashion of *taglieri* ('come

a modo di tagliere').
16. Spallanzani (1997), p.153. The 1423 inventory of Bartolomeo di Messer Bartolomeo Da Prato lists '40 taglieri'. It is not clear if these are made of wood or pewter. As trenchers were cheap, they are often not mentioned in inventories.
17. Spallanzani (1997), p.150: 'schodelle grandi di stagno da ministrare'.
18. Wilson (1996), p.35; Mallet and Dreier (1998), p.12; Spallanzani (1997), p.104.
19. Spallanzani (2002), p.373.
20. Cora (1973), p.418, doc. 965.
21. Origo (1959), p.98.
22. Spallanzani (2002), p. 374.
23. Spallanzani (2002), p.377.
24. Mazzi (1911), pp.155–63.
25. Mazzi (1911), p.168: 'Una tavola da mangiare, con trepiei [sic]: Tre banche da sedere: Una sedia, trista'.
26. Sabban (2005), p.40.
27. Frati (1900): Anonimo Veneziano, *Libro per cuoco*, 14th/15th century.
28. Spallanzani (2002), p.373: '144 scodelle belle, di bella grandezza' (in 1393) and another '144 scodellini da salsa, 12 taglieri grandi'.
29. Ciappi et al. (1995), pp.32–42, and Mendera (2000), pp.78–105, figs 14–18, for the glass production at Gambassi.
30. Lydecker (1987a), p.311, nn.75, 78 (Luigi di Luigi Martelli, in Florence, selected expenditures 1515–80, purchase of 13 november 1567): '6 bichieri, 4 di christallo e 2 di nostro' (6 beakers, 4 of crystal glass and 2 of 'our own') and (of 23 August 1567) '3 saliere e 3 ghuastada di vetro nostrale' (3 salts and 3 bottles of 'our own' glass).
31. Spallanzani (1997), pp.165–6: '8 paia di saliere azzure e una chol pie … 11 vaxi di chalzidoniy di diversi forme' (8 pairs of blue salts and one with foot … 11 vessels of chalcedony of various forms).
32. It was also produced in Tuscany. Nepoti (1991) gives the best introduction of the development and chronology of incised slipware in northern Italy.
33. Goldthwaithe (1989), pp.5–9; Berti (1997), (1998) and (1999).
34. Nepoti (1991), pp.114–17.
35. Syson and Thornton (2001), pp.212–13.
36. Syson and Thornton (2001), pp.223–7.
37. Brody (2000), p.39. The Salviati *paesi* service (see below) appears in an inventory of 1583, remaining virtually intact since its manufacture twenty or thirty years before, indicating that there had been very little loss due to use during that period.
38. Mallet and Dreier (1998), p.36; Spallanzani (1994), p.129: 'Vedendo mangiare Nostro Signore su piatti di

terra in bianco sopra bianco, ho dimandato al suo siscalco perché la Santità Sua [Clemente VII de' Medici] non mangiava in quelli depinti a figure. Hamme detto lei non mangiare in altro, reservando quelli per uso di Cardinale'.
39. Lightbown and Caiger-Smith (1980), facs. ed. with commentary of Cipriano Piccolpasso, 'I tre libri dell'arte del vasaio' (c.1557), see Piccolpasso (1980).
40. Coutts (2001), p.33, fig. 40.
41. Ravanelli Guidotti (1996), pp.34–5.
42. Ravanelli Guidotti (1996), pp.86–8.
43. Ravanelli Guidotti (1996), p.407, cat.33; pp.484–5, cat.136.
44. Heikamp (1986) illustrates many design drawings for elaborate and fanciful vessels; Liefkes (1997), p.54.

19. Art in the *Casa*
1. Belting (1994). This concept has been nuanced by, for example, Nagel (2000), pp.18–19.
2. Brown (2004), pp.54–6.
3. Darr and Preyer (1999).
4. Jeremy Warren will shortly be publishing the fireplace with an attribution to Vincenzo and Gian Matteo Grandi. We are grateful to him for discussing the attribution and allowing us to make this reference in advance of publication.
5. Schiaparelli (1983), I, p.107: the form was to 'assume the importance of a true monument'; see pp.88–113 for fireplaces generally, 106–8 on the relationship between hoodless fireplaces and classical architecture; see also Thornton (1991), pp.20–27 for fireplaces.
6. Spallanzani and Gaeta Bertelà (1992), p.71 (inventory f.38): 'Uno paio d'alari grandi, forchetta, paletta e molli, pesono lib. 100', valued at 3 florins. Weights are provided for similar works in the inventories of Venetian foundries, and it was common practice to quote weights for precious materials, notably goldsmiths' work which could be melted down and reused.
7. See Motture (2003).
8. We are grateful to Claudia Kryza-Gersch, who proposed this suggestion at a symposium at the Metropolitan Museum in April 2004, highlighting that fireplaces in Venice became increasingly sculptural with elaborate overmantels, such as that designed by Scamozzi and executed by Girolamo Campagna, Tiziano Aspetti and others for the Sala dell'Anticollegio in the Palazzo Ducale; for the design see Thornton (1991), p.22, fig. 19; for the fireplace see Timofiewitsch (1972), pp.251–2, cat.10, pl.38.
9. These terms and the social virtues mentioned below, magnificence and

gentilezza, are thoroughly discussed and related to domestic objects in Syson and Thornton (2001), pp.23–33.

10. Eco (1986).

11. On the other hand, it is arguable that particular artists were employed in the design of functional works in order to ensure both quality and an element of *ingegno*, such as the firedogs designed by Giulio Romano for the Gonzaga in Mantua: see Thornton (1991), p.25, no.26.

12. See, for example, Motture (2003); for foundry production see also Avery (2003), esp. pp.241–5.

13. O'Malley (2005), pp.148–51.

14. Syson and Thornton (2001), *passim*.

15. We are extremely grateful to Caroline Elam and Brenda Preyer for discussing this issue with us, and for providing valuable references. In particular, we would like to acknowledge Brenda Preyer's assistance in gauging the heights and widths of doorways and supplying us with information as to the height of the Gondi fireplace.

16. For the Gondi figures, see Giancarlo Gentilini in Barocchi (1992), pp.45–7, cats 7–8.

17. For Cozzarelli's panels see, most recently, Santi and Strinati (2005), pp.194–5, cat.2.15.

18. Thornton (1991), pp.221–2.

19. Haines (1983), pl.III. The cupboards below are replacements.

20. Spallanzani and Gaeta Bertelà (1992).

21. See Barriault (1994), p.30: 'Uno armadio di noce antico … con sue spalliere a l'antice[a] dipinto in telo di mano del Ghirlandaio con cornice.' Shearman (1975), pp.12–27.

22. Barriault (1994), p.18: 'Una testa di marmo di tutto rilievo e uno Cristo a piè di detto tabernacolo [painted *colmo* – a painting or sculpture with an arched top – in tabernacle with gilded and painted *sportelli*] e in sul chappelinaio del lettuccio'.

23. Lightbown (1978), II, pp.51–3, cat.B39.

24. See Frimmel (1888), p.84: 'La nuda grande destesa da driedo el letto fu de man de Hieronimo Sauoldo Bressano.'

25. For example, Virgin and Child *colmo*, Spallanzani and Gaeta Bertelà (1992), p.6. See also Lydecker (1987a), p.162, n.29.

26. Spallanzani and Gaeta Bertelà (1992), p.6.

27. The tondo in this scene is of course intended to be read as both real and visionary, but the proportions of the room are close to surviving examples, and it is likely that the setting was intended to chime with the experience of these objects as encountered in real life (making them visionary as well).

28. Vasari (1878–85), II, pp.148–9: 'E per molti anni fu di sorte questa cosa in uso, che eziandio i più eccellenti pittori in così fatti lavori si esercitavano, senza vergognarsi, come oggi molti farebbono, di dipignere e mettere d'oro simili cose. E che ciò sia vero, si è veduto insino a' giorni nostri, oltre molti altri, alcuni cassoni, spalliere e cornici nelle camere del magnifico Lorenzo Vecchio de' Medici, nei quali era dipinto di mano di pittori non mica plebei, ma eccellenti maestri, tutte le giostre, torneamenti, cacce, feste et altri spettacoli fatti ne' tempi suoi, con giudizio, con invenzione e con arte maravigliosa. Delle quali cose se ne veggiono…nel palazzo e nelle case vecchie de' Medici.'

29. This is what Ghirlandaio's canvases were called in the Cinquecento: see n.21 above. The issue was examined by Schiaparelli (1983), I, pp.159–68; Wackernagel (1981), pp.153–9; Barriault (1994), p.2: 'These painted narratives on panel were intended for sequential placement in domestic chambers. They were encased within wooden pilasters and entablatures, and attached above cupboards, settles, beds, and chests (*armadi*, *lettucci*, *cassoni*) or within the middle registers of wall woodwork. Their original locations must be reconstructed, however'.

30. For a thorough but not always convincing discussion of the meaning of the word, see Barriault (1994), pp.9–49.

31. Thornton (1991), pp. 48, 173, 341.

32. We are extremely grateful to Brenda Preyer for providing the information on which these heights are based.

33. Syson in Santi and Strinati (2005), pp.199–205, cats 2.18–2.20.

34. On portrait busts, see particularly Pope-Hennessy (1966), pp.64–100, esp. pp.71–86; Pope-Hennessy (2002), pp.181–97; Lavin (1998); Schuyler (1976), *passim*; Pope-Hennessy (1994), pp.181–97; Warren (1998); Luchs (2000); for the Medici in particular, see Zuraw (1993); Paoletti (1998); for the *all'antica* bust in the sixteenth century, see additionally: Martin (1998), esp. pp.1–21 (many Venetian busts were placed on public display, notably on tombs and other church settings); Boström (2003).

35. Regarding the cult of fame, see Schuyler (1976), pp.11–20, p.13 referencing Pliny's *Natural History* XXXV. See also Belting (1994), pp.9–14, relating the significance of 'portraits' of saints, memory and the connection to place.

36. Schuyler (1976), pp.15–16.

37. Cennini (1960), pp.124–7.

38. Schuyler (1976), p.24; Cruttwell (1904), pp.96–9, relating these busts to another entry in Tommaso's inventory 'per achonciatur di tutte le teste chotalie che sono sopra a gli usci del chortile in Firenze' ('for the adornment of all the heads that are above the exits of the courtyard in Florence'; see Butterfield 1997, p.5, for the Medici heads). This practice of life-casting also relates to the production of votive effigies cast in wax, which peopled churches such as Orsanmichele and SS. Annunziata in Florence.

39. See Schuyler (1976), pp.16–17, 20–28; Vasari (1878–85), III, p.373. These busts were placed primarily within the home. Schuyler states that it was necessary to get permission from the Signoria to display them in public places (Schuyler 1976, p.10) – Antonio Rossellino's bust of Matteo Palmieri was placed above the exterior doorway to his house (e.g. Schuyler 1976, p.16); Lydecker (1987a), p.71, includes references to sculpted busts on *lettucci*, on beds and on mouldings, but these were unidentified heads and not necessarily portrait busts; see pp.61–79 for locations of art in the home.

40. The bust is ascribed to Antonio de'Benintendi; see Boucher *et al.* (2001).

41. Zuraw (1993), pp.319–20, highlighting the disparity in date between the making of Mino's busts and the 1492 Medici inventory, suggests that these highly finished works were originally intended to be seen in the round and therefore possibly placed on a piece of furniture rather than in a high setting and moved subsequently.

42. Brown (2001), pp.110–11, cat.4.

43. Dülberg (1990), pp.116–53, 226–9, 236–9: cats 162–9, 183–4, 186, 188; for a surviving velvet portrait bag (albeit French), see p.230, cat.174. For related information, see also Syson (2002).

44. Brown (1988), pp.692–3. See also Lydecker (1987a), pp.66–7, for other permanent locations.

45. Its placement is partly a pictorial decision by the painter. However, this constitutes a more valuable clue than many equivalent representations, given the paucity of written evidence from Venice.

46. See Johnson (1997), esp. p.4, figs 1.7, 1.8.

47. Spallanzani and Gaeta Bertelà (1992), p.52: 'Una tavoletta, dipintovi di [*sic*] una testa di dama franzese, cholorito a olio, opera di Pietro Cresci da Bruggia, f.10'. This is often identified, though evidence is lacking, with Petrus Christus's *Portrait of a Woman* (*c*.1470) in Berlin, referred to below.

48. Amonaci and Baldinotti (1992), pp.126–8; Caglioti (2000), pp.265–81; Gordon (2003), pp.383–5, 387–8, 390–99.

49. See, for example, Paoletti (1998).

50. Spallanzani and Gaeta Bertelà (1992), p.33. Paoletti (1998) points to the Medici as leading or exceptional, with others later following their practice. This may be largely correct. The fame of their palace was remorseless. However, he also claims (p.84): 'What all of these devotional sculpted images of the Virgin and Child indicate – regardless of their medium – is that within the domestic context they presented an iconic rather than a narrative image. Narrative sculpture did appear in major public commissions such as Arnolfo's overdoor sculpture of the Nativity … But within a private household, religious narrative apparently was restricted to painted images.' This statement seems more difficult to sustain given the presence of Donatello's great narrative *Ascension Relief*, now in the V&A, in the *camera grande*.

51. Paoletti (1998), p.84. The room also contained large *colmi* measured at between 4½ and 1½ *braccia* with images (views?) of Rome, Italy and the universe, and one of 2½ *braccia* with portraits of Francesco Sforza and Gattamelata. It is not clear whether this is height or, more likely, width, with the works perhaps placed high.

52. See notably Johnson (1997), pp.1–17, esp. pp.7–10; Musacchio (1999), for example, p.130.

53. Versions exist in stucco and terracotta: see Bule *et al.* (1992), pp.48–53, cat.1, and for reproduction of Florentine Madonnas, pp.16–23.

54. Butterfield and Franklin (1998), p.820: 'homo di gran riputatione et nome grande in detta arte'.

55. See Paoletti (1998); Randolph (2002), pp.139–92, especially pp.154–60; Radke (2003); Motture (2005).

56. See, for example, Welch (2005), pp.36–7. For Ghibertesque figures of the Virgin and Child, see Jolly (1998), pp.95, 97, no.12. 5 and pl.14. See McHam (1986) for the political associations of the *Dovizia*. Lots of these works were reproduced from moulds – from the ubiquitous Virgin and Child relief to domestic and collector's bronzes. However, even cast 'multiples' could be made unique by differing the details of their frames or painted surfaces, varying the consoles on which they rested, or by combining well-recognized signature elements in new ways.

57. Vasari (1878–85), IV, p.17: 'Grandissimi doni si veggiono piovere dagl'influssi celesti ne'corpi umani, molte volte naturalmente, e soprannaturali talvolta; straboccchevolmente accozzarsi in un corpor solo, bellezza, grazia e virtù in una maniera, che divina, che lasciandosi dietro tutti gli altri uomini,

manifestamente si fa conoscere per cosa, com'ella è, largita da Dio e non acquistata per arte umana. Questo lo videro gli uomini in Lionardo da Vinci …'

58. Meyer Zur Capellen (2001), pp.219–22, 227–32, 257–63, 272–6: cats 27, 30, 35, 39; Chapman *et al.* (2004), pp.40–42, 194–9, cat.60.

59. Vasari (1878–85), IV, p.321: 'al quale, avendo preso donna in que' giorni'.

60. Brown (2004), pp.173–6.

61. Borenius (1923). For another example of the organisation of a Venetian collection, see Avery (2001).

62. Brown (2004), pp.236–7.

63. Brown (2004), p.237, fig.265.

The (*Acquaio*) Wall-Fountain and Fireplace in Florence

1. Darr and Preyer (1999), pp.726–8.

2. Pope-Hennessy (1964), II, pp.405–6.

3. Cicognara (1813–18), II, p.299.

4. Godby (1982).

5. Communication from Prof. Elizabeth McGrath, The Warburg Institute.

6. Alan Darr, The Detroit Institute of Arts, brought this work to my attention.

7. Pope-Hennessy (1964), II, p.405.

8. Naldi (2002), pp.218–19.

9. Vasari (1878–85), III, p.373: 'onde si vede in ogni casa di Firenze, sopra i cammini, usci, finestre e cornicioni, infiniti di detti ritratti'.

The Medici Study

1. Fusco and Corti (2006). See also Syson and Thornton (2001), pp.81–2, for which Laurie Fusco had kindly given the authors' permission to quote the document. In the latter publication the loggia was wrongly described as opening off the study.

2. Hatfield (1970b).

3. Christiansen (2005), pp.198–9, cat.25 (with bibliography). Christiansen's opinion that they were executed by several hands should be treated with caution.

4. Thornton (1997), esp. p.4.

5. Filarete knew Piero and in 1465 dedicated one of the earliest-known small bronzes to him, his *Emperor Commodus Antoninus* (Antoninus Pius), now in Dresden. See Schweikhart (1993), pp.369–85.

6. Filarete (Antonio Averlino) (1972), pp.687–8.

7. Spallanzani (1996), pp.93–9.

8. Spallanzani (1996), pp.107–17.

9. Spallanzani (1996), pp.139–45.

10. Spallanzani (1996), pp.151–7.

11. Spallanzani and Gaeta Bertelà (1992).

12. Dacos *et al.* (1973).

20. Bronzes

1. Pliny, *Natural History*, XXXIV, 48.

2. Thornton (2001), p.33.

3. Kent (2000), p.28.

4. Warren (2002), pp.25–6. For two other sculptural commissions from this exceptional patron, see Schulz (1998), pp.240–42, no.5D, pls 87–8 and pp.244–6, no.7B, pls 89–90.

5. Thornton (1997), pp.30–33.

6. Sighinolfi (1916), p.151: 'Una testa de cavallo de metallo / Una testa de homo de metallo / Una figureta de metallo.'

7. Castiglione (1999), p.215 (Ricordo CXIII: 'Circa il conversare co vitiosi'): 'Che diremo noi della vanità di quell'altro, che spende li cinquecento & mille ducati in una statua di metallo, o di pietra, delle quali non se ne serve, ne si può servire in cosa alcuna; & non ardisce comprare per venticinque ducati un servo vivo & vero, dal quale potrebbe essere servito & aiutato in molte cose? Et di quell'altro che và à piede per non spendere dieci ducati in un cavallo, & poi spende li cinquecento ducati in un cavalluccio antico di bronzo, un palmo grande, il quale non solamente non può portare, ma è forza che esso sia portato.'

8. Bombe (1928), p.57, no.223, and p.59, no.311.

9. Sabba da Castiglione (1999), p.167 (Ricordo CIX: 'Circa gli ornamenti della casa').

10. Cortesi (2000), pp.176–7.

11. Filarete (1972), I, p.268.

12. Hildburgh (1951), p.48.

13. For a recent discussion of the technical processes of bronze casting in the Renaissance, see Sturman (2004).

14. For Severo da Ravenna, see Avery and Radcliffe (1983), and Warren (2001b).

15. Ashmolean Museum, Oxford, Invs. WA 1888.CDEF.B1024 and 1888.CDEF.B1025. For a recent discussion, see *Donatello e il suo tempo* (2001), p.167, no.38.

16. Bode (1980), pls 87–9.

17. Ludwig (1911), p.57: 'Un caramal de bronzo.'

18. Thornton (1997), pp.142–67.

19. Weihrauch (1967), esp. pp.102–4, 459–61; Radcliffe (1997), pp.87–8.

20. Gaurico (1999), pp.140–41: 'Quanquam satyriscis, hydris, chimaeris, monstris denique, quae nusquam viderint, fingendis ita praeoccupantur, ut nihil praeterea reliquum esse videatur.'

21. For Riccio, see Planiscig (1927) and, more recently, Radcliffe (1972), (1982) and (1997).

22. Rigoni (1970), pp.219–20.

23. Planiscig (1927), pp.241–324; Radcliffe (1997), pp.88–9.

24. Radcliffe (1997), p.88.

25. For this celebrated bronze, see Anthony Radcliffe's entry in Krahn

(1995), pp.202–3, no.30; and, more recently, Motture (2004).

26. Gaurico (1999), pp.136–9, 144–7.

27. Warren (2001b), pp.95–7, fig.23.

28. Palmer (1993).

29. Mattioli (1995), I, p.204: 'Ma mi giovò che piu celesti odori / Di Muschio, d'Ambra, acqua Nampha, e Zibetto / Che di piu profumiere uscivan fuori, / Mi circondorno, e raddolcirno'l petto.'

Splendour

1. See, for example, Cicero (2000), p.434, and Cicero (2001), pp.471–3, 497.

2. The 1498 edition consisted of five books on the related virtues of splendour, magnificence, liberality, charity and hospitality. For Pontano's books, see Pontano (1999). An English translation of *De splendore* can be found in Welch (2002).

3. On *supelectiles*, see Pontano (1999), p.228: 'Supelectilem vocamus omne domesticum instrumentum, ut vasa, lances, textilia, lectos et id genus coetera, sine quibus commode vive non potest.' On *ornamenta*, see Pontano (1999): p.232, where the relevant entry reads: 'Ornamenta autem vocamus ea, quae non tam ad usum comparata sunt, quam ad ornatum ac nitorem, ut sunt signa, tabulae pictae, aulea, fulcra, eburnae sellae, stragola gemmis intertexta, pixides et arculae ex Arabicis pigmentis, vascula e christallo et huius generis alia, quibus domus pro tempore ornatur et abaci mensaeque instruuntur; delectat autem eorum aspectus, ac domino pariunt auctoritatem, dum multi, ut ea videant, domos ipsas frequentant.

4. For a fuller discussion of splendour, see Lindow (2004). For domestic display, see Lindow (2005).

21. Middle-Eastern objects

A number of colleagues and friends have been very generous in spending time discussing various issues with me over the three years of this project. I am grateful to all of them, and in particular to the other members of the team for their stimulating comments during our many discussions about the various issues of this vast project, and to Professor Michael Rogers whose knowledge of the subject is superlative and has guided me over the years. I am also very grateful to Professor Marco Spallanzani, University of Florence, for reading a draft of this chapter and for his insightful comments. Mr Ünver Rüstem, my research assistant, has greatly helped the project with his enthusiasm and good humour. I should also like to thank all the museums and collections, beginning with the V&A,

that have assisted me with the research for this chapter: the Correr Museum, the Marciana Library and the Palazzo Ducale in Venice; the Bargello Museum in Florence; the Museo Civico Medievale in Bologna; and the British Museum and the Wallace Collection in London.

1. Dante, *Inferno*, xvii, 6: 'drappi tartari e turchi'.

2. For technical analysis of the Veneto-Saracenic wares, see Ward *et al.* (1995).

3. Allan (1986), p.58; Ward (1993), p.103; Auld (2004), pp.40–41.

4. Lavoix (1862); Auld (2004), p.40.

5. Huth (1972); Auld (1989), p.186; Contadini (1999), p.13.

6. Vasari (1878–85), VIII, p.211. Also Allan (1989), p.168.

7. For arguments to this effect, see Allan (1986); Ward (1989); Ward (1993), pp.102–3; Auld (1989); Auld (2004).

8. Auld (2004).

9. Allan (1986), pp.56–8; Allan (1989), p.168; Auld (1989), p.186; Ward *et al.* (1995), p.243; Auld (2004), pp.8, 41–2, 60.

10. Museo Civico Correr, Venice, inv. no.XII 11. For this object, see Curatola (1993), p.488, no.305 and col. pl.; and Auld (2004), p.122, no.1.14.

11. Ward (1992), pp.73–4; Auld (2004), pp.111–12.

12. Museo Nazionale del Bargello, Florence, inv. Bronzi 292 and 299. For these incense burners, see Spallanzani (1980), pls 27 and 28; Curatola and Spallanzani (1981), pp.7–9, no.1; Auld (1989), p.187; Auld (2004), p.108, 123, no.1.16.

13. For the burning of perfume in the Renaissance home, see Thornton (1991), pp.249–51.

14. Auld (2004), pp.109–10.

15. Auld (2004), p.110: '1 poma da schaldare le manu d'argento, dorata'.

16. Museo Nazionale del Bargello, Florence, inv. Bronzi 292 and 299; Spallanzani (1980), p.115 and pls 27–28.

17. See Melikian-Chirvani in *Arts de l'Islam* (1971), entry no.173.

18. V&A: M. 32–1946. For this piece, see Hildburgh (1941), pp.18, 21 and fig.F; *Fifty Masterpieces of Metalwork* (1951), pp.56–7, no.27; Haedeke (1970), p.ix, no.72 and fig.72; Sievernich and Budde (1989), p.601, no.4/97 and col. pl.692; Auld (2004), p.294, no.8.3; Stanley *et al.* (2004), p.127 and col. pl.152.

19. For the Molino family and its members, see *Dizionario Biografico Universale* (1844–5), p.1174; *Enciclopedia Italiana* (1934), p.579.

20. See Hildburgh (1941), p.21 and fig.E; Dexel (1962), pp.62–3, p.406, no.214 and fig.214; Stanley *et al.* (2004), p.127 and col. pl.150.

21. See Auld (2004), pp.42–3.
22. Hildburgh (1941); *Fifty Masterpieces of Metalwork* (1951), pp.56–7, no.27; Sievernich and Budde (1989), p.601, no.4/97; Stanley *et al.* (2004), p.127.
23. Allan (1986), p.58.
24. Museo Nazionale di Capodimonte, inv. no.11148/393. For this ewer, see Scerrato (1967), p.31, no.36 and fig.31; Auld (2004), pp.295–6, no.8.5.
25. Dexel (1962), p.406, no.214.
26. See Thornton (1991), p.244.
27. See Auld (2004), p.215.
28. Filarete (1965), II, f.129v: 'i quali non altrimenti parevano a vedere senon come angioli', 'con uno bacino dargento in mano' and 'con una mesciroba con acqua dentro nell'altra mano'.
29. Thornton (1991), p.244: 'bazile [bacili/bacini] quatro de bronzo, cum li bronzini: cum le arme de argento fin smalta nel mezzo'.
30. A German painting of the *Birth of the Virgin* of 1498 in the Staatliche Kunsthalle, Karlsruhe, depicts an undecorated ewer of very similar form with accompanying basin. A detail of the painting is reproduced in Haedeke (1970), fig.62.
31. Museo Civico Correr, Venice, inv. no. Cl. XII, 22 and 23. For these candlesticks, see Curatola (1993), pp. 488–9, nos 306a and 306b and col. pls 306 and 306a; Auld (2004), p.249, nos 6.1 and 6.2.
32. As, for example, in *Birth of the Virgin* by Vittore Carpaccio and in the *Annunciation* painted by Carlo Crivelli in 1486, in the National Gallery, London, for which see Zampetti (1986), col. pl.74.
33. As, for instance, in Carpaccio's *St Augustine in his Study*; see plate 20.4.
34. Giovanni Antonio Tagliente, '... la vera arte dello Excellente scrivere ...', British Library, London, B.L. C.31.f.15.
35. Ward (1993), pp.102–3; Allan (1986), (1989) and (1991), p.158, n.4; Auld (2004), pp.50–53, 62–6, 104–5.
36. For discussion of these two masters, see Auld (2004), pp.11–35.
37. V&A: 1826–1888. For this piece, see Mayer (1959), p.91, no.II; Robinson (1967), p.173, no.198; Lightbown (1981), fig.312; Sievernich and Budde (1989), pp.601–2, no.4/98; Auld (2004), pp.33–4, pp.269–70, no.7.2; Stanley *et al.* (2004), p.128, col. pl.154
38. See Haedeke (1970), pp.69–71; Thornton (1991), p.245.
39. V&A: 2061–1855. For this salver, see Kühnel (1925), p.151 and fig.120; Mayer (1959), p.57, no.V (where it is mistakenly categorized as one of the pieces signed by Mahmud al-Kurdi); Huth (1971), p.4, pl.4 (where the piece is again misattributed to Mahmud al-Kurdi); Auld (2004), p.235, no.5.27.

40. Auld (2004), p.215.
41. See, for example, Thornton (1991), col. pl.170.
42. Auld (2004), pp.66–8.
43. Auld (2004), pp.60–62.
44. V&A: 553–1865. For this piece, see Mackay (1942), pls I, F; Auld (2004), p.261, no.6.26.
45. V&A: 554–1865.
46. Mackay (1942).
47. V&A: 4301–1857. See Melikian-Chirvani (1982), pp.321–32, no.146 and the entry by A.R.E. North in Sievernich and Budde (1989), p.606, no.4/104.
48. Museo Nazionale del Bargello, Florence, inv. 786 C. For this object, see *Catalogo del R. Museo Nazionale di Firenze* (1898), p.148, no.786; Gerspach (1904), p.32 and fig.40; Grigaut (1958), p.155, no.417; Mariacher (1981), p.86, fig.B.
49. See Sangiorgi (1895), p.22, no.55 and pl.55; *Catalogo del R. Museo Nazionale di Firenze* (1898), p.148, no.787; Gerspach (1904), p.32 and fig.39; Grigaut (1958), p.155, no.417 and fig.417; Mariacher (1981), p.86, fig.A; Gonzáles-Palacios (1986), I, p.305, and II, figs 691, 697; *Arti del Medio Evo e del Rinascimento* (1989), p.318, no.108, including two figs; Curatola (1993), no.308. See also following note.
50. One of these is in the Louvre, Paris, for which see Lièvre and Sauzay (1863), pl.CIV and text on facing page; and Grigaut (1958), p.155, no.417. Another is also in Paris in the Musée Jacquemart-André (no.1187), for which see de Ricci (1914), pp 21–2, and plate on p.20; and Grigaut (1958), p.155, no.417. The third burner is in the Wallace Collection, London, for which see Gonzáles-Palacios (1986), I, p.305, and II, fig.697.
51. See Fehérvári (1976), p.85 and pl.33; Ward (1992), pp.69–73; Ward (1993), fig.74 and col. pl.61.
52. Museo Diocesano, Treviso, h 15 cm, d of base 20 cm. For this piece, see Gabrieli and Scerrato (1979), p.558; Curatola (1993), cat. no.180; Contadini (1999), p.4, fig.1.
53. Museo Civico Correr, Venice, inv. no. Cl. XII, no.26. See Atil (1981), p.97; Curatola (1993), cat. no.181.
54. For reproductions of the painting see Zorzi (1988), col. pl.48 and detail pl.51. Also Contadini (1999), p.4 and figs 1, 2a and 2b.
55. For comprehensive discussion on the topic of the Eastern carpet in the West, see King in King and Sylvester (1983).
56. King in King and Sylvester (1983), p.24; Mills (1983a), p.11; Curatola and Spallanzani (1983), esp. p.4; Contadini (1999), pp.6–7.
57. See Archivio del Museo Correr, MS PD 509/C-1, dated 1555, published in Curatola (2004), p.130.

58. Erdmann (1970), p.96; Kendrick and Tattersall (1931), p.22; Mills (1983a), p.18.
59. King, Franses and Pinner (1985), p.358.
60. See Erdmann (1970), pp.21–3; Mills (1983a) and (1983b).
61. Erdmann (1970), pp.96, 98, 198; King, Pinner and Franses (1981), pp.46–7; Mills (1983a), p.14.
62. Erdmann (1970), p.198: 'tapedi da desco', 'tapedi da tavola', 'tapedi da terra'.
63. For these carpets, see Erdmann (1970), pp.57–60; Ellis (1975); King in King and Sylvester (1983), pp. 27, 67–70; King, Franses and Pinner (1985), pp.365–7. For Lotto's depictions of them, see Mills (1981), p.281; Mills (1983a), p.16 and pl.18.
64. See Mills (1981), pp.281–7; Mills (1983b), pp.28–30; Mills (1983a), p.16; King in King and Sylvester (1983), pp.27–8, 67; King, Franses and Pinner (1985), p.365.
65. See Erdmann (1970), p.211 and fig.273; Mills (1981), 288–9; Mills (1983a), pp.16, 20; Spuhler (1988), p.23; King, Franses and Pinner (1985), p.365.
66. Kendrick and Tattersall (1931), pp.21–2; Erdmann (1970), p.59; Ellis (1975); Mills (1981), p.279; Curatola (1983), pp.45–8; King in King and Sylvester (1983), pp.29–30, 70, 73; King, Franses and Pinner (1985), pp.357–8, 365.
67. Erdmann (1970), pp.53, 187–9; Ellis (1975); Wearden in Baker and Richardson (2003), p.36.
68. V&A: 903-904–1897 and T.348–1920. For these carpets, see Kendrick and Tattersall (1931), pp.24–5 and fig.130 on pl.XIX; King, Franses and Pinner (1985), pp.354, 366–7, 381, figs. 2, 6, 7 and col. pl.I; Wearden in Baker and Richardson (2003), p.36 and col. pls 114, 115.
69. Kendrick and Tattersall (1931), p.24; Erdmann (1970), pp.58–60; Ellis (1975), p.19; King in King and Sylvester (1983), pp.27, 67; King, Franses and Pinner (1985), p.365.
70. For fuller discussion of the borders of these carpets and the Lotto type in general, see Erdmann (1970), p.60; Ellis (1975), pp.19–20, 22–3, 24; Erdmann (1977), pp.31–2; Mills (1981), pp.287–8; Mills (1983a), p.16; King, Franses and Pinner (1985), pp.364–5. For the related borders of the Holbein carpets, see Pinner and Stranger (1978).
71. For the Holbein carpets and their relationship to the Lottos, see Erdmann (1970), pp.21–2, 52–60; King in King and Sylvester (1983), pp.26–7, 52–6, 67; King, Franses and Pinner (1985), pp.363–5.
72. King in King and Sylvester (1983),

p.25.
73. Spallanzani (1989), pp.88–9 and figs 4 and 5.
74. King in King and Sylvester (1983), pp.27, 59–64, 79; King, Pinner and Franses (1981), pp.37–40, 42–3.
75. See, for example, King and Sylvester (1983), no.18, p.60; Boralevi (1999), cat. no.1.
76. Erdmann (1939), p.176; Erdmann (1970), p.97.
77. Erdmann (1970), p.97; King, Pinner and Franses (1981), pp.37, 43 and n. 43; Suriano (2004), pp.101–4.
78. Erdmann (1939), pp.176–7; Erdmann (1970), pp.97–8.
79. Erdmann (1939), p.176; King and Sylvester (1983), pp.79–83; King, Pinner and Franses (1981), pp.38–40, 43–7.
80. Boralevi (1983); King and Sylvester (1983), pp.24, 27, no.21, pp.61–2, 79, no.56, p.83; Curatola (1993), no.191, pp.326–7.
81. V&A: 151–1883, Kendrick and Tattersall (1931), pp.23–4; Erdmann (1950) pp.55–81 and fig.15; Erdmann (1962), p.65 and fig.15; Erdmann (1970), p.199; Ettinghausen (1974), p.301 and fig.40; King, Pinner and Franses (1981), pp.36, 47, 50 and fig.11; Curatola (1983), p.169; King and Sylvester (1983), no.52, p.81; Wearden in Baker and Richardson (1997), no.103, p.256 (inc. col. pl.); Bier (1998), p.96 (inc. col. pl.); Wearden in Baker and Richardson (1997), no.103, p.256; Wearden (2003), p.32 and col. pl.83.
82. Eredità Bardini no.7876. See Boralevi (1999), no.5.
83. Erdmann (1970), p.198.
84. Museo Civico, San Gimignano, Erdmann (1940), p.73 and fig.14; Erdmann (1962), p.65; Erdmann (1970), p.199 and fig.253; King, Pinner and Franses (1981), p.47; Yetkin (1981), p.105 and fig.64; Curatola (1983), p.169 (inc. col. pl.); Curatola (1993), no.247, pp.396–8 (inc. col. pl.).
85. Museum of Islamic Art, Berlin, inv. no.88, 146. For this fragment and its reconstruction, see Erdmann (1962), p.65; Erdmann (1970), p.199; King, Pinner and Franses (1981), p.47; Spuhler (1988), no.67, p.62 and col. plate on p.210.
86. Kendrick and Tattersall (1931), pp.23–4; Erdmann (1940), p.74; Erdmann (1962), p.65; Erdmann (1970), p.199; Ettinghausen (1974), p.301.
87. Erdmann (1970), pp.98, 198–9 and figs 251–2; Ettinghausen (1974), p.301; King and Sylvester (1983), nos 62–3, pp.62–3 and col. pl.23.
88. For the terms and their meanings, see Denny (1982), p.122; Tezcan and Delibas (1986), pp.15–17; Gürsu (1988), pp.27–30; Baker (1995), pp.92–3; Atasoy *et al.* (2001), pp.16, 217–25.

89. Denny (1982), p.122; Tezcan and Delibas (1986), p.15; Gürsu (1988), pp.19, 22, 39–40; Baker (1995), p.86; Atasoy *et al.* (2001), pp.155, 157–60.
90. Gürsu (1988), p.22.
91. Atasoy *et al.* (2001), p.182.
92. Tezcan and Delibas (1986), pp.33–4; Baker and Wearden (1996), pp.28–9; Atasoy *et al.* (2001), pp.176–81, p.186.
93. Öz (1950), p.73; Wearden (1985), p.26; Gürsu (1988), p.28; Atasoy *et al.* (2001), pp.182–90.
94. Denny (1982), p.125; Baker, Wearden and French (1990), p.137; Atasoy *et al.* (2001), pp.182–3, 186–90.
95. Museo Nazionale del Bargello, Florence, inv. Franchetti 639. Suriano and Carboni (1999), no.25.
96. *Brief Guide to the Turkish Woven Fabrics* (1923), pp.7–9; *Brief Guide to the Turkish Woven Fabrics* (1931), pp.12–14; *Brief Guide to the Turkish Woven Fabrics* (1950), pp.7–9; Mackie (1973–4), p.13; Gürsu (1988), pp.41, 72, 89, 165, 167, 182–3; Atasoy *et al.* (2001), pp.187, 190; Stanley *et al.* (2004), p.125.
97. Gürsu (1988), pp.45–6; Atasoy *et al.* (2001), pp.155, 171–2.
98. *Brief Guide to the Turkish Woven Fabrics* (1923), p.15; Andrews Reath (1927); *Brief Guide to the Turkish Woven Fabrics* (1931), pp.21–2; *Brief Guide to the Turkish Woven Fabrics* (1950), pp.15–16; Gürsu (1988), pp.43, 72. 167. 182; Atasoy *et al.* (2001), pp.183, 187, 224, 300, 333–5 and col. pls 67–8, 70–72.
99. *Brief Guide to the Turkish Woven Fabrics* (1923), p.15; *Brief Guide to the Turkish Woven Fabrics* (1931), pp.22–3; *Brief Guide to the Turkish Woven Fabrics* (1950), p.15; Wearden (1985), p.27; Atasoy *et al.* (2001), p.183.
100. Tezcan and Delibas (1986), p.16; Gürsu (1988), p.28; Atasoy *et al.* (2001), pp.222–4.
101. Atasoy *et al.* (2001), p.232, no.101, p.339 and col. pl.101.
102. Gürsu (1988), p.167; Atasoy *et al.* (2001), p.186.
103. Mackie (1973–4), p.14; Gürsu (1988), p.165.
104. Tezcan and Delibas (1986), p.28.
105. Öz (1950), p.38; Mackie (1973–4), p.14; Denny (1982), p.137; Gürsu (1988), p.28.
106. Richards (1932), p.137; Contadini (1999), p.12; Atasoy *et al.* (2001), p.186.
107. For a detailed discussion of these shields within the *cuoridoro* art, see Contadini (1989); also Contadini (1999), pp.14–15 and fig.35.
108. This group is now in the Carolino-Augusteum Museum in Salzburg. See Contadini (1989), pp.236–7 and notes 36–40.
109. Marachio (1794), pp.122–3; Grevembroch (1764), under 'Fabbricatore di cuoia d'oro'.

110. Berchet (1865), p.66; also Berchet (1871–2).
111. ASV, Decreta III, 'Dispacci di Costantinopoli', filza 4.
112. For example, the binding now in Chicago, Newberry Library, datable to 1570–77, reproduced in colour on the cover of Grube (1989).
113. V&A: 272–1893. For a col. plate see Stanley *et al.* (2004), pp.74–5.
114. Brown (2004), pp.19–20, 73, 224 n.60, p.271 and fig.22; Thornton (1991), p.269.
115. Brown (2004), p.20 and n.68, p.265.
116. Brown (2004), p.271 n.60.
117. As attested by the sixteenth-century *Il Libro del Sarto* in the Querini Stampalia Library in Venice, 944, CL VIII, Cod. I. See Mottola Molfino *et al.*, (1987). See also Saxl (1936).
118. Contadini (1999), p.11.

22. Prints

My first and greatest debts are to Marta Ajmar-Wollheim and Flora Dennis for inviting me to participate in this project, thereby giving me access to their own formidable expertise which they shared with great generosity, as well as to that of the other members of the Getty team.

This chapter was prepared during a secondment to the V&A Museum's Research Department in 2004. I should like to thank Christopher Breward for his suggestions and encouragement, and Corinna Gardiner for her practical support.

Colleagues at the AHRC Centre for the Study of the Domestic Interior commented on an early version of this chapter at a Home Debates session conducted at the Centre, where Inge Daniels directed me to some especially useful literature.

Tim Miller helped to clarify the flow and content at a crucial stage. Word & Image Department colleagues Margaret Timmers and Carlo Dumontet provided invaluable editorial and linguistic help respectively, while Kirstin Kennedy of the Museum's Medieval and Renaissance Galleries Project provided very timely input on a late draft.

1. Pasini (1936); *Xilografie italiane* (1987), pp.30–32.
2. Parshall and Schoch (2005).
3. Stroo and Syfer-d'Olne (1996), pp.37–50.
4. Turner (1998), p.14.
5. Saffrey (1984), p.4.
6. McDonald (2005) p.74.
7. Landau and Parshall (1994), p.49.
8. Matchette (2005).
9. Landau and Parshall (1994), p.91.
10. Martin (1993), p.144 and 157.

11. Duggan (1989), p.227 .
12. Honée (1994), p.157.
13. Honée (1994), p.159.
14. Goldthwaite (1993), p.114.
15. Geary (1986), Pinney (2001).
16. Antoniano (1584), p.54: 'Et quanto alle pitture de' Santi, che come si è cominciato a dire, è molto espediente haver nelle case proprie, chi non può havere di quelle fatte con colori, & con maggior artifitio, bastarà havere delle stampate, che ve ne sono di bellisime, & si hanno per piccolo prezzo; & è bene collocarle secondo la grandezza della casa, non confusamente, ma in certi luoghi principali, benche in alcuna parte della casa, come in qualche oratorietto, ò loggia, starà anchor bene haver molte imagini insieme, disposte con ordine, & consequenza delle cose; come per essempio, i quindici misterii del santo Rosario della Madonna, & simili. & si fatti luoghi sono come giardini spirituali, per ricreatione dell'anima.'
17. Sotheby Parke Bernet & Co., Ellesmere collection of drawings by the Caracci and other Bolognese Masters, Part I, London, 11 July 1972, lot 45.
18. Johnson (1997), p.7.
19. Wilmering (1999), pp.64–73.
20. Colle (*c.*1996), pp.130–31, no.154.
21. Wilmering (1999), p. 64
22. Wilmering (1999), p.74 and pl.2–18, and Schubring (1915), pp.384–5, no.731; Mallé (1972), p.55, fig.41.
23. Bury (1985), p.12.
24. Museo Bardini, Florence, inv. no.1509.
25. ASF, Dichiarazione agli ufficiali del catasto. Gonfalone Nicchio (f.315v), cited in Kristeller (1897), pp.ii–iii.
26. Sotheby & Co., London, 30 November 1970, F36; Alba (1991), p.58.
27. Louvre Museum, OA 3975.
28. Miller (2001), p.1.
29. Bury (2001), pp.152–3, no.103.
30. Battaglia (2000), XX p.1007.
31. Barocchi (1971–8), III, p.2926: 'E chi le adorna con carte impresse in rame et in legno, in Italia o altrove, e sopra tutto di quelle venute di Germania e massimamente di mano di Alberto Durreri, certo non che ecellentissimo, ma divino nel bollino, o di Luca suo discepolo, il quale va avicinandosi assai al suo gran maestro.'
32. Bury (1985), pp.19–20.
33. Popham (1971), pp.264–70.
34. Pope-Hennessy (1985), p.283.
35. Avery (1981), p.86: 'Uno Giudizio di Michelagniolo piccolo in carta con adornamento di albero'.
36. Bury (1985), p.14, n.23.

23. Everyday Objects

The research for this essay was supported by a grant from the Getty Foundation, which allowed me to visit collections in northern Italy. I am grateful to the following who showed me material and provided information: Gabriella Pantò, Soprintendenza per i Beni Archeologici del Piemonte; Lynn Passi Pitcher and Anna Ceresa Mori, Soprintendenza per i Beni Archeologici della Lombardia; Claudio Salsi, Civiche Raccolte d'Arte Applicata, Castello Sforzesco, Milan; Gian Piero Martino and Piera Melli, Soprintendenza per i Beni Archeologici della Liguria; Carlo Varaldo and Fabrizio Benente, University of Genoa; Rita Lavagna, Museo Archeologico al Priamár, Savona; Giovanni Murialdo and Paolo Palazzi, Museo Archeologico del Finale, Finalborgo; Maurizia De Min, Soprintendenza dei Beni Archeologici del Veneto; Laura Anglani, NAUSICAA, Venice; Francesca Saccardo, Galleria G. Franchetti alla Ca' d'Oro, Venice; Giuseppe Zeni Zigni, Castelnuovo Bariano; Tiziana Casagrande, Museo Civico, Feltre; Chiara Guarnieri, Soprintendenza dei Beni Archeologici dell'Emilia Romagna; Silvia Battestini, Museo Civico Medievale, Bologna; Sergio Nepoti, Bologna; Maria Teresa Gulinelli, Civici Musei d'Arte Antica, Ferrara; Mario Pagni, Soprintendenza dei Beni Archeologici per la Toscana; Marta Caroscio, University of Florence; Fausto Berti, Museo Archeologico e della Ceramica, Montelupo Fiorentino; Graziella Berti, Pisa.

1. On repair: Pandiani (1915), pp.309–10; on remaking: Lydecker (1987a), pp.300–1, 303, 309, 313.
2. For example, Venice: Palumbo Fossati (1984), p.140; Molmenti (1906), doc.B2.
3. Belgrano (1875), p.183, n.1; Davis (1991), p.100. For objects *in pignore*, or pawned: Pandiani (1915), docs 10, 12–13, 15; ASG 1–2, 4, 6, 8; Piattoli (1926), p.116; Cargneluti (1992).
4. Pandiani (1915), doc.10.
5. Cambruzzi (1873–4), pp.229–53.
6. Inventories relate to the following towns. Venice, 'bourgeois': Giovanni Venturini (1454), Molmenti (1905), doc.C9. Venice, noble: Agostino Badoer (1520), Molmenti (1906), doc.B1; Clara Marcello (1534), doc.B2; Lorenzo Correr (1584), doc.B4; Maria Pollani (1590), doc.B5.
Verona, noble: Gaspare Aleardi (1407), Cipolla (1882); Marco Gasparo (1578), Smith (1998).
Bologna: Zamboni, painter (1405), Frati (1900), pp.236–7; Nicolò di Zambeccari (1412), Frati (1900), pp.237–40.
Modena: Ferdinando Trotti, governor (1554), Pardi (1901). Florence: and villa in Val d'Elsa, Puccio di Antonio Pucci (1449), Merkel (1897); Francesco di

Baldino Inghirrami (1471), Musacchio (1999), appendix A; Francesco Angelo Gaddi (1496), Bologna (1883); Jacopo di Giannozzo Pandolfini (1503), Lydecker (1987a), appendix 3. Siena: Giovanni di Pietro Fecini (1450), Mazzi (1911); and Massa Marittima, Bartalo di Tura di Bandino (1483), Mazzi (1896–1900). Tuscan glassmakers: Lorenzo d'Orlando d'Antonio da Fiesole and Giovanni d'Orlando (1547); Bacio di Giusto Rustichelli (1598); Giuseppe di Giovanni Coscetti pisano (1602), Cantini Guidotti (1983).

7. Inventories published in Pandiani (1915): 1) Gerolamo de Ricobono (1451); 2) Tomaso Italiano (1451); 3) Eliana Salvaghi (1456); 4) Benedetto de Vivaldi (1456); 5) Luchina di Negro (1456); 6) Aimone Pinelli (1456); 7) Brigida Lomellini (1458); 8) Nicolò Antonio Spinola (1459); 9) Leonardo Busarini (1461); 10) Lazarino Vario, cooper (1462); 12) Battista Valle (1488); 13) Giacomo Ponzone (1488). Transcribed for Sandra Cavallo: 1) Domenico Troti, shoemaker (1453), ASG, Notai Antichi 661, doc.196; 2) Francesco di Uncio, reseller of textiles (1463), ASG, Not. Ant. 661, docs 668–9; 3) Everaldo di Egre, diamond master (1448), ASG, Not. Ant. 661, doc.473; 4) Giovanni Bianchi, spicer (1501), ASG, Not. Anti. 1402; 5) Giovanni Battista di Franchi di Oneto – including his tools (1572), ASG, Not. Ant. 2327, doc.231; 6) Giovanni Antonio di Chiavari, shoemaker (1549), ASG, Not. Ant. 2430; 7) Nicolò di Borgosesia, silk textiles (1548), ASG, Not. Ant. 2430; 8) Giovanni Battista Granarie, linen (1566), ASG, Not. Ant. 2437; 9) Giovanni di Portofino, fisherman (1498), ASG, Not. Ant. 1436, doc.112; 10) Giovanni di Milano, painter (1419), ASG, Not. Ant. 467, doc.237; 11) Giovanni di Rusasco, baker (1411), ASG, Not. Ant. 487; 12) Antonio di Pavia, baker (1417), ASG, Not. Ant. 544; 13) Simone di Bargagli, cheesemaker (1413), ASG, Not. Ant. 496; 14) Giovanni Rici, wool (1413), ASG, Not. Ant. 544; 15) Giovanni di Cogorno, tailor (1412), ASG, Not. Ant. 564; 16) Francesco Cavalleri, silk (1566), ASG, Not. Ant. 2437; 17) Vincenzo Ravasco, sheet-metal worker (1566), ASG, Not. Ant. 2437; 18) Giovanni Agostino Marchi, silk (1583), ASG, Not. Ant. 2445. These transcribed inventories are referred to by the list number above, i.e. ASG 1, etc. For socio-cultural distinctions, cf. Ciardi Duprè et al. (1977), pp.268–71.

8. 1451: Pandiani (1915), doc.1. 1453: ASG 1. For convenience, I assume that a ducat and florin were each equal to a lira.

9. On the second-hand market in Venice: Allerston (1998), pp.35–7; (2000), pp.375–9.

10. ASG 9. I have added the materials from which these are likely to have been made, cf. ASG 10.

11. De la Roncière (1988), p.198.

12. Pandiani (1915), doc.12 ASG 3: 'garete parve, gare mezzane' (small and medium jars); Pandiani (1915), docs 7, 13: 'Burnea terre di Malica' (Malaga earthenware jar).

13. Francovich and Vannini (1976); Conti (1980), pp.217–21; Berti and Butti (2002), pp.10, 22–5; Bianchi (1988), nos 35–6.

14. Scappi (1570), p.13; Pisanelli (1586), pp.126–7; Mileham (1998), pp.351, 363, 373, 375.

15. Cipolla (1882), p.50.

16. Cf. Pandiani (1915), doc.12: inventoried bronze, 'lebete rotondo' (round cooking pot); and Pandiani (1915) doc.4; Molmenti (1906), doc.B1: stone 'lebetes petre' or 'lavezi de piera'.

17. ASG 11; Pandiani (1915), doc.7: 'petiati' (repaired).

18. Gelichi (1987), pp.202–3, pls 3–4; Palazzi et al. (2003), pp.209, 226, figs 57.58, 58.

19. Mannoni (1970), pp.309, pls 6B, 7D; Gelichi and Librenti (1994), p.17.

20. Nepoti Frescura (1976), pp.131, 134–5, n.6; Varaldo (2001), pp.312–13; Thornton (1991), pls 84, 165, 283; Scappi (1570), pl.[12]; Kristeller (1897), woodcut 176; Gelichi and Librenti (1994), fig.6; Museo Archeologico Nazionale store, Ferrara.

21. Molmenti (1906), docs B4: 'scalda vivande de laton', and B5; Smith (1998), p.390; Bologna (1883), p.28; Pardi (1901), p.44; Spallanzani and Gaeta Bertelà (1992), p.198; Cantini Guidotti (1983), p.131.

22. Scappi (1570), pl.[17].

23. ASG 3: 'catena ferri pro cochina' (iron kitchen chain); ASG 9: 'lebetem cum catena' (cookpot with chain). Mileham (1998), p.371: 'testum bene unctum' (well-greased pan). Scappi (1570), p.12, pls.[5–7, 14–16]: 'trepiedi' (tripod stands); also Nigro (1996), pl.9.

24. Musacchio (1999), pp.167, 170; Scappi (1570), pp.4, 13–14, pls.[7, 9, 14].

25. Bologna (1883), p.28; Cantini Guidotti (1983), p.12; Musacchio (1999), pp.167–8, 171; Bertoni and Vicini (1907), p.134, no.2483; Semino (1998), pl.1.25–6.

26. Images: Kristeller (1897), woodcuts 48, 65, 69; Scappi (1570), pls. [7–9]; Hughes (1997), p.39; Thornton (1991), pl.239. Pandiani (1915), doc.14: 'testum ferri pro tortis' (iron griddle for pies).

27. See Tegamini in Martino and Bracco (1999), pp.225–6, pl.1f.

28. Pandiani (1915), docs 1, 4–5, 12; ASG 3; Cantini Guidotti (1983), p.131.

Copper ladles: Pandiani (1915), docs 3, 5, 10–13; iron: Pandiani (1915), docs 6–7, 12; wood: Cipolla (1882), p.52; perforated: ASG 7–8; D'Addario (1966), p.67; Cantini Guidotti (1983), p.121; Musacchio (1999), pp.168, 171. Images: Kristeller (1897), woodcut 69; Scappi (1570), pl.[16].

29. Mazzi (1900), p.304: 'mescola di legno da macheroni' (wood ladle for pasta).

30. Thornton (1991), pls 312, 316; Faccioli (1966), 1, p.293; Kristeller (1897), woodcuts 69, 176.

31. ASG 10: 'conchas tres ligni, conchetam unam terre parvam' (three wood basins, one small earthenware basin).

32. Bianchi (1988), no.37; Berti (1999), pp.222, 439, pl.406; Berti and Buti (2002), p.12.

33. These can also be found at Modena: Pardi (1901), p.44. Cipolla (1882), pp.50–51. ASG 3: 'siculla cum sua cucia' (bucket with its ladle).

34. ASG 10. De Floriani et al. (1978), pp.120–3, figs 5–7.

35. Schiaparelli (1908), p.80, n.3: 'paio di unzini da ripigliare sechie' (pair of hooks to retrieve buckets); Hughes (1997), p.36.

36. Molmenti (1906), p.631; Musacchio (1999), p.171; Cora (1973), pp.162, 403: 'mezine chol manico di sopra' (basket-handled jars); Cora and Fanfani (1987), p.146; Bianchi (1988), nos 33–4; De Marinis (1997), nos 57–8; Berti (1999), pp.222–3, 440, pl.404. For images of use, see Morachiello (1995), p.27; Kristeller (1897), woodcut 165.

37. Pandiani (1915), doc. 2: 'bacille cum sua stagnaria latoni' (brass basin with its jug), and docs 6, 8–10, 12; ASG 4; ASG 3: 'stagnonum rami pro aqua' (copper water jug).

38. Mazzi (1898), p.275; Thornton (1991), pls 21, 104, 122.

39. For example, Piattoli (1926), p.117: 'bacino da dare l'acqua a le mani di terra fatto di Maiolica' (Spanish earthenware basin for giving water to the hands); Sebregondi (1994), p.58.

40. Boccaccio, Decameron, IX, introduction; X.9; Faccioli (1966), I, p.109; Sacchetti (1984), Novelle (Stories) 51, 98; end of meal: Sacchetti (1984) Novelle 183, 187; Giulini (1912), p.174; Bembo (1525), bk III, ch.79; Messisbugo (1992), p.58; Montaigne (1946), p.99.

41. Della Casa (1906), pp.64–5.

42. Messisbugo (1992), pp.32, 51, 56, 58, 61; Faccioli (1966), I, pp.272, 359; Gandini (1889), p.6; Ciardi Duprè et al. (1977), p.282; Benporat (2001), p.174. Acanfora (1985), pp.54–7.

43. Thornton (1991), pl.170; Benporat (1996), p.3.

44. Zastrow (1981); Ciardi Duprè et al.

(1977), p.281, n.2; Theuerkauff-Liederwald (1988), pp.16–18.

45. V&A: M.337–1924.

46. Thornton (1991), pl.22; Schottmüller (1928), pl.5.

47. Spallanzani and Gaeta Bertelà (1992), p.123; Nigro (1996), p.385.

48. Theuerkauff-Liederwald (1988), nos 321, 326.

49. Scappi (1570), pl.[24]; Musacchio (1999), p.162: 'misciroba a boccha aperte grande d'ottone' (big brass jug with an open mouth).

50. See the example with handle found in Como, Nepoti (1984), p.125, fig.11; also Ericani (1986), no.182.

51. Two orciuoli di rame (small copper jugs) listed with copper secchie da aquaio (water basin buckets), Merkel (1897), p.189.

52. Hughes (1997), pp. 55, 60–61; Thornton (1991), pl.371. For an example in front of a credenza: Sebregondi (1994), pl.16.

53. Mazzi (1897), p.362: 'bacino grande d'oton col piedistallo ne la sala dei priori ove si lavano i mani' (large brass basin with pedestal in the Priors' hall in which they wash their hands).

54. Callmann (1974), pls 163, 201.

55. Schiaparelli (1908), p.80: 'catini da lavar scodelle'.

56. Schottmüller (1928), pl.4; V&A: 5804–1859, Benporat (1996), pl.2; Benporat (2001), pl.10.

57. Kristeller (1897), woodcuts 69, 165; Torriti (1980), p.226.

58. Musacchio (1999), pp.158, 171; Merkel (1897), p.197; Bologna (1883), p.28; Spallanzani and Gaeta Bertelà (1992), p.71, 'per uso di sechio dall'acquaio' (to use as an acquaio pail), and pp.113, 123, 134, 140–1; Mazzi (1898), p.87.

59. Molmenti (1905), doc.C9; Molmenti (1906), docs B2, B4, B5; Palumbo Fossati (1984), p.125. On this object, see Molmenti (1906), p.475.

60. Cf. the pail held by the Samaritan woman in the early fourteenth-century painting by Duccio in the Thyssen-Bornemisza Museum, Madrid, and North European engraved bowls for hand washing, Müller (1997), fig.2.

61. Pandiani (1915), docs 1, 5–6, 8–9, 13; ASG 1–2, 8, 15–16. Cf. Florence: Ciardi Duprè et al. (1977), pp.268–71.

62. Della Casa (1906), pp.64–5.

63. Pandiani (1915), doc.1: 'bacile a balneo cum stagnaria' (bath basin with jug).

64. Thornton (1991), pls 100, 116, 124, 173, 179, 218, 250, 275, 284; Musacchio (1999), figs 9, 112.

65. Schottmüller (1928), pls 41, 49; De la Roncière (1988), p.213. Spallanzani and Gaeta Bertelà (1992), p.107: 'bacini da lavare i piè' (basins for washing the feet);

Merkel (1897), p.194.

66. Pandiani (1915), doc. 10: 'bacile pro barbitonsore' (basin for hair cutting) or 'bacino da barbiere' (barber's basin); Molmenti (1906), doc.B2; Bologna (1883), p.28; Mazzi (1897), p.347; Pandiani (1915), docs 5,7; Spallanzani and Gaeta Bertelà (1992), pp.80, 150.

67. Verga (1931), p.263.

68. Spallanzani and Gaeta Bertelà (1992), p.10; Cantini Guidotti (1983), p.119: 'astuzio da rasoi con più rasoi e priete e pettine e altre zachere' (razor case with razors and stone and comb and other knick-knacks).

69. Pandiani (1915), docs 9, 13; Molmenti (1905), doc.C8; Merkel (1893), pp.102, 124. Molmenti (1905), doc.C9: 'pectenis de avolio et operatus et depictus auro' (worked and gold-painted ivory comb); V&A: 158–1879.

70. Bandini (1999), p.94, fig.6.22–3; Bonatti (1985), no.62.46; Visser Travagli (1995), p.102; De Marinis (1997), nos 109–10.

71. Santore (1997), figs 10, 12, for combs on the table: figs 2–3, 8; Thornton (1991), pl.192.

72. Musacchio (1999), p.162: 'pettine d'avorio dipinto' in the 'schrittoio'; Biagi (1899), p.16; Giulini (1912), p.194; Merkel (1893), pp.102, 124.

73. Musacchio (1999), p.168: 'stuzichatoio d'ariento da orecchi' (silver ear stick); Verrone castle (prov. Biella), 2001, stratigraphical unit 26; S. Antonio in Polesine convent, Ferrara.

74. Coryat (1905), pp.410–12; Moryson (1907–8), p.102; Hughes (1903), p.425; Bonatti (1985), nos 61.43–61.46, 61.62; Visser Travagli (1989), no.43; Gelichi (1992), pp.204–5; Berti (1995), no.241; Guarnieri (1998), p.219, fig.16; Bianchi (1988), no.87; Bandini (1999), p.91, fig.6.25; Guarnieri (n.d.), p.13, figs 15–19.

75. Thornton (1991), pls 249, 271; Santore (1997), figs 1–3, 8, 12–13; Verga (1900), p.54.

76. Bandello (1952), *Novella* IV.24.

77. Pandiani (1915), docs 5, 7, 12. ASG 12: 'cantaretus', often 'parvus' (small). Also Pandiani (1915), doc.13, ASG 5, 8, 12. Molmenti (1906), doc.B5: ten 'secchi a soza, et otto da acqua schietti'.

78. Gardini and Benente (1994), p.53; Martino and Bracco (1999), pp.224–5.

79. Thornton (1991), pl.112; Scappi (1570), pl.[23]: 'sedietta' and 'orinale'; Spallanzani (1996), p.9: 'orinale colla vesta' ('dressed' urinal) recorded in the *agiamento* (lavatory) of Giovanni di Bicci de Medici's *camera*.

80. Vecellio (1664), pp.144–5; Merkel (1893), p.138; ASG 1, 3–4, 6–7, 15; Pandiani (1915), docs 7, 9.

81. For needles: Varaldo (2001), nos 1570–1, 'agoiairoli' (needle cases). For

pins: Andrews and Pringle (1977), pp.194–5, nos 39–41; Museo Archeologico Nazionale, Ferrara, inv.68372, 67824; Venetian lagoon, Galleria Franchetti alla Ca' D'Oro, Venice, inv.64; Ericani (1986), no.187; Gelichi (1987b), pl.21.6; Pantò (1996), p.270, fig.201.7.

82. Biagi (1899), p.16.

83. Biagi (1899), p.16: 'anello da qucire' (ring for sewing); Musacchio (1999), p.165. ASG 5. Andrews and Pringle (1977), pp.194–5, nos 36–8; Ceresa Mori (1997), scheda 15. For ring thimbles: Brignano Frascata, inv. 62665; for dome thimbles: via Manzoni, Vercelli, inv. 62606, in Soprintendenza dei Beni Archeologici museum store, Turin. Museo Archeologico al Priamàr, Savona, and Varaldo (2001), nos 1566–7; Venetian lagoon, Galleria Franchetti alla Ca' D'Oro, Venice, inv. 69–73. For thimbles made from a folded sheet (rather than cast): Rocca Ricciarda, University of Florence History Department store; Ericani (1986), nos 184–5; Pantò (1996), p.270, fig.201.8.

84. Bonatti (1985), no.61.53; Museo Archeologico del Finale, Finale Ligure.

85. Musacchio (1999), p.165: 'sachetto di fusaiuoli di vetro' (bag of glass spindle whorls); Varaldo (2001), pp.460–6. For spindles: Bonatti (1985), nos 61.65–6; Bandini (1999), p.94; also Gelichi (1987b), pl.22.1–3.

86. In kitchens – Pandiani (1915), doc.10: 'tanonum rami' (copper brazier); Cantini Guidotti (1983), p.137: 'caldano da camera di rame con li manichi' (copper chamber brazier with handles). Pandiani (1915), doc.12: 'scadaleto' (bed warmer); Molmenti (1906), doc.B4; Mazzi (1911), p.168; Bologna (1883), p.28. ASG 4: ten 'candelarii bronzi' (bronze candlesticks); ASG 10: two 'lucernas' (lamps), three 'candelabros ligni' (wood candlesticks); Pandiani (1915), doc.5: 'luxerna'; Merkel (1897), p.189: ten 'lucerne'; Mazzi (1911), p.167: five 'lucerne'.

87. For brass: Pandiani (1915), docs 3, 5, 7, 10, 12; ASG 3, 5–6, 16–17. For bronze: Pandiani (1915), docs 1, 4, 10–11; ASG 4. Iron – ASG 10: 'candelabrum ferri in muro' (in wall). For wood – ASG 10: 'candelabros ligni tres'. Cipolla (1882), p.46: five iron and three wood 'candelabra'; Pardi (1901), p.44: 11 brass and one tin 'candelieri'. For damascened metal: Pandiani (1915), doc.4; Pandiani (1915), doc.6: 'candelabri damasche cum argento' (damascene candlesticks [inlaid] in silver).

88. Thornton (1991), pls 40, 56, 116, 153, 262; Thornton (1997), fig.109; Brown (2004), frontispiece, fig.87; fresco of *credenza*, Altemps Palace, Rome.

89. ASG 12; Piattoli (1926), p.113.

90. Thornton (1997), fig.29. Mazzi (1898), pp.274–5; Mazzi (1900), p.300; Cantini Guidotti (1983), p.139; Musacchio (1999), pp.160, 163, 173. For brass: Cantini Guidotti (1983), pp.121, 123, 137–9; Lydecker (1987a), p.278; Musacchio (1999), p.162; Spallanzani (1976), p.138; Spallanzani and Gaeta Bertelà (1992), pp.123, 157. For iron: Cantini Guidotti (1983), pp.118, 122; Mazzi (1898), p.277. For glass: Spallanzani (1976), p.138.

91. Scappi (1570), pls [1–2]; Thornton (1991), pls 23, 29, 262, 294, 300.

92. Rocca Ricciarda excavation material in the University of Florence History Department store.

93. Bianchi (1988), nos 41, 129–131; De Marinis (1997), nos 65, 151–3.

94. Basin, Baldoni (1999), no.160.

24. Textiles and clothing

1. ASF, Venturi Ginori Lisci 342, 3r and 3v: 'tre pezzi di velluti falsi fra d'oro e turchini', 'ventiquattro braccia di lana azzurra e braccia 13 d'accia azzurra per fare una tela per un padiglione'.

2. Ago (1997), p.666.

3. Fennell Mazzaoui (1981), pp.89–90.

4. ASF, Capponi 147, f.39v.

5. ASF, Orsini XVII, Amministrazione Patrimoniale, loose booklet marked 'Libretto di diversi conti della Signora Virginia Orsini' dating from 1569 to 1572: 'per filatura di rese alla moglie del giardiniere', 'al tessitore per fare una tela stretta', 'per filatura di pelo di lino', 'per cucire le camicie del Signore Alessandro', 'per panno per le culle'.

6. Mira (1940), p. 135.

7. Tagliaferro (1995), p.73.

8. Strozzi (1877), pp.308 and 387: 'quattro grandi per tenere al cappellinaio, e due piccoli per le spalle quando vi pettinate'.

9. Santangelo (1959), pp.13, 28–9, and Boccherini (1999), pp.35 and 44.

10. ASF, Panciatichi (Dono 1) 193, 28, Donora della Cassandra Covoni moglie di Pietro Guicciardini.

11. Tagliaferro (1995), p.76.

12. Bistort (1969), p.354.

13. Bologna (1883), p.22.

14. Bologna (1883), p.22.

15. Wearden (2003), p.618.

16. Mira (1940), pp.214–15.

17. ASF, Mediceo del Principato 1171, Ins. III, f.106r: 'perché si muoiano di freddo, non avendo indosso altro che ermisino'.

18. Ibid., f.147r.

19. Ricci (1972), p.49, ff.321v–322r: 'Messer Domenico commise che fosse introdotto, e gittatosi adosso una zimarra restò in sul letto come era'. Although the textile is unspecified, given the rank of the visitor this particular garment was

probably made of silk.

20. On the reciprocal influences between Eastern and Western dress fashions during this period see *L'abito per il corpo* (1998).

21. This became even more pronounced during the course of the following century. See Ago (2003), pp.144–5, on the number of garments *da camera* and *da casa* listed in Roman inventories from 1700 onwards.

22. Morselli (1956), p.21.

23. Bellezza (1983), pp.65–7.

24. Cataldi Gallo (2000), p.32.

25. Catalogue entries in Buss (1983) pp.101, 118–19.

26. ASM, Notarile 14356: 'l'altra [sottana] turchina con oro si è disfatta per bisogno di mia casa'.

27. This change was referred to as early as 1546 in a report by the Venetian ambassador, Marino Cavalli; see Molà (2000), p.96. See also Orsi Landini (1999), pp.17–22.

28. Archivio di Stato, Milan, Litta Modignani, Titolo V – Doti attive, Cartella n. 1, Gruppo 5: 'una robba d'ormisino verde, guarnita di lavoro d'oro da portare per casa nuova'.

29. ASF, Venturi Ginori Lisci 342, f.2r: 'una casacca da parto di domasco scarnatino con nastri d'argento'.

BIBLIOGRAPHY

Acanfora, E., 'La tavola', in Bertelli and Crifò, eds, *Rituale, cerimoniale, etichetta* (Milan, 1985), pp.53–66

Acidini Luchinat, C., 'Niccolò Gaddi collezionista e dilettante del cinquecento', *Paragone*, XXXI (1980), pp.141–75

Acidini Luchinat, C., ed., *Treasures of Florence: The Medici Collection 1400–1700* (Munich and New York, 1997)

Achillini, Giovanni Filoteo, *Epistole … al magnificentissimo Missere Antonio Rudolpho Germani* ([Bologna], *c.*1510)

Adami, Antonio, *Il novitiato del maestro di casa* (Rome, 1657)

Agee, R., 'Ruberto Strozzi and the Early Madrigal', *Journal of the American Society of Musicology*, XXXVI (1983), pp.1–17

Agee, R., 'Filippo Strozzi and the Early Madrigal', *Journal of the American Society of Musicology*, XXXVIII (1985), pp.227–37

Ago, R., 'Gerarchia delle merci e meccanismi dello scambio a Roma nel primo seicento', *Quaderni storici*, XCVI (1997), pp.663–84

Ago, R., 'Il linguaggio del corpo', in Belfanti and Giusberti, eds, *La moda, Storia d'Italia*, XIX (Turin, 2003), pp.117–47

Ahl, D. C., 'Renaissance Birth Salvers and the Richmond Judgement of Solomon', *Studies in Iconography*, VII (1981), pp.157–74

Aikema, B., 'The Lure of the North: Netherlandish Art in Venetian Collections', in Aikema and Brown, eds, *Renaissance Venice and the North: Crosscurrents in the Time of Bellini, Dürer and Titian* (Milan, 1999), pp.83–91

Aikema, B., *De Heilige Hieronymus in het Studeervertrek of: Hoe Vlaams is Antonello da Messina* (Nijmegen, 2000)

Aikema, B. and Brown, B., eds, *Renaissance Venice and the North: Crosscurrents in the Time of Bellini, Dürer and Titian* (Milan, 1999)

Ainsworth, M. W., *Petrus Christus: Renaissance Master of Bruges* (New York, 1994)

Ainsworth, M. W. and Christiansen, K., eds, *From Van Eyck to Bruegel: Early Netherlandish Painting in The Metropolitan Museum of Art* (New York, 1998)

Ait, I. and Vaquero Piñeiro, M., *Dai casali alla fabbrica di San Pietro. I Leni: uomini d'affari del Rinascimento* (Rome, 2000)

Ajmar, M., 'Women as Exemplars of Domestic Virtue in the Literary and Material Culture of the Italian Renaissance' (unpub. Ph.D. diss., The Warburg Institute, University of London, 2004)

Ajmar, M. and Thornton, D., 'When is a Portrait not a Portrait? *Belle donne* on Maiolica and the Renaissance Praise of Local Beauties', in Mann and Syson, eds, *The Image of the Individual: Portraits in the Renaissance* (London, 1998), pp.138–53

Alba, A. S., *A Vitoria, Barajas* (Vitoria-Gasteiz, 1991)

Alberici, C., 'Sono milanesi del secolo XV i coltelli da mensa con i manici in argento niellato e provenienti dalla Collezione Trivulzio', *Rassegna di studi e notizie*, VI (1978), pp.91–131

Alberici, C., *Il mobile veneto* (Milan, 1980)

Alberti, Leon Battista, *I libri della famiglia*, ed. C. Grayson (Bari, 1960); ed. Tenenti and Romano (Turin 1969; repr. 1980), ed. F. Furlan (Turin, 1994)

Alberti, Leon Battista, *The Family in Renaissance Florence. A Translation of I libri della famiglia by Leon Battista Alberti*, trans. R. Neu Watkins (Columbia, 1969)

Alberti, Leon Battista, *On the Art of Building in Ten Books*, trans. J. Rykwert et al. (Cambridge, 1988)

Alexander, J. J. G., ed., *The Painted Page. Italian Renaissance Book Illumination 1450–1550* (Munich and New York, 1994)

Alexander, J. J. G. and De la Mare, A. C., eds, *The Italian Manuscripts in the Library of Major J. R. Abbey* (London, 1969)

Alexandre-Bidon, D., 'La dent et le corail, ou la parure prophylactique de l'enfance à la fin du Moyen Age', *Razo*, VII (1987), pp.5–33

All the Paintings of the Rijksmuseum in Amsterdam: A Completely Illustrated Catalogue (Amsterdam, 1976)

Allan, J. W., *Metalwork of the Islamic World: The Aron Collection* (London, 1986)

Allan, J. W., 'Venetian-Saracenic Metalwork: The Problems of Provenance', in Grube, Carboni and Curatola, eds, *Arte veneziana e arte islamica. Atti del primo simposio internazionale sull'arte veneziana e l'arte islamica* (Venice, 1989), pp.167–83

Allan, J. W., 'Metalwork of the Turcoman Dynasties of Eastern Anatolia and Iran', *Iran*, XXIX (1991), pp.153–9

Allerston, P., 'Wedding Finery in Sixteenth-Century Venice', in Dean and Lowe, eds, *Marriage in Italy, 1300–1650* (Cambridge, 1998), pp.25–40

Allerston, P., 'Clothing and Early Modern Venetian Society', *Continuity and Change*, XV (2000), pp.367–90

Altieri Biagi, M. L. et al., eds, *Medicina per le donne nel cinquecento. Testi di Giovanni Marinello e di Girolamo Mercurio* (Turin, 1992)

Altieri, Marco Antonio, *Li nuptiali*, ed. E. Narducci (Rome, 1995)

Ames-Lewis, F., 'Fra Filippo Lippi and Flanders', *Zeitschrift für Kunstgeschichte*, XLII (1979), pp.255–73

Ames-Lewis, F., 'Early Medicean Devices', *Journal of the Warburg and Courtauld Institutes*, XLII (1979), pp.122–43

Ames-Lewis, F., *The Library and Manuscripts of Piero di Cosimo de' Medici* (New York and London, 1984)

Ames-Lewis, F., 'On Domenico Ghirlandaio's responsiveness to North European Art', *Gazette des beaux-arts*, CXIV (1989), pp.111–22

Ames-Lewis, F., 'Art in the Service of the Family. The Taste and Patronage of Piero de Cosimo de' Medici', in Beyer and Boucher, eds, *Piero de' Medici 'il Gottoso' (1416–1469). The Taste and Patronage of Piero di Cosimo de' Medici* (Berlin, 1993), pp.207–20

Ames-Lewis, F., 'Fra Angelico, Fra Filippo Lippi and the Early Medici', in F. Ames-Lewis, ed., *The Early Medici and their Artists* (London, 1995), pp.107–24

Amonaci, A. M. and Baldinotti, A., 'La "chamera grande terrena" di Lorenzo in Palazzo Medici: ipotesi di ricostruzione', in Morolli, Acidini Luchinat and Marchetti Gordon, eds, *L'architettura di Lorenzo il Magnifico* (Florence, 1992), pp.126–8

Andreatta, E. and Quinterio, F., 'La Loggia dei Servi in piazza SS. Annunziata a Firenze', *Rivista d'arte*, XL (1988), pp.169–331

Andrews Reath, N., 'Velvets of the Renaissance, from Europe and Asia Minor', *Burlington Magazine*, L (1927), pp.298–304

Andrews, A. and Pringle, D., 'Lo scavo dell'area sud del convento di San Silvestro a Genova (1971–1976)', *Archeologia medievale*, IV (1977), pp.47–212

Anselmi, G. M. et al., *La 'memoria' dei mercatores. Tendenze ideologiche, ricordanze, artigianato in versi nella Firenze del quattrocento* (Bologna, 1980)

Antoniano, Silvio, *Tre libri dell'educatione christiana dei figliuoli* (Verona, 1584; repr. Milan, 1821), ed. L. Pogliani (Turin, 1926)

Antoninus, Saint, *Summa theologica*, 4 vols (Graz, 1959)

Apfelstadt, E. C., 'The Later Sculpture of Antonio Rossellino' (unpub. Ph.D. diss., Princeton University, 1987)

Aquino, L., 'La camera di Lodovico De Nobili opera di Francesco del Tasso e qualche precisazione sulla cornice del Tondo Doni', *Paragone*, LVIIII (2005), pp.86–111

Arasse, D., *L'Annonciation Italienne. Une histoire de perspective* (Paris, 1999)

Arbace, L., *Antonello da Messina: catalogo completo dei dipinti* (Florence, 1993)

Arcangeli, A., *Davide o Salomè?: il dibattito europeo sulla danza nella prima età moderna* (Treviso, 2000)

Aretino, Pietro, *Il filosofo* (Venice, 1546)

Aretino, Pietro, *The Ragionamenti or Dialogues of the Divine Pietro Aretino Literally Translated into English*, trans. I. Liseux (Paris, 1889)

Aretino, Pietro, *Sei giornate*, ed. G. Aquilecchia (Bari, 1975)

Ariès, P., *Centuries of Childhood: A Social History of Family Life*, trans. R. Baldick (New York, 1962)

Arnold, J., *Patterns of Fashion: The Cut and Construction of Clothes for Men and Women, c.1560–1620* (London, 1985)

Aromatico, A. and Peruzzi, M., eds, *Medicamenti, pozioni e incantesimi del ricettario magico urbinate* (Fano, 1997)

Arslan, E., *I Bassano*, 2 vols (Milan, 1960)

Art Treasures and Antiquities from the Famous Davanzati Palace (New York, 1916)

Arti del Medio Evo e del Rinascimento – Omaggio ai Carrand 1889–1989 (Florence, 1989)

Arts de l'Islam dès origines à 1700 dans les collections publiques françaises (Paris, 1971)

Assandri, Giovan Battista, *Della economica ovvero disciplina domestica, libri quattro* (Cremona, 1616)

Astell, A. W., *The Song of Songs in the Middle Ages* (Ithaca and London, 1990)

Atasoy, N. et al., *Ipek – The Crescent and the Rose: Imperial Ottoman Silks and Velvets* (London, 2001)

Atil, E., *Renaissance of Islam – Art of the Mamluks* (Washington D.C., 1981)

Attardi, L., *Il camino veneto del cinquecento. Struttura architettonica e decorazione scultorea* (Venice, 2002)

Attwood, P., *Italian Medals c.1530–1600 in British Public Collections* (London, 2003)

Auld, S., 'Master Mahmud: Objects Fit for a Prince', in Grube, Carboni and Curatola, eds, *Arte veneziana e arte islamica. Atti del primo simposio internazionale sull'arte veneziana e l'arte islamica* (Venice, 1989), pp. 185–201

Auld, S., *Renaissance Venice, Islam and*

Mahmud the Kurd: A Metalworking Enigma (London, 2004)

Averlino, Antonio, see Filarete

Avery, C., *Florentine Renaissance Sculpture* (New York, 1970)

Avery, C., *L'opera completa del Cellini* (Milan, 1981)

Avery, C., *Donatello* (Florence, 1991)

Avery, C., *Donatello: An Introduction* (New York, 1994)

Avery, C. and Radcliffe, A., 'Severo Calzetta da Ravenna: New Discoveries', in J. Rasmussen, ed., *Studien zum europäischen Kunsthandwerk. Festschrift Yvonne Hackenbroch* (Munich, 1983), pp.107–122

Avery, V. J., 'The House of Alessandro Vittoria Reconstructed', *The Sculpture Journal*, V (2001), pp.7–32

Avery, V. J., 'State and Private Bronze Foundries in Cinquecento Venice: New Light on the Alberghetti and di Conti Workshops', in P. Motture, ed., *Large Bronzes in the Renaissance* (Washington, 2003), pp.241–75

Azzaiolo, Filippo, *Il primo libro de villotte del fiore alla padoana* (Venice, 1557)

Bacci, M., *Piero di Cosimo* (Milan, 1966)

Bacci, M., *L'opera completa di Piero di Cosimo* (Milan,1976)

Bacci, O., 'Un trattatello mnemonico di Michel del Giogante', in O. Bacci, *Prosa e prosatori. Scritti storici e teorici* (Milan, Palermo and Naples, 1907), pp.99–138

Bagnoli, A., Bartalini, R. and Maccherini, M., eds, *Domenico Beccafumi e il suo tempo* (Siena, 1990)

Baker, M., 'Giambologna, Donatello and the Sale of the Gaddi, Marucelli and Stosch bronzes', *Städel Jahrbuch*, XII (1989), pp.179–94

Baker, M. and Richardson, B., eds, *A Grand Design: The Art of the Victoria and Albert Museum* (London and New York, 1997)

Baker, P.L., *Islamic Textiles* (London, 1995)

Baker, C. and Henry, T., *The National Gallery Complete Illustrated Catalogue* (London, 1995)

Baker, T. and Wearden, J., *Silks for the Sultans* (Istanbul, 1996)

Baker, T., Wearden, J. and French, A., 'Momento Mori – Ottoman Children's Kaftans in the Victoria and Albert Museum', *Hali*, XII/3 (1990), pp.130–40 and 151–2

Balboni Brizza, M. T., ed., *Stipi e cassoni* (Turin, 1995)

Baldacci, C., *La danza a Genova tra cinque e seicento* (Genova, 2004)

Baldoni, D., ed., *Scavi archeologici a Cesena: storia di un quartiere urbano* (Ravenna, 1999)

Baldwin, R., 'A Window from the Song of Songs in Conjugal Portraits by Fra Filippo Lippi and Batholomaeus Zeitblom', *Source*, V/2 (1985–86), pp.7–14

Baldwin, R., '"Gates Pure and Shining and Serene": Mutual Gazing as an Amatory Motif in Western Literature and Art', *Renaissance and Reformation*, X/1 (1986), pp.23–48

Ballarin, A., *Jacopo Bassano*, 2 vols (Cittadella, 1995)

Bandello, Matteo, *Tutte le opere di Matteo Bandello*, ed. F. Flora (Milan, 1952)

Bandello, Matteo, *La prima parte de le novelle*, ed. D. Maestri (Alessandria, 1992)

Bandello, Matteo, *La seconda parte de le novelle*, ed. D. Maestri (Alessandria, 1993)

Bandera, L., *Il mobile emiliano* (Milan, 1972)

Bandini, F., 'Considerazioni preliminari su un complesso di manufatti lignei recuperati negli scavi di Genova–Porto Antico (XVII–XVIII sec.)', *Archeologia postmedievale*, III (1999), pp.87–97

Bandini, G., '"Delle impagliate" ossia annotazioni intorno alle maioliche da puerpera cinquecentesche', in Bandini and Piccolo Paci, eds, *Da donna a madre. Vesti e ceramiche particolari per ornamenti speciali* (Florence, 1996), pp. 55–109

Baratta, M., *Curiosità vinciane* (Turin, 1905)

Barb, A. A., 'Birds and Medical Magic', *Journal of the Warburg and Courtauld Institutes*, XIII (1950), pp.316–318

Bargagli, Girolamo, *Dialogo de' giuochi che nelle vegghie sanesi si usano di fare*, ed. P. D'Incalci Ermini (Siena, 1982)

Bargagli, Girolamo, 'Discorso intorno al fare et al ricevere le visite che occorrono infra le private persone', Biblioteca degli Intronati, Siena, MS P.IV.27, no.4

Bargagli, Scipione, *I trattenimenti* (Venice, 1587)

Barnes, J., 'The Specious Uniformity of Italian Harpsichords', in E. M. Ripin, ed., *Keyboard Instruments; Studies in Keyboard Organology, 1500–1800* (Edinburgh, 1971; repr. New York, 1977), pp.1–10

Barocchi, P., ed., *Scritti d'arte del cinquecento*, 3 vols, (Milan and Naples, 1971–78)

Barocchi, P., ed., *Il giardino di San Marco* (Florence, 1992)

Barocchi, P. and Gaeta Bertelà, G., eds, 'La Fortuna di Donatello nel Museo Nazionale del Bargello', in P. Barocchi *et al.*, eds, *Omaggio a Donatello 1386–1986: Donatello e la storia del museo* (Florence, 1985), pp.77–121

Barovier Mentasti, R., *Il vetro veneziano* (Milan, 1982)

Barovier Mentasti, R., ed., *Mille anni di arte del vetro a Venezia* (Venice, 1982)

Barriault, A. B., *Spalliera Paintings of Renaissance Tuscany: Fables of Poets for Patrician Homes* (University Park, Penn., 1994)

Bartrum, G., *Albrecht Dürer and his Legacy* (London, 2002)

Bartsch, A. von, *Le peintre-graveur*, 21 vols (Vienna, 1803–21)

Baskins, C., *Cassone Painting, Humanism and Gender in Early Modern Italy* (Cambridge, 1998)

Bassi, E., *Palazzi di Venezia: Admiranda Urbis Venetae* (Venice, 1976; repr. 1980)

Battaglia, S., *Grande dizionario della lingua italiana* (Turin, 2000)

Baxandall, M., *Painting and Experience in Fifteenth-Century Italy* (Oxford, 1972)

Bayley, J., 'Alloy Nomenclature', in Egan and Pritchard, eds, *Dress Accessories c.1150–c.1450* (Woodbridge, 2002), pp.13–17

Bec, C., *Les marchands ecrivans: affaires et humanisme a Florence, 1375–1434* (Paris, 1967)

Becchi, E., 'Umanesimo e rinascimento', in Becchi and Dominique, eds, *Storia dell'infanzia. Dall'antichità al seicento* (Bari, 1996), pp.115–53

Belfanti, C. M. and Giusberti, F., eds, *La moda*, Storia d'Italia, XIX (Turin, 2003)

Belgrano, L.T., *Della vita privata dei genovesi* (Genoa, 1875; repr. Rome, 1970; repr. Genoa 2003)

Belgrano, L.T., 'Delle feste e dei giuochi dei genovesi', *Archivio storico italiano*, XIII, XIV, XV (1871, 1872), pp.42–71, 64–118, 417–77

Bell, R. M., *How to Do It: Guides to Good Living for Renaissance Italians* (Chicago and London, 1999)

Bellavitis, A., *Identité, mariage, mobilité sociale. Citoyennes et citoyens à Venise au XVIe siècle* (Rome, 2001)

Bellavitis, A., 'Genere e potere politico fra Medioevo ed Età Moderna', *Quaderni storici*, XL (2005), pp.230–8

Bellettini, P., Campioni, R. and Zanardi, Z., eds, *Una città in piazza. Comunicazione e vita quotidiana a Bologna tra cinque e seicento* (Bologna, 2000)

Bellezza Rosina, M., 'Tre corredi inediti della seconda metà del quattrocento', in Buss, Molinelli and Butazzi, eds, *Tessuti serici italiani, 1450–1530* (Milan, 1983), pp.64–8

Bellocchi, U. and Fava, B., *L'interpretazione grafica dell'Orlando furioso* (Reggio Emilia, 1961)

Belmonte, Pietro, *Institutione della sposa* (Rome, 1587)

Belting, H., *Likeness and Presence: A History of the Image before the Era of Art*, trans. E. Jephcott (Chicago and London, 1994)

Beltramini, G., *Andrea Palladio: The Complete Illustrated Works* (New York, 2001)

Bembo, Pietro. *Prose della volgar lingua* (Venice, 1525)

Benporat, C., *Cucina italiana del quattrocento* (Florence, 1996)

Benporat, C., *Feste e banchetti: convivialità italiana fra tre e quattrocento* (Florence, 2001)

Berchet, G., *La Repubblica di Venezia e la Persia* (Turin, 1865)

Berchet, G., *Le relazioni degli stati europei lette al Senato dagli ambasciatori veneziani, Turchia* (Venice, 1871–1872)

Berenson, B., *Italian Pictures of the Renaissance* (Oxford, 1932)

Berenson, B., *Italian Pictures of the Renaissance: Central Italian and North Italian Schools* (London, 1968)

Bergström, I., '*Medicina, fons et scrivium*: A Study in Eyckian Symbolism and its Influence in Italian Art', *Kunsthistorisk Tidskrift*, XXVI (1957), pp.1–20

Bernard of Clairvaux, Saint, *On the Song of Songs*, 3 vols, trans. Walsh and Edmons (Kalamazoo, 1976–9)

Bernardi, Ruberto di Guido, *Una curiosa raccolta di segreti e di pratiche superstiziose fatta da un popolano fiorentino del secolo XIV*, ed. G. Giannini (Città di Castello, 1898)

Bernstein, J., *Music Printing in Renaissance Venice: The Scotto Press (1539–1572)* (New York and Oxford, 1998)

Berriot-Salvadore, E., 'The Discourse of Medicine and Science', in Davis and Farg, eds, *Renaissance and Enlightenment Paradoxes*, vol. III of Duby and Perrot, eds, *A History of Women in the West* (Cambridge, MA, 1993), pp.348–388

Bertarelli, A. and Novati, F., *Piano analitico della mostra d'iconografia popolare italiana* (Rome, 1911)

Bertarelli, A., *L'imagerie populaire italienne* (Paris, 1929)

Berti, F., *Storia della ceramica di Montelupo*, 3 vols (Montelupo, 1997–9)

Berti, F., *Capolavori della maiolica rinascimentale: Montelupo 'fabbrica' di Firenze, 1400–1630* (Florence, 2002)

Berti, F., *Uno sguardo sul passato: archeologia nel ferrarese* (Florence, 1995)

Berti, F. and Butti, S., *Terre fiorentine: le città toscane di antica tradizione ceramica* (Figline Valdarno, 2002)

Berti, L., *Il Museo di Palazzo Davanzati a Firenze* (Florence, 1971)

Berti, L., *L'opera completa di Pontormo* (Milan, 1973)

Berti, L., ed., *Gli Uffizi: storia e collezioni* (Florence, 1979)

Berti, L., *Pontormo e il suo tempo* (Florence, 1993)

Bertoni, G. and Vicini, E. P., *Il Castello di Ferrara ai tempi di Niccolò III: inventario della suppellettile del castello* (Bologna, 1907)

Bestor, J. F., 'Marriage Transactions in Renaissance Italy and Mauss's Essay on the Gift', *Past & Present*, CLXIV (1999), pp.6–46

Bettoni, A., 'La ceramica a Pesaro tra il XIV e il XVII secolo', in G.C. Bojani, ed., *Fatti di ceramica nelle Marche dal trecento al novecento* (Macerata and Milan, 1997), pp.31–95

Biagi, G., *Due corredi nuziali fiorentini* (Florence, 1899)

Bianchi, M. L. and Grossi, M. L., 'Botteghe, economia e spazio urbano', in Franceschi and Fossi, eds, *La grande storia dell'artigianato: il quattrocento* (Florence, 1999), pp.27–63

Bianchi, S., 'Tavola e dispensa nella Toscana dell'umanesimo: mostra archeologica', in *Firenze a tavola* (Florence, 1988), pp.17–88

Bier, C., 'The South Kensington Ideal', *Hali*, XCVI (1998), pp.100–1

Biraben, J.-N., *Les Hommes et la peste en France et dans les pays européens et méditerranées* (Paris, 1975–6)

Bistort, G., *Il magistrato alle pompe nella Republica di Venezia* (Bologna, 1912)

Bistort, G., *Il lusso nella vita e nelle leggi* (Bologna, 1969)

Blair St George, R., *Conversing by Signs: Poetics of Implication in Colonial New England Culture* (Chapel Hill and London, 1998)

Blum, S. N., 'Hans Memling's Annunciation with Angelic Attendants', *Metropolitan Museum Journal*, XXVII (1992), pp.43–58

Boccherini, T., ed., *Il museo del tessuto di Prato* (Milan, 1999)

Bode, W. von, *Die Italienischen Hausmöbel der Renaissance* (Leipzig, 1902)

Bode, W. von, *The Italian Bronze Statuettes of the Renaissance*, ed. J. D. Draper, trans. W. Grétor (New York, 1980)

Boggero, F. and Simonetti, F., *Argenti genovesi da parata* (Turin, 1991)

Bollettino dei Musei Civici Veneziani, 'Un torchietto quattrocentesco al Museo Correr', VII/2 (1962), p.30

Bologna, C., *Inventario de mobili di Francesco di Angelo Gaddi, 1496: nozze Bumiller Stiller* (Florence, 1883)

Bolzoni, L., 'Teatralità e tecniche della memoria in Bernardino da Siena', *Intersezioni*, IV/2 (1984), pp.271–88

Bolzoni, L., 'Il *Colloquio spirituale* di Simone da Cascina. Note su allegoria e immagini della memoria', *Rivista di letteratura italiana*, n.3 (1985), pp.9–65

Bolzoni, L., 'Costruire immagini. L'arte della memoria tra letteratura e arti figurative', in Bolzoni and Corsi, eds, *La cultura della memoria* (Bologna, 1992), pp.57–97

Bolzoni, L., 'Predicazione in volgare e uso delle immagini da Giordano da Pisa a San Bernardino da Siena', in Auzzas, Baffetti and Delcorno, eds, *Letteratura in forma di sermone: i rapporti tra predicazione e letteratura nei secoli XIII–XVI. Atti del Seminario di studi, Bologna* (Florence, 2003), pp.29–52

Bombe, W., ed., *Nachlass-Inventare des Angelo da Uzzano und des Lodovico di Gino Capponi, Beiträge zur Kulturgeschichte des Mittelalters und der Renaissance*, XXXVI/20 (Leipzig and Berlin, 1928)

Bona, A., 'Gli inventari 'post mortem' e le abitazioni dei veronesi: un contributo alla storia degli "ambienti del Rinascimento"', in Lanaro, Marini and Varanini, eds, *Edilizia privata nella Verona Rinascimentale* (Milan, 2000), pp.170–183

Bonacini, C., *Bibliografia delle arti scrittorie e della calligrafia* (Florence, 1953)

Bonatti, E., *Il Museo Civico in Ferrara: donazione e restauri* (Ferrara, 1985)

Bonfil, R., *Jewish Life in Renaissance Italy*, trans. A. Oldcorn (Berkeley, 1994)

Böninger, L., '"Altare portatile" e "cappella privata": il caso dei Medici', *Mitteilungen des Kunsthistorischen Institutes in Florenz*, XLIV (2000), pp.335–337

Bonnaffé, E., *Voyages et voyageurs de la Renaissance* (Paris, 1895)

Bonnet, J., *Lorenzo Lotto* (Paris, 1996)

Boralevi, A., 'The Discovery of Two Great Carpets: The Cairene Carpets of the Medici', *Hali*, V/3 (1983), pp.282–83

Boralevi, A., ed., *Geometrie d'Oriente. Stefano Bardini e il tappeto antico* (Livorno, 1999)

Borchert, T.-H., *The Age of Van Eyck: The Mediterranean World and Early Netherlandish Painting, 1430–1530* (London, 2002)

Borea, E. et al., *Xilografie italiane del quattrocento da Ravenna e da altri luoghi* (Ravenna, 1987)

Borean, L., 'Nuove proposte e interpretazioni per le storie della Vergine di Carpaccio nella Scuola degli Albanesi', *Saggi e memorie di storia dell'arte*, XIX (1994), pp.21–72

Borenius, T., *The Picture Gallery of Andrea Vendramin* (London, 1923)

Borghini, G. et al., *Una farmacia preindustriale in Valdelsa. La spezieria e lo spedale di Santa Fina nella città di San Gimignano secc. XIV–XVIII* (San Gimignano, 1981)

Bornstein, D., 'Spiritual Kinship and Domestic Devotions', in Brown and Davis, eds, *Gender and Society in Renaissance Italy* (London and New York, 1998), pp.173–192

Boström, A., 'Ludovico Lombardo and the Taste for the *all'antica* Bust in Mid-Sixteenth-Century Florence and Rome', in P. Motture, ed., *Large Bronzes in the Renaissance* (Washington, 2003), pp.155–79

Botticelli, F., 'Rifacimenti e falsificazioni', in A. Restucci, ed., *L'architettura civile in Toscana. Il Rinascimento* (Siena, 1997), pp.394–403

Boucher, B., ed., *Earth and Fire: Italian Terracotta Sculpture from Donatello to Canova* (London and New Haven, 2001)

Braham, A., 'The Bed of Pierfrancesco Borgherini', *Burlington Magazine*, CXXI (1979), pp.754–65

Branca, V., 'Introduzione', in *Mercanti scrittori. Ricordi nella Firenze tra Medioevo e Rinascimento* (Milan, 1986)

Braunstein, P., 'Approches de l'intimité, XIV–XV siècle', in Ariès and Duby, eds, *L'Histoire de la vie privée, de l'Europe féodale à la Renaissance* (Paris, 1985), pp.526–619

Brevaglieri, S., 'Tiziano, le dame con il piatto e l'allegoria matrimoniale', *Venezia cinquecento. Studi di storia dell'arte e della cultura*, V/10 (1995), pp.123–60

Bridges, T. W., 'The Publishing of Arcadelt's First Book of Madrigals', 2 vols (unpub. Ph.D. diss., Harvard University, 1982)

Brief Guide to the Turkish Woven Fabrics (London, 1923; repr. 1931 and 1950)

Brody, M. J., '"Terra d'Urbino tutta dipinta a paesi con l'armi de' Salviati": The "Paesi" Service in the 1583 Inventory of Jacopo di Alamanno Salviati (1537–1586)', *Faenza*, IV–VI (2000), pp.30–46

Broise, H. and Maire Vigueur, J.-C., 'Strutture famigliari, spazio domestico e architettura civile a Roma alla fine del Medio Evo', in F. Zeri, ed., *Storia dell'arte italiana. Momenti di architettura*, XII (Turin, 1983), pp.99–160

Bromehead, C. N., 'Aetites or the Eagle-Stone', *Antiquity*, XXI (1947), pp.16–22

Brooks, J. A., *Glass* (Maidenhead, 1975)

Brown, D. A., ed., *Virtue and Beauty: Leonardo's Ginevra de' Benci and Renaissance Portraits of Women* (Washington, 2001)

Brown, H. M., 'Chansons for the Pleasure of a Florentine Patrician: Florence, Biblioteca del Conservatorio di Musica, MS Basevi 2442', in J. LaRue et al., eds, *Aspects of Medieval and Renaissance Music: A Birthday Offering in Honor of Gustave Rees* (New York, 1966), pp.56–66

Brown, H. M., 'The Music of the Strozzi Chansonnier (Florence, Biblioteca del Conservatorio di Musica, MS Basevi 2442)', *Acta musicologica*, XL (1968), pp.115–29

Brown, H. M., 'Women Singers and Women's Songs in Fifteenth-Century Italy', in Bowers and Tick, eds, *Women Making Music: The Western Art Tradition* (Urbana, 1989a), pp.62–89

Brown, H. and Lucco, M., *Lorenzo Lotto: Rediscovered Master of the Renaissance* (Washington, 1997)

Brown, J. C., 'A Woman's Place was in the Home: Women's Work in Renaissance Tuscany', in Ferguson, Quilligan and Vickers, eds, *Rewriting the Renaissance: The Discourses of Sexual Difference in Early Modern Europe* (Chicago, 1986b), pp.206–24

Brown, J. C. and Davis, R. C., eds, *Gender and Society in Renaissance Italy* (London and New York, 1998)

Brown, J. C., and Goodman, J., 'Women and Industry in Florence', *Journal of Economic History*, XL (1980), pp.73–80

Brown, P. F., *Venetian Narrative Painting in the Age of Carpaccio* (New Haven, 1988)

Brown, P. F., *Private Lives in Renaisssance Venice: Art, Architecture and the Family* (New Haven and London, 2004)

Browne, C., *Lace from the Victoria and Albert Museum* (London, 2004)

Brucker, G., ed., *Two Memoirs of Renaissance Florence: The Diaries of Buonaccorso Pitti and Gregorio Dati*, trans. J. Martines (New York, 1967)

Brucker, G., *Florence. The Golden Age, 1138–1737* (Berkeley, Los Angeles and London, 1984)

Brucker, G., 'Urban Parishes and their Clergy in Quattrocento Florence: A Preliminary *Sondage*', in A. Morrogh et al., eds, *Renaissance Studies in Honor of Craig Hugh Smyth*, 2 vols (Florence, 1985), II, pp.17–28

Brucker, G., *Giovanni and Lusanna: Love and Marriage in Renaissance Florence* (Berkeley, 1986)

Brucker, G., ed., *The Society of Renaissance Florence. A Documentary Study* (New York, 1971)

Brulez, W., *Marchands flamands à Venise (1568–1605)*, *Études d'histoire économique et sociale*, VI (Rome, 1965)

Bruno, Matteo, *Discorsi* (Venezia, 1569)

Bruschi, A., *Un antico forziere nuziale* (Florence, 1994)

Bucci, M. and Bencini, R., *Palazzi di Firenze. Quartiere di Santa Croce* (Florence, 1971)

Buck, A., *Clothes and the Child: A Handbook of Children's Dress in England, 1500–1900* (Carlton, 1996)

Bule, S., Darr, A. P. and Gioffredi, F. S., eds, *Verrocchio and Late Quattrocento Italian Sculpture* (Florence, 1992)

Bulgarelli, F. *et al.*, eds, *Archeologia dei pelligrinaggi in Liguria* (Savona, 2001)

Bulst, W. A., 'Die ursprüngliche innere Aufteilung des Palazzo Medici in Florenz', *Mitteilungen des Kunsthistorischen Institutes in Florenz*, XIV (1970), pp.369–92

Bulst, W. A., 'Uso e trasformazione del Palazzo Mediceo fino ai Riccardi', in Cherubini and Fanelli, eds, *Il Palazzo Medici Riccardi di Firenze* (Florence, 1990)

Buonpigli, Piero da Monte Varchi, *Instrutione a un maestro di casa di qualunque principe con il modo di governare e aministrare quella il tutto con ordine di scritture* (Florence, 1569)

Burckhardt, J., *The Civilization of the Renaissance in Italy*, ed. and trans. L. Goldscheider (London, 1945; repr. 1995)

Burke, J., *Changing Patrons: Social Identity and the Visual Arts in Renaissance Florence* (University Park, 2004)

Burke, P., *The Historical Anthropology of Early Modern Italy* (Cambridge, 1987)

Burke, P., Harrison, B. and Slack, P., eds, *Civil Histories: Essays Presented to Sir Keith Thomas* (Oxford, 2000)

Burns, H., Boucher, B. and Fairbairn, L., *Andrea Palladio 1508–1580: The Portico and the Farmyard* (London, 1975)

Bury, M., 'The Taste for Prints in Italy to c.1600', *Print Quarterly*, II/1 (1985), pp.12–26

Bury, M., *The Print in Italy 1550–1620* (London, 2001)

Bury, S., *Jewellery Gallery: Summary Catalogue* (London, 1982)

Buss, C., ed., *Tessuti serici italiani, 1450–1530* (Milan, 1983)

Butterfield, A., *The Sculptures of Andrea del Verrocchio* (New Haven and London, 1997)

Butterfield, A. and Franklin, D., 'A Documented Episode in the History of Renaissance *terracruda* Sculpture', *Burlington Magazine*, CXL (1998), pp.819–24

Bynum, W. F. and Porter, R., eds, *Medicine and the Five Senses* (Cambridge, 1993)

Cadogan, J. K., *Domenico Ghirlandaio: Artist and Artisan* (New Haven and London, 2000)

Caglioti, F., *Donatello e i Medici. Storia del David e della Giuditta* (Florence, 2000)

Caglioti, F., 'Nouveautés sur la *Bataille de San Romano* de Paolo Uccello', *Revue du Louvre*, LI (2001), pp.37–54

Callmann, E., *Apollonio di Giovanni* (Oxford, 1974)

Callmann, E., *Beyond Nobility, Art for the Private Citizen in the Early Renaissance* (Allentown, Pa., 1980)

Callmann, E., 'William Blundell Spence and the Transformation of Renaissance *Cassoni*', *Burlington Magazine*, CXLI (1999), pp.338–48

Camillo, E., 'Un falso libro dei segreti. Il *Veni Mecum* di Pietro di Bairo', *Studi piemontesi*, XV/1 (1986), pp.149–52

Campbell, L., *Renaissance Portraits. European Portrait Painting in the 14th, 15th and 16th Centuries* (New Haven and London, 1990)

Campbell, L., *National Gallery Catalogues: The Fifteenth-Century Netherlandish Schools* (London, 1998)

Campbell, L., 'Bruges: Jan van Eyck, Early Netherlandish Painting and Southern Europe', *Burlington Magazine*, CXLIV (2002), pp.367–71

Campbell, T., 'Portolan Charts from the Late Thirteenth Century to 1500', in Harley and Woodward, eds, *The History of Cartography*, 2 vols (Chicago, 1987), I, pp.371–463

Canart, P., 'Démétrius Damilas: alias le "Librarius Florentinus"', *Rivista di studi bizantini e neoellenici*, XIV–XVI (1977–1979), pp.281–347

Caniato, G. and Dal Borgo, M., *Le arti edili a Venezia* (Rome, 1990)

Cantelli, G., ed., *Il Museo Stibbert a Firenze*, 2 vols (Milan, 1974)

Cantini, L., ed., *Legislazione toscana* (Florence, 1800–8)

Cantini Guidotti, G., *Tre inventari di bicchierai toscani fra cinque e seicento* (Florence, 1983)

Cantini Guidotti, G., *Orafi in Toscana tra XV e XVII secolo: storie di uomini, di cose e di parole*, 2 vols (Florence, 1994)

Carboni, F., *Il vivo fonte. Trattato del sec. XVI sull'arte del vino* (L'Aquila, 2003)

Cargneluti, L., 'Ori e preziosi nei registri dei pegni del Monte di Pietà di Udine', in G. Bergamini, ed., *Ori e tesori d'Europa* (Udine, 1992), pp.345–54

Carl, D., 'Il pergamo di Benedetto da Maiano in Santa Croce a Firenze', *Giuliano e la bottega dei da Maiano, Acts of the International Conference Fiesole, 1991* (Florence 1994), pp.158–67

Carl, D., *Benedetto da Maiano* (forthcoming)

Carmichael, A. G., *Plague and the Poor in Renaissance Florence* (Cambridge, 1986)

Caroli, F., *L'anima e il volto: ritratto e fisiognomica da Leonardo a Bacon* (Milan, 1998)

Carrara, Michele, *Intavolatura di liuto di Michele Carrara, Roma 1585*, ed. B. Disertori (Florence, 1972)

Carruthers, M., *The Craft of Thought: Meditation, Rhetoric and the Making of Images, 400–1200* (Cambridge, 1998)

Carruthers, M. and Ziolkowski, J. M., eds, *The Medieval Craft of Memory: An Anthology of Texts and Pictures* (Philadelphia, 2002)

Carter, T., 'Music-selling in Late Sixteenth-Century Florence: The Bookshop of Piero di Giulio Morosi', *Music and Letters*, LXX (1989), pp.483–504

Casamassima, E., *Trattati di scrittura del cinquecento italiano* (Milan, 1966)

Casola, Pietro, *Viaggio di Pietro Casola a Gerusalemme* (Milan, 1855)

Cassidy, B., 'A Relic, Some Pictures and the Mothers of Florence in the Late Fourteenth Century', *Gesta*, XXX (1991), pp.91–9

Castellani, Francesco di Matteo, *Ricordanze A (1436–1459)*, ed. G. Ciappelli (Florence, 1992)

Castiglione, Sabba da, *Ricordi, overo, ammaestramenti* (Venice, 1554); ed. S. Cortesi (Faenza, 1999)

Cataldi Gallo, M., 'Seta nei salotti, nei guardaroba e nelle sacrestie genovesi', in M. Cataldi Gallo, ed., *Arte e lusso della seta a Genova dal 500 al 700* (Turin, 2000), pp.29–75

Catalogo del R. Museo Nazionale di Firenze (Rome, 1898)

Catalogue of the Manuscript Maps, Charts and Plans and Topographical Drawings in the British Museum, 3 vols (London, 1844)

Cavallo, S. and Cerutti, S., 'Female Honor and the Social Control of Reproduction in Piedmont between 1600 and 1800', in Muir and Ruggiero, eds, *Sex and Gender in Historical Perspective* (Baltimore and London, 1990), pp.73–109

Céard, J. and Margolin, J.-C., *Rébus de la Renaissance. Des images qui parlent* (Paris, 1986)

Celebrino, Eustachio, *Opera nova che insegna apparecchiar una mensa a uno convito … intitulata Refettorio* (Venice, 1526)

Cennini, Cennino, *The Craftsman's Handbook*, trans. D. V. Thompson Jr. (New York, 1960)

Ceresa Mori, A., ed., *Dal cantiere alla storia: lo scavo di via Puccini a Milano* (Milan, 1997)

Cervelli, L., 'Brevi note sui liutai tedeschi attivi in Italia dal sec. XVI al XVIII', *Analecta musicologica*, V (1968), pp.299–337

Chabot, I., '"Sola, donna, non gir mai". Le solitudini femminili nel trecento', *Memoria. Rivista di storia delle donne*, III (1986), pp.7–24

Chabot, I., 'Ricchezze femminili e parentela nel Rinascimento. Riflessioni intorno ai contesti veneziani e fiorentini', *Quaderni storici*, XL (2005), pp.203–209

Chambers, D., 'Spas in the Italian Renaissance', in M. A. Di Cesare, ed., *Reconsidering the Renaissance: Papers from the Twenty-first Annual Conference* (Binghampton NY, 1992), pp.3–27

Chambers, D. and Pullan, B., eds, *Venice. A Documentary History 1450–1630* (Oxford, 1992; repr. Toronto, 2001)

Chapman, H., Henry, T. and Plazzotta, C., *Raphael: From Urbino to Rome* (London, 2004)

Cheles, L., *The Studiolo of Urbino: An Iconographic Investigation* (Wiesbaden, 1986)

Chellini, Giovanni, *Le ricordanze di Giovanni Chellini da San Miniato: medico, mercante e umanista*, ed. M. T. Sillano (Milan, 1984)

Cherubini, G., 'I "libri di ricordanze" come fonte storica', in *Civiltà comunale, libro, scrittura, documento, atti del convegno, Genova, 8–11 novembre 1988, Genova: Società ligure di storia patria* (1989), pp.569–91

Cherubini, G. and Fanelli, G., eds, *Palazzo Medici Riccardi di Firenze* (Florence, 1990)

Cherubino da Spoleto, *Lo tractato delle septe regule spirituale* (Naples, c.1477–1480)

Chiarugi, S., 'Arredi lignei', in R. Pavoni, ed., *Museo Bagatti Valsecchi*, 2 vols (Milan, 2003), I, pp.67–190

Chojnacka, M., *Working Women of Early Modern Venice* (Baltimore, 2001)

Chojnacki, S., 'Dowries and Kinsmen in Early Renaissance Venice', *Journal of Interdisciplinary History*, V (1975), pp.571–600

Chojnacki, S., *Women and Men in Renaissance Venice: Twelve Essays on Patrician Society* (Baltimore and London, 2000)

Christiansen, K., *Gentile da Fabriano* (London, 1982)

Christiansen, K., 'The View from Italy', in Ainsworth and Christiansen, eds, *From Van Eyck to Bruegel: Early Netherlandish Painting in The Metropolitan Museum of Art* (New York, 1998), pp.39–61

Christiansen, K., ed., *From Filippo Lippi to Piero della Francesca: Fra Carnevale and the Making of a Renaissance Master* (New York, 2005)

Christol, M. and Lassalle, C., *Monnaies d'or de l'Empire Romain* (Nimes, 1988)

Church, A. H., 'Pomanders', *The Portfolio: An Artistic Periodical*, XVII (1886), pp.165–9

Ciappelli, G. and Rubin, P., eds, *Art, Memory and Family in Renaissance Florence* (Cambridge, 2000)

Ciappi, S. *et al.*, *Il vetro in Toscana: strutture, prodotti, immagini (sec. XIII–XX)* (Poggibonsi, 1995)

Ciardi Duprè, M. *et al.*, eds, *L'oreficeria della Firenze del quattrocento* (Florence, 1977)

Cicchetti, A. and Mordenti, R., 'La scrittura dei libri di famiglia', in *Letteratura italiana*, 18 vols (Turin, 1982–91), III, pp.1117–59

Cicero, *Orations: Pro Cluentio*, trans. H. G. Hodge (Cambridge, Mass., 2000)

Cicero, *Orations: Pro Flacco*, trans. C. Macdonald (Cambridge, Mass., 2001)

Cicognara, L., *Storia della scultura dal suo risorgimento in Italia sino al secolo di Napoleone* (Venice, 1813–18)

Cioci, F., 'I Della Rovere di Senigallia e alcune testimonianze ceramiche', *Faenza*, V–VI (1982), pp.251–60

Cipolla, C., 'Libri e mobilie di casa Aleardi al principio del secolo XV', *Archivio veneto*, XXIV (1882), pp.28–53

Citolini da Serravalle, Alessandro, *La tipocosmia* (Venice, 1561)

Clapp, F. M., *Jacopo Carucci da Pontormo: His Life and Work* (New Haven, 1916)

Clarke, G., *Roman House – Renaissance Palaces: Inventing Antiquity in Fifteenth-Century Italy* (Cambridge, 2003)

Cohen, H., *Description historique des monnaies frappées sous l'Empire Romain communément appelées Médailles Impériales* (Paris, 1880–92)

Cohen, E. and Cohen, T., *Words and Deeds in Renaissance Rome. Trials Before the Papal Magistrates* (Toronto, 1993)

Cohen, E. and Cohen, T., 'Open and Shut: The Social Meanings of the Renaissance Italian House', *Studies in the Decorative Arts*, IX (2001–2002), pp. 61–84

Cohn, S. K. Jr., *The Cult of Remembrance and the Black Death: Six Renaissance Cities in Central Italy* (Baltimore, 1992)

Colle, E., *Museo d'Arte Applicata: mobili e intagli lignei* (Milan, c.1996)

Concina, E., *A History of Venetian Architecture*, trans. J. Landry (Cambridge, 1998)

Constable, G., 'A Living Past: The Historical Environment of the Middle Ages', *Harvard Library Bulletin*, I/3 (1990), pp.49–70

Contadini, A., '"Cuoridoro": tecnica e decorazione di cuoi dorati veneziani e italiani con influssi islamici', in E. Grube, ed., *Arte veneziana e arte islamica. Atti del primo simposio internazionale sull'arte veneziana e l'arte islamica* (Venice, 1989), pp.231–51

Contadini, A., 'Artistic Contacts and Future Tasks', in Burnett and Contadini, eds, *Islam and the Italian Reinassance, Colloquia 5, The Warburg Institute* (London, 1999), pp.1–65

Conte, T., *Cesare Vecellio 1521c.–1601* (Belluno, 2001)

Conti, C., *La prima reggia di Cosimo I de' Medici nel palazzo già della Signoria di Firenze* (Florence, 1893)

Conti, G., ed., *La civiltà del cotto: arte della terracotta nell'area fiorentina dal XV al XX secolo* (Impruneta, 1980)

Contini, G., ed., *Cinque volgari di Bonvesin de la Riva* (Modena, 1937)

Cook, H.W., *Important Collection of Objects of Art of the Middle Ages and Renaissance* (London, July 7–10, 1925)

Cook, W. F., *Catalogue of the Art Collection, 8 Cadogan Square, S.W.* (London, 1904)

Coonin, A.V., 'Portrait Busts of Children in Quattrocento Florence', *Metropolitan Museum Journal*, XXX (1995), pp.61–71

Cora, G., *Storia della maiolica di Firenze e del contado: secoli XIV e XV* (Florence, 1973)

Cora, G. and Fanfani, A., 'Vasai del contado di Firenze (parte prima)', *Faenza*, LVIII (1987), pp.129–49

Corazzol, G., 'Varietà notarile: scorci di vita economica e sociale', in Cozzi and Prodi, eds, *Storia di Venezia dalle origini alla caduta della Serenissima: dal Rinascimento al Barocco*, VI (Rome, 1994), pp.775–91

Cornaro, Alvise, *La vita sobria*, ed. A. Di Benedetto (Milan, 1993)

Cortelazzo, M. and Lebole Di Gangi, C. M., 'I manufatti metallici', in Micheletto and Venturino Gambari, eds, *Montaldo di Mondovì: un insediamento protostorico, un castello* (Rome, 1991), pp.203–34

Cortese, C., 'Immagini e ritratti infantili dal XVI al XX secolo', in Filippini and Plebani, eds, *La scoperta dell'infanzia: cura, educazione e rappresentazione. Venezia 1750–1930* (Venice, 1999), pp.235–47

Cortesi Bosco, F., 'Il ritratto di Nicolò della Torre disegnato da Lorenzo Lotto', in Zampetti and Sgarbi, eds, *Lorenzo Lotto, Atti del Convegno Internazionale di studi per il V centenario della nativita* (Venice, 1981), pp.313–24

Cortesi, S., *I due testamenti di Fra Sabba da Castiglione* (Faenza, 2000)

Corti, G., 'Un contratto di allogazione di mobili e l'attività di un legnaiolo fiorentino a Siena ai primi del cinquecento', *Paragone*, XXXVI (1985), pp.105–12

Coryat, Thomas, *Coryat's Crudities* (Glasgow, 1905)

Costamanga, P., *Pontormo* (Milan, 1994)

Coster, W., 'Tokens of Innocence: Infant Baptism, Death, and Burial in Early Modern England', in Gordon and Marshall, eds, *The Place of the Dead: Death and Remembrance in Late Medieval and Early Modern Europe* (Cambridge, 2000), pp.266–87

Cotrugli Raguseo, Benedetto, *Il libro dell'arte di mercatura*, ed. U. Tucci (Venice, 1990)

Coutts, H., *The Art of Ceramics: European Ceramic Design 1500–1830* (New Haven and London, 2001)

Cox-Rearick, J., *The Drawings of Pontormo* (Cambridge, 1964)

Cox-Rearick, J., *The Drawings of Pontormo: A Catalogue Raisonné with Notes on the Paintings*, 2 vols (New York, 1981)

Crabb, A., *The Strozzi of Florence: Widowhood and Family Solidarity in the Renaissance* (Ann Arbor, 2000)

Crainz, F., *La tazza da parto* (Rome, 1986)

Cramer, P., *Baptism and Change in the Early Middle Ages, circa 200–circa 1150* (Cambridge, 1993)

Croce, Giulio Cesare (?), [pseud. 'Grotto, Giulio'], *La Violina* (Ferrara, n.d [1590?])

Croce, Giulio Cesare, *Gioco della sposa* (Ferrara, 1601)

Croce, Giulio Cesare, *I parenti godevoli* (Bologna, 1609)

Croce, Giulio Cesare, *Ducento enigmi piacevoli da indovinare* (Venice, 1611)

Croce, Giulio Cesare, *Veglia carnevalesca* (Bologna, 1620)

Croce, Giulio Cesare, *Barcelletta piacevolissima sopra i fanciulli, che vanno vendendo le ventarole per la città, & un capitolo, e lode sopra la bella ventarola* (Bologna, 1639)

'Cronaca de' Freschi', Biblioteca Marciana, Venice, MSS Italiani cl. VII, 165 (8867)

Croniques de Jean d'Anton (Paris, 1835)

Crouzet-Pavan, É., 'Sopra le acque salse': Espaces urbains, pouvoir et société à Venise à la fin du Moyen Âge, 2 vols (Rome, 1992)

Crovato, A., *The Venetian Terrazzo* (Treviso, 2002)

Cruttwell, M., *Verrocchio* (London, 1904)

Cunningham, H., *Children and Childhood in Western Society since 1500* (London and New York, 1995)

Curatola, G., *Oriental Carpets* (London, 1983)

Curatola, G., ed., *Eredità dell'Islam: arte islamica in Italia* (Venice, 1993)

Curatola, G., 'A Sixteenth-Century Quarrel about Carpets', in Behrens, Abouseif and Contadini, eds, *Studies in Honor of J. M. Rogers, Muqarnas*, XXI (2004), pp.129–37

Curatola, G. and Spallanzani, M., *Metalli islamici dalle collezioni Granducali – Islamic Metalwork from the Grand Ducal Collection* (Florence, 1981)

Curatola, G. and Spallanzani, M., *Tappeti* (Firenze, 1983)

Curtis, P., ed., *Depth of Field: The Place of Relief in the Time of Donatello* (Leeds, 2004)

Dacos, G., Giuliano, A. and Pannuti, U.,

eds, *Il tesoro di Lorenzo il Magnifico. Le gemme* (Florence, 1973)

Dal Poggetto, P., *Museo di Fucecchio: catalogo* (Fucecchio, 1969)

Dale, W., 'Donatello's Chellini Madonna: "Speculum sine macula"', *Apollo*, CXLI/397 (1995), pp.3–9

Dalli Regoli, G., *Il gesto e la mano* (Florence, 2000)

Dallington, Robert, *A Survey of the Great Dukes State of Tuscany: In the year of our Lord 1596* (London, 1605; facs. ed., Amsterdam, 1974)

Dalton, O. M., *Catalogue of the Finger Rings: Early Christian, Byzantine, Teutonic, Medieval and Later* (London, 1912)

Danti, Ignazio, 'Vita di M. Jacomo Barozzi da Vignola architetto e prospettico eccellentissimo', in *Le due regole della prospettiva pratica di M. Jacomo Barozzi da Vignola* (Rome, 1583)

Darr, A., ed., *Italian Renaissance Sculpture in the Time of Donatello* (Detroit, 1985)

Darr, A. P. and Preyer, B., 'Donatello, Desiderio da Settignano and his Brothers and "Macigno" Sculpture for a Boni Palace in Florence', *Burlington Magazine*, CXLI (1999), pp.720–31

Dati, Goro, *Il libro segreto di Goro Dati*, ed. C. Gargiolli (Bologna, 1869)

Däubler-Hauschke, C., *Geburt und Memoria. Zum Italienischen Bildtyp der Deschi da Parto* (Munich, 2003)

Davanzo Poli, D., 'La moda nella Venezia del cinquecento', in L. Puppi, ed., *Architettura e utopia nella Venezia del cinquecento* (Milan, 1980), pp.219–34

Davanzo Poli, D., *I mestieri della moda a Venezia nei secoli XIII–XVIII*, 2 vols (Venice, 1984–6)

Davanzo Poli, D., *Il merletto veneziano* (Novara, 1998)

Davanzo Poli, D., 'La moda infantile', in Filippini and Plebani, eds, *La scoperta dell'infanzia: cura, educazione e rappresentazione. Venezia 1750–1930* (Venice, 1999), pp.193–207

Davies, M., 'Fra Filippo Lippi's Annunciation and Seven Saints', *Critica d'arte*, VIII (1950), pp.356–63

Davies, M., *National Gallery Catalogues: The Earlier Italian Schools* (London, 1961)

Davies, P. and Hemsoll, D., 'I portali dei palazzi veronesi nel Rinascimento', in Lanaro, Marini and Varanini, eds, *Edilizia private nella Verona rinascimentale* (Milan, 2000), pp.252–66

Davis, C., 'Camini del Sansovino', *Annali di architettura*, VIII (1996), pp.93–114

Davis, R., *Shipbuilders of the Venetian Arsenal: Workers and Workplace in the*

Preindustrial City (Baltimore and London, 1991)

Davis, R., *The War of the Fists: Popular Culture and Public Violence in Late Renaissance Venice* (Baltimore, 1994)

D'Addario, M., 'La casa', in P. Bargellini, ed., *Vita privata a Firenze nei secoli XIV e XV* (Florence, 1966)

D'Afflito, C., 'La Madonna della Pergola: eccentricità e bizzarria in un dipinto pistoiese del cinquecento', *Paragone*, XLV (1994), pp.47–59

D'Ancona, P., *La miniatura fiorentina (secoli XI–XVI)*, 2 vols (Florence, 1914)

D'Avezac Macaya, M., 'Note sur un atlas hydrographique aujourd'hui au Musée Britannique', *Bulletin de la Société de Géographie de Paris*, XIV (1845)

Dean, T. and Lowe, K., eds, *Marriage in Italy, 1300–1650* (Cambridge, 1998)

Debby, N. B.-A., *Renaissance Florence in the Rhetoric of Two Popular Preachers* (Turnhout, 2001)

Debby, N. B.-A., 'The Preacher as Goldsmith: The Italian Preacher's Use of the Visual Arts', in C. Muessig, ed., *Preacher, Sermon and Audience in the Middle Ages* (Leyden, Boston and Cologne, 2002), pp.127–53

De Carli, C., *I deschi da parto e la pittura del primo Rinascimento toscano* (Turin, 1997)

De Commynes, Philippe, *Memoires*, 4 vols (Paris, 1747)

De Floriani, A. *et al.*, eds, *Restauri in Liguria* (Genoa, 1978)

De Giorgio, M. and Klapisch-Zuber, C., eds, *Storia del matrimonio* (Rome and Bari, 1996)

De la Mare, A. and Alexander, J. J. G., 'Florentine Manuscripts of Livy in the Fifteenth Century', in T. A. Dorey, ed., *Livy* (London, 1971)

De la Roncière, C., 'Tuscan Notables on the Eve of the Renaissance', in G. Duby, ed., *A History of Private Life: Revelations of the Medieval World* (Cambridge, MA and London, 1988), pp.157–309

Del Bravo, C., 'Per Giovan Francesco Caroto', *Paragone*, XV/173 (1964), pp.3–16

Delcorno, C., 'Ars praedicandi e ars memorativa nell' esperienza di San Bernardino da Siena', *Bullettino abruzzese di Storia Patria*, LXX (1980)

Della Casa, Giovanni, *Galateo*, ed. S. Ferrari (Florence, 1906); trans. R. S. Pine-Coffin (Middlesex, 1958); ed. G. Manganelli and C. Milanini (Milan, 1977); ed. E. Scarpa (Modena, 1990); ed. S. Prandi (Turin, 2000)

Delmarcel, G., *Flemish Tapestries* (London, 1999)

De Marchi, A., *Gentile da Fabriano: un viaggio nella pittura italiana alla fine del*

gotico (Milan, 1992)

De Marinis, G., *Archeologia post-classica a Firenze: la cultura materiale negli scavi urbani* (Offagna, 1997)

De' Mori, Ascanio, *Giuoco piacevole*, ed. M. G. Sanjust (Roma, 1989)

Dempsey, C., *Inventing the Renaissance Putto* (Chapel Hill & London, 2001)

Dennis, F., 'Music and Print. Book Production and Consumption in Ferrara, 1538–1598' (unpub. Ph.D. diss., University of Cambridge, 2002)

Denny, W. B., 'Textiles', in Y. Petsopoulos, ed., *Tulips, Arabesques & Turbans – Decorative Arts from the Ottoman Empire* (London, 1982), pp.121–67

Depaulis, T., 'L'apparition de la xylographie et l'arrivée des cartes a jouer en Europe', *Nouvelles de l'estampe*, CLXXXV–VI (2002–3), pp.7–19

De Ricci, S., 'Institut de France: Musée Jacquemart-André – Les objets d'art', *Les arts*, CLIII (1914), pp.2–32

De Roover, R., *The Rise and Decline of the Medici Bank 1397–1494* (Cambridge, 1963)

De Roover, R., *San Bernardino of Siena and Sant'Antonino of Florence: Two Great Economic Thinkers of the Middle Ages* (Boston, 1967)

De Simone, D., ed., *A Heavenly Craft. The Woodcut in Early Printed Books* (New York, 2004)

De Voragine, J., *The Golden Legend*, trans. W. G. Ryan and H. Ripperger (New York, 1941); trans. W. G. Ryan, 2 vols (Princeton, 1993)

Dexel, W., *Das Haugerät Mitteleuropas* (Berlin, 1962)

Di Cesare, M. A., ed., *Reconsidering the Renaissance: Papers from the Twenty-first Annual Conference* (Binghampton NY, 1992)

Didi-Huberman, G., *Fra Angelico: Dissemblence et Figuration* (Paris, 1990)

Didi-Huberman, G., 'Obscures survivances, petits retours et grande Renaissance: remarque sur les modeles de temps chez Warburg et Panofsky', in Grieco, Rocke and Superbi, eds, *The Italian Renaissance in the Twentieth Century: Acts of an International Conference, Florence, Villa I Tatti, June 9–11, 1999* (Florence, 2002), pp. 207–22

Digby, G. W., *Victoria and Albert Museum: The Tapestry Collection, Medieval and Renaissance* (London, 1980)

Dini, Bruno, 'Le ricordanze di un rammendatore (1488–1538)', *Nuova rivista storica*, LXXIV/3–4 (1990), pp.417–44

Disegni italiani della Galleria degli Uffizi (Jerusalem, 1984)

Dizionario biografico universale (Florence,

1844–45)

Dolce, Lodovico, *Dialogo della institution delle donne* (Venice, 1545; repr. 1547; repr. 1559)

Dominici, Giovanni, *Regola del governo di cura familiare*, ed. D. Salvi (Florence, 1860); ed. P. Bargellini (Florence, 1927a)

Dominici, Giovanni, *On the Education of Children*, trans. A. B. Coté (Washington, D. C.,1927b)

Donatello e il suo tempo. Il bronzetto a Padova nel quattrocento e nel cinquecento (Padua, 2001)

Doni, Anton Francesco, *Dialogo della musica* (Venice, 1544)

Doni, Anton Francesco, *I marmi*, ed. E. Chiòrboli (Bari, 1928)

Doran, S., ed., *Elizabeth* (London, 2003)

Dorigato, A., *Murano Island of Glass* (San Giovanni Lupato, 2003)

Draper, J. D., *Bertoldo di Giovanni: Sculptor of the Medici Household* (Columbia, 1992)

Duby, G., *Saint Bernard et l'art cistercien* (Paris, 1976)

Duby, G, and Perrot, M., eds, *Storia delle donne in Occidente*, vol.III of *Dal Rinascimento all'età moderna*, ed. Davis and Farge (Rome and Bari, 1991)

Duggan, L. G., 'Was Art Really the "Book of the Illiterate?"', *Word & Image*, III/1 (1989), pp.227–51

Dülberg, A., *Privatporträts: Geschichte und Ikonologie einer Gattung im 15. und 16. Jahrhundert* (Berlin, 1990)

Dursi, M., ed., *Affani e canzoni del Padre di Bertoldo. La poesia populare di Giulio Cesare Croce* (Bologna, 1966)

Eamon, W., *Science and the Secrets of Nature: Books of Secrets in Medieval and Early Modern Culture* (Princeton, 1994)

Eamon, W., *La scienza e i segreti della natura* (Genova, 1999)

Ebert-Schifferer, S., ed., *Natur und Antike in der Renaissance* (Frankfurt am Main, 1985)

Eckstein, N. A., *The District of the Green Dragon: Neighbourhood Life and Social Change in Renaissance Florence* (Florence, 1995)

Eco, U., *Art and Beauty in the Middle Ages*, trans. H. Bredin (New Haven and London, 1986)

Edgerton, S.Y. Jr., 'Mensurare temporalia facit Geometria spiritualis: Some Fifteenth-Century Italian Notions about Where and When the Annunciation Happened', in Lavin and Plummer, eds, *Studies in Late Medieval and Renaissance Painting in Honor of Millard Meiss*, 2 vols (New York, 1977), I, pp.115–30

Edgerton, S.Y. Jr., *Pictures and Punishment: Art and Criminal Prosecution during the Florentine Renaissance* (Ithaca, 1985)

Edgerton, S.Y. Jr., and Steinberg, L., 'How Shall This Be? Reflections on Filippo Lippi's *Annunciation* in London', *Artibus et Historiae*, XVI (1987), pp.25–53

Edgerton, S.Y. Jr., *The Heritage of Giotto's Geometry: Art and Science on the Eve of the Scientific Revolution* (Ithaca and London, 1991)

Edwards, N. E., 'The Renaissance "stufetta" in Rome: The Circle of Raphael and the Recreation of the Antique' (unpub. Ph.D. diss., University of Minnesota, 1983)

Egger, H., *Francesca Tornabuoni und ihre Grabstätte in Santa Maria sopra Minerva* (Vienna, 1934)

Ehrle, F., *Roma prima di Sisto V: la pianta di Roma du Pérac-Lafréry del 1557* (Rome, 1908)

Eisenach, E., *Husbands, Wives, and Concubines: Marriage, Family, and Social Order in Sixteenth-Century Verona* (Kirksville, 2004)

Ellis, C. G., 'The "Lotto" Pattern as a Fashion in Carpets', in Ohm and Reber, eds, *Festschrift für Peter Wilhelm Meister zum 65. Geburtstag am 16. Mai 1974* (Hamburg, 1975), pp.19–31

Enciclopedia italiana (Rome, 1934)

Endrei, W., 'Les Étoffes dites de Pérouse, leurs antécédents et leur descendence', *Bulletin du CIETA*, LXV (1987), pp.61–8

Erdmann, K., 'Cairo as a Centre of Carpet Manufacture', *Research and Progress*, V/3 (1939), pp.173–9

Erdmann, K., 'Kairener Teppiche. Teil II: Mamluken – und Osmanenteppiche', *Ars islamica*, VII (1940), pp.55–81

Erdmann, K., *Europa und der Orientteppich* (Berlin, 1962)

Erdmann, K., *Seven Hundred Years of Oriental Carpets*, ed. H. Erdmann (London, 1970)

Erdmann, K., *The Early Turkish Carpet*, trans. R. Pinner (London, 1977)

Ericani, G., *Il ritrovamento di Torretta: per uno studio della ceramica padana* (Venice, 1986)

Esch, A., 'Roman Customs Registers 1470–80: Items of Interest to Historians of Art and Material Culture', *Journal of the Warburg and Courtauld Institutes*, LV (1995), pp.72–87

Et coquatur ponendo. Cultura della cucina e della tavola in Europa tra medioevo ed età moderna (Prato, 1996)

'E io je onsi le juncture'. Un manoscritto genovese tra quattro e cinquecento: medicina, tecnica e quotidianità*, ed. G. Palmero (Recco, 1997)

Ettinghausen, R., 'The Impact of Muslim Decorative Arts and Painting on the Arts of Europe', in Schacht and Bosworth, eds, *The Legacy of Islam*

(Oxford, 2nd ed., 1974), pp.292–320

Evans, M., 'The After-Life of St Jerome: Giovanni Bilivert's Portrait of Neri Corsini', in Hamburger and Korteweg, eds, 'Circumdederunt me amici multi': A Tribute to James Marrow from his Friends (Turnhout, 2006), pp.189–96

Fabbri, L., Alleanza matrimoniale e patriziato nella Firenze del '400: studio sulla famiglia Strozzi (Florence, 1991)

Fabris, D., 'Giochi musicali e veglie "alla senese" nelle città non toscane dell'Italia rinascimentale', in Alm, McLamore and Reardon, eds, Musica Franca: Essays in Honor of Frank A. D'Accone (Stuyvesant, NY, 1996), pp.213–29

Fabris, G., 'Libri e strumenti musicali di Marc'Antonio Genova (1491–1564)', Padova, XII (1934), pp.29–42

Faccioli, E., Arte della cucina: libri di ricette, testi sopra lo scalco, il trinciante e i vini dal XIV al XIX secolo (Milan, 1966)

Fachard, D., Biagio Buonaccorsi. Sa vie, son temps, son oeuvre (Bologna, 1986)

Faenson, L., Italian Cassoni (Leningrad, 1983a)

Faenson, L., ed., Cassoni italiani delle collezioni d'arte dei musei sovietici (Perugina and Leningrad, 1983b)

Fazio, I., 'Percorsi coniugali nell'Italia moderna', in De Giorgio and Klapisch-Zuber, eds, Storia del matrimonio (Rome and Bari, 1996), pp.151–214

Fehérvári, G., Islamic Metalwork of the Eighth to the Fifteenth Century in the Keir Collection (London, 1976)

Feldman, M., 'The Academy of Domenico Venier, Music's Literary Muse in Mid-Cinquecento Venice', Renaissance Quarterly, XLIV (1991), pp.476–507

Feldman, M., City Culture and the Madrigal at Venice (Berkeley and London, 1995)

Felici, Costanzo, Dell'insalata e piante che in qualunque modo vengono per cibo del'huomo, ed. G. Arbizzoni (Urbino, 1986)

Fenlon, I., Music, Print and Culture in Early Sixteenth-Century Italy (London, 1995a)

Fenlon, I., 'The Status of Music and Musicians in the Early Italian Renaissance', in J. M. Vaccaro, ed., Le concert des voix et des instruments à la Renaissance (Paris, 1995b), pp.57–70

Fenlon, I., 'Gioseffo Zarlino and the Accademia Venetiana della Fama', in I. Fenlon, Music and Culture in Late Renaissance Italy (Oxford, 2002), pp.118–38

Fenlon, I. and Haar, J., The Italian Madrigal in the Early Sixteenth Century: Sources and Interpretation (Cambridge, 1988)

Fennell Mazzaoui, M., The Italian Cotton Industry in the Later Middle Ages, 1100–1600 (Cambridge, 1981)

Fermor, S., Piero di Cosimo: Fiction, Invention and Fantasia (London, 1993)

Ferrante, L., 'Gli sposi contesi. Una vicenda bolognese di metà cinquecento', in Seidel Menchi and Quaglioni, eds, Matrimoni in dubbio. Unioni controverse e nozze clandestine in Italia dal XIV al XVIII secolo (Bologna, 2001), pp.329–62

Ferrari, G., Il legno nell'arte italiana (Milan, n.d. [1910])

Ferrari, G., Il legno e la mobilia nell'arte italiana: la grande scultura e la mobilia della casa (Milan, n.d. [1916])

Ferrari, S., 'Canzoni ricordate nell'incatenatura del Bianchino', Giornale di filologia romanza, IV (1883), pp.58–97

Ferrari, S., 'L'incatenatura del Bianchino (nuove ricerche)', Giornale linguistico di archeologia, storia e letteratura, XV (1888), pp.124–7

Ferraro, J. M., Marriage Wars in Late Renaissance Venice (Oxford, 2002)

Ferrazza, R. and Bruschi, A., Un Pontormo ritrovato (Florence, 1992)

Ferrero, G. G., ed. Lettere del cinquecento (Turin, 1948)

Ferri, N. P., Indice geografico analitico dei disegni di architettura civile e militare esistenti nella R. Galleria degli Uffizi (Rome, 1885)

Fifty Masterpieces of Metalwork (London, 1951)

Filarete (Antonio Averlino), Trattato di architettura, 2 vols, ed. Finoli and Grassi (Milan, 1972)

Filarete (Antonio Averlino), Filarete's Treatise on Architecture, 2 vols, ed. J. Spencer (New Haven and London, 1965)

Findlen, P., 'The Renaissance in the Museum', in Grieco, Rocke and Superbi, eds, The Italian Renaissance in the Twentieth Century: Acts of an International Conference, Florence, Villa I Tatti, June 9–11, 1999 (Florence, 2002), pp.93–116

Fiocco, C. and Gherardi, G., 'Una targa della collezione Cora attribuibile alla bottega del Frate da Deruta (Plate. CXIV–CXXVII)', Faenza, LXX/5–6 (1984), pp.403–14

Fiocco, C. and Gherardi, G., Museo Communale di Gubbio. Ceramiche (Perugia, 1995)

Fiorin, A., 'I giochi dell' infanzia tra evoluzione e continuità', in Filippini and Plebani, eds, La scoperta dell'infanzia: cura, educazione e rappresentazione Venezia 1750–1930 (Venice, 1999), pp.209–19

Flandrin, J. L., 'Soins des beauté et recueil de secrets', in D. Menjot, ed., Les Soins de beauté. Moyen Âge, temps modernes, Actes du colloque de Grasse (Nice, 1987)

Fletcher, J., 'Marcantonio Michiel: His Friends and Collection', Burlington Magazine, CXXIII (1981), pp.453–67

Fogolari, G., La Galleria Giorgio Franchetti alla Ca' d'Oro di Venezia (Rome, 1965)

Fonseca, Roderigo, Del conservar la sanità (Florence, 1603)

Forlani Tempesti, A. and Capretti, E., Piero di Cosimo (Florence, 1996)

Fortini, Pietro, Le giornate delle novelle dei novizi, 2 vols, ed. A. Mauriello (Rome, 1988)

Fortini Brown, P., see Brown, P. F.

Fortnum, C. D. E., Maiolica (Oxford, 1896)

Franceschi, F., Oltre il 'tumulto'. I lavoratori fiorentini dell'arte della lana tra tre e quattrocento (Florence, 1993)

Franceschi, F., 'Un'industria "nuova" e prestigiosa: la seta', in Franceschi and Fossi, eds, La grande storia dell'artigianato: Il Quattrocento (Florence, 1999), pp.167–79

Franco Fiorio, M. T., Giovan Francesco Caroto (Verona, 1971)

Francovich, R. and Vannini, G., 'Gli orci di Palazzo "Coverelli" a Firenze', Atti IX Convegno Internazionale della Ceramica (Albisola, 1976), pp.109–28

Franzoi, U., L'armeria del Palazzo Ducale a Venezia (Treviso, 1990)

Franzoni, C., 'Le raccolte del Theatro di Ombrone e il viaggio in oriente del pittore: le Epistole di Giovanni Filoteo Achillini', Rivista di letteratura italiana, VIII/2 (1990), pp.287–335

Frati, L., ed., Libro di cucina del secolo XIV (Livorno, 1899)

Frati, L., La vita privata a Bologna dal secolo XIII al XVII (Bologna, 1900; 2nd ed. 1928)

Freedberg, D., The Power of Images. Studies in the History and Theory of Response (Chicago, 1989)

The Frick Collection: An Illustrated Catalogue. Furniture, Italian and French (New York, 1992)

Frick, C. C., Dressing Renaissance Florence: Families, Fortunes, and Fine Clothing (Baltimore, 2002)

Friedländer, M. J., Early Netherlandish Painting. The Van Eycks, Petrus Christus (Leiden, 1967)

Frigerio, Bartolomeo, L'economo prudente di Bartolomeo Frigerio di Ferrara (Rome, 1579)

Frigo, D., Il padre di famiglia. Governo della casa e governo civile nella tradizione dell'economica tra cinque e seicento (Rome, 1985)

Frimmel, T. von, ed., Der Anonimo Morelliano (Marcanton Michiel's Notizia d'opere del disegno): Abtheilung, Text und Übersetzung (Vienna, 1888)

Frommel, C. L., Der Römische Palastbau der Hochrenaissance, 3 vols (Tübingen, 1973)

Frommel, C. L., 'Abitare nei palazzetti romani del primo cinquecento', in A. Scotti Tosini, ed., Aspetti dell'abitare in Italia tra XV e XVI secolo. Distribuzione, funzioni, impianti (Milan, 2001), pp.23–37

Frothingham, A. W., Lustreware of Spain (New York, 1951)

Fryde, E. B., 'Lorenzo's Greek Manuscripts and in Particular his own Commissions', in Mallett and Mann, eds, Lorenzo the Magnificent: Culture and Politics (London, 1996), pp.93–104

Fusco, L., 'The Use of Sculptural Models in Fifteenth-Century Italy', Art Bulletin, LXIV/2 (1982), pp.177–94

Fusco, L. and Corti, G., Lorenzo de' Medici: Collector of Antiquities (Cambridge and New York, 2006)

Fusoritto, Reale da Narni, Il maestro di casa di Cesare Pandini, ne Il trinciante di M. Vincenzo Cervio, ampliato et ridotto a perfettione dal Cavalier Reale Fusoritto da Narni (Venice, 1581; repr. 1593)

Gabrieli, F. and Scerrato, U., eds, Gli Arabi in Italia (Milan, 1979)

Gaeta Bertelà, G., Paolozzi Strozzi, B. and Spallanzani, M., eds, Acquisti e donazioni del Museo Nazionale del Bargello 1970–1987 (Florence, 1988)

Galoppi Nappini, D., Castiglion Fiorentino: Pinacoteca (Montepulciano, 2000)

Gamba, C., Catalogo illustrato della Fondazione Horne (Florence, 1921)

Gamba, C., Illustrated Catalogue of the Horne Museum, (Florence, 1926)

Gamba, C., Il Museo Horne a Firenze. Catalogo con 400 illustrazioni (Florence, 1961)

Gandini, L., Tavola, cantina e cucina della corte di Ferrara nel quattrocento (Modena, 1889)

Garcia Marsilla, J. V., 'L'alimentazione in ambito mercantile. I conti della filiale Datini di Valencia (1404–10)' in S. Cavaciocchi, ed., Alimentazione e nutrizione secc. XIII–XVIII (Florence, 1997), pp.831–9

Gardini, A. and Benente, F., 'Ceramica postmedievale in Liguria: dati archeologici', in Atti XXVII Convegno Internazionale della Ceramica (Albisola, 1994), pp.47–65

Garside, A., ed., Jewelry: Ancient to Modern (New York and Baltimore, 1979)

Garzelli, A., 'Sulla fortuna del Gerolamo Mediceo del van Eyck nell'arte fiorentina del quattrocento', Scritti di storia dell'arte in onore di Roberto Salvini (Florence, 1984), pp.347–53

Garzelli, A., *Miniatura fiorentina del Rinascimento, 1440–1525. Un primo censimento*, 2 vols (Scandicci, 1985)

Gasparri, C., ed., *Le gemme Farnese* (Naples, 1994)

Gatti, L., *Artigiani delle pelli e dei cuoi. Maestri e garzoni nella società genovese tra XV e XVI secolo, Quaderni del Centro di Studio sulla Storia della Tecnica del CNR*, XIII (Genoa, 1986)

Gaurico, Pomponio, *De sculptura*, ed. P. Cutolo (Naples, 1999)

Geary, P., 'Sacred Commodities: The Circulation of Medieval Relics', in A. Appadurai, ed., *The Social Life of Things: Commodities in Cultural Perspective* (Cambridge, 1986), pp.169–91

Geiger, G. L., 'Filippino Lippi's Carafa *Annunciation*: Theology, Artistic Conventions and Patronage', *Art Bulletin*, LVIII (1981), pp.62–73

Gelichi, S., 'La pietra ollare in Emilia Romagna' in *La pietra ollare dalla preistoria all'età moderna* (Como, 1987a), pp.201–13

Gelichi, S., ed., *Ricerche archeologiche nel Castello delle Rocche di Finale Emilia* (Finale Emilia, 1987b)

Gelichi, S., ed., *Ferrara prima e dopo il castello: testimonianze archeologiche per la storia della città* (Ferrara, 1992)

Gelichi, S. and Librenti, M., 'La ceramica postmedievale in Emilia Romagna: un primo bilancio', *Atti XXVII Convegno Internazionale della Ceramica* (Albisola, 1994), pp.13–27

Gennari, G., 'Virgiliotto Calamelli e la sua bottega', *Faenza*, XLII/3 (1956), pp.57–60

Gentile, R., ed., *Diario fiorentino 1405–1439* (Anzio, 1991)

Gentili, A., '*Virtus e voluptas* nell'opera di Lorenzo Lotto', in Zampetti and Sgarbi, eds, *Lorenzo Lotto. Atti del convegno internazionale di studi per il V centenario della nascita* (Treviso, 1980), pp.415–24

Gentili, A., 'Lorenzo Lotto e il ritratto cittadino: Leoncino e Lucina Brembate', in A. Gentili, ed., *Il ritratto e la memoria. Materiali 1* (Rome, 1989), pp.174–7

Gentilini, G., *I Della Robbia. La scultura invetriata nel Rinascimento* (Florence, 1992)

Gerspach, E., 'La Collection Carrand au Musée National de Florence', *Les arts*, XXXI (July 1904), pp.2–32

Gherardi da Prato, Giovanni, *Il Paradiso degli Alberti*, ed. A. Lanza (Rome, 1975)

Ghiara, C., 'Filatoi e filatori a Genova tra XV e XVIII secolo', *Quaderni storici*, LII (1983)

Ghiara, C., *Famiglie e carriere artigiane. Il caso dei filatori da seta, Quaderni del Centro di Studio sulla Storia della Tecnica*

del CNR, VI (Genoa, 1991)

Ghisi, Andrea, *Il nobile et piacevole gioco, intitolato il passatempo* (Venice, 1620)

Gianighian, G. and Pavanini, P. *Dietro i palazzi. Tre secoli di architettura minore a Venezia* (Venice, 1984)

Giardini, C., *Pesaro. Museo delle Ceramiche* (Bologna, 1996)

Giegher, Mattia, *Li tre tratta[t]i…Nel primo si mostra con facilita grande il modo di piegare ogni sorte di panni lini* (Padua, 1639)

Ginori Conti, P., ed., *La vita del Beato Ieronimo Savonarola, scritta da un anonimo del sec. XVI e già attribuita a Fra Pacifico Burlamacchi* (Florence, 1937)

Giordano, L., 'On Filarete's *Libro architettonico*', in Hart and Hicks, eds, *Paper Palaces. The Rise of the Renaissance Architectural Treatise* (New Haven and London, 1998), pp.51–65

Giovanni di Dio da Venezia, *Decor puellarum* (Venice, 1471)

Giove, T. and Villone, A., 'Dallo studio al tesoro: le gemme Farnese da Roma a Capodimonte', in C. Gasparri, ed., *Le gemme Farnese* (Naples, 1994), pp.31–59

Giuliano, A., 'La glittica antica e le gemme di Lorenzo il Magnifico' and 'Catalogo delle gemme che recano l'iscrizione: LAV.R', in Dacos, Giuliano and Pannuti, eds, *Il tesoro di Lorenzo il Magnifico. Le gemme* (Florence, 1973), pp.17–35, 37–66

Giulini, A., 'Drusiana Sforza moglie di Iacopo Piccinino', in P. Boselli, ed., *Miscellanea di studi storici in onore di Antonio Manno* (Turin, 1912), pp.163–214

Glassie, H., 'Vernacular Architecture', *Journal of the Society of Architectural Historians*, XXXV (1976), pp.293–95

Gli Uffizi: catalogo generale (Florence, 1979)

Godby, M., 'The Boni Chimney-piece in the Victoria and Albert Museum. A Fifteenth-Century Domestic Cenotaph', *De arte*, XXVII (1982), pp.4–17

Goffen, R., 'Icon and Vision: Giovanni Bellini's Half-Length Madonnas', *Art Bulletin*, LVII (1975), pp.487–518

Goffen, R., *Giovanni Bellini* (New Haven and London, 1989)

Goldthwaite, R. A., 'The Empire of Things: Consumer Demand in Renaissance Italy', in Kent and Simons, eds, *Patronage, Art, and Society in Renaissance Italy* (Oxford, 1987), pp.153–75

Goldthwaite, R., 'The Economic and Social World of Italian Renaissance Maiolica', *Renaissance Quarterly*, XLII (1989), pp.1–32

Goldthwaite, R. A., *Wealth and the Demand for Art in Italy 1300–1600*

(Baltimore and London, 1993)

Goldthwaite, R. A., 'The Economic Value of a Renaissance Palace. Investment, Production, Consumption', in R. A. Goldthwaite, *Banks, Palaces and Entrepreneurs in Renaissance Florence* (Aldershot, 1995), pp.1–10

Gonzàlez-Palacios, A., *Il mobile nei secoli*, 2 vols (Milan, 1969)

Gonzàlez-Palacios, A., *Il tempio del gusto. Roma e il regno delle due Sicilie* (Milan, 1984)

Gonzáles-Palacios, A., *Il tempio del gusto. Le arti decorative in Italia fra classicismi e barocco: Il Granducato di Toscana e gli stati settentrionali*, 2 vols (Milan, 1986)

Gonzalez-Palacios, A., *Il mobile in Liguria* (Genoa, 1996)

Gordon, D., *National Gallery Catalogues. The Fifteenth-Century Italian Paintings* (London, 2003)

Gould, C., 'Lorenzo Lotto and the Double Portrait', *Saggi e memorie di storia dell'arte*, V (1966), pp.45–51

Gould, C., *National Gallery Catalogues. The Sixteenth-Century Italian Schools* (London, 1975)

Goy, R. J., *The House of Gold: Building a Palace in Medieval Venice* (Cambridge, 1992)

Gozzi, Niccolò Vito di, *Governo della famiglia* (Venice, 1589)

Grafton, A., and Jardine, L., *From Humanism to the Humanities: Education and the Arts in Fifteenth- and Sixteenth-Century Europe* (Duckworth, 1986)

Grazzini, Antonfrancesco (Il Lasca), *Le cene*, ed. R. Bruscagli (Rome, 1976)

Gregori, M., ed., *Mostra dei tesori segreti delle case fiorentine* (Florence, 1960)

Gregori, M., *Gli stili in Italia* (Florence, 1966)

Gregori, M., 'Giovan Battista Moroni', in *I pittori bergamaschi: il cinquecento* (Bergamo, 1979), pt.3, pp.95–377

Gregori, M., *Paintings in the Uffizi and Pitti Galleries* (Boston, 1994)

Green, M., *Women's Healthcare in the Medieval West* (Aldershot, 2000)

Grendi, E., 'Profilo storico degli alberghi genovesi', *Mélanges de l'Ecole Française de Rome*, LXXXVII (1975), pp.241–302

Grendler, P., *Schooling in Renaissance Italy: Literacy and Learning, 1300–1600* (Baltimore and London, 1989)

Grevembroch, J., *Varie venete curiosità. Sacre e profane, Biblioteca del Museo Correr, MS Gr. Dolfin 65/III* (Venice, 1764)

Grieco, A. J., 'Food and Social Classes in Late Medieval and Renaissance Italy', in Flandrin and Montanari, eds, *Food: A Culinary History from Antiquity to the Present* (New York, 1999), pp. 302–12

Grieco, A. J., Rocke, M. and Superbi, F.,

eds, *The Italian Renaissance in the Twentieth Century: Acts of an International Conference, Florence, Villa I Tatti, June 9–11, 1999* (Florence, 2002)

Grigaut, P., *Decorative Arts of the Italian Renaissance, 1400–1600* (Detroit, 1958)

Gropetio, Roberto, 'Un breve et notabile trattato del regimento della sanità ridotto della sostanza della medicina', in Domenico Romoli, *La singola dottrina* (Venezia, 1560)

Groppi, S., *L'archivio Saminiati-Pazzi* (Milan, 1990)

Grossi Bianchi, L. and Poleggi, E., *Una città portuale del Medioevo: Genova nei secoli X–XVI* (Genoa, 1979)

Grossi Bianchi, L., 'Palazzi del XVI e XVII secolo nella Genova dei carruggi', in F. D'Angelo, ed., *Argomenti di architettura genovese tra XVI e XVII secolo* (Genoa, 1995)

Grubb, J., 'Memory and Identity: Why Venetians Didn't Keep Ricordanze', *Renaissance Studies*, VIII (1994), pp.375–87

Grubb, J., *Provincial Families of the Renaissance: Private and Public Life in the Veneto* (Baltimore and London, 1996)

Grube, E. J., ed., *Arte veneziana e arte islamica. Atti del primo simposio internazionale sull'arte veneziana e l'arte islamica* (Venice, 1989)

Guarnieri, C., 'Suppellettile vitrea proveniente dagli scavi del convento di S. Antonio in Polesine a Ferrara: nota preliminare' in *Il vetro dall'antichità all'età contemporanea: aspetti tecnologici, funzionali e commerciali* (Milan, 1998), pp.217–24

Guarnieri, C., ed., 'S. Antonio in Polesine. Archeologia e storia di un monastero estense', *Quaderni di Archeologia dell'Emilia Romagna*, XII (Florence, 2005)

Guarnieri, C., *Lugo tra Medioevo ed Età Moderna: reperti dallo scavo di Piazza Baracca – Via Magnapassi* (Lugo, n.d.)

Guazzo, Stefano, *Dialoghi piacevoli* (Piacenza, 1587)

Guazzo, Stefano, *La civil conversazione* (Venice, 1574), 2 vols, ed. A. Quondam (Modena, 1993)

Guicciardini, Francesco, *Diario del viaggio in Spagna*, ed. P. Guicciardini (Florence, 1932)

Guidobaldi, N., 'Images of Music in Cesare Ripa's *Iconologia*', *Imago musicae*, VII (1990), pp.41–68

Gürsu, N., *The Art of Turkish Weaving – Designs through the Ages* (Istanbul, 1988)

Haar, J., 'On Musical Games in the Sixteenth Century', *Journal of the American Musicological Society*, XV/1 (1962), pp.27–35

Haar, J., 'Notes on the *Dialogo della musica* of Antonfrancesco Doni', *Music and Letters,* XLVII (1966), pp.198–224

Haar, J., 'Arie per cantar stanze ariostesche', in M. A. Balsano, ed., *L'Ariosto. La musica, i musicisti* (Florence, 1981), pp.31–46

Haar, J., 'From "cantimbanco" to Court: The Musical Fortunes of Ariosto in Florentine Society', in Rossi and Superbi, eds, *L'arme e gli amori. Ariosto, Tasso and Guarini in Late Renaissance Florence,* 2 vols (Florence, 2004), II, pp.179–97

Haas, L., '*Il mio buono compare*: Choosing Co-Parents and the Uses of Baptismal Kinship in Renaissance Florence', *Journal of Social History,* XXIX (1995), pp.341–56

Hackens, T. and Moucharte, G., *Technologie et analyse des gemmes anciennes. Technology and Analysis of Ancient Gemstones. Proceedings of the European Workshop held at Ravello, European University Centre for Cultural Heritage, November 13–16, 1987* (Rixensart, 1989)

Hadeln, D. von, 'Two Portraits by Paolo Veronese', *Burlington Magazine,* XLV (1924), pp.209–10

Haedeke, H. U., *Metalwork* (London, 1970)

Haines, M., *The 'Sacrestia delle Messe' of the Florentine Cathedral* (Florence, 1983)

Hall, E., 'Cardinal Albergati, St. Jerome and the Detroit Van Eyck', *Art Quarterly,* XXXI (Spring 1968), pp.2–34

Hall, E., 'The Detroit Saint Jerome in Search of its Painter', *Bulletin of the Detroit Institute of Arts,* LXXII/1–2 (1998), pp.10–37

Hanke, S., 'I bagni privati nei palazzi e nelle ville genovesi', *Archeologia postmedievale,* VIII (2004), pp.143–50

Hanke, S., 'Bathing *all'antica*. Bathrooms in Genoese Villas and Palaces in the Sixteenth Century', *Renaissance Studies* (forthcoming, 2006)

Harprath, R., 'Ippolito Andreasi as a Draughtsman', *Master Drawings,* XXII/1 (1984), pp.3–27

Harrisse, H., *The Discovery of North America* (London and Paris, 1892)

Harthan, J., *Books of Hours and their Owners* (London, 1977)

Harthan, J., *Bookbindings* (London, 1985)

Hatfield, R., 'The Compagnia de' Magi', *Journal of the Warburg and Courtauld Institutes,* XXXIII (1970a), pp.107–61

Hatfield, R., 'Some Unknown Descriptions of the Medici Palace in 1459', *Art Bulletin,* LII (1970b), pp.232–49

Hayez, J., 'Io non so scrivere a l'amicho per

siloscismi. Jalons pour une lecture de la lettre marchande toscane de la fin du Moyen Age', *I Tatti Studies,* VII (1997), pp.37–79

Hayez, J., 'L'Archivio Datini. De l'invention de 1870 à l'exploration d'un système d'écrits privés', *Mélanges de l'École Française de Rome. Moyen Age,* CXVII (2005), pp.121–91

Hayward, J. F., *European Armour* (London, 1951)

Hayward, J. F., *Virtuoso Goldsmiths and the Triumph of Mannerism, 1540–1620* (London, 1976)

Heers, J., *Genova nel '400* (Milan, 1984)

Heikamp, D., *Studien zur Mediceischen Glaskunst: Archivalien, Entwurfszeichnungen, Gläser und Scherben* (Florence, 1986)

Heikamp, D. and Grote, A. eds, *Il tesoro di Lorenzo il Magnifico: I vasi* (Florence, 1972)

Heimbürger, M., *Dürer e Venezia: Influssi di Albrecht Dürer sulla pittura veneziana del primo cinquecento* (Rome, 1999)

Henneberg, J. von, 'Two Renaissance Cassoni for Cosimo I de' Medici in the Victoria and Albert Museum', *Mitteilungen des Kunsthistorischen Institutes in Florenz,* XXXV (1991), pp.115–32

Henschenius, G. and Patebrochius, D., eds, *Acta Sanctorum. Maji.* (Venice, 1737)

Herlihy, D., 'Family', *American Historical Review,* XCVI/1 (1991), pp.1–16

Herlihy, D. and Cohn, S. K. Jr, eds, *The Black Death and the Transformation of the West* (Cambridge, 1997)

Herlihy, D., and Klapisch-Zuber, C., *Les toscans et leurs familles. Une étude du catasto florentin de 1427* (Paris, 1978); trans., *Tuscans and their Families: A Study of the Florentine Catasto of 1427* (New Haven, 1985)

Heywood, C., *A History of Childhood: Children and Childhood in the West from Medieval to Modern Times* (Cambridge, 2001)

Hildburgh, W. L., 'Italian Wafering Irons of the Fifteenth and Sixteenth Centuries', *Proceedings of the Society of Antiquaries of London,* XXVII/2 (1915), pp.161–201

Hildburgh, W. L., '"Dinanderie" Ewers with Venetian-Saracenic Decoration', *Burlington Magazine,* LXXIX (1941), pp.17–22

Hildburgh, W. L., 'Some Italian Renaissance Caskets with Pastiglia Decoration', *The Antiquaries Journal,* XXVI (1946), pp.123–37

Hildburgh, W. L., 'Aeolipiles as Fire-blowers', *Archaeologia,* XCIV (1951), pp.27–55

Hill, G. F., *A Corpus of Italian Medals of the Renaissance before Cellini* (London,

1930)

Hill, G. F. and Pollard, G., *Renaissance Medals from the Samuel H. Kress Collection* (London, 1967)

Hills, P., *Venetian Colour: Marble, Mosaic, Painting and Glass 1250–1550* (New Haven and London, 1999)

Hind, A. M., *An Introduction to a History of Woodcut, with a Detailed Survey of Work Done in the Fifteenth Century* (London, 1935)

Hobson, A., *Apollo and Pegasus. An Enquiry into the Formation and Dispersal of a Renaissance Library* (Amsterdam, 1975)

Hofer, P., 'Illustrated Editions of "Orlando Furioso" Pro Bonum Malum', in J. H. Fragonard, *Fragonard Drawings for Ariosto* (New York, 1945), pp.27–40

Holzhausen, W., 'Studien zum Schatz des Lorenzo il Magnifico', *Mitteilungen des Kunsthistorischen Institutes in Florenz,* III/3 (1919–32), pp.104–131

Honée, E., 'Image and Imagination in the Medieval Culture of Prayer: A Historical Perspective' in H. W. van Os, ed., *The Art of Devotion* (Amsterdam, 1994), pp.157–74

Honey, W. B., *Glass: A Handbook for the Study of Glass Vessels of All Periods and Countries and a Guide to the Museum Collection* (London, 1946)

Horne, H. P., 'Botticelli's "Last Communion" of St. Jerome', *Burlington Magazine,* XXVIII (1915), pp.45–46

Howard, D., *The Architectural History of Venice* (New Haven and London, 2002)

Howell Jolly, P., *Jan van Eyck and St. Jerome: A Study of Eyckian Influence on Colantonio and Antonello da Messina in Quattrocento Naples* (London, 1982)

Howell Jolly, P., 'Antonello da Messina's St. Jerome in his Study: An Iconographic Analysis', *Art Bulletin,* LXV/2 (1983), pp.238–53

Hughes, C., *Shakespeare's Europe: Unpublished Chapters of Fynes Moryson's Itinerary* (London, 1903)

Hughes, D. O., 'Sumptuary Law and Social Relations in Renaissance Italy', in J. Bossy, ed., *Disputes and Settlements: Law and Human Relations in the West* (Cambridge, 1983), pp.69–99

Hughes, D. O., 'Domestic Ideals and Social Behavior: Evidence from Medieval Genoa', in C. E. Rosemberg, ed., *The Family in History* (Philadelphia, 1984), pp.115–43

Hughes, D. O., 'Representing the Family: Portraits and Purposes in Early Modern Italy', *Journal of Interdisciplinary History,* XXVII (1986), pp.7–38

Hughes, G., *Renaissance Cassoni. Masterpieces of Italian Art: Painted Marriage Chests 1400–1550* (Polegate and London, 1997)

Humfrey, P., *Lorenzo Lotto* (New Haven and London, 1997)

Humfrey, P., *Giovanni Battista Moroni: Renaissance Portraitist* (Fort Worth, 2000)

Humfrey, P., 'L'importazione di dipinti veneziani a Bergamo e nelle sue valli, da Bartolomeo Vivarini a Palma il Vecchio', in F. Rossi, ed., *Bergamo. L'altra Venezia. Il Rinascimento negli anni di Lorenzo Lotto. 1510–1530* (Milan, 2001), pp.43–7

Humfrey, P. et al., *The Age of Titian: Venetian Renaissance Art from Scottish Collections* (Edinburgh, 2004)

Hunt, J., 'Jewelled Neck Furs and "Flohpelze"', *Pantheon,* XXI (1963), pp.150–57

Huth, H., '"Sarazenen" in Venedig?', in Bloch and Zick, eds, *Festschrift für Heinz Ladendorf* (Cologne and Vienna, 1970), pp.58–68

Huth, H., *Lacquer of the West* (Chicago and London, 1971)

I legni incisi della Galleria Estense: quattro secoli di stampa (Modena, 1986)

I legni incisi della Galleria Estense: a Milano nel 50 anniversario della morte di Achille Bertarelli (1938–1988) (Milan, 1988)

Indovinelli, riboboli, passerotti et farfalloni (n.p., [16th c.])

Ilgner, C., *Die volkswirtschaftlichen Anschaugen Antonins von Florenz (1389–1459)* (Paderborn, 1904)

I secreti de la Signora Isabella Cortese ne quali si contengono cose minerali, medicinali (Venice, 1561)

Jackson, C. J., 'The Spoon and its History', *Archaeologia,* LIII (1892), pp.107–46

Jacquart, D., and Thomasset, C., *Sexuality and Medicine in the Middle Ages,* trans. M. Adamson (Princeton, 1988)

Jansen. D.-E., 'Fra Filippo Lippis Doppelbildnis im New Yorker Metropolitan', *Wallraf-Richartz Jahrbuch,* XLVIII–XLIX (1988), pp.97–121

Janson, H. W., 'Giovanni Chellini's "Libro" and Donatello', in Lotz and Möller, eds, *Studien zur Toskanischen Kunst: Festschrift für Ludwig Heinrich Heydenreich* (Munich, 1964), pp.131–8

Jarrett, B., *S. Antonino and Mediæval Economics* (London, 1914)

Jenkins, I. and Sloan, K., *Vases and Volcanoes: Sir William Hamilton and his Collection* (London, 1996)

Jenner, M., 'Civilization and Deodorization? Smell in Early Modern English Culture', in Burke, Harrison and Slack, eds, *Civil*

Histories: Essays Presented to Sir Keith Thomas (Oxford, 2000), pp.132–4

Jenner, M. and Wallis, P., eds, *The Medical Market-Place Re-Visited* (forthcoming, 2007)

Johnson, G., 'Art or Artefact? Madonna and Child Reliefs', in Currie and Motture, eds, *The Sculpted Object, 1400–1700* (Aldershot, 1997), pp.1–24

Johnson, G., 'Family Values: Sculpture and the Family in Fifteenth-Century Florence', in Ciappelli and Rubin, eds, *Art, Memory and Family in Renaissance Florence* (Cambridge, 2000), pp.215–33

Johnson, G. and Matthews-Grieco, S., eds, *Picturing Women in Renaissance and Baroque Italy* (Cambridge, 1997)

Jolly, A., *Madonnas by Donatello and his Circle* (Frankfurt am Main, 1998)

Kauffmann, C. M., *Catalogue of Foreign Paintings. Victoria and Albert Museum*, 2 vols (London, 1973)

Kecks, R., *Madonna und Kind. Das häusliche Andachtsbild im Florenz des 15. Jahrhunderts* (Berlin, 1988)

Kemp, W., 'Visual Narratives, Memory and the Medieval *Esprit du Système*', in Küchler and Melion, eds, *Images of Memory: On Remembering and Representation* (Washington and London, 1991), pp.87–108

Kendrick, A. F. and Tattersall, C. E. C., eds, *Guide to the Collection of Carpets* (London, 1931)

Kent, D., *Cosimo de' Medici and the Florentine Renaissance* (New Haven and London, 2000)

Kent, D. and Kent. F. W., *Neighbours and Neighbourhood in Renaissance Florence* (New York, 1982)

Kevill-Davies, S., *Yesterday's Children: The Antiques and History of Childcare* (Woodbridge, 1991)

Kieckhefer, R., *Magic in the Middle Ages* (Cambridge, 1989)

King, D., 'The Carpets in the Exhibition', in King and Sylvester, eds, *The Eastern Carpet in the Western World from the 15th to the 17th Century* (London, 1983), pp.24–48

King, D., Franses, M. and Pinner, R., 'East Mediterranean Carpets in the Victoria and Albert Museum', *Hali,* IV/1 (1981), pp.36–52

King, D., Franses, M. and Pinner, R., 'Turkish Carpets in the Victoria and Albert Museum', *Hali,* VI/4 (1984), pp.354–81

Kirkendale, W., 'Franceschina, Girometta, and their Companions in a Madrigal "a diversi linguaggi" by Luca Marenzio and Orazio Vecchi', *Acta musicologica,* XLIV (1972), pp.181–235

Klapisch-Zuber, C., 'Le "zane" della sposa: la fiorentina e il suo corredo nel Rinascimento, *Memoria,* XI–XII (1984), pp.12–23

Klapisch-Zuber, C., *Women, Family and Ritual in Renaissance Italy* (Chicago and London, 1985a)

Klapisch-Zuber, C., 'Holy dolls: Play and Piety in Florence in the Quattrocento', in C. Klapisch-Zuber, *Women, Family and Ritual in Renaissance Italy* (Chicago and London, 1985b), pp.310–29

Klapisch-Zuber, C., 'Les Coffres de mariage et les plateaux d'accouchés à Florence: archive, ethnologie, iconographie', in S. Deswarte-Rosa, ed., *A travers l'image. Lecture iconographique et sens de l'oeuvre* (Paris, 1994a), pp.309–34

Klapisch-Zuber, C., 'Les Femmes dans les rituels de l'alliance et de la naissance à Florence', in Chiffoleau, Martines and Bagliani, eds, *Riti e rituali nelle società medievali* (Spoleto, 1994b), pp.3–22

Klapisch-Zuber, C., 'Il bambino, la memoria e la morte', in Becchi and Dominique, eds, *Storia dell'infanzia. Dall'antichità al seicento* (Bari, 1996), pp.156–9

Knox, D., 'Civility, Courtesy and Women in the Italian Renaissance', in L. Panizza, ed., *Women in Italian Renaissance Culture and Society* (Oxford, 2000), pp.2–17

Kovesi Killerby, C., 'Practical Problems in the Enforcement of Italian Sumptuary Law, 1200–1500', in Dean and Lowe, eds, *Crime, Society and the Law in Renaissance Italy* (Cambridge, 1994), pp.99–120

Krahn, V., ed., *Von allen Seiten schön: Bronzen der Renaissance und des Barock* (Heidelberg, 1995)

Krahn, V., *Bronzetti Veneziani: die venezianischen Kleinbronzen der Renaissance aus dem Bode-Museum Berlin* (Berlin, 2003)

Kreisel, H., *Die Kunst des deutschen Mobel. Von den Anfangen bis zum Hochbarock* (Munich, 1981)

Kristeller, P. O., *Early Florentine Woodcuts* (London, 1897)

Krohn, D., 'The Framing of Two Tondi in San Gimignano attributed to Filippino Lippi', *Burlington Magazine,* CXXXVI (1994), pp.160–63

Kruft, H. W., *Portali genovesi del Rinascimento* (Florence, 1971)

Kühnel, E., *Islamische Kleinkunst* (Berlin, 1925)

Kwastek, K., *Camera. Gemalter und realer Raum der italienischen Frührenaissance* (Weimar, 2001)

L'abito per il corpo, il corpo per l'abito (Florence, 1998)

La casa italiana nei secoli. Mostra delle arti decorative in Italia dal trecento all'ottocento (May–October, 1948, Palazzo Strozzi, Florence)

La Chiesa greca in Italia dall'VIII al XVI secolo. Atti del convegno storico interecclesiale, 3 vols (Padua, 1972–3)

La pittura a Genova e in Liguria dagli inizi del cinquecento (Genoa, 1987)

Ladis, A., *Italian Renaissance Maiolica from Southern Collections* (Athens, 1989)

Ladis, A., 'Immortal Queen and Mortal Bride: The Marian Imagery of Ambrogio Lorenzetti's Cycle at Montesiepi', *Gazette des beaux-arts,* CXXXIX (1992), pp.189–200

Lambert, S., *The Image Multiplied: Five Centuries of Printed Reproductions of Paintings and Drawings* (London, 1987)

Lanaro, P., Marini, P. and Varanini, G. M., eds, *Edilizia private nella Verona rinascimentale* (Milan, 2000)

Landau, D. and Parshall, P., *The Renaissance Print* (London, 1994)

Lando, Ortensio, ed., *Ragionamenti familiari di diversi autori* (Venice, 1550)

Lando, Ortensio. *Paradossi: ristampa dell'edizione Lione 1543* (Pisa, 1999)

Lanmon, D., *Glass in The Robert Lehman Collection* (New York, 1993)

Lanteri, Giacomo, *Della economica trattato* (Venice, 1560)

Lauber, R., 'Per un ritratto di Gabriele Vendramin: nuovi contributi', in Borean and Mason, eds, *Figure di collezionisti a Venezia tra cinque e seicento* (Udine, 2002), pp.25–75

Laughran, M. A., 'Oltre la pelle. I cosmetici e il loro uso', in Belfanti and Giusberti, eds, *La moda, Storia d'Italia,* XIX (Turin, 2003), pp.43–82

Lauts, J., *Carpaccio: Paintings and Drawings* (London, 1962)

Lavin, I., 'On the Sources and Meaning of the Renaissance Portrait Bust', *Art Quarterly,* XXXIII (1970), pp.207–26; repr. in S. Blake McHam, ed., *Looking at Italian Renaissance Sculpture* (Cambridge, 1998), pp.9–28

Lavoix, H., 'Les Azziministes', *Gazette des beaux-arts,* VXII (1862), pp.64–74

Le lettere di Francesco Datini alla moglie Margherita (1385–1410), ed. E. Cecchi (Prato, 1990)

Lefebvre, H., *The Production of Space,* trans. D. Nicholson-Smith (Oxford, 1991)

Leithe-Jasper, M. and Wengraf, P., *European Bronzes from the Quentin Collection* (New York, 2004)

Lemay, H. R., 'Guido Bonatti: Astrology, Society and Marriage in Thirteenth-Century Italy', *Journal of Popular Culture,* XVII (1984), pp.79–90

Lemay, H., 'Women and the Literature of Obstetrics and Gynecology', in J. T. Rosenthal, ed., *Medieval Women and the Sources of Medieval History* (Athens, 1990), pp.189–209

Lensi, A., 'Museo Bardini – dipinti, cornici, cose varie', *Dedalo,* X (1929), pp.68–80

Levecque-Agret, I., 'Les Parfums à la fin du Moyen Age', in D. Menjot, ed., *Les Soins de beauté. Moyen Age, temps modernes, Actes du colloque de Grasse* (Nice, 1987)

Levey, S. M., *Lace: A History* (London, 1983)

Lewis, D., 'The Plaquettes of "Moderno" and his Followers', in A. Luchs, ed., *Italian Plaquettes, CASVA Symposium Papers,* IV (Washington, 1989), pp.105–41

Lewis, M., *Antonio Gardano, Venetian Music Printer 1538–1569. A Descriptive Bibliography and Historical Study,* 2 vols (New York and London, 1988–97)

Liebenwein, W., *Studiolo. Storia e tipologia di uno spazio culturale,* ed. C. Cieri Via (Ferrara, 1992)

Liebrich, J., *Die Verkündigung an Maria. Die Ikonographie der italienischen Darstellungen von den Anfängen bis 1500* (Cologne, 1997)

Liefkes, R., ed., *Glass* (London, 1997)

Lièvre, E. and Sauzay, A., *Musée Impérial du Louvre – Collection Sauvageot* (Paris, 1863)

Lightbown, R., 'Giovanni Chellini, Donatello, and Antonio Rossellino', *Burlington Magazine,* CIV (1962), pp.102–4

Lightbown, R., *Sandro Botticelli* (London, 1978)

Lightbown, R., 'L'esotismo', in Previtali and Zevi, eds, *Storia dell'arte italiana,* X (Turin, 1981), pp.449–72

Lightbown, R., *Medieval European Jewellery: With a Catalogue of the Collection in the Victoria and Albert Museum* (London, 1992)

Lightbown, R., *Carlo Crivelli* (New Haven and London, 2004)

Lillie, A., 'The Patronage of Villa Chapels and Oratories near Florence: A Typology of Private Religion', in Marchand and Wright, eds, *With and Without the Medici: Studies in Tuscan Art and Patronage, 1434–1530* (Aldershot, 1998), pp.19–46

Lillie, A., *Florentine Villas in the Fifteenth Century: An Architectural and Social History* (Cambridge, 2005)

Lindow, J., 'Magnificence and Splendour: The Palace in Renaissance Florence' (unpub. Ph.D. diss., Royal College of Art, 2004)

Lindow, J., 'For Use and Display: Selected Furnishings and Domestic Goods in Fifteenth-Century Florentine Interiors', *Renaissance Studies,* XIX/5 (2005), pp.634–46

Lingohr, M., *Der florentiner Palastbau der Hochrenaissance. Der Palazzo Bartolini Salimbeni in seinem historischen und architekturgeschichtlichen Kontext*

(Worms, 1997)

Lloyd, C., *Renaissance Bronzes in the Ashmolean Museum* (Oxford, 1980)

Logan, A.-M., *The "Cabinet" of the Brothers Gerard and Jan Reynst* (Amsterdam and New York, 1979)

Lombardi, D., 'Fidanzamenti e matrimoni dal Concilio di Trento alle riforme settecentesche', in De Giorgio and Klapisch-Zuber, eds, *Storia del matrimonio* (Rome and Bari, 1996), pp.215–51

Lombardi, D., *Matrimoni di antico regime* (Bologna, 2001)

Longhurst, M., *Catalogue of Carvings in Ivory* (London, 1929)

Lorenzelli, P. and Veca, A., eds, *Tra/E teche, pissidi, cofani e forzieri dall'Alto Medioevo al Barocco* (Bergamo, 1984)

Lotto, Lorenzo, *Il 'libro di spese diverse' con aggiunta di lettere e d'altri documenti*, ed. P. Zampetti (Venice, 1969)

Lotz, A., *Bibliographie der Modelbücher. Beschreibendes verzeichnis der Stick- und Spitzenmusterbücher des 16. und 17. Jahrhunderts* (Leipzig, 1933)

Luchs, A., 'Lorenzo from Life? Renaissance Portrait Busts of Lorenzo de' Medici', *The Sculpture Journal*, IV (2000), pp.6–23

Ludwig, G., 'Inventar des Nachlasses des Alvise Odoni', *Italienische Forschungen*, IV–V (Berlin, 1911), pp.56–74

Luigini, Federico, *Il libro della bella donna* (Venice, 1554)

Luzio, A., 'La prammatica del Cardinale Ercole Gonzaga contro il lusso (1551)', in *Scritti varii di erudizione e di critica in onore di Rodolfo Renier* (Turin, 1912), pp.65–78

Luzio, A. and Renier, R., *Mantova e Urbino. Isabella d'Este ed Elisabetta Gonzaga nelle relazioni famigliari e nelle vicende politiche* (Turin, 1893)

Lydecker, J. K., 'The Domestic Setting of the Arts in Renaissance Florence' (unpub. Ph.D. diss., The Johns Hopkins University, 1987a)

Lydecker, J. K., 'Il patrizio fiorentino e la committenza artistica per la casa', in D. Rugiadini, ed., *I ceti dirigenti nella Toscana del quattrocento, Atti del convegno di studi* (Monte Oriolo, 1987b), pp.209–22

McClanan, A. L. and Encarnaçion, K. R., eds, *The Material Culture of Sex, Procreation and Marriage in Premodern Europe* (New York, 2002)

McDonald, M. P., *Ferdinand Columbus Renaissance Collector (1488–1539)* (London, 2005)

McGeary, T., 'Harpsichord Mottoes', *Journal of the American Musical Instrument Society*, VII (1981), pp.5–35

McGee, T., 'Misleading Iconography: The Case of the "Adimari Wedding Cassone"', *Imago musicae*, IX–XII

(1992–5), pp.139–57

McHam, S., 'Donatello's Dovizia as an Image of Florentine Political Propoganda', *Artibus et Historiae*, XIV (1986), pp.9–28

McKillop, S. R., 'L'ampliamento dello stemma mediceo e il suo contesto politico', *Archivio storico italiano*, CL (1992), pp.641–713

Machiavelli, Bernardo, *Libro di ricordi*, ed. C. Olschki (Florence, 1954)

Machiavelli, Niccolò, *Clizia*, ed. L. Blasucci, *Opere di Niccolò Machiavelli*, IV (Turin, 1989), pp.170–228

Macinghi Strozzi, Alessandra, see Strozzi, Alessandra Macinghi

Mack, R. E., *Bazaar to Piazza: Islamic Trade and Italian Art, 1300–1600* (Berkeley and Los Angeles, 2002)

Mackay Thomas, W. G., 'Old English Candlesticks and their Venetian Prototypes', *Burlington Magazine*, LXXX (1942), pp.145–51

Mackie, L. W. *The Splendour of Turkish Weaving* (Washington D.C., 1973–74)

Maclagan, E., *Catalogue of Italian Plaquettes* (London, 1924)

Maetzke, A., *Il Museo Statale d'Arte Medievale e Moderna in Arezzo* (Florence, 1987)

Magnus, Albertus, *Book of Minerals*, trans. D. Wyckoff (Oxford, 1967)

Malaguzzi Valeri, F., *La corte di Ludovico il Moro. La vita privata e l'arte a Milan nella seconda meta del quattrocento* (Milan, 1913)

Mallé, L., *Museo Civico di Torino: mobili e arredi lignei, arazzi e bozzetti per arazzi. Catalogo* (Turin, 1972)

Mallé, L., *Maioliche italiane dalle origini al settecento* (Milan, 1974)

Mallet, J., and Adrian Dreier, F., *The Hockemeyer Collection, Maiolica and Glass* (Bremen, 1998)

Malquori, A., *Tempo d'aversità. Gli affreschi dell'altana di Palazzo Rucellai* (Florence, 1993)

Martini, Francesco di Giorgio, *Trattati di architettura, ingegneria e arte militare*, 2 vols, ed. C. Maltese (Milan, 1967)

Mancini Della Chiara, M., *Maioliche del Museo Civico di Pesaro. Catalogo* (Bologna, 1979)

Mancino, G., 'Le forme del profumo', in L. Villoresi, ed., *Il profumo, storia, cultura e tecniche* (Florence 1995)

Manni, G., *Mobili in Emilia* (Modena, 1986)

Mannini, M. P. and Fagioli, M., *Filippo Lippi. Catalogo completo* (Florence, 1997)

Mannoni, T., 'La ceramica d'uso comune in Liguria prima del secolo XIX (prime notizie per una classificazione)', *Atti III Convegno Internazionale della Ceramica* (Albisola, 1970)

Marachio, M., *Istituto di tenere in corpi le*

arti, riguardato nelle sue teorie e nelle sue forme (Venezia, 1794)

Marchini, G., *Filippo Lippi* (Milan, 1975)

Maretto, P., *La casa veneziana nella storia della città dalle origini all'ottocento* (Venice, 1986)

Mariacher, G., *Il Museo Correr di Venezia. Dipinti dal XIV al XVI secolo* (Venice, 1957)

Mariacher, G., *Vetri italiani del cinquecento* (Milan, 1959)

Mariacher, G., *Italian Blown Glass: From Ancient Rome to Venice* (London 1961)

Mariacher, G., *Lampade e lampadari in Italia dal quattrocento all'ottocento* (Milan, 1981)

Marinoni, A., *I rebus di Leonardo da Vinci: raccolti e interpretati* (Florence, 1954)

Marks, R. and Williamson, P., eds, *Gothic Art for England* (London, 2003)

Marquet de Vasselot, J.-J., *Catalogue sommaire de l'orfèvrerie, de l'émaillerie, e des gemmes du Moyen Age au XVIIe siècle* (Paris, 1914)

Marshall, N., *Three Centuries of Children's Costume* (forthcoming)

Martin, A. S., 'Makers, Buyers and Users: Consumerism as a Material Culture Framework', *Winterthur Portfolio*, XXVIII/2–3 (1993), pp.141–57

Martin, J., *Histoire du texte des phénomènes d'Aratos* (Paris, 1956)

Martin, T., *Alessandro Vittoria and the Portrait Bust in Renaissance Venice* (Oxford, 1998)

Martineau, J. and Hope, C., eds, *The Genius of Venice 1500–1600* (London, 1983; repr. New York, 1984)

Martino, G. P. and Bracco, C., 'Il Leudo del Mercante', *Archeologia postmedievale*, III (1999), pp.207–36

Marubbi, M., *Catalogo delle Collezioni del Museo Civico di Cremona. La Pinacoteca Ala Ponzone. Il cinquecento* (Cremona, 2003)

Masi, G., 'La ceroplastica in Firenze nei secoli XV–XVI e la famiglia Benintendi', *Rivista d'arte*, IX (1916), pp.124–42

Massinelli, A. M., *Bronzetti e anticaglie dalla guardaroba di Cosimo I* (Florence, 1991)

Massinelli, A. M., *Il mobile toscano. 1200–1800* (Milan, 1993)

Massonio, Salvatore, *Archidipno ovvero dell'insalata e dell'uso di essa* (Venice, 1627)

Masterpieces of Cutlery and the Art of Eating (London, 1979)

Matchette, A., 'Unbound Possessions: The Circulation of Used Goods in Florence c.1450–1600' (unpub. Ph.D. diss., University of Sussex, 2005)

Matthews-Grieco, S., 'Corpo, aspetto e sessualità', in Davis and Farge, eds, *Dal*

Rinascimento all'Età Moderna, vol.III of Duby and Perrot, eds, *Storia delle donne in Occidente* (Rome and Bari, 1991), pp.53–99

Matthews-Grieco, S., 'Persuasive Pictures: Didactic Prints and the Construction of the Social Identity of Women in Sixteenth-Century Italy', in L. Panizza, ed., *Women in Italian Renaissance Culture and Society* (Oxford, 2000), pp.284–314

Matthews-Grieco, S. and Brevaglieri, S., eds, *Monaca, moglie, serva, cortigiana. Vita e immagine delle donne tra Rinascimento e Controriforma* (Florence, 2001)

Mattioli, Pietro Andrea, *Il Magno Palazzo del Cardinale di Trento* (Venice, 1539); repr. in E. Castelnuovo, ed., *Il Castello del Buonconsiglio. Percorso nel Magno Palazzo*, 2 vols (Trent, 1995)

Mattingly, H., *Coins of the Roman Empire in the British Museum: Nerva to Hadrian* (London, 1936)

Mattox, E. P., 'The Domestic Chapel in Renaissance Florence, 1400–1500', (unpub. Ph.D. diss., Yale University, 1996)

Mayer, L. A., *Islamic Metalworkers and their Works* (Geneva, 1959)

Mazzi, C., *La congrega dei Rozzi di Siena nel secolo XVI* (Florence, 1882)

Mazzi, C., 'La casa di Maestro Bartalo di Tura', *Bullettino senese di storia patria*, III (1896), pp.142–76, 394–401; IV (1897), pp.107–114; V (1898), pp.81–8, 270–77, 436–51; VI (1899), pp.139–46, 393–400, 513–9; VII (1900), pp.300–324

Mazzi, C., 'La mensa dei priori di Firenze nel secolo XIV', *Archivio storico italiano*, XX (1897), pp.336–68

Mazzi, C., 'Libri e masserizie di Giovanni di Pietro (Fecini) nel 1450 in Siena', *Bullettino senese di storia patria*, XVIII (1911), pp.150–72

Mazzi, G., 'La costruzione della città cinquecentesca', in Lanaro, Marini and Varanini, eds, *Edilizia private nella Verona rinascimentale* (Milan, 2000), pp.192–217

Mazzi, M. S. and Raveggi, S., *Gli uomini e le cose nelle campagne fiorentine del quattrocento* (Florence, 1983)

Mazzoni, G., ed., *Falsi d'autore. Icilio Federico Joni e la cultura del falso tra otto e novecento* (Siena, 2004)

'Medicinalia quam plurima', Biblioteca Universitaria, Genova, MS F.VI.4

Meek, C., 'Un'unione incerta: la vicenda di Neria, figlia dell'organista, e di Baldassino, merciaio pistoiese', in Seidel Menchi and Guaglioni, eds, *Matrimoni in dubbio. Unioni controverse e nozze clandestine in Italia dal XIV al XVIII secolo* (Bologna, 2001), pp.107–22

Meiss, M., *Painting in Florence and Siena*

after the Black Death (Princeton, 1951)

Meiss, M., 'Light as Form and Symbol in Some Fifteenth-Century Paintings', in M. Meiss, *The Painter's Choice: Problems in the Interpretation of Renaissance Art* (New York, 1976), pp.3–18

Melikian-Chirvani, S., *Islamic Metalwork from the Iranian World: 8–18th Centuries* (London, 1982)

Mendera, M., 'Gambassi Terme', in *Una via dell'arte in Toscana: il sistema museale della Valdelsa Fiorentina* (Florence, 2000) pp.78–105

Mengozzi, N., 'Il Monte dei Paschi di Siena', *Bullettino senese di storia patria,* XI/1–2 (1904), pp.470–635

Menjot, D., ed., *Les Soins de beauté. Moyen Age, temps modernes, Actes du colloque de Grasse* (Nice, 1987)

Mentasti, R. B. *et al*, eds, *Mille anni di arte del vetro a Venezia* (Venice, 1982)

Merkel, C., 'Tre corredi milanesi del quattrocento illustrati', *Bullettino dell'Istituto storico italiano,* XIII (1893), pp.97–184

Merkel, C., *I beni della famiglia di Puccio Pucci: inventario del sec. XV illustrato* (Bergamo, 1897)

Merzario, R., *Il paese stretto: strategie matrimoniali nella diocesi di Como, secoli XVI–XVIII* (Turin, 1981)

Messisbugo, Cristoforo, *Banchetti composizione di vivande e apparecchio generale,* ed. F. Bandini (Vicenza, 1992)

Messisbugo, Cristoforo, *Libro novo nel qual s'insegna a far d'ogni sorte di vivanda* (Venice, 1557; repr. Bologna, 1982)

Meyer Zur Capellen, J., *Raphael: A Critical Catalogue of his Paintings* (Landshut, 2001)

Michiel, Marcantonio, *Notizia d'opere del disegno,* ed. T. Frimmel (Florence, 2000)

Milano, A., 'Prints for Fans', *Print Quarterly,* IV (1987), pp.2–19

Milano, A. and Villani, E., *Museo d'Arti Applicate, Raccolta Bertarelli: ventole e ventagli* (Milan, 1995)

Mileham, M., *Platina: On Right Pleasure and Good Health* (Tempe, 1998)

Milesi, S., *Moroni e il primo cinquecento bergamasco: Lotto, Previtali, Cariani, Palma il Vecchio, Licinio* (Bergamo, 1991)

Miller, D., *Material Culture and Mass Consumption* (Oxford, 1987)

Miller, D., ed., *Home Possessions: Material Culture behind Closed Doors* (Oxford, 2001)

Millon, H. A. and Lampugnani, V. M., eds, *The Renaissance from Brunelleschi to Michelangelo. The Representation of Architecture* (London and Milan, 1994)

Mills, J., '"Lotto" Carpets in Western Paintings', *Hali,* III/4 (1981), pp.278–89

Mills, J., 'The Coming of the Carpet to the West', in King and Sylvester, eds, *The Eastern Carpet in the Western World from the 15th to the 17th Century* (London, 1983a), pp.10–23

Mills, J., *Carpets in Paintings* (London, 1983b)

Milsom, J., 'The Nonsuch Music Library', in Banks, Searle and Turner, eds, *Sundry Sorts of Music Books: Essays Presented to O.W. Neighbour on his 70th Birthday* (London, 1993), pp.146–82

Mira, G., *Vicende economiche di una famiglia italiana dal XIV al XVII secolo* (Milan, 1940)

Miziolek, J., *Soggetti classici sui cassoni fiorentini alla vigilia del Rinascimento* (Warsaw, 1996)

Miziolek, J., *Miti, leggende, exempla. La pittura profana del Rinascimento italiano della collezione Lanckoroński* (Warsaw, 2003)

Molà, L., *The Silk Industry of Renaissance Venice* (Baltimore and London, 2000)

Molà, L., 'Le donne nell'industria serica veneziana del Rinascimento', in Molà, Mueller and Zanier, eds, *La seta in Italia dal Medioevo al seicento. Dal baco al drappo* (Venice, 2000), pp.423–59

Molho, A., *Marriage Alliance in Late Medieval Florence* (Cambridge, MA, 1994)

Molmenti, P., *La storia di Venezia nella vita privata,* 3 vols (Bergamo, 1905–8)

Montaigne, Michel de, *Journal de voyage en Italie par la Suisse et l'Allemagne en 1580 et 1581,* ed. C. Dédéyan (Paris, 1946)

Morachiello, P., *Fra Angelico: The San Marco Frescoes* (London, 1995)

Morassi, A., *Il tesoro dei Medici: oreficerie, argenterie, pietre dure* (Milan, 1963)

Morazzoni, G., *La maiolica antica veneta* (Milan, 1955)

Morelli, Giovanni di Pagolo, *Ricordi,* ed. V. Branca (Florence, 1956)

Morison, S., 'Some New Light on Verini', *Newberry Library Bulletin,* III/2 (1953), pp.41–5

Morison, S., *Early Italian Writing-Books: Renaissance to Baroque,* ed. N. Barker (Verona, 1990)

Morselli, A., *Il corredo nuziale di Caterina Pico (1474)* (Modena, 1956)

Mortimer, R., *Catalogue of Books and Manuscripts. Part II, Italian 16th-Century Books* (Cambridge, MA, 1974)

Moryson, Fynes, *An Itinerary Containing his Ten Yeeres Travell* (London, 1617; fasc.ed., New York, 1971; 4 vols, Glasgow, 1907–08)

Mostra del costume nel tempo: momenti di arte e di vita dall'età ellenica al romanticismo (Venice, 1951)

Mostra dell'antica arte senese, aprile–agosto 1904: catalogo generale illustrato (Siena, 1904)

Mostra mercato internazionale dell'antiquariato, Palazzo Strozzi (Florence, 1963)

Mottola Molfino, A., 'Nobili, sagge e virtuose donne. Libri di modelli per merletti e organizzazione del lavoro femminile tra cinquecento e seicento', in R. Grispo, ed., *La famiglia e la vita quotidiana in Europa dal '400 al '600. Fonti e problemi* (Rome, 1986), pp.277–93

Mottola Molfino, A. *et al.*, *Il libro del sarto della Fondazione Querini Stampalia di Venezia* (Torino and Modena, 1987)

Motture, P., *Bells and Mortars and Related Utensils: Catalogue of Italian Bronzes in the Victoria and Albert Museum* (London, 2001a)

Motture, P., '"None but the finest things": George Salting as a Collector of Bronzes', *The Sculpture Journal,* V (2001b), pp.42–61

Motture, P., 'The Production of Firedogs in Renaissance Venice', in P. Motture, ed., *Large Bronzes in the Renaissance, CASVA Symposium Papers,* XLI (Washington, 2003), pp.277–307

Motture, P., 'Shouting Horseman' in A. Boström, ed., *The Encyclopedia of Sculpture* (New York, 2004), pp. 1425–7

Motture, P., 'Charity', in D. Franklin, ed., *Leonardo da Vinci, Michelangelo, and the Renaissance in Florence* (Ottawa, 2005), pp.184–5

Muir, E., 'The Virgin on the Street Corner: The Place of the Sacred in Italian Cities', in S. Ozment, ed., *Religion and Culture in the Renaissance and Reformation* (Ann Arbor, 1989), pp.25–40

Müller, U., 'Different Shape – Same Function? Medieval Handwashing Equipment in Europe', *Material Culture in Medieval Europe: Papers of the 'Medieval Europe Brugge 1997' Conference,* VII (Zellick, 1997), pp.251–64

Murphy, C., 'Lavinia Fontana and Female Life Cycle Experience in Late Sixteenth-Century Bologna', in Johnson and Matthews-Grieco, eds, *Picturing Women in Renaissance and Baroque Italy* (Cambridge, 1997), pp. 111–38

Murphy, C., 'Il ciclo di vita femminile: Norme comportamentali e pratiche di vita', in Matthews-Grieco and Brevaglieri, eds, *Monaca, moglie, serva, cortigiana. Vita e immagine della donna tra Rinascimento e Controriforma* (Florence, 2001), pp.14–47

Musacchio, J. M., 'Pregnancy and Poultry in Renaissance Italy', *Source,* XVI (1997), pp.3–9

Musacchio, J. M., 'The Medici-Tornabuoni *Desco da Parto* in Context', *Metropolitan Museum Journal,* XXXIII (1998), pp.137–51

Musacchio, J. M., *The Art and Ritual of Childbirth in Renaissance Italy* (London and New Haven, 1999)

Musacchio, J. M., 'The Madonna and Child, a Host of Saints and Domestic Devotion in Renaissance Florence', in Neher and Shepherd, eds, *Revaluing Renaissance Art* (Aldershot, 2000), pp.147–64

Musacchio, J. M., 'Weasels and Pregnancy in Renaissance Italy', *Renaissance Studies,* XV (2001), pp.172–87

Musacchio, J. M., 'The Medici Sale of 1495 and the Second-Hand Market for Domestic Goods in Florence', in Fantoni, Matthews and Matthews-Grieco, eds, *The Art Market in Italy: 15th–17th Centuries* (Ferrara, 2003), pp.313–323

Musacchio, J. M., 'Lambs, Coral, Teeth, and the Intimate Intersection of Religion and Magic in Renaissance Italy', in Montgomery and Cornelison, eds, *Image, Relic, and Devotion in Late Medieval and Renaissance Italy* (Tempe, 2005), pp. 139–56

Il Museo del Bargello (n.p., 1984)

Il Museo Horne. Una casa fiorentina del Rinascimento (Florence, 2001)

Museo Poldi Pezzoli. Ceramiche, vetri, mobili e arredi (Milan, 1983)

Nadi, Gaspare, *Diario bolognese,* ed. Ricci and Bacchi della Lega (Bologna, 1969)

Nagel, A., *Michelangelo and the Reform of Art* (Cambridge and New York, 2000)

Naldi, R., *Andrea Ferrucci, marmi gentili tra la Toscana e Napoli* (Naples, 2002)

Nepoti, S., 'Ceramiche dei secoli XIV–XVI rinvenute a Como: un primo bilancio sommario', in *Archeologia urbana in Lombardia: Como* (Como, 1984), pp.119–26

Nepoti Frescura, S., 'Cucina e ceramica nei ricettari dei secoli XIV–XVII', *Atti IX Convegno Internazionale della Ceramica* (Albisola, 1976), pp.129–48

Nepoti, S., *Ceramiche graffite della Donazione Donini Baer* (Faenza, 1991)

Neri di Bicci, *Le ricordanze,* ed. B. Santi (Pisa, 1976; repr. 1978)

Nesbitt, A., *A Descriptive Catalogue of the Glass Vessels in the South Kensington Museum* (London, 1878)

Newcomb, A., 'Courtesans, Muses, or Musicians? Professional Women Musicians in Sixteenth-Century Italy', in Bowers and Tick, eds, *Women Making Music: The Western Art Tradition* (Urbana, 1986), pp.90–115

Newett, M. M., ed., *Canon Pietro Casola's Pilgrimage to Jerusalem in the*

Year 1494 (Manchester, 1907)

Niccoli, O., *Prophecy and People in Renaissance Italy* (Princeton, 1990)

Nicoud, M., 'Les médecins italiens et le bain thermal', *Médiévales,* XLIII (2002), pp.13–40

Nigro, G., *Il tempo liberato. Festa e svago nella città di Francesco Datini* (Florence, 1994)

Nordenskiöld, A. E., *Facsimile Atlas to the Early History of Cartography* (Stockholm, 1889)

Norman, D., *Siena and the Virgin: Art and Politics in a Late Medieval City State* (New Haven and London, 1999)

Nova, A., 'Hangings, Curtains, and Shutters of Sixteenth-Century Lombard Altarpieces', in Borsook and Superbi Gioffredi, eds, *Italian Altarpieces, 1250–1550* (Oxford, 1994), pp.177–89

Nuovo, A., *Il commercio librario nell'Italia del Rinascimento* (Milan, 3rd edn, 2003)

Nuovo, A. and Sandal, E., *Il libro nell'Italia del Rinascimento* (Brescia, 1998)

Nuttall, P., *From Flanders to Florence: The Impact of Netherlandish Painting, 1400–1500* (New Haven and London, 2004)

O'Malley, M., *The Business of Art: Contracts and the Commissioning Process in Renaissance Italy* (New Haven and London, 2005)

Olson, R. J. M., *The Florentine Tondo* (Oxford, 2000)

Oman, C. C., *Catalogue of Rings* (London, 1930)

Oman, C. C., *Italian Secular Silver* (London, 1962)

Ongaro, G., 'The Tieffenbruckers and the Business of Lute-Making in Sixteenth-Century Venice', *Galpin Society Journal,* XLIV (1991), pp.46–54

Ongaro, G., 'The Library of a Sixteenth-Century Music Teacher', *Journal of Musicology,* XII (1994), pp.57–75

Opera nuova intitolata dificio di ricette (Venice, 1534)

Orefice, G., *Rilievi e memorie dell'antico centro di Firenze. 1885–1895* (Florence, 1986)

Origo, I., *The Merchant of Prato* (London, 1957)

Origo, I., *The World of San Bernardino* (London, 1963)

Orsi Landini, R., 'All'origine della produzione moderna: il differenziarsi della produzione per abbigliamento e arredamento nei velluti fra cinque e seicento', in Zanni, Bellezza Rosina and Ghirardi, eds, *Velluti e moda tra XV e XVII secolo* (Milan, 1999), pp.17–22

Osley, A. S., *Luminario. An Introduction to the Italian Writing-Books of the Sixteenth and Seventeenth Centuries* (Nieuwkoop, 1972)

Öz, T., *Turkish Textiles and Velvets – XIV–XVI Centuries* (Ankara, 1950)

Paciolo, Luca, *Trattato de' computi e delle scritture,* ed. V. Gitti (Turin, 1878)

Pagliara, P. N., '"Destri" e cucine nell'abitazione del XV e XVI secolo, in specie a Roma' in A. Scotti Tosini, ed., *Aspetti dell'abitare in Italia tra XV e XVI secolo. Distribuzione, funzioni, impianti* (Milan, 2001), pp.39–99

Palatino, Giovambattista, *Libro…nel qual s'insegna à scrivere ogni sorte di lettera* (Rome, 1545), in facs. ed., *Three Classics of Italian Calligraphy* (New York, 1953)

Palazzi, P. et al., 'Archeologia urbana a Finalborgo (1997–2001): gli scavi nella piazza e nel complesso conventuale di Santa Caterina', *Archeologia medievale,* XXX (2003), pp.183–242

Palazzo Vecchio: committenza e collezionismo medicei (Florence, 1980)

Paleario, Aonio, *Dell' economia o vero del governo della casa,* ed. S. Caponetto (Florence, 1983)

Paliaga, F., *Vincenzo Campi: scene del quotidiano* (Milan, 2000a)

Paliaga, F., 'Natura morta e collezionismo nel Veneto', in G. Godi, ed., *Fasto e rigore. La natura morta nell'Italia settentrionale dal XVI al XVIII secolo* (Milan, 2000b), pp.77–87

Palisca, C.V., *The Florentine Camerata: Documentary Studies and Translations* (New Haven, 1989)

Palladio, Andrea, *I quattro libri dell'architettura di Andrea Palladio,* 4 vols (Venice, 1570); ed. Magagnato and Marini (Milan, 1980)

Pallavicino, Giulio, *Inventione di Giulio Pallavicino di scriver tutte le cose accadute alli tempi suoi (1583–1589),* ed. E. Grendi (Genoa, 1975)

Pallucchini, R., *Mostra di Paolo Veronese* (Venice, 1939)

Palmer, R., 'Pharmacy in the Republic of Venice in the Sixteenth Century', in Wear, French and Lonie, eds, *The Medical Renaissance of the Sixteenth Century* (Cambridge, 1985), pp.100–17

Palmer, R., '"In this our lightye and learned tyme": Italian Baths in the Era of the Renaissance', *Medical History,* X (1990), pp.14–22

Palmer, R., 'In Bad Odour: Smell and its Significance in Medicine from Antiquity to the Seventeenth century', in Bynum and Porter, eds, *Medicine and the Five Senses* (Cambridge, 1993), pp.61–8

Palumbo Fossati, I., 'L'interno della casa dell'artigiano e dell'artista nella Venezia del cinquecento', *Studi veneziani,* VIII (1984), pp.109–53

Palumbo Fossati, I., 'Livres et lecteurs dans la Venise du XVIe siècle', LIV, *Revue francaise d'histoire du livre* (1985), pp.481–513

Palumbo Fossati, I., 'La casa veneziana di Gioseffe Zarlino nel testamento e nell'inventario dei beni del grande teorico musicale', *Nuova rivista musicale italiana,* IV (1986), pp.633–41

Palumbo Fossati, I., 'La casa veneziana', in Toscano e Valcanover, eds, *Da Bellini a Veronese. Temi di arte veneta* (Venice, 2004), pp.443–91

Pancino, C., 'Soffrire per ben comparire. Corpo e bellezza, natura e cura', in Belfanti and Giusberti, eds, *La moda, Storia d'Italia,* XIX (Turin, 2003), pp.31–2

Pandiani, E., *Vita privata dei genovesi nel Rinascimento* (Genoa, 1915)

Panelli, Spacca, *Nuova maniera d'imparare molte sorti di giochi* (Padua and Bassano, n.d.)

Panizza, L., ed., *Women in Italian Renaissance Culture and Society* (Oxford, 2000)

Panofsky, E., *Early Netherlandish Painting: Its Origins and Character* (Cambridge, MA, 1953)

Pantò, G., ed., *Il Monastero della Visitazione a Vercelli: archeologia e storia* (Alessandria, 1996)

Pantò, G., 'Vita castellana e strutture difensive del Biellese dalle fonti archeologiche', in L. Spina, ed., *I castelli biellesi* (Milan, 2001), pp.17–31

Pantò, G. and Carli, L., 'Villata: chiesa di San Barnaba apostolo', *Quaderni della Soprintendenza Archeologica del Piemonte,* IV (1985), pp.67–8

Paoletti, J., 'Familiar Objects: Sculptural Types in the Collections of the Early Medici', in S. Blake McHam, ed., *Looking at Italian Renaissance Sculpture* (Cambridge, 1998), pp.79–110

Paolin, G., ed., *Lettere familiari della nobildonna veneziana Fiorenza Capello Grimani 1592–1605* (Trieste, 1996)

Paolini, C., 'Una raffinata dimora signorile', *MCM La storia delle cose,* V/14 (1991), pp.28–31

Paolini, C., *Il mobile del Rinascimento: la collezione Herbert Percy Horne* (Florence, 2002)

Paolini, C., *I luoghi dell'intimità. La camera da letto nella casa fiorentina del Rinascimento* (Florence, 2004)

Pardi, G., 'La mobilia di un gentiluomo ferrarese del cinquecento', *Atti della Deputazione Ferrarese di Storia Patria,* XIII (1901)

Pardi, G., 'La suppellettile dei palazzi estensi in Ferrara nel 1436', *Atti e memorie della Deputazione Ferrarese di Storia Patria,* XIX (1908), pp.3–181

Pardo, M., 'Memory, Imagination, Figuration: Leonardo da Vinci and the Painter's Mind', in Küchler and Melion, eds, *Images of Memory: On Remembering and Representation* (Washington and London, 1991), pp.47–73

Paré, A., *On Monsters and Marvels,* trans. J. L. Pallister (Chicago, 1982)

Park, K., *Doctors and Medicine in Early Renaissance Florence* (Princeton, 1985)

Parshall, P. and Schoch, R., *Origins of European Printmaking: Fifteenth-Century Woodcuts and their Public* (Washington, 2005)

Paschetti, Bartolomeo, *Del conservar la sanità et del vivere dei genovesi* (Genoa, 1602)

Pasini, A., *Storia della Madonna del Fuoco di Forlì* (Forlì, 1936)

Passerini, G. L., ed., *Ricette da fare bella* (Florence, 1912)

Passerini, L., *Genealogia e storia della famiglia Panciatichi* (Florence, 1858)

Pastoureau, M., *Bleu. L'histoire d'une couleur* (Paris, 2000)

Pavoni, R., *Museo Bagatti Valsecchi a Milano* (Milan, 1994)

Pavoni, R., *Reviving the Renaissance: The Use and Abuse of the Past in Nineteenth-Century Italian Art and Decoration,* trans. A. Belton (Cambridge, 1997)

Pazzi, P., *Introduzione al collezionismo di argenteria civile e metalli veneti antichi* (Venice, 1993)

Pediconi, A., *The Art and Culture of Bathing in Renaissance Rome* (unpub. M.A. diss., Royal College of Art, 2003)

Pellecchia, L., *The Gondi Palace Step Ends: The Greek and Arabic Sources* (forthcoming)

Pennell, S., *Women and Medicine: Remedy Books 1533–1865 from the Wellcome Library for the History and Understanding of Medicine, London* (Reading, 2004)

Pennell, S., 'Credit and Credibility in the "Medical Marketplace": Thinking about the Cultural Economics of Early Modern Medicine', in Jenner and Wallis, eds, *The Medical Market-Place Re-Visited* (forthcoming, 2007)

Penny, N., *National Gallery Catalogues: The Sixteenth-Century Italian Paintings,* I (London, 2004)

Penny, N., 'Introduction: Toothpicks and Green Hangings', *Renaissance Studies* XIX/5 (2005a), pp.581–90

Penny, N., 'Cradles in the *Portego*', *London Review of Books* (5 January, 2005b), pp.20–22

Perosa, A., ed., *Giovanni Rucellai e il suo zibaldone. Il zibaldone quaresimale* (London, 1960)

Pesce, G., 'Gemme medicee del Museo Nazionale di Napoli', *Rivista dell'Istituto d'Archeologia e Storia dell'Arte,* V (1935), pp.50–97

Pettenati, S., *I vetri dorati e graffiti e i vetri dipinti* (Turin, 1978)

Pettenati, S., *Dagli ori antichi agli anni venti: le collezioni di Riccardo Gualino* (Milan, 1982)

Pezzarossa, F., 'La tradizione fiorentina della memorialistica', in Anselmi, Pezzarossa and Avellini, eds, *La 'memoria' dei mercatores. Tendenze ideologiche, ricordanze, artigianato in versi nella Firenze del quattrocento* (Bologna, 1980), pp.39–149

Phan, M. C., 'Pratiques cosmétiques et idéal féminin dans l'Italie des XVème et XVIème siècles', in D. Menjot, ed., *Les Soins de beauté. Moyen Age, temps modernes, Actes du colloque de Grasse* (Nice, 1987)

Phillips, M., 'Matchmaking and Other Troubles', in M. Phillips, *The Memoir of Marco Parenti. A Life in Medici Florence* (Princeton, 1987), pp.150–168

Piacenti, C. A., *Il Museo degli Argenti a Firenze* (Florence and Milan, 1967)

Piana, M., 'Acqua e fuoco nella casa veneziana del cinquecento', in A. Scotti Tosini, ed., *Aspetti dell'abitare in Italia tra XV e XVI secolo. Distribuzione, funzioni, impianti* (Milan, 2001), pp.93–9

Pianca, V. and Velluti, F., *Interno veneto: arredamento domestico fra Trevigiano e Bellunese dal Gotico al Rinascimento* (Vittorio Veneto, 2002)

Piattoli, R., 'In una casa borghese del secolo XIV', *Archivio storico pratese*, VI (1926), pp.112–23

Piattoli, R., 'Un mercante del trecento e gli artisti del tempo suo', *Rivista d'arte*, XI (1930), pp.221–53, 396–437

Picciani, A., 'Sant'Antonino, San Bernardino e Pier di Giovanni Olivi nel pensiero economico medioevale', *Economia e storia. Rivista italiana di storia economica e sociale*, III (1972), pp.315–41

Piccinini, Alessandro, *Intavolatura di liuto e di citarrone libro primo* (Bologna, 1620)

Piccolomini, Alessandro, *L'Hortensio* (Venice, 1574)

Piccolomini, Alessandro, *La Raffaella ovvero della bella creanza delle donne* (Milan, 1862)

Piccolomini, Enea Silvio, *I commentari*, ed. G. Bernetti, 5 vols (Siena, 1972–6)

Piccolpasso, Cipriano, *Li tre libri dell'arte del vasaio*, National Art Library, London, MS MSL 1861 7446; ed. Lightbown and Caiger-Smith (London, 1980)

Piemontese, Alessio, *Secreti medicinali* (Venice, 1603)

Pignatti, T., ed., *Lorenzo Lotto* (Milan, 1953)

Pignatti, T., *Carpaccio* (Geneva, 1958)

Pignatti, T., *Mobili italiani del Rinascimento* (Milan, 1962)

Pignatti, T., *Veronese* (Venice, 1976)

Pignatti, T., ed., *Le scuole di Venezia* (Milan, 1981)

Pignatti, T. and Pedrocco, F., *Veronese*, 2 vols (Milan, 1995)

Pinner, R. and Stranger, J., '"Kufic" Borders on "Small Pattern Holbein" Carpets', *Hali*, I/4 (1978), pp.335–8

Pinney, C., 'Piercing the Skin of the Idol', in Pinney and Thomas, eds, *Beyond Aesthetics: Art and the Technologies of Enchantment* (Oxford, 2001), pp.157–79

Piovene, G. and Marini, R., eds, *L'opera completa del Veronese* (Milan, 1968)

Pisanelli, Baldassare, *Trattato della natura de' cibi et del bere* (Venice, 1586)

Planiscig, L., *Andrea Riccio* (Vienna, 1927)

Planiscig, L., *Bernardo und Antonio Rossellino* (Vienna, 1942)

Poeschke, J., *Die Skulptur der Renaissance in Italien: Donatello und seine Zeit* (Munich, 1990)

Poleggi, E., 'Un documento di cultura abitativa', in G. Biavati, ed., *Rubens e Genova* (Genoa, 1978), pp.85–148

Politi, G., *La società cremonese nella prima età spagnola* (Milan, 2002)

Polizzotto, L., '*Dell'arte del ben morire*: The Piagnone Way of Death 1494–1545', *I Tatti Studies*, III (1989), pp.27–87

Pollard, A., ed., *Italian Book Illustrations and Early Printing: A Catalogue of Early Italian Books in the Library of C. W. Dyson Perrins* (Oxford, 1914)

Pollen, J. H., *Ancient and Modern Furniture and Woodwork in the South Kensington Museum* (London, 1874; repr. 1875)

Pollen, J. H., *South Kensington Museum Art Handbook, Furniture Ancient and Modern* (London, 1875)

Pollen, J. H., *Ancient and Modern Furniture and Woodwork in the South Kensington Museum* (London, 1924)

Pontano, Giovanni, *De Liberalitate, De Beneficentia, De Magnificentia, De Splendore, De Conviventia* (Naples, 1498)

Pontano, Giovanni, *Opera omnia soluta oratione composita* (Venice, 1518)

Pontano, Giovanni, *I trattati delle virtù sociali*, ed. F. Tateo (Rome, 1965)

Pontano, Giovanni, *I libri delle virtù sociali*, ed. F. Tateo (Rome, 1999)

Popham, A. E., *Catalogue of Drawings of Parmigianino*, 3 vols (New Haven and London, 1971)

Pope-Hennessy, J., 'A Cartapesta Mirror Frame', *Burlington Magazine*, XCII (1950), pp.288–91

Pope-Hennessy, J., *Italian Renaissance Sculpture* (London, 1958; 4th ed. 1996; repr. 2002)

Pope-Hennessy, J., *Catalogue of Italian Sculpture in the Victoria and Albert Museum*, 3 vols (London, 1964)

Pope-Hennessy, J., *Renaissance Bronzes from the Samuel H. Kress Collection* (London, 1965)

Pope-Hennessy, J., *The Portrait in the Renaissance* (London and New York, 1966)

Pope-Hennessy, J., 'The Altman Madonna by Antonio Rosselino', *Metropolitan Museum Journal*, III (1970), pp.133–48

Pope-Hennessy, J., 'The Madonna Reliefs of Donatello', *Apollo*, CIII (1976), pp.172–91

Pope-Hennessy, J., *Luca della Robbia* (Oxford, 1980)

Pope-Hennessy, J., *Cellini* (London, 1985)

Pope-Hennessy, J., *Donatello* (Berlin, 1986)

Pope-Hennessy, J., 'The Study of Italian Plaquettes', in A. Luchs, ed., *Italian Plaquettes*, *CASVA Symposium Papers*, IV (Washington, 1989), pp.19–32

Pope-Hennessy, J., *On Artists and Art Historians: Selected Book Reviews of John Pope-Hennessy*, ed. Kaiser and Mallon (Florence, 1994)

Pope-Hennessy, J. and Christiansen, K., 'Secular Painting in 15th-century Tuscany: Birth Trays, Cassone Panels, and Portraits', *Metropolitan Museum of Art Bulletin*, XXXVIII (1980), pp.4–64

Porter, R., *The Greatest Benefit to Mankind: A Medical History of Humanity from Antiquity to the Present* (London, 1997)

Prampolini, G., *L'Annunciazione nei pittori primitivi italiani* (Milan, 1939)

Pratt, L. and Woolley, L., *Shoes* (London, 1999)

Preyer, B., 'The "chasa overo palagio" of Alberto di Zanobi: A Florentine Palace of about 1400 and its Later Remodeling', *Art Bulletin*, LXV/3 (1983), pp.387–401

Preyer, B., *Il Palazzo Corsi-Horne. Dal Diario di Restauro di H. P. Horne* (Rome, 1993)

Preyer, B., 'Planning for Visitors at Florentine Palaces', *Renaissance Studies*, XII (1998) pp.357–74

Preyer, B., 'Around and In the Gianfigliazzi Palace in Florence: Developments on Lungarno Corsini in the 15th and 16th Centuries', *Mitteilungen des Kunsthistorischen Institutes in Florenz*, XLVIII (2004), pp.55–104

Preyer, B., 'Il palazzo di messer Benedetto degli Alberti, e di Leon Battista', in E. Bentivoglio, ed., *Il testamento di Leon Battista Alberti. I tempi, i luoghi, i protagonisti* (Rome, 2005), pp.89–92

Preyer, B., '*Da chasa gli Alberti*: The "Territory" and Housing of the Family' (forthcoming)

Priever, A., *Paolo Caliari, Called Veronese 1528–1588* (Cologne, 2000)

Princely Magnificence: Court Jewels of the Renaissance, 1500–1630 (London, 1980)

Proto Pisani, R., *La raccolta di arte sacra del Museo di Fucecchio* (Florence, 2004)

Puppi, L., 'Schedule per la storia della pittura veronese tra la fine del '400 e l'inizio del '500', *Arte antica e moderna*, XXVIII (1965), pp.416–27

Puppi, L., 'Un racconto di morte e di immortalità: San Girolamo nello studio di Antonello da Messina', in G. Ferroni, ed., *Modi del raccontare* (Palermo, 1987), pp.34–45

Quando gli dei si spogliano. Il bagno di Clemente VII a Castel Sant'Angelo e le altre stufe romane del primo Cinquecento (Rome, 1984)

Rackham, B., *Catalogue of Italian Maiolica*, 2 vols (London, 1940)

Radcliffe, A., 'Bronze Oil Lamps by Riccio', *Victoria and Albert Museum Yearbook*, III (1972), pp.29–58

Radcliffe, A., 'Ricciana', *Burlington Magazine*, CXXIV (1982), pp.412–24

Radcliffe, A. and Boucher, B., 'Sculpture', in *The Genius of Venice 1500–1600*, ed. Martineau and Hope (London, 1983), pp.355–91

Radcliffe, A., 'The Debasement of Images: The Sculptor Andrea Riccio and the Applied Arts in Padua in the Sixteenth Century', in Currie and Motture, eds, *The Sculpted Object, 1400–1700* (Aldershot, 1997), pp.87–98

Radcliffe, A. and Avery, C., 'The Chellini Madonna by Donatello', *Burlington Magazine*, CXVIII (1976), pp.377–87

Radcliffe, A., Baker, M., and Maek-Gérard, M., *The Thyssen-Bornemisza Collection: Renaissance and Later Sculpture with Works of Art in Bronze* (London, 1992)

Radke, G., 'Verrocchio and the Image of the Youthful David in Florentine Art', in G. Radke, ed., *Verrocchio's David Restored: A Renaissance Bronze from the Nazional Museum of the Bargello* (Florence, 2003), pp.35–53

Ragghianti Collobi, L., *La sedia italiana nei secoli* (Florence, 1951)

Raggio, O. and Wilmering, A. M., *The Gubbio Studiolo and its Conservation* (New York, 1999)

Ragusa, I. and Green, R. B., eds, *Meditations on the Life of Christ: An Illustrated Manuscript of the Fourteenth Century, Paris, Bibliothèque Nationale, Ms. Ital. 115* (Princeton, 1961)

Rainey, R. E., 'Sumptuary Legislation in Renaissance Florence' (unpub. Ph.D. diss., Columbia University, 1985)

Randolph, A. W. B., 'Performing the Bridal Body in Fifteenth-Century Florence', *Art History*, XXI/2 (1998), pp.182–200

Randolph, A. W. B., *Engaging Symbols: Gender, Politics, and Public Art in Fifteenth-Century Florence* (New Haven and London, 2002)

Randolph, A. W. B., 'Gendering the Period Eye: Deschi da Parto and Renaissance Visual Culture', *Art History*, XXVII (2004), pp.538–62

Randall, R. H., 'A Mannerist Jewel', *Bulletin of the Walters Art Gallery*, XX/1 (1967)

Rasmussen, J., *Italienische Majolika* (Hamburg, 1984)

Ravanelli Guidotti, C., 'Osservazioni sul servizio di Alfonso II d'Este con il motto ARDET AETERNUM', *Annali di studi Pennabilli nel Montefeltro. VII Convegno della Ceramica* (Pennabilli, 1986) pp.27–37

Ravanelli Guidotti, C., *Donazione Paolo Mereghi: ceramiche europee ed orientali* (Casalecchio di Reno, c.1987)

Ravanelli Guidotti, C., 'Maioliche faentine datate: un disco di censo con lo stemma Cattoli del 1532', *Faenza*, LXXIV/4–6 (1988), pp.213–18

Ravanelli Guidotti, C., ed., *La donazione Angiolo Fanfani: ceramiche dal Medioevo al XX secolo* (Faenza, 1990)

Ravanelli Guidotti, C., *Faenza-Faïence: "Bianchi" di Faenza* (Ferrara and Montorio, 1996)

Ravanelli Guidotti, C., *Thesaurus di opere della tradizione di Faenza* (Faenza, 1998)

Ravanelli Guidotti, C., *Delle gentili donne di Faenza. Studio del 'ritratto' sulla ceramica faentina del Rinascimento* (Ferrara, 2000)

Ravanelli Guidotti, C., *Musica di smalto: maioliche fra XVI e XVIII secolo del Museo Internazionale delle Ceramiche in Faenza* (London and Ferrara, 2004)

Ray, A., *Spanish Pottery, 1248–1898: With a Catalogue of the Collection in the Victoria and Albert Museum* (London, 2000)

Rearick, R., 'The Early Portraits of Paolo Veronese', in M. Gemino, ed., *Nuovi studi su Paolo Veronese* (Venice, 1990), pp.347–58

Rebora, G., 'La cucina medievale italiana tra Oriente e Occidente', *Miscellanea storica ligure*, XIX (1987), pp.1431–1579

Reist, I. J., 'Olympia déjà vue', *Gazette des beaux-arts*, CXI (1988), pp.265–7

Rerum Italicarum Scriptores, 'Cronache senesi', XV/4 (Bologna, 1934)

Reynolds, C., 'Reality and Image: Interpreting Three Paintings of the Virgin and Child in an Interior Associated with Campin', in Foister and Nash, eds, *Robert Campin: New*

Directions in Scholarship (Turnhout, 1996), pp.183–95

Ricci, C., *Il Palazzo Pubblico di Siena e la mostra d'antica arte senese* (Bergamo, 1904)

Ricci, Giuliano de', *Cronaca 1532–1606*, ed. G. Sapori (Milan and Naples, 1972)

Ricci, M., 'Peruzzi e Serlio a Bologna', in R. J. Tuttle, ed., *Jacopo Barozzi da Vignola* (Milan 2002), pp.119–25

Riccò, L., 'L'invenzione del genere "veglie di Siena"', in *Passare il tempo. La letteratura del gioco e dell'intrattenimento dal XII al XVI secolo* (Rome, 1993), pp.373–98

Riccò, L., *Giuoco e teatro nelle veglie di Siena* (Rome, 1993)

Rice, E. F. Jr., *Saint Jerome in the Renaissance* (Baltimore, 1988)

Richards, G. R. B., ed., *Florentine Merchants in the Age of the Medici* (Cambridge MA, 1932)

Richardson, B., *Printing, Writers and Readers in Renaissance Italy* (Cambridge, 1999)

Rigoli, A. et al., *Fuoco, acqua, cielo, terra: stampe popolari profane della 'Civica Raccolta Achille Bertarelli'* (Vigevano, 1995)

Rigoni, E., 'Testamenti di tre scultori del cinquecento', in *L'arte rinascimentale in Padova. Studi e documenti* (Padua, 1970), pp.217–37

Rinaldi, G., *L'attività commerciale nel pensiero di San Bernardino da Siena (1380–1444)* (Rome, 1959)

Ringbom, S., 'Devotional Images and Imaginative Devotions', *Gazette des beaux-arts*, LXXXIII (1969), pp.159–70

Ringhieri, Innocenzio, *Cento giuochi liberali et d'ingegno* (Bologna, 1551)

Roberts, S., 'Lying among the Classics: Ritual and Motif in Elite Elizabethan and Jacobean Beds', in L. Gent, ed., *Albion's Classicism: The Visual Arts in Britain, 1550–1660* (New Haven and London, 1995), pp.325–57

Robertson, G., *Vincenzo Catena* (Edinburgh, 1954)

Robinson, J. C., *Catalogue of the Soulages Collection* (London, 1856)

Robinson, W., 'Oriental Metalwork in the Gambier-Parry Collection', *Burlington Magazine*, CIX (1967), pp.167–73

Rocke, M., *Forbidden Friendships. Homosexuality and Male Culture in Renaissance Florence* (New York and Oxford, 1996)

Rohlmann, M., *Auftragskunst und Sammlerbild: altniederländische Tafelmalerei im Florenz des Quattrocento* (Alfter, 1994)

Romano, D., *Patricians and 'Popolani': The Social Foundations of the Venetian Renaissance State* (Baltimore, 1987)

Romano, D., *Housecraft and Statecraft: Domestic Service in Renaissance Venice, 1400–1600* (Baltimore and London, 1996)

Romoli, Domenico, *La singolare dottrina... dell'ufficio dello scalco* (Venice, 1560)

Rosello, Paolo, 'Dialogo nel qual si tratta il modo di conoscere, et di fare la scelta d'un servitore, et de l'ufficio', in *Due dialoghi di Messer Paolo Rosello* (Venice, 1549)

Rossi, F., *Il Museo Horne a Firenze* (Milan, 1966–67)

Rossi, F., *Accademia Carrara, Bergamo: catalogo dei dipinti* (Bergamo, 1979)

Rossi, F., *Accademia Carrara. Catalogo dei dipinti sec. XV–XVI* (Bergamo, 1988)

Rossi, F., *Il Moroni* (Soncino, 1991)

Rossi, F., ed., *Bergamo, l'altra Venezia: Il Rinascimento negli anni di Lorenzo Lotto, 1510–1530* (Milan and Bergamo, 2001)

Rossi, F. and Gregori, M., eds, *Giovan Battista Moroni (1520–1578)* (Bergamo, 1979)

Roux, S., *La casa nella storia* (Rome, 1982)

Rovida, M. A., *La casa come 'bene di consumo' nelle operazioni immobiliari di Francesco Sassetti. Modi d'abitare e strategie insediative nella Firenze del secondo quattrocento* (Florence, 2003)

Rubin, P. L., *Images and Identity in Fifteenth-Century Florence* (forthcoming, New Haven and London, 2006)

Rubin, P. L. and Wright, A., eds, *Renaissance Florence: The Art of the 1470s* (London, 1999)

Rubens, Peter Paul, *Palazzi di Genova* (Antwerp, 1622)

Ruda, J., 'Flemish Painting and the Early Renaissance in Florence: Questions of Influence', *Zeitschrift für Kunstgeschichte*, XLVII (1984), pp.210–36

Ruda, J., *Fra Filippo Lippi: Life and Work with a Complete Catalogue* (London, 1993)

Ruggiero, G., *The Boundaries of Eros: Sex Crime and Sexuality in Renaissance Venice* (New York, 1985)

Ruggiero, G., *Binding Passions: Tales of Magic, Marriage and Power at the End of the Renaissance* (Oxford, 1993)

Rummel, E., ed., *Erasmus on Women* (Toronto and Buffalo, 1996)

Russell, R. and Baines, A., *Catalogue of Musical Instruments*, 2 vols (London, 1968)

Saalman, H. and Mattox, P., 'The First Medici Palace', *Journal of the Society of Architectural Historians*, XLIV (1985), pp.329–45

Sabba da Castiglione, see Castiglione, Sabba da

Sabban, F., and Serventi, S., *A tavola nel*

Rinascimento (Laterza, 2005)

Sabin, J., *A Dictionary of Books relating to America* (New York, 1868–1936)

Sacchetti, Franco, *Il trecentonovelle*, ed. A. Lanza (Florence, 1984; repr. Milan, 1993)

Sachs, A., *Le nozze in Friuli nei secoli XVI e XVII* (Bologna, 1983)

Sadie, S., ed., *The New Grove Dictionary of Music and Musicians*, 29 vols (London, 2001)

Saffrey, H., 'Ymago de facili multiplicabilis in cartis: un document méconnu de 1412 sur l'origine de la gravure sur bois à Venise', *Nouvelles de l'estampe*, LXXIV (1984), pp.4–7

Salmi, M., *Il Palazzo e la collezione Chigi-Saracini* (Siena, 1967)

Salvatici, L., *Posate, pugnali, coltelli da caccia del Museo Nazionale del Bargello* (Florence, 1999)

Sander, M., *Le livre à figures italien depuis 1467 jusqu'à 1530* (Milan, 1942)

Sandström, S., *Levels of Unreality: Studies in Structure and Construction in Italian Mural Painting during the Renaissance* (Stockholm, 1963)

Sangiorgi, G., ed., *Collection Carrand au Bargello* (Rome, 1895)

Sansovino, Francesco, *Vita della illustre signora Contessa Giulia Bemba della Torre* (Venice, 1565)

Sansovino, Francesco, *Venetia. Città nobilissima et singolare* (Venice, 1581); with additions by Giustiniano Martinioni, 2 vols (Venice, 1663)

Santangelo, A., *Tessuti d'arte italiani dal XII al XVIII secolo* (Milan, 1959)

Santi, B., *La collezione Chigi Saracini* (Siena, 1998)

Santi, B. and Strinati, C., eds, *Siena e Roma. Raffaello, Caravaggio e i protagonisti di un legame antico* (Siena, 2005)

Santore, C., 'Julia Lombardo, "Somtuosa Meretrize": A Portrait by Property', *Renaissance Quarterly*, XLI (1988), pp.44–83

Santore, C., 'The Tools of Venus', *Renaissance Studies*, XI (1997), pp.179–207

Sanudo, Marino, *De origine, situ et magistratibus urbis Venetae ovvero La città di Venetia (1493–1530)*, ed. A. Caracciolo Aricò (Milan, 1980)

Sarti, R., *Vita di casa. Abitare, mangiare e vestire nell'Europa moderna* (Rome–Bari, 1999; repr. 2003)

Sarti, R., *Europe at Home. Family and Material Culture 1500–1800* (New Haven and London, 2002)

Sartori, F., ed., *La Casa Grande dei Foscari in volta de canal: documenti* (Venice, 2001)

Savage, N. et al., *Early Printed Books 1478–1840: Catalogue of the British Architectural Library Early Imprints Collection* (London, 1994)

Sberlati, F., 'Un lapidario del cinquecento. La "Miniera del Mondo" di Giovanni Maria Bonardo', *Filologia critica*, XXI/2 (1966), pp.188–241

Scalia, F., in *Palazzo Vecchio: committenza e collezionismo medicei 1537–1610, Firenze e la Toscana dei Medici nell'Europa del cinquecento* (Florence, 1980)

Scalia, F. et al., eds, *Art from Florentine Collections* (Philadelphia, 1982)

Scalia, F. et al., eds, *Messaggio artistico da Firenze a Kyoto* (Kyoto, 1983)

Scalia, F. and De Benedictis, C., *Il Museo Bardini a Firenze* (Milan, 1984)

Scamozzi, Vincenzo, *Dell'idea della architettura universale* (Venice, 1615)

Scappi, Bartolomeo, *Opera* (Venice, 1570: repr. Bologna, 1981)

Scappi, Bartolomeo, *Dell'arte del cuoco, del trinciante, e maestro di casa* (Venice, 1643)

Scerrato, U., *Arte islamica a Napoli* (Naples, 1967)

Schaefer, S., 'Io Guido Reni Bologna, Man and Artist', in S. Caroselli, ed., *Guido Reni 1575–1642* (Los Angeles, 1988)

Scheper, G. L., *The Spiritual Marriage: The Exegetic History and Literary Impact of the Song of Songs in the Middle Ages* (Princeton, 1971)

Scher, S., ed., *The Currency of Fame: Portrait Medals of the Renaissance* (New York, 1994)

Schiaparelli, A., *La casa fiorentina e i suoi arredi nei secoli XIV e XV* (Florence, 1908; repr., 2 vols, 1983)

Schiedlausky, G., 'Zum Sogenannten Flohpelz', *Pantheon*, VI (1972), pp.469–80

Schlereth, T., *Material Culture Studies in America* (Nashville, Tennessee, 1982)

Schmidt, V. M., 'Painting and Individual Devotion in Late Medieval Italy: The Case of Saint Catherine of Alexandria', in Ladis and Zuraw, eds, *Visions of Holiness: Art and Devotion in Renaissance Italy* (Athens, 2001), pp.21–36

Schmidt, V. M., *Painted Piety: Panel Paintings for Personal Devotion in Tuscany, 1250–1400* (Florence, 2005)

Schnapper, A., *Le géant, la licorne, et la tulipe. Collections et collectionneurs dans la France du XVIIe siècle* (Paris, 1988)

Schott, H., Baines, A. and Yorke, J., eds, *Catalogue of Musical Instruments in the Victoria and Albert Museum* (London, 1998)

Schottmüller, F., *Wohnungskultur und Möbel der Italienischen Renaissance* (Stuttgart, 1921a; repr. 1928a)

Schottmüller, F., *I mobili e l'abitazione del Rinascimento in Italia* (Turin, 1921b)

Schottmüller, F., *Die Italienischen Möbel und Dekorativen Bildwerke im Kaiser Friedrich Museum* (Stuttgart, 1922)

Schottmüller, F., *Furniture and Interior Decoration of the Italian Renaissance* (Stuttgart, 1928b)

Schreiber, W. L., *Handbuch der Holz- und Metalschnitte des XV. Jahrhunderts* (Leipzig, 1926–30)

Schreiber, W. L., *Die ältesten Spielkarten und die auf das Kartenspiel Bezug habenden Urkunden des 14. und 15. Jahrhunderts* (Strasbourg, 1937)

Schubring, P., *Cassoni: Truhen und Truhenbilder der italienischen Frührenaissance* (Leipzig, 1915)

Schulz, A. M., *The Sculpture of Bernardo Rossellino and his Workshop* (Princeton, 1977)

Schulz, A. M., *Giammaria Mosca Called Padovanino: A Renaissance Sculptor in Italy and Poland* (University Park, 1998)

Schulz, J., 'The Houses of Titian, Aretino, and Sansovino', in D. Rosand, ed., *Titian: His World and His Legacy* (New York, 1982), pp.73–118

Schulz, J., *The New Palaces of Medieval Venice* (University Park, 2004)

Schutte, A. J., '"Trionfo delle donne": tematiche di rovesciamento dei ruoli nella Firenze rinascimentale', *Quaderni storici*, XLIV (1980), pp.474–96

Schuyler, J., *Florentine Busts: Sculpted Portraiture in the Fifteenth Century* (New York and London, 1976)

Schweikhart, G., 'Piero de' Medici, Alberti und Filarete', in Beyer and Boucher, eds, *Piero de' Medici, 'il Gottoso': Art in the Service of the Medici* (Berlin, 1993), pp.369–85

Scotti Tosini, A., 'Milano', in *La maison de ville à la Renaissance. Recherches sur l'habitat urbain en Europe aux XVe et XVIe siècles*, Actes du Colloque (Paris, 1983), pp.71–5

Scotti Tosini, A., ed., *Aspetti dell'abitare in Italia tra XV e XVI secolo. Distribuzione, funzioni, impianti* (Milan, 2001)

Scuola salernitana del modo di conservarsi in sanità (Perugia, 1587)

Sebregondi, L., 'La tavola: desinari, feste e conviti nel Rinascimento fiorentino', in *Itinerari nella casa fiorentina del Rinascimento* (Florence, 1994), pp.47–63

Seidel Menchi, S., and Quaglioni, D., eds, *Matrimoni in dubbio. Unioni controverse e nozze clandestine in Italia dal XIV al XVIII secolo* (Bologna, 2001)

Sekules, V., 'Spinning yarns. Clean linen and domestic values in late medieval French culture', in McClanan and Encarnaçion, eds, *The Material Culture of Sex, Procreation and Marriage in Premodern Europe* (New York, 2001), pp.83–4

Semino, F., 'Gli strumenti della cucina', in *Sapore di Liguria: arte e tradizione in cucina* (Genoa, 1998), pp.101–19

Serlio, Sebastiano, *Regole generali di architettura* (Venice, 1537)

Serlio, Sebastiano, *The Five Books of Architecture* (London 1611; facs. ed. New York, 1978 and 1982)

Serlio, Sebastiano, *Architettura civile. Libro sesto settimo e ottavo nei manoscritti di Monaco e Vienna*, ed. F. P. Fiore (Milan, 1994)

Serlio, Sebastiano, *Sebastiano Serlio on Architecture: Books I–V of Tutte l'opere d'architettura et prospettiva*, ed. and trans. Hart and Hicks (New Haven and London, 1996)

Sermini, Gentile, *Le novelle* (Livorno, 1874)

Sforza Riario, C., *Ricettario di bellezza di Caterina Riario Sforza*, ed. L. Pescasio (Castiglione delle Stiviere, 1972)

Sframeli, M., ed., *Il centro di Firenze restituito. Affreschi e frammenti lapidei nel Museo di San Marco* (Florence, 1989)

Sgarbi, V., *Carpaccio* (Bologna, 1979)

Shahar, S., *The Fourth Estate: A History of Women in the Middle Ages* (London and New York, 1983)

Shearman, J., 'The Collections of the Younger Branch of the Medici', *Burlington Magazine*, CXVII (1975), pp.12–27

Sheridan, M. P., 'Jacopo Ragona and his Rules for Artificial Memory', *Manuscripta*, IV/3 (1960), pp.131–9

Shirley, R., *The Mapping of the World: Early Printed World Maps 1472–1700* (London, 1984)

Sigerist, H. E., *Landmarks in the History of Hygiene* (London, 1956)

Sighinolfi, L., 'Note biografiche intorno a Francesco Francia', *Atti e Memorie della Reale Deputazione di Storia Patria per le Romagne*, VI, 4th ser. (1916), pp.135–53

Sievernich, G. and Budde, H., eds, *Europa und der Orient 800–1900* (Berlin, 1989)

Sigismondi, Sigismondo, *Prattica cortigiana, morale et economica nella quale si discorre minutamente de' ministri, che servono in corte d'un cardinale e si dimostrano le qualità, che loro convengono* (Ferrara, 1604)

Silva, R., 'Strumenti musicali "alla greca e all'antica" nel Rinascimento', in S. Settis, ed., *Memoria dell'antico nell'arte italiana*, 3 vols (Turin, 1984), I, pp.361–72

Simon, A., *Bibliotheca gastronomica* (London, 1953)

Simons, P., 'Women in Frames: The Gaze, the Eye, the Profile in Renaissance Portraiture', *History Workshop Journal*, XXV (1988), pp.4–30

Singleton, C. S., ed., *Canti carnascialeschi del Rinascimento* (Bari, 1936)

Skelton, R. A., *Introduction to the Facsimile of the 1511 edition of Ptolemy's Geographia* (Amsterdam, 1969)

Slim, H. C., 'Music in Majolica', *Early Music*, XII (1984), pp.371–3

Slim, H. C., *Painting Music in the Sixteenth Century* (Aldershot, 2002)

Smith, A., 'Gender, Ownership and Domestic Space: Inventories and Family Archives in Renaissance Verona', *Renaissance Studies*, XII (1998), pp.375–91

Smith, A., 'Material Goods and Female Identity in Renaissance Palaces', in Lanaro, Marini and Varanini, eds, *Edilizia privata nella Verona rinascimentale* (Milan, 2000), pp.134–53

Sofonisba Anguissola e le sue sorelle (Milan, 1994)

Spallanzani, M., 'Vetri, ceramiche, e oggetti metallici nella collezione di Cosimo di Bernardo Rucellai', *Metropolitan Museum Journal*, XI (1976), pp.137–42

Spallanzani, M., 'Metalli islamici nelle raccolte medicee da Cosimo I a Ferdinando I', in *Le arti del Principato Mediceo* (Firenze, 1980), pp.95–115

Spallanzani, M., 'Un 'fornimento' di maioliche di Montelupo per Clarice Strozzi de' Medici', *Faenza*, LXXI/5-6 (1984), pp.381–7

Spallanzani, M., 'Fonti archivistiche per lo studio dei rapporti fra l'Italia e l'Islam: le arti minori nei secoli XIV–XVI', in E. Grube, ed., *Arte veneziana e arte islamica. Atti del primo simposio internazionale sull'arte veneziana e l'arte islamica* (Venezia, 1989), pp.83–100

Spallanzani, M., *Ceramiche alla Corte dei Medici nel Cinquecento* (Modena, 1994)

Spallanzani, M, ed., *Inventari Medicei, 1417–65* (Florence, 1996)

Spallanzani, M., *Ceramiche orientali a Firenze nel Rinascimento* (Florence, 1997)

Spallanzani, M., 'Maioliche Ispano-moresche a Firenze nei secoli XIV-XV', in S. Cavaciocchi, ed., *Istituto Internazionale di Storia Economica 'F. Datini', Prato. Serie II, Atti della 'Trentatreesima Settimana di Studi', 30 aprile–4 maggio 2000* (Florence, 2002), pp.367–77

Spallanzani, M., 'Maioliche Ispano-moresche a Firenze nel Rinascimento* (Florence, 2006)

Spallanzani, M. and Gaeta Bertelà, G., eds, *Libro d'inventario dei beni di Lorenzo il Magnifico* (Florence, 1992)

Speroni, Sperone, *Dialoghi* (Venice, 1596)

Speroni, Sperone, *Opere*, 5 vols (Venice, 1740; repr. Rome, 1989)

Spuhler, F., *Oriental Carpets in the Museum of Islamic Art, Berlin*, trans. R. Pinner (London and Boston, 1988)

Sricchia Santoro, F., ed., *Da Sodoma a Marco Pino: pittori a Siena nella prima metà del cinquecento* (Sienna, 1988)

Stanley, T., Rosser-Owen, M. and Vernoit, S., eds, *Palace and Mosque: Islamic Art from the Middle East* (London, 2004)

Statuta populi et communis Florentiae: publica auctoritate, collecta, castigata, et praeposita anno salutis MCCCCXV (Freiburg, 1778)

Steinberg, L., *The Sexuality of Christ in Renaissance Art and in Modern Oblivion* (Chicago, 2nd ed., 1996)

Stighelen, K. van der, '"Bounty from Heaven": The Counter-Reformation and Childlikeness in the Southern Netherlands', in Bedaux and Ekkart, eds, *Pride and Joy: Children's Portraits in the Netherlands 1500–1700* (Ghent and Amsterdam, 2000), pp.33–42

Stone, R., 'Antico and the Development of Bronze Casting in Italy at the End of the Quattrocento', *Metropolitan Museum Journal*, XVI (1981), pp.87–116

Stras, L., '"Al gioco si conosce il galantuomo": Artifice, Humour and Play in the Enigmi Musicali of Don Lodovico Agostini,' *Early Music History*, XXIV (2005), pp.213–86

Strocchia, S.T., *Death and Ritual in Renaissance Florence* (Baltimore, 1992)

Stroo, C. and Syfer-d'Olne, P., *The Master of Flémalle and Rogier van der Weyden Groups* (Brussels, 1996)

Strozzi, Alessandra Macinghi, *Lettere di una gentildonna fiorentina del secolo XV ai figliuoli esuli*, ed. C. Guasti (Florence, 1877)

Sturman, S., 'Interpreting the Bronzes: A Technical View', in Radcliffe and Penny, eds, *Art of the Renaissance Bronze 1500–1650: The Robert H. Smith Collection* (London, 2004), pp.297–309

Subbrizio, M., 'I materiali dallo scavo della casa di Brignano Frascata', in G. Pantò, ed., *Archeologia nella valle del Curone* (Alessandria, 1993), pp.239–47

Superbi, Agostino, *Apparato degli uomini illustri di Ferrara* (Ferrara, 1620)

Suriano, C. M., 'A Mamluk Landscape – Carpet Weaving in Egypt and Syria under Sultan Qaitbay', *Hali*, CXXXIV (2004), pp.95–105

Suriano, C. M. and Carboni, S., eds, *La seta islamica. Temi ed influenze culturali / Islamic Silk. Design and Context* (Firenze, 1999)

Syson, L., 'Consorts, Mistresses and Exemplary Women: The Female Medallic Portrait in Fifteenth-Century Italy', in Currie and Motture, eds, *The Sculpted Object,* 1400–1700 (Aldershot, 1997), pp.43–64

Syson, L., 'Holes and Loops: The Display and Collection of Medals in Renaissance Italy', *Journal of Design History*, XV/4 (2002), pp.229–44

Syson, L., 'Bertoldo di Giovanni, Republican Court Artist', in Campbell and Milner, eds, *Artistic Exchange and Cultural Translation in the Italian Renaissance City* (Cambridge, 2004), pp.96–133

Syson, L. and Thornton, D., *Objects of Virtue: Art in Renaissance Italy* (London, 2001)

Szabó, G., *The Robert Lehman Collection* (New York, 1975)

Tait, H., *The Golden Age of Venetian Glass* (London, 1979)

Tait, H., *Seven Thousand Years of Jewellery* (London, 1986)

Tagliaferro, L., *La magnificenza privata: argenti, gioie, quadri e altri mobili della famiglia Brignole Sale, secoli XVI–XIX* (Genoa, 1995)

Tagliente, Giovanni Antonio, *Libro maistrevole* (Venice, 1524)

Tanner, N., *Decrees of the Ecumenical Councils*, 2 vols (London, 1990)

Taübe, D. R., 'Zwischen Tradition und Fortschritt: Stefan Lochner und die Nierlande', in F. G. Zehnder, ed., *Stefan Lochner, Meister zu Köln: Herkunft, Werke, Wirkung* (Cologne, 1993), pp.55–67

Tawney, R. H., *Religion and the Rise of Capitalism: A Historical Study* (London, 1926)

Taylor, G., *Art in Silver and Gold* (London, 1964)

Taylor, G. and Scarisbrick, D., *Finger Rings from Ancient Egypt to the Present Day* (London, 1978)

Tempestini, A., *Giovanni Bellini* (New York, 1999)

Tenenti, A., 'Il mercante e il banchiere', in E. Garin, ed., *L'uomo del Rinascimento* (Rome–Bari, 1988)

Terni De Gregory, W., *Vecchi mobili italiani* (Milan, 1957)

Tezcan, H. and Delibas, S., eds, *The Topkapı Saray Museum – Costumes, Embroideries, and Other Textiles*, ed. and trans. J. M. Rogers (London, 1986)

The Rival of Nature: Renaissance Painting in its Context (London, 1975)

Theuerkauff-Liederwald, A.-E., *Mittelalterliche Bronze und Messinggefässe: Eimer – Kannen – Lavabokessel* (Berlin, 1988)

Thomas, A., *The Painter's Practice in Renaissance Tuscany* (Cambridge, 1995)

Thomas, K., *Religion and the Decline of Magic* (New York, 1971)

Thornton, D., *The Scholar in his Study: Ownership and Experience in Renaissance Italy* (New Haven and London, 1997)

Thornton, D., 'The Status and Display of Small Bronzes in the Italian Renaissance Interior', *The Sculpture Journal*, V (2001), pp.33–41

Thornton, P., 'Mobili italiani al Victoria & Albert Museum: parte seconda: il XVI secolo', *Arte illustrata*, III (1970), pp.116–25, 183–4

Thornton, P., 'Capolavori lignei in formato ridotto', *Arte illustrata*, V (1972), pp.9–12

Thornton, P., 'Cassoni, Forzieri, Goffani and Cassette. Terminology and its Problems', *Apollo*, CXX (October, 1984), pp.246–51

Thornton, P., 'The restello: what was it?', *Furniture History*, XXVI (1990), pp.174–82

Thornton, P., *The Italian Renaissance Interior: 1400–1600* (London and New York, 1991)

Thornton, P., *Interni del Rinascimento italiano* (Milan, 1992)

Tietzel, B., 'Neues vom "Meister der Schafsnasen": Überlegungen zu dem New Yorker Doppelbildnis des Florentiner Quattrocento', *Wallraf-Richartz Jahrbuch*, LII (1991), pp.17–42

Timofiewitsch, W, *Girolamo Campagna. Studien zur venezianischen Plastik um das Jahr 1600* (Munich, 1972)

Tinagli, P., *Women in Italian Renaissance Art. Gender, Representation, Identity* (Manchester and New York, 1997)

Tinti, M., *Il mobilio fiorentino* (Milan and Rome, 1928)

Toderi, G. and Toderi, F.V., *Placchette: secoli XV–XVIII nel Museo Nazionale del Bargello* (Florence, 1996)

Toesca, P., *La Casa Bagatti Valsecchi a Milano: arredi dal secolo XIV al XVI* (Milan, 1918)

Toffolo, S., *Strumenti musicali a Venezia nella storia e nell'arte dal XIV al XVIII secolo* (Cremona, 1995)

Torresi, A. P., *Il ricettario Bardi. Cosmesi e tecnica artistica nella Firenze medicea* (Ferrara, 1994)

Torriti, P., *La Pinacoteca Nazionale di Siena: i dipinti dal XV al XVIII secolo* (Genoa, 1980)

Traffichetti, Bartolomeo, *L'arte di conservar la sanità tutta intiera* (Pesaro, 1585)

Trexler, R. C., 'Florentine Religious Experience: The Sacred Image', *Studies in the Renaissance*, XIX (1972), pp.7–41

Trexler, R. C., 'The Foundlings of Florence, 1395–1455', *History of Childhood Quarterly*, I (1973), pp.259–84

Trexler, R. C., 'The Magi Enter Florence: The Ubriachi of Florence and Venice', *Studies in Medieval and Renaissance History*, I (1978), pp.129–218

Trexler, R. C., *Public Life in Renaissance Florence* (New York and Ithaca, 1980)

Trionfi Honorati, M., 'A proposito del "lettuccio"', *Antichità viva*, XX/3 (1981), pp.39–47

Tucci, U., *Mercanti, navi, monete nel cinquecento veneziano* (Bologna, 1981)

Tucci, U., 'Il documento del mercante', in *Civiltà comunale: libro, scrittura, documento, Atti del Convegno* (Genoa, 1989), pp.541–565

Turchini, A., *Ex-voto. Per una lettura dell'ex-voto dipinto* (Milan, 1992)

Turner, A., *Early Scientific Instruments: Europe, 1400–1800* (London, 1987)

Turner, S., *The Book of Fine Paper* (London, 1998)

Tuttle, R. J., 'La formazione bolognese', in R. J. Tuttle, ed., *Jacopo Barozzi da Vignola* (Milan, 2002), pp.114–17

Urbani de Gheltof, G. M., *I merletti a Venezia* (Venice, 1876)

Valcanover, F., *Ca' d'Oro. La Galleria Giorgio Franchetti* (Milan, 1986)

Valcanover, F. and Wolters, W., eds, *L'architettura gotica veneziana* (Venice, 2000)

Valeri, A. M., 'Gli scavi alla villa medicea di Cafaggiolo', *Faenza*, LXXXVIII (2002), pp.213–16

Valtieri, S., *Il palazzo del principe, il palazzo del cardinale, il palazzo del mercante nel Rinascimento* (Roma, 1988)

Vannini, G., Caroscio, M. and Degasperi, A., 'Dalla maiolica all'ingobbiata: il vasellame da tavola nella Firenze rinascimentale. Il contributo dello scavo di Cafaggiolo', *Faenza*, XCI/1–6 (2005)

Varaldo, C., *Maiolica ligure* (1994)

Varaldo, C., ed., *Archeologia urbana a Savona: scavi e ricerche nel complesso monumentale del Priamár. Palazzo della Loggia (scavi 1969–1989): i materiali* (Bordighera and Savona, 2001)

Varchi, Benedetto, *Opere…ora per la prima volta raccolte* (Trieste, 1859)

Vasari, G., *Le vite de' più eccellenti pittori, scultori ed architettori*, 9 vols, ed. G. Milanesi (Florence, 1878–85)

Vasari, Giorgio, *Le opere di Giorgio Vasari con nuove annotazioni e commenti*, ed. G. Milanesi (Florence, 1906; repr. 1973)

Vavassore, Zoan Andrea, *Esemplario di lavori* (Venice, 1530)

Vecellio, Cesare, *De gli habiti antichi, et moderni di diverse parti del mondo libri due* (Venice, 1590; repr. 1664)

Velluti, Donato, *La cronica domestica di Messer Donato Velluti, scritta fra il 1367 e il 1370, con le addizioni di Paolo Velluti, scritte fra il 1555 e il 1560*, ed. Del Lungo and Volpi (Florence, 1914)

Venturelli, P., *Gioielli e gioiellieri milanesi: storia, arte, moda: 1450–1630* (Milan, 1996)

Venturino, A., *Il coro intarsiato di San Domenico in Bologna* (Bologna, 2002)

Verga, E., 'Le leggi suntuarie e la decadenza dell'Industria in Milano 1565–1750', *Archivio storico lombardo*, XIII (1900), pp.49–116

Verga, E., *Storia della vita milanese* (Milan, 1931)

Verini, Giovan Baptista, *Luminario*, trans. A. F. Johnson (Cambridge and Chicago, 1947)

Vernon, W. W., *Readings on the Paradiso of Dante, Chiefly Based on the Commentary of Benvenuto da Imola* (New York, 1909)

Viale, V., *Gotico e Rinascimento in Piemonte* (Turin, 1939)

Vickery, A., *The Gentleman's Daughter, Women's Lives in Georgian England* (New Haven and London, 1998)

Vigarello, G., *Le Propre et le sale. L'Hygiène du corps depuis le Moyen Age* (Paris, 1985)

Vincenzo, Citaredo, *Contrasto di una madre con sua figliuola* (Modena, [1600?])

Vio, G. and Toffolo, S., 'La diffusione degli strumenti musicali nelle case dei nobili, cittadini e popolani nel XVI secolo a Venezia', *Il flauto dolce*, XVII–XVII (1987–8), pp.33–40

Visser Travagli, A., *Ceramiche a Ferrara in età estense dalla collezione Pasetti* (Florence, 1989)

Visser Travagli, A., *Ferrara nel Medioevo: topografia storica e archeologia urbana* (Casalecchio di Reno, 1995)

Vizani, Pompeo, *Breve trattato del governo famigliare* (Bologna, 1609)

Varagine, da see De Voragine

Wackernagel, M., *The World of the Florentine Renaissance Artist*, trans. A. Luchs (Princeton, 1981)

Walker, J., *National Gallery of Art, Washington* (Washington, 1995)

Ward, A. et al., *The Ring: From Antiquity to the Twentieth Century* (London, 1981)

Ward, R., 'Metallarbeiten der Mamluken-Zeit: Hergestellt für den export nach Europa', in Sievernich and Budde, eds, *Europa und der Orient 800–1900* (Berlin, 1989), pp.202–9

Ward, R., 'Incense and Incense Burners in Mamluk Egypt and Syria', *Transactions of the Oriental Ceramic Society 1990–1991*, LV (1992), pp.67–82

Ward, R., *Islamic Metalwork* (London, 1993)

Ward, R. et al., '"Veneto-Saracenic" Metalwork: An Analysis of the Bowls and Incense Burners in the British Museum', in Hook and Gaimster, eds, *Trade and Discovery – The Scientific Study of Artefacts from Post-Medieval Europe and Beyond* (London, 1995), pp.235–58

Warren, J., 'A Terracotta Bust of Lorenzo de' Medici in Oxford', *The Sculpture Journal*, II (1998), pp.1–12

Warren, J., *Renaissance Master Bronzes from the Ashmolean Museum, Oxford: The Fortnum Collection* (London, 1999), pp.1–12

Warren, J., '"The Faun who plays on the Pipes": A New Attribution to Desiderio da Firenze', in D. Pincus, ed., *Small Bronzes in the Renaissance*, *CASVA Symposium Papers*, XXXIX (Washington, 2001a), pp.82–103

Warren, J., 'Severo Calzetto detto Severo da Ravenna', in *Donatello e il suo tempo. Il Bronzetto a Padova nel quattrocento e nel cinquecento* (Padua, 2001b), pp.131–43

Warren, J., 'Bronzes in the Wernher Collection', *Apollo*, CLV (2002), pp.23–8

Warren, J., 'Sir Hans Sloane as a Collector of Small Sculpture', *Apollo*, CLIX (2004), pp.31–8

Watson, R., *Illuminated Manuscripts and their Makers* (London, 2003)

Watson, W. M., *Italian Renaissance Ceramics From the Howard I. and Janet H. Stein Collection and the Philadelphia Museum of Art* (Philadelphia, 2001)

Weale, W. H. J., *Bookbindings and Rubbings of Bindings in the National Art Library, South Kensington Museum*, 2 vols (London, 1894)

Wear, A., French, R. K. and Lonie, I. M., eds, *The Medical Renaissance of the Sixteenth Century* (Cambridge, 1985)

Wearden, J., 'Siegmund von Herberstein: An Italian Velvet in the Ottoman Court', *Costume*, XIX (1985), pp.22–9

Wearden, J., *Oriental Carpets and their Structure: Highlights from the V&A Collection* (London, 2003)

Wearden, J. and Standen, E., 'Early Modern Tapestries and Carpets, c.1500–1780', in D. Jenkins, ed., *The Cambridge History of Western Textiles* (Cambridge, 2003), pp.597–630

Weigelt, C., 'Das Neue Stadtmuseum in Florenz – Museo Civico Bardini', *Der Kunstwanderer*, VII (1926), pp.188–91

Weihrauch, H., *Europäische Bronzestatuetten. 15–18 Jahrhundert* (Brunswick, 1967)

Weinberg, G. S., 'D. G. Rossetti's Ownership of Botticelli's 'Smeralda Brandini' [sic]', *Burlington Magazine*, CXLVI (2004), pp.20–6

Weinstein, R., *Marriage Rituals Italian Style. A Historical Anthropological Perspective on Early Modern Italian Jews* (Leiden and Boston, 2004)

Weinstein, D., and Hotchkiss, V. R., eds, *Girolamo Savonarola: Piety, Prophecy and Politics in Renaissance Florence* (Dallas, 1994)

Weiss, F., 'Bejewelled Fur Tippets – and the Palatine Fashion', *Costume*, IV (1970), pp.37–43

Welch, E. 'Public Magnificence and Private Display: Pontano's *De splendore* and the Domestic Arts', *Journal of Design History*, XV (2002), pp.211–27

Welch, E., *Shopping in the Renaissance: Consumer Cultures in Italy, 1400–1600* (New Haven and London, 2005)

Wentzel, H., 'Mittelalterliche Gemmen in den Sammlungen Italiens', *Mitteilungen des Kunsthistorischen Institutes in Florenz*, VII (1953–6), pp.239–78

Wethey, H., *The paintings of Titian*, 3 vols (London, 1969–75)

Wiesner-Hanks, M., 'Women's History and Social History: Are Structures Necessary?', in Schutte, Kuehn and Seidel Menchi, eds, *Time, Space and Women's Lives in Early Modern Europe* (Kirksville, 2001), pp.3–16

Wilkins, D. G., 'Opening the Doors to Devotion: Trecento Triptychs and Suggestions Concerning Images and Domestic Practice in Florence', in V. M. Schmidt, ed., *Italian Panel Painting of the Duecento and Trecento* (New Haven and London, 2002), pp.371–93

Williamson, P., ed., *European Sculpture at the Victoria and Albert Museum* (London, 1996)

Wilmering, A. M., *The Gubbio Studiolo and Its Conservation. Italian Renaissance Intarsia and the Conservation of the Gubbio Studiolo* (New York, 1999)

Wilson, T., *Ceramic Art of the Italian Renaissance* (London, 1987)

Wilson, T., 'The Beginnings of Lustreware in Renaissance Italy', in *The International Ceramics Fair and Seminar* (London, 1996), pp.35–43

Wilson, T., 'Faenza Maiolica Services of the 1520s for the Florentine Nobility', in Chong, Pegazzano and Zikos, eds, *Raphael, Cellini and a Renaissance Banker: The Patronage of Bindo Altoviti* (Boston, 2003), pp.175–86

Wingfield Digby, G., *The Tapestry Collection: Medieval and Renaissance* (London, 1980)

Winston-Allen, A., *Stories of the Rose: The Making of the Rosary in the Middle Ages* (University Park, 1997)

Wisch, B. and Cole Ahl, D., eds, *Confraternities and the Visual Arts in Renaissance Italy: Ritual, Spectacle and Image* (Cambridge, 2000)

Wittmann, B., 'Der Gemalte Witz: Giovan Francesco Carotos "Knabe mit Kinderzeichnung"', *Wiener Jahrbuch fur Kunstgeschichte*, L (1997), pp.185–206, 381–388

Wolters, W., *La scultura veneziana gotica, 1300–1460* (Venice, 1976)

Woodward, D., 'Introduction', in *The World Maps by Joannes Ruysch and Bernardus Sylvanus* (Chicago, 1983)

Works of Art from the Wernher Collection (Christie's, London, 5 July, 2000)

Wraight, D., *The Stringing of Italian Keyboard Instruments c.1500–c.1650* (unpub. Ph.D. diss., Queen's University of Belfast, 1997)

Wraight, D., 'The Pitch Relationships of Venetian String Keyboard Instruments', in F. Seydoux, ed., *Fiori musicologi: studi in onore di Luigi Fernando Tagliavini* (Bologna, 2000), pp.573–604

Wright, A., *The Pollaiuolo Brothers: The Arts of Florence and Rome* (New Haven and London, 2005)

Xilografie italiane del quattrocento da Ravenna e da altri luoghi (Ravenna, 1987)

Yates, F. A., *The Art of Memory* (Chicago, 1966)

Yates, F. A., 'Lodovico da Pirano's Memory Treatise', in C. H. Clough, ed., *Cultural Aspects of the Italian Renaissance: Essays in Honour of Paul Oskar Kristeller* (Manchester, 1976), pp.111–22

Yetkin, S., *Historical Turkish Carpets* (Istanbul, 1981)

Zabata, Cristoforo, *Ragionamento di sei nobili fanciulle genovesi* (Pavia, 1588)

Zafran, E. M., *Fifty Old Master Paintings from The Walters Art Gallery* (Baltimore, 1988)

Zambrano, P., and Nelson, J., *Filippino Lippi* (Milan, 2004)

Zampetti, P., *Lotto* (Bologna, 1983)

Zampetti, P., *Carlo Crivelli* (Florence, 1986)

Zappella, G., *Le marche dei tipografi e degli editori italiani del Cinquecento*, 2 vols (Milan, 1986)

Zappaterra, B., 'I manufatti in osso ed avorio', in C. Guarnieri, ed., 'S. Antonio in Polesine. Archeologia e storia di un monastero estense', *Quaderni di archeologia dell'Emilia Romagna*, XII (Florence, 2005)

Zastrow, O., 'La collezione di bacili di ottone del XV e XVI secolo nelle Civiche Raccolte d'Arte Applicata del Castello Sforzesco', *Rassegna di studi e di notizie*, IX (1981), pp.473–603

Zastrow, O., *Museo d'Arti Applicate: oreficerie* (Milan, 1993)

Zehnder, F. G., ed., *Stefan Lochner, Meister zu Köln: Herkunft, Werke, Wirkung* (Cologne, 1993)

Ziliotto, B., 'Frate Lodovico da Pirano e le sue "Regulae memoriae artificialis"', *Atti e Memorie della Società istriana di Archeologia e Storia Patria*, XLIX (1937), pp.189–224

Zlatohlávek, M., *The Bride in the Enclosed Garden: Iconographic Motifs from the Biblical Song of Songs* (Prague, 1995)

Zorzi, L., *Carpaccio e la rappresentazione di Sant'Orsola* (Turin, 1988)

Zuffi, S., *Il ritratto: capolavori tra la storia e l'eternità* (Milan, 2000)

Zumiani, D., 'Modelli di edilizia privata veronese tra Gotico e Rinascimento: "case con cortile e scala a cielo aperto"', in Lanaro, Marini and Varanini, eds, *Edilizia privata nella Verona rinascimentale* (Milan, 2000), pp.307–25

Zupko, R.E., *Italian Weights and Measures from the Middle Ages to the Nineteenth Century* (Philadelphia, 1981)

Zuraw, S., 'The Medici Portraits of Mino da Fiesole', in Beyer and Boucher, eds, *Piero de' Medici 'il Gottoso' (1416–1469): Art in the Service of the Medici* (Berlin, 1993), pp.317–39

Zuraw, S., 'The Efficacious Madonna in Quattrocento Rome: Spirituality in the Service of Papal Power', in Ladis and Zuraw, eds, *Visions of Holiness: Art and Devotion in Renaissance Italy* (Athens, 2001), pp.101–21

Zurla, P., *Di Marco Polo e degli altri viaggiatori* (Venice, 1818)

PICTURE CREDITS

Illustrations have kindly been provided by the following individuals and institutions.

ITALY

Accademia di Belle Arti di Brera, Milan. Courtesy of the Ministero per i Beni e le Attività Culturali **p.144 and 23.1**

Accademia Carrara, Bergamo **8.10, 9.1**

Accademia Carrara, Bergamo © 1991, Photo Scala, Florence **1.1**

Alinari Archives, Florence **19.3**

Archivio di Stato di Firenze, Courtesy of the Ministero per i Beni e le Attività Culturali **2.3, 2.11**

Photograph by Arrigo Coppitz **15.21**

© Arsenale Editrice, Venice **4.3**

© Arti Doria Pamphilj, Rome **6.3**

Banca Monte dei Paschi di Siena, Collezione Chigi Saracini. Photograph by LENSINI, Siena **7.21, 14.11**

Photograph by Nicolò Orsi Battaglini **22.2**

Biblioteca e Raccolta teatrale del Burcardo, Rome **10.1**

Biblioteca Casanatense, Rome, ms. 4182, c. Courtesy of the Ministero per i Beni e le Attività Culturali **18.2**

Biblioteca Comunale dell'Archiginnasio, Bologna **16.12**

Biblioteca Medicea Laurenziana, Florence. Courtesy of the Ministero per i Beni e le Attività Culturali ms 12,19 **19.22**, ms 82,3 **19.23**

Biblioteca Nazionale Centrale, Florence, Fondo Nazionale. Courtesy of the Ministero per i Beni e le Attività Culturali B.R 142/1 **11.16**, II.I. 140, pp.69v–70r **19.15**

Biblioteca Nazionale Marciana, Venice. Photograph by Foto Toso **13.2**

Biblioteca Universitaria Alessandrina, Rome **16.11**

Drawings by Massimo Brusegan and Emilia Culiat (from the survey of Ca' Gussoni, by Giorgio Gianighian, 1983) **3.2**

Civiche Raccolte d'Arte Applicata, Milan. Photographs by Saporetti Immagini d'Arte S.n.c **1.4, 22.5**

Civica Raccolta delle Stampe "Achille Bertarelli", Milan. Photographs by Saporetti Immagini d'Arte S.n.c **p.102, 11.2, 15.11**

Diocesi di San Miniato, Treviso **21.7**

Gallerie dell'Accademia, Venice. Courtesy of the Ministero per i Beni e le Attività Culturali **13.18, 14.3, 20.10**

Galleria Franchetti alla Ca' d'oro, Venice. Courtesy of the Ministero per i Beni e le Attività Culturali **7.22, 8.1**

Istituto di Storia Economica, Università 'L.Bocconi', Milan **2.15**

Photograph by Giorgio Liverani **22.1**

Museo Archeologico e della Ceramica di Montelupo. Photographs by Alessio Ferrari **10.4, 11.5, 18.7, 23.10**

Museo Archeologico Nazionale, Florence. Courtesy of the Soprintendenza per i Beni Archeologici per la Toscana **12.7, 12.8, 15.12**

Museo Archeologico Nazionale, Naples. Courtesy of the Ministero per i Beni e le Attività Culturali **19.24**

Museo Bagatti Valsecchi, Milan Red Room **9.4**, Library **15.24**

Museo della Casa Trevigiana Ca' Da Noal, Treviso. Photograph by Luigi Baldin Fotografo d'Arte **10.2**

Museo del Castelvecchio, Verona. Photograph by Umberto Tomba **9.7**

Museo Civico Ala Ponzone - Pinacoteca, Cremona **1.17**

Museo Civico d'Arte Antica e Palazzo Madama, Turin **7.9, 14.8, 15.14** (bottom right)

Museo Civico di Feltre, Feltre **23.3**

Museo Civico, Pesaro. Permission granted by the City of Pesaro Museum Service **7.2**

Museo Civico, Pistoia © 1996, Photo Scala, Florence **8.6**

Musei Civici, San Gimignano © 1990, Photo Scala, Florence **6.2**

Musei Civici Veneziani, Armeria di Palazzo Ducale, Venice. Photographs by Fotoflash Mario **21.12, 21.13, 21.14**

Musei Civici Veneziani, Museo Correr, Venice. Photographs by Fotoflash Mario **p.32** and **5.1, 11.6, 11.8, 13.7, p.204** and **17.1, 20.15, 21.1, 21.3**

Musei Civici Veneziani, Museo del Vetro di Murano, Venice. Photograph by Fotoflash Mario **3.7**

Museo di Fucecchio, Fucecchio. Permission granted by the Curia Vescovile di San Miniato, Pisa **19.18**

Museo Horne, Florence **2.8, 7.18, 15.22**

Museo Internazionale delle Ceramiche, Faenza **15.5, 15.8, 15.9, 16.14, 18.10, 18.11**

Museo Nazionale Archeologico, Ferrara. Photographs by Orselli Sergio fotografia **11.11** (left), **23.6, 23.8, 23.12**

© Museo Poldi Pezzoli, Milan **7.19**

INDEX

Catalogue numbers are shown in **bold**.
Page numbers in *italic* relate to subjects
and topics mentioned in illustration
captions and give the page on which
the caption appears.

LIST OF CONTRIBUTORS

Marta Ajmar-Wollheim (PhD, Warburg Institute) is Renaissance Course Tutor at the V&A Museum, specializing in the Italian Renaissance. In 1996 she set up the Renaissance Decorative Arts and Culture MA within the V&A/RCA History of Design programme. She was Lead Scholar of *The Domestic Interior in Italy, 1400–1600*, a collaborative exhibition research project funded by the Getty Foundation, a contributing scholar to the AHRC Centre for the Study of the Domestic Interior and is initiator and co-curator of the exhibition *At Home in Renaissance Italy*. She has published on gender and material culture in the Renaissance and is currently co-writing with Flora Dennis a book on sources and approaches to Renaissance decorative arts.

Anna Bellavitis completed a PhD at the École des Hautes Études en Sciences Sociales, Paris. She has taught at the Universities of Tours and Lyon and, since 2001, has been Maître de Conférences in Early Modern History at the University of Paris, 10-Nanterre. She has published many essays about Venetian history and society during the early modern period, and her books include *Noale: Struttura sociale e regime fondiario di una podesteria nella prima metà del XVI secolo* (1994) and *Identité, mariage, mobilité sociale: citoyennes et citoyens à Venise au XVIe siècle* (2001).

Jim Bennett is Director of the Museum of the History of Science, University of Oxford. His research interests are in the histories of astronomy, practical mathematics and scientific instruments. He is preparing a catalogue of the mathematical instruments in the Museum of the History of Science

in Florence, a collection that originated in the Medici court.

Hugo Blake is Reader in Medieval Archaeology at the University of London. He teaches courses on the material world and material culture in the Department of History at Royal Holloway; his research focuses on medieval and early modern Italy. He is joint editor of the journal *Post-Medieval Archaeology*.

Fausto Calderai runs a professional art consultancy in Florence. He studied at the University of Florence and until 1982 was responsible for the Furniture Department at Sotheby's in Italy. He has published widely on decorative arts and in 1992 was one of the curators of an exhibition on Agostino Fantastici (Palazzo Pubblico, Siena). He is currently preparing a catalogue of the furniture and furnishings of the Isabella Stewart Gardner Museum in Boston.

Sandra Cavallo is Reader in Early Modern History at Royal Holloway, University of London. Her research interests are in family and gender history, health care, the body and welfare. Forthcoming publications include *Artisans of the Body in Early Modern Italy: Identities, Families, Masculinities* (2007) and *Domestic and Institutional Interiors in Early Modern Europe* (2007), co-edited with Silvia Evangelisti.

Isabelle Chabot (PhD, European University Institute) is a French researcher who lives and works in Florence, Italy. Specializing in the history of the family in the late Middle Ages, she is particularly interested in the position and identity of women within the domestic group.

Simone Chiarugi studied art history at the University of Florence. In 1994 he published *Mobilieri in Toscana 1790–1900* and in 2003 the catalogue of the furniture in the Museo Bagatti Valsecchi, Milan. He is in charge of his family's furniture restoration workshop, founded by his grandfather in 1928 within the ex-Convento della Madonna della Pace in Florence. The workshop specializes in fine furniture and works extensively for museums, private collectors and art dealers.

Anna Contadini is Senior Lecturer in the Arts and Archaeology of Islam at the School of Oriental and African Studies, University of London. Her specializations include the artistic and cultural contacts between the Islamic world and Italy. Publications include *Islam and the Italian Renaissance*, co-edited with C. Burnett (1999) and 'Le stoffe islamiche nel Rinascimento italiano dal XIV al XVI secolo', in *Intrecci Mediterranei* (ed. Daniela Degl'Innocenti, 2006).

Donal Cooper is a lecturer in History of Art at the University of Warwick, specializing in the sacred art and religious culture of Italy from the thirteenth to sixteenth centuries. He has published widely on the patronage of the Franciscan Order in Italy, and also contributes to the re-display of the Medieval and Renaissance Galleries at the V&A.

Elizabeth Currie is an independent scholar based in Milan. She was a curatorial assistant in the Furniture, Textiles & Fashion department at the V&A before completing her doctoral thesis, 'The Fashions of the Florentine Court: Wearing, Making and Buying Clothing 1560–1620', in

2004. She writes and lectures on early modern dress and textiles and is the author of *Inside the Renaissance House* (V&A, 2006).

Flora Dennis is a Research Fellow at the AHRC Centre for the Study of the Domestic Interior, having completed her doctoral thesis and lectured at the University of Cambridge. She has written on representations of domestic interiors for *Imagined Interiors* (V&A, 2006), published on music at the Ferrarese court, and written and broadcast on Italian Futurist music and musicians. She is a member of the editorial advisory board of the *Journal for the Society of Renaissance Studies* and is co-curator of the exhibition *At Home in Renaissance Italy*. She is currently co-writing with Marta Ajmar-Wollheim a book on sources and approaches to Renaissance decorative arts.

Patricia Fortini Brown is Professor of Art and Archaeology at Princeton University and was Slade Professor at the University of Cambridge. Her books include: *Venetian Narrative Painting in the Age of Carpaccio* (1988); *Venice & Antiquity* (1997); *The Renaissance in Venice* (1997) and *Private Lives in Renaissance Venice: Art, Architecture, and the Family* (2004).

Franco Franceschi is Professor of Medieval History at the University of Siena. A specialist in the history of urban Italy, he has published *Oltre il 'Tumulto': I lavoratori fiorentini dell'Arte della Lana fra Tre e Quattrocento* (1993) and numerous studies on work, guilds and the economic history of the thirteenth to sixteenth centuries.

Allen J. Grieco received his PhD from the École des Hautes Études en Sciences Sociales, Paris, with a

thesis on the historical anthropology of food in Renaissance Italy. He is currently Senior Research Associate at Villa I Tatti, and Assistant Director for Scholarly Programs. He has contributed widely to journals, has co-edited several collective volumes: *The Italian Renaissance in the Twentieth Century* (2002); *Ospedali e città: L'Italia del Centro-Nord, XIII-XVI secolo* (1997); *Dalla vite al vino: fonti e problemi della vitivinicoltura italiana nel medioevo* (1994); *Le Monde végétal (XIIe-XVIIe siècles): savoirs et usages sociaux* (1993) and published *The Meal* (1992). He is currently editor-in-chief of the journal *Food and Foodways* and on the editorial board of the journal *Food & History*.

Guido Guerzoni is Senior Lecturer in Early Modern History at the Luigi Bocconi University in Milan, where he obtained a PhD in Social and Economic History in 1996. He is especially interested in Italian Renaissance courts and the history of art markets, on which he has written books and articles including: *Apollo e Vulcano: i mercati artistici in Italia, 1400–1700* (2006); the forthcoming *Courtiers, Clients and Workmen, The Este Courts, 1450–1650* (2007) and, with Allen Grieco and Evelyn Welch, the volume *Riti, comportamenti, e stile di vita nell'Italia e l'Europa Rinascimentale.*

Stephanie Hanke is assistant at the Bibliotheca Hertziana (Max Planck Institute for Art History) in Rome. She completed a PhD at the University of Bonn on grottoes in Genoese gardens and palaces, and has published on Genoese grottoes and private baths and Italian art nouveau architecture.

Reino Liefkes was born in the Netherlands and studied Art History at Leiden University. Since 1992 he has worked at the V&A, where he now heads the Ceramics and Glass department. He is an expert on European glass, Italian maiolica and Dutch delftware, on which he has published articles, books and catalogues, and he also edited the V&A's handbook *Glass* (1997).

James Lindow completed his MA in the History of Art and Architecture at the University of East Anglia, and was the first Renaissance PhD from the RCA/V&A History of Design course. He lectures in the UK and overseas, and is currently fine art underwriter for AXA Art Insurance in London.

Sara Matthews-Grieco is Professor of History and Coordinator of Women's and Gender Studies at Syracuse University in Florence. She works on Renaissance and early modern history in Italy and France, with an emphasis on two areas of historical enquiry: the history of women, the family and sexuality, and the construction of social identity via early visual communications. She is author of *Ange ou diablesse: les représentations de la femme au XVIe siècle* (1991) and co-editor and contributor to *Picturing Women in Renaissance and Baroque Italy* (1997), *Monaca moglie serva cortigiana: vita e immagine della donna tra rinascimento e controrifroma* (2001) and *The Art Market in Italy: 15th–17th Centuries* (2003).

Elizabeth Miller is a curator in the Word & Image Department of the V&A, a member of the V&A's Medieval and Renaissance Galleries Project core team and author of *16th-century Italian Ornament Prints in the Victoria and Albert Museum* (1999). From November 2004 to August 2006 she was an Associate Director of the AHRC for the Study of the Domestic Interior.

Peta Motture is currently Chief Curator of the Medieval and Renaissance Galleries, opening at the V&A Museum in November 2009. She has published widely on medieval and later sculpture and was co-curator of the exhibitions *Earth and Fire* (Houston and London 2001–2) and *Depth of Field* (Leeds 2004–5).

Jacqueline Marie Musacchio is Associate Professor of Art at Vassar College. She specializes in the domestic art and material culture of the Italian Renaissance, and her publications include the award-winning book *The Art and Ritual of Childbirth in Renaissance Italy* (1999) and the forthcoming *Art, Marriage, and Family in the Florentine Renaissance Palazzo.*

Claudio Paolini is an Art Historian for the Soprintendenza per i Beni Architettonici of Florence. He has directed two projects for the European Commission on the study and valuation of traditional artistic techniques. As an expert in the history of furniture and furnishings he has taught at the Università degli Studi of Florence and Milan, and published numerous volumes including the furniture catalogue for the Museo Horne, Florence (2002), and papers on the Florentine house from the fifteenth to seventeenth century.

Brenda Preyer, Professor Emerita in the Department of Art and Art History at The University of Texas at Austin, has written extensively about Florentine palaces dating from 1300 until the early sixteenth century with respect to urbanism, architectural style, patronage, interior planning, decoration and restoration. Her book *Il Palazzo Corsi Horne* (1993) published Herbert Horne's Journal of Restoration, which became the point of departure for her own historical study of the palace and for her intensive study of Renaissance interiors.

Luke Syson is Curator of Italian Painting, 1460–1500 at the National Gallery, London. He worked previously at the British Museum (as curator of medals) and at the V&A. His publications include *Pisanello* (co-written with Dillian Gordon, 2001) and *Objects of Virtue: Art in Renaissance Italy* (co-written with Dora Thornton, 2001).

Jeremy Warren is Head of Collections at the Wallace Collection. He has written extensively on sculpture and the history of collecting. He is currently completing the catalogue of Medieval and Early Renaissance sculpture in the Ashmolean Museum, and beginning work on a new catalogue of sculpture in the Wallace Collection.

Rowan Watson is a Senior Curator in the National Art Library, part of the V&A's Word & Image Department. His interests include illuminated manuscripts and modern artists' books. He teaches on the MA in the History of the Book at the Institute of English Studies, School of Advanced Study, University of London.